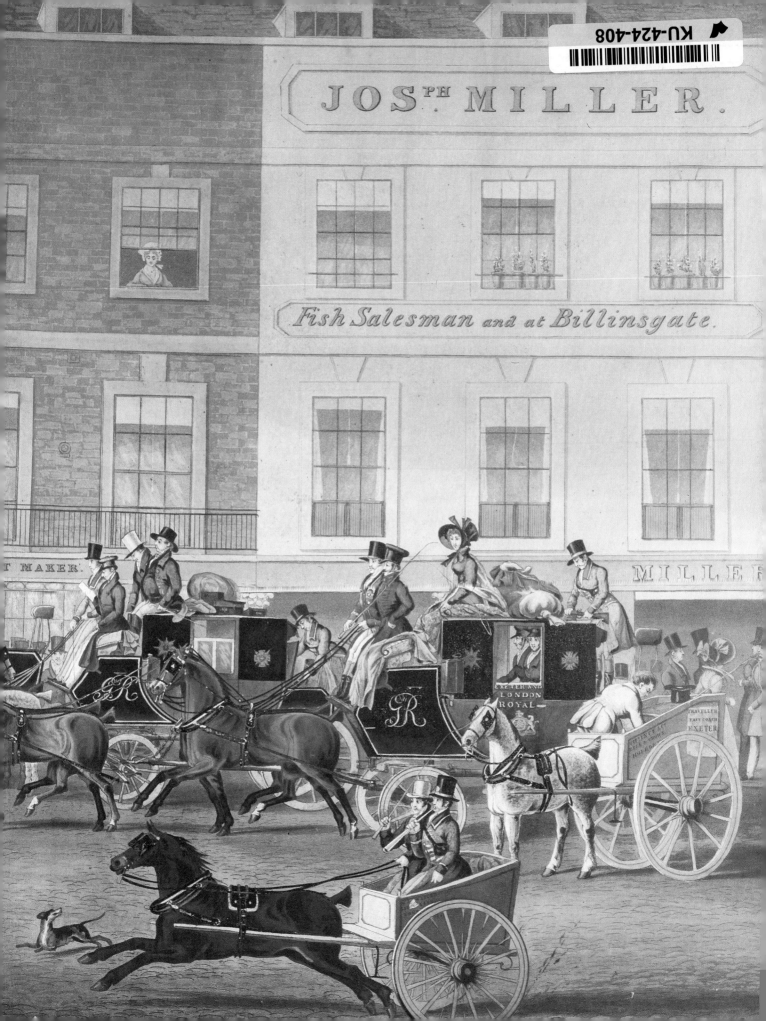

British PRINTS

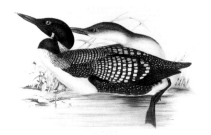

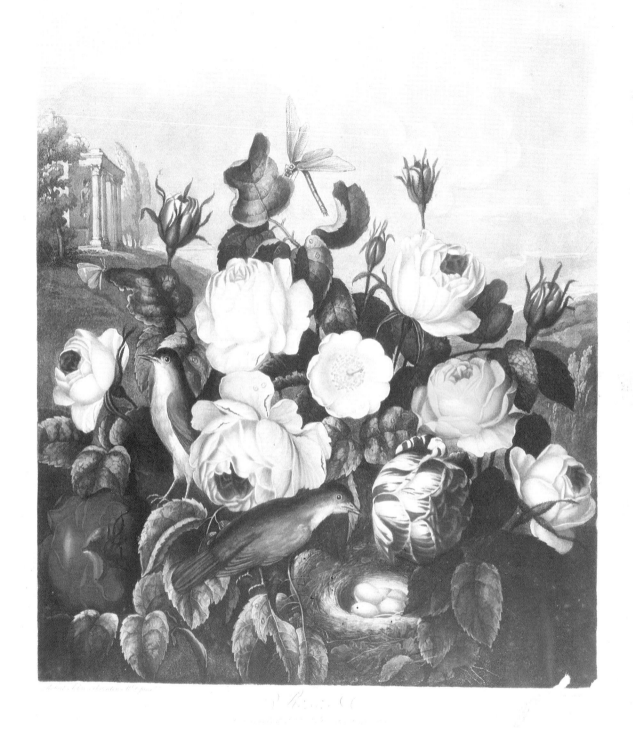

British PRINTS

DICTIONARY AND PRICE GUIDE

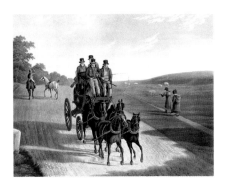

Ian Mackenzie

ANTIQUE COLLECTORS' CLUB

ISBN 1 185149 235 6

British Library Cataloguing-in-Publication Data
A catalogue record for this book is available from the British Library

Printed in England by the Antique Collectors' Club Ltd., Woodbridge, Suffolk IP12 1DS
on Consort Royal Era Satin from Donside Mill, Aberdeen, Scotland

Frontispiece: *EARLOM, Richard. 'Roses', after Dr R.J. Thornton, from Thornton's* Temple
of Flora, *1805, mezzotint, printed in colour. The most sought-after subject from this
popular series.*

Antique Collectors' Club

T HE ANTIQUE COLLECTORS' CLUB was formed in 1966 and quickly grew to a five figure membership spread throughout the world. It publishes the only independently run monthly antiques magazine, *Antique Collecting*, which caters for those collectors who are interested in widening their knowledge of antiques, both by greater awareness of quality and by discussion of the factors which influence the price that is likely to be asked. The Antique Collectors' Club pioneered the provision of information on prices for collectors and the magazine still leads in the provision of detailed articles on a variety of subjects.

It was in response to the enormous demand for information on 'what to pay' that the price guide series was introduced in 1968 with the first edition of *The Price Guide to Antique Furniture* (completely revised 1978 and 1989), a book which broke new ground by illustrating the more common types of antique furniture, the sort that collectors could buy in shops and at auctions rather than the rare museum pieces which had previously been used (and still to a large extent are used) to make up the limited amount of illustrations in books published by commercial publishers. Many other price guides have followed, all copiously illustrated, and greatly appreciated by collectors for the valuable information they contain, quite apart from prices. The Price Guide Series heralded the publication of many standard works of reference on art and antiques. *The Dictionary of British Art* (now in six volumes), *The Pictorial Dictionary of British 19th Century Furniture Design, Oak Furniture* and *Early English Clocks* were followed by many deeply researched reference works such as *The Directory of Gold and Silversmiths*, providing new information. Many of these books are now accepted as the standard work of reference on their subject.

The Antique Collectors' Club has widened its list to include books on gardens and architecture. All the Club's publications are available through bookshops world wide and a full catalogue of all these titles is available free of charge from the addresses below.

Club membership, open to all collectors, costs little. Members receive free of charge *Antique Collecting*, the Club's magazine (published ten times a year), which contains well-illustrated articles dealing with the practical aspects of collecting not normally dealt with by magazines. Prices, features of value, investment potential, fakes and forgeries are all given prominence in the magazine.

Among other facilities available to members are private buying and selling facilities and the opportunity to meet other collectors at their local antique collectors' club. There are eight in Britain and more than a dozen overseas. Members may also buy the Club's publications at special pre-publication prices.

As its motto implies, the Club is an organisation designed to help collectors get the most out of their hobby: it is informal and friendly and gives enormous enjoyment to all concerned.

For Collectors — By Collectors — About Collecting

ANTIQUE COLLECTORS' CLUB
5 Church Street, Woodbridge Suffolk IP12 1DS, UK
Tel: 01394 385501 Fax: 01394 384434

or

Market Street Industrial Park, Wappingers' Falls, NY 12590, USA
Tel: 914 297 0003 Fax: 914 297 0068

To my darling Suzie

<div align="center">⁕⁕⁕</div>

Acknowledgements

I am indebted to my friends and colleagues in the Print Department at Sotheby's whose support and assistance have been invaluable, including Richard Godfrey, Jonathan Pratt and Georgina Flint. Also to Konrad Jay for research. With special thanks to Deborah Scales, who has taken most of the photographs used. Acknowledgements also to Louise Nasson, Michael Campbell and Norman Blackburn.

Photographs courtesy of Sotheby's, Christie's South Kensington and Gordon Cooke.

Contents

Introduction to 1987 Edition

The aim of this book is to provide as comprehensive a list as possible of British printmakers working in the three centuries from 1650 to 1950, together with a brief description of their work, biographical details where known, and an idea of market values of specific works or general categories. The list also includes foreign printmakers who either worked in Britain during that period or who worked abroad but reproduced paintings by British artists.

In simple terms, a print can be defined by three elements: an image on paper, printed from the inked surface of a block, plate or stone, from which can be taken further copies of that image (impressions). This multiplicity is the crucial factor which distinguishes the printmaking medium from that of painting and drawing. For, after settling upon the image he requires, the print collector must always choose between the varying qualities of differently printed impressions, and then further decide to what extent the condition of the paper of a particular impression matters to him.

This book includes all those artists who worked by hand on a block, plate or stone to create an image but, with a few exceptions, does not contain information on those prints which have been mechanically or photographically produced.

Unlike some earlier books, I have attempted to cover not only the separate prints produced in the period but also illustrations executed for books (bookplates). There are a number of reasons for their inclusion. Firstly, since many printmakers produced both separate plates and bookplates, it would be difficult to decide which parts of an artist's *oeuvre* to include and which to leave out. Secondly, the collector will doubtless see many prints which were originally included in books but which have subsequently been taken out and framed. Thirdly, many prints were issued in book form by the publisher as a convenience to the purchaser (particularly in paper wrappers) but did not illustrate or accompany a text and were often intended to be framed. The collector has to accept, however, that there are dangers of omission in such a considerable extension of my original frames of reference. There are also the practical difficulties of valuing single plates extracted from a book which has an independent and perhaps completely different value to a book collector.

The printmakers listed can be divided roughly into two categories: 'original' printmakers who have been involved in the creative process from start to finish and who have both designed the image and executed the work on the block, plate or stone; and 'reproductive' printmakers who have been commissioned to reproduce an image or composition originated by another. Before the introduction of photomechanical processes towards the end of the nineteenth century, reproductions had to be made by hand, the printmaker copying the painting or drawing on to a block, plate or stone from which a number of impressions of the image could then be printed.

The development of several different printmaking processes from the late seventeenth through to the nineteenth centuries bears testimony to the huge rise in demand for accurate reproductions. This was fuelled by the burgeoning middle classes who wanted pictures to hang on their walls but could not afford to buy the original oils or watercolours, or who wanted representations of exotic places, costumes, plants and animals, as well as historical events such as naval battles, which they could not see for themselves.

Printmaking was the medium for the dissemination of popular images and, before the etching revival of the mid-nineteenth century, few printmakers concentrated solely on creating their own original works. Some of those who did were also successful painters, such as Gainsborough, Stubbs and Constable; they could afford to experiment with printmaking while not having to worry too much whether their prints were commercially viable. Other artists, such as Blake, were obliged by financial necessity to reproduce the designs of others in order to subsidise their original work.

While there is inevitably a preponderance of reproductive printmakers to be found in this book, there are enormous differences in the quality of the reproductions which they executed. It is often impossible to distinguish between, for instance, the engravers of the countless small topographical bookplates produced in the eighteenth and nineteenth centuries, while the aquatints of, say, William Daniell, whether reproducing his own designs or those of others. are unmistakably his hand.

The painters themselves were only too well aware of the potential benefit to their careers from successful representations of their works. For them it could lead to more commissions as well as higher fees, not only for the paintings themselves but also for the sale of copyright to

the paintings. Reynolds was quoted as saying that he had been immortalised by James MacArdell's mezzotint engravings of his works. Artists such as Turner and Constable would, therefore. take considerable pains to ensure that their work was being accurately represented by the printmaker. by closely following the progress of the engraving and making meticulous proof corrections.

Processes

Printmaking processes divide into three basic categories. In relief, which includes the woodcut, wood engraving and linocut, the flat printing surface stands above the remainder of the block which has been cut away. Lithography is a planographic process in which the printing surface is on the same level as the remainder of stone or plate which does not print because of chemical treatment. The remainder of the processes listed here are intaglio, in which lines are incised into a metal plate. Paper is laid over the inked plate which is then put into a roller press, and the action of the press forces the paper into the incised line, thereby picking up the ink.

Aquatint

A method of etching designed to imitate the tones of watercolours and wash drawings. It was introduced to England by P.P. Burdett in 1771 and the first major work to employ the technique was Paul Sandby's 'Views in South Wales', published 1774-5.

Its primary use was for reproducing topographical views and then, by extension, for naval, military and sporting subjects where the action would be contained in a seascape or landscape. Originally aquatints were often printed in sepia ink; later they would be commonly printed in black (or black and blue) and hand coloured with watercolour.

The copper plate is covered with a powdered resin which is fused by heat. The plate is immersed in acid which is repelled by the resin but which bites the spaces in between, so forming a granular texture. White areas are retained by painting on stopping-out varnish which prevents those areas from being bitten by the acid.

Crayon manner engraving

A method of etching which was first used in France in the 1750s and introduced to England by W.W. Ryland in the early 1760s. In order to imitate the texture of a chalk drawing, dotted lines are etched on to the copper plate using a roulette, a tool with a small wheel containing spikes. These lines could then be strengthened using the graver or burin. This method was principally used for 'fancy' subjects and was the precursor to the more common stipple engraving. Plates were often printed in red.

Drypoint

Lines are drawn on to the copper plate using a needle, but the plate is not bitten with acid as in the etching process. Early impressions characteristically display a rich burr which prints from ink caught by the ridge of metal thrown up when the lines are incised. This is quickly worn away. Drypoint was mostly employed in original rather than reproductive works.

Engraving

This term was commonly used to describe a variety of intaglio techniques but, in essence, means the incising of clear furrows on copper or steel using a graver or burin. a steel instrument, lozenge-shaped in section, with a wooden handle. The engraved line can be varied in width and depth by the angle at which the tool meets the plate and the amount of force with which it is pushed. The engraver could build up tones by placing lines very close together and then, for even darker areas, by laying a further pattern of lines at an angle over the first (cross-hatching). From the early eighteenth century it became increasingly common to etch the basic design on to the plate before finishing the work with the burin.

In the eighteenth and early nineteenth centuries, the technique was used for the largest and grandest reproductions of paintings by the major artists, and particularly for Italianate landscapes by Claude Lorrain, Poussin and Richard Wilson, as well as for representations of important contemporary naval and military engagements.

In the text, 'line engraving' has been used to differentiate the specific technique from the general term which has often been used to include all the intaglio techniques on metal.

Etching

Lines are drawn with a needle on to a metal plate, most commonly copper but also zinc or steel, which has been covered with a thin film of wax or varnish and then smoked so that the lines stand out clearly. When the plate is immersed in a solution of nitric acid, the lines exposed by the needle will be bitten down by the acid, while the remainder of the plate is protected by the wax. The strength of the line will depend on the solution of acid and the duration of immersion. If weaker lines are required, they can be 'stopped-out' using the wax or varnish.

The method was more appropriate for making original rather than reproductive prints, because the artist could freely draw his design straight on to the plate and, with the etching revival in the mid-nineteenth century, etchers such as Francis Seymour Haden would commonly sketch

with the needle on prepared plates in the open air. In the eighteenth and early nineteenth centuries, etching was more commonly used to establish the basic design of a reproductive engraving.

Lithography

Invented in 1798 by the Czech Aloys Senefelder, the process was brought to England at the very beginning of the nineteenth century and relies on the antipathy of grease and water. A drawing is made on limestone (later also zinc or aluminium) using a greasy lithographic crayon or ink. The stone is then treated with acid, gum arabic and water so that, when ink from a roller is applied, it adheres to the drawing but is repelled by the dampened surface of the remainder of the stone.

The technique had two main advantages over other printmaking processes. Firstly, an artist could draw directly on to the stone without restraint, and secondly, many more impressions could be printed than with intaglio techniques. In the first few years of the nineteenth century, a number of painters were encouraged to make drawings on stone and these were published as 'Specimens of Polyautography'. They were not a commercial success and it was not until the 1820s that the process became more widely used, mainly to reproduce topographical views.

Further colours could be printed using a different stone for each colour. But, in the second quarter of the nineteenth century, the majority of topographical lithographs were printed with an additional beige tone plate (tinted lithograph) and could then be hand coloured.

Mezzotint

In this technique, developed in Germany in the seventeenth century by Ludwig von Siegen, the engraver works from dark to light. The plate is completely covered with masses of tiny indentations using a multi-toothed device called a rocker. When inked, the plate would print a uniform dense black. Lighter areas are then 'scraped' by burnishing the plate in varying degrees so that less ink is caught by the smoother surface,

The technique was ideal for rendering the tones of oil painting and as such was used mainly for the reproduction of portraits as well as genre and decorative subjects. Painters much admired the rich velvety texture for representing their draperies. The major drawback, however, was that only about one hundred really fine impressions could be taken before the plate began to show wear.

Soft-ground etching

This technique provides the artist with a method of etching closer to pencil drawing. A sheet of paper is laid on a plate which has been prepared with a mixture of tallow and wax ground. The drawing is made on to the paper with a pencil which causes the ground to adhere to the paper. When the paper is lifted off, the drawing is then exposed and can be bitten in the normal way.

Used in the late eighteenth century, this technique was largely superseded by lithography which could more accurately reproduce pencil drawing and allow more impressions to be printed.

Stipple engraving

This technique was an extension of the crayon manner engraving, using the same tools and methods, but covering the whole plate with small dots and flicks to build up the full tonal range of an oil painting. The main outlines and such details as hair would commonly be etched in beforehand and a special curved burin was used for 'dotting' in addition to the etching needle and roulette.

Stipple was the main medium used for the popular 'furniture prints' which appeared in vast quantities in the late eighteenth century. Scenes from mythology, literature and history, both classical and contemporary, were specially adapted by artists such as Angelica Kauffmann and G.B. Cipriani, but the chief exponent of the style was Francesco Bartolozzi. The engravings were often designed as ovals or roundels and printed in sepia or red.

Woodcut

Here the plank of a soft wood, such as apple or pear, is cut with a knife along the grain. The areas cut away appear as white and the remaining areas upstanding when inked define the image. In the eighteenth and nineteenth centuries, apart from John Baptist Jackson's magnificent chiaroscuros, in which several blocks were employed, use of the process was restricted mainly to popular broadsheets. In the twentieth century a number of artists imitated Japanese colour woodcuts, but the major exponent in the medium was Edward Wadsworth.

Wood engraving

The same principle is used as in woodcutting, but engraving tools such as the burin are employed to incise lines into the end grain of a very hard wood such as boxwood. In the late eighteenth century Thomas Bewick used 'white line' for his natural history illustrations, but its principal use in the nineteenth century was for reproducing illustrations in books, magazines and periodicals. The artist would make his drawing on to the block and the engraver would then cut around his lines. It was revived as an original print medium by artists such as William Nicholson and Paul Nash.

Subject Matter
Portraits
Generally portraits as a collecting field are unfashionable and the values, therefore, will depend on such factors as the sitter, the artist or printmaker, the medium and the decorative qualities or otherwise of the print.

Few sitters, *per se,* are particularly sought after unless they were involved in an interesting activity, and this is especially true if they are actually depicted performing this activity. Examples might be a doctor treating his patient, a cricketer holding a cricket bat, a balloonist flying his balloon.

Some portraits, whoever the sitter is, will be more valuable than others because of who they are painted or engraved by.

The main media for portraits are etching, line, stipple and mezzotint engraving and lithography. Few portraits were engraved on wood or in aquatint. In the main, portraits etched, engraved in line or lithographed are likely to be worth little unless executed by an important artist. The value of portraits engraved in stipple depends on how decorative they are; they are more valuable if printed in brown or red or in colours. Mezzotint portraits are potentially the most valuable, and in the first thirty years of this century were the subject of a collecting mania, with some prints fetching the price of a small house. In this medium, the quality and condition of an impression are paramount, but the guidelines are as follows: female portraits are likely to be more valuable than male portraits because they are more decorative and, for the same reason, whole length subjects are more valuable than three quarter or half length. Again group portraits, equestrian portraits or those where the sitter is portrayed against an elaborate backdrop are likely to have increased decorative appeal.

Early mezzotint portraits from the late seventeenth century are rare and their freshness of technique make them particularly sought after. Mezzotints engraved on steel from the mid-nineteenth century onwards have a dull, mechanical quality and, unless the subject is decorative, attract few collectors.

Sport
The great age of the English sporting print stretches from the late eighteenth through to the mid-nineteenth century. The principal medium used was the aquatint engraving, a technique introduced from the Continent in the 1770s. Impressions taken from aquatint plates should be hand coloured with watercolour. From the 1820s impressions were often also partly printed in colours to reduce the amount of hand colouring needed.

Sporting prints have always been popular and consequently many plates were reprinted, but because they were designed as decorations to be framed and hung, many impressions have suffered light- and backboard-staining and other worse damages over the years. Early impressions with good unfaded colour have, therefore, become increasingly rare. The intending collector should be aware that he is more likely to come across reprints which to the untutored eye look little different to impressions from the first edition (see pages 22 and 38), but which may only be worth a fraction of the value of the latter.

Aside from separate plates, such as racehorse portraits, sporting prints were generally issued in sets of four, six, eight or even twelve. Incomplete sets are worth a fraction of the value of a full set, although individual plates from a set will have different values according to their decorative qualities. For example, from a set of foxhunting, 'Full Cry' will be much easier to live with than 'The Death of the Fox'.

Different sports attract different collectors in different numbers and it follows that values will differ correspondingly. Rarity of prints of a particular sport, however, will also have an effect. For example, there are few prints of golf, cricket, tennis, rowing or football subjects from the eighteenth and nineteenth centuries, and those which appear can be very expensive, even when the quality is poor. A rough order of desirability is as follows:

1. Golf	6. Boxing	11. Fox Hunting
2. Cricket	7. Fishing	12. Deer Hunting
3. Tennis	8. Horse Racing	13. Coursing
4. Rowing	9. Shooting	14. Bear Baiting
5. Football	10. Steeple Chasing	15. Cock Fighting

Caricatures
The main medium for caricatures was etching and the plates were usually both designed and etched by the caricaturist. In the classic period from the 1790s to the 1820s, the best known names are James Gillray. Thomas Rowlandson and George Cruikshank, but there is a host of other names, mostly following or influenced by these three giants.

Caricatures divide into two main categories: political and social. The values of political satires will normally depend on the fame of the figure lampooned, but today, because the subject matter of political satires is likely to be obscure and need researching, they are less desirable to the collector and so often less valuable than social satires. These latter, depicting, for instance, the incompetence of the medical or legal professions, absurd new fashions, incredible scientific developments or the cuckolding of

husbands, are immediately understandable, and not only to English speakers. From the 1780s these etchings are usually found hand coloured with watercolour. Uncoloured examples, which are not so decorative, are worth little unless the subject is important or unusual.

From the mid- to late eighteenth century a number of caricatures in mezzotint also appeared. Most of these were engraved anonymously, merely bearing the publisher's address, and the drawing is often rather crude. Impressions of these mezzotints are sometimes found with thick gouache colouring.

Topographical views

Values depend primarily on the place depicted. Currently Australia, Hong Kong, the Americas, the West Indies, Greece and Switzerland are the most sought after locations, followed by West Germany, India, Scandinavia and Italy.

In the United Kingdom, London is followed by the industrial cities and ports of the Midlands and the North, then cities such as Brighton and Bath.

Transport

Coaching, railways, shipping and ballooning are all different collecting fields. Amongst coaching subjects, the most sought-after prints have always been the aquatints by or after James Pollard, covering the period just before the railways began to compete as the principal means of transport. In the mid-1980s the later aquatints after the Victorian artist William Shayer attracted higher prices.

Most railway prints were issued in book form. Some of these sets are rarer than others. T.T. Bury's 'Coloured Views on the Liverpool and Manchester Railway' are relatively common compared to his 'Coloured Views on the London and Birmingham Railway', which are very rare. Aquatints, therefore, from these two sets will have a different value, although the engraver is the same and the subject matter similar. Complete sets will command a premium.

There are three broad categories of shipping and naval subject, according to period and medium: the uncoloured etching and line engraving of the mid-eighteenth century, engraved by P.C. Canot, D. Lerpinière and others after such artists as R. Paton and D. Serres; the coloured aquatint of the early nineteenth century whose best known exponents were Robert Dodd, artist and engraver, and Edward Duncan, engraver of paintings by the marine artist William Huggins; and the mid-nineteenth century coloured-tinted lithograph, whose most famous exponent was Thomas Goldsworth Dutton.

Natural history subjects

These prints are collected mainly for their decorative appeal, and the price therefore depends on how colourful the subject is as well as the size, though rarity and national importance (for instance Audubon's 'Birds of America', engraved by R. Havell) will also affect the value. The main categories seem to be botanical and ornithological, and the vast majority of the plates come from eighteenth and nineteenth century scientific books which have, over the years, regrettably been broken up. There are a few smaller but highly desirable collecting fields such as prints of dogs.

Identification of prints

Very often, all the information needed for identifying a print can be found on the print itself, either from details or a signature engraved or lithographed within the subject, or contained below the subject in an inscription space, or, in the case of original prints from the mid-nineteenth century onwards, from a signature inscribed in pen or pencil below the subject.

The Engravers' Copyright Act of 1735, championed by Hogarth to protect the printmaker's or printseller's copyright, made it compulsory to include the publisher's name, address and the date of publication in the inscription space below the subject. However, it had already been customary before then to include not only those details but also the painter's and engraver's names.

Generally the painter's or draughtsman's name appears on the left just below the subject: 'Painted by Francis Grant', 'J. Reynolds pinxit/pinx. [painted]', 'G. Stubbs invenit/inv. [designed]', 'T. Gainsborough delineavit/ delin./del. [drew, but can also mean etched or lithographed]'; and the printmaker's name on the right: 'Engraved by William Blake', 'Edwd. Rooker sculpsit/sculp. [engraved]', 'W. Pether fecit/fec. [made]'; where the printmaker both designed and executed the work himself, the inscription might appear on either side: 'Drawn on the Spot and Etched by J.T. Serres', 'P. Sandby del. et fec. [drew and made, i.e. etched], 'L. Mansion inv. et del. [designed and drew on the stone, i.e. lithographed]'.

The publication line normally appears in the centre, either just below the subject or along the bottom of the inscription space below the title. Very often the work was dedicated by the printmaker or printseller to the sitter if a portrait, to the owner of the original painting, to the owner of the house painted, or to anyone else to whom he might feel indebted. A typical inscription might, therefore, read as follows: 'To William, Duke of…This View of…is most humbly dedicated by his Lordship's obedient servant…' For the purposes of identification of

prints, the dedication is usually irrelevant, but it may have to be read to ascertain the title or printmaker's or printseller's name.

Decorative prints from the eighteenth and early nineteenth centuries were often cut down to the subject for a variety of reasons. Firstly, since glass was very expensive and prints were relatively cheap, it was not thought worth the expense of framing the inscription space, which could be cut off and pasted on the back of the frame. Secondly, hand-coloured prints might be cut down so as to imitate the original watercolours from which they were taken. Thirdly, the stipple engravings of the school of F. Bartolozzi were often designed to be cut down to ovals or roundels; these popular 'furniture prints' could then be hung by the fireplace or in bedrooms.

The removal of the inscription space may make identification more difficult, but it should be remembered that for today's collector any loss of the printed surface is considered a major damage which would reduce the value of the print substantially.

Original prints, those designed and executed by the artist, from the later nineteenth century onwards might be signed 'in the plate' (within the subject), in which case every impression will bear the same printed signature, or each impression from an edition might be individually signed by the artist in pencil or pen below the subject. Identification is, therefore, possible provided that the signature can be read correctly.

Impressions of both original and reproductive prints dating from the turn of the century should in general be individually signed by the artist. Unsigned impressions or impressions which have had the margins cut off so losing the signature will have a value considerably less than signed impressions. Of course, there are major exceptions. Walter Sickert, for example, often did not sign impressions of his etchings.

Many prints have been reprinted, copied or reproduced photographically due to the popularity of the image. For every genuine impression of 'The Cries of London' after Francis Wheatley, I have probably seen several hundred copies or reproductions. Since the reprints, copies or reproductions often include a facsimile of the original inscription with the details of the engraver's name, date of publication, etc., the aspiring collector should satisfy himself that he is purchasing a genuine impression from the plate. Unfortunately, it is not within the scope of this book to inform the collector how to tell the difference between the first issue of a print and the reprint or reproduction. It is a matter of visual experience gathered from examining the genuine article in auction rooms, dealers' premises or at museums.

Principles of evaluation of prints

The values of two impressions of the same print will differ if there are differences between them in the quality of printing or in the condition of the paper on which they are printed.

In general, earlier impressions are superior to later impressions because the block, plate or stone will have suffered less of the wear and tear involved in the printing process. However, whereas woodblocks might show little wear after several thousand printings, the various methods of etching and engraving on copper will wear away the plate at different rates. Over five hundred good impressions could be printed from an etching, but perhaps only fifty really fine impressions could be taken from a mezzotint before the rich, velvety texture began to disappear. Aquatints would begin to lose background details after only a few hundred printings.

If a print or a series of prints was popular, the publisher or printseller could reprint it, having had any worn areas retouched. A plate could survive several further printings if skilfully retouched, the publisher sometimes employing the original engraver to do the job. Hogarth's plates, for instance, were retouched several times throughout the late eighteenth and early nineteenth centuries and eventually 'restored' by James Heath c.1820.

Popular sporting aquatints of the early nineteenth century were reprinted many times, even into the twentieth century; in the latest impressions, virtually all the aquatint ground has gone and the compositions are held together merely by heavily re-etched lines and hand colouring. By contrast, Iain Bain in 1972 was able to obtain very good impressions from Gainsborough's aquatint plates which showed little wear, due partly to their lack of popularity at the time of publication in the 1790s and partly to their careful preservation in the intervening period.

The invention of the steel plate in 1822 meant that printsellers could produce several thousand impressions of an engraving without any significant decrease in quality of impression or loss of detail. Previously, the number of impressions had been limited ultimately by the softness of the copper.

From the eighteenth century connoisseurs had begun to attach a cachet to 'proof' impressions which were trials printed by an engraver to see how the work was progressing. These were considered to be superior because they were taken from the plate before the edition was printed and so showed no wear. However, even in the eighteenth century, printsellers printed more 'proofs before letters', or 'proofs with scratched letters', than they needed in order to take advantage of the collectors'

preference; they would then charge more for these so-called 'proofs' which sometimes looked as worn as the published edition.

By the 1840s it was possible to print from the new steel plates large numbers of proofs which showed no wear at all. In order to protect their prices (generally between four and fifteen guineas for proofs, compared with one or two guineas for ordinary prints), the printsellers decided amongst themselves to limit the printing of proof impressions to an openly declared number. The size of the edition would be notified to the Printsellers' Association, formed in 1847, often with the promise that the plate had been destroyed after printing. To add a further cachet to the proofs before letters, which after all did not look qualitatively different from the lettered prints, publishers began to ask the painters and engravers to sign their names in the blank space below the subject. From this time on it became customary for printmakers to sign all impression in pen or pencil and this represented the artist's approval of the printing of the particular impression. Notable exceptions to this custom include J.A.M. Whistler who signed most of his Venetian subjects with his butterfly monogram but otherwise only rarely signed impressions of his prints. In later life Seymour Haden, so the story goes, would charge a guinea to collectors for signing impressions which had originally been issued unsigned. By the 1920s the individual signing of original prints had become mandatory. and the individual numbering of impressions to show the edition size was also common.

Condition and rarity

Apart from the quality of printing, the other major factor which differentiates one impression of a print from another is the physical condition of the paper. An impression in good condition should have a surface unblemished by stains or dirt, and should have a margin of blank paper beyond the printed surface. The paper should not have suffered any tears or losses and should only be affixed to a mount with paper hinges.

Staining can be caused by the paper coming into contact with water or other liquids, mounting materials, such as cardboard, glue and wooden back boards, as well as by direct sunlight. (The little brown spots – foxing – occur when elements in the paper react to changes in the atmosphere.) The damage caused by staining depends on how easily stains can be removed by cleaning. In the case of handcoloured prints, even if stains can be removed, the cleaning process may affect the colour and this should be taken into account.

Tears or losses can always be repaired or restored, although to the print collector they will always be there, albeit concealed. The seriousness of the damage will depend on where the tears or losses have occurred: within the subject, in the Inscription space below or in the margins.

Margins were often cut off in the past when prints were being mounted or framed. Loss of the margins is considered a much more serious defect in the case of original prints of the twentieth century, presumably because the collector will have a greater opportunity of finding another impression with its margins still intact. Older engravings which have lost the margins but still carry the platemark (the indentation produced as a result of pressure when the plate is printed) can be prized nearly as highly as those impressions with margins provided that they have suffered no other damage. Unlike the collector of paintings who must take the particular image he wants in whatever condition he finds it, the print collector has a choice of either paying less for an impression in poor condition, or alternatively waiting for another in better condition to come on to the market, for which he would have to pay more.

The decision whether to wait or not will, to a large extent, be governed by the rarity of the print. A collector, for instance, may decide to buy a damaged impression of an extremely rare print now because he considers the chances of finding another in better condition in his lifetime very remote. On the other hand, the chances of obtaining an impression in good condition of a print published a few years ago in an edition of, say, 75 would be very high. The rarity of a particular print will depend on the number of impressions taken from the plate or stone as well as how old it is.

While today it makes commercial sense for the printer to run off an entire edition before the print is offered to the public, in the days before the introduction of the limited edition, printsellers would only print as many impressions as they could sell. If a print did not find favour with the public, therefore, few impressions would be taken and such a print would very likely be rare today. The engravings of both George Stubbs and Thomas Gainsborough, for example, were much less popular than those engraved by others after their paintings and consequently are all rare.

A print's scarcity may also be due to the deliberate destruction of a number of impressions, or even the entire edition, by an artist or printmaker who was not satisfied with the work or by the authorities attempting to censor or suppress a work for political or moral reasons. Several of Gillray's caricatures, for instance, were considered to have overstepped the mark, and at one time the satirist was even bribed to stop lampooning one political party. Edwin Landseer once bought up and destroyed all the impressions of an engraving by J.C.

Zeitter after one of his paintings, 'The Dancing Lesson', because he did not want to be known for his depiction of extreme cruelty.

The inevitable losses of or damages to prints over the years due to accidents, mishandling, changes in fashion or other reasons mean two things. Firstly, the older the print is, the fewer impressions are likely to have survived; and secondly, even if a print is common because many impressions were printed at the time or later, the more difficult it will be to find an impression in good condition.

Prices

The prices given are for good impressions of the prints listed in good condition, sold at auction. A particularly fine impression could fetch considerably more if it attracts those collectors who would not normally bother with ordinary impressions. Similarly, a poor impression or one in poor condition will attract few buyers. Good condition does not necessarily mean perfect, but without serious damage such as stains, tears or losses within the subject.

Auction prices may well be much less than retail prices. This reflects the fact that auctioneers are often obliged, because of cost and convenience, to dispose of portfolios or parcels of mixed prints. The retailer meanwhile carries a standing stock with a large choice. In other words, the collector may be able to buy a print estimated in this book at, say, £5, if he also buys a large quantity of items he does not necessarily want, but he would probably have to give the specialist stockist £8, £10 or £15 for the individual print.

Finally, where prices are given for works either hand coloured or printed in colours, it should be assumed that prices for the same prints uncoloured will be less. How much less depends on the medium and the subject matter. Decorative stipples and sporting aquatints if uncoloured are generally worth between a quarter and a tenth of coloured impressions. But a very fine impression of a mezzotint portrait could easily be worth nearly as much as an impression printed in colours.

See also 8 below.

How to read the entries in the Dictionary (pp. 73-367)

1. Artist's name: surname, forenames or initials where known; alternative initials and spelling or pseudonym in brackets.
2. Precise dates of birth and death where known, otherwise approximate period of creativity.
3. Principal and subsidiary media in which printmaker worked.
4. Main subject matter in which printmaker worked.

5. If the printmaker has executed reproductions of other artists' works, the word 'after' is used to denote from which categories of artist he has taken the designs of his prints, e.g. Old Master painters, his contemporaries,
6. Brief biographical details where known, including place of birth, family if relevant to career, main training, places where artist lived and worked. If artist is better known for his work in another medium, e.g. as a painter or watercolourist, less emphasis has been given to biographical details which will be available in other specialised works mentioned in the Bibliography at the end of the book, and more attention paid to the artist's printmaking.
7. Details of works. (The listing below gives a general indication of the details which may be included. In some cases other information may also be given; for instance, rarity, the process used, whether the sitter is shown half, three-quarter, or full length in a portrait, etc.)
 (a). Title or description.
 (b). Painter or designer after whom the print is taken, if applicable.
 (c). Date: the year in which the work was executed if known, otherwise the year of publication.
 (d). If a set, the number of plates.
 (e). Where possible, the size given is the size of the plate or block, or, if a lithograph, the size of the printed surface to the nearest ¼in./.5cm. However, because I have often been unable to measure the prints myself or have been unable to locate a recent record, I have had to take measurements from old reference works, which may not have used the same criteria. Measurements, therefore, should be treated with caution as a rough guide to size and not necessarily as definitive. In the case of prints issued in book form, I have given traditional book sizes: folio, 4to., 8vo., etc.
 (f). If the example is coloured or printed in colours, this is denoted after the price. If no indication, the print is not coloured.
 (g). References to relevant works and *catalogues raisonnés* are indicated at the end of the entry. I have not listed all for a particular artist but only those which I consider to be the most comprehensive or most recent.
8. Prices.
 (a). If all the printmaker's works, whatever the subject, size or medium, are worth less than £5, no details will be given and the phrase 'small value' is used.
 (b). If the printmaker worked in a single genre, e.g. landscapes, which are all roughly the same value, no details will be given and one price band will be noted, e.g. '£20-£50'.

(c). If the printmaker executed one or two, or a very few, prints, full details will be given where possible of each work, together with individual prices.

(d). If the printmaker worked in different media, or produced different subjects, specific examples or categories will be given to show the range in values. This is particularly necessary in the case of printmakers making reproductions, who may have been commissioned to produce widely-differing subject matter. The reader can assume that a work which is similar in subject size and colour, as well as date of printing, will have a similar value to one listed.

The market for British prints during the twentieth century

While there has been a consistent demand throughout the period in certain areas, such as sporting prints where fine examples of early impressions or first editions have always made relatively good prices, the market as a whole has undergone extreme fluctuations.

In the early part of the century, there was a considerable vogue for portraits and decorative subjects from the late eighteenth and early nineteenth centuries. Prices in two figures for good impressions were common before and after World War I, but fine examples of famous subjects could make several hundred pounds and some first states made over £1,000. Possibly the highest price achieved in the period was £3,045 for 'The Ladies Waldegrave', after Reynolds by Valentine Green.

Interest in modern etchings had steadily increased from the turn of the century but reached a fever pitch in the md-1920s. Subscribers to new etchings by the best-known artists of the day could put their prints into auction at Sotheby's and within a few months make a profit of several times the issue price. The wild speculation which forced the prices up so dramatically within a few years meant that etchings were treated like stocks and shares and, when the Wall Street crash occurred in October 1929, confidence in the etching market also dissipated and prices crumbled. This coincided with a change of fashion in the market for portraits and decorative prints, and it is probably true to say that for nearly forty years, from the early 1930s to the late 1960s, most British prints, whoever the artist and whatever the subject, quality of impression or condition, could be acquired for a very few pounds or less.

The reappraisal which came in the 1970s reflected not only the realisation of the increasing scarcity of pictorial works of quality which had already been noted in the market for British, and in particular Victorian, paintings, but also a new appreciation of the merits of British printmaking in its own right, which had been disregarded for so long. However, in the field of portraits and decorative prints, the previous obsession with states was no longer of paramount interest to the new breed of collector and dealer, who was more concerned with the actual quality of an impression and its condition rather than its hypothetical excellence. Many of the mezzotints which had been so highly prized because they were first states or early proofs were found to have been treated appallingly in the days before proper paper conservation was understood, and had been glued into cardboard mounts, ironed flat, had their spots retouched, and so on. This fact, allied with the probable destruction of countless prints during the long period of neglect, has meant that fine impressions in good condition are now very rare and fetch prices many times the value of a poor or damaged impression.

Similarly, amongst original British prints, the emphasis has been away from the 'blue-chip' names of the 1920s, such as Bone, Cameron, Briscoe and McBey, and attention has instead focused not only on those artists who were innovative in technique or imaginative in vision, but also on those who drew inspiration from modern continental movements. While prices for the above four etchers have been bumping along in the lower hundreds or less, works by the Vorticists, C.R.W. Nevinson and Edward Wadsworth, and the linocut artists of the Claude Flight school have been soaring into the thousands.

After the sharp rises of the early to mid-1970s, prices for British prints generally have failed to keep pace with inflation. The main beneficiaries have been those prints which have appealed to foreign, and particularly American, buyers, such as the above-mentioned Vorticists and linocut artists as well as earlier original prints by well-known British artists such as Stubbs, Gainsborough and Blake, and incunabula such as early lithographs. Otherwise, the only prints to have made large percentage gains have been large Victorian reproductive engravings, but then a £1 print which has risen 1,000 per cent is still only worth £11.

Ian Mackenzie
May 1987

Introduction to 1998 Edition

It is just over eleven years since *British Prints* first appeared and it is now time to review the changes that have occurred in the print market in the period since 1987. Prices generally have remained stable for 'reproductive' works, including sporting, decorative and topographical prints, while at the top end of the market in 'original' prints, there has been an encouraging upward movement and many Modern British prints have doubled in value. Where prices for works of printmakers have changed little since 1987, details have not been included in this update.

Auction house figures tend to obscure this picture. Sales of British prints in all categories have sharply declined in the major London houses in the last ten years. There are two principal reasons for this. Firstly, the main London houses, Sotheby's and Christie's King Street have continued to raise their minimum lot value, so excluding more and more British prints at the cheaper end of the market. When I worked at Sotheby's Belgravia twenty years ago, we would sell roughly 250 lots five or six times a year. Now, Sotheby's includes a handful of selected prints in their New Bond Street auctions, and sells perhaps seventy lots three times a year in Billingshurst.

This points up the second problem – scarcity. Twenty years ago the London market was fed by a seemingly inexhaustible supply of material from the country auction houses. A number of dealers could make a reasonable living simply by reselling material in London which had been bought in the provinces. Now there are fewer country sales – and correspondingly fewer dealers.

The market has shrunk but it has become more concentrated – and the major concentration is on condition, over and above rarity. The condition of prints, since they are multiples, has always been a major feature of pricing, but never more than now. One dealer I know has an impression hanging in his gallery of the mezzotint 'Drawing From the Gladiator' after Joseph Wright of Derby by William Pether, which in perfect condition he could sell for £2,000 several times over. However, he has been unable to sell his somewhat damaged but still good impression for £850; at the same time it is worth noting that a fine impression in a June 1993 auction sold for £4,200.

This is another anomaly of auction house prices in this narrow and insecure market – sudden, quirky high prices – which are not later sustained elsewhere. For this reason some of my prices may look conservative in the light of recent auction results, but I am reflecting the underlying strength of market and not the volatile peaks or troughs. I have, therefore, often and deliberately quoted the spectacular prices which have been achieved in certain auctions without changing my estimate.

But though the market has shrunk, it has also strengthened. 'Original' prints have appreciated in value, even substantially. In 1987, my upper estimate for George Stubbs' 'Recumbent Lion', one of his most sought after engravings, was £6,000. In June 1993, at Christie's one sold for £17,000, almost three times my 1987 estimate and the highest price for a Stubbs print at auction.

There is evidence that the specialist decorative market among dealers and private collectors is also beginning to fight back. Dealers I have spoken with report an upward trend in the market and new collectors coming in. In London there has been a notable increase in Italian interest in British sporting and decorative prints. Oval allegories by Bartolozzi are particularly popular at the time of writing. Top American dealers continue an interest in the best sporting and decorative prints - recently a superb set of Henry Alken's 'Beaufort Hunt' sold privately for £14,500 to a collector – double my 1987 estimate of £6,000–£9,000, and well up on the price of £8,000 which the last really good set had made in 1987.

Again, it is important to recognise that this is not a general trend but individual prices for top flight works based on condition and scarcity value. One angry collector wrote to me a few years ago to report that he had paid £18,000 for a set of 'The Months in Flowers', after Peter Casteels by Henry Fletcher, when I had quoted £300–£600 for individual plates. The premium for having the whole set, he argued, could not be worth over £10,000. I must have underestimated these engravings. At this time, however, I had no precedent for the sale of a complete set in perfect condition.

But the booksellers with whom I have spoken bear out this story: while individual plates from sets which were issued bound or contained in portfolios make average prices on their own, a scarce set in consistent, fresh condition (like the Flowers) will fetch a price well above the aggregate of the values of the plates. I have noted some of these extraordinary prices. One dealer even told me that the sum of £40,000 which he gave for a set of

Robert Havell's 'Views of the Public Buildings and Bridges in London' in 1988 (individually worth £200–£500) was quite exceptional and quirky, saying that he wanted to prevent the set from falling into the hands of an American institution and intimating that he would be unlikely to go over the top like that again. He also mentioned another crazy price of £19,000 paid for a set of William Daniell's 'Six Views of the London Docks' (normally worth around £800 each) in 1990 – apparently the competition was between two new residents in the recently redeveloped Docklands.

There will always be anomalies and exceptions. Even with prints, provenance can on rare occasions influence price. Some years age I did a valuation at the magnificent Calke Abbey. It was an eccentric repository of specimens of flora and fauna collected in the Victorian period from all over the world. A naturalist's heaven, it was like a museum which had never been opened. In the nursery, I discovered, supporting a cot mattress, a portfolio of marvellous sporting and decorative prints which had not been touched for 150 years – there was no light damage, no handling creases – no mount staining. While it is extremely rare to find such material in perfect condition anyway, given the spectacular nature of Calke, I would not have been surprised if collectors had been prepared to pay a premium for this provenance. In fact, the house and its entire contents were given to the National Trust, and the prints did not go to auction. But that was seventeen years ago and I have not seen another collection like it until Sotheby's spectacular sale in November 1997 of a large collection of eighteenth century English prints which had come from a German *schloss*. These had evidently been bought at the time of their publication, and then just put away and never mounted or framed. The incredible freshness of this material as well as the extreme rarity of some of the prints brought out all the collectors and also spurred genuine and feverish competition in the trade for the first time in years. Prices soared well over estimates. For example, £3,910 for a set of four sporting prints by S. Alken after S. Howitt; £3,220 each for two mezzotints by G.T. Stubbs after G. Stubbs; £5,520 for 'An Iron Forge' by R. Earlom after J. Wright of Derby; £2,990 for a portrait of Viscount Mountstuart by J.R. Smith after J.-E. Liotard; £5,750 for the rare portrait of the American revolutionary Samuel Adams by S. Okey after J. Mitchell, an amazing £20,700 for T. Gosse's 'Transplanting of the Bread-Fruit-Trees from Otaheite' printed in colours, and £10,925 for his 'Founding of the Settlement of Port Jackson at Botany Bay in New South Wales'. For the reasons outlined above, it would be unlikely that similar sums will be lavished on other impressions coming up in the near future, and we shall have to wait for the discovery of another cache of untouched prints to see again displays of this kind of extravagance.

Reproductive Prints

I have noted price rises in some categories:

1. Later reprints of coloured sporting aquatints, printed perhaps 20–50 years after the first issue, would have been worth considerably less in the past. Now, because most of the first issues have been hanging on the walls of country houses for 150–200 years, with consequent fading and staining, the later printings with good (contemporary) colour in good order have become much more sought after by collectors, frustrated at the lack of availability of an early set in good condition. So, for example, a later set of H.T. Alkens' 'The Quorn Hunt' might now fetch up to £1,200.

2. Again, due to the increasing shortage of earlier material, there have been rises in prices for later Victorian sporting and coaching prints such as those after H.G. Alken and W.J. Shayer.

3. Appreciation of the merits of large decorative Victorian engravings generally has increased and many of these have doubled in price in the intervening period. Because they are now considered to be great 'wall-fillers', they will be of even greater value if in undamaged contemporary frames. It is extraordinary to think that whereas classic sporting prints have never really gone out of fashion, these vast Victorian behemoths after Edwin Landseer, William Powell Frith and others would have been casually discarded and destroyed even as recently as twenty years ago. Remember, the subject matter is all-important, and the many religious subjects produced in this period, excepting those engravings after the Pre-Raphaelite painters, are still out of favour.

4. There has also been an increased awareness of the values of eighteenth and early nineteenth century prints in original frames. In the past, collectors would not consider engravings cut down to fit the frames (as they often were at the time). These would consequently be worth much less than impressions still with their margins or at least showing the platemark. Now, the reverse may be true if a print or series of prints in their original frames presents an attractive ensemble.

The ovals and roundels engraved in stipple by Francesco Bartolozzi and his school after Angelica Kauffmann and Giovanni Battista Cipriani were designed to be cut down to the shape of the subject and framed to decorate bedrooms or fireplaces. These prints have become increasingly sought after, particularly in contemporary frames, and prices have gone up rapidly against the general trend.

5. The decorative appeal of the larger eighteenth century landscape engravings by William Woollett, Francois Vivares and others have made these prints much more desirable whether they are after earlier painters such as Claude or Poussin or after contemporary artists; any topographical interest will additionally influence prices.

6. Portraits I have rarely altered: unless they have specific decorative qualities, they are likely to be less appreciated as the identity of the sitters becomes more obscure. Fine impressions in excellent condition will probably command a premium, as well as unusual or interesting subjects, such as 'Mr Banks' by J.R. Smith after West which made £4,000 in 1989.

7. Caricatures generally have risen. Scarcity of good examples at the top end has pushed up prices enormously for major prints by James Gillray. Fewer good examples by Thomas Rowlandson and George Cruikshank have been seen on the market in recent years, though prices have probably not risen very much. But because of the general demand for prints which are both decorative and amusing, it is now difficult to buy any coloured caricature by even lesser artists for less than £50.

8. Topographical views generally have not moved either way very much, except for some colonial views notably in the Middle East, India and the Far East. I have recorded sales of some rare sets.

Original Prints

Etched or engraved works by major eighteenth and early nineteenth century figures such as Thomas Gainsborough, George Stubbs, William Blake and John Martin have appreciated considerably over the period due mostly to their re-appraisal as 'Old Master' prints and their consequent interest to international buyers. But interest in early lithographs such as those executed for the series 'Specimens of Polyautography' has levelled off.

In the Modern British field starting with the 'Etching Revival', I have doubled most prices except in the case of works published in large unsigned editions for magazines; some artists such as Sickert have absolutely rocketed. There are, however, a number of classic figures such as D.Y. Cameron, Muirhead Bone and F.L. Griggs whose prints appear to have marked time or perhaps risen in price and fallen again to remain broadly where they were eleven years ago.

Two points to make here: firstly, it is still a small market in which the arrival of just two new collectors can make a colossal difference if they happen to focus their interest on one particular artist, as for example happened to the etchings of Seymour Haden in the late 1980s. Secondly, international interest can affect prices dramatically – at the end of the day, prices for the top British prints whether original or reproductive are still low compared to the most expensive Old Master or Modern (Continental and American) prints. Given the long term decline in sterling's value, to the foreign buyer prices for many prints will have fallen.

Although posters do not strictly come within the scope of this book (largely because it is often difficult to decide whether a poster designer actually worked on the plates so making the poster an 'original'), it is worth mentioning that there has been a steadily increasing interest in British poster art over the period. Works by, for example, the Beggarstaff Brothers (James Pryde and William Nicholson) have gone up considerably in price, and the later travel posters, particularly those commissioned by the Shell oil company and railway posters advertising trips to golfing resorts, have also risen substantially in value.

Because they are much larger than the average etching or lithograph, condition should play an even bigger part, and some very high prices have been paid for travel posters which had been folded up and put in a drawer and never used. However, some of the top prices recently have been given for works which were in relatively poor condition, but were extremely rare and important posters by artists or designers such as the Beggarstaff's. The collectors realised that, because of their size and function as advertisements and because far fewer were printed than the French *fin-de-siècle* posters (a few hundred compared to several thousand of, say, a Toulouse-Lautrec), they might never see another example.

Finally, a word of caution concerning auction prices included from the period 1988–90. Just as in the rest of the art market, it was a boom time and prices seemed to spiral upwards with no thought of tomorrow. I believe that it is relevant to know what the top prices were at that time, just as long as one remembers that it may not give the collector much of a clue as to what he or she should give for a print today.

Ian Mackenzie
May 1998

Addenda

MOORE, Henry Spencer, O.M., page 257
Bibl: Cramer, G., 'H. M. The Graphic Work', Vols. I – IV, 1973–1986, Geneva

NASH, Paul, page 261
Bibl: Postan, A., 'The Complete Graphics of P. N.', 1973

NEVINSON, Christopher Richard Wynne, A.R.A., page 262
Bibl: Guichard, K.M., 'British Etchers 1850–1940', 1997

PIPER, John, page 275
Bibl: Levinson, O., 'The Complete Graphic Works 1923–1983', 1987

POWER, Cyril L., page 281
Bibl: Redfern Gallery, 'The Linocuts of C. P. 1872–1951', 1989

ROUSSEL, Theodore Casimir, A.R.E., page 296
Bibl: Hausberg, M.D., 'The Prints of T. R.', New York, 1991

STUBBS, George, A.R.A., page 323
Bibl: Lennox-Boyd, C., Dixon, R.S., Clayton, T., 'The Complete Engraved Works', 1989

Corrigendum

STUBBS, George Townly, page 324
'The Sebra [*sic*] or Wild Ass', after G. Stubbs, 1771, 10 x 14in/25 x 35cm

The
PLATES

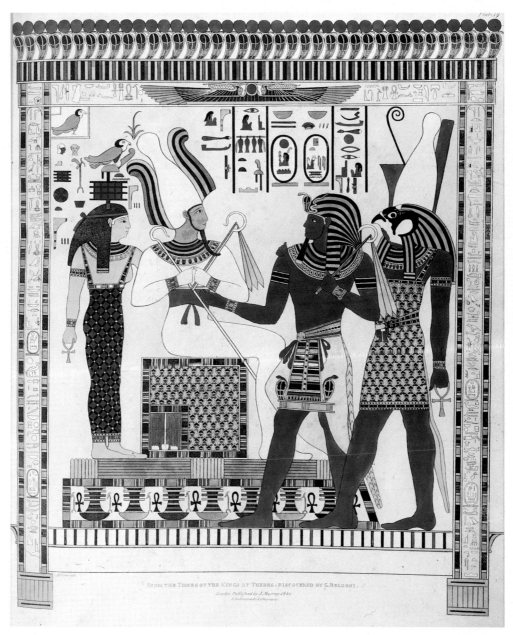

AGLIO, Agostino. Plate for G.B. Belzoni's *Plates Illustrative of the Researches in Egypt and Nubia*, 1820, coloured.

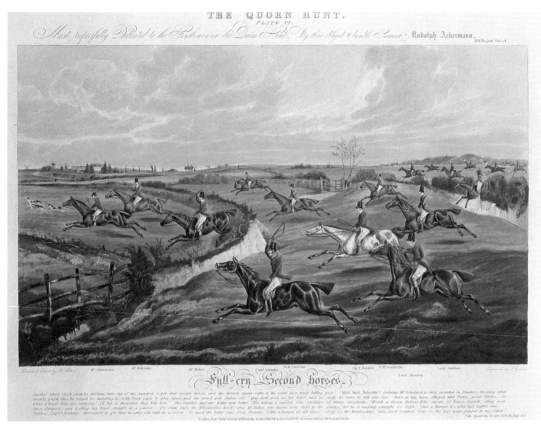

ALKEN, Henry Thomas. Plate VI of 'The Quorn Hunt', drawn and etched by Alken, aquatinted by F.C. Lewis I. A fine example from the first edition.

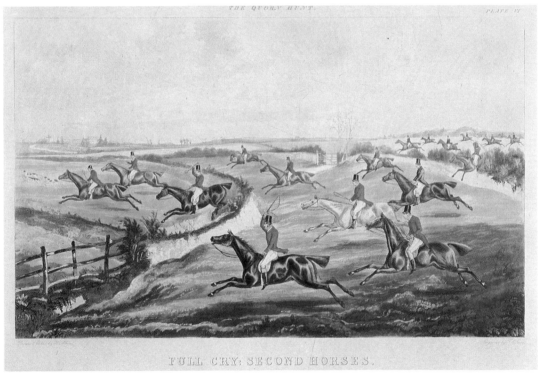

ALKEN, Henry Thomas. Plate VI of 'The Quorn Hunt', drawn and etched by Alken, aquatinted by F.C. Lewis I. An example of a late reprint.

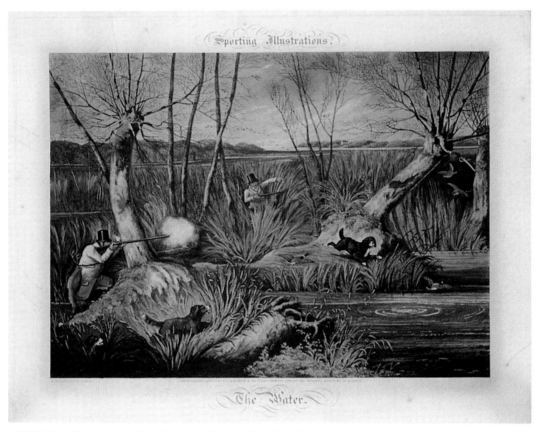

ALKEN, Henry Thomas. One of four plates from 'Sporting Illustrations: Shooting – The Water', 1837, aquatint.

ALKEN, Henry Thomas. One of eight plates from 'The Beaufort Hunt: Finding (In a bog)', after W.P. Hodges, 1833, etching with aquatint. The illustration shows a particularly fine example of the coloured sporting aquatint.

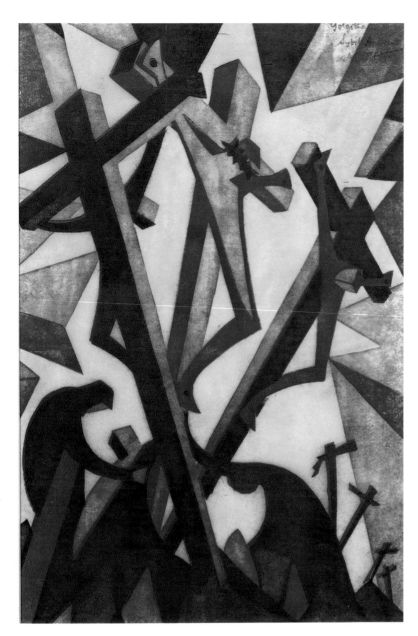

ANDREWS, Sybil. 'Golgotha'.

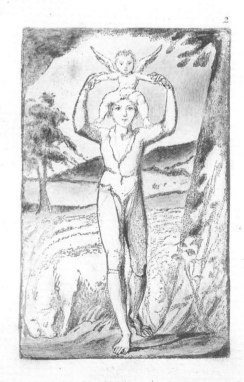

BLAKE, William. Frontispiece to the *Songs of Innocence and Experience*, relief etching hand-coloured by the artist.

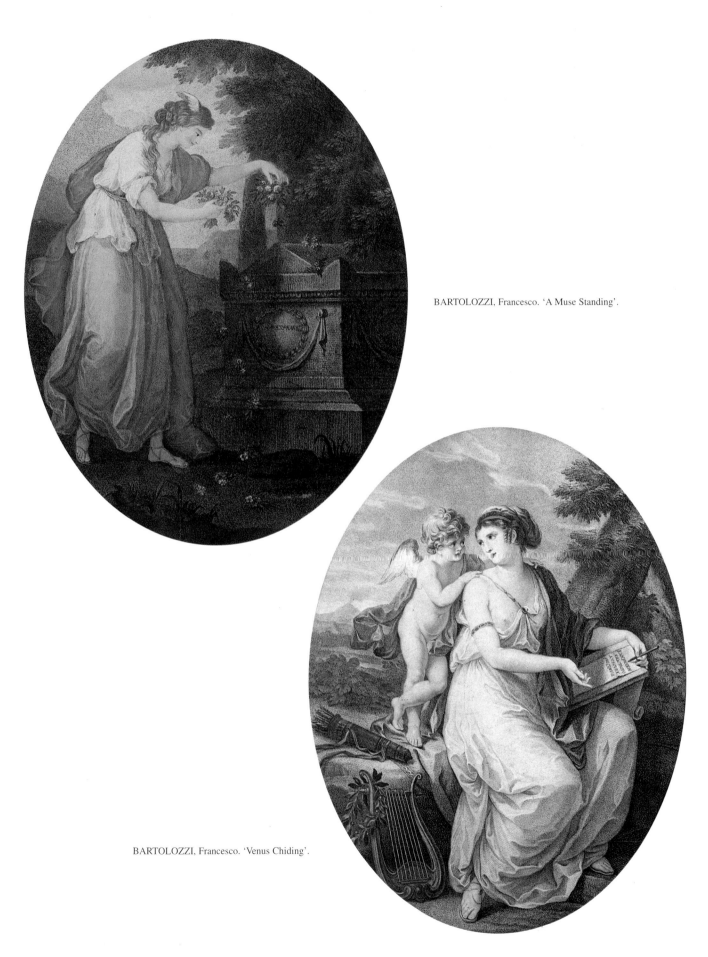

BARTOLOZZI, Francesco. 'A Muse Standing'.

BARTOLOZZI, Francesco. 'Venus Chiding'.

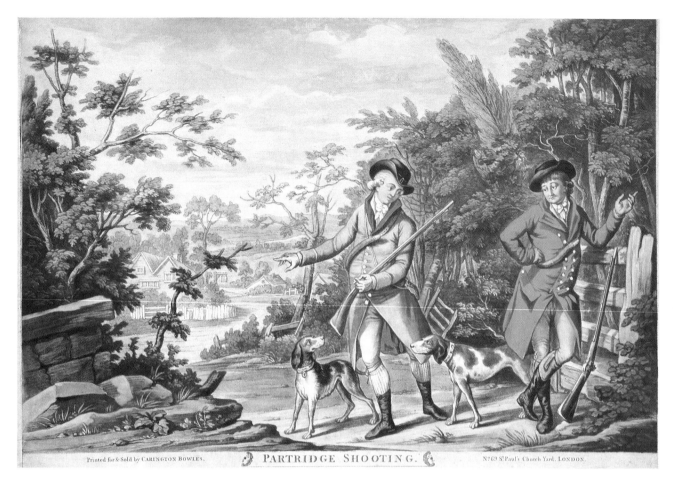

BOWLES, Carington. 'Partridge Shooting', one of the four plates from 'Shooting', after R. Dighton, 1787. An example of an 18th century mezzotint with contemporary gouache colouring.

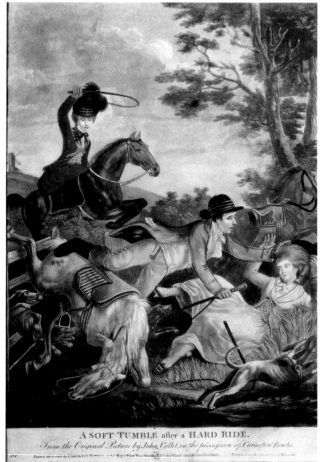

BOWLES, Carington. 'a Soft Tumble after a Hard Ride'.

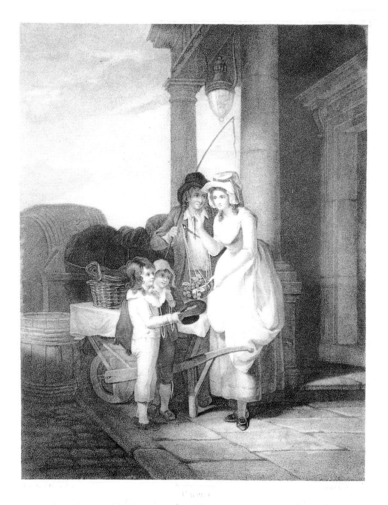

CARDON, Antoine. 'Round and Sound, Fivepence a Pound, Duke Cherries', from F. Wheatley's 'Cries of London'. One of the rarest and most commonly reproduced of decorative prints.

CLARK, John. One of thirty-five plates from 'Views in Scotland: The Town of Inverary', 1824, coloured. The illustration shows a particularly fine example of the topographical aquatint.

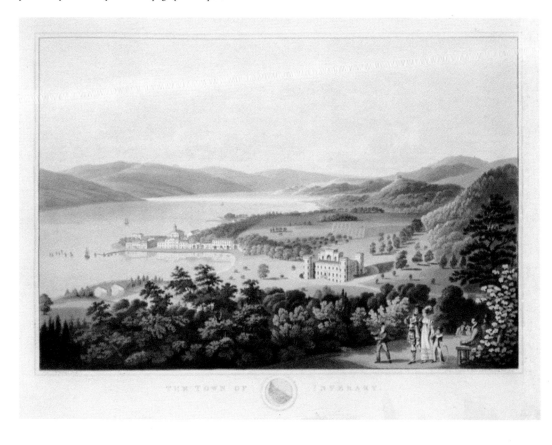

THE TOWN OF INVERARY.

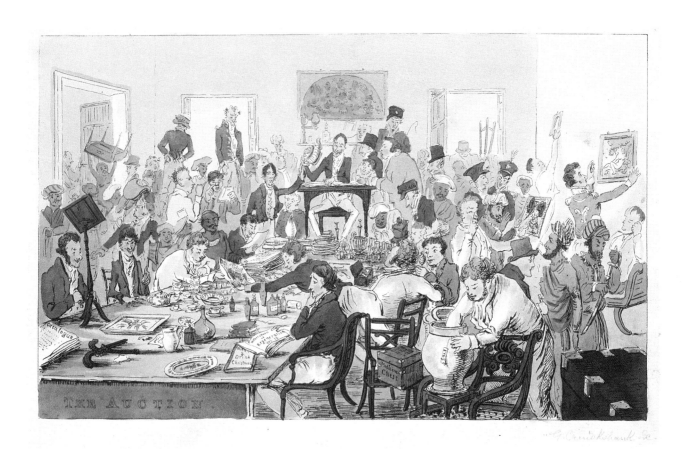

CRUIKSHANK, George. 'The Auction'.

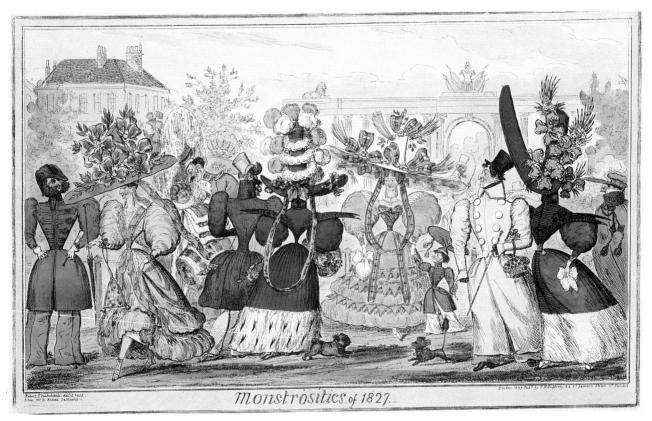

CRUIKSHANK, Isaac Robert. 'Monstrosities of 1827', coloured. A splendid example of an early 19th century satire on fashion.

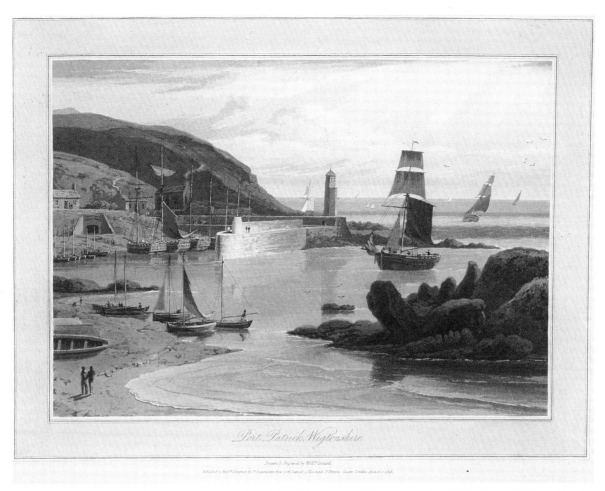

Port-Patrick. Wigtonshire.

Drawn & Engraved by Will.™ Daniell.

Published by Will.™ Longmans & C.º Paternoster Row & W. Daniell. 9 Cleveland St Fitzroy Square London. June 15, 1816.

DANIELL, William. One of the 308 plates from 'A Voyage Round Great Britain: Port Patrick, Wigtonshire', 1814-25, coloured. 'A Voyage Round Great Britain' was one of William Daniell's most important works and a famous topographical series.

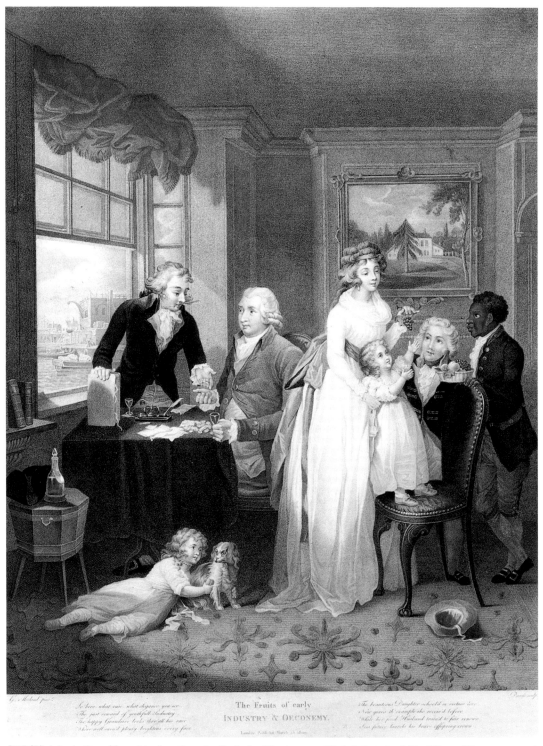

The Fruits of early

INDUSTRY & OECONEMY.

London, Publish'd March 3d, 1800.

DARCIS, J. Louis. One of four plates from the series 'the fruits of Oeconomy and Early Industry' and 'The Effects of Extravagance and Idleness', after G. Morland and H. Singleton, 1800, coloured.

DUBOURG, Matthew. (Page 31, top) 'Mail Coach', after J.L. Agasse, 1824, coloured

DUBOURG, Matthew. (Page 31, bottom) 'London Market', after J. Pollard, 1822, coloured.

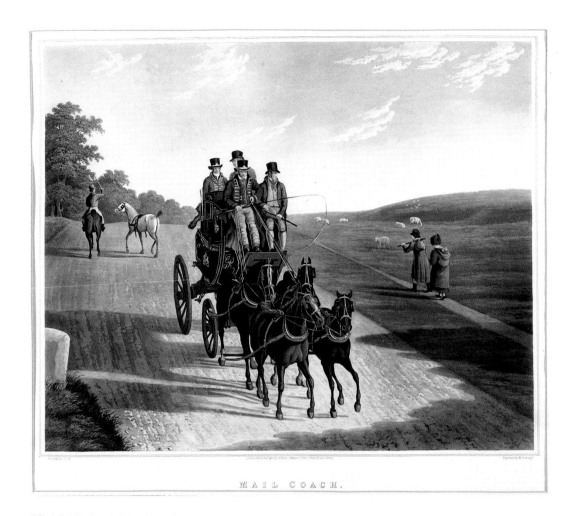

MAIL COACH.

LONDON MARKET.

31

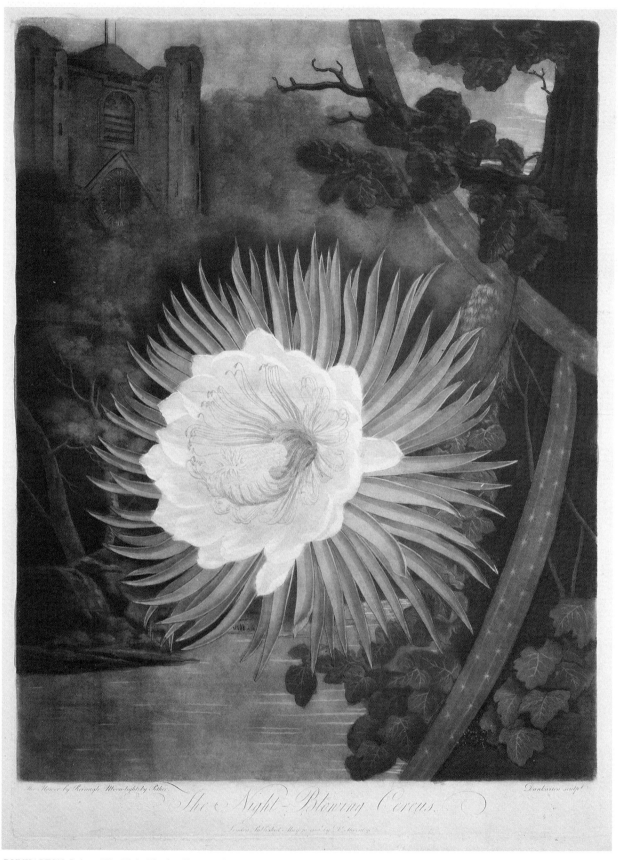

The Flower by Reinagle Moon-light by Pether Dunkarton sculp.

The Night-Blowing Cereus.

London Published May 31 1800 by Dr Thornton.

DUNKARTON, Robert. 'The Night-Blowing Cereus', after P. Reinagle and W. Pether, 1800, mezzotint, printed in colour. A good example of this type of mezzotint.

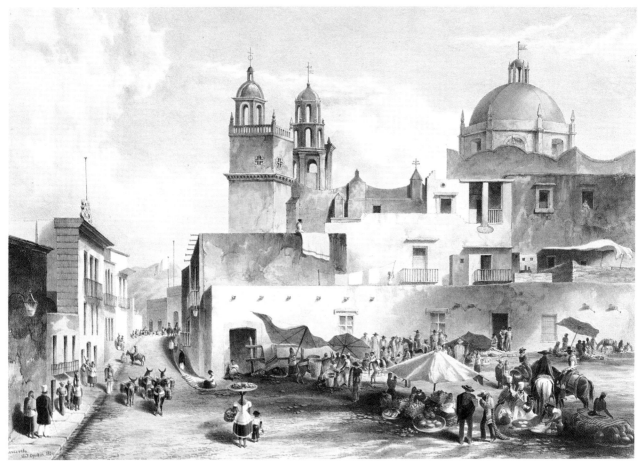

EGERTON, Daniel Thomas. One of twelve plates from the very rare 'Views of Mexico: Guanaxuato', 1840, lithograph. These views must be some of the finest examples of hand-coloured topographical lithographs.

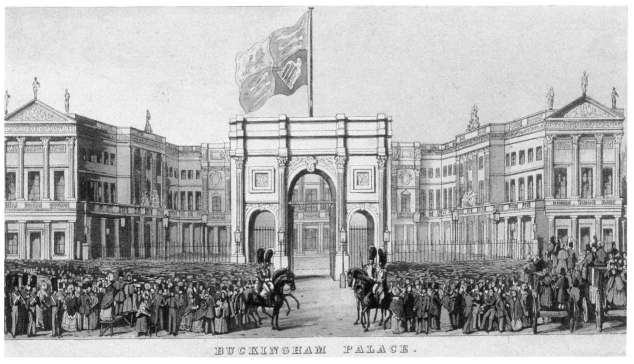

BUCKINGHAM PALACE.

FORES, S.W. 'Buckingham Palace, detail from the 'Panorama of the Marriage Procession of Queen Victoria and Prince Albert', 1840.

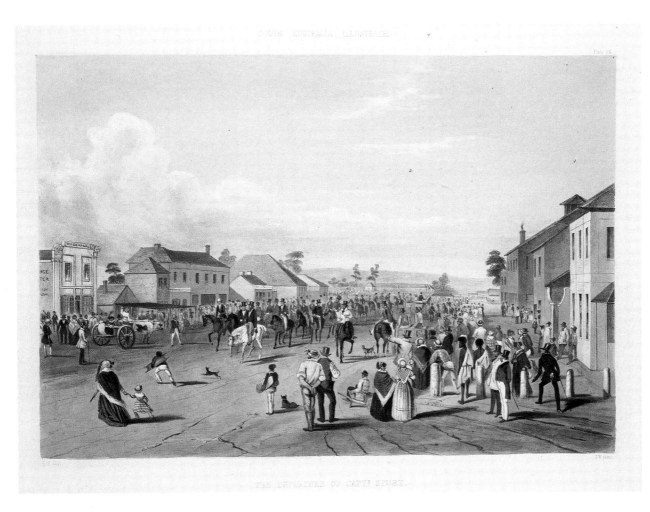

THE DEPARTURE OF CAPTN. STURT.

GILES, John West. 'The Departure of Captn. Sturt', after T.S. Gill, coloured. One of sixty-two tinted plates, from G.F. Angas' *South Australia Illustrated*.

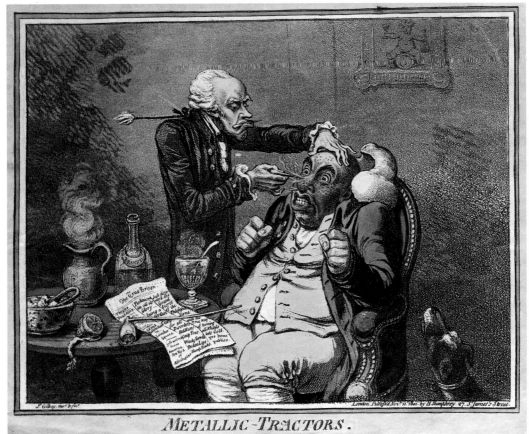

METALLIC-TRACTORS.

GILLRAY, James. 'Metallic Tractors', 1801, coloured.

35

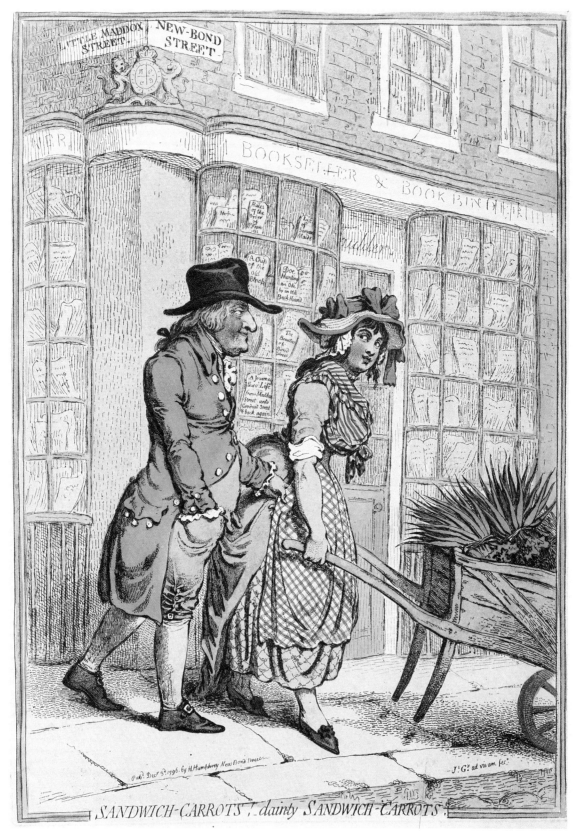

GILLRAY, James. 'Sandwich-Carrots! dainty Sandwich-Carrots', 1796, etching, coloured.

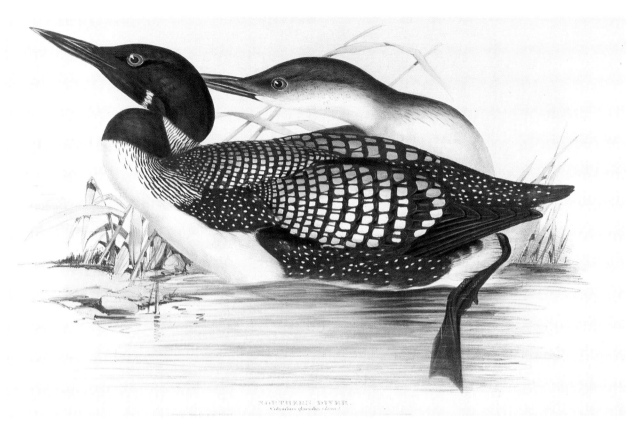

GOULD, John. 'Northern Diver', coloured. A typical example of Gould's well-known ornithological studies.

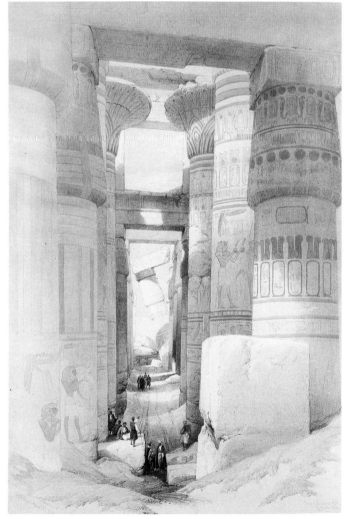

HAGHE, Louis. 'Karnac', a tinted plate from David Roberts' *Holy Land, Egypt and Nubia*, 1842-9, one of the most famous 19th century topographical series.

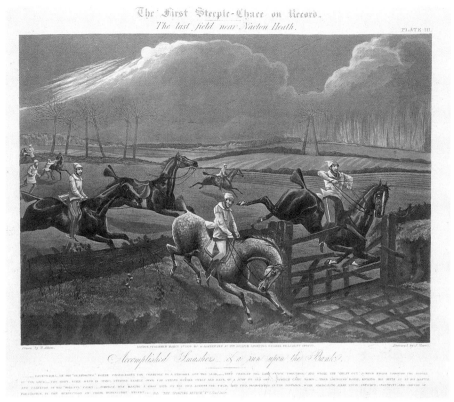

HARRIS, John III. Plate III of 'The First Steeple Chace on Record', after H.T. Alken, 1839. A fine example from the first edition.

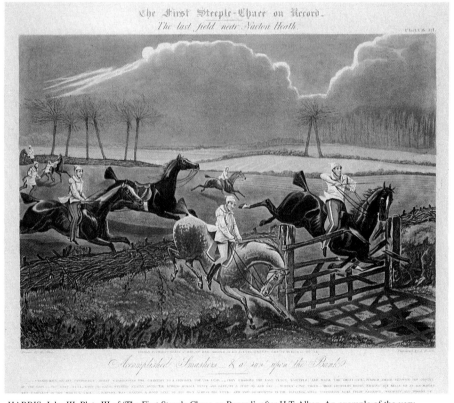

HARRIS, John III. Plate III of 'The First Steeple Chace on Record', after H.T. Alken. An example of the very common reprint with the Ben Brooks publication line.

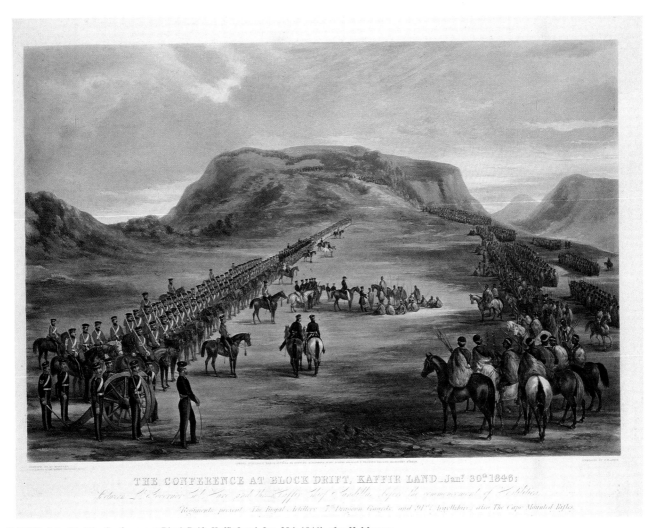

THE CONFERENCE AT BLOCK DRIFT, KAFFIR LAND_Jan.ʸ 30ᵗʰ 1846;

Between Lʲ Governor Col. Hare, and the Kaffir Chief Sandilla, before the commencement of Hostilities.

Regiments present_The Royal Artillery_7ᵗʰ Dragoon Guards_and 91ˢᵗ Argyllshire; also The Cape Mounted Rifles.

HARRIS, John III. 'The Conference at Block Drift, Kaffir Land, Jan. 30th 1846', after H. Martens.

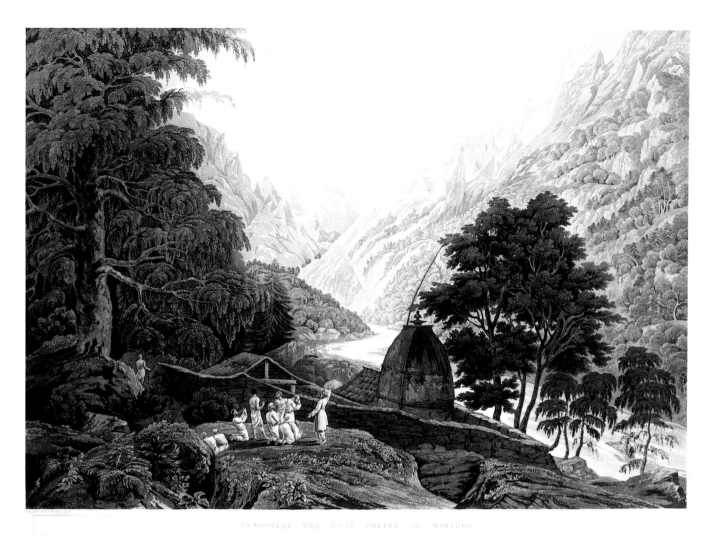

HAVELL, Robert I. 'Gungotree the Holy Shrine of Mahadeo'. From J.B. Fraser's *Views in the Himala Mountains*, after 1820.

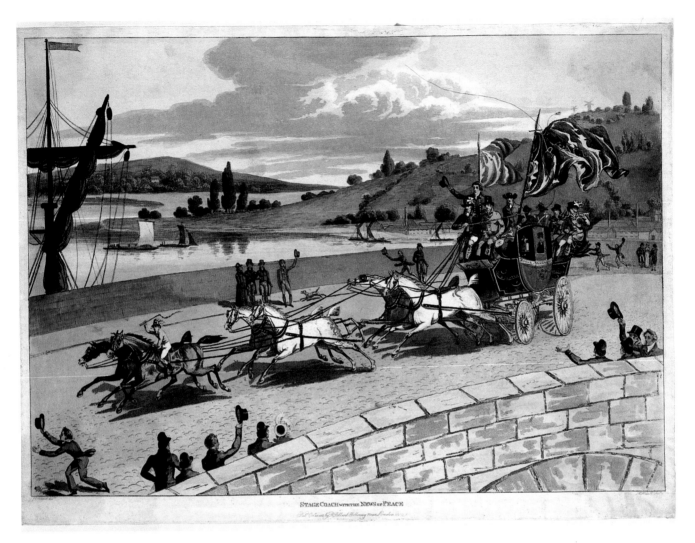

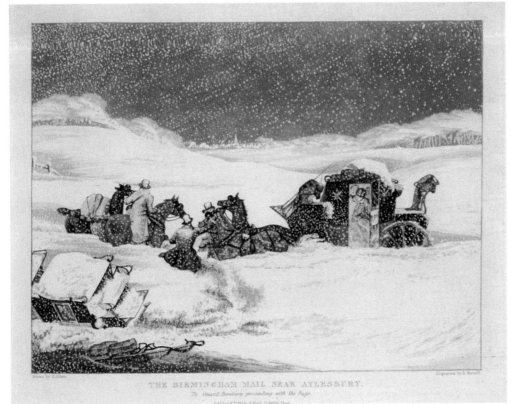

HAVELL, Robert II. 'Stage Coach with the News of Peace', after J. Pollard, 1815.

HAVELL, Robert II. One of six plates from 'Coaching Scenes During the Severe Winter of 1836/7: The Birmingham Mail Near Aylesbury', after H. Alken. This is a particularly atmospheric example of an aquatint printed in two colours, blue for the sky and black for the remainder, with hand colour applied mostly to the figures and coaches in the centre. The snowflakes in the sky are created by 'stopping out' the aquatint ground, and those on the figures and coaches by using spots of gouache over the watercolour.

41

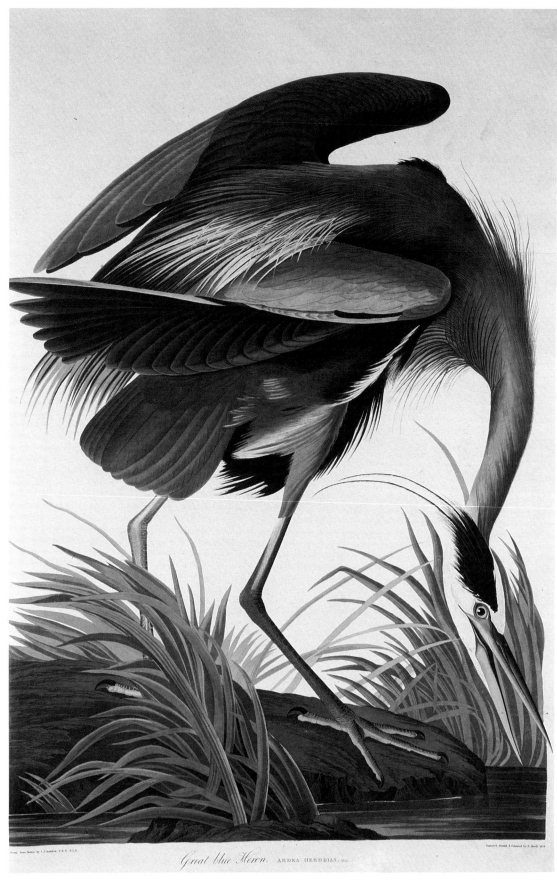

Great blue Heron. ARDEA HERODIAS, Wils.

HAVELL, Robert II. 'Great Blue Heron', after J.J. Audubon, from *Birds of America*. One of the best subjects from this sought-after series, most of which were engraved by Havell, 1827-38.

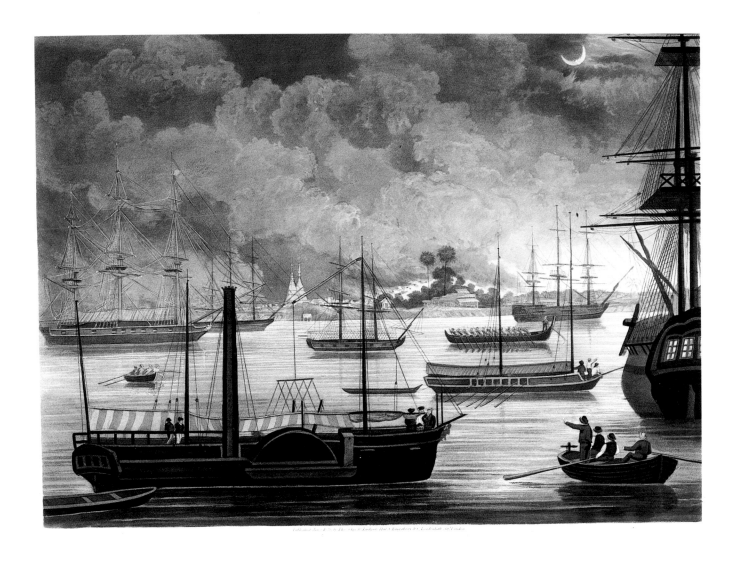

HILL, John. 'The Conflagration of Dalla on the Rangoon River!'. From Lieut. J. Moore's and Capt. F. Marryat's *Rangoon Views* 1825.

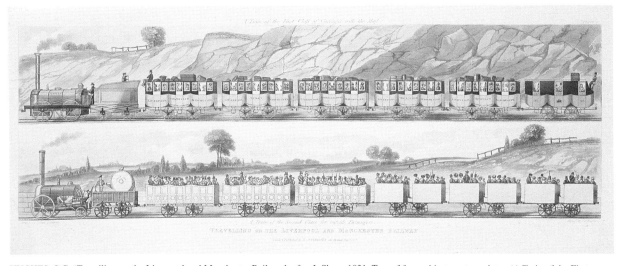

HUGHES, S.G. 'Travelling on the Liverpool and Manchester Railway', after I. Shaw, 1831. Two of four subjects on two plates: 'A Train of the First Class Carriages with the Mail', and 'A Train of the Second Class for Outside Passengers'. One of the most famous series of early railway prints.

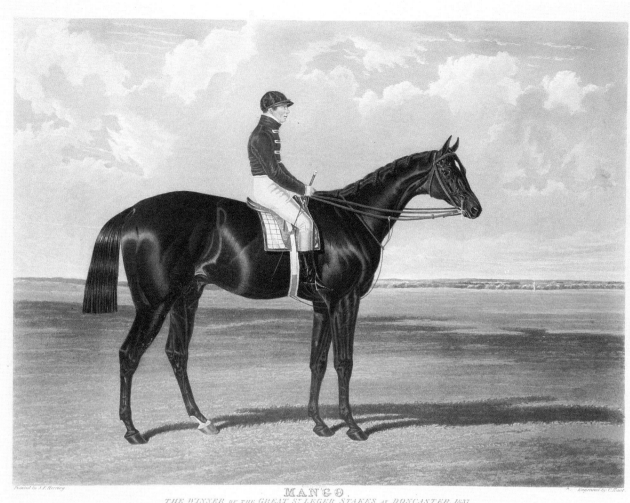

MANGO.
THE WINNER OF THE GREAT ST LEGER STAKES AT DONCASTER, 1837.

HUNT, Charles I. 'Mango, the winner of the Great St. Leger Stakes at Doncaster, 1837', after J.F. Herring. The illustration shows a fine example from the series of St. Leger and Derby Winners.

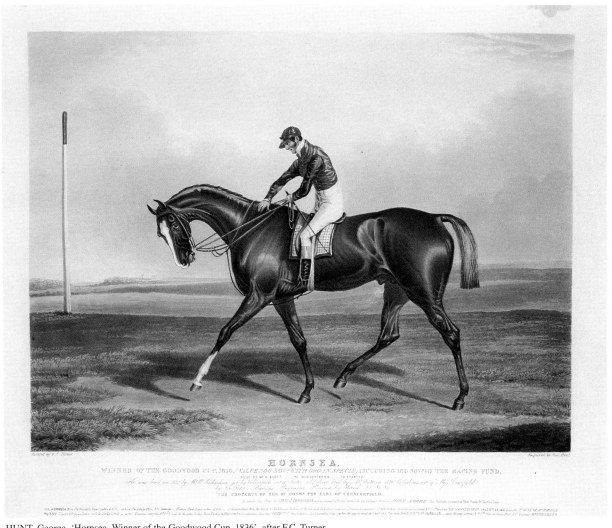

HORNSEA,
WINNER OF THE GOODWOOD CUP, 1836, (VALUE 300 SOVS WITH 600 IN SPECIE,) INCLUDING 100 SOVS BY THE RACING FUND.
RODE BY WM. SCOTT. — 40 SUBSCRIBERS — 15 STARTED.

THE PROPERTY OF THE RT HONBLE THE EARL OF CHESTERFIELD.

HUNT, George. 'Hornsea, Winner of the Goodwood Cup, 1836', after F.C. Turner.

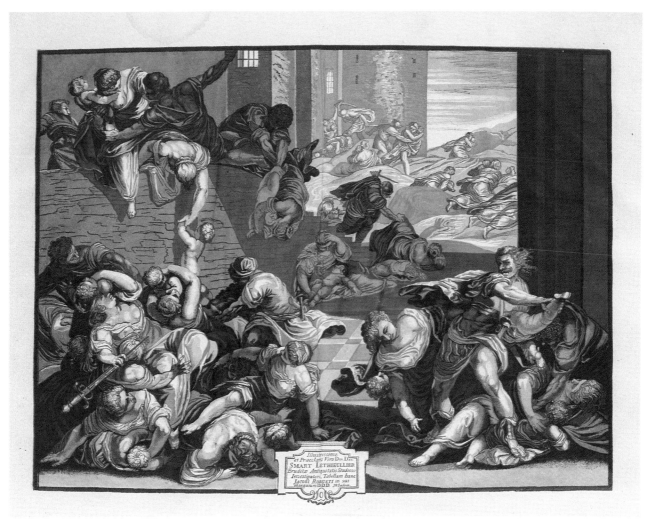

JACKSON, John Baptist. 'Titiani, Vecelli, Pauli, Caliari, Jacobo Robusti et Jacobi de Ponte. Opera Selectiora…', 1745. One of the twenty-four plates after Venetian painters for which this artist is famous.

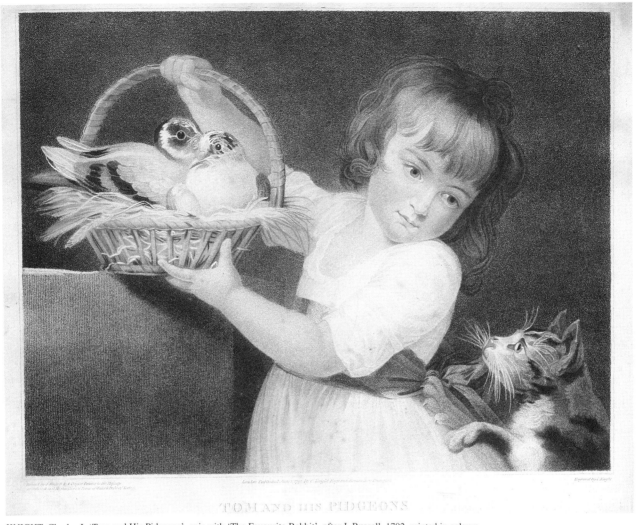

KNIGHT, Charles I. 'Tom and His Pidgeons', pair with 'The Favourite Rabbit', after J. Russell, 1792, printed in colours.

LEBLOND, Abraham and Robert. One of the famous Leblond 'Ovals'.

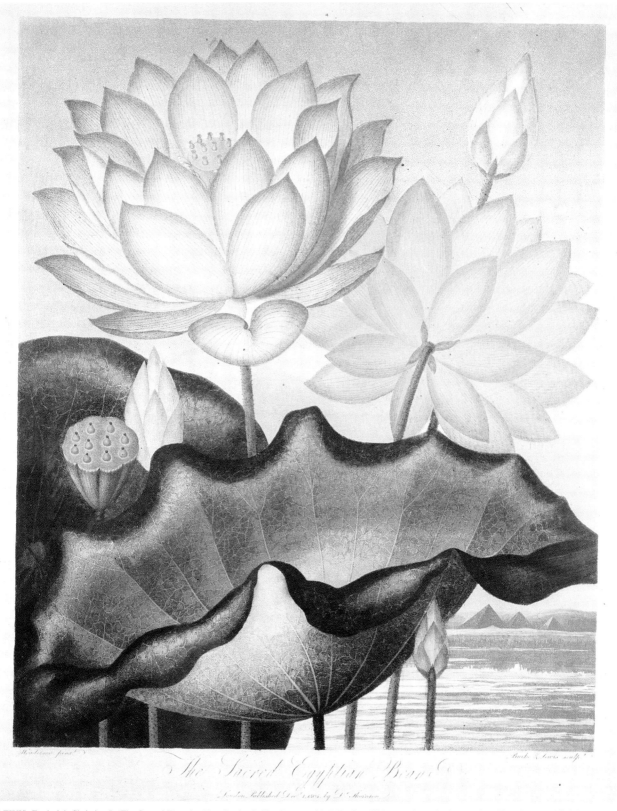

LEWIS, Frederick Christian I. 'The Sacred Egyptian Bean', after P. Henderson, with T. Burke, 1804, aquatint and stipple, printed in colours and finished by hand.

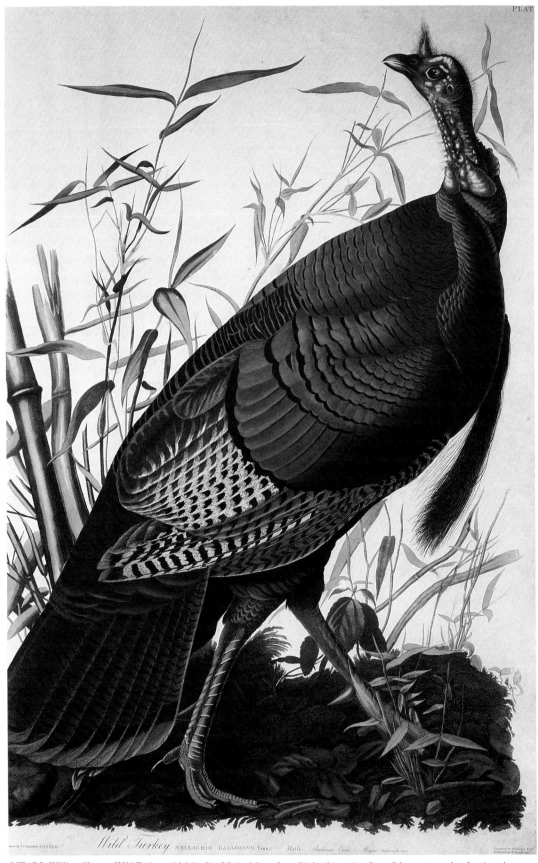

Wild Turkey, MELEAGRIS GALLOPAVO, Linn. *Male*, American Cane, Miegia macrosperma.

LIZARS, William Home. 'Wild Turkey…Male', after J.J. Audubon, from *Birds of America*. One of the most sought-after American prints engraved by a Briton.

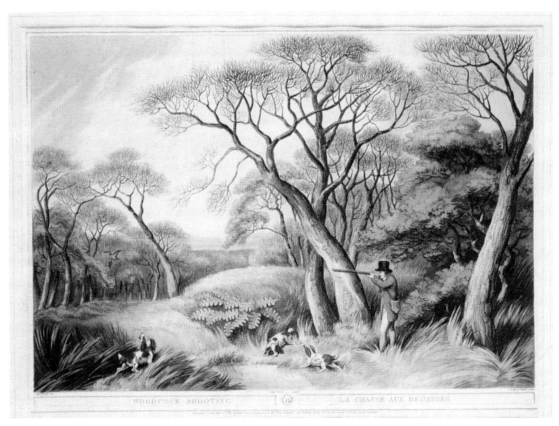

MERKE, Henri. 'Woodcock Shooting', after S. Howitt, from Orme's *Collection of British Field Sports*, coloured.

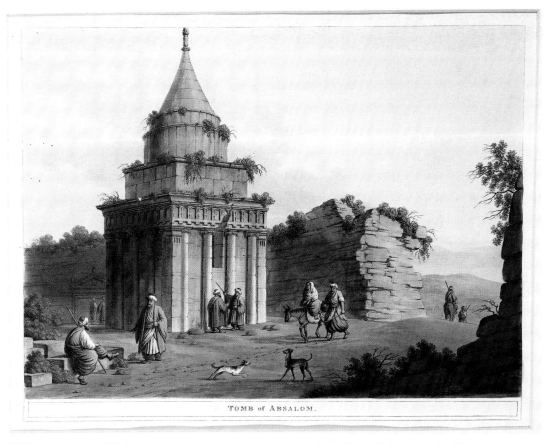

MILTON, Thomas. 'Tomb of Absalom', from L. Mayer's *Views in Egypt, Palestine and other Parts of the Ottoman Empire*, 1804, coloured.

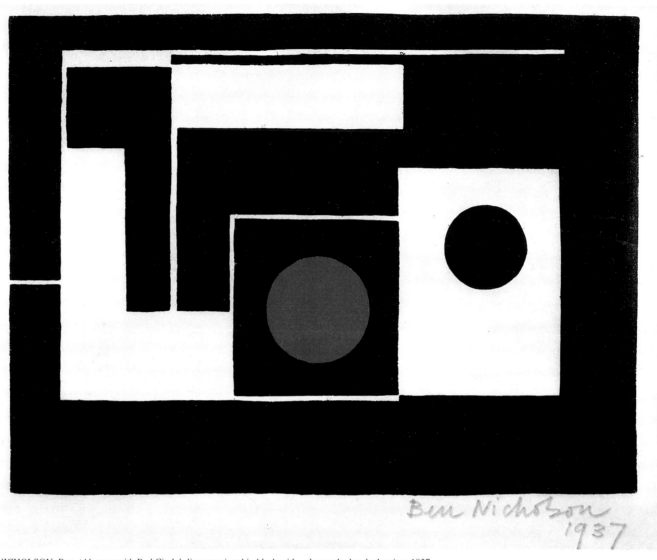

NICHOLSON, Ben. 'Abstract with Red Circle', linocut printed in black with red gouache handcolouring, 1937.

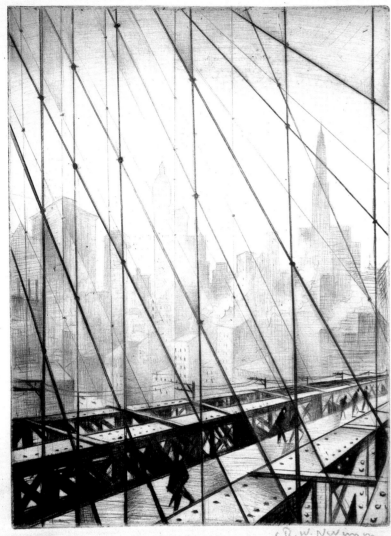

NEVINSON, Christopher Richard Wynne. 'Brooklyn Bridge', drypoint.

POLLARD, James. 'Stage Coach', 1826, aquatint, coloured. A typical but rare engraving by the master coaching artist, many of whose paintings were engraved by other professionals.

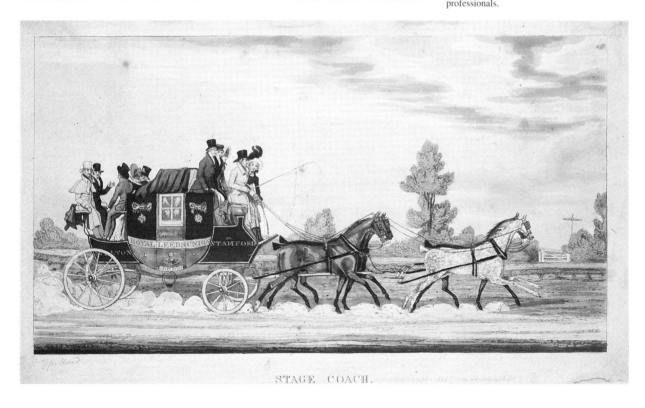

STAGE COACH.

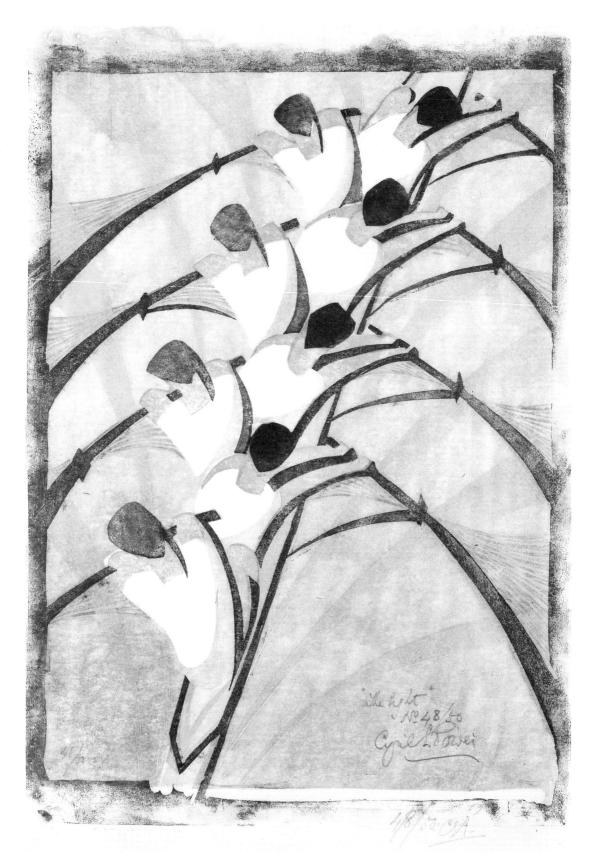

POWER, Cyril. L. 'The Eight'.

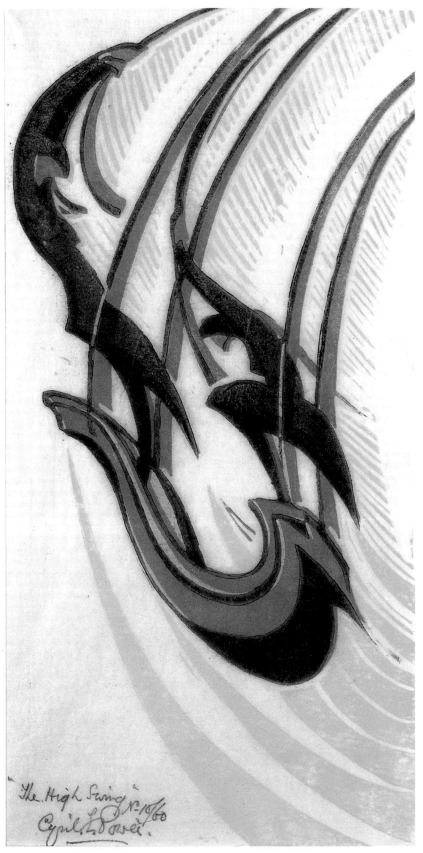

"The High Swing"

Nᵒ 10/60

Cyril L Power.

POWER, Cyril L. 'The High Swing'.

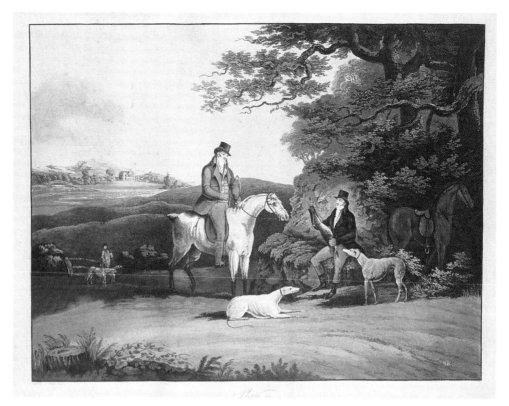

REEVE, Richard. One of four plates from 'Coursing', after D. Wolstenolme.

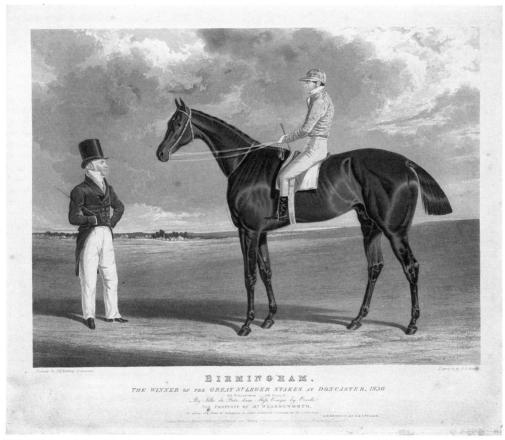

REEVE, Richard Gibson. 'Birmingham, the winner of the Great St. Leger Stakes at Doncaster, 1830', after J.F. Herring, 1831, aquatint. An impression from a second issue, with the colours slightly faded by exposure to light, and the paper stained by foxing and the backboard. A fine impression in good condition would fetch considerably more than a poor impression in poor condition.

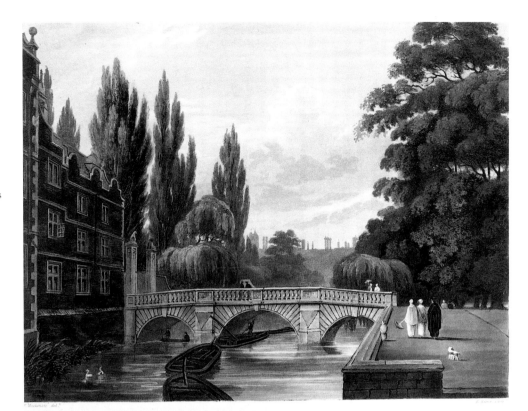

REEVE, Richard Gilson. 'St John's College, From the Gardens'.

ROSENBERG, Charles II. 'West Country Mails at the Gloucester Coffee House, Piccadilly', after J. Pollard, 1828, coloured.

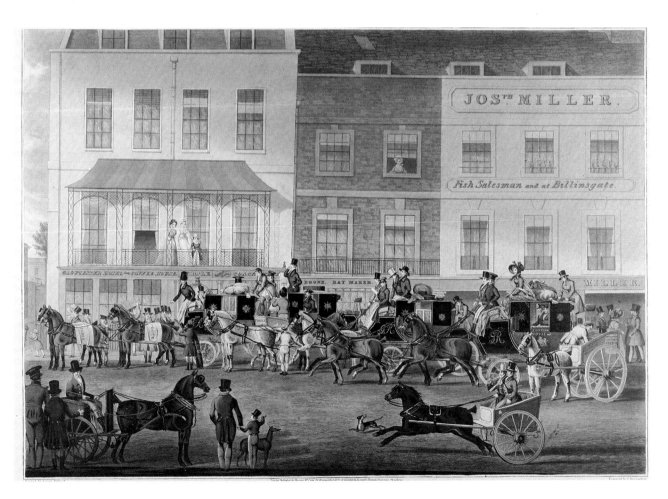

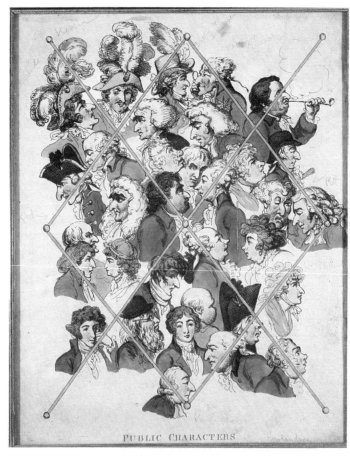

ROWLANDSON, Thomas. 'Public Characters', c.1800, etching, coloured. The heads
of contemporary figures can be seen in this delightful caricature. They include
William Pitt, James Fox, Edmund Kean, Horatio Nelson, and Rowlandson himself in
the centre of the lowest diamond.

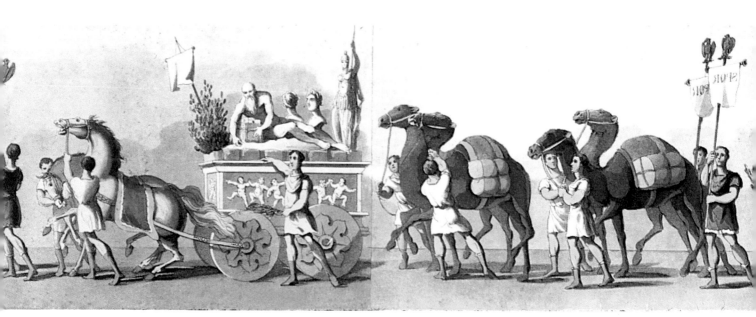

SAMS, William. 'Roman Procession', panorama, 1822, aquatint.

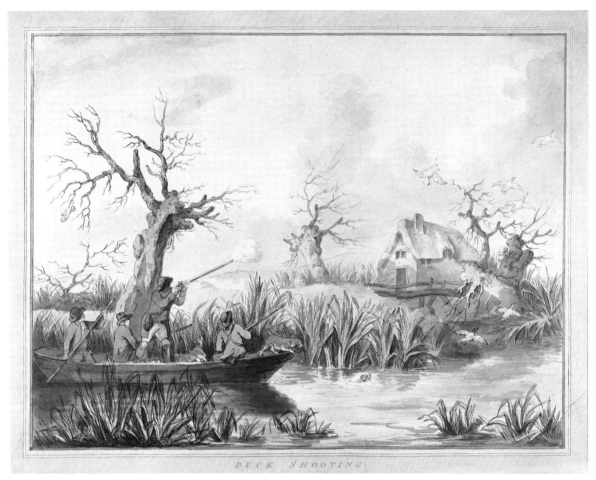

ROWLANDSON, Thomas. 'Duck Shooting' one of four plates from 'Shooting', after G. Morland, 1789. Etching, before aquatint was added by S. Alken, finely coloured with watercolour.

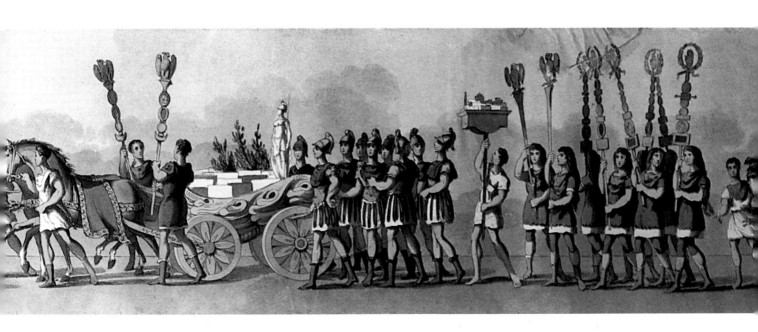

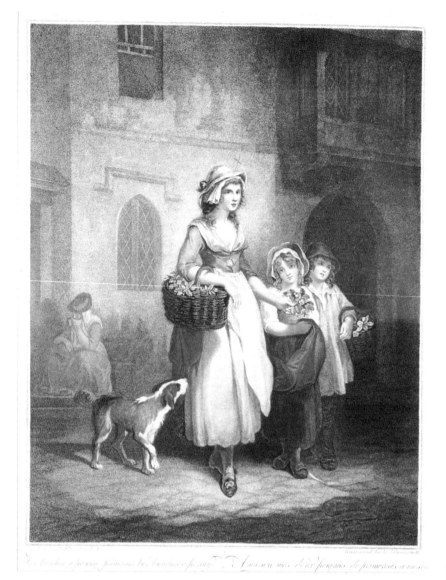

SOIRON, François Davide. (Right) 'St James's Park', after G. Morland, 1805, oval.

SCHIAVONETTI, Luigi. 'Two bunches a penny primroses, two bunches a penny', from 'The Cries of London', after F. Wheatley, 1793-7, printed in colours. A fine example of a much-reproduced series.

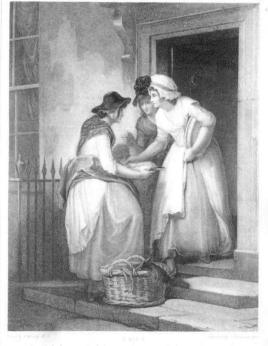

SCHIAVONETTI, Niccolo. 'New Mackrel, New Mackrel', from 'The Cries of London', after F. Wheatley, 1793-7, printed in colours.

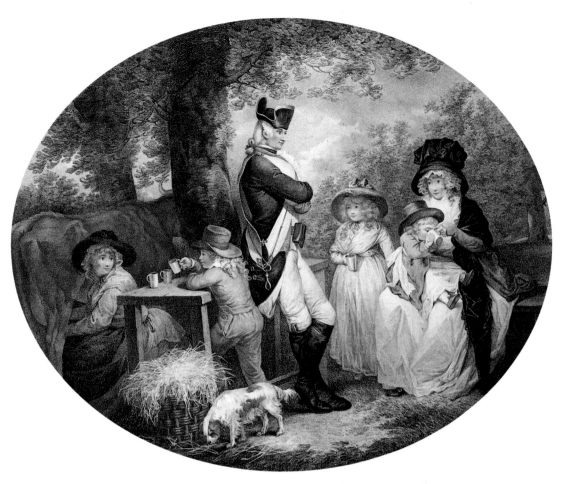

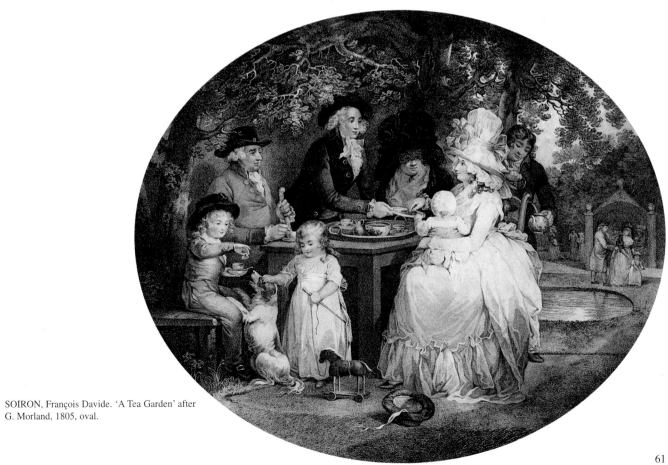

SOIRON, François Davide. 'A Tea Garden' after
G. Morland, 1805, oval.

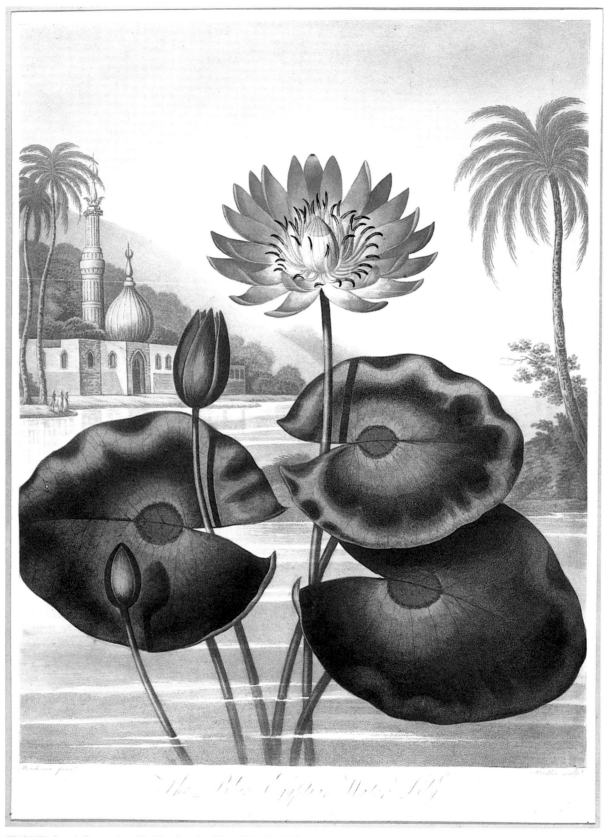

STADLER, Joseph Constantine. 'The Blue Egyptian Water-Lily', after P. Henderson, from Thornton's *Temple of Flora*, 1804.

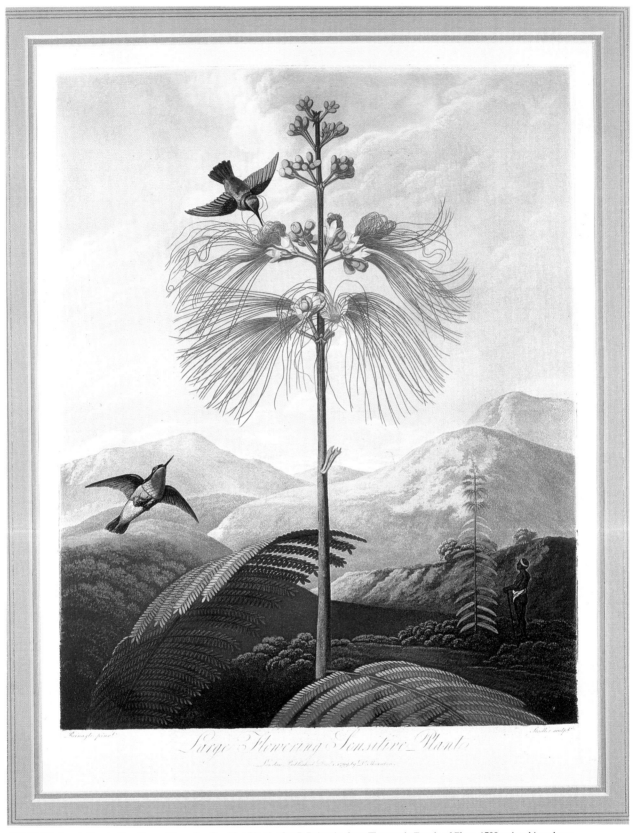

STADLER, Joseph Constantine. 'Large Flowering Sensitive Plant', after P. Reinagle, from Thornton's *Temple of Flora*, 1799, printed in colours.

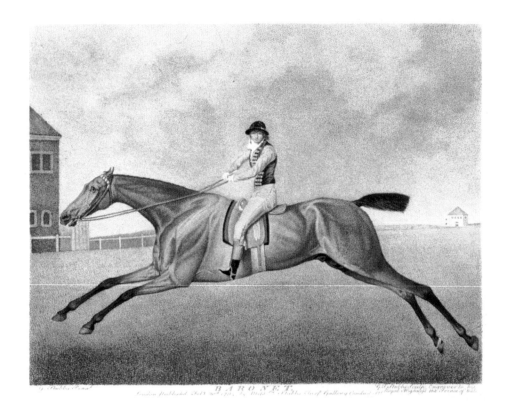

STUBBS, George Townly. 'Baronet',
after G. Stubbs, 1794. This and the
illustration below are both fine examples
of stipples printed in colours.

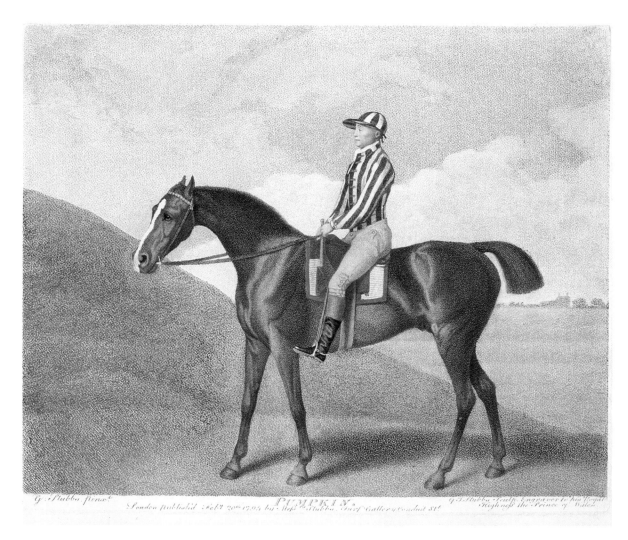

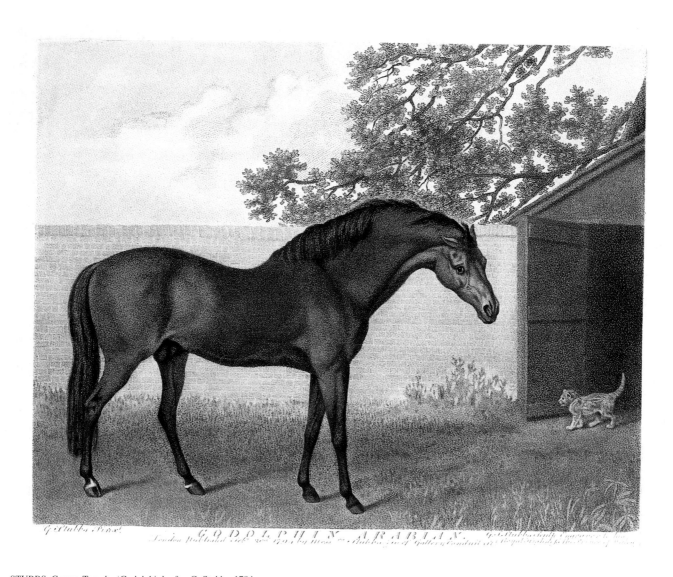

STUBBS, George Townly. 'Godolphin', after G. Stubbs, 1794.

STUBBS, George Townly. 'Pumpkin', after G. Stubbs, 1794.

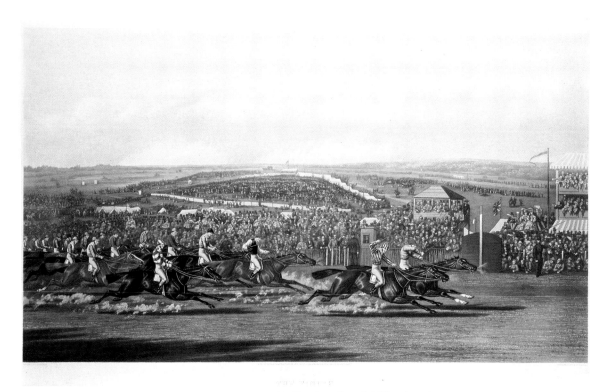

SUMMERS, William. 'Racing: The Finish', after H. Alken, pair with 'Tattenham Corner', 1871, coloured.

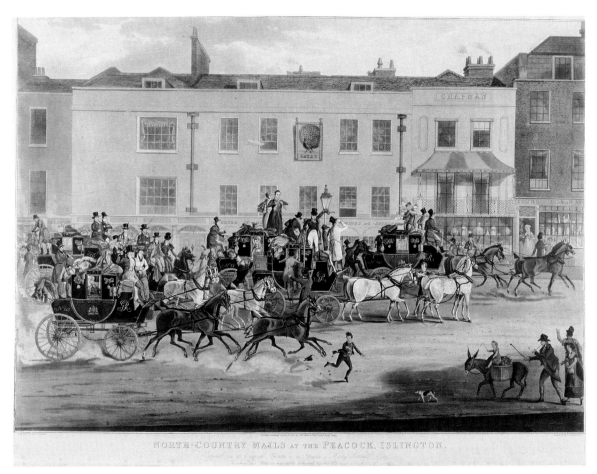

NORTH-COUNTRY MAILS at the PEACOCK, ISLINGTON.

SUTHERLAND, Thomas. 'North-Country Mails at The Peacock, Islington', after J. Pollard, 1823, coloured. One of the finest coaching prints of the period.

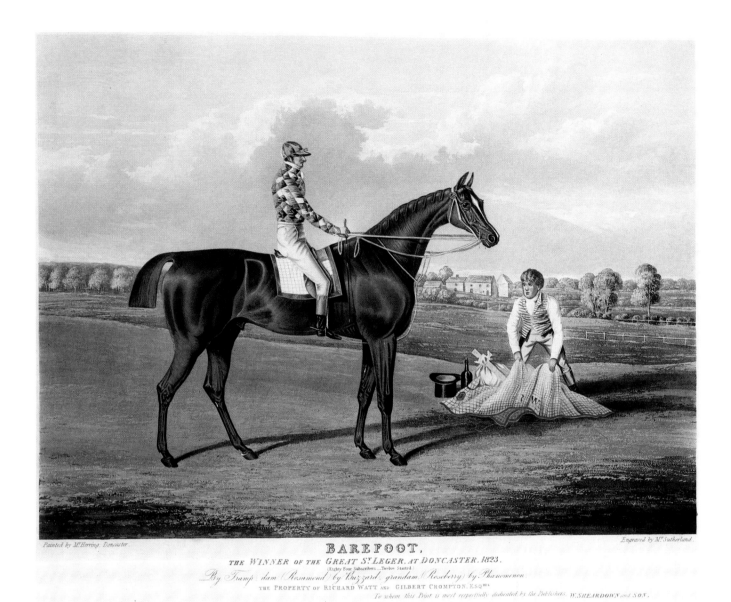

Painted by Mr Herring, Doncaster. Engraved by Mr Sutherland.

BAREFOOT,
THE *WINNER* OF THE *GREAT ST. LEGER, AT DONCASTER, 1823.*
(Eighty Four Subscribers.—Twelve Started.)
By Tramp, dam Rosamond by Buzzard, grandam Roseberry by Phænomenon.
THE PROPERTY OF RICHARD WATT AND GILBERT CROMPTON, ESQRS
To whom this Print is most respectfully dedicated by the Publishers, W. SHEARDOWN and SON.

SUTHERLAND, Thomas. 'Barefoot', the winner of the 1823 great St. Leger at Doncaster.

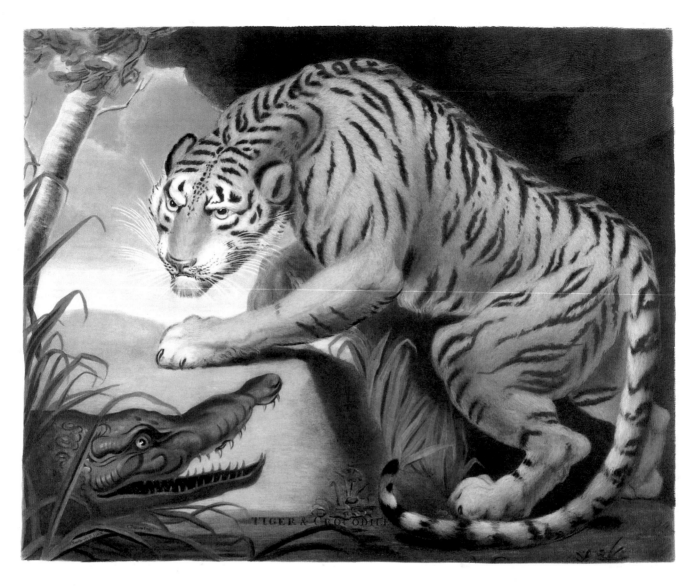

TURNER, Charles. 'Tiger and Crocodile', after J. Northcote, 1799, printed in colour and finished by hand.

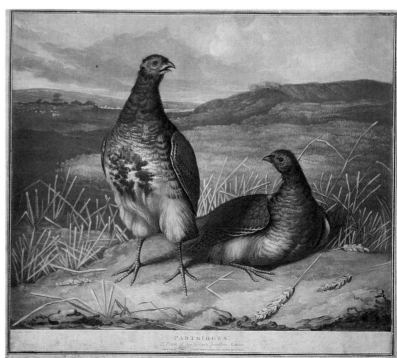

TURNER, Charles. One of fourteen plates from 'British Feather Game: Partridges', after J. Barenger, 1810, mezzotint, printed in colours.

TURNER, Joseph Mallord William. A plate from *Liber Studiorum* drawn and etched by Turner and mezzotinted by William Say. All the plates in *Liber Studiorum* were printed in sepia tones.

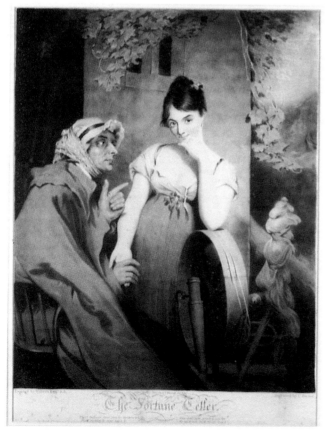

TURNER, Charles. 'The Fortune Teller', after W. Owen, 1824, printed in colours.

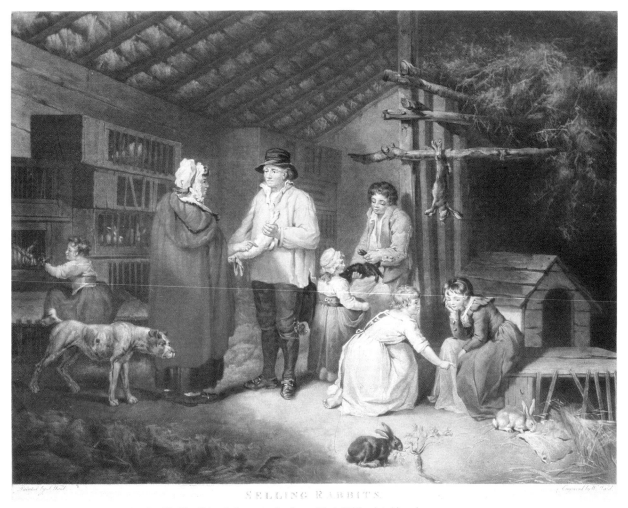

SELLING RABBITS.

WARD, William. 'Selling Rabbits', pair with 'The Citizen's Retreat', after James Ward, 1796, printed in colours.

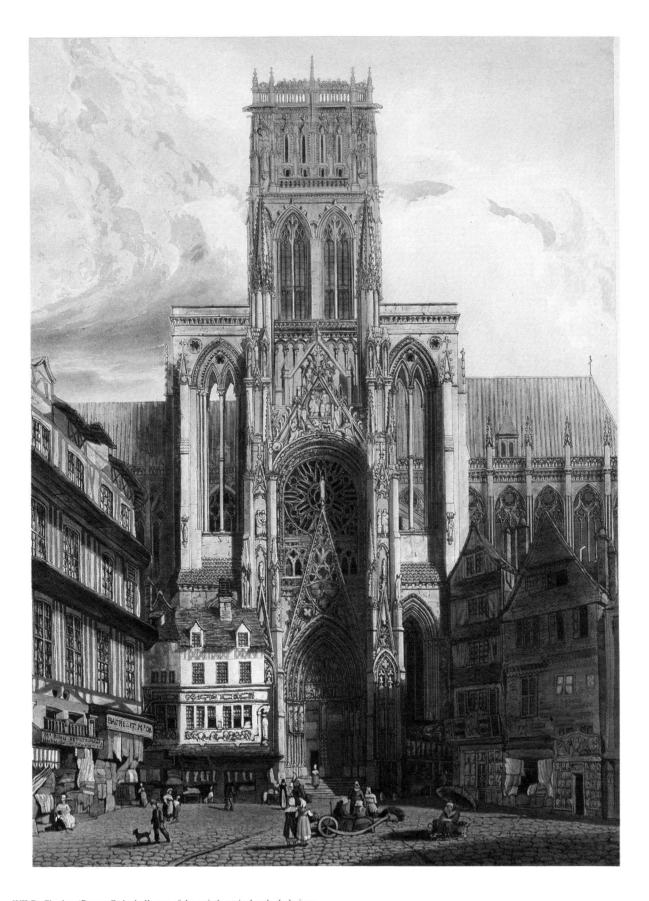

WILD, Charles. 'Rouen Cathedral', one of the artist's typical cathedral views.

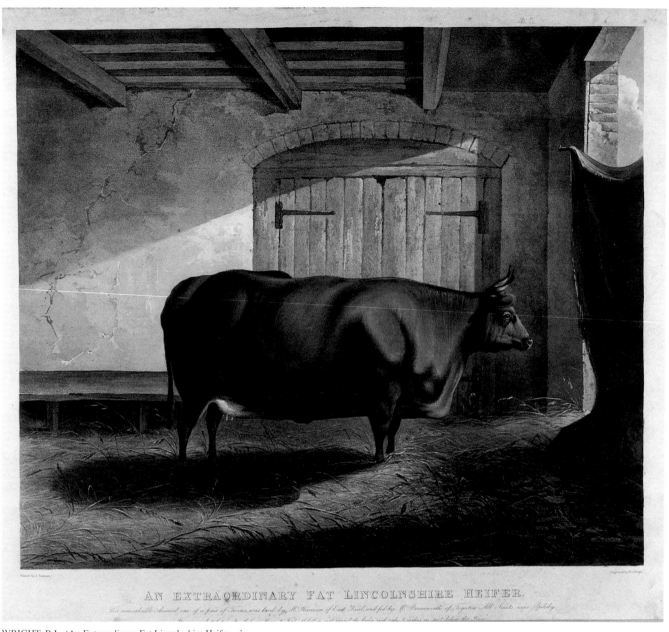

AN EXTRAORDINARY FAT LINCOLNSHIRE HEIFER.

WRIGHT, R.L. 'An Extraordinary Fat Lincolnshire Heifer…'

DICTIONARY
of British Printmakers 1650 – 1950

Abbreviations and conventions

A.	– Associate
anon.	– anonymous
approx.	– approximately
aq.	– aquatint, -s -ed (see Processes in the Introduction)
ave.	– average, averaging
b.	– born
b. & w.	– black and white
c.	– circa
cat.	– catalogue
chromolitho.	– chromolithograph, -s, -cd
cm	– centimetre, -s
col.	– coloured (colour added by hand to print), colours
CS	– Chaloner-Smith (see Bibliography)
d.	– died
diam.	– diameter
e.	– each
edn.	– edition, s
eng.	– engraving, -s, -ed, -er(s) (see Processes in the Introduction)
fl.	– floruit (flourished
fo.	– folio (see also 4to., 8vo., 12mo., etc., below)
frontis.	– frontispiece, -s
HL	– half length
imp.	– impression, -s
inc.	– including
in.	– inches
Jun.	– Junior
lge.	– large
litho.	– lithograph, -s -ed (see Processes in the Introduction)
Man Cat.	– F.H. Man (see Bibliography)
mezzo.	– mezzotint, -s. -ed (see Processes in the Introduction)

misc.	– miscellaneous
obl.	– oblong
O.M.	– Order of Merit
P.	– President
P.C.Q.	– *Print Collectors' Quarterly* (see Bibliography)
pl.	– plate, -s
prd.	– printed
prd. in col.	– printed in colours (printed with more than one colour)
publ.	– published
q.v. (qq.v.)	– quod vide (which see)
R.A.	– Royal Academy
R.C.A.	– Royal College of Art
R.E.	– Royal Society of Painter-Etchers and Engravers
R.S.A.	– Royal Scottish Academy
R.S.W.	– Royal Scottish Water Colour Society
R.W.S.	– Royal Society of Painters in Water Colours
Sen.	– Senior
TQL	– three quarter length
tt.	– tinted (applied to lithograph printed with a tintstone, mostly of a beige colour)
uncol.	– uncoloured
v.	– very
vol.	– volume
WL	– whole length
fo., 4to.,	– standard book sizes (also used where size of individual sheet or print is not known)
8vo., 12mo., Royal 4to., Royal 8vo., small 8vo., etc.	

Sizes, where given, are height by width.

ABBE, Solomon van 1883-1955
Dutch painter and drypoint etcher of genre subjects and portraits. Born in Amsterdam, he settled in London and was a pupil of E. Blampied (q.v.) whose style he imitated.
Legal subjects £80-£200.
Others £40-£90.

ABBOTT, Henry 1768-1840
London draughtsman and etcher.
'Antiquities of Rome', aq. by various eng., 1820, 24 pl., 13¾ x 19in/35 x 48.5cm, sepia, e. £10-£20.

ABBOTT, John White 1763-1851
Amateur painter and etcher of landscapes. Born and educated in Exeter, he established a practice as a surgeon and studied art under his friend, Francis Towne. Only sixteen prints are recorded, mostly etchings, all are very rare.
£50-£80, £150-£300 touched with pencil or wash by artist.

ACKERMANN fl. late 18th/early 19th century
Publishers of caricatures, decorative and sporting subjects and topographical views. The firm was founded in 1796 by Rudolph Ackermann (1764-1834), a German emigré,
who published a vast number of books with coloured plates as well as single plates. The plates in most of these books have an artist's and engraver's name, but almost all the plates for the magazine *Repository of Arts*, named after Ackermann's gallery in the Strand, London, are unsigned. Nearly 1,500 were published between 1809 and 1828.
Pl. for Repository of Arts, aq.: topographical views e.£10-£40 col.; others £5-£20 col.
Bibl: Ford, J. 'A., 1783-1983', 1983.

ADAM, John fl. late 18th century
Stipple engraver of small bookplates, including portraits and decorative subjects after his contemporaries. He worked in London.
Small value.

ADAM, Joseph Denovan, R.S.A. 1842-1896
Scottish painter who etched some animal subjects. He was born in Glasgow.
£10-£30.

ADAMS, Francis Edward fl. 1760-1773
Draughtsman and mezzotint engraver of portraits, caricatures and decorative subjects after his contemporaries as well as his own designs.
'Air', after Raoux, 14 x 10in/35.5 x 25.5cm, £100-£300.
'Counseller Cozen Consulting Cases', 1773, 14 x 9⅞in/35.5 x 25cm, and other caricatures, £200-£500.
Portraits £15-£40.
CS.

ADLARD, Henry fl. mid-19th century
Line engraver mostly of landscapes and topographical views after his contemporaries.

'Cannon Street Station and Bridge from the Thames', after J. O'Connor, 10¼ x 18in/27.5 x 46cm, £100-£160.
Other lge. views £20-£30.
'Athens from the Hill of the Museum', after W. Purser, £20-£30.
Other bookplates small value.

ADYE, J. fl. early 19th century
Draughtsman and lithographer.
Greek figures, 17 x 12in/43 x 30.5cm, e. £200-£300 col.

AFFLECK, Andrew F. fl. early 20th century
Painter and etcher of architectural views. He worked in England and on the Continent.
£20-£60.

AGAR, John Samuel 1775-1851 or later
Painter and stipple engraver of portraits after his contemporaries and costume plates after T. Uwins for Ackermann's *Oxford and Cambridge* and the *Public Schools* 1814-18. He is best known for his plates after R. Cosway.
Pl. after Cosway, e. £60-£200 prd. in col.
Pl. after Uwins, e. £5-£15 col.

AGLIO, Agostino 1777-1857
Italian painter and lithographer of landscapes and architectural views after his own designs and those of his contemporaries. Born in Cremona, he settled in England in 1803. He also worked as a decorator.
'Views of Manchester', after J. Ralston, 1823, 11 x 14¾in/28 x 37.5cm, e. £100-£300.
'Views in Switzerland', after C. Bourgeois, 1822, fo., e. £20-£60.
Pl. for G.B. Belzoni's Plates Illustrative of the Researches in Egypt and Nubia, *1820, fo., e.*

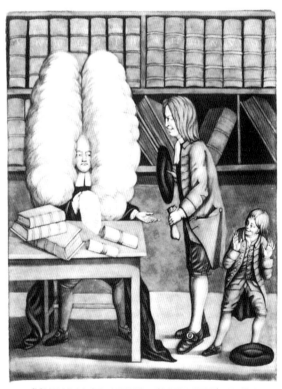

ADAMS, Francis Edward. 'Counsellor Cozen Consulting Cases', 1773.

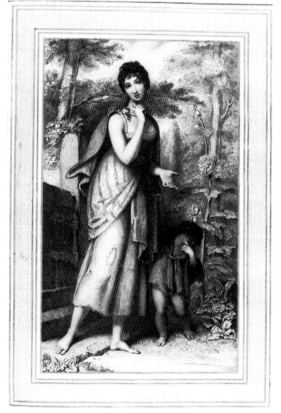
AGAR, John Samuel. A typical stipple engraving after Cosway.

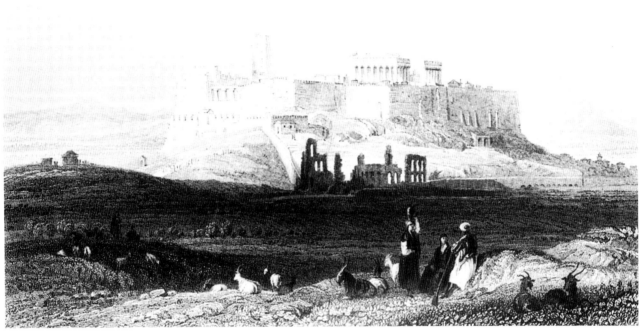

ADLARD, H. 'Athens, from the Hill of the Museum', after W. Purser.

£50-£70 col.
Six views of Hastings, 1823, obl. fo., e. £25-£40 col.
Small landscape studies small value.
Colour plate page 21.

AIKEN, John Macdonald, A.R.S.A., A.R.E.
1880-1961
Scottish painter and etcher of landscapes and architectural views. He was born in Aberdeen and studied at the School of Art there and at the R.C.A.
£15-£30.

AIKMAN, Alexander fl. mid-19th century
Line engraver of small bookplates including topographical views and religious and genre subjects after Old Masters and his contemporaries. He worked in Edinburgh.
Small value.

AIKMAN, G. fl. mid-19th century
Line engraver of small bookplates including landscapes and architectural views after his contemporaries. He worked in Edinburgh.
Small value.

AIKMAN, George W. 1830-1905
Scottish painter, etcher and mezzotint engraver of landscapes and portraits mainly after his own designs. Born in Edinburgh, he began his career engraving plates for the *Encyclopaedia Britannica;* later he contributed to *English Etchings* and similar publications.
Pl. for Encyclopaedia Britannica, *small value.*
'A Round of the Links: Views of the Golf Greens of Scotland', after J. Smart, 1893, e. £40-£100.
Others £5-£8.

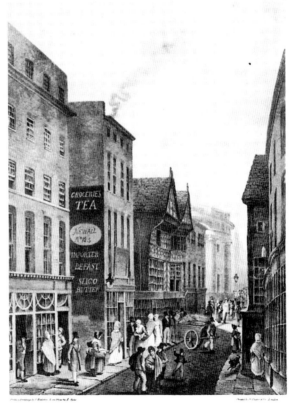

AGLIO, Agostino. One of the plates from 'Views of Manchester: Market Street', after J. Ralston, 1823.

ALAIS, Alfred Clarence. 'Winter Quarters', after F. Paton, 1881.

Below:
ALDIN, Cecil Charles Windsor. A typical drypoint study of a dog.

AIRY, Anna, R.E. 1882-1964
Painter and etcher, especially of still life, who lived in Suffolk.
£10-£30.

AITKEN, Robert J. fl. late 19th century
Lithographer.
Small value.

ALAIS, Alfred Clarence fl. late 19th century
Mixed-method engraver of sentimental and sporting subjects after his contemporaries. Worked in London.
Larger pl.: sporting subjects £60-£200.
'Winter Quarters', after F. Paton, 1881, and others, £40-£100.
Add more if in fine contemporary frame.
Pl. for the Library Edition of The Works of Sir Edwin Landseer *e. small value.*

ALAIS, John fl. early 19th century
Stipple engraver of decorative subjects and portraits after his contemporaries.
'Juvenile Opposition' and 'Juvenile Reluctance', after F. Wheatley, pair £300-£400 prd. in col.
'Mr. Rae as Sir Edward Mortimer', after S. de Wilde, 15 x 9¾in/38 x 25cm, £30-£40.
Small portraits and bookplates small value.

ALAIS, William John fl. late 19th century
Mixed-method engraver of sentimental subjects and portraits after British 18th century painters and his contemporaries. He was the son of A.C. Alais (q.v.).
Views of Brighton, after W.A. Delamotte or F. Ford, e. £15-£40.
Others small value.

ALBERT OF SAXE-COBURG,
Prince Consort 1819-1861
Amateur draughtsman and etcher of figure subjects and animals. He and Queen Victoria were taught etching by G. Hayter (q.v.), and they produced a few plates c.1840-41, both after Edwin Landseer's designs as well as their own. Their plates are scratchy and bad, but are none the less sought-after curiosities.
'The Prince of Wales', his only lithograph, 1846, extremely rare, 9¾ x 7¾in/25 x 19.5cm; and others £100-£300.
Bibl: Scott-Elliot, A.H., 'The Etchings of Queen Victoria and Prince Albert', Bulletin of the New York Public Library, 65, 1961.

ALDIN, Cecil Charles Windsor 1870-1935
Well-known painter of sporting and coaching subjects, who was born in Slough and lived near Reading. While he himself produced a few drypoints, mainly of dogs, most of the prints which bear his name are, in fact, after his paintings.
Drypoints: dogs £100-£300; coaching and hunting subjects £150-£300.
Signed artist's proofs (i.e. reproductions of watercolours signed in pencil) of hunting subjects £100-£400 prd. in col., depending on which hunt.
Litho. of old inns and humorous scenes £30-£80 prd. in col.
Photogravures of coaching subjects £100-£200.

ALEXANDER, William 1767-1816
Draughtsman, watercolourist, etcher, stipple and aquatint engraver of costume plates, etc. Born in Maidstone, he accompanied the Earl of Macartney's expedition to China 1792-94, from which resulted many drawings and later engravings. After serving as Professor of Drawing to the Military College at Great Marlow, he joined the British Museum, 1808, where he became the first Keeper of Prints and Drawings.
'Costume of China', 1805, 48pl., 4to., soft-ground etchings, e. £5-£8 col.
'Representation of the Dinner Given by Lord Romney to the Kentish Volunteers in Presence of Their Majesties and Royal Family', 1800, 15¼ x 22¼in/39 x 56.5cm, aq., £400-£600 col.
Bibl: Legouix, S. 'Image of China: W. A.', 1980.

ALIAMET, François-Germain 1734-1790
French etcher and line engraver of religious and decorative subjects and portraits after his contemporaries and Old Master painters. Born at Abbeville, he studied drawing under a local artist, before completing his training under his brother Jacques' tutelage in Paris. Around 1756 he emigrated to London where he opened a drawing school and married. He worked for R. Strange (q.v.).
Religious subjects and portraits eng. in London mostly small value.
'Mrs. Pritchard as Hermoine', after R.E. Pine, 1765, 17½ x 12¾in/44.5 x 32.5cm, £20-£40.

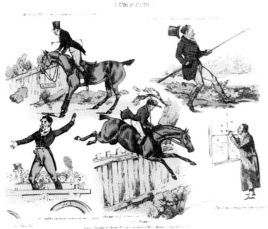

ALKEN, Henry Thomas. A plate from 'Symptoms', 1822. An example of Alken's many humorous illustrations etched in soft-ground.

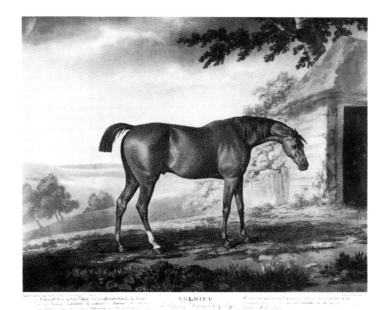

ALKEN, Samuel. 'Soldier', after G. Garrard, 1793.

ALKEN, Henry Thomas (Henry Alken I)
1785-1851

Famous painter, etcher, aquatint engraver and lithographer of sporting subjects mainly after his own designs but also after those of his contemporaries. Born in London, he was the son and pupil of Samuel Alken (q.v.) and also studied under the miniaturist J.T. Barker Beaumont. In 1810 he and his wife went to live in Melton Mowbray. The first engravings after his paintings were published in 1813, and the first prints by him in 1815. There followed a vast output of prints by or after him right through the 1820s and 1830s. He later settled in London where he died.
'On the Road to the Derby', panorama, 2½ x 160in/6.5 x 406.5cm, etching, £600-£1,200 col.
'Sporting Illustrations', 1837, 4 aq., 17 x 21in/43.5 x 53.5cm, set £2,000-£3,000 col.
'Hunting: The Right Sort', 1821-2, 6 litho., 9¼ x 12in/23.5 x 30.5cm, set £600-£800 col.
'Studies of the Horse', 1830, 24 soft-ground etchings, 7½ x 10½in/19 x 26.5cm, e. £5-£10.
'Hunting, or One Day's Sport by Three Real Good Ones from the East End', 1823, 6 soft-ground etchings, 9¼ x 13in/24.5 x 33cm, set £500-£800 col.
'The Seven Ages of the Horse', 1825, 7 soft-ground etchings, 8¼ x 10¼in/22.5 x 27cm, set £400-£600 col.
'The Beaufort Hunt', after W.P. Hodges, 1833, 8 etchings with aq., 16¼ x 23¼in/41.5 x 59cm, set £6,000-£12,000 col.
'The Quorn Hunt', drawn and etched by H.T.A., aq. by F.C. Lewis, set £4,000-£8,000 col.; later reprints: set £300-£900 col.
'Ide . . .' 1826-30, 4 soft-ground etchings, 10¼ x 8in/26 x 20cm, e. £10-£30 col.
'Symptoms', 1822, 42 soft-ground etchings, e. £10-£30 col.
Colour plates pages 22 and 23.

ALKEN, Samuel
1756-1815

Aquatint engraver of landscapes, topographical views and sporting subjects after his contemporaries. Born in London, where he lived and worked, he was the son of a carver and gilder, and studied at the R.A. Schools. He was the father of H.T. Alken (q.v.).

'Shooting', after G. Morland and etched by T. Rowlandson (qq.v.), 1789, 17 x 22in/43.5 x 56cm, set £4,000-£6,000 col.
'Soldier', after G. Garrard, 1793, 16½ x 20½in/42 x 52 cm, £400-£700 col.
'An Excursion to Brightelmstone', after and etched by T. Rowlandson (q.v.), 1790, 8 pl., 9¼ x 13¾in/24.5 x 35cm, sepia, e. £20-£40.
'View of Hall Place School near Bexley, Kent' (with cricket match in progress), after W.B. Noble, 15 x 21in/38 x 53.5cm, £400-£600 col.
'North and South Views of Windsor Castle', after R. Cooper, 1799, 18¾ x 28½in/7.5 x 72.5cm, pair £300-£400.
Views of Norwich, after R. Ladbrooke, 1806, 4 pl., 14 x 19¼in/5.5 x 49cm, e. £60-£120.
'Duke of Newcastle's Return from Shooting', after F. Wheatley with F. Bartolozzi (qq.v.), 1792, 21¼ x 26¼in/ 54 x 68 cm, £800-£1,200 prd. in col.
'Magdalen College', after J.C. Buckler, 1799, 18¾ x 25in/47.5 x 63.5cm, £150-£300.
Small landscape pl. after W. Gilpin, etc., small value.

ALKEN, Samuel Henry (Henry Alken II, Henry Gordon Alken)
1810-1896

Painter of sporting and coaching subjects who etched a few plates after his own designs. Born in London, he was the son of H.T. Alken (q.v.) whose style he imitated. Many of his paintings were engraved by professionals.
'Herne Bay Grand Steeple Chase . . .1834', 4 pl., 10½ x 13¼in/27 x 35cm, soft-ground etchings with added etching, set £300-£500 col.
'The Sporting Exploits of the Late Henry Hunt', c.1840, 12¼ x 14½in/31 x 37cm, soft-ground etchings, pair £120-£180 col.

ALLAN, David
1744-1796

Famous Scottish painter of portraits and historical subjects, who also etched and aquatinted several plates. After 14 years in Italy, 1764-77, he settled in Edinburgh.
Italian genre scenes, etchings, £30-£70.
Illustrations to Alan Ramsey's Gentle Shepherd, 1788, 12 pl., 4to., aq., e. £10-£20.
'A Highland Laird', 7 x 4¼in/17.5 x 11cm, £40-£70.
Bibl: Gordon, Crouther T., David Allan of Alloa, The Scottish Hogarth, Alva, 1951.

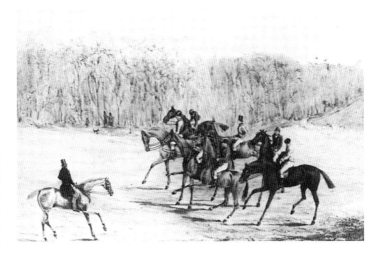

ALKEN, Samuel Henry. 'Herne Bay Grand Steeple Chase, April 3rd 1834', one of four plates, soft-ground etchings.

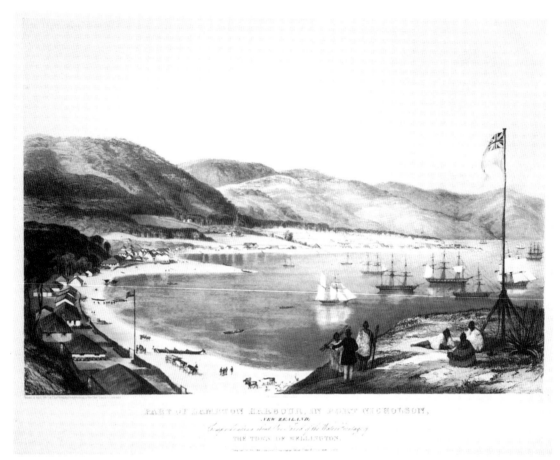

ALLOM, Thomas. 'Part of Lambton Harbour, in Port Nicholson', from C. Heaphy's *Views in New Zealand*, c.1842.

ALLAN, Robert Weir, R.W.S., R.S.W.
 1851-1942
Glaswegian painter of marines and landscapes who produced some etchings and drypoints. *£10-£30.*

ALLEN, James Baylis 1803-1876
Line engraver on steel of small bookplates including landscapes, topographical views and decorative subjects after his contemporaries. Born in Birmingham, he came to work in London, commencing with the Findens (qq.v.) in 1824.
Small value.

ALLEN, James C. fl. early 19th century
Line engraver of small bookplates including topographical views and decorative subjects after his contemporaries. Born in London, he was a pupil of W.B. Cooke (q.v.), with whom he collaborated on views of the Coliseum in Rome.
Views of the Coliseum, 1821, 15 pl., e. £10-£20. Others small value.

ALLINGHAM, William J.
 fl. late 19th/early 20th century
Etcher of topographical views and decorative subjects after his contemporaries. He is known mainly for his reproductions of public school views by F.P. Barraud, the prices of which depend on the school.
Views of public schools: e.g. Eton £40-£100; Haileybury £30-£80.
'The Months' after W. Hamilton, 1913, 11¼ x 9¾in/30 x 25cm, set of twelve prd. in cols. £600-£1000.
Others £5-£20.

ALLOM, Thomas 1804-1872
Architect and painter of topographical views. He travelled extensively abroad producing many drawings for reproduction by the steel engravers, e.g. for G.N. Wright's *China and France*. He himself also lithographed several architectural and topographical views.
Pl. for P.F. Robinson's Designs for Gate Cottages, Lodges and Park Entrances, *1837, 4to., e. small value.*
Pl. for D. Robert's Picturesque Sketches in Spain, *1837, fo., tt., e. £30-£70 col.*
Pl. for Sir K.A. Jackson's Views in Affghaunistan, *1841, fo., tt., e. £30-£50 col.*
Pl. for C. Heaphy's Views in New Zealand, *c.1842, 14 x 20½in/35.5 x 52cm, e. £200-£500 col.*

ALLPORT, J. fl. mid-19th century
Mezzotint engraver of small book illustrations.
Small value.

ALMA-TADEMA, Sir Lawrence, O.M., R.A.
 1836-1912
Well-known late Victorian painter of classical scenes. Born in Holland, he studied in Antwerp, and settled in London in 1870. While many of his paintings were reproduced either by professional etchers or by photogravure, he himself etched only a few plates.
Original etchings £100-£300.
Etchings after Alma-Tadema by A. Blanchard, A. Boulard, L. Lowenstam (qq.v.), etc., £100-£300.
Photogravures £50-£150.
Add more if in fine contemporary frame.

ALSTON, J.W. fl. early 19th century
Draughtsman and aquatint engraver.
'Hints to Young Practitioners in the Study of Landscape Painting', 1804, 8vo., 6pl., small value.

ANDERSON, Alfred Charles Stanley, R.A., R.E. 1884-1966
Painter, etcher, drypointer and line engraver of portraits, landscapes, architectural views and genre subjects. Born in Bristol, he served an apprenticeship under his father, a professional engraver, and studied under F. Short (q.v.). His prints can roughly be divided into two periods, the earlier consisting mainly of etchings and drypoints of landscapes and architectural views which are sometimes monotonous. In the 1930s he turned to line engraving and concentrated more on figure and genre subjects. Without doubt, his most important works are the series of engravings depicting rural crafts and trades, which combine technical excellence, a sympathetic eye and serious historical interest.
Rural crafts and trades e. £250-£500.
Others £50-£120.
Bibl: Hardie, M., 'The Etchings and Engravings of S.A.', *P.C.Q.,* 1933, XX, pp.221-46.

ANDERSON, John
fl. late 18th/early 19th century
Wood engraver of book illustrations. He was a pupil of T. Bewick (q.v.) and later abandoned engraving. *Small value.*

ANDERSON, John Corbet fl. mid-19th century
Draughtsman and lithographer mainly of portraits of cricketers. He produced both single and group portraits.
'United All England Eleven', 21 x 27½in/53.5 x 70cm, £800-£2,000 col.
'Joseph Guy', 1853, and other single portraits, approx. 13 x 8¾in/33 x 22cm, e. £100-£300 col.
Group of Indian subjects, after Dr. C.R. Francis, fo., e. £3-£6.

ANDERSON, Kay b.1902
Painter, etcher, engraver and lithographer who lived in London.
£15-£30.

ANDERSON, Robert 1842-1885
Scottish etcher and engraver of landscapes, etc., who lived in Edinburgh.
Small value.

ANDRADE, Athene b.1908
Painter, etcher and lithographer of portraits and landscapes.
£10-£20.

ANDREWS, H.B. fl. late 19th century
Etcher.
£4-£10.

ANDREWS, Sybil b.1898
Colour linocut artist of figure subjects in a futurist style. Born at Bury St. Edmunds, Suffolk, she worked on aircraft construction during World War I. After the war she met C.E. Power (q.v.) and they exhibited together in Bury and then shared a studio in Hammersmith. In 1925 they helped I. McNab and W.C. Flight (qq.v.) to set up the New Grosvenor School of Modern Art, and were taught lino cutting by Flight. From 1929 the collaboration of Andrews and Power extended to poster design, primarily for the London Underground. It is her linocuts which have now become much sought after. She emigrated to Canada after World War II.
'The Race', 1930, 11½ x 15¼in/29 x 39cm, £4,000-£6,000.
'Concert Hall', 1929, 9 x 11in/23 x 28cm, £2,500-£3,500 (made £4,000 in 1990).
'The Gale', 1930, 9 x 9¼in/23 x 24.5cm, £1,600-£2,400.
'Pieta', 1932, 10¼ x 7¼in/27 x 18.5cm, £300-£500.
'Sledgehammers', 1933, 10½ x 12½in/26.5 x 31.5cm, £800-£1,200.
'Golgotha', £300-£500.
'Racing', 1934, 10¼ x 13½in/26 x 34.5cm, £2,500-£3,500 (made £4,800 in 1990).
'Bringing in the Boat', 1933, 13 x 10¼in/33 x 26cm, £2,500-£3,500 (made £4,000 in 1990).

ANGAS, George French 1822-1886
Topographical draughtsman who travelled widely and is best known for his views of Australia where he spent several years. While most of his drawings and illustrations were reproduced by professionals, it appears that he both drew and lithographed the following:
'Six Views of the Gold Fields of Ophir', 1851, fo., e. £300-£700 col.
'The Kaffirs Illustrated', 1849, 31 pl., fo., e. £60-£120 col.

ANGIER, Paul c.1725-1757 or later
Line engraver.
Small value.

ANGUS, Stanley fl. early/mid-20th century
Scottish etcher of landscapes.
£15-£40.

ANGUS, William fl. c.1753-1821
Painter, etcher and line engraver mainly of small topographical bookplates after his contemporaries.

ANDREWS, Sybil. 'Golgotha'. Colour plate page 24.

ANDREWS, Sybil. 'Concert Hall', 1929.

ANDERSON, Alfred Charles Stanley. One of Anderson's important engravings of rural crafts and trades.

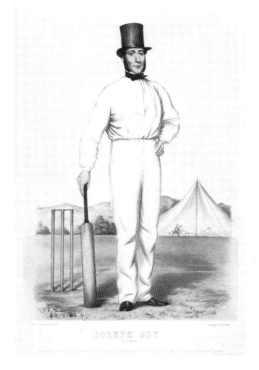
ANDERSON, John Corbet. 'Joseph Guy', 1853. Typical of Anderson's portraits of cricketers.

ANSDELL, Richard. One of Ansdell's contributions to the Etching Club publications.

Pl. for Seats of Nobility in Great Britain and Wales, *1787, obl. 4to., e. small value.*
Pl. for W. Wilkins' The Antiquities of Magna Graecia, *1807, e. £10-£20.*
One pl. for T. Baldwin's Airopaedia Containing the Narrative of a Balloon Excursion from Chester, the eighth of September, *1785, 8vo., £10-£15.*
View of Paris £12-£18.

ANNIS, William Thomas fl. 1799-1811
Mezzotint engraver of decorative subjects, landscapes and portraits after his contemporaries.
'The Cunning Gypsy', after J. Ward, 1802, 18 x 21¼in/46 x 55cm, £200-£300.
'Repairing to Market', 'At Market', 'Coming from Market', 'Returned from Market', 4 pl. after F. Wheatley, 1803, 21¼ x 18 in/55 x 45.5cm, set £1,600-£2,400 prd. in col.
Pl. for J.M.W. Turner's Liber Studiorum *e. £80-£200.*
'Death of Nelson', after S. Drummond, c.1815, 23½ x 27½in/59.5 x 70cm, £100-£150.
'John Fawcett as Dr. Pangloss in The Rivals*', after S. de Wilde, 1803, 20 x 15in/51 x 38cm, £100-£160.*
'Mary Wollstonecraft Godwin', HL, after J.Opie, 1802, 15 x 11in/38 x 28cm, £30-£70.
CS.

ANSDELL, Richard, R.A. 1815-1885
Painter and etcher especially of animal and sporting subjects. Born in Liverpool, he lived in London and Farnborough, and was one of the more significant contributors to the Etching Club publications.
£15-£40.

ANSELL, William Henry, A.R.E. 1872-1959
Nottingham-born architect and etcher.
£8-£15.

ANSTED, William Alexander
 fl. late 19th century
Painter and etcher mainly of landscapes after his own designs as well as those of his contemporaries. He lived in London.
£5-£10.

APOSTOOL, Cornelis 1762-1844
Dutch painter and aquatinter. Born in Amsterdam, he worked in London in the early 1790s reproducing topographical views and Old Master paintings for books as well as a few larger single plates. He returned to Amsterdam in 1796, and became Director of the Museum there in 1808.
Pl. for Albanis de Beaumont's Travels through the Rhaetian Alps, *1792, 10 pl., fo., sepia, e. £80-£120.*
Pl. for S. Ireland's A Picturesque Tour through Holland, Brabant, and Part of France, *1790, 47 pl., fo., e. £10-£20 col.*
'The Beauties of the Dutch School', 1793, 14 pl., obl. fo., e. £5-£8 col.
'A Meeting of the Society of Royal British Archers in Gwersyllt Park, Denbighshire', after R. Smirke and J. Emes, 1794, 19¼ x 24½in/49 x 62cm, £900-£1,400 col.
Naval subject: 'Nymphe and Cleopatra', after Lieut. F. Yates, 1794, 14 x 21¼in/35.5 x 54cm, £250-£350 col.

APPLEBY, Wilfred Crawford b.1889
Worcestershire-born painter and etcher of landscapes, architectural views and portraits.
£6-£12.

APPLETON, Thomas Gooch 1854-1924
Essex-born mezzotint engraver of portraits and sentimental and sporting subjects after 18th century British painters as well as his contemporaries.
Sporting subjects £80-£200.
Others £30-£100.

ARCHER, James fl. early 19th century
Line engraver of small bookplates.
Small value.

ARCHER, John Wykeham 1808-1864
Etcher and line engraver mainly of small topographical bookplates after his contemporaries. Born in Newcastle, he was apprenticed to John Scott (q.v.) and then in W. and E. Finden's studio in London.
Pl. after J.M.W. Turner in early or proof imp. £20-£80.
Pl. for J. Carmichael's Fountains Abbey, Yorkshire, *eng. with W. Collard, e. £10-£30.*
'Vestiges of Old London', 1851, £5-£8.
Others small value.

ARDAIL, Albert
 fl. late 19th/early 20th century
French etcher of figure subjects after his contemporaries. He is mentioned here for his reproductions of sentimental works by Meissonier and W. Dendy Sadler.
After Meissonier and Dendy Sadler £20-£80; others small value.

ARDIZZONE, Edward Jeffrey Irving, R.A.
 1900-1979
Painter, humorous illustrator, lithographer of posters and figure subjects. Born in the Far East of Italian and Scottish parents. During World War II he worked as Official War Artist in Belgium and Holland, 1940, Sicily, 1943, France, 1944, and Germany, 1945.
£100-£300.

ARENDZEN, Petrus-Johannes
 fl.late 19th/early 20th century
Dutch etcher of portraits, sentimental subjects, etc., after Dutch Old Masters and his contemporaries. He worked in London.
'Eloquent Silence', after L. Alma-Tadema, c.1890, 20 x 16in/51 x 40.5cm, and others after the same, £100-£250.
Others small value.

ARMOUR, Heda b.1916
Painter and etcher.
Small value.

ARMSTRONG, Cosmo 1781-1836
Line engraver mainly of small book illustrations after his contemporaries. Born in Birmingham, he was a pupil of T. Milton (q.v.).
Small value.

ARMSTRONG, Elizabeth Adela 1859-1912
Etcher and drypointer of female figure subjects. She was married to the painter Stanhope A. Forbes.

ARENDZEN, Petrus-Johannes. 'Eloquent Silence', after L. Alma-Tadema. c.1890.

ATKINSON, John Augustus. One of the plates from 'Sixteen Scenes Taken from the Miseries of Human Life', 1807.

£30-£80.
Bibl: Sabin, A.K., 'The Drypoints of E.A.A.', *P.C.Q.*, 1922, IX.

ARMSTRONG, Thomas fl. early/mid-19thcentury
Wood engraver of small book illustrations.
Small value.

ARMYTAGE, James Charles 1802-1897
Line engraver of small bookplates including topographical views, portraits and historical subjects after his contemporaries.
Pl. after J.M.W. Turner in early or proof imp. £20-£80.
Others small value.

ARNOLD, G. fl. early 19th century
Lithographer.
2 portraits, 1806, e. £50-£150.
Man Cat.

ARTLETT, Richard Austin 1807-1873
Stipple and line engraver of small bookplates including sentimental subjects and portraits after his contemporaries.
'England, Folkestone' and 'France, Boulogne', after J.J. Jeakins, 1855, 19½ x 13¾in/49.5 x 35cm, pair £80-£200.
Others mostly small value.

ARUNDEL SOCIETY fl. 1848-1897
A society publishing chromolithographic reproductions of Old Master paintings, particularly of religious subjects. Named after Thomas Howard, Earl of Arundel, an early patron of the arts in England, the Society was set up in 1848 to publish information and engravings about paintings. It played a pioneering part in recording and protecting Italian frescoes, and is best known for its reproductions of Italian painting, most of which were produced in Berlin by the firm of Storch and Kramer, and were fashionable as decorations in the last century.
£15-£100 depending on the decorative quality of the contemporary framing.
Bibl: Johnson, W.N. 'Handbook to the Chromo-lithographs . . . published by the A.S'. Manchester, 1907.

ASHLEY, Alfred fl. mid-19th century
Minor etcher of landscapes.
Small value.

ATKINSON, Charles fl. early 19th century
Lithographer.
'A Match at Lord's Cricket Ground', 8 x 10in/20.5 x 25.5cm, £250-£400.
'Views through Hobart Town, Tasmania', obl. fo., e. £100-£300.

ATKINSON, Francis E. fl. late 19th century
Mezzotint engraver of sentimental subjects after his contemporaries.
Small value.

ATKINSON, George, R.H.A. 1880-1941
Irish painter, sculptor and etcher who was born in and lived in Dublin. He was Head of the Metropolitan School of Art, Dublin, and later Director of the National College of Art there.
£20-£60.

ATKINSON, John Augustus 1775-1831/3
Painter, soft-ground etcher and aquatint engraver of historical subjects, costumes and humorous illustrations. In 1784, when very young, he accompanied to Russia his uncle James Walker, who had entered the service of the Empress Catherine. He remained there until 1801 painting Russian historical subjects, and when he returned he produced first: 'Four Panoramic Views of St. Petersburg', and 'Manners, Costumes and Amusements of the Russians', perhaps his most important work with text by his uncle Walker. His later productions include 'Costumes of Great Britain', and 'Sixteen Scenes Taken From the Miseries of Human Life'.
'Four Panoramic Views of St. Petersburg', c.1802, 15 x 30in/38 x 76cm, aq., e. £300-£500 col.
'Manners, Costumes and Amusements of the Russians', 1803/4, fo., 101 soft-ground etchings with some aq., e. £10-£25 col.
'Costumes of Great Britain', 1807, fo., 33 aq., e. £20-£50 col.
'Sixteen Scenes Taken From the Miseries of Human Life', 1807, small obl. 4to., 16 soft-ground etchings, e. £15-£30 col.

ATKINSON, Thomas Lewis b.1817
Notable line and mezzotint engraver of portraits and sentimental subjects after his contemporaries. A pupil of S. Cousins (q.v.), he

ATKINSON, Thomas Lewis. 'Cinderella', after J.H.F. van Lerius, 1870.

AUSTIN, Robert Sargent. Portrait of a lady reclining.

worked in London, reproducing many of the best-known works by the great Victorian painters.
'The Black Brunswicker', after J.E. Millais, 1864, 16¾ x 25in/42.5 x 63.5cm, £150-£300.
'Love Birds', after J.E. Millais, 13 x 17¼in/33 x 45cm, £30-£70.
'Isambard Kingdom Brunel', after J.C. Horsley, 1858, 13 x 16¼in/33 x 41cm, £130-£250.
'Flora', after V.W. Bromley, 1876, 16½ x 30in/42 x 76cm, £80-£160.
'Cinderella', after J.H.F. van Lerius, 1870, 26¼ x 33in/68 x 83.5cm, £120-£200.
'Let Sleeping Dogs Lie', after B. Riviere, 1883, 23 x 17½in/58.5 x 44.5cm, £30-£80.
'Sir Moses Montefiore', after G. Richmond, 1876, 14 x 17in/35.5 x 43cm, £10-£30.
Add more for fine contemporary frames.

ATTWOLD, R. fl. mid-18th century
Draughtsman and etcher.
'Military Nurse or Modern Officer', 8¾ x 5¾in/22.5 x 14.5cm, £10-£30.

AUBRY, Edward fl. mid-19th century
Lithographer.
Pl. after Lieut. J.S. Cotton for F.W.N. Bayley's The New Tale of a Tub, 1841. 7 pl., e. £5-£10 col.

AUDINET, Philip 1766-1837
Engraver in line and occasionally in mezzotint and aquatint, mainly of small portraits after his contemporaries. Of French extraction, he was born and lived in London and was apprenticed to J. Hall (q.v.). He contributed plates to Harrison's and amongst the larger bookplates are:
'Temple Bar' after B. Cooper, 12½ x 10¼in/32 x 27cm, aq., £60-£120.
'Sir Benjamin Hobhouse', after T. Phillips, 1825, 10½ x 8in/26.5 x 20cm, £5-£10.
'Dr. Johnson', after J. Barry, 10¼ x 8in/27 x 20cm, £15-£30.
Other portraits and bookplates small value.
CS.

AUERBACH, Arnold 1898-1979
Sculptor who made a few prints (etchings, drypoints, woodcuts) of figure subjects; these were not published in editions during his lifetime and contemporary impressions are very rare. Born in Liverpool, he studied at the School of Art there.
£100-£200. Contemporary impressions.

AULD, Patrick C. fl. mid-19th century
Painter and occasional lithographer of landscapes and topographical views.
Two pl. for Hay's Views of Aberdeen, 1840, fo., e. £20-£30 col.

AUSTEN, Winifred Marie Louise 1876-1964
Painter, etcher and aquatinter of birds and animals. Born in Kent, she lived on the coast in Suffolk producing many prints which, while possessing great charm and delicacy, are also exceedingly accurate studies of small creatures.
£80-£160.
Bibl: 'Catalogue of the Etchings and Drypoints of W.A.', *Bookman's Journal*, 1927, XV, p.30.

AUSTIN, Frederick George, R.E. b.1901
Etcher and engraver who was the less talented brother of R.S. Austin (q.v.).
£15-£40.

AUSTIN, Robert Sargent, R.A., R.E.
 1895-1973
Painter, etcher, drypointer, but mainly a line engraver of figure subjects and animals. Born in Leicester, he studied under F. Short (q.v.) at the R.C.A. and later taught engraving himself. Austin's prints show the strong influence of the early German masters, not only in his technique but also in his often bleak and depressing imagery.
Portrait of a lady reclining £80-£160.
'Mask' 1933, 8 x 7½in/20.5 x 18.5cm, edition of 40; 'Young Mother' 1936, 5 x 4in/13 x 10cm, e.£100-£200.
Others mainly £60-£200.
Bibl: Dodgson, C., *A Catalogue of Etchings and Engravings by Robert Austin R.A., R.E., 1913-29*, London, The Twenty-One Gallery, 1930.

AUSTIN, T. fl. mid-19th century
Lithographer.
Pl. for Architectural Parallels, after E. Sharpe, 1848, e. small value.

AUSTIN, William 1721-1820
Etcher and line engraver of landscapes after Old Master painters, and caricatures after his own designs. Born in London, he was a pupil of G. Bickham (q.v.), and worked mainly as a drawing master; he later gave up teaching and engraving for publishing. He died in Brighton.
'A Specimen of Sketching Landscapes', after Lucatelli, 1781, 30 pl., small fo., etchings, small value.
Macaronis and other characters, 1773, 12 pl., ave. 10¼ x 14¼in/27.5 x 37.5cm, e. £30-£80.
'Laugh and Grow Fat', 1778, 9¼ x 15½in/23.5 x 39.5cm, £30-£80.

AYLESFORD, Heneage Finch, fourth Earl of 1751-1812
Amateur etcher of landscapes who amassed a considerable collection of Rembrandt's etchings and successfully imitated the Master in his prints.
£30-£70.
Bibl: Oppé, A.P., 'The Fourth Earl of Aylesford', *P.C.Q.*, 1924, XI, pp. 262-92.

AYLSFORD, Heneage Finch. A typical imitation of Rembrandt's landscape etchings.

BACHELOR, Philip H. Wilson
fl. mid-20th century
Etcher of landscapes.
£10-£40.

BACKSHELL, W. fl. early/mid-19th century
Genre painter and line engraver of small
landscape plates after his contemporaries.
Small value.

BACON, Frederick 1803-1887
Line and mezzotint engraver of sporting and
historical subjects and portraits after his
contemporaries.
*'John Bunyan in Bedford Gaol', after T.G.
Donval, 1851, 25 x 32in/63.5 x 81cm, £40-£80.*
*'Burial of Harold', after F.R. Pickersgill, 1851,
17½ x 14in/44.5 x 35.5cm, £30-£60.*
*'The Duke of Wellington in his Library', after
T.G. Barker, 1854, 17¼ x 13¼in/45 x 35cm, £40-
£80.*
*'The Shot', after R. Ansdell, 12 x 22in/30.5 x
56cm, £120-£200.*
Add more for fine contemporary frames.
Small bookplates small value.

BACON, G.W. & Co.
fl. 19th/early 20th century
Publishers of chromolithographs depicting
engagements in the Zulu and Boer Wars.
£60-£120.

BACON, J. fl. mid-19th century
Lithographer of 'Eminent Women', pair with
'Eminent Men', by J.W. Giles (q.v.), both after
W. Warman, 1856, 28 x 22½in/71 x 57cm (SH),
tt. pl., pair col. (some damages) fetched £280
April 1996.

BACON, Marjorie May b.1902
Suffolk etcher, engraver, lithographer and
aquatinter.
£10-£40.

BADELEY, Sir John Fanshawe, R.E.
1874-1951
Amateur etcher and engraver of heraldic
emblems and ex-libris. He worked in the
Judicial Office of the House of Lords and was
later Clerk of the Parliaments.
£10-£40.

BADMIN, Stanley Roy, R.W.S., R.E.
1906-1989
Etcher of rural scenes, landscapes and
architectural views. Born in London, he studied
under M. Osborne (q.v.) and R. Austin (q.v.) at
the R.C.A. and lived in Sussex. His charming
little prints are very much in the pastoral
tradition of S. Palmer (q.v.).
£150-£300.

BAGG, W. fl. mid-19th century
Lithographer.
*1 pl. for Dr. Bennett's Gatherings of a Naturalist
in Australasia, 1860, £10-£15 col.*

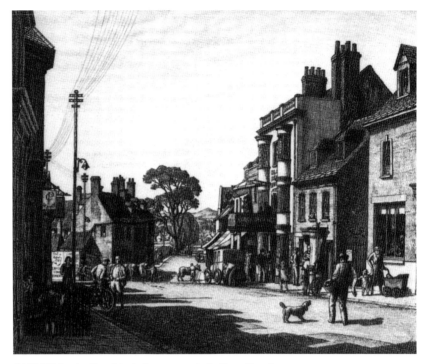
BADMIN, Stanley Roy. A typical town scene in the Home Counties.

BAGNOLD, Enid (Lady Jones) b.1890
Author and playwright who made some
etchings of figure subjects, influenced by W.
Sickert (q.v.).
£60-£120.

BAILEY, John fl. late 18th century
Draughtsman and line and wood engraver
mainly of small bookplates. He was self-taught.
Later, he abandoned engraving and became a
land agent and agriculturist in Northumberland,
writing several books on the subject.
*'The Blackwell Ox', after G. Cuit the Elder,
1780, 13 x 16¼in/33 x 41.5cm, eng., £300-£500.*
Bookplates small value.

BAILEY, J. *see* BAILY, J.

BAILLIE, Capt. William 1723-1810
Irish amateur etcher and engraver in mezzotint,
aquatint and line who reproduced Old Master
paintings as well as copying or reworking Old
Master prints, particularly those of Rembrandt.
Born in Kilbride, he came to London in 1741 to
study law but joined the army instead, serving at
the Battle of Culloden. Later he was made
Commissioner of Stamps, a post he retained for
20 years until his retirement in 1795. He
executed over 100 prints and Boydell issued a
collection of 113 in 1792 (reissued in 1803). He
is best remembered for his reworking of

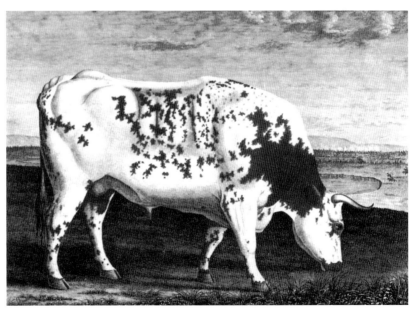
BAILEY, John. 'The Blackwell Ox', after G. Cuit, 1780.

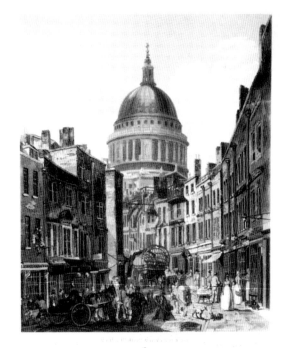

BALLIN, John. 'A Question of Propriety Before the Holy Inquisition', after E. Long, 1877.

BAILY, James. 'View of St. Paul's from St. Martin's Le Grand', after T. Girtin, 1815.

Rembrandt's 'Hundred Guilder' print.
'Hundred Guilder print', after Rembrandt, £1,000-£2,000.
'James, Duke of Monmouth', after Wyck and Netscher, 1774, 15¼ x 16½in/40 x 42cm, mezzo., £80-£160.
'Camillus Hone', after N. Hone, 1771, 13 x 9in/33 x 23cm, mezzo., £20-£50.
Etched copies of Old Masters £1-£10.
CS.

BAILY (Bailey), James
 fl. late 18th/early 19th century
Line and aquatint engraver of coaching, sporting and naval subjects, and topographical views after his contemporaries.
'Foxhunting', after R. Pollard, 1810, 4 pl., 15 x 20in/38 x 51cm, set £1,000-£1,500 col.
'Stage Wagon', after J.-L. Agasse, 1820, 11¼ x 14½in/30 x 37cm, £300-£400 col.
'Mail Arriving at Temple Bar', after C.B. Newhouse, 1834, 11½ x 16¼in/29 x 41cm, £500-£800 col.
'Snow Storm' and 'Delay of the Mail', after C.B. Newhouse, 1837, 11½ x 16¼in/29 x 41cm, pair £800-£1,200 col.
'The Spartan' and 'The Sparviero' (naval subjects), after T. Whitcombe, 1812, 2 pl., 14½ x 20¼in/37 x 51.5cm, pair £400-£600 col.
'A View of St. Paul's from St. Martin's Le Grand', after T. Girtin, 1815, 23¾ x 18¼in/60.5 x 47.5cm, £300-£500 sepia.
Pl. for Jenkins' Naval Achievements, *after T. Whitcombe and N. Pocock, 1816-17, etched by Baily and aq. by T. Sutherland (q.v.), 4to., e. £50-£80 col.*
Pl. for Pyne's Royal Residences, *1819, 4to., £20-£50 col.*
Pl. for Picturesque Tour of the River Thames, *after W. Westall and S. Owen, 1828, Royal 4to., e. £100-£200 col.*
Pl. for Grindlay's Scenery, Costumes and Architecture of India, *after W. Westall, 1826, £40-£90 col.*

BAIRD, Johnstone fl. 1920s/1930s
Scottish painter and etcher of landscapes and architectural views.
£15-£40.

BAKER, B.R. fl. early 19th century
Lithographer of architectural plans.
Small value.

BAKER, John H. fl. mid-19th century
Stipple and line engraver of small bookplates including portraits and decorative subjects after his contemporaries.
Small value.

BAKER, Oliver, R.E. 1856-1939
Birmingham painter and etcher of landscapes and architectural views. He contributed plates to *English Etchings.* He was the elder brother of S.H. Baker (q.v.).
Small value.

BAKER, Samuel Henry 1824-1909
Birmingham painter and etcher of landscapes and architectural views. Like his younger brother, O. Baker (q.v.), he contributed plates to *English Etchings.*
Small value.

BALDREY, Joshua Kirby fl. 1784-1815
Draughtsman, soft-ground etcher and stipple engraver of portraits and decorative subjects after his contemporaries. He worked as a drawing master in Cambridge and died in Hatfield. There was also a John Baldrey, 1758-1805 or later, who was a stipple engraver.
'The Benevolent Physician' and 'The Rapacious Quack', after E. Penny, 1784, 14 x 11in/35.5 x 28cm, pair £200-£300.
'Finding of Moses', after S. Rosa, 1785, 20½ x 15in/52 x 38cm, £40-£60 prd. in col.
'January' and 'May' from 'The Months' after W. Hamilton, 1787, ovals, 8 x 6¾in/20 x 17cm,

e. £100-£200 prd. in col.
'Welsh Peasants' and 'English Peasants', after H.W. Bunbury, 1783, ovals, 13¾ x 15¼in/35 x 39cm, pair £300-£400 prd. in col.
Pl. for 'Sketches by Morland', 1792-9, soft-ground etchings, e. £15-£20 col.
Portraits £4-£7.

BALL, Robert, A.R.E. b.1918
Birmingham-born painter, etcher and engraver in line, mezzotint and aquatint.
£20-£60.

BALL, Wilfred Williams, R.E. 1853-1917
Painter and etcher of landscapes and river and marine subjects at home and abroad. He lived in Putney and executed several views of the Thames. He contributed plates to *The Etcher.*
£5-£15.

BALLIN, John 1822-1885
Etcher and engraver in line, mezzotint and mixed-method of portraits and sentimental subjects after his contemporaries. He worked in London and on the Continent. His best plate is 'Les Adieux', after Tissot.
'Les Adieux', after J.J. Tissot, 1873, 28¾ x 19in/73 x 48cm, £300-£600.
'A Question of Propriety Before the Holy Inquisition', after E. Long, 1877, and other lge. pl. £15-£60.
Small pl. small value.

BANCK, Pieter van der 1649-1697
Minor French line engraver of portraits after his contemporaries. Born in Paris, he worked in England reproducing paintings by Kneller, Lely, etc.
£4-£10.

BANKES, Henry ? 1757-d.1834
Lithographer about whom nothing is known except that he was an early exponent of the

medium.
'Chronos', 1810, roundel, 2¾in/7cm diam. £80-£100.
View of a town, 1810, 4 x 6¼in/10 x 16cm, £60-£80.
2 coastal scenes after Weirotter, 3¼ x 7¼in/8 x 20cm, e. £20-£30.
Man Cat.

BANKS, Harry 1869-1947
Etcher and aquatinter of topographical views.
£10-£30.

BANKS, J.H. fl. early/mid-19th century
Aquatint engraver.
Pl. for Gamonia or the Art of Preserving Game . . . , 1837, 15 pl., 8vo., small value individually.

BANKS, Thomas 1735-1805
Sculptor who etched the following plate:
'The Fallen Titan', 12 x 15in/30.5 x 38cm, £600-£1,000.

BANKS, William fl. mid-19th century
Line engraver of small topographical views.
Views of the English Lakes, c.1860, 26 pl., e. £5-£15.

BANNER, Hugh Harmwood b.1865
Glaswegian painter and mezzotinter.
Small value.

BANNERMAN, Alexander fl.1760-87
Line engraver of book illustrations including portraits, religious subjects, etc., after his contemporaries and Old Master painters.
Small value.

BANTING, John 1902-1972
Painter and occasional printmaker of Surrealist and abstract subjects. Born in Chelsea, he worked in Paris.
'Blue Prints', 1931-2, 10¼ x 7¾in/26 x 19.5cm, 12 pl., edn. of 100 signed, blueprints, set £1,500-£2,500 (made £3,000 March

BANTING, John. 'The 100th Lie', from portfolio of twelve blueprints, 1931-2.

1990).
'For Social Service', book with one wood-engraving, c.1936, 23 x 18in/58.5 x 46cm, fetched £700 in November 1990.
1970s' reprints of 1930s' linocuts e. £20-£60.

BARBER, Thomas fl. early/mid-19th century
Line engraver of small topographical plates

after his contemporaries.
Small value.

BARCLAY, John Rankin b.1884
Edinburgh painter and etcher of landscapes, architectural views and figure subjects.
£20-£60.

BARFOOT, J.R. fl. mid-19th century
Draughtsman and lithographer.
'The Progress of Cotton', 1840, 12 pl., obl. fo., set £3,000-£5,000 col.
'The Cotton Plant', after T.R. Thorpe, £100-£250 col.

BARKER, Anthony Raine 1880-1963
Painter, etcher, wood engraver and lithographer of landscapes and architectural views.
First Italian Portfolio, 1912, etchings; *First Belgian Portfolio*, 1914, litho., e. £20-£60.

BARKER of Bath, Thomas 1769-1847
Painter of landscapes, portraits and genre. Born in Monmouthshire, he moved with his family to Bath, where he taught himself to paint, and where he settled after a trip to Rome, 1790-93. He was one of the first artists to experiment with the new medium of lithography, executing five in the period 1802-03, all rustic genre scenes. After these, he made no more prints until 1813, when he issued 'Forty Lithographic Impressions of Rustic Figures' and a year later 'Thirty Two Lithographic Impressions, From Pen Drawings of Landscape Scenery'. The latter series especially shows not only Barker's exceptionally vigorous draughtsmanship but also the ability of the new medium to reproduce his drawings.
'Young Boy Seated', 1803, 8½ x 7¾in/21.5 x 19.5cm, £200-£300; on original mount £500-£800.
'Tile Makers', 1803, 9 x 12¼in/23 x 31cm, £200-£300.
Pl. for Rustic Figures e. £10-£25.
Pl. for Landscape Scenery e. £10-£25.
Man Cat.

BARFOOT, J.R. One of twelve plates from 'The progress of Cotton: Printing'.

BARKER of Bath, Thomas. 'Young Boy Seated', 1803, on original mount.

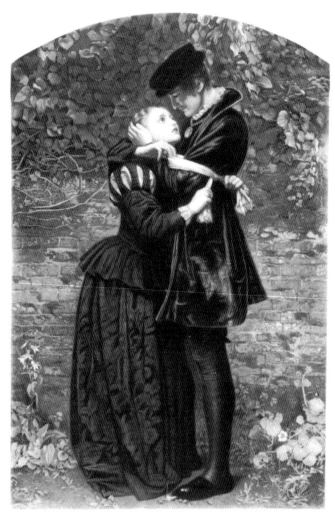
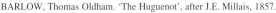

BARLOW, Thomas Oldham. 'The Huguenot', after J.E. Millais, 1857.

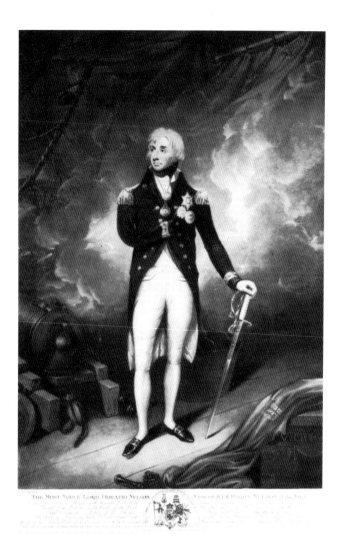

BARNARD, William S. 'Lord Horatio Nelson', after L.F. Abbott, 1799.

BARLOW, Francis c.1626-1704
Painter and etcher of animal, figure and sporting subjects, and landscapes. Born in Lincolnshire, he lived and worked in Drury Lane, London. As well as being one of the earliest English sporting artists, Barlow was also one of the first etchers of any great merit which this country has produced. His own designs were etched by R. Gaywood, J. Griffier, W. Hollar, T. Neale, F. Place (qq.v.).
12 illustrations for E. Benlowe's poem Theophila or Love's Sacrifice*, 1652, set £2,000-£3,000.*
'Multae et Diversae Avium Species', 1658, 5½ x 7in/14 x 18cm, e. £15-£50.
'Aesop's Fables', 1687, 32pl. (110 illustrations in text), fo., e. pl. £10-£25.
'The Last Horse Race Run before Charles II of Blessed Memory by Dorsett Ferry, near Windsor Castle, August 24 1684', 1687, the first English print to represent such a scene, approx. 12 x 16in/30.5 x 40.5cm, £3,000-£4,000.
'The Chase of the Dutch Rebellion', c.1678, 10¼ x 13¼in/26 x 33.5cm, £120-£180.

BARLOW, Thomas Oldham 1824-1889
Notable etcher and mezzotint engraver of portraits, sentimental and sporting subjects after many of the best known Victorian painters. Born in Oldham, Lancashire, he lived and worked in London.
Portraits: £16-£30, but 'Charles Dickens', after W.P. Frith, 1862, 16½ x 13½in/42 x 34cm, £100-£160, and 'Queen Victoria and her Grandchildren', after J. Sant, 1876, lge. pl., £200-£300.
Sentimental subjects: smaller pl., e.g. 'Courtship', after J. Phillips, 1848, 13 x 10in/33 x 25.5cm, £10-£30; larger pl., e.g. 'The Death of Chatterton', after H. Wallis, 1862, 16 x 24in/40.5 x 61cm, £30-£50; pl. after J.E. Millais (q.v.), e.g. 'The Huguenot', 1857, 29 x 20in/74 x 51cm, £160-£240, and 'The Jersey Lily' (Mrs. Langtry), 1881, 18½ x 13½in/47 x 34cm, £100-£160.
Sporting subjects after R. Ansdell £160-£360.
'The Wreck of the Minotaur', after J.M.W. Turner, 1856, 26¼ x 34¼in/68 x 87cm, £140-£180.
Add more for fine contemporary frames.
Some book illustrations small value.

BARNARD, George fl. mid-19th century
Draughtsman and lithographer of landscapes and topographical views after his contemporaries. He was a pupil of J.D. Harding (q.v.), and in 1870 was appointed Professor of Drawing at Rugby. Amongst his own works are the following:
'Reminiscences of Hastings', c.1839, 6 pl., obl.
fo., e. £15-£25 col.
'Switzerland, Scenes and Incidents of Travel in the Bernese Oberland', 1843, fo., 27 tt. pl., e. £30-£50 uncol. Landscape paintings, 1858, 30 pl., 8vo., small value individually.
Pl. for C. Bentley and R.M. Schomburgk's Twelve Views in the Interior of Guiana, 1841, fo., tt. pl., e. £200-£400 col.
'Rugby School with Football Match', 13½ x 20in/34 x 51cm, £400-£600 col.

BARNARD, J. fl. mid-19th century
Lithographer.
Pl. after J.M.W. Turner (q.v.) for Scotland Delineated, 1847-54, fo., e. £10-£20.

BARNARD, William S. 1774-1849
Mezzotint engraver of decorative subjects and also some portraits and sporting subjects after his contemporaries.
'Summer' and 'Winter', after G. Morland, 1802, 19 x 24in/48 x 61cm, pair £700-£1,100 prtd. in col.
'Disobedience in Danger' and 'Disobedience Detected', after J. Ward, 1799, 19 x 24in/48 x 61cm, pair £700-£1,100 prtd. in col.
'Lord Horatio Nelson', after L.F. Abbott, 1799, 25 x 16in/63.5 x 40.5cm, £300-£600 prtd. in col.
'Rt. Hon. Earl of St. Vincent', after J. Keenan, 17 x 13¼in/43 x 35cm, £250-£350 prtd. in col.

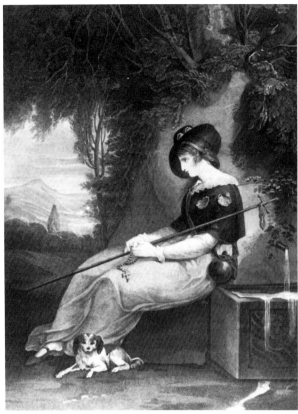

BARNEY, Joseph. 'The Pilgrim', after W. Hamilton, pair with 'Sylvia and her Dying Fawn', 1805.

BARNEY, William Whiston. 'The Rt. Hon. John Sullivan', after W. Beechey, 1809.

'Richard Bell Livesay', after G. Marshall, 14 x 10in/35.5 x 25.5cm, £10-£15.
'John Silvester', after S. Drummond, 1812, 20 x 14in/51 x 35.5cm, £20-£40.
CS.

BARNET, W. fl. early 19th century
Aquatint engraver.
'H.M.S. Centurion and Two Merchant Ships at Anchor off Vizagapatam in the East Indies', after F. Sartorius, 1805, 19½ x 27¼in/49.5 x 69cm, £400-£600 col.

BARNEY, Joseph 1751-1827
Draughtsman and stipple engraver of decorative and sentimental subjects after his own designs and those of his contemporaries. Born in Wolverhampton, he studied under Zucchi and A. Kauffmann (q.v.), and was later drawing master at the Royal Academy for twenty-seven years.
'The Fisherman Going Out' and 'The Fisherman's Return', after F. Wheatley, 1793, 20 x 23¼in/51 x 59cm, pair £500-£700 prd. in col.
'The Thatcher', 1802, 25 x 17½in/63.5 x 44.5cm, £250-£350 prd. in col.
'Spring', after W. Hamilton, 1792, oval, 7½ x 6¼in/19 x 16cm, £200-£300 prd. in col.
'The Dairy', 5¾ x 4in/14.5 x 10cm, £150-£200 prd. in col.
'The Pilgrim', after W. Hamilton and 'Sylvia And Her Dying Fawn', 1805, 21¾ x 17½in/55 x 44.5cm, pair £300-£400 prd. in col.

BARNEY, William Whiston
 fl. late 18th/early 19th century
Mezzotint engraver of portraits and decorative

and sporting subjects after contemporary painters. The son of a flower painter and drawing master at the Royal Miliary Academy, he was apparently a pupil of S.W. Reynolds I (q.v.). He gave up engraving c.1810 and joined the army.
'Georgiana, Duchess of Devonshire', after T. Gainsborough, 1808, 28 x 17½in/71 x 44.5cm, £300-£500.
'Lords George and Charles Spencer', after R. Cosway, 1807, 21 x 16in/53.5 x 40.5cm, £200-£300.
'The Rt. Hon. John Sullivan', after W. Beechey, 1809, £20-£30.
'Thomas Malton', after G. Stuart, 1806, 14½ x 11½in/37 x 29cm, and other HLs, £15-£25.
'Foxhunting' and 'Fowling', after P. Reinagle, 1810, 22½ x 17½in/57 x 44.5cm, pair £500-£700.
'Happy Cottagers', after W. Hamilton, 1794, 14 x 17in/35.5 x 43cm, £300-£500 prd. in col.

BARON, Bernard c.1696-1762
French etcher and engraver of portraits, sentimental subjects, satires, etc., after his contemporaries and Old Master painters. Born in Paris, he was a pupil of N. Tardieu and came to London in 1712, working there for much of the rest of his life. He died in Piccadilly.
'Achilles Discovered', from 'The Life of Achilles' after P.P. Rubens, lge. obl. fo., title page and set of 8 pl. £80-£140.
'Philip, Earl of Pembroke', after A. Van Dyck, 1740, 26½ x 16in/67 x 40.5cm, £20-£40.
'The Card Players', after D. Teniers, 1751, 20 x 15in/51 x 38cm, £20-£40.
'A Village Plundered by the Enemy' and 'The Country People's Revenge', after A. Watteau,

1748, 13½ x 16½in/34.5 x 42cm, pair £120-£200.
'Henry VIII Granting a Diploma to the Royal College of Surgeons', after H. Holbein, 1736, 18 x 30in/46 x 76cm, £160-£240.
'Evening', after W. Hogarth, 1738, 19¼ x 16in/49 x 40.5cm, £100-£150.
Pl. for 'Marriage-à-la-Mode' and 'The Four Times of Day', after W. Hogarth (q.v. for details).
'Views of Stowe Gardens', after J. Rigaud, 1739, 16 pl., e. £50-£100.

BARRAUD, Allan F. fl. late 19th century
Painter and etcher of landscapes.
Small value.

BARRY, James, R.A. (expelled) 1741-1806
Irish painter, etcher, aquatint, mezzotint and line engraver and lithographer of figure subjects with biblical or mythological themes. He was brought to London in 1764 by Edmund Burke who then sent him to Italy where he remained for five years. In 1777, he undertook the decoration of the Great Rooms of the Society of Arts, apparently living on bread and apples while working on the project entitled 'Paintings of the Progress of Human Knowledge'. In 1799 he was expelled from the R.A. for insulting the Dilettanti Society. His etchings divide into two main groups: mid-1770s, biblical and mythological subjects, reworked c.1790; and reproductions of his murals for the Society of Arts, first published 1792.
Trial proofs up to £3,000; contemporary imp. of former group £600-£1,000, of latter group £100-£200 (complete set of latter, 15 pl., from 1808 edn., bound in book with text, fetched

87

ACHILLES DETECTUS.

ACHILLES DISCOVERED

BARRY, James. 'Adam and Eve', etching, trial proof.

BARON, Bernard. 'Achilles Discovered', a plate from 'The Life of Achilles' after P.P. Rubens.

£440 April 1996).
Self-portrait, begun c.1802, mezzo., v. rare, fetched £5,800 in December 1988.
'King Lear', 1803, 9¼ x 12½in/23.5 x 32cm, pen-litho., £600-£800; on original mount up to £2,500.
Bibl: Pressly, W.L., *The Life and Art of J.B.,* 1981, Yale University; Man Cat.

BARRY, John fl. late 18th/early 19th century
Miniaturist who executed one early lithograph previously attributed to James Barry.
'Old Beggar and Young Woman', 1803, 14¼ x 10½in/36 x 26.5cm, £150-£250.

BARTHOLOMEW, V.
 fl. early/mid-19th century
Lithographer of J.B.'s 'Views at St. Leonards near Hastings'.
'Views at St. Leonards near Hastings', 1829, with T. Dighton, 11 pl., obl. 4to., e. £20-£30 col.

BARTOLOZZI, Francesco, R.A. 1727-1815
Famous Italian draughtsman, etcher, line and stipple engraver of portraits, decorative and historical subjects, etc., after his own designs and those of his contemporaries and Old Master painters. A pupil of Joseph Wagner in Venice, he started his career reproducing works by Italian painters and his best plates of this period are his etchings of 'The Months of the Year' after G. Zocchi. In 1764, he came to England where, after reproducing Guercino's drawings in the Royal Collection, he took up stipple engraving – the medium for which he is best known. He set up a studio which turned out vast quantities of 'furniture prints', invariably roundels or ovals, which were often cut down to fit the frame, thereby rendering them worth much less to today's collector. He is particularly remembered for his renderings of allegorical and mythological subjects after his fellow Italian painters G.B. Cipriani and A. Kauffmann (q.v.), which are found printed in red, sepia or in colours. He often signed the plates of his pupils and assistants, including the famous 'Miss Farren' portrait.

'The Months of the Year', after G. Zocchi, 14¼ x 18¼in/36 x 46.5cm, set £1,500-£2,500.
'Outside' and 'Inside the Royal Exchange in London', after J. Chapman and P.J. de Loutherbourg, 1788, 18½ x 22¼in/47 x 58cm, pair £250-£350.

'Lady Smythe and Children', after Sir J. Reynolds, 1789, 14½ x 10in/37 x 25.5cm, £350-£500 prd. in col.
'Their Royal Highnesses the Princesses Mary, Sophie and Amelia', after J. S. Copley, 19 x 14¼in/48 x 36cm, £700-£1,200 prd. in col.

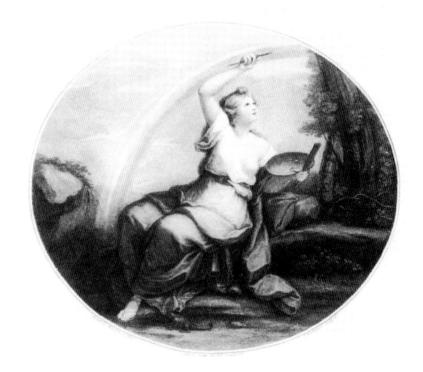

COLOURING

BARTOLOZZI, Francesco. 'Colouring', after A. Kauffmann, 1787.

BARTOLOZZI, Francesco. One of twelve etchings from 'The Months of the Year: Settembre', after G. Zocchi.

'The Duke of Newcastle's Return from Shooting', after F. Wheatley, with S. Alken (q.v.), 1792, 21¼ x 26¼in/68cm, £800-£1,200 prd. in col.
'A Saint Giles's Beauty' and 'A Saint James's Beauty', after J.H. Benwell, 1783, 8 x 6¾in/20 x 17cm, pair £600-£800 prd. in col.
'Imitations of Original Drawings by Hans Holbein: Portraits of Illustrious Persons in the Court of Henry VIII', 1792-6, fo., e. £40-90 prd. in col.
Etchings and eng. after drawings by Guercino and other Old Masters e. £10-£30.
'Bacchanalians' and 'Nymphs', after A. Kauffmann, 1786, 12¼ x 13¼in/31 x 33.5cm, pair £300-£500 prd. in col.
Various ovals, decorative and allegorical subjects after A. Kauffmann or his own designs, ave. size 10¼ x 7in/26 x 18cm, £100-£300 prd. in sepia or in col.
Small ovals of putti and allegorical subjects after G.B. Cipriani, etc., £40-£70 prd. in sepia or in col.
Ovals and roundels can be more if in contemporary or period frames: pair illustrated in colour fetched £450 in April 1995; 'Zephire and Flore', 'Vertumnus and Pomona', pair after A.Coypel, 1776, 13½ x 10½in/34 x 27cms, prd. in col., with elaborate faux frames prd. in col., fetched £1,600 April 1995.
Bibl: Calabi, A., F.B. Catalogue des estampes et notice biographique d'après les manuscrits de A. de Ves . . . , Milan, 1928.
Colour plates page 25.

BASEBE, Charles J. fl. mid-19th century
Lithographer of topographical views.
3 pl. for 'Six Views of Windsor Castle', c.1835, fo., e. £30-£60 col.
Pl. for Alfred Crowquill's A Peep at Brighton, 1848, 6 pl., Royal 8vo., e. £4-£8 col.

BASIRE, James I 1730-1802
Line engraver of portraits, historical and antiquarian subjects and topographical views after his contemporaries. The son of Isaac Basire, a map engraver, he was a pupil of R. Dalton (q.v.) and later became Engraver to the Society of Antiquaries. An old-fashioned line engraver, he influenced his most famous pupil W. Blake (q.v.).
'Le Champ de Drap d'Or', after E. Edwards, 1774, and 'The Embarkation of King Henry VIII at Dover', after S. H. Grimm, 1781, 25½ x 46in/65 x 117cm, pair £400-£600.
'The Hon. Lady Stanhope', after B. Wilson,
1772, 18 x 13¾in/45.5 x 35cm, £20-£30.
'Distribution of Maundy Money by George III', 1777, 17 x 28in/43 x 71cm, £60-£90.
Views of Oxford £20-£40.
Various antiquarian subjects, small portraits and bookplates small value.

BASIRE, James II 1769-1822
Line engraver who, like his father James Basire I, engraved for the Society of Antiquaries. His son, also called James, worked as an engraver of antiquarian subjects.
'The Tapestry of Bayeux', after C.A. Stothard, 1822, 17 pl., lge. obl. fo., e. £10-£20 col.
Antiquarian subjects small value.

BASKETT, Charles Henry, R.E. 1872-1953
Essex painter, etcher and aquatinter mainly of coastal and river scenes.
£30-£60.
Bibl: Allhusen, E.L., 'The Aquatints of C.H.B., R.E.', Print Connoisseur, 1924, IV, p.325.

BATE, Fortescue fl.1804-1832
Line, stipple and aquatint engraver of small bookplates including portraits and architectural views after his contemporaries.
Small value.

BATE, M.N. 'Come Father Hope! – Come Mother's Glory! Now Listen to a Pretty Story', after A. Buck, 1808.

BASIRE, James II. One of seventeen plates from 'The Tapestry of Bayeux', after C.A. Stothard, 1822.

BATE, Martin Newland c.1785-1821 or later
Stipple engraver of decorative subjects after his contemporaries.
'Come Father's Hope! – Come Mother's Glory! Now Listen to a Pretty Story', after A. Buck, 1808, 9 x 8¼in/23 x 21cm, £80-£160 prd. in col.
'Woburn Sheepshearing', after G. Garrard, 1811, with J.C. Stadler, T. Morris and Garrard (qq.v.), 21 x 30in/53 x 76.5cm, etching, stipple and aq., £400-£600.

BATEMAN, James, A.R.W.S., R.E.
1893-1959
Cumbrian-born painter and wood engraver of landscapes.
£15-£40.

BATEMAN, William 1806-1853
Engraver of views of Chester where he was born.
Small value.

BATES, Lydia fl. late 18th century
A capable etcher of figure subjects after J.H. Mortimer (q.v.), who was patronised by her father.
£15-£40.

BATLEY, Henry William b.1846
London painter and etcher of sentimental subjects, portraits and landscapes after his own designs and those of his contemporaries.
Small value.

BATTEN, John Dickinson 1860-1932
Painter and engraver of woodcuts printed in colours.
£20-£60.

BAUERLE (Bowerly), Amelia, A.R.E. d.1916
Illustrator and etcher of figure subjects. Born in London, she trained under F. Short (q.v.).
£30-£80.

BAUGNIET, Charles 1814-1886
Belgian lithographer of portraits mainly after his own designs, who worked in London for several years.
Small value.

BAUMER, Lewis Christopher Edward
1870-1963
Painter, illustrator and etcher of figure subjects including nude studies.
£40-£120.

BAWDEN, Edward b.1903
Essex painter, line engraver, linocutter and lithographer of landscapes and architectural views. He was an Official War Artist during World War II.
Early drypoints and engravings: (Pine Trees) £100-£200; others mostly £100-£500.
Later linocuts prd. in col. £100-£200.

BAWDEN, Edward. Line engraving of pine trees.

BAXTER, George 1804-1867
Famous colour printmaker who reproduced a wide variety of subjects mainly after his own designs. Born in Lewes, Sussex, he began his career as a wood engraver of book illustrations before developing his own process of printing in oil colours from several blocks, both wood and copper, in the early 1830s. He took up his patent in 1835 and he was later to license other publishers to use his invention, the best known being Abraham Leblond (q.v.). In their subject matter, so often patriotic and sentimental, and their capacity for the mass reproduction of fussy detail, these prints above all encapsulate Victorian values and aspirations. And so fittingly, the Great Exhibition of 1851, which celebrated the triumph of manufacturing, was represented by Baxter in one of his most famous series, *Gems of the Exhibition*, 1854. Baxter prints have always been very popular, but most seen today are in poor condition (either faded or remounted), and consequently those damaged will be worth less than £10. Only prints in good condition, with the colours fresh, are likely to be valuable.
Needle-box size £10-£35.
Medium size £30-£100.
Lge. size £100-£300.
Add more if in fine contemporary frame (but note that if a print has been framed for 150 years, it is very likely to have faded).
Bibl: Courtney Lewis, C.T., *G.B. the Picture Printer,* London, 1934; see also, Ball. A., and Martin, M., *The Price Guide to Baxter Prints,* Woodbridge, 1974; revised edn. 1983.

BAXTER, Thomas 1782-1821
Watercolourist and china painter who engraved a few views of Swansea when he worked at the porcelain factory there 1816-19.
Views of Swansea, 1818, obl. 4to., e. £15-£30 col.

BAYES, Alfred Walter, R.E. 1831-1909
Yorkshire-born painter and etcher mainly of landscapes and architectural views. He contributed several plates to *English Etchings,* including some London views.
£8-£15.

BAYLEY, P. One of four rare, early lithographs by this artist.

BAYNES, Thomas Mann. 'Gibraltar. Governor's Cottage, Europa', from H.A. West's 'Views of Gibraltar', 1828.

BAYLEY, Peter c.1778-1823
Obscure draughtsman and early experimenter with lithography.
4 prints are known, 1802 and 1803, e. £300-£500.
Bibl: Man Cat.

BAYNES, Thomas Mann 1794-1854
Watercolourist, draughtsman and lithographer of topographical views after his own designs and those of his contemporaries.
'Environs of London', 1823, 20 pl., fo., e. £100-£200 col.
Pl. for Sir F. W. Trench's Lithographic Sketch of the North Bank of the Thames . . . Showing the Proposed Quay, 1825, 10 pl., panorama, set £300-£600.
Views of Gibraltar, after H.A. West, 1828, obl. fo., 2 parts, e. 6 pl., e. £40-£80.
'Select Views of Roman Antiquities', after G. Wightwick, 1827, 20 pl., fo., e. £10-£20.
Pl. for Capt. A.F. Gardiner's Narrative of a Journey to the Zoolu Country in South Africa, 1836, 25 pl., 8vo., most uncol., e. £5-£15.
'Picturesque Scenery on the Banks of the Wye', after W.H. Bartlett, c. 1835, 6 pl., obl. 4to., e. £15-£30 col.
'Picturesque Views of the City and Environs of Edinburgh', 1822, 20 pl., fo., e. £10-£30.
'Views of Canterbury and Whitstable Railway on the Opening Day, May 3 1830', 13½ x 18¼in/34 x 46.5cm, tt. pl., pair £600-£800 col.
Views of Kent for Britannia Depicta, 1822-3, obl. fo., e. £30-£70.
'Wolverhampton Race Course', after R. Noyes, 15 x 24in/38 x 61cm, £300-£500 col.
'Adventures of a Fox by Moonlight', 1836, 6 pl., 6 x 9in/15 x 22.5cm, set £400-£600 col.

BEARD, Thomas
 fl. late 17th/early 18th century
Irish mezzotint engraver of portraits mainly of Irish clergy after his contemporaries.
£20-£60.
CS lists 7 pl.

BEARDSLEY, Aubrey 1872-1898
Well-known *fin de siècle* draughtsman and illustrator whose drawings were designed for reproduction by the process line block. Amongst the works he illustrated in his short but brilliant career are *La Morte d'Arthur*, 1893, and Wilde's *Salome*, 1893.
Contemporary pl. £20-£50.

BEAUMONT, Leonard b.1891
Sheffield painter, etcher and linocut artist mainly of landscapes and architectural views.
£60-£140.
Bibl: Dodgson, C., 'L.B.', *P.C.Q.*, 1933, XX, pp.159-67.

BECKER, Ferdinand d.1825
Draughtsman and etcher. He seems to have worked in Bath.
'Etchings from Nature', 1821, 79 pl., 4to., vol. £200-£400.

BECKER, Harry 1865-1928
Painter, etcher and lithographer of genre subjects.
£30-£60.

BECKETT, Isaac 1653-1688
Mezzotint engraver and publisher, mainly of portraits after Kneller, Lely and Wissing, but also some religious and mythological subjects and landscapes. Born in Kent, he was a pupil of Lutterel (q.v.) and lived and worked in London, publishing his prints at 'ye Golden Head in ye

BEAUMONT, Leonard.
A typical architectural view.

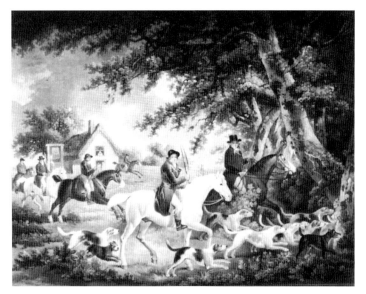

BELL, Edward. One of four plates from 'Foxhunting: Going into Cover', after G. Morland, 1800.

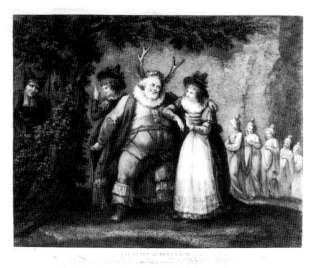

BENEDETTI, Michele. 'Falstaff at Hern's Oak', from H.W. Bunbury's *Illustrations to Shakespeare*, 1793.

Old Baily'. He is considered to be one of the founders of the English school of mezzotint engravers and a fine printmaker.
HLs mostly £10-£40, but up to £100 if v. fine.
WLs mostly £30-£80, but up to £250 if v. fine.
CS.

BECKWITH, R. fl. mid-19th century
Etcher and mezzotint engraver.
'The Forester in Search of Game', after C. Hancock, 1837, 14¾ x 17in/37.5 x 43cm, £150-£200.

BEDFORD, Celia Frances 1904-1959
London painter and lithographer of portraits and figure subjects.
£20-£50.

BEDFORD, Francis Jun 1816-1894
Lithographer of topographical and architectural views, particularly churches and cathedrals in the North of England. He trained as an architect but took up lithography, working in York with W. Monkhouse (q.v.) in the 1840s before moving to London to work with Day & Co. (q.v.). He gave up lithography to become a photographer c.1862.
'The Churches of York', by W. Monkhouse and F.B., c.1835, fo., 27 tt. pl., e. £5-£10.
'Sketches in York', c.1840, fo., tt. pl., e. £10-£20.
'A Guide to York Cathedral', 1850, 35 pl., 8vo., e. small value.
Pl. for M. Digby Wyatt's Industrial Arts of the Nineteenth Century at the Great Exhibition, 1853, 158 pl., fo., e. small value.
Pl. for Owen Jones 'Grammar of Ornament', 1856, lge. fo., e. £8-£20.

BEEVER, W.A. fl. mid-19th century
Line engraver of small bookplates.
Pl. for A.C. Key's Narrative of the Recovery of H.M.S. Gorgon Stranded in the Bay of Monte Video, 1847, 16 pl., 8vo., e. £5-£10.
Others small value.

BEGGARSTAFF, J. & W. *see* **NICHOLSON, W. and PRYDE, J.**

BEKEN, Annie fl.1920s
Painter and etcher of still life who lived in London.
£30-£60.

BELCHER, George Frederick Arthur
1875-1947
London cartoonist, etcher of portrait caricatures in the manner of Robert Dighton (q.v.), sometimes hand-coloured like the Georgian cartoons.
£60-£140.

BELISARIO, J.M. fl.1830s
Draughtsman and lithographer.
'Sketches of Character . . . of the Negro Population in the Island of Jamaica', 1837-8, fo., 12 pl. in 3 parts, e. £200-£400 col.

BELL, Andrew 1726-1809
Scottish line and occasional mezzotint engraver of portraits and bookplates. He lived and worked in Edinburgh, starting his career as a lettering engraver and eventually making his fortune as publisher of the *Encyclopaedia Britannica* in which he had a half share and for which he had produced all the plates.
Bookplates small value.
Portraits £5-£15.
CS lists 1 pl.

BELL, Edward fl. late 18th/early 19th century
Mezzotint engraver of sentimental subjects and portraits after his contemporaries.
'Selling Cherries' and 'Selling Peas', 1801, after G. Morland, 20 x 24¾in/51 x 63cm, pair £800-£1,400 prd. in col.
'Foxhunting', after G. Morland, 1800, 4 pl., 22 x 27in/55.5 x 68.5cm, set £1,600-£2,400.
'J. Bannister', after S. de Wilde, 1794, 23½ x 16in/59.5 x 40.5cm, £80-£120.
'Lord Nelson', after W. Beechey, 1805, 27 x 17in/68.5 x 43cm, £400-£700 prd. in col.
HL portraits £15-£40.
CS lists 19 pl.

BELL, Eric Sinclair b.1884
Architect and etcher of architectural views who was born in Warrington and lived in Scotland.
£20-£50.

BELL, J. fl. mid-18th century
Wood engraver.
'Cruelty in Perfection' and 'Reward for Cruelty', after W. Hogarth, 16¼ x 13in/41 x 33cm, e. £10-£30.

BELL, John 1811-1895
Sculptor, painter and etcher. Born in Suffolk, he worked in London and contributed plates to some of the Etching Club's publications, including Gray's *Elegy*.
Pl. for Gray's Elegy, 1847, e. £15-£30.

BELL, Robert Anning, R.A., R.W.S.
1863-1933
Painter, sculptor, designer and lithographer of figure subjects. Born in London, he was Professor of Design at the R.C.A. 1918-24.
£10-£40.

BELL, Robert Charles 1806-1872
Scottish line and mezzotint engraver of portraits and sentimental subjects after his Scottish contemporaries. Born in Edinburgh, he was a pupil of J. Beugo (q.v.). Most of his plates were engraved for *The Art Journal* and other books. His largest work, 'The Battle of Preston Pans', after W. Allan, was only completed just before the engraver's death.
'The Battle of Preston Pans', after W. Allan, £80-£200; add more if in fine contemporary frame.
Bookplates small value.

BELL, Vanessa (*née* Stephen) 1879-1961
Bloomsbury Group artist who produced occasional lithographs. She was the sister of Virginia Woolf and married Clive Bell, the art critic.
£50-£150.

BELLIN, Samuel 1799-1894
Line and mezzotint engraver of portraits, historical and sentimental subjects after the most famous Victorian painters. Born in

BENOIST, Guillaume Philippe. 'Cricket', after F. Hayman.

BENNETT, William James. 'South West View of St. Paul's Cathedral and Blackfriars Bridge', after G.F. Robson, 1810.

London, he was a pupil of J. Basire II (q.v.). Amongst his numerous works, which include several very large plates, are the following:
'The Earl of Sefton', after P. Westcott and R. Ansdell, 1851, 33¼ x 23¼in/ 84.5 x 60cm, £250-£400.
'Charles I Parting from His Children', after J. Bridge, 1841, 20 x 15½in/51 x 39.5cm, £20-£30.
'John Wesley and his Friends at Oxford', after M. Claxton, 1862, 25 x 32in/63 x 81cm, £100-£160.
'John Gibson, R.A.', after A. Geddes, 1839, 12 x 9in/30.5 x 23cm, £10-£16.
'The Opening of the Great Exhibition of All Nations, 1851, by H.M. Queen Victoria', after H.C. Selous, 1856, 25 x 36in/63.5 x 91.5cm, £300-£500.
Add more if in fine contemporary frame.

BENAZECH, Peter Paul 1728-1798
Line and stipple engraver of naval subjects, topographical views and decorative subjects after his contemporaries. He was a pupil of F. Vivares (q.v.).
'Battle of Quiberon Bay', after F. Swaine, 11¼ x 17½in/30 x 44.5cm, £250-£350.
'Capture of Guadeloupe, South West View of Port Royal, 1759', after Lieut. A. Campbell, 12¾ x 20in/32.5 x 51cm, £400-£600.
'The Storm', after C.W. Bamfylde, 1779, 15 x 19in/38 x 48cm, £60-£100.
'View of the North West Part of the City of Quebec', after R. Short, 1761, 13¼ x 19¼in/35 x 50cm, £400-£700.
'Louis XVI avec son Confesseur Edgeworth, un instant avant sa mort', after Casenave, 19 x 22½in/48 57.5cm, £30-£50.
Lge. landscape pl. £30-£80.

BENEDETTI, Michele 1745-1810
Italian stipple engraver of decorative subjects after contemporary painters. Born in Viterbo, he worked in London for some years and may originally have been a pupil of F. Bartolozzi (q.v.). He died in Vienna.
'The Night Beauty' and 'Sophia Laughs', after A. Hickel, 1793, 9½ x 7½in/24 x 19cm, pair £200-£300 prd. in col.
Pl. for H.W. Bunbury's Illustrations to Shakespeare, 1792-4, 16½ x 19in/42 x 48cm, e. £40-£80 prd. in col.

BENJAMIN, E. fl. mid-19th century
Line engraver of small topographical bookplates after his contemporaries.
Small value.

BENNET, C. fl. early 19th century
Aquatint engraver.
'Glasgow', after W. Wilson, 1818, 19¾ x 25¼in/50 x 64cm, £300-£600 col.

BENNETT, John see SAYER, Robert

BENNETT, William James 1787-1844
Watercolourist and aquatint engraver mainly of topographical views, including several after his own designs, but also some military, naval and sentimental subjects after his contemporaries. He was a pupil of R. Westall (q.v.) and worked in London and on the Continent before emigrating to America c.1826. He is best known today for his large American views.
Lge. American views generally e. £2,000-£5,000 col.
'A Brisk Gale, Bay of New York', 1839, 19¼ x 25½in/50 x 65cm, col. imp. fetched £7,500 October 1988; lge. views of American cities can be worth up to $20,000-$30,000 depending on place.
'South West View of St. Paul's Cathedral and Blackfriars Bridge', after G.F. Robson, 1810, 19¼ x 27¼in/50 x 69cm, £900-£1,600 col.
'The Country Butcher', after J. Holmes, 24½ x 18½in/62 x 47cm, £600-£1,000 prd. in col.
'The Royal Military College, Sandhurst', after De la Motte, 1813, 15 x 22in/38 x 56cm, £600-£1,000 prd. in col.
'Hackney from the Downs', after W. Walker, 1814, 19 x 27in/48 x 68.5cm, £400-£700 col.
'The Supreme Court of Judicature in the Island of Ceylon', after J. Stephanoff, 16¼ x 25in/42.5 x 63.5cm, £300-£700 col.
'The Royal British Bowmen at Erthig, Denbighshire', after Townshend, 1823, 12 x 14in/30.5 x 35.5cm, £450-£900 col.
'View of Liverpool from Seacombe', after H.F. James, 1817, 19¼ x 34¼in/50 x 88.5cm, £450-£700 col.
Pl. for M. Gartside's Ornamental Groups, 1808, fo., e. £100-£200 col.
Pl. for Ackermann's Oxford, 1814, and Public

Schools, 1816, and W.H. Pyne's Royal Residences, 1819, e. £20-£60 col.

BENNING, R. fl. mid-18th century
Engraver of maps, topographical views and figure subjects.
'View of London as it was in the Year 1647', 1756, 2 pl., overall size 12 x 37½in/30.5 x 96cm, £200-£400.
'View of the Highland Deserters . . . as they were Conducted Under a Strong Guard of Horse and Foot to the Tower of London on Tue. 31 May 1743', 15½ x 18in/39.5 x 46cm, £80-£120 col.
Small bookplates small value.

BENOIST, Antoine 1721-1770
French draughtsman, etcher and line engraver of military subjects, landscapes, topographical views, etc., after his contemporaries and his own designs. Plates signed 'Benoist' may have been engraved by G.P. Benoist (q.v.).
'The March of an Army Supposed to have been Attack'd by a Party of the Enemy', 1771, 19 x 26¼in/48 x 68cm, £40-£60.
1 pl. for Campaigns of The Duke of Marlborough, 1736-7, 7¼ x 6½in/18.5 x 16.5cm, £8-£12.
'A View of The Church of Notre Dame de la Victoire, Quebec', after R. Short, 1761, 13¼ x 19¼in/35 x 50cm, £400-£700.
Small landscape pl. small value.

BENOIST, Guillaume Philippe 1725-1800
French etcher and line engraver of portraits, topographical views, decorative, military and mythological subjects, etc., after his contemporaries as well as his own designs. Born in Normandy, he seems to have worked in England for some time and is said to have died in Paris. Plates signed 'Benoist' may have been engraved by A. Benoist (q.v.).
'Capture of Belleisle', after D. Serres and R. Short, 1777, from a set of seven, 14½ x 20½in/36.5 x 52cm, e. £250-£350.
'Two Views of Malta', after J. Goupy, 14¼ x 21in/36 x 53cm, pair £400-£700 col.
'Cricket', after F. Hayman, 10½ x 14½in/26.5 x 36.5cm, £600-£1000.
Portraits and bookplates small value.

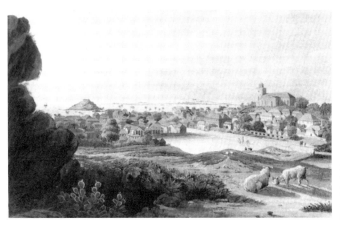

BENTLEY, Charles. 'Views in the West Indies: St. John's Antigua', after J. Johnson, 1827-9.

BENTLEY, Alfred, R.E. 1879-1923
Etcher, mainly of landscapes but also some portraits and figure subjects.
£20-£50.

BENTLEY, Charles 1806-1854
Watercolourist, aquatint engraver of topographical views and sporting and coaching subjects after his contemporaries. Born in London, he was apprenticed to Theodore Fielding (q.v.), with whom he worked on a number of bookplates for Grindlay's *Scenery, Costumes and Architecture of India,* 1826-30.
Pl. for Grindlay's Scenery, Costumes and Architecture of India, *1826-30, fo., e. £40-£90 col.*
Pl. for Picturesque Tour of the River Thames, *after W. Westall and S. Owen, 1828, Royal 4to., e. £100-£200 col.*
Pl. for Views in the West Indies, *after J. Johnson, 1827-9, obl. fo., e. £400-£600 col.*
'The Birmingham Tally-Ho Coaches, Passing the Crown at Holloway', after J. Pollard, 1828, 23½ x 30in/60 x 76cm (amongst his larger pl.), £1,500-£2,500 col.
'Shooting', after H. Alken, 1835, 4 pl., 9¾ x 11¼in/25 x 30cm, set £600-£1,000 col.
'Grand Leicestershire Steeple Chase', after H. Alken, 1830, 8 pl., 10 x 14¼in/25.5 x 36cm, set £2,600-£3,400 col.

BENTLEY, Joseph Clayton 1809-1851
Line engraver of small topographical bookplates after his contemporaries as well as plates after Old Master painters for *The Art Journal* and similar works. Born in Bradford, Yorkshire, he was a pupil of R. Brandard (q.v.) and died in London.
'Island and Castle of Corfu', after W. Purser, £15-£40.
Others small value.

BERGHE (Burgh), Ignaz Joseph van den 1752-1824
Stipple engraver of decorative subjects after his contemporaries. Apparently born in Antwerp, he came to London and studied under F. Bartolozzi (q.v.).
'Pallas and Ulysses' and 'Ulysses Slaying the Suitors of Penelope', after W. Hamilton, 1803, 12½ x 9¾in/32 x 25cm, pair £30-£80.
Pl. for H.W. Bunbury's Illustrations to Shakespeare, *1792-4, 16½ x 19in/42 x 48cm, £40-£80 prd. in col.*
'Haymakers Going Out' and 'The Cottagers Return'd', after F. Wheatley, 12 x 14in/30.5 x 35.5cm, pair £400-£600 prd. in col.
'Venus and Cupid', after L. Giordano, 12 x 15½in/30.5 x 39.5cm, £50-£80 prd. in col.

BERKELEY, Stanley, R.E. 1840-1909
Painter and etcher of landscapes and sporting and military subjects, etc. He lived in London and Surrey.
£30-£80.

BERNIE, F. *see* **BIRNIE, F.**

BESTLAND, Cantelo 1763-1837 or later
Etcher, line and stipple engraver of portraits and decorative subjects after his own designs and those of his contemporaries. He worked in London.
'Portraits of the Royal Academicians', after H. Singleton, 1802, 22½ x 29in/57 x 73.5cm, £200-£400.
'The Soldier's Farewell' and 'The Sailor's Return', ovals 8 x 6½in/20 x 16.5cm, pair £200-£300 prd. in col.

BETTELINI, Pietro 1763-1828
Italian line and stipple engraver of decorative subjects, especially with a mythological or allegorical theme, after his contemporaries and Old Master painters. Born at Lugano, he was a pupil of F. Bartolozzi (q.v.) and died in Rome.
'Picturesque Amusements' and 'Practical Exercise', after A. Kauffmann, 9½ x 12in/24 x 30.5cm, pair £200-£400 prd. in col.
'Love Rules in Air, Earth and Sea', after G. Reni, 1791, 9 x 7in/23 x 18cm, £40-£60 prd. in col.
Pl. for H.W. Bunbury's Illustrations to Shakespeare, 1792-4, 16½ x 19in/42 x 48cm, e. £40-£80 prd. in col.
'Music has charms . . .', after R. Cosway, £80-£160.

BEUGO (Bengo), John 1759-1841
Scottish line engraver mainly of portraits after his contemporaries. He was born in Edinburgh and is best known for the following plates:
'Dr. Nathaniel Spens in the Uniform of a Scottish Archer', 27 x 18in/68.5 x 46cm, £300-£600.
'Robert Burns', used as a frontis. to the Edinburgh edn. of his poems, 1787, £80-£140.
Views of Scottish fishing ports, 4 pl., after Lieut. J. Pierie, 11½ x 15¼in/29 x 40cm, e.£100-£200.
Other pl. small value.

BEVAN, Robert Polhill 1865-1925
Painter, etcher and lithographer of landscapes, animals, portraits, hunting, market and stable scenes. Born in Hove, Sussex, he studied at the Westminster School of Art and at the Academy Julian in Paris. He visited Pont-Aven in Brittany twice in the 1890s, meeting Gauguin by whom

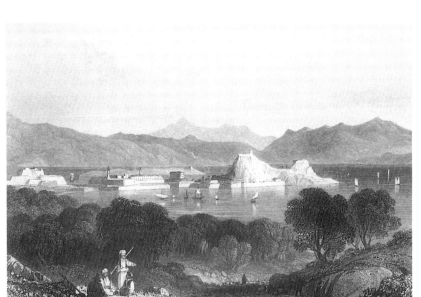

BENTLEY, Joseph Clayton. 'Island and Castle of Corfu', after W. Purser.

BETTELINI, Pietro. 'Music has charms…', after R. Cosway.

BEVAN, Robert Polhill. A typical landscape.

he was influenced. He was a founder member of the Camden Town Group, 1911, and later the London Group, 1913. Bevan's early prints (up to 1901) were mostly unpublished and are consequently rare. His later prints (between 1919 and 1925) were issued in editions of between twenty-five and eighty. He did not always sign these impressions.
Early pl. £400-£1,600.
Later pl. unsigned £200-£400; signed £400-£600.
Bibl: Dry, G., *R.B., 1865-1925, Catalogue Raisonné of the Lithographs and Other Prints,* London, 1968.

BEVAN, William fl. 1848-1856
Painter and lithographer of topographical views after his contemporaries. He worked first with

W. Monkhouse (q.v.), and then, until 1856, with John Storey.
Views of Wakefield, after Rev. T. Kilby, 1853, 15 tt. pl., e. £5-£15.

BEWICK, Robert Elliot 1788-1849
Newcastle wood engraver of book illustrations. The son and pupil of Thomas Bewick (q.v.), he became his father's partner.
Small value.

BEWICK, Thomas 1753-1828
Celebrated wood engraver mainly of natural history subjects. Born in Northumberland, he was apprenticed aged fifteen to the engraver Ralph Beilby in Newcastle where, apart from brief spells in London and Scotland, he spent the rest of his life. Beginning his career cutting woodblocks for local printers, he developed his own 'white line method' and is justly credited with founding the English school of wood engraving. His classic autobiography gives a vivid picture of his early life and career. Among his many works are the following:
'The Chillingham Bull', 1789, (a) before and (b) after the removal of decorative border and (c) with the splits in the block, also (d) rare proofs on vellum: (a) £400-£700, (b) £250-£400, (c) £150-£250, (d) £600-£1,000.
'Remarkable Kyloe Ox', c.1790, 10¼ x 13in/26 x 33cm, etching and eng. on copper, £200-£300.
'Lion, Tiger, Elephant and Zebra', 1799, 4 lge. pl. on India and on vellum, set £250-£400.
'Cadger's Trot' (his only litho.), 'Sketched by T.B. at Edinburgh, 21st. Aug. 1823', not more than 25 imp., oval, £200-£300.
'Waiting for Death' (his last work and left unfinished at his death), 8¼ x 11½in/22 x

29.5cm, £200-£400.
'The Hull, York and Newcastle Mail Coach', 5 x 14¼in/13 x 37.5cm, v. rare, e. £300-£500.
Bookplates small value, but if proofs up to £300.
Bibl: Hugo, T., *The Bewick Collector: a descriptive catalogue of the works of Thomas and John Bewick,* London, 1866; supplement, London, 1868; both reprinted New York, Singing Tree Press, 1968.

BICHEBOIS fl. mid-19th century
Lithographer.
Pl. for Lady Chatterton's The Pyrenees with Excursions into Spain, 1843, 16 pl., 8vo., e. £4-£8 col.

BICKHAM, George d.1758
Etcher and line engraver of topographical views, portraits, sporting subjects, etc., after his contemporaries and his own designs. He was also a very important early caricaturist and a skilful exploiter of the ideas of others, notably W. Hogarth and H. Gravelot (qq.v.). The son of a famous writing engraver of the same name, he collaborated with his father on *The Musical Entertainer,* a song book with decorative headpieces.
Original caricatures £20-£60.
Pl. after Hogarth and Gravelot e. £10-£30.
'An Introductive Essay on Drawing, with the Nature and Beauty of Light and Shadows', 1747, e. small value.
Pl. for The Musical Entertainer, 1737-9, e. £10-£20.
'Foxhunting', 2 lge. pl., e. £200-£400.
'A View of the Monument Erected in Memory of the Dreadful Fire in the Year 1666', after Canaletto, 9¾ x 12¼in/25 x 31cm, £50-£70.

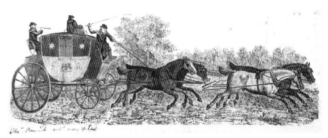
BEWICK, Thomas. 'The Hull, York and Newcastle Mail Coach'.

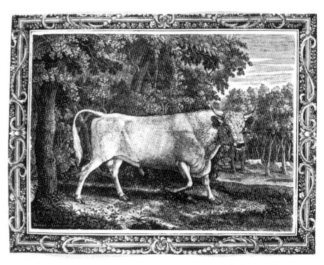

BEVAN, W. One of fifteen views of Wakefield, after Rev. T. Kilby, 1853.

BEWICK, Thomas. 'The Chillingham Bull', 1789, the artist's most famous print shown here with the decorative border.

BIRCHE, Henry. 'Game Keepers', pair with 'Labourers', after G. Stubbs, 1790.

'Plans for Chinese Gardens', 1751, 8 x 12in/20.5 x 30.5cm, e. £50-£100 col.
'Views of the Gardens of Stow', after J.B. Chatelain, 10 pl., 9½ x 13½in/24 x 34.5cm, e. £50-£100 col.
'A Cutter', after Brooking, 18 x 15in/46 x 39cm £200-£300.
Bookplates small value, but 'A Curious Antique Collection of the Several Counties in England and Wales', 50 pl., 2nd. edn. 1796, fetched £3,800 April 1989.

BILLINGS, Robert William 1815-1874
London architect, painter and engraver in line and aquatint of topographical views and architectural subjects after his own designs and those of others.
Pl. for J. Britton's Architectural Illustrations of Carlisle Cathedral, 1840 and similar works depicting Durham Cathedral, Temple Church and Kettering Church, e. £4-£8.

BILLON, E. fl. early 19th century
Lithographer.
Pl. for Grierson's Twelve Select Views of the Seat of War Including Views taken at Rangoon, Cachat and Andaman Islands, 1825, obl. fo., e. £10-£15.

BINKS, Reuben Ward fl.1930s
Painter and aquatint engraver of sporting dogs.
£40-£100.

BIRCH, William Russell 1755-1834
Enamel painter, line and stipple engraver of topographical views and portraits after his contemporaries. In 1794 he emigrated to Philadelphia, engraving a view of the town in 1800, as well as portraits of prominent Americans, including Washington and Lafayette.
British views, after various artists, 1788-90, 4to., and British portraits, small value.
'View of Philadelphia', 1800, £400-£600.
American portraits £30-£70.

BIRCHE, Henry fl. late 18th century
Mezzotint engraver of decorative subjects and portraits. Nothing is known about his life, though many now believe that Birche was a pseudonym for R. Earlom (q.v.).
'Labourers' and 'Gamekeepers', after G. Stubbs, 1790, 17½ x 26in/44.5 x 66cm, pair £1,200-£2,500.
'Boys and Dogs' and 'Cottage Children', after T. Gainsborough, 1791, 23 x 15½in/58.5 x 39.5cm, pair £600-£800.
'George Cranfield Berkeley', after T. Gainsborough, 1793, 26 x 18in/66 x 46cm, £60-£100.

BIRD, Charles Brooke, A.R.E. b.1856
As a mezzotint engraver reproduced Old Master painters; as an etcher produced original views of English churches, cathedrals and other public buildings.
Mezzo. small value.
Etchings £15-£40.

BIRNIE, F. fl. late 18th century
Aquatint engraver of topographical views after his contemporaries.
Views of Ripon Minster, after W.H. Wood, 1790, 4 pl., 9¼ x 13½in/23.5 x 34cm, set £200-£300 col.
Views of Weymouth, after F. Bowles, 1791, 10 x 11½in/25.5 x 29cm, e. £60-£120.
'Panorama of the Thames from the Albion Mills near Blackfriars Bridge', after R. Barker, etched by H.A. Barker, 1792-3, 6 pl., 18½ x 22¾in/47 x 58cm, set £800-£1,600 sepia.

BIRRELL, Andrew c.1754-1816 or later
Line engraver of small portrait plates for books.
Small value.

BLACK, G. fl.19th century
Lithographer of sporting subjects.
'Jockeys of the North and South of England', after A.A. Martin, 2 pl., 13¼ x 20in/35.5 x 51cm, pair £400-£800 col. (fetched £1,250 in June 1987).

BLACKBERD, Charles ?1755-1827
Painter and line engraver of small portrait plates.
Small value.

BLACKMORE, John/Thomas 1740-1780
Mezzotint engraver mainly of portraits after his contemporaries. He was born in London.
'Henry Bunbury', after J. Reynolds, 14 x 10in/35.5 x 25.5cm, £30-£50.
'Samuel Foote', after J. Reynolds, 1771, 18 x 13in/45.5 x 33cm, £60-£120.
Others £15-£50.
CS lists 7 pl., dated 1769-71.

BLACKWELL, Elizabeth c.1710-74
Painter and engraver of flowers. She was the wife of an adventurer, John Blackwell, and was

BIRNIE, F. 'View of Weymouth, up the Harbour', after F. Bowles, 1791.

BLAKE, William. One of twenty-one illustrations of the *Book of Job*, 1826.

obliged to make prints in order to help him out of his pecuniary difficulties.
'A Curious Herbal', 1737 (later edn. were titled 'Herbarium Blackwellianum'), 500 pl., e. £5-£10 col.

BLAKE, Robert fl. early/mid-19th century
Draughtsman and etcher of landscapes.
Norwich School artist.
£15-£40.

BLAKE, William 1757-1827
Poet, painter, etcher, line, stipple and wood engraver of figure subjects after his contemporaries as well as his own designs. Born in London, he was apprenticed to J. Basire I (q.v.) 1772-9. During this period and the early 1780s he spent much time drawing and engraving the monuments in Westminster Abbey and his later work was much influenced by the Gothic art he saw there. After his training with Basire he started work as a reproductive engraver, and throughout his career he was obliged by poverty to engrave the work of others as well as his own. From the 1790s, however, he proceeded to experiment with print-making techniques, producing the large colour monotypes and small relief etchings used as illustrations for his books. These latter plates incorporated both text and illustration in the same way as illuminated manuscripts had done in medieval times. Impressions were coloured by him and his wife. Later works which showed his skill as a traditional engraver in pure line include the illustrations of the *Book of Job*, the large engravings for Dante's *Divine Comedy* and *The Canterbury Pilgrims*. He also illustrated Virgil's *Eclogues* with wood engravings. He produced one early lithograph,

known only in four impressions.
'Fertilization of Egypt' and 'Tornado', after H. Fuseli, both from the Botanic Garden, 1795, 10½ x 8¼in/27 x 21cm, e. £80-£160.
Illustrations of the Book of Job, *1826, 21 pl., 8½ x 6¾in/21.5 x 17cm, e. £300-£800; George Richmond's copy, £24,000, another copy from 1825 edn. £15,000.*
Illustrations to Young's Night Thoughts, *1797, 43 pl., fo., vol. £3,000-£6,000.*
Illustrations to Hayley's Life and Posthumous Writings of William Cowper, *1803, 6 pl., 4to., e. £20-£50.*
Illustrations to Dante's Divine Comedy, *1827, 7 pl., 10¾ x 14in/27.5 x 35.5cm, set £18,000-£24,000.*
Illustrations to Narrative of a Five Year's Expedition Against the Revolted Negroes of Swinam, in Guiana, *after Capt. J.G. Stedman,*

BLAKE, William. 'Rev. John Caspar Lavater'.

BLAKE, William. One of seven illustrations for Dante's *Divine Comedy*, 1827.

1793, 15 pl., 10½ x 8in/27 x 20cm, e. £50-£100.
Illustrations to Virgil's Eclogues, *edited by Dr. Thornton, 1821, e. £200-£400; if early proofs (before blocks cut down) e. £800-£1,600.*
Pl. for the Songs of Innocence and Experience, *relief etchings, generally £5,000-£12,000 hand col. or prd. in col.*
'The Poison Tree', prd. in col. and hand-col., fetched £28,000 October 1988; extremely rare complete set, all prd. in col. and hand-col. fetched $1,200,000 in New York in 1991.
Enoch, Blake's only litho., c.1806-10, 8½ x 12in/21.5 x 30.5cm., £30,000-£50,000.
The Canterbury Pilgrims, depending on how early the imp., £2,000-£10,000.
'Rev. John Caspar Lavater', £500-£800.
Rinder Collection sold by Christie's November 1993: 'Jerusalem . . .', set of 100 relief etchings, the last complete set remaining in private hands, fetched £560,000; extremely rare separate plates; 'Milton' £55,000; 'The Pastorals of Virgil' £53,000; 'Man Sweeping the Interpreter's Parlour', two imp., £46,000 and £50,000.
Bibl: Bindman, D., *The Complete Graphic Works*

of W.B., London, 1978; Essick, R.N., *W.B. Printmaker,* 1980, and *The Separate Plates of W.B.: a Catalogue,* Princeton, 1983; Keynes, G., *Engravings by W.B.: the Separate Plates,* Dublin, 1956. Colour plate page 24.

BLAMPIED, Edmund, R.E. 1886-1966
Jersey etcher and lithographer of animals and genre subjects. The son of a farmer, he studied art in London at Lambeth Art School, but spent most of his life in Jersey, including the period of German occupation during World War II. Apart from his studies of farm horses, he depicted the working life as well as leisure hours of farmers and labourers, often with a touch of humour. He also produced a rare set of twelve woodcuts.
Etchings: animal subjects £150-£400; genre subjects £200-£600.
'L'Aperitif', 1927, drypoint, £200-£600.
'Les Deux Petites Verres' (with only self-portrait, showing artist and his wife sitting in a bar), 1928, 10½ x 10½in/26.5 x 26.5cm £600-£1,200.
Woodcuts, 10 x 12½in/25.5 x 31.5cm, set of 12 £1,000-£1,500.
Bibl: Dodgson, C., *A Complete Catalogue of*

the Etchings and Drypoints of E.B., R.E., London, 1926.

BLANCHARD, Auguste Thomas Marie
 1819-1898
Notable French etcher and line engraver of genre, historical, mythological and biblical subjects after his English and French contemporaries. Two famous Victorian paintings he reproduced are 'The Derby Day', after W.P. Frith, 1863 and 'The Finding of the Saviour in the Temple', after W. Holman Hunt, 1863.
'The Derby Day', after W.P. Frith, 1863, 20 x 44in/51 x 112cm, £500-£700.
'The Finding of the Saviour in the Temple', after W. Holman Hunt, 1863, 15½ x 26in/39.5 x 66cm, £120-£160; in its original frame designed by the artist, depending on condition of frame £600-£3,500.
'The Vintage Festival', 1875, and others after L. Alma-Tadema, £80-£180.
'Coming of Age in the Olden Time' after W.P. Frith, £200-£400.
Other lge. pl. £20-£80.
Add more if in fine contemporary frame.

BLEECK, Pieter van 1695/1700-1764
Dutch painter and mezzotint engraver of portraits, religious subjects, etc., after his own works, those of his contemporaries and earlier painters. He lived and worked in London and his best subjects are considered to be theatrical portraits.
Theatrical portraits £200-£600.
Others £15-£60.
CS.

BLINKS, Thomas 1860-1912
Painter and etcher of animals and sporting subjects. He was born in Kent and lived in London.
£30-£70.

BLISS, Douglas Percy 1900-1984
Painter and wood engraver of landscapes; also engraved some rather exotic subjects, including book illustrations. Studied at the RCA, he was later Director of Glasgow School of Art.
£30-£80.

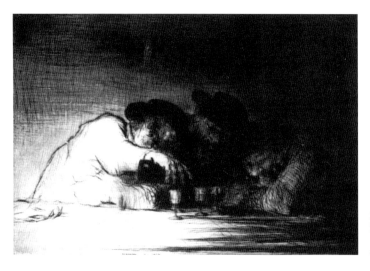

BLAMPIED, Edmund. 'L'Aperitif', 1927, drypoint.

BLOOD, Thomas c.1789-1829
Stipple engraver of small portrait plates.
Small value.

BLOOTELING, Abraham 1640-1690
Dutch line and mezzotint engraver of portraits, after his contemporaries. He was in London for a few years in the 1670s, when his main work was reproducing paintings by Lely. He was also famed for improving the method of laying a mezzotint ground.
Mezzo. £100-£200.
'James Duke of Monmouth', after P. Lely, c.1675, 13½ x 10in/34 x 25.5cm, line eng., £50-£80.
Other line eng. £10-£50.
CS lists 19 mezzo. pl.
Bibl: Wessely, J.E., A.B., *Verzeichniss seiner Kupferstiche und Schabkunstblätter*, Leipzig, 1867.

BLORE, Edward 1789-1879
Architect, draughtsman and line engraver of architectural subjects. Born in Derby, he was the son of Thomas Blore, the antiquarian, and provided illustrations for several works, engraving a few plates himself.
'Views of the Town and Palace of Linlithgow', c.1860, 5 pl., fo., e. £8-£15 col.

BLUCK, John fl. early 19th century
Aquatint engraver mainly of topographical views, but also marine and sporting subjects, all after his contemporaries. He produced plates for many books.
Pl. for E.E. Vidal's Picturesque Illustrations of Buenos Ayres and Monte Video, *1820, 24 pl., lge. 4to., e. £100-£200 col.*
Pl. for H. Salt's Twenty-four Views in St. Helena, The Cape, India, Ceylon, The Red Sea, Abyssinia and Egypt, *1809, fo., Abyssinian*

BLANCHARD, Auguste Thomas Marie. 'The Finding of the Saviour in the Temple', after W. Holman Hunt, 1863.

views £100-£150 col.; others £300-£500 col.
Pl. for T. Hofland and T. Barber's Six Views in Derbyshire, *1805, fo., e. £80-£160 col.*
Pl. for Rowlandson and Pugin's Microcosm of London, *fo., law courts e. £30-£70 col.; others e. £20-£60 col.*
Pl. for Ackermann's Westminster Abbey, *1812,* Oxford, *1814,* Cambridge, *1815,* Public Schools, *1816, e. £20-£60 col.*
Views of Weymouth, after J.W. Upham, 1813, 2 pl., 19¾ x 25½in/50 x 65cm, pair £400-£700 col.
'Snipe Shooting', after P. Reinagle, 1807, with W. Nichols (q.v.), 14½ x 20in/37 x 50.5cm, £400-£600 col.
'Regent's Street', after T.M. Shepherd, 17 x 20½in//43 x 53cm, £600-£1,000 col.
'A Bird's Eye View of Covent Garden Market' and 'A Bird's Eye View of Smithfield Market', after T. Rowlandson and A.C. Pugin, 17¼ x 21¼in/45 x 54cm, pair £1,000-£2,000 col.

BLUNDELL, A. fl.1920s
Etcher of architectural views.
£10-£30.

BLYTH, Robert 1750-1784
Etcher. He was a pupil of J. H. Mortimer (q.v.), whose drawings he reproduced. He committed suicide.
'Death on a Pale Horse', lge. fo., £100-£200.
'Rustick Dancers', 1780, and others after J.H. Mortimer, £30-£90.
Others £10-£30.

BOAK, Robert Cresswell b.1875
Irish painter and etcher of landscapes and portraits. He was born in Co. Donegal and lived in Belfast and London.
£15-£50.

BOBBIN, Tim 1708-1786
Northern satirical writer, painter, draughtsman and engraver of caricatures. Born near Manchester as John Collier, he worked as a schoolmaster as well as writing and painting. In 1746, he published his *View of the Lancashire Dialect*, an early attempt to record the dialect words and phrases of East Lancashire. His main visual work, however, is 'The Human Passions Delineated', 1773.
'The Human Passions Delineated', 1773, 44 pl., all designed by but only a few eng. by T.B., fo., e. £5-£10.

BOCKMAN, ?George or ?Gerhard
fl.mid-18th century
Painter and mezzotint engraver of portraits after his own designs and those of his contemporaries. He lived and worked in London.
'Princesses Louisa and Mary', after Worsdale, 14½ x 9¾in/37 x 25cm, pair £50-£80.
'Children of Frederick, Prince of Wales', after E. Seeman, 1739, 13¼ x 9½in/33.5 x 24cm, £30-£50.
HLs mostly £10-£40.
Others £5-£20.
CS lists 25 pl.

BLYTH, Robert. 'Rustick Dancers', after J.H. Mortimer, 1780.

BOILVIN, Emile. 'Vespertina Quies', after
E. Burne-Jones, 1897.

BOCQUET, ?E. fl. early 19th century
Stipple engraver of small plates, including
portraits and decorative subjects after his
contemporaries.
Small value.

BODGER, John fl. late 18th century
Etcher and aquatint engraver of a few sporting
plates and the very rare 'Chart of the Beautiful
Fishery of Whittlesea Mere', 1786. Originally a
land surveyor, he lived at Stilton.
*'Chart of the Beautiful Fishery of Whittlesea
Mere', 1786, 18½ x 20½in/47 x 52cm, £300-
£500 col.*
*'Carriage Match on Newmarket Heath', 1789,
17½ x 28in/44.5 x 71cm, £300-£500 col.*
*'Trains of Running Horses Taking their Exercise
on Warren Hill, near Newmarket', 1794, with
J. Collyer (q.v.), 18½ x 27 1/2in/47 x 70cm,
£400-£600.*

BOMBERG, David. One of six plates from
'Russian Ballet', 1919.

BOILVIN, Emile 1845-1899
French etcher of decorative and religious
subjects, etc., after Old Master painters and his
French and English contemporaries. He was
born in Metz and died in Paris. His one valuable
plate is 'Vespertina Quies', after E. Burne-
Jones, 1897.
*'Vespertina Quies', after E. Burne-Jones, 1897,
15½ x 8¾in/39.5 x 22.5cm, £800-£1,600.*
Others mostly £10-£50.

BOITARD, Louis Philippe fl.1733-67
French etcher and line engraver, mainly of book
illustrations. He was a pupil of La Farge and
was brought to England by his father. He
married an English woman and died in London
after 1760.
*'The Imports of Great Britain from France'
(caricature), 1757, 7¾ x 13¼in/19.5 x 33.5cm,
£50-£100.*
*Lge. anatomical illustrations, 1747, 21¼ x
15¼in/55 x 40cm, e. £100-£200.*
Small bookplates small value.

BOLINGBROKE, Minna, R.E.
 fl. late 19th/early 20th century
Painter and etcher of landscapes. She was
married to C.J. Watson (q.v.), and lived in
London.
£20-£60.

BOLTON, James d.1799
North country watercolourist and etcher of
botanical subjects. He was apprenticed to
B. Clowes (q.v.).
*'Isaac Polack', after Burgess, 1779, 14 x
10in/35.5 x 25.5cm, mezzo., £5-£15.*
Botanical pl. e. small value.
CS lists 1 portrait, noted above.

BOMBERG, David 1890-1957
Painter of figure subjects, still life and
landscapes who lithographed an abstract series
entitled 'Russian Ballet'. Born in Birmingham,
he studied at the Westminster School of Art
under W. Sickert, and at the Slade. He was a
founder member of the London Group and
travelled in the Middle East, Europe, Russia and
North Africa.
*'Russian Ballet', 1919, 6 pl., e. sheet approx. 8¼
x 5in/21 x 13cm, set £1,800-£2,400.*

BOND, H.W. fl. early/mid-19th century
Line engraver of small topographical
bookplates after his contemporaries.
Small value.

BOND, William
 fl. late 18th/early 19th century
Stipple engraver of decorative subjects and
portraits after his contemporaries. He was
President of the Society of Engravers, founded
1803.
*'The Weary Sportsman' and 'Shepherds
Reposing', after G. Morland, 1803, 20 x
14in/51 x 35.5cm, pair £500-£700 prd. in col.*
*'Samson and Delilah', after H. Singleton, 22 x
17in/56 x 43cm, £40-£60 prd. in col.*
*'The Little Forester', after J.L. Bond and 'The
Young Gipsy', after G. A. Barker, 1806, 18¼ x
22in/46.5 x 56cm, pair £300-£500 prd. in col.*
*'The Shepherd Boy', after S. de Koster, 1801, 21
x 16in/53.5 x 41cm, pair with 'Gleaning Girl',
by T. Burke (q.v.), pair £400-£600 prd. in col.*
Small pl. small value.

BONE, Sir David Muirhead 1876-1953
Eminent Scottish etcher and lithographer of

architectural views, landscapes and portraits.
Born in Glasgow, he studied at the School of Art
there, and came to London in 1901. He worked
widely in Britain and on the Continent and was
an Official War Artist in both wars. A very
prolific artist, he produced nearly 500 plates,
though many were issued in very small editions.
Etchings and drypoints:
*'A Spanish Good Friday', 12½ x 8in/32 x 20cm,
£600-£900.*
*'Piccadilly Circus', 11¾ x 14¾in/30 x 37.5cm,
£400-£600.*
*'Windy Night, Stockholm', 10¼ x 8¾in/26 x
22cm, £300-£500.*
*'Manhattan Demolition', 11 x 11½in/28 x 29cm,
£400-£600.*
Other etchings and drypoints mostly £80-£300.
'Building Ships', from The Great War: Britain's
Efforts and Ideals, *1917, 6 litho., 18 x 14in/46 x
35.5cm, set £300-£500.*
*'Midnight in Venice' litho, c.1920, 15½ x
8¼in/39.5 x 22.5 cm £200-£300.*
Bibl: Dodgson, C., 'Etchings and Drypoints by
M.B.', *P.C.Q.,* 1922, IX, pp. 173-200.

BONE, Stephen 1904-1958
London painter, illustrator and wood engraver
of landscapes, portraits, etc. Born in Chiswick,
he was the son of M. Bone (q.v.), some of
whose drawings he reproduced. He was an
Official War Artist in World War II.
£15-£50.

BONINGTON, Richard Parkes 1802-1828
Important watercolourist, etcher and
lithographer of landscapes and architectural
views. Born in Nottinghamshire, he moved with
his family to Calais in late 1817 or early 1818.
They then settled in Paris, where he spent most
of his short life before contracting brain fever
from which he died. All his lithographs were
produced in France and he contributed several
plates to *Voyages Pittoresques et Romantiques
dans l'Ancienne France,* 1820-78. His prints are

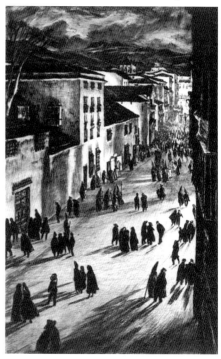

BONE, David Muirhead. 'A Spanish Good Friday'.

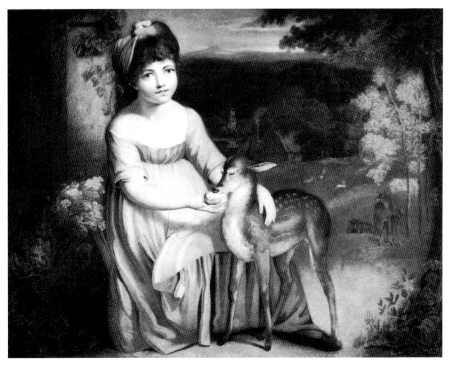

BOND, William. 'The Young Gipsy', after G.A. Barker, pair with 'The Little Forester', after J.L. Bond, 1806.

much closer in style to the French Romantic school than to English topographical drawings. Amongst his pupils in Paris was T.S. Boys (q.v.)
Scotch sketches, 13 pl., sheet size 18½ x 12¼in/47 x 31cm, e. £20-£40.
Others mostly £60-£250.
Bibl: Curtis, A., *Catalogue de l'Œuvre lithographié et gravé de R.P.B.*, Paris, 1939.

BONNEFOY, ?F. or ?J. fl. late 18th century
Stipple engraver of decorative subjects after his contemporaries. Parisian copyist included here because he also copied contemporary English engravings.
'West Family', after B. West, 10 x 12½in/25.5 x 32cm, £60-£140 prd. in col.
'The Hon. Miss Bingham', after J. Reynolds, 1786, 8¼ x 6¾in/21 x 17cm, £60-£120 prd. in col.
'Innocent Recreation' and 'Animal Affection', after W. Miller, 1800, pair £200-£300 prd. in col.
'Achilles Discovered by Ulysses', after A. Kauffmann, 13 x 10in/33 x 25.5cm, and other ovals £80-£160 prd. in col. or in sepia; add more if in contemporary frame.

BONNER, George Wilmot 1796-1836
Draughtsman, wood engraver and colour printer who worked in London.
Small value.

BONNOR, Thomas 1745-1815 or later
Draughtsman, line and aquatint engraver of topographical views and book illustrations after his contemporaries. Born in Gloucestershire, he was a pupil of H. Roberts (q.v.).
'The Oxford Almanack for 1768', after J.B. Malchair, £20-£40.
Bookplates small value.

BOOTH, T. fl. 1745
Etcher and engraver.
'Perspective View and Section of an Engine Propos'd to be Built by Subscription, Which Will Shave Sixty Men, also Oyl, Comb and Powder their Wigs', 1745, 9½ x 15¾in/24 x 40cm, £60-£90.

BOREEL, Wendela, A.R.E. b.1895
French-born painter, etcher, engraver and lithographer of figure subjects, portraits and architectural views. She was a pupil of W. Sickert (q.v.) and imitated his style.
£60-£140.

BORROW, William H. fl. mid-/late 19th century
Painter and etcher of landscapes and marine

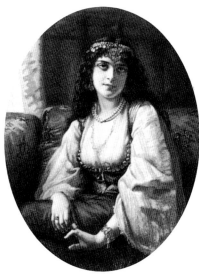

BOURNE, Herbert.'The Syren', after C.L. Muller.

subjects who contributed to *English Etchings.*
£4-£8.

BOSC, C. du *see* **DUBOSC, C.**

BOUCHER, William Henry 1842-1906
London etcher of sentimental subjects after W. Dendy Sadler as well as his own designs. He contributed plates to *English Etchings* and *The Etcher.*
Pl. after D. Sadler £30-£80.
Others £5-£15.

BOULARD, Auguste 1852-1927
French etcher and engraver of landscapes and decorative subjects after his French and English contemporaries.
Pl. after J.E. Millais and L. Alma-Tadema £80-£200.
After other artists £10-£50.

BOULTON, Mrs. fl. mid-19th century
Draughtswoman and lithographer.
4 views of Blundell's School, Tiverton, 1831, obl. fo., e. £5-£10 col.

BOULTON, Doris, A.R.E.
fl. early/mid-20th century
Wood engraver and etcher of Middle Eastern scenes.
£15-£50.

BOURLIER, Mary Ann fl. early 19th century
Stipple engraver of portraits and decorative subjects after her contemporaries.
Portraits small value.
Decorative subjects £8-£25 prd. in col.

BOURNE, Herbert fl. mid-/late 19th century
Line engraver of biblical, mythological and historical subjects and portraits mainly after his contemporaries.
Pl. after J.E. Millais and Lord Leighton £60-£140.
After other artists £10-£40.
Add more if in fine contemporary frame.
Small pl. small value.

BOURNE, John Cooke 1814-1896
Draughtsman and lithographer of topographical views after his contemporaries and railway subjects after his own designs. He is best known for the following two books of railway prints which are considered fine examples of tinted lithography:
'Drawings of the London and Birmingham Railway', 1839, fo., 30 tt. pl., and 'The History of the Great Western Railway', 1846, fo., 46 tt. pl., e. vol. respectively £1,000-£1,500 and £1,200-£1,800 uncol.; e. pl. £60-£160 col.
Pl. for E.P. Thompson's Life in Russia, 1848, 8vo., 4 tt. pl., e. small value.
Pl. for R. Hay's Views in Kairo, 1840, fo., 30 tt. pl., e. £20-£50.

BOUSEFIELD, J. Jun. fl. mid-19th century
Draughtsman and lithographer.
'View of the Opening of the Stockton and Darlington Rail Road', 10½ x 19¾in/26.5 x 50cm, £120-£180.

BOUVIER, J. fl. early/mid-19th century
Lithographer of portraits, railway subjects, etc., after his contemporaries.
'View of the Railway from Hefton Colliery to the Depot on the Banks of the River Wear near Sunderland', 17 x 29in/43.5 x 73.5cm, £200-£300.

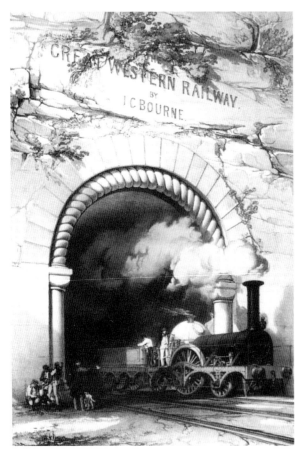

BOURNE, John Cooke. Title page for 'The History of the Great Western Railway', 1846.

BOWLES, Carington. 'An English Sloop Engaging a Dutch Man of War', mezzotint.

'Portraits of Greek Revolutionaries', after A. de Friedel, 1827, 24 pl., fo., e. £100-£200; rare set with period col. fetched £13,500 October 1989.
'Manners and Customs of the Indians and Anglo-Indians', after W. Taylor, 6 pl., fo., set

BOUVIER, J. One of twenty-four plates from 'Portraits of Greek Revolutionaries: Lord Cochrane, Great Admiral of the Greek Fleet', after A. de Friedel, 1827.

£1,200-1,600 col., fetched £2,000 May 1995 in special Indian sale.
Other portraits small value.

BOVI, Mariano b.1758
Italian etcher and stipple engraver of portraits and historical and decorative subjects after his contemporaries. Born in Naples, he was taught by F. Bartolozzi (q.v.), and worked in London.
Portraits after R. Cosway and others £30-£80 prd. in col.
Allegorical and mythological subjects after G. B. Cipriani and others £80-£200 prd. in col. or sepia; add more if in contemporary frame.
'A Gleaner's Child' and 'A Reaper's Child', after R. Westall, 1797, 12 x 10½in/30.5 x 26.5cm, pair £250-£400 prd. in col.
'Incidents in the Life of the Royal Family of France', after D. Pellegrini, 1793-6 and 1806, 6 pl., 18¼ x 23¼in/46.5 x 60cm, e. £50-£150 prd. in col.
'Countess Spencer as Education', after Lavinia, Countess Spencer, 1791, 13½ x 11¼in/34 x 28.5cm, £150-£300, prd. in col.

BOWLES, Carington fl. late 18th century
London publisher of caricatures and decorative subjects, engraved in mezzotint, and of sporting and topographical views engraved in line. The plates were usually unsigned by the engraver and often crude in technique.
'The Prodigal Son', after Le Clerc, by R. Purcell, 6 pl., 8¾ x 10½in/22 x 27cm, set £400-£700 col.
'The Months', after R. Dighton, 13¼ x 10in/35 x

25.5cm, set £2,000-£4,000 col.
'Coursing' and 'Shooting', after R. Dighton, 1786-90, e. set 4 pl., 9¾ x 13⅛in/25 x 35cm, former set £1,500-£2,000, latter £2,000-£2,500 with contemporary gouache col.
Caricatures £100-£300; up to £500 with contemporary gouache col.
'An English Sloop Engaging a Dutch Man of War', mezzo., £100-£200.
'Views of the Earl of Burlington's House at Chiswick', 6 pl., 10¼ x 16¼in/26 x 41cm, set fetched £1,400 Feb. 1996.
For topographical views generally, see T. Bowles.
Colour plate page 26.

BOWLES, John fl. mid-18th century
Draughtsman and line engraver of topographical views. He worked in London, often in conjunction with T. Bowles (q.v.). They published their own prints as well as those commissioned by them.
Prices see T. Bowles.

BOWLES, Thomas fl. mid-18th century
Draughtsman and line engraver of topographical views. He worked in London, often in conjunction with J. Bowles (q.v.). They published their own prints as well as those commissioned by them.
Views, depending on place, £60-£300 col.: 'A View of the Custom House, with part of the Tower . . .', after J. Maurer, and other London views, £100-£200 col., Malta £200-£300 col., Venice £60-£100 col., Upper Thames £60-£120 col.

BOWLES, Thomas. 'A view of the Custom House, with part of the Tower, taken from ye River Thames London', after J. Maurer.

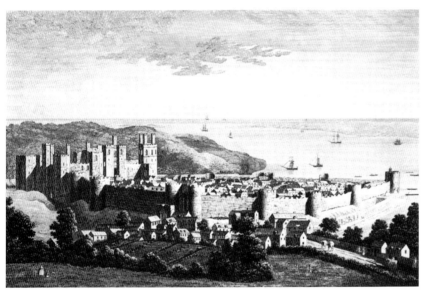

BOYDELL, John. 'Another prospect of Caernarvon, taken on the East side', a typical view.

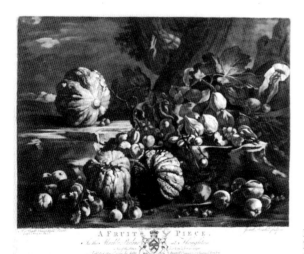

BOYDELL, Josiah. 'A Fruit Piece', after M.A. di Campidoglio, 1779.

BOYDELL, John 1719-1804
Draughtsman, line engraver, publisher and printseller. Born in Shropshire, he was apprenticed to W.H. Toms (q.v.) and began his career as a typical engraver of landscapes and topographical views. He gave up printmaking in 1767 and turned to publishing prints by other engravers. His initial success was based on 'Niobe', which he had commissioned W. Woollett (q.v.) to engrave after R. Wilson's painting. He went on to publish enormous quantities of prints, both employing engravers and painters to work for him as well as purchasing old plates and reprinting them (he bought all Hogarth's plates from his wife and republished them in 1790). Boydell effectively changed the English print trade from an import one to an export one and in so doing made a large fortune. In 1790 he became Lord Mayor of London. His financial success was somewhat dented, however, by his most ambitious project which was to illustrate Shakespeare's plays. He commissioned all the best-known painters of the day and in 1803 published a set of nearly 100 plates. It was a disastrous flop, partly because the war with France prevented exports but also because many of the plates are very dull. See under various engravers.
Prices for Boydell's own prints:
Most views £30-£100 but 'East Prospect of Elizabeth Castle', Jersey, after J. Auvergne, 21 x 28½in/53.5 x 72.5cm, £300-£500.
'H.M.S. Invincible', after R. Short, 1751, 20 x 24in/51 x 61cm, £400-£500.
Shipping subjects after C. Brooking e. £50-£80.

BOYDELL, Josiah 1752-1817
Painter, mezzotint engraver of portraits and decorative subjects after Old Master painters, and publisher. Born in Flintshire, he was a nephew of John Boydell (q.v.), who brought him to London and made him his partner. He became an Alderman in the City on his uncle's death.
'A Fruit Piece', after M.A. di Campidoglio, 1779, 11¼ x 13¼in/30 x 35cm, from the 'Houghton Gallery' series, £300-£500.
Other pl. after Old Masters from the 'Houghton Gallery' series £20-£80.
Portraits £10-£30.

BOYNE, John d.1810
Irish draughtsman and etcher of caricatures. He was apprenticed to W. Byrne (q.v.) in London.
'Non-commission Officers Embarking for Botany Bay', 1796, 16¼ x 20½in/41 x 52cm, pair col. £300-£500.
Other caricatures £30-£80 col.
He also produced an early lithograph for Specimens of Polyautography: *'Shepherd with Dog and Sheep', 1806, 9 x 13in/23 x 33cm, £80-£160/on orig. mount £200-£400.*
Man. Cat.

BOYS, Thomas Shotter 1803-1874
Important watercolourist and lithographer of landscapes and architectural and topographical views. Born in London, he was apprenticed to the engraver G. Cooke (q.v.) and went to live in Paris when he was about twenty. An early influence there was R.P. Bonington (q.v.) and, like him, Boys contributed plates to Baron Taylor's *Voyages Pittoresques et Romantiques dans l'Ancienne France,* 1820-78, having first produced a few soft-ground etchings reminiscent of the Paris views by T. Girtin (q.v.). Boys returned to England in 1837, and initially reproduced others' designs,

BOYS, Thomas Shotter. One of twenty-six plates from 'Original Views of London As It Is: Temple Bar from the Strand', 1842, first edition trimmed and mounted on card with contemporary colour.

BOYS, Thomas Shotter. 'Original Views of London As It Is: Temple Bar from the Strand', 1842, one of the twenty-six tinted lithographs with later colour. These untrimmed plates bear the artist's name at lower right below subject.

contributing plates to, for instance, D. Roberts' *Picturesque Sketches in Spain*, 1837, and Clarkson Stanfield's *Sketches on the Moselle, the Rhine and the Meuse*. In 1839, Boys produced his own *Picturesque Architecture in Paris, Ghent and Antwerp*, the first English book with lithographic plates printed entirely in colours. In 1841 came *A Series of Views in York*; finally, in 1842, appeared his most famous work *Original Views of London As It Is*.
Soft-ground etchings e. £50-£150.
Lithographs:
Pl. for Voyages Pittoresques et Romantiques dans l'Ancienne France, *1820-78, fo., e. £50-£150.*
Pl. for D. Roberts' Picturesque Sketches in Spain, *1837, fo., tt. pl., e. £30-£60 uncol.*
Pl. for C. Stanfield's Sketches on the Moselle, the Rhine and the Meuse, *fo., tt. pl., e. £40-£70.*
'Picturesque Architecture in Paris, Ghent and Antwerp', 25 pl., fo., e. £50-£150.
'A Series of Views of York', 1841, 10 pl., fo., e. £40-£60.
'City and Harbour of Sydney from near Vaucluse', after G.F. Angas, 1852, 12½ x 22in/32 x 56cm, tt., £800-£1,500 col.
'Original Views of London As It Is', fo., 26 tt. pl. (a) trimmed and mounted with contemporary col., (b) with later col.: (a) e. £300-£600, (b) e. £200-£300; uncol. e. £100-£200 (prices for pl. with later col. have been approaching those with contemporary col., e.g. set with later col.

fetched $9,000 June 1992, while sets with contemporary col. £7,000-£9,000, though one sold recently for only £5,500).
Bibl: Groschwitz, Gustave von, 'The Prints of T.S.B.', *Prints*, ed. Carl Zigrosser, New York, 1962.

BRACEBRIDGE, Mrs. fl. late 1830s
Draughtswoman and zincographer.
'Panorama of Athens', 1839, 10 x 108½in/25.5 x 276cm, £500-£800 uncol.

BRADBURY, Henry fl. mid-19th century
Draughtsman and etcher.
'The Ferns of Great Britain and Ireland', 1855, 22 x 15in/56 x 38cm, relief etchings, £8-£12 prd. in col.

BRADFORD, Dorothy Elizabeth
fl. early/mid-20th century
Painter and etcher from Cambridge.
£15-£40.

BRADLEY, Thomas
fl. early/mid-19th century
Line engraver of small bookplates including architectural views and portraits after his contemporaries.
Small value.

BRADSHAW, Brian, A.R.E. b.1923
Bolton painter, etcher and aquatinter. Pupil of

R.S. Austin (q.v.) at the R.C.A.
£20-£50.

BRADSHAW, Samuel fl. 1832-1880
Line engraver of small bookplates including landscapes and topographical views after his contemporaries.
Small value.

BRAGG, Aston fl. early/mid-19th century
Draughtsman and lithographer.
'John C. Heenan' (boxer), 1861, 9¾ x 6in/25 x 15cm, tt., £40-£60 col.

BRAGG, Gerard fl. 20th century
Liverpudlian lithographer and etcher of architectural subjects.
£20-£50.

BRAGG, T. fl. early 19th century
Line engraver of small portrait plates.
Small value.

BRAIN, E. fl. early 19th century
Line engraver.
'Brighton', after J. Whittemore, 1825, 7 pl., 12mo., e. small value.

BRAITHWAITE, Sam Hartley b.1883
Painter and etcher of landscapes. Born in Cumberland, he lived in Bournemouth.
£15-£40.

BRAMMER, Leonard Griffith. A view of The Potteries.

BRANDARD, John. 'The Parades with the Regent Hotel, Leamington'.

BRAMMER, Leonard Griffith, R.E. b.1906
Painter, etcher, drypointer, mezzotinter and lithographer of landscapes and topographical views. Born in Burslem, Staffordshire, he was a pupil of M. Osborne and R.S. Austin (qq.v.) at the R.C.A. Returning to Staffordshire, he concentrated on producing atmospheric views of The Potteries which have a certain historical interest today.
£60-£140.

BRANDARD, Edward P. 1819-1898
Line engraver of small landscape plates after his contemporaries. He was the brother of J. Brandard and R. Brandard (qq.v.).
'City of Louisville', after A.C. Warren, 1872, 9 x 12½in/23 x 32cm, £50-£70.
Pl. after J.M.W. Turner, early imp. or proofs, £20-£80.
Others small value.

BRANDARD, John 1812-1863
Lithographer of music frontispieces, naval subjects, topographical views and portraits after contemporary artists. Born in Birmingham he was the brother of E. Brandard and R. Brandard (qq.v.).
Pl. for Sir John Ross' Narrative of a Second Voyage in Search of a North West Passage, 1835, 25 pl., 4to., e. £20-£30 col.
Pl. for Mann's Views of Hastings, obl. fo., 8 tt. pl. after J. Thorpe, e. £30-£60 col.
Pl. for F.S. Marryat's Mountains and Molehills (Californian Gold Rush), 1855, 5½ x 8½in/14 x 21.5cm, e. £10-£20 col.
'Bombardment of Bomarsund', after E.T. Dolby, 18½ x 33in/47 x 83.5cm, tt., £80-£140 col.
'The Parades with the Regent Hotel, Leamington', £50-£100.
Music frontis. and portraits £10-£35 col.

BRANDARD, Robert 1805-1862
Etcher and line engraver of small bookplates including landscapes and topographical views after his contemporaries. Born in Birmingham, he was the brother of E. Brandard and

J. Brandard (qq.v.) and a pupil of E. Goodall. He worked in London.
Pl. after J.M.W. Turner: 'Crossing the Brook', 18¾ x 15¼in/48 x 39cm, £150-£250, add more if in fine contemporary frame (touched proof, fetched £2,600 April 1990); sm. pl. early imp. or proofs, £20-£80.
Pl. for N.P. Willis' American Scenery, mostly after W.H. Bartlett, 1839-40, 4to., e. £5-£15. Other bookplates small value.

BRANDLING, Henry Charles
 fl. mid-19th century
Draughtsman and lithographer of topographical views.

Views in Northern France, 1848, 12 pl., 9¾ x 13½in/25 x 34cm, e. £10-£20 col.

BRANGWYN, Sir Frank William, R.A., R.W.S., R.E. 1867-1956
Well-known painter, etcher and lithographer especially of architectural views, but also of genre and marine subjects. Born in Bruges, Belgium, the son of a Welsh architect, he worked for three years for William Morris designing tapestries. He travelled extensively and many of his etchings are of Continental views. During World War I he produced several lithographic war posters but etching was his true interest. His use of a deeply-bitten line

BRANGWYN, Frank William. 'Breaking up the *Hannibal*', etching.

BRETHERTON, James. 'Portrait of George Stubbs', after J. Orde.

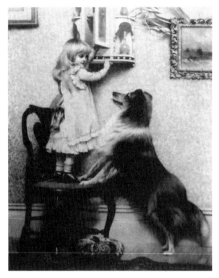

BRIDGWATER, Henry Scott. 'When She Got There...', after C. Burton Barber, 1893.

combined with lots of ink left on the plate for tonal effects, as well as very large plates make his etchings distinctive, though their overall heaviness does not appeal to the taste of all collectors.
'Making Sailors', from The Great War: Britain's Efforts and Ideals, 1917, 6 pl., 17¾ x 14in/45 x 35.5cm, litho., e. £30-£60.
War posters £20-£60.
Etchings: v. lge. pl., e.g. 'Breaking up the Hannibal', £200-£400; otherwise depending on subject £60-£200.
Bibl: Grant, W., *Etchings of F.B., R.A., Catalogue Raisonné*, London, 1926.

BRANGWYN, Leslie Maurice Leopold
b.1896
London etcher and wood engraver.
£15-£50.

BRANNON, George fl. early/mid-19th century
Draughtsman, engraver and publisher of topographical views, mainly of the Isle of Wight.
'Vectis Scenery', various dates, e. £5-£15.

BRANSTON, Allen Robert 1778-1827
Engraver of book illustrations, first on copper and later on wood. Born in Norfolk, he worked in Bath and London and is said to have founded the London school of wood engraving in competition with Bewick's Northern school.
Small value.

BRESSLERN-ROTH, Norbertine 1891-1978
Austrian colour woodcut artist included here because most of her prints were both created in and first exhibited in Britain. She later settled in America.
£40-£90.

BRETHERTON, James fl. late 18th century
Etcher and stipple and aquatint engraver mainly of caricatures after H.W. Bunbury. His son, Charles, 1760-1783, also engraved a few plates.
'Portrait of George Stubbs', after J. Orde, 7¾ x 5¾in/19.5 x 14.5cm, £60-£140.
'Hyde Park', and 'A City Hunt', both after H.W. Bunbury, 1780, 23½ x 65in/60 x 165cm, e. £200-£400.
Others £10-£50.

BREWER, James Alphege fl. early 20th century
Painter and etcher of architectural views.
£30-£90.

BREWER, Otto fl. 1862
Lithographer.
'The Battle for the Championship of England and £400 Between Tom King and Jem Moore at Thames Haven', 1862, publ. by G. Newbold, £300-£400 col.

BRIDGENS, Henry fl. mid-1830s
Draughtsman and lithographer of topographical views.
'West India Scenery', 1836, 27 pl. all drawn and several litho. by R.B., fo., e. £100-£200 col.
'Italian Views' e. £20-£40 col.

BRIDGWATER, Alan b.1903
Sculptor, painter and etcher. Lived in Birmingham.
£15-£40.

BRIDGWATER, Henry Scott b.1864
Mezzotint engraver of portraits and sentimental subjects after 18th and early 19th century British artists as well as his contemporaries.
'When She Got There . . .', after C. Burton Barber, 1893, £60-£140.
Others £20-£100.
Add more if in fine contemporary frame.

BRIGGS, F. fl. mid-19th century
Draughtsman and lithographer.
'A Panorama of Rio de Janeiro', 13 x 95in/33 x 241cm, tt., £3,000-£5,000 col.

BRIGHTWELL, Cecilia Lucy 1811-1876
Norwich School etcher of original landscapes and topographical views as well as copies of Old Masters. She was born at Thorpe, near Norwich and produced views of East Anglia and the East Midlands.
Original pl. £20-£60.
Copies after Rembrandt and other Old Masters small value.

BRIGHTWELL, L. fl. 1920s
Drypoint etcher of animal subjects.
£30-£80.

BRIGHTY, G.M. fl. early 19th century
Draughtsman and aquatint engraver of landscapes and topographical views.
Pl. for G. Shepherd's Vignette Designs, 1814-15, 16 pl., 4to., e. £10-£20 col.
'The Chain Pier at Brighton with Characters', 1824, 12¾ x 21in/32.5 x 53cm, £250-£350.

BRISCOE, Arthur John Trevor, R.E.
1873-1943
Notable painter and etcher of marine subjects. Born in Birkenhead, he studied at the Slade and in Paris and then spent his time sailing. He both painted and wrote on yachting subjects. After World War I he used to go sailing with J. McBey (q.v.) who arranged the publication of Briscoe's first plates in 1925. Most of his etchings depict sailing ships and his vigorous compositions present an invaluable historical record of the working of the last great commercial vessels.

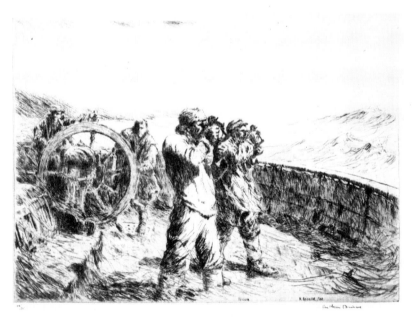

BRISCOE, Arthur John Trevor. 'Noon', 1930.

BROCKHURST, Gerald Leslie. 'James McBey', 1931.

BROMLEY, Frederick. 'The Meeting of H.M. Stag Hounds on Ascot Heath', after F. Grant, 1839.

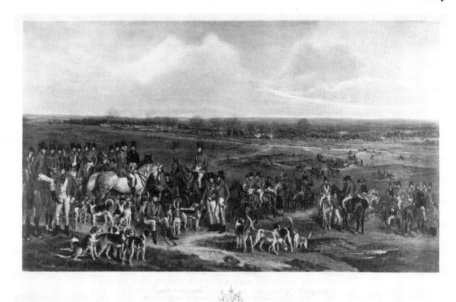

Immensely popular for a few years in the 1920s, these prints were out of favour for a long time until recently.
'Noon', 1930, £150-£250.
Others £80-£350.
Bibl: Laver, J., *A Complete Catalogue of the Etchings and Drypoints of A.B., A.R.E.,* London, 1930; Wright, H.J.L., 'A.B., A Chronological List of His Later Etchings', *P.C.Q.,* 1939, XXVI, pp.97-103.

BROCAS, Henry Jun. 1798-1873
Irish painter and etcher of landscapes and topographical views. Born in Dublin, he was the son of Henry Brocas Sen. and etched 'Select Views of Dublin', after drawings by his brother Samuel, c. 1820.
'Select Views of Dublin', c.1820, 12 pl., fo., e. £70-£120 col.

BROCK, John fl. early 19th century
Line engraver of architectural views after his contemporaries and earlier artists.
Pl. for J.T. Smith's Antiquities of Westminster, *1807, 4to., e. small value.*

BROCKHURST, Gerald Leslie, R.A., R.E.
b.1890
Prominent painter, etcher and lithographer of portraits and figure studies, especially of young women. Born in Birmingham, he studied at the School of Art there and in France and Italy. His etchings, which show the influence of the Early Renaissance Italian painters as well as Augustus John (q.v.), are meticulously built up through the use of short, fine lines; his precision and craftsmanship have been much admired.
'Adolescence' (his most sought-after print), 1932, 14½ x 10½in/37 x 26.5cm, £6,000-£8,000.
'Dorette', 1932, 9 x 7¼in/23 x 18.5cm, £700-£900.
'James McBey', 1931, £250-£400.
Others mostly £80-£300.
Bibl: Stokes H., 'The Etchings of G.L.B.', *P.C.Q.,* 1924, XI, pp.409-43; Wright, H.J.L., 'The Later Etchings of G.L.B., A.R.A.', *P.C.Q.,* 1934, XXI, pp.317-36 and 1935, XXII, pp.62-77.

BROCKMAN DAVIS, William David *see* **DAVIS, W.D. Brockman**

BRODZKY, Horace 1885-1969
Australian painter, etcher, drypointer and woodcut artist of portraits and figure studies. Born in Melbourne, he worked both in U.S.A. and London before finally settling in England in 1923. He wrote biographies of Henri Gaudier-Brzeska, 1933, and Jules Pascin, 1946.
'Self-portrait' drypoint, 1919, 4¾ x 3¾in/12 x 9.5cm £200-£300.
Others £60-£140.

BROMLEY, Clough W. b.1850
Painter and etcher of landscapes, topographical views, portraits, etc., after his own designs and those of his contemporaries. Many of his prints are views in and around London where he lived. He was the son of W. Bromley (q.v.).
Original etchings £10-£40.
Reproductive pl. small value.

BROMLEY, Frederick fl. mid-19th century
Mezzotint engraver of portraits and historical and sentimental subjects after his contemporaries. The son of W. Bromley (q.v.), he lived and worked in London.
Lge. equestrian portraits and sporting subjects, e.g. 'The Meeting of H.M. Stag Hounds on Ascot Heath', after F. Grant, 1839, 16½ x 28½in/42 x 72.5cm, £400-£800; 'The Royal Cortège in Windsor Park', after R.B. Davis,

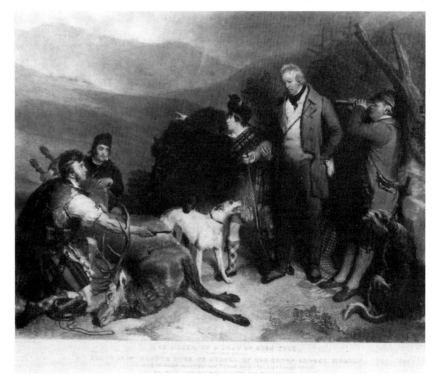

BROMLEY, John Charles. 'The Death of a Stag in Glen Tilt', after E. Landseer, 1844.

BROOKS, Vincent. 'Col. Charles De-Laet Waldo Sibthorp M.P.', after J. Ferneley.

1840, 16¾ x 28½in/42.5 x 72.5cm, £300-£500;
'Peninsular Heroes', after J.P. Knight, 1847,
21¾ x 35¼in/55 x 89.5cm, £300-£400.
Lge. sentimental and historical pl. £30-£80.
Portraits £10-£30.
Add more if in fine contemporary frame.

BROMLEY, James 1800-1838
Mezzotint engraver mainly of portraits after his
contemporaries. He was the son of W. Bromley
(q.v.).
'View of the Interior of the House of Peers
During the Trial of Queen Caroline, 1820',
after Hayter, assisted by J. Porter and J. G.
Murray (qq.v.), 1832, 22¾ x 34¼in/58 x 87cm,
£200-£300.
Portraits £10-£30.
Add more if in fine contemporary frame.

BROMLEY, John Charles 1795-1839
Mezzotint engraver of portraits and sentimental
subjects after his contemporaries. He was the
son of W. Bromley (q.v.).
'The Death of a Stag in Glen Tilt', after
E. Landseer, 1844, £150-£350.
'Reform Banquet', after B. R. Haydon, 1837, 21
x 26¼in/53.5 x 66.5cm, £200-£300.
Other lge. historical and sentimental pl. £30-
£80.
Portraits £10-£30.
Bookplates small value.
Add more if in fine contemporary frame.

BROMLEY, William, A.R.A. 1769-1842
Etcher, line, stipple and mezzotint engraver of
portraits and historical and decorative subjects
mainly after contemporary artists. Born in the
Isle of Wight, he lived and worked in London
and was the father of the other four Bromleys
listed.
Lge. naval and military pl. (contemporary
events), e.g. 'Decisive Charge of the Life Guards
at the Battle of Waterloo', after L. Clennell, 1821,
10 x 18in/25.5 x 45.5cm; 'The Death of Admiral
Lord Nelson', after A. W. Devis, 1812, 16½ x
23in/42 x 58.5cm, e. £160-£400.

Other lge. pl. £40-£100.
'Seven Ages of Man', after T. Stothard, 11½ x
8¼in/29 x 21cm, set £300-£400 prd. in col.
Add more if in fine contemporary frame.
Small bookplates small value.

BROOK, Arthur b.1867
Portrait and landscape painter, mezzotint
engraver of portraits after British 18th century
painters.
£15-£50.

BROOKES, T. fl. mid-19th century
Draughtsman and lithographer.
'A West View of the House and Manufactories of
Enoch Wood & Sons, Burslem', 1833, 9½ x
15in/24 x 38cm, £80-£120 col.

BROOKS, John fl. mid-18th century
Irish mezzotint engraver of portraits after
contemporary artists. Born in Dublin, he learnt
to engrave in London and then trained several
mezzotint engravers in his native city, among
them J. MacArdell (q.v.) whom he brought to
England in 1747. In later years, a project for
enamelling on china was ruined by his
dissipation.
HLs £20-£80.
WLs £60-£160.
CS.

BROOKS, Vincent 1814-1885
Lithographer of topographical views, decorative
and naval subjects, etc., after contemporary
artists. After working for Day & Son (see
William Day, 1797-1845), he set up his own
lithographic printing and publishing company,
Vincent Brooks, Day and Sons Ltd. His plates
were usually printed with one or more
tintstones.
Decorative subjects, e.g. 'The Ass-tocratic
Stakes', after J. A. Fitzgerald, £40-£80 col.
'Steam Ship John Bright', after J. F. Taylor,
£250-£350 col.
'Views of the Great Exhibition', 1851, after
G. F. Bragg, 3 lge. pl., e. £100-£200 prd. in col.

'Liverpool', 1859, after J. R. Isaac, 24½ x
34in/62 x 86.5cm, £500-£800 prd. in col.
'Col. Charles De-Laet Waldo Sibthorp, M.P.',
after J. Ferneley, £100-£200 col.
'Scenes from the Snowfields of Mont Blanc',
after E. T. Coleman, 1859, 19 pl. on 12 sheets,
chromolitho., e. £100-200 (set sold £4,600
October 1988).

BROOKSHAW, George fl. early 19th century
Draughtsman, aquatint engraver and publisher
of botanical subjects. His most famous work is
Pomona Britannica, 1812. The ninety plates
depict the fruit grown around London and
particularly in the Royal gardens at Hampton
Court. Pomona Britannica has been described
by Prideaux in Aquatint Engraving as 'one of
the finest colour plate books in existence'.
Pl. for Pomona Britannica, 1812, fo., e. £200-
£500 prd. in col. and finished by hand.
Smaller pl. for later works vary from £5-£15
col. to £30-£70 col. e.g. for 1817 edn. 4to of
Pomona Brittanica.

BROOKSHAW, Richard b.1736
Mezzotint and stipple engraver of portraits and
sporting and decorative subjects, mainly after
contemporary artists. Several of his portraits are
reduced-size copies of other mezzotints. He
visited Paris in the 1770s and engraved a
number of portraits of the Royal Court.
'Monsieur Masson, the Tennis Player' (his most
important print), after J. H. Mortimer, 1769, 20
x 14in/50.5 x 35.5cm, £400-£600.
'The Flight into Egypt', after P. P. Rubens, £10-
£20.
'Louis XVI' and 'Marie Antoinette', 1774, 15½ x
11in/39.5 x 28cm, pair £100-£150.
'Miss Williams', after R. Pyle, 14 x 10in/35.5 x
25cm, £10-£20.
'Eclipse' (racehorse), after F. Sartorius, 1770,
14 x 16in/35.5 x 41cm, £150-£250.
Reduced-size copies of other mezzo. portraits
£2-£6.
CS.

BROWN, Denise Lebreton, R.E.
Mrs. Waters) b.1911
Illustrator of children's books and etcher of
genre and figure subjects.
£20-£60.

BROWN, G. fl. mid-19th century
Aquatint engraver.
'Formosa' (racehorse), after E. Lambert, 19¼ x
22¾in/49 x 58cm, £300-£400 col.

BROWN, Henry James Stuart 1871-1941
Scottish etcher of landscapes in Britain and on
the Continent. Born in West Lothian, he took up
etching as a hobby, producing over two hundred
plates, many worked on in the open air.
Although he is one of the best etchers of the
period, his work is still much underrated.
£30-£90.
Bibl: Wright, H. J. L., 'A Chronological List of
the Etchings and Drypoints of H.S.B.', P.C.Q.,
1927, XIV, pp.362-92.

BROWN, Joseph fl. mid-19th century
Line and stipple engraver mainly of small
portrait plates after his contemporaries.
Small value.

BROWN, T.B. fl. early 19th century
Stipple engraver of small bookplates including
decorative subjects after his contemporaries.
Small value.

BROWN, Henry James Stuart. A typical landscape.

BROWNE, Alexander　　fl. late 17th century
Miniature painter, writer on art, etcher and
mezzotint engraver of portraits after his
contemporaries and his own designs. He was
also a drawing master and lived and worked in
London. While he published all the forty-four
plates after Van Dyck and Lely listed by CS, we
cannot be certain that he engraved them all
himself, since they are all merely signed
'excudit' or 'sold by Alex. Browne at ye Blew
Ballcony in little Queen Street'. In 1675 he
published *Ars Pictoria* which contains the first
detailed description of the mezzotint technique.
Male HLs £20-£60.

Male TQLs £40-£100.
*Female TQLs and WLs £60-£200, but could be
double for superb, early imp.*
CS.

BROWNE, Hablot Knight ('Phiz') 1815-1882
Draughtsman, etcher of small bookplates and
lithographer of larger hunting and coaching
subjects, all of a humorous nature. Born in
Kennington, he was apprenticed to W. Finden
(q.v.) and worked in London. He is best known
under his pseudonym 'Phiz' as the illustrator of
Dickens and other Victorian novelists.
'Pippins Has a Day Out With the Surrey

Hounds', fo., 12 litho., set £300-£500 prd. in
col.
*'The Derby Day – The Road and the Course',
1866, 8 litho., set £500-£800 prd. in col.*
*'Hunting Bits', obl. fo., 12 tt. pl., set £300-£500
col.*
*Small bookplates: etched illustrations for R.S.
Surtees (foxhunting subjects), £10-£20 col.;
others small value.*

BROWNE, John　　　　　　　1741-1801
Etcher and engraver of landscapes and
religious, mythological and genre subjects after
Old Masters and his contemporaries. Born in
Essex, he was apprenticed to J. Tinney (q.v.),
and later worked with W. Woollett (q.v.). Many
of his prints were published by J. Boydell (q.v.).
He was elected an Associate Engraver to the
R.A. in 1770.
*'Going to Market', after P.P. Rubens, 1783, 22 x
30¼in/56 x 78cm, £80-£200.*
Landscapes £50-£150.
Others £10-£50.
See also Hodges, W.

BROWNE, Philip　　　fl. mid-19th century
Landscape, sporting and genre painter who
lived in Shrewsbury and lithographed a series of
views of Hawkestone Park.
Views of Hawkestone Park e. £5-£10.

BRUCE, J. (?James)　　fl. early 19th century
Draughtsman, aquatint engraver and publisher
of Brighton views.
*'Select Views of Brighton', 1824, 9 pl., obl. 4to.,
e. £60-£140 col.*
*'The History of Brighton With the Latest
Improvements to 1835', 9 pl., 12 mo., e. £20-
£35 col.*

BRUNAIS, Augustin *see* **BRUNIAS,
Abraham**

BRUNET DEBAINES, Alfred Louis　b.1845
French etcher of landscapes after Old Masters
and his English and French contemporaries as

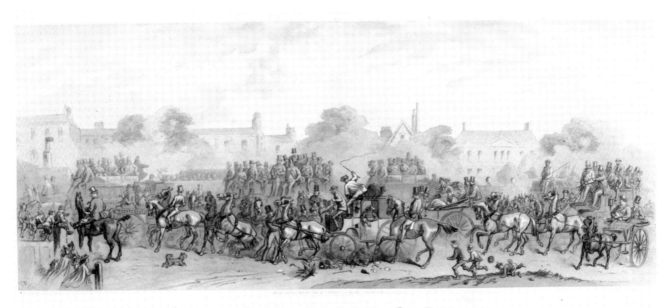

BROWNE, Hablot Knight. One of eight lithographs from 'The Derby Day – The Road and the Course: 'The Return' – "Tickets Gents, Tickets!" ', 1866.

BROWNE, John. 'Corte in Corsica', after J. Kent, 1772, a typical landscape subject.

BRUCE, J. One of nine plates from 'Select views of Brighton: Chain Pier at Brighton', 1824.

BUCK, Nathaniel and Samuel. 'The Southwest prospect of Birmingham', 1731, one of the brothers' eighty-three 'Prospects'.

well as after his own designs.
Larger pl. £10-£40.
Small pl. small value.

BRUNIAS, Abraham (Brunais, Augustin)
fl. late 18th century
Landscape and figure painter, draughtsman and stipple engraver of West Indian subjects, published in London 1780-99.
West Indian subjects, 9 x 14¾in/23 x 37.5cm, e. £150-£200 prd. in col.; £80-£150 col.

BRYAN, M. fl. 1920s/1930s
Wood engraver.
£15-£40.

BRYANT, Joshua fl. late 18th/early 19th century
Draughtsman, etcher and aquatint engraver of landscapes and architectural views after his own designs and those of others.
'Progressive Lessons in Landscape Drawn and Engraved by Joshua Bryant', 1807, 67 pl., J.B. etched Part 1 and drew Part 2 which was aq. by others, obl. 4to., e. small value.
'Col. Thornton's Sporting Tour Through France', 1806, 55 pl., J. B. drew most and eng. 3, 4to., aq., e. small value.

BRYDEN, Robert, R.E. 1865-1939
Scottish sculptor, etcher and wood engraver of architectural views and portraits. Born in Ayrshire, he studied at the R.C.A. and R.A. schools. He lived in Ayr.
'Men of Letters of the 19th Century', 1899, woodcuts; 'Ayrshire Castles', 3 vols., 1899, 1908 and 1910, etchings; 'Twenty Etched Portraits from Life', 1916; e. pl. from these £5-£15.

BRYER, Henry c.1744-1778
Mezzotint engraver of portraits. Printseller in partnership with W.W. Ryland (q.v.), and originally his pupil.
'Anne, Duchess of Cumberland', WL, 24 x 15in/61 x 38cm, £200-£400.
'Diana', HL, after Nixon, 1773, 15 x 11in/38 x 28cm, £40-£70.
CS lists 2 pl., noted above.

BRYSON, R.M. fl. mid-19th century
Lithographer of topographical views and naval and military subjects after his contemporaries. He worked for Day & Son (see William Day, 1797-1845), producing plates (all tt.) for their books on travel and military campaigns.
'H.M.S. Hannibal leaving Anapa' from O.W. Brierly's Marine and Coast Sketches of the Black Sea, 1856, fo., £150-£250.
Most other bookplates small value; e. £8-£25 if col. or prd. in col.

BUCHANAN, Col. Bertram
fl. early 20th century
Amateur etcher and aquatinter of landscapes. He was a professional soldier.
£15-£40.

BUCK, Nathaniel fl. early/mid-18th century
BUCK, Samuel 1696-1779
Well-known draughtsmen, etchers and line engravers of English topographical views. Samuel engraved his own drawings from 1711 to 1726, after which Nathaniel collaborated with his brother in both the drawing and engraving of the plates. They went on sketching tours during the summer and engraved the sketches during the winter. While the perspective of the Buck views is often primitive

BUCK, Nathaniel and Samuel. 'Views of the Venerable Remains…of Castles, Monasteries, Palaces, etc.: The North View of Netley Abbey in Hampshire', 1733.

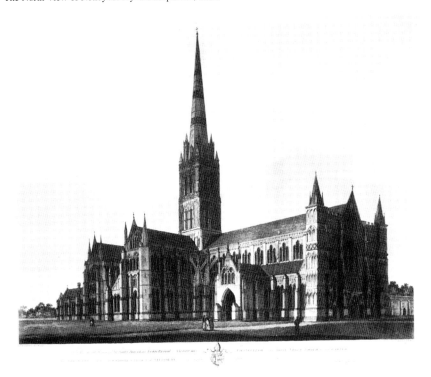

BUCKLER, John. 'North West View of the Cathedral Church of Salisbury', 1803.

and the engraving technique crude compared to contemporary topographers, the body of their work none the less represents a significant contribution to the topographical genre and their 'Prospects of English Towns' have always been known and loved.
'Views of the Venerable Remains of Above Four Hundred Castles, Monasteries, Palaces, etc., in England and Wales', about 428 pl. produced over 30 years from 1720s, issued in parts and collected and publ. by R. Sayer in 3 vols., 1774, 9 x 13in/23 x 33cm, e. £10-£30.
83 'Prospects' of the larger towns and cities, prices depend on town: Liverpool £200-£350; Cambridge £180-£300; Bury St. Edmunds £120-£200; Birmingham £150-£300.
'Panorama of the Thames from Westminster Bridge to London Bridge, Sept. 1749', 5pl., overall size 12¼ x 32in/31 x 81.5cm, £1,000-£2,000.

BUCKLE, D. fl. mid-19th century
Line engraver of small topographical bookplates after his contemporaries.
Small value.

BUCKLER, A. fl. mid-19th century
Draughtsman and lithographer.
'View of Malvern', 8 x 10in/20.5 x 25.5cm, £10-£30.

BUCKLER, John 1770-1851
Architect, draughtsman and etcher of architectural views. Born on the Isle of Wight,

he worked all over England and died in London.
'Views of English Churches and Cathedrals', 1803-10, ave. size 20½ x 25½in/52 x 65cm, and slightly smaller, etchings aq. by various eng., £60-£140.

BUCKMAN, Edwin b.1841
Painter and etcher of figure and genre subjects. He worked in London and contributed plates to English Etchings.
'British Athletic Sports and Games', 1886, 3 pl., e. £40-£80.
Others small value.

BUCKTON, Eveleen 1872-1962
Painter and etcher of landscapes. She studied at the Slade and attended F. Short's (q.v.) engraving classes.
£10-£30.

BULL, T. fl. mid-19th century
Stipple engraver of small bookplates.
Small value.

BULLEN, C. fl. 1920s/1930s
Wood engraver.
£10-£30.

BULLEN, John fl. mid-19th century
Draughtsman and lithographer.
'Charles Payne, Huntsman to the Pytchley Hunt', 20¼ x 27in/52.5 x 68.5cm, tt. pl., £100-£150.

BUNBURY, Henry William 1756-1811
Well-known amateur draughtsman of caricatures, whose works were often reproduced by colleagues such as T. Rowlandson (q.v.), made a few etchings and drypoints himself. These are rare and mostly belong to the period 1770-80.
'A Riding-House', 1780, 14¼ x 21¼in/37 x 52.5cm, col. imp. fetched £750, June 1995; others mostly £100-£200.

BURDETT, Peter Perez d.1793
Liverpool artist who was the first engraver to use the aquatint technique in Britain, having learnt it from J.B. Le Prince in Paris. He exhibited two plates at the Society of Arts in 1772. Only three aquatints by him are known all of which are very rare:
'Banditti Terrifying Fishermen', 1771, 14¼ x 18¾in/37.5 x 48cm, and 'Skeleton on a Rocky Shore', 34.5 x 46cm, both after J.H. Mortimer, e. £800-£1,200.
'Two Boys Blowing a Bladder', 1773, 12½ x 8½in/32 x 21.4cm, after J. Wright of Derby, fetched £3,000 June 1990.

BURFORD, Leonard fl. late 17th/early 18th century
Engraver of portraits, title pages and landscapes.
Small value.

BURFORD, Thomas fl. mid-/late 18th century
Mezzotint engraver of portraits, decorative and more especially sporting subjects after his contemporaries as well as his own designs. He died in London.
'Foxhunting', after J. Seymour, 1755, 4 pl., 14 x 20in/35.5 x 50.5cm, set £1,200-£1,600.
'Foxhunting', after J. Seymour, 1754, 6 pl., 10 x 14in/25.5 x 35.5cm, set £1,500-£2,000 col.
12 sporting pl. after J. Seymour, 1752, 10 x 13¾in/25.5 x 35cm, mezzo., e. £140-£280.
'The Months', 1747, 13 x 8 3/4in/33 x 22cm, set £1,200-£1,800.

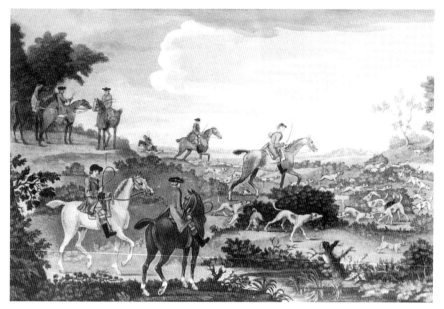

BURFORD, Thomas. One of six plates from 'Fox Hunting', after J. Seymour, 1754.

BURGESS, Henry William. One of the plates from 'Eidodendron: The King Oak in Windsor Forest', 1827.

'Gen. J. Oglethorpe, Commander-in-Chief of H.M. Forces in Georgia and Carolina', 13¼ x 9¾in/35 x 25cm, £400-£600.
Other portraits: HLs £10-£30; TQLs and WLs £10-£60.
CS lists 22 portraits.

BURGES, W. fl. late 18th century
Draughtsman and etcher.
'A Summer Evening Repast', aq. by J.W. Edy (q.v.), 1788, 17¼ x 22¼in/44 x 56.5cm, £150-£250 prd. in col.

BURGESS, Henry William fl. early 19th century
Landscape painter and drawing master at Charterhouse. He lived in London and was draughtsman and lithographer of the following:
'Eidodendron, Views of the General Character and Appearance of Trees', 1827, 54 pl., fo., e. £10-£20.
'Temple of Absimbal in Nubia', after Major Felix, 23 x 28in/58.4 x 71.1cm, £200-£300.

BURGESS, James Howard 1817-1890
Irish draughtsman and lithographer of landscapes and topographical views.
'Select Views in the North of Ireland', c.1830. 4 pl., fo., e. £40-£70 col.

BURGESS, J.C. fl. 1829
Lithographer.
Chelsea views, 1829, 12 x 15in/30.5 x 38cm, e. £50-£70.

BURGESS, William, of Dover 1805-1861
Draughtsman and lithographer of topographical views and military subjects. Born in Canterbury, he worked mainly in Dover, and all his subjects relate to Dover.
Sketches of Dover, 1844, 7 tt. pl., obl. 4to., e. £8-£15 col.
'Dover Castle, A.D. 1642', 1847, 8 pl., fo., e. £8-£15 col.
Military subjects £80-£200 col.

BURGESS, William d.1813
Draughtsman and engraver. He was also the pastor of a Baptist congregation.
Views of Churches in Lincolnshire and Cambridgeshire, 1800-5, 12 pl., obl. fo., e. £15-£50.

BURGESS, William Walter, R.E. 1856-1908
Etcher of landscapes and architectural views. Born in Southampton, he lived and worked in London, specialising in views of London and English cathedrals.
Inns of Court £10-£25.
Other London views £7-£15.
Others £4-£10.

BURGH, J.J. van den see BERGHE, I.J. van den

BURGHERS, Michael c.1653-1727
Dutch line engraver of most of the Oxford Almanacks from 1676-1719 after contemporary designs but full of figures from Old Master engravings. Born in Amsterdam, he settled in Oxford in 1673, working under D. Loggan (q.v.) and succeeding him as Engraver to the University.
Almanacks, e. approx. 19¾ x 17¾in/50 x 45cm, line eng., e. £20-£50.
Portraits and bookplates small value.
'Anthony Wood', mezzo., £40-£60.
CS lists the mezzo. noted above.

BURKE, Thomas 1749-1815
Irish engraver of portraits and decorative subjects after his contemporaries. Born in Dublin, he was taught mezzotint engraving by J. Dixon (q.v.) but

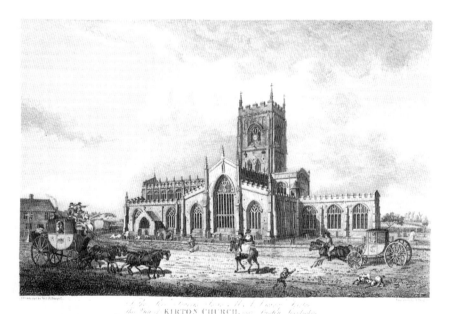

BURGESS, William. 'View of Kirton Church, near Boston, Lincolnshire', 1803.

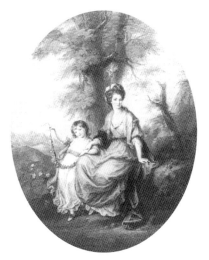

BURKE, Thomas. 'Lady Rushout & Daughter', after A. Kauffmann, 1784.

BURNET, John. 'The Jews Harp', after D. Wilkie, 1809.

BUSBY, Thomas Lord. One of twenty-four plates from 'Costume of the Lower Orders of London: Bell-Ringer', 1820.

turned to stipple engraving religious, mythological and ancient history subjects mainly after A. Kauffmann and G.B. Cipriani (ovals and roundels, printed in red, brown or in colours).
'Lady Rushout and Daughter' (his most famous print), after A. Kauffmann, 1784, 17 x 12¼in/43 x 32.5cm, £500-£800 prd. in col.
'The Vicar Receiving His Tithes' and 'The Vicar Returning from His Duties', after H. Singleton, pair £400-£600 prd. in col.
'Saturday Morning, Favourite Chickens Going to Market' and 'Saturday Night, or the Cottagers' Merchandise', after W.R. Bigg, 1797, 22 x 24½in/56 x 62cm, pair £700-£1,100 prd. in col.
'Eclipse', after G. Stubbs, 1773, 18 x 22in/45.5 x 56cm, mezzo., £1,000-£1,600 prd. in col.; £700-£1,200 b. & w.
'Gleaning Girl', after S. de Koster, 1801, 21 x 16¼in/53.5 x 41.5cm, with 'Shepherd Boy', by W. Bond (q.v.), pair £400-£600 prd. in col.
'A Flower', painted by Verelst after A. Kauffmann, 1784, 16 x 12¼in/41 x 31cm, £150-£250 prd. in col.
'Happiness', from a set of 4 with 'Wisdom' by J. P. Simon (q.v.), and 'Providence' and 'Innocence' by B. Smith (q.v.), all after J.F. Rigaud, 1799, 22½ x 16in/57 x 40.5cm, set £500-£800 prd. in col.
Other portraits and decorative subjects generally e. £40-£120 prd. in col., e.£10-£25 prd. in red or brown; but ovals and roundels £50-£150 prd. in red, brown and in col., more if in original frame.
CS.

BURN, Gerald M. fl. 1920s
Etcher of architectural views.
£10-£35.

BURN, Henry fl. mid-19th century
Draughtsman and lithographer of topographical views.
'Northampton from Huntsbury Hill', c.1860, 13¾ x 19¼in/35 x 49cm, £200-£300 col.
'Leicester from Knighton Hill' (showing the Leicester and Swannington Railway), 1846, 14½ x 18¾in/37 x 47.5cm, £250-£400 col.

BURNET, John 1784-1868
Scottish painter, etcher and engraver in line and

mezzotint of genre, sentimental and historical subjects after his contemporaries, especially D. Wilkie, and Old Master painters as well as his own paintings. Born in Midlothian, he was apprenticed to R. Scott (q.v.) and worked in Edinburgh. He was one of the first engravers to specialise in the mass reproduction of paintings which the new middle class could afford. His use of steel plates, which made possible from the 1820s large editions as well as the use of the mixed-method technique, give his prints the characteristic mechanical and hard finish of the Victorian reproductive engraving.
'The Chelsea Pensioners Reading the Account of the Battle of Waterloo', after D. Wilkie, 17 x 28in/43 x 71cm, £150-£300.
'The Battle of Waterloo', after J.A. Atkinson and A.W. Devis, 1819, 19¾ x 25¼in/50 x 64cm, £140-£280.
'Heroism and Humanity', after W. Allan, 1842, 16¾ x 11in/42.5 x 28cm, £20-£50.
'A Family Saved from Shipwreck', after J. B., 1829, 25 x 18in/63.5 x 45.5cm, £40-£80.
'The Jews Harp', after D. Wilkie, 1809, £30-£50.
Add more if in fine contemporary frame.
Small bookplates small value.

BURNLEY, C.B. fl. 1920s/1930s
Wood engraver.
£10-£30.

BURRA, Edward 1905-1976
Painter and theatrical designer, influenced by the Surrealists, who made several woodcuts in the late 1920s which were not editioned until 1971, and then made three etchings in 1972.
Nine woodcuts fetched £1,100, set of etchings £250 in October 1988.

BURRIDGE, Frederick Vango, R.E.
 1869-1945
Painter and etcher of landscapes. He was a pupil of F. Short (q.v.) and worked in Liverpool and London, teaching art. His few plates display a facility for capturing atmospheric effects in sky.
£30-£70.
Bibl: Newbolt, F., 'Etchings of F.V.B.', *Studio*, 1908, XLII, p.279.

BURRIDGE, George
 fl. early/mid-19th century

Lithographer of architectural views after his contemporaries.
Pl. for P.F. Robinson's Designs for Farm Buildings and Designs for Ornamental Villas, both 1830, 4to., small value.

BURTON, C. fl. early 19th century
Draughtsman and lithographer.
'Panorama of Hastings and St. Leonards', c.1830 7 x 57in/8 x 145cm, £200-£500 col.

BURTON, Edward fl. mid-19th century
Etcher and mezzotint engraver.
'Stealing a March', after E. Landseer, 1846, 15 x 18in/38 x 45.5cm, £40-£90.

BURY, Thomas Talbot fl. 1830s
Architect and draughtsman of topographical views and railway subjects. He worked in London and Liverpool and assisted Pugin in designing the details of the Houses of Parliament. He is best known for his *Coloured Views on the Liverpool and Manchester Railway*' and on the *'London and Birmingham Railway'. These aquatints were engraved by others, but Bury engraved some plates for Owen Jones and Jules Goury.*
'Coloured Views on the Liverpool and Manchester Railway', 1834, 13 pl., e. £80-£160 col.
'London and Birmingham Railway', 1837, 6 pl., e. £100-£200 col.
Pl. for Jones and Goury's Plans, Elevations, Sections and Details of the Alhambra, 1841-5, fo., e. small value.

BUSBY, Thomas Lord fl. early 19th century
Draughtsman, etcher and engraver of costume plates and some topographical views, mainly after his own designs.
'Fishing Costumes of Hartlepool', 1819, 6 pl., 4to., e. £25-£40 col.
'Costume of the Lower Orders of London', 1820, 24 pl., e. £20-£30 col.
'Cries of London', 1823, 24 pl., 12mo., e. £15-£25 col.
'View of the Town and Harbour of St. Thomas, West Indies, from Blackbeard's Castle', after W.J. Lord, 1820, 19 x 24½in/48 x 62.5cm, £400-£600.
Pl. for G. Hamilton's Elements of Drawing, 1812, 8vo., small value.

BYRNE, Letitia and William. 'Horse at Play', after G. Stubbs, 1795.

BYRON, Richard. A typical Rembrandt copy.

BUSH, Reginald Edgar James, R.E.
1869-1956
Painter and etcher of landscapes and topographical views. Born in Cardiff, he studied at the R.C.A. and lived and worked in Bristol teaching art.
£40-£90.

BUSIERE, Louis 1880-1960
French mezzotint engraver of portraits and decorative subjects after British 18th century painters.
£20-£60 prd. in col.
Others small value.

BUSS, Richard William 1804-1875
Victorian theatrical, historical and genre painter who produced a few etchings. His paintings were lithographed or engraved by others.
Small value.

BUTCHER, Enid Constance
fl. late 1920s/early 1930s
Line engraver of figure subjects. Born in London, she was a pupil of R.S. Austin (q.v.) whose style she imitated closely.
£30-£70.

BUTLER, Augustus fl. mid-19th century
Lithographer (and zincographer) of topographical views after his contemporaries.
Pl. for J.H. Allen's A Pictorial Tour in the Mediterranean, 1843, fo., 40 tt. pl., e. £5-£10.

BUTLER, W. fl. mid-19th century
Lithographer.
2 pl. for C.J. Richardson's Studies of Ornamental Design, 1851, fo., small value.

BYRNE, Elizabeth fl. early/mid-19th century
Painter, etcher and line engraver of small bookplates, including landscapes, topographical views and botanical subjects after her contemporaries. Born in London, she was the youngest daughter and pupil of W. Byrne (q.v.).
Pl. for R.B Harraden's Cantabrigia Depicta, 1809, obl. 4to, £10-£25.
Others small value.

BYRNE, John 1786-1847
Painter, etcher and line engraver of bookplates, including landscapes and topographical views after his contemporaries. Born in London, he was the son and pupil of W. Byrne (q.v.). He later turned to watercolour painting.
Pl. after J.M.W. Turner, when proofs or early imp., £20-£80.
Others small value.

BYRNE, Letitia 1779-1849
Painter, etcher and line engraver mainly of landscapes and topographical views after her contemporaries. Born in London, she was the third daughter and pupil of W. Byrne (q.v.) with whom she collaborated on several plates.
Pl. for P. Amsinck's Tunbridge Wells and Its Neighbourhood, 1810, 43 pl., fo., e. £5-£10.
Pl. after J.M.W. Turner, when proof or early imp., e. £20-£80.
Other bookplates small value.
Lge. West Country views after J. Farington £30-£70.
'Horse at Play', after G. Stubbs, with W. Byrne (q.v.), 1795, 10¼ x 13in/26 x 33cm, £600-£1,000.

BYRNE, William 1743-1805
Etcher and line engraver of landscapes, topographical views, and decorative subjects after his contemporaries. He studied in Paris under Aliamet and G. Wille and was the father and teacher of the other three Byrnes listed. He formed a close collaboration with T. Hearne (q.v.), many of whose drawings he engraved.
'Horse at Play', after G. Stubbs, with L. Byrne (q.v.), 1795, 10¼ x 13in/26 x 33cm, £600-£1,000.
'Death of Captain Cook', engraved with F. Bartolozzi (q.v.), after J. Webber, 1784, 19 x 24in/48.5 x 61cm, £60-£100.
'Niagara Falls', after R. Wilson, £150-£250.
'South East View of the City of Bath', after T. Hearne, fo., £150-£250.
'Carnarvon Castle', after R. Wilson, 1776, 20½ x 14½in/ 52 x 37cm, £40-£80.
Pl. for The Antiquities of Great Britain, after T. Hearne, 1777-81, small value.
'Twelve Rustic and Sporting Landscapes', after T. Hearne, 1810, obl. fo., ovals, e. £30-£40 col.

BYRON, The Hon. Revd. Richard 1724-1811
Etcher of figure studies, topographical views, etc., after his own designs and those of Rembrandt. He was the great-uncle of the poet George, Lord Byron.
Small value.

CADENHEAD, James, R.S.A., R.S.W.
1858-1927
Scottish painter, etcher and lithographer mainly
of landscapes. Born in Aberdeen, he lived in
Edinburgh.
£20-£50.

CADZOW, James b.1881
Scottish painter and etcher of landscapes.
£30-£70.

CAIN, Charles William 1893-1962
Painter and drypoint etcher of landscapes and
marine subjects. Born in Surrey, he travelled
extensively in the Middle East, India and Burma
and many of his charming prints have an
Oriental theme.
*Generally £30-£150, but a few small pl. £10-
£30.*
Bibl: Greig, J., *C.W.C., Catalogue of Drypoints,*
London, 1927.

CALDERON, Philip Hermogenes, R.A.
1833-1898
Painter and occasional etcher of genre and
historical subjects. Born in France, he studied in
London and Paris and settled in London. He
contributed one plate to an Etching Club
publication.
£10-£30.

CALDWELL, James b.1739
Draughtsman, etcher and line, stipple and
aquatint engraver of decorative subjects,
topographical views, portraits and caricatures
after his contemporaries. He was born in
London and was a pupil of J.K. Sherwin (q.v.).
*'Mrs. Siddons as "Isobella"', after
W. Hamilton, 1783, 24 x 18in/61 x 45.5cm, line,
£40-£80.*
Other portraits £10-£40.
*'Naval Engagement between the Quebec and
the Surveillante', after G. Carter, 1780, 17 x
23½in/43 x 59.5cm, aq., £350-£500 col.*
*'View of Stockton Church and Market Place,
Durham', after Sheraton, c.1790, 14 x 23in/35.5
x 58.5cm, aq., £250-£350 col.*
*'The Cotillon Dance', after J. Collet, 1771, 10 x
14½in/25.5 x 36.5cm, eng., e. £60-£120.*
*'The Allemande Dance', after C. Brandoin,
1772, e.£60-£120.*
*'Group of Carnations', after P. Henderson,
1803, 20 x 15in/51 x 38cm, £1,000-£2,000 prd.
in col.*
*'The Blue Passion Flower', after P. Reinagle,
1800, 20 x 15in/51 x 38cm, £300-£500 prd. in
col.*
*'Views in a Pavilion Erected for a Fête
Champêtre in the Garden of the Earl of Derby
at the Oaks in Surrey', after R. Adam, 1780, 17¼
x 23in/44 x 58.5cm, line, pair £200-£400.*
Small bookplates small value.
Pl. after Old Masters small value.

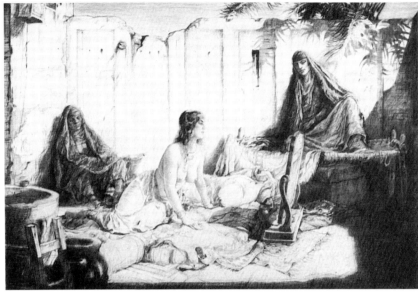

CAIN, Charles William. One of the artist's Oriental subjects.

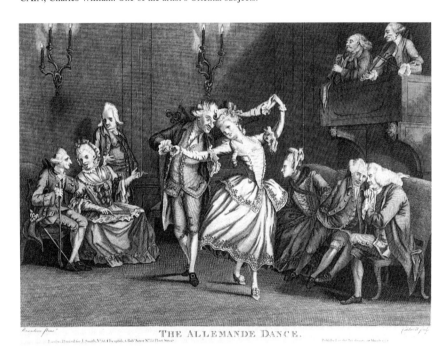

CALDWELL, James. 'The Allemande Dance', after C. Brandoin, 1772.

CALLCOTT, Sir Augustus Wall, R.A.
1779-1844
Painter of landscapes and historical and marine
subjects, and occasional etcher. He lived and
worked in London and amongst his plates are
some illustrations for Gray's *Elegy,* published
by the Etching Club.
£10-£30.

CALLOW, William 1812-1908
Well-known watercolourist and aquatint
engraver.
*'A View in Regent's Park, with a Favourite
Horse, the Property of Thomas Harcourt', after
T. Pollard, 13 x 17½in/33 x 44.5cm, £400-£600.*

CALVERT, Edward 1799-1883
Painter and engraver on wood and copper of
landscapes and figure subjects. Born in Devon,
he turned to art after serving in the Navy,
studying in Plymouth and at the R.A. Schools.
He then became one of W. Blake's (q.v.)
followers, 'The Ancients', frequently travelling
down to S. Palmer's (q.v.) cottage in Shoreham
in the 1820s. He produced most of his prints in
the period 1827-31, including two lithographs.
However, few contemporary impressions
survive and it was not until 1893 that his plates
were commercially printed in *A Memoir of E.C.,*
by S. Calvert. In this edition, the wood blocks
were printed on a yellowish wove paper and the

CALVERT, Edward. 'The Bride', 1828, line engraving published in *A Memoir.*

CAMERON, David Young. 'Ben Ledi', 1911, the artist's most famous print.

copper engravings on laid India. The lithographs were reproduced by line block. The plates were then reprinted in 1904 in *The Carfax Portfolio:* 'eleven proofs on India paper from the original blocks'.
Contemporary imp. £2,000-£5,000.
Later imp. as reprinted in A Memoir *and* The Carfax Portfolio: *wood eng. £200-£500; line eng. £400-£1,000; litho. reproduced by process blocks small value.*
A Memoir, *1893, fo., vol. £2,000-£3,000.*
Bibl: Lister, R., *E.C.*, London, 1962.

CALVERT, Frederick
 fl. early/mid-19th century
Irish draughtsman and lithographer of landscapes and topographical views after his contemporaries and his own designs. Came to England c.1815.
Pl. for T. Harral and S. Ireland's Picturesque Views of the River Severn, *1824, fo., 52 pl., e. £6-£9 col.*
Pl. for G. Clowe's Picturesque Tour by the New Road over the Splügen, *1826, 4to., 13 pl., e. £12-£20 col.*
Pl. from various drawing books small value.

CAMERON, Sir David Young,
R.A., R.S.A., R.W.S., R.S.W., R.E. 1865-1945
Prominent Scottish painter, etcher and

drypointer of landscapes and architectural views. Born in Glasgow, he studied part-time at the School of Art there. He lived in Scotland where he executed most of his five hundred plates, though the period 1892-1909 also saw views of London, the Continent and Egypt. His earlier prints are pure etching; later ones have drypoint additions; his last plates are mostly pure drypoint. He is rightly regarded as one of the masters of the British School of landscape and architectural etching and his treatment of the Scottish landscape, capturing its sombre and moody feeling, is unsurpassed. The first three plates listed below have always been the most valued of his prints, while the remaining four were published in *The Studio* and other books and are very common.
'The Five Sisters of York', 1907, 15¼ x 7in/39 x 18cm, £200-£400.
'Ben Ledi', 1911, 15 x 12in/38 x 30.5cm, £300-£600.
'Ben Lomond', 1923, 10½ x 16½in/27 x 42cm, £150-£300.
'Perth Bridge', 'Arran', 'Amboise', 'A Norman Village', all publ. in lge. unsigned edn., e. £5-£15.

Others mostly £30-£150.
Bibl: Rinder, F., *D.Y.C. An Illustrated Catalogue of his Etchings and Drypoints, 1887-1932,* Glasgow, 1932.

CAMERON, John
 fl.1920s
Scottish etcher of landscapes.
£15-£40.

CAMERON, Katherine, A.R.E.
 1874-1965
Scottish painter and etcher of landscapes and flowers. Born in Glasgow, she was the sister of D.Y. Cameron (q.v.) who strongly influenced her landscape studies.
£20-£60.

CAMPBELL, Charles William
 1855-1887
Mezzotint engraver of portraits and figure subjects after his own designs and paintings by his contemporaries.
Pl. after E. Burne-Jones £150-£400.
'Ellen Terry' £30-£80.
Others £10-£30.

CAMPBELL, E.V.
 fl. mid-19th century
Line engraver of small topographical bookplates.
Pl. for Ernest Seyd's California and Its Resources, *1858, 8vo., e. £10-£30.*
Others small value.

CAMPBELL, Nora Molly, A.R.E.
 d.1971
London-born painter, sculptor and etcher of figure subjects.
£15-£40.

CAMPFIELD, G.
 fl. mid-19th century
Wood engraver of figure subjects after his contemporaries.
Pl. for E. Burne-Jones' Tale of Cupid and Psyche, *ave. 4 x 2in/10 x 5cm, e. £40-£70.*

CAMPION, George Bryant
 1796-1870
Painter of landscapes, topographical views and military subjects. He taught drawing at the Royal Military Academy, Woolwich and later lived in

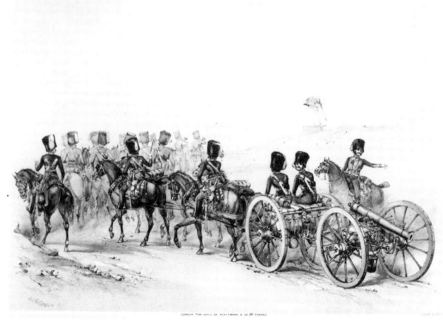

CAMPION, George Bryant. 'Royal Horse Artillery: Marching Order', c.1846, one of six plates.

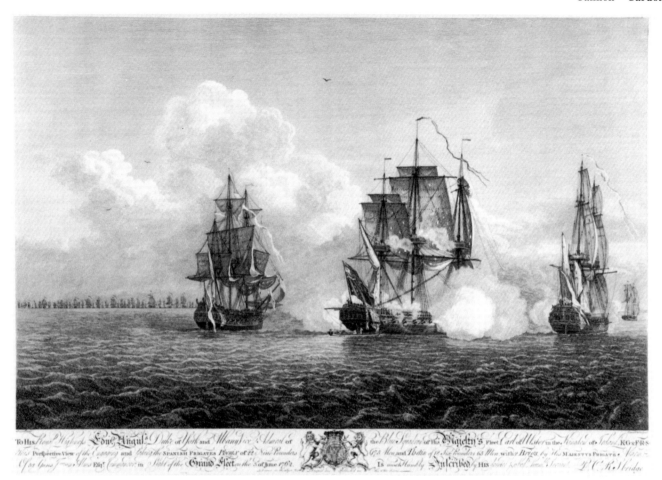

CANOT, Pierre Charles. 'The Engaging and Taking of the Spanish Frigates *Phenix* and *Thetis* by H.M.F. *Alarm*, 1762, after D. Serres.

Munich. He lithographed two sets of prints:
'*Scenes During the Snowstorm of December 1836*', *after J. Pollard, 1837, 4 pl., 10 x 15in/25.5 x 38cm, set £1,200- £1,800 col.*
'*Royal Horse Artillery*', *after G.B.C., c.1846, 6 tt. pl., 13¼ x 17¾in/34 x 45cm, set £300-£500.*
'*Sketches of the Picturesque Character of Great Britain*', *1836, fo. 12pl., set £500-£1,000 col.*

CANNON, W. fl. mid-18th century
Line engraver.
Coursing subjects after J. Seymour, 6¾ x 10½in/17 x 27cm, e. £30-£50 col.

CANOT, Pierre Charles, A.R.A. 1710-1777
French etcher and line engraver of topographical views and marine and sporting subjects after his contemporaries. Born near Paris, he came to England in 1740 and worked there for the remainder of his life. He was elected associate engraver of the R.A. in 1770. He died in London at Kentish Town.
'*Foxhunting*', *after J. Wootton, with L. Truchy (q.v.), 1735, 7 pl., 19¾ x 15¾in/50 x 40cm, set £5,000-£7,000; 1770 edn. set £1,200-£1,800.*
'*Victorious*', *after T. Spencer, c.1750, 11¼ x 11¾in/30 x 30cm, £140-£200.*
'*Westminster Bridge*' *and* '*London Bridge*', *after S. Scott, 1758, 13½ x 23in/34.5 x 58.5cm, pair £600-£1,200.*
'*View of Brightelmstone*', *after J. Lambert, 16¼ x 24½in/41.5 x 62.5cm, and other British views £150-£400.*
'*South East*' *and* '*South West Views of New*

York', *after Capt. T. Howdell, e. £1,000-£2,000. Other American and Canadian views £300-£700.*
'*View of Cape of Good Hope*', *after Hirst, 1766, 11¾ x 18½in/30 x 47cm, £300-£600.*
'*The Reduction of Havannah*', *after D. Serres, 12 pl. (some by J. Mason, q.v.), 17¾ x 25¾in/45 x 65.5cm, e. £200-£400.*
'*The Engaging and Taking of the Spanish Frigates Phenix and Thetis by H.M.F. Alarm, 1762*' *after D. Serres, £250-£350.*
'*Capture of Severndroog*', *6½ x 8½in/16.5 x 21cm, £40-£60.*
'*Capt. Forrest engages de Kersaint*', *after R. Paton, 1759, 14¼ x 22⅞in/36 x 58cm, and naval subjects of similar size, £250-£400.*

CANTON, C.J. fl. early 19th century
Aquatint engraver of topographical views after his contemporaries.
2 pl. for R. Johnston's Travels Through Part of the Russian Empire, *1815, 4to., £5-£10 col.*

CANTON, R. fl. mid-19th century
Draughtsman and lithographer.
'*The Procession of Prince Edward and Princess Alexandra from Eton to Windsor*', *1863, 3¾ x 216in/9.5 x 549cm, £400-£700 col.*

CAPONE, William Henry
 fl. mid-19thcentury
Line engraver of small topographical bookplates after his contemporaries.
Small value.

CARDON, Antoine (Anthony) 1772-1813
Prominent Belgian line and stipple engraver of portraits and decorative, military, historical and sporting subjects after his contemporaries. Born in Brussels, he was taught by his father, Antoine Alexandre Joseph Cardon, a painter and engraver. He came to England in 1792 where he first worked for Colnaghi, engraving bookplates

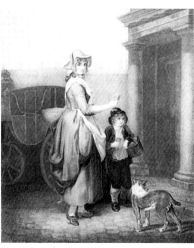

CARDON, Antoine. 'Do You Want Any Matches?', 1794, from F. Wheatley's 'Cries of London'.

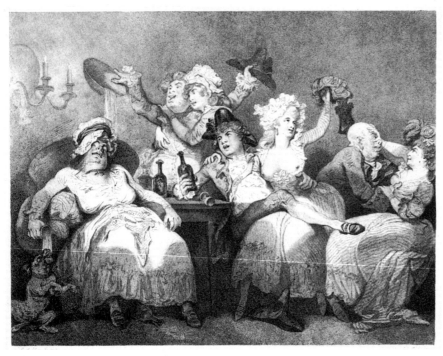

CAREY, W.P. 'A Sketch from Nature', after T. Rowlandson.

as well as some of the 'Cries of London' after F. Wheatley. He apparently died from 'over-application'.
Portraits after R. Cosway, £80-£200 prd. in sepia or in col.
'The Return from Coursing', after W. Hamilton, 1803, 18½ x 24in/47 x 61cm, £800-£1,200 prd. in col.
'The Battle of Alexandria', after P.J. De Loutherbourg, 1802, 20½ x 30½in/52 x 77.5cm, £400-£600 prd. in col.
'Credulity', after F. Wheatley and 'Calculation', after R. Westall, 1798, 8½ x 11¾in/21.5 x 30cm, pair £400-£600 prd. in col.
'A New Love Song, Only Ha'Penny a Piece', 1796, from F. Wheatley's 'Cries of London', 16½ x 13in/42 x 33cm, and similar plates from Wheatley's 'Cries of London', £250-£350 prd. in col.
'The Sortie Made by the Garrison of Gibraltar on Nov. 27, 1781', 30 x 51½in/76 x 131cm, line eng., £140-£180.
'Moses and the Ten Commandments', after P. de Champagne, 1812, 28 x 21¼in/71 x 54cm, £40-£60 prd. in col.
Bookplates and small portraits in b. & w. small value.
Colour plate page 27.

CARDONNEL, Adam de d.1820
Archaeologist, etcher and line engraver of bookplates depicting coins, antiquities, landscapes and topographical views. He worked in Edinburgh and engraved plates for *Numismata Scotiae*, 1786, and his own *Picturesque Antiquities of Scotland*, 1788-93. His amateur views of romantic Gothic ruins are signed ADC in the plate.
Landscapes and topographical views £10-£30.
Others small value.

CAREY, W.P. 1759-1839
Painter and stipple engraver of decorative subjects and caricatures after his

contemporaries. Born in Dublin, he later turned to art criticism after suffering an accident to his eyes.
'Annals of Horsemanship', after H.W. Bunbury e.£30-£60.
'A Sketch from Nature', after T. Rowlandson, 12 x16in/30.5 x 40.5cm, £80-£200.
'The Balloon' and 'The Parachute', after N. Colibert, 5 x 4in/12.5 x 10cm, pair £150-£300 prd. in col.

CARLOS, W. fl. mid-19th century
Line and mezzotint engraver of portraits and decorative subjects mainly after his contemporaries.
'Sir C. Napier at the Siege of Acre', after T.M. Joy, 1847, 31 x 21in/79 x 53.5cm, £60-£120.
Others £10-£30.
Add more if in fine contemporary frame.

CARPENTER, William Hookham 1792-1866
London-born Keeper of Prints and Drawings at the British Museum, 1845-66, who etched some portraits. His son, also William, was a painter, etcher and lithographer of portraits.
Small value.

CARRICK, J. Mulcaster fl. mid-19th century
Painter and etcher of landscapes and figure subjects. He worked in and around London and was a member of the Junior Etching Club.
£10-£30.

CARRICK, Robert C. fl. mid-19th century
Lithographer of topographical views and military and marine subjects after his contemporaries. He worked in London for Day & Son (see William Day II). All his plates were printed with a tintstone.
Pl. for O.W. Brierley's English and French Fleets in the Baltic, 1855, lge. fo., e. £150-£250.
Pl. for Capt. G. de la Poer's Scenes in Southern Albania, 1855, 12 pl., fo., rare, e. £80-£150.
Pl. for W. Simpson's Seat of War in the East,

1855-6, fo., e. £10-£20 col.
Pl. for Lieut. J. Rattray's Scenery, Inhabitants and Costumes of Afghanistan, 1847-8, lge. fo., e. £40-£100 col.
Pl. for P. Brannon's The Park and Crystal Palace, 1851, fo., e. £150-£300 col.
Pl. for J. LeCapelain's The Queen's Visit to Jersey, 1847, fo., e. £30-£70.
'The Old School, 1755', after G.H. Andrews, 1855, 21½ x 28½in/55.5 x 72.5cm, £150-£250 col.; with 'The New School, 1855', by T.G. Dutton (q.v.) after Andrews, pair £600-£1,000 col.

CARTER, Frederick, A.R.E. 1885-1967
Painter and etcher of figure subjects and later landscapes and portraits. Born near Bradford, he abandoned a career in engineering and learnt etching from F. Short (q.v.). *Fin-de-siècle* French posters and the Italian *commedia dell'arte* inspired many of his earlier works.
'Augustus John and William Nicholson at the Café Royal', 8½ x 6in/21.5 x 15cm, £100-£200.
Portraits of: D.H. Lawrence £200-£400.
'Arthur Machen, Esq.' £40-£90.
Others mostly £50-£150.
Bibl: Furst, H.C., 'F.C.', *P.C.Q.*, 1933, XX, p.347.

CARTER, James 1798-1855
Line and mezzotint engraver of landscapes, topographical views and portraits after his contemporaries. Born in London, he was apprenticed to an architectural engraver. He died leaving a large family without provision.
'The Port of Liverpool', after G. Chambers, 1841, 22½ x 35½in/57.5 x 90.5cm, £200-£400.
'M.I. Brunel', after S. Drummond, 1846, 16½ x 13½in/42 x 33.5cm, £60-£140.
Add more if in fine contemporary frame.
Pl. for the Annuals and small bookplates small value.

CARTER, John 1748-1817
Draughtsman, etcher and line engraver of architectural views and antiquities. Born in London, he drew for *The Builder's Magazine* and for The Society of Antiquaries.
Pl. for 'Specimens of the Ancient Sculpture and Painting now Remaining in this Kingdom', c.1780, and other works, e. small value.

CARTER, Frederick. 'Arthur Machen, Esq'.

CARTWRIGHT, Thomas. 'Jesus College', from R. Harraden's *Views of Cambridge*, 1798.

CARTER, William fl. late 17th century
Etcher of vignettes, ornaments and illustrations. Pupil and imitator of W. Hollar (q.v.).
Small value.

CARTWRIGHT, Joseph 1789-1829
Marine painter, draughtsman and aquatint engraver of topographical views after his own designs and those of his contemporaries. He was appointed Paymaster-General of the Forces at Corfu when the Ionian Islands came into British possession, and he is best remembered as the draughtsman of the 'Views in the Ionian Islands', engraved by R. Havell I (q.v.).
1 pl. for J. Hakewill's Picturesque Tour of the Island of Jamaica, *1824-5, fo., £200-£300 col.*
Several pl. for R. Harraden's Views of Cambridge, *1800, obl. 4to., e. £10-£30.*

CARTWRIGHT, Thomas fl. early 19th century
Aquatint engraver of topographical views after his contemporaries.
Pl. for R. Harraden's Views of Cambridge, *1798, 16½ x 21¾in/42 x 55cm, £60-140; 1800, smaller size obl. 4to., e. £10-£30.*
Pl. for J. Connop's Views in Yorkshire and Derbyshire, *c.1810, 4to., e. £10-£30 col.*
Pl. for E. Pugh's Cambria Depicta, *1816, 4to., e. £5-£10 col.*
'Dudley Castle, with the Loyal Association', after T. Phillips, 1799, 19 x 26in/48.5 x 66cm, £300-£500.

CARWITHAM, John
 fl. early/mid-18th century
Line and mezzotint engraver of portraits, topographical views, book illustrations, etc.
'South West View of Fort George and the City of New York' and 'South East View of the City of Boston in America', e. approx. 10 x 15in/25.5 x 38cm, both v. rare, e. £1,000-£2,500 col.
'Kings of England', 2 pl., with 32 ovals, each 14 x 10in/35.5 x 25.5cm, mezzo., pair £60-£100.
Bookplates small value.
CS lists 3pl.

CARY, J. fl. late 18th century
Engraver of decorative subjects after his contemporaries. Also naval subjects.
Latter 6 x 9in/15.5 x 23cm, e. £20-£30.
Others mostly small value.

CATTERMOLE, Charles 1832-1900
London painter and etcher of historical and period sporting subjects after his own designs and those of his uncle G. Cattermole.
£10-£30.

CATTON, Charles, Jun. 1756-1819
Painter of topographical views and animals who also produced some engravings. Born in London, the son of Charles Catton Sen., he studied at the R.A. Schools. He emigrated to America in 1804 where he died.
'Animals Drawn from Nature', 1788, e. £10-£20.
'The Abbey and Palace of Dunfermline', after J. Farington, 1791-2, 18 x 14in/46 x 36cm, aq., £50-£80 col.

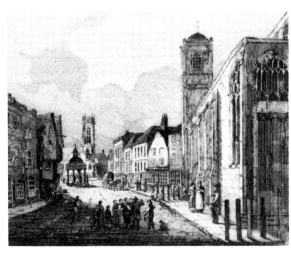

CAVE, Henry. One of his forty views from 'Picturesque Buildings of York'.

'Shooting', after G. Morland, 1789-91, 4 pl. (C.C. did at least 1, probably 3; pl. 4 by J.G. Wells q.v.), 14 x 17in/36 x 43cm, stipple and aq., set £3,000-£5,000 col.

CAVE, Henry 1779-1836
York draughtsman and etcher of local topographical views. He was the son and pupil of William Cave Sen.
'Picturesque Buildings of York', fo., 40 pl., e. £7-£14.

CAWDOR, Lady Caroline (née Howard)
 1771-1848
Amateur artist who made two lithographs 1802 and ?1806.
£30-£80.
Man Cat.

CAWSE, John 1779-1862
Portrait and history painter who also etched some caricatures.
'An Ever-Green' (William Pitt), 1806, 20¼ x 4¼in/51.5 x 11cm, £200-£300 col.
Others mostly £30-£70 col.

CECIL (Cecill), Thomas
 fl. early/mid-17th century
Line engraver of portrait frontispieces and emblematic title pages.
£5-£15.

CHADWICK, Tom 1914-1942
Wood engraver of figure subjects. Born in Yorkshire he was taught engraving by I. Macnab (q.v.). He was killed in the battle of El Alamein in North Africa.
£50-£150.

CHALLIS, Ebenezer fl. mid-19th century
Etcher and line engraver of topographical views after his contemporaries.
Cambridge views after B. Rudge, etc., e. £30-£50.
Small bookplates small value.

CHALON, Henry Barnard
 fl. early/mid-19th century
Well-known sporting artist who produced a few lithographs and soft-ground etchings.
'Wild Horses', 1804, publ. in Specimens of Polyautography, *1806, 9 x 12¾in/23 x 32.5cm, litho., £200-£300; on original mount, £600-£1,000.*
Pl. for A Comparative View of the English Racer and Saddle Horse, *after his own and*

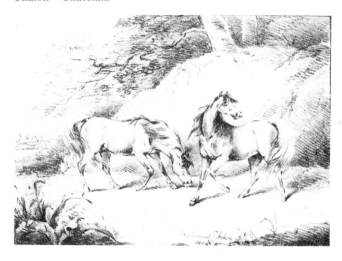

CHALON, Henry Barnard. 'Wild Horses', 1804, lithograph on original mount.

others' designs, 1836, 11½ x8¾in/29 x 22.5cm, litho., e. £20-£50.
'The Passions of the Horse', 1826/7, 6 pl., 17 x 20½in/43.5 x 52cm, litho., e. £50-£80.
'Drawing Book of Animals and Birds', 16 pl., 6½ x 5½in/126.5 x 35cm and slightly smaller, soft-ground etchings, e. £5-£15.
Man Cat.

CHALON, John fl. late 18th/early 19th century
Etcher of copies or imitations of Rembrandt's etchings.
Self-portrait, 1788, 6½ x 5½in/16.5 x 14cm £60-£120.
100 pl. after Rembrandt, 1802, e. small value.

CHALON, John James fl. early 19th century
Painter of landscapes and genre subjects. Born in Geneva, died in London. He produced one set of lithographs.
'Twenty-four Subjects Exhibiting the Costume of Paris', 1822, fo., e. £20-£40 col.

CHAMBERS & Son fl. mid-19th century
Lithographers.
'The Railway Bridge over the River Severn at Worcester', after E. Doe, c.1840, 16¼ x 18½in/41.5 x 47cm, £300-£500 col.

CHAMBERS (Chambars), Thomas
 fl. mid-/late 18th century
Line and stipple engraver of portraits and figure subjects after Old Master painters and his contemporaries. Born in London, of Irish extraction, he studied in Dublin and Paris. He worked on religious and mythological plates for John Boydell (q.v.) and apparently drowned himself in the Thames because of rent arrears.
'The Good Man at the Hour of Death' and 'The Wicked Man at the Hour of Death', after F. Hayman, pair £80-£200.
Portraits after R. Cosway, £60-£140 prd. in col.
Pl. after Old Masters £5-£15.
Bookplates small value.

CHANT, James John b.1819
Mezzotint engraver of portraits and genre, sporting and historical sentimental subjects after his contemporaries. He lived and worked in London.
Sporting and contemporary historical pl. £60-£160.
Portraits and other pl. £10-£40.
Add more if in fine contemporary frame.

CHAPMAN, John
 fl. late 18th/early 19th century
Stipple engraver of portraits and decorative subjects after his contemporaries. He appears to have worked in London.
Pl. for H.W. Bunbury's Illustrations to Shakespeare, 1792-4, 16½ x 19in/42 x 48cm, £40-£80 prd. in col.
Allegorical subjects (sciences etc.), after R. Corbould and J. Smith, 1807, 7 pl., 15 x 17in/38 x 43cm, e. £60-£100 prd. in col.
Small portraits £10-£30 prd. in col.
Small bookplates small value.

CHAPMAN, John Watkins b.1832
Mezzotint engraver of portraits after British 18th century painters and sentimental subjects after his contemporaries. He worked in and around London.
£10-£50.

CHAPMAN, William fl. mid-19th century
Line engraver of small bookplates and plates for the Annuals, including landscapes and topographical views after his contemporaries.
Pl. after J.M.W. Turner, if proofs or early imp., £20-£80.
Others small value.

CHARLES, William fl. early 19th century
Etcher.
Pl. for Geoffrey Gambado's Surprising Feats in Horsemanship, after H.W. Bunbury, 1824, 12 pl., 3¼ x 5½in/8.5 x 14cm, e. £15-£30 col.

CHARLTON, Edward William 1859-1935
Kent painter and etcher of landscapes, coastal and shipping scenes. He emigrated to Germany in 1904.
£15-£40.

CHATELAIN, Jean Baptiste Claude
 1710-1771
French draughtsman, etcher and line engraver of landscapes, topographical views and decorative subjects after 17th century painters, his contemporaries and his own drawings. He worked for John Boydell (q.v.) in London, engraving Italianate landscapes after Claude and Poussin and English views. Slater describes him as talented but lazy.
Views of the Lake District, after W. Bellers, 1752, 8 pl. with S.F. Ravenet (q.v.), 15¼ x 21in/40 x 53cm, e. £100-£250.
'Four Times of Day', etched by Chatelain and mezzo. by R. Houston (q.v.), set £300-£700.
'La Dévideuse Italienne', and 'La Cuisinière Italienne', after H. Roberts, 10½ x 14in/26.5 x 36cm, pair £40-£70.
Small views of Churches, etc. near London, by Chatelain and H. Roberts (q.v.), 1750, 50 pl., e. £10-£30.
Landscapes after Claude Lorraine and G. Poussin £50-£150.
Views in the Gardens at Stow, 9½ x 13½in/24 x 34cm, e. £50-£120 col.

CHAPMAN, John. 'Rosalind, Celia and Touchstone', 1792, from H.W. Bunbury's *Illustrations to Shakespeare*.

CHATTOCK, Richard Samuel, R.E.
1825-1906
Solihull painter and etcher of landscapes. He contributed plates to *The Etcher* and *The Portfolio*.
Pl. for W. Wood's Sketches of Eton, *1873, and others, e. £15-£40.*

CHAUVEL, Charles
fl. late 19th/early 20th century
French etcher of landscapes after his British contemporaries, especially B. Leader.
£10-£30.

CHAUVEL, Theophile-Narcisse b.1831
French painter, etcher and later lithographer of landscapes after French and British contemporaries, especially B. Leader.
£10-£30.
Bibl: Delteil, L., *T.C.: A Catalogue Raisonné of the Engraved and Lithographed Work*, 1900.

CHAVANNE, ?E. fl. mid-19th century
Line engraver of small bookplates including landscapes and decorative subjects after his contemporaries.
Small value.

CHEESMAN, Thomas 1760-after 1834
Stipple engraver of portraits and historical and decorative subjects after his contemporaries. He was a pupil of F. Bartolozzi (q.v.).
'The Spinster' (Lady Hamilton), and 'The Seamstress' 15¼ x 10½in/40 x 26.5cm, e. £200-£400 prd. in col.
'The Marchioness of Townshend and Son', after A. Kauffmann, 1792, 9¼ x 8in/25 x 20cm, £250-£400 prd. in col.
'Venus and Cupid', after Titian, 19 x 13½in/48 x 34cm, £30-£50 prd. in col.
Add more if in fine contemporary frame.
'General Washington', after Trumbull, £300-£500.
Pl. for E. Harding's Portraits of the Royal Family, *1806, fo., e. £10-£20 prd. in col.*

CHEESEMAN, Thomas. 'The Spinster', after G. Romney 1789.

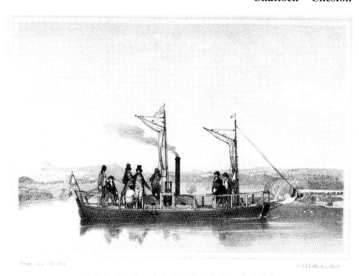

CHEFFINS, C.F. 'Double Pleasure Boat', after J.C. Bourne.

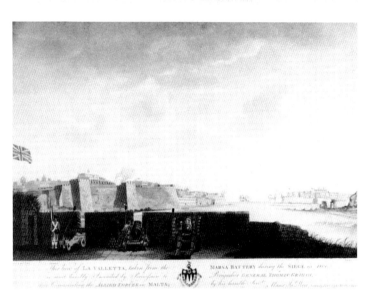

CHESHAM, Francis. One of a pair of 'Views of La Valetta, the siege of 1800', after J. Weir, 1803.

'Rudiments of Drawing the Human Figure from Cipriani, Guido, etc.', small value.

CHEFFINS, C.F. fl. mid-19th century
Lithographer of topographical views, and railway and shipping subjects after his contemporaries. He worked for Day & Haghe (see William Day II).
1 pl. for Scenery in the North of Devon, *after G. Wilkin, c.1837, obl. 4to., £10-£20.*
Various English landscapes with railways, after J.C. Bourne, 13 x16in/33 x 41cm, tt. pl., e. £80-£120.
'Double Pleasure Boat', after J.C. Bourne, 5¾ x 7¼in/14.5 x 18.5cm, tt., £15-£30.

CHESHAM, Francis 1749-1806
Draughtsman, etcher, line and aquatint engraver mainly of landscapes, topographical views and naval subjects after his contemporaries. He died in London. He sometimes collaborated with other engravers.
'Views of the Geyser in Iceland', 1789, after Sir J.T. Stanley, 1797, 11 x 15in/28 x 38cm, aq., pair £300-£500 col.
'Views of La Valetta, the Siege of 1800', after

Maj. J. Weir, 1803, 15¾ x 20¼in/40 x 52.5cm, aq., pair £500-£1,000 col.
'Views of Coalbrook Dale', after G. Robertson, 1788, 16 x 21½in/41 x 54.5cm, line, e. £120-£250.
'Views in the West Indies', after Lieut. C. Forrest, 1783-5, 8 pl., v. rare, fo., aq. in sepia, e. £300-£600.
'Victory of the Nile', after W. Anderson, 1799, 4 pl. with W. Ellis (q.v.), 13¾ x 18in/35 x 45.5cm, aq. with eng., set £800-£1,600 col.
'Engagement between the Santa Margarita and La Thamise', after N. Pocock, 1789, 16½ x 24in/42 x 61cm, line, £300-£400.
Small pl. of naval battles for Russell's History of England, *7 x 11½in/18 x 29cm, line, e. £10-£12.*
'Heraldic Coats of Arms after C. Catton', 9 x 7¼in /23 x 18.5cm, e. £15-£25 col.

CHESTON, Charles Sidney, R.W.S., R.E.
1882-1960
London-born painter and etcher of landscapes.
£30-£70.
Bibl: Laver, J., 'The Etchings of C.S.C.', *P.C.Q.*, 1929, XVI, p.287.

CHEVALIER, Nicholas 1828-1902
German painter, draughtsman and lithographer of topographical views. Born in St. Petersburg, he studied in Switzerland and Germany and worked in London and Melbourne.
Views of Australia, 1852, 12 pl., 9½ x 13in/24 x 33cm, e. £150-£250 prd. in col.
Album of chromolitho., 1865, 12 pl., fo., e. £50-£80.
Pl. for Sir H. Layard's Discoveries in the Ruins of Ninevah and Babylon, *1852, tt. pl., e. £10-£25.*

CHEVALIER, William 1804-1866
French line engraver mainly of small bookplates including sentimental subjects, landscapes and topographical views after Old Master painters and his contemporaries. Born in Paris, he worked in London. He later engraved several large plates.
'The Saints Day', after J.P. Knight, 1843, 18 x 24in/45.5 x 61cm, and other lge pl. £20-£60.
Add more if in fine contemporary frame.
Small bookplates small value.

CHEYNE, Ian 1895-1955
Scottish colour woodcut artist of landscapes. He contributed to the Society of Artist Printmakers.
£30-£70.

CHILD, G. fl. mid-/late 18th century
Line engraver of landscapes and topographical views, mainly bookplates.
Small value.

CHILDS, George fl. mid-19th century
Painter and lithographer of landscapes and topographical views after his own designs and those of his contemporaries. He produced several drawing and sketch books, one of which contained Hampstead views.
Pl. for H. Hughes' The Picturesque Scenery of Carnarvon, *c.1840, 4 tt. pl., obl. 4to., e. £15-£30 col.*
Pl. for Capt. P.M. Taylor's Sketches in the Deccan, *1837, fo., tt., e. £15-£25 col.*
'The Proposed Railway Street through Westminster', with W. Webbe, 18½ x 32¼in/47 x 83cm, tt., £300-£500 col.
Hampstead views e. £15-£40.
Other views mostly £10-£30.

CHINNERY, George 1748-1847
Famous painter of Oriental topography and figure subjects. There are a number of monotypes attributed to him in the British Museum.
£300-£500.

CIPRIANI, Giovanni Battista, R.A. 1727-1785
Italian draughtsman and painter who produced a few etchings. Born in Florence, he came to England in 1755 and, as well as being a Foundation Member of the R.A., formed a successful partnership with F. Bartolozzi (q.v.), drawing mythological subjects which Bartolozzi and his studio engraved as decorative prints.
His own etchings £30-£70.

CLAMP, R. fl. late 18th century
Stipple engraver of small portrait plates after his contemporaries and Old Master painters. Appears to have worked in London.
Small value.

CLARK, Charles Herbert b.1890
Liverpudlian etcher of architectural views.
£10-£30.

CLARK, E fl. early/mid-19th century
Aquatint engraver of small topographical bookplates after his contemporaries.
Small value.

CLARK, J. I fl.18th century
Engraver of small bookplates.
Small value.

CLARK, John (?J. II/I)
fl. late 18th/early 19th century
Draughtsman and aquatint engraver of topographical views and sporting and marine subjects. Nothing is known about his life and it is impossible to be certain of his identity or to know whether in fact there were two engravers since plates of identical style are just signed 'Clark' or 'J.' or 'I. Clark'. (Many plates signed thus may in fact have been engraved by the painter John Heaviside Clark (c.1771-1863) several of whose works were engraved in aquatint.) While Clark mostly engraved plates after the designs of his contemporaries, often in conjunction with M. Dubourg (q.v.), he both drew and engraved the following important topographical works:
'Views in Scotland', 1824, 35 pl., fo., e. £200-£500 col.
'Panorama of the Thames between London & Richmond', c.1824, 2 strips: 'View of London', 9 x 68in/23 x 173cm, and 'The Panorama to Richmond', 8½ x 804in/21.5 x 2042cm, pair £1,500-£2,500 col.
Amongst many other works are:
'Capture of the Rivoli', by J.C. and C. Rosenberg, 1815, 17 x 24¼in/43 x 61.5cm, £300-£400 col.
'View of Cape Town with Table Mountain', after W. M. Craig, 1806, 19 x 26in/48 x 66cm, £600-£1,200 col.
'Foxhunting: Morning, Noon, Evening and Night', after D. Wolstenholme, by J.C. and J. Jeakes (q.v.), 1811, 4 pl., 14½ x 18½in/36.5 x 47cm, set £1,200-£1,800 col. *'The National Sports of Great Britain', after H. Alken, 1820, 50 pl. obl. fo., depends on subject, e.g. 'Bear Baiting' £20-£30 col.; 'Salmon Fishing' £140-£280 col. (set col. fetched £6,800 October 1988).*
'Orme's British Field Sports', 1808, after S. Howitt, by J.C. and H. Merke (q.v.), obl. fo., e. £500-£1,000 col. (set of 20 col. fetched £16,500 October 1988).
Pl. for Lieut. R. Temple's Eight Views of the Mauritius, *1813, 10¼ x 18¼in/27 x 46cm, set £3,000-£4,500 col. (set col. fetched £4,200 October 1991).*
'Sailors at Prayer after the Battle of the Nile', after J.A. Atkinson, with M. Dubourg, 1816, 7¾ x 11in/20 x 28cm, £15-£25 col.
4 views of Sydney, after J. Eyre, 1810, 16 x 21¼in/40.5 x 55cm, set £5,000-£10,000 col.
Pl. for D. and J.T. Serres' Liber Nauticus, *1805-6, fo., e. £30-£80.*
'Sixteen Views in the Persian Gulph (sic)', after R. Temple, 1813, obl. fo., set col. fetched £11,000 April 1990.
Colour plate page 27.

CLARK, John Heaviside *see* **CLARK, John**

CLARK, Joseph Benwell b.1857
Etcher of landscapes and house interiors after his own designs, and mezzotint engraver of decorative and genre subjects after his contemporaries. Born in Dorset, he was a pupil of A. Legros (q.v.) and worked in London.
Small value.

CLARK, T. (?J.) fl. mid-19th century
Line engraver of small topographical bookplates after his contemporaries.
German and Swiss views e. £5-£10.
Others small value.

CLARK, W. I fl. early/mid-19th century
Aquatint engraver of topographical views.
3 pl. for S.H. Lloyd's Sketches of Bermuda, *1835, 8vo., e. £20-£50.*
4 pl. for W.R. Wilson's Records of a Route through France and Italy, *1835, 4to., small value.*

CLARK, W. II fl. mid-19th century
Draughtsman and lithographer.
'Foxhunting', 4 pl., 11½ x 15¼in/29 x 39cm, set £300-£400 col.

CLARK, William fl. early 19th century
Draughtsman and possibly aquatint engraver of 'Ten Views in the Island of Antigua'.
'Ten Views in the Island of Antigua', 1823, obl. fo., e. £300-£500 col. (set col. fetched £5,000 Sept. 1988).

CLARK, John. 'View from the Deck of the *Upton Castle* Transport of the British Army Landing', from R. Temple's *Eight Views of the Mauritius*, 1813.

CLARKE, C. fl. mid-19th century
Lithographer.
'Contrasts', c.1850, 12 pl., obl. fo., e. £5-£15 col.

CLARKE, Samuel Barling
 fl. mid-19th century
Draughtsman and lithographer of topographical views.
Views of Ipswich, 4 pl., 12¼ x 21½in/32.5 x 54.5cm, tt., e. £100-£250 col.

CLARKE, William fl. late 17th century
Line and mezzotint engraver of portraits and frontispieces.
'John Shower', 4to., £20-£40.
'Charles and Elizabeth, Duke and Duchess of Somerset', HLs, ovals, 13½ x 9½in/34 x 24cm, pair £100-£200.
Line eng. small value.
CS lists 3 pl., noted above.

CLAUSEN, Sir George, R.A., R.W.S.
 1852-1944
Painter, etcher and lithographer of landscapes and rustic genre. Born in London, he studied in South Kensington and, in 1883, in Paris. He lived and worked in London and the Home Counties. He visited Holland and Belgium in 1875-6; was Professor of Painting at the R.A. 1904-6, and later Director of the R.A. Schools. His work shows the influence of his Dutch and French contemporaries. The most interesting of his prints is the set of six lithographs 'Making Guns'.
'Making Guns', from the series The Great War: Britain's Efforts and Ideals, 1917, set of 6 litho., fo., e. £30-£50.
Etchings: 'Self-portrait', 1895, extremely rare, 4¾ x 3¼in/12 x 8.5cm, £150-£250.
Others mostly £30-£100.
Bibl: Gibson, F., 'The Etchings and Lithographs of G.C., R.A.', *P.C.Q.*, 1921, VIII, p.203.

CLAYTON, Alfred B. 1795-1855
Architect who worked in London and Manchester and produced a set of lithographs:
'Views of the Liverpool and Manchester Rail Road', c.1830, 3 pl. (1 by F. Nicholson after Clayton), 12¼ x 17in/32 x 43cm, e. £150-£200 (set col. with text has sold for £1,900).

CLAYTON, B. I fl. mid-19th century
Draughtsman and etcher.
'Great Exhibition of Doings in London', 1851, humorous panorama, 5½ x 190in/14 x 482.5cm, £400-£600 col.

CLAYTON, B. II fl. mid-19th century
Draughtsman and lithographer of military costumes. He seems to have been a professional soldier.
'Costumes of the First or Grenadier Regiment of Guards', c.1853, 14 x 18¼in/35.6 x 48cm, £100-£300 col.
'The Coldstream Guards leaving St. George's Barracks, Charing Cross', c.1854, 8 x 11½in/20 x 29cm, £100-£200 col.

CLEGHORN, J. fl. early 19th century
Etcher and line and aquatint engraver of topographical and architectural views after his contemporaries.
5 of 6 pl. for T.H. Shepherd's Views of the Regent's Canal, c.1825, obl. fo., aq., e. £300-£600 col.
Bookplates in line small value.

CLEMENS, Johann Friedrich 1749-1835
Continental line engraver of military and religious subjects, etc., after his contemporaries.
'Death of General Montgomery at the Attack of Quebec', after J. Trumbull, 1798, 20 x 30¼in/51 x 77cm, £200-£400.
Religious subjects small value.

CLEMENT, A. fl. early 19th century
Stipple engraver of decorative subjects after his contemporaries.
'A Calabrian's Family from the Environs of Reggio' and 'Cottagers at the Bottom of Mount Vesuvius', after T. Weber and C. Gauffier, 15½ x 18¼in/39 x 48cm, pair £400-£600 prd. in col.
'The Family's Distress Occasioned by the Loss of a Child' and 'The Family's Happiness Restored by the Child's Return', after L. Cosse, 1801, 15½ x 18¼in/ 39 x 48cm, pair £300-£500 prd. in col.

CLENNELL, Luke 1781-1840
Draughtsman and wood engraver of natural history and other book illustrations. Born in Northumberland, he was apprenticed to T. Bewick (q.v.) and is considered to have been one of his best pupils. He moved to London in 1804 and turned to painting full-time in 1810. He later became insane.
Small value.

CLERK & Co. fl. mid-19th century
Lithographers.
'View of the Shakespeare Viaduct and the Eastern Entrance of the Shakespeare Tunnel on the Dover Railway', 12¼ x16¼in/31 x 41cm, tt., £200-£300 col.

CLERK of Eldin, John 1728-1812
Amateur draughtsman and etcher of landscapes. Born in Penicuick, he was a successful merchant in Edinburgh and retired to Eldin in 1773. Prompted by P. Sandby (q.v.) he took up etching in about 1770, producing romantic views of Scottish ruins. These small prints possess great charm and sensitivity. The Bannatyne Club published twenty-eight of his plates in 1825 and eighty in 1855. (His brother, Sir George Clerk-Maxwell of Penicuick, also etched Scottish views.)
Contemporary imp. e. £50-£150.
Bannatyne Club reprints £5-£15.
Bibl: Lumsden, E.S., 'The Etchings of J.C. of Eldin', *P.C.Q.*, 1925, XII and 1927, XIII.

CLILVERD, Graham Barry b.1883
London-born painter and drypoint etcher of architectural views in Britain and Italy.
'The Spires of Oxford', 1932, 8¾ x 16in/22.5 x 40.5cm, e. £60-£120.
Others £20-£60.

CLINT, George, A.R.A. 1770-1854
Miniature and portrait painter, mezzotint and occasional stipple engraver of portraits and decorative subjects after his contemporaries and Old Masters. Born in London, he worked for a fishmonger and then as a decorator before turning to miniature painting. Later he learnt to engrave, probably taught by Edward Bell (q.v.) and reproduced paintings by Morland, Hoppner, etc. He made his name, however, painting and engraving theatrical portraits, his first successful print being of the Kemble family acting in 'The Trial of Queen Catherine'.
'The Trial of Queen Catherine', after G. H. Harlow, 1819, 26 x 33in/66 x 84cm, £150-£250.
'James Belcher, the Pugilist', after Allingham, £150-£250.

CLAUSEN, George. A typical etching.

'The Death of Nelson', after W. Drummond, 1807, 25 x 31in/63.5 x 78.5cm, £250-£350 prd. in col.
'The Frightened Horse', after G. Stubbs, stipple, £500-£1,000.
'Wm. Congreve directing the Fire Rocket . . . into the Town of Copenhagen', after J. Lonsdale, 1807, 27 x 19½in/69 x 49.5cm, £200-£400.
'W. Pitt', after J. Hoppner, 1806, 20 x 14in/51 x 35.5cm, and portraits of similar size £30-£60.
Stipple outlines after G. Morland, £20-£40 col.
Pl. for J.M.W. Turner's Liber Studiorum e. £80-£200.

CLOUSTEN, Robert S. d.1911
Hertfordshire mezzotint engraver of portraits after British 18th century artists and sentimental subjects after his contemporaries. In 1909, he emigrated to Australia where he died.
£15-£50.

CLOWES, Butler d.1782
Mezzotint engraver of portraits after his own designs and portraits, genre and decorative subjects after Old Master painters and his contemporaries.
'Starching', 1769, 15½ x 11in/39.5 x 28cm, £100-£200.
'Female Bruisers', after J. Collett, 1770, 16 x 18in/40.5 x 45.5cm, £150-£250.
'Jovial Peasants', after Heemskerk, 9 x 14in/23 x 35.5cm, £20-£40.
'The Engineer', after Colson, 14 x 10in/35.5 x 25.5cm, £60-£120.
'Charles Dibdin as Mungo', 1769, 11 x 12½in/28 x 32cm, £60-£100.
Various HL portraits £15-£40.
CS.

COATS, A.M. fl.1920s/1930s
Wood engraver.
£10-£30.

COCKBURN, Edwin fl. mid-19th century
Painter of domestic genre. He painted at Whitby early in his career and lithographed views of the town.
Views of Whitby, 6 tt. pl., 12¼ x 17in/32.5 x 43cm, e. £40-£70 col.

COCKBURN, ?Ralph fl. early 19th century
Custodian of Dulwich Picture Gallery who reproduced the paintings there in aquatint.
50 pl., 1816, obl. fo., small value.

COCKERELL, Charles Robert, R.A.
 1788-1863
Architect, archaeologist, draughtsman and occasional etcher of landscapes and architectural views. He travelled extensively in the Mediterranean 1810-16, particularly in

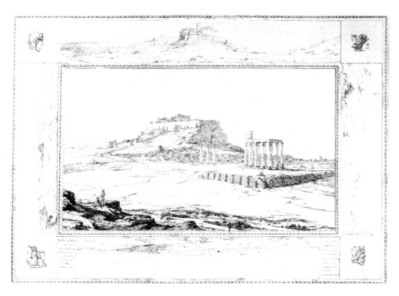 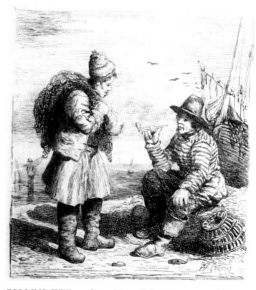

COCKERELL, Charles Robert. 'The View of Athens…from the Eastern Bank of the Ilissus…',1816.

COLLINS, William. One of the artist's attempts at etching.

Greece, before returning to England to practise architecture, becoming Professor of Architecture in 1840.
'The View of Athens . . . from the Eastern Bank of the Ilissus, surrounding it a Panorama of Athens', 1816, 12 x 17½in/30.5 x 44.5cm, £300-£600.

COLE, A. Ernest b.1890
Sculptor, draughtsman and drypointer of portraits and figure subjects. Born in Greenwich, he was Professor of Sculpture at the R.C.A. 1924-6.
£20-£60.
Bibl: Dodgson, C., 'Catalogue of the Drypoints of E.C.', *P.C.Q.,* 1925, XII, pp.7-13.

COLE, Benjamin c.1697-1783
Line engraver of bookplates, including portraits, decorative subjects, etc., after his contemporaries.
'Engagement with Spanish Armada near Plymouth', 7½ x 13¾in/19 x 35cm, £20-£60.
'Action between Florissant and Buckingham', 1758, 7½ x 13in/19 x 33cm, £60-£100.
Others mostly small value.

COLE, James fl. from 1720-d.1749
Engraver of topographical bookplates.
Pl. for John Dart's History and Antiquities of Westminster, *1727, e. £3-£10.*

COLEMAN, Charles fl. mid-19th century
Draughtsman and etcher of the following series:
'Views in the Campagna of Rome and the Pontine Marshes', 1850, 53 pl., fo., vol. £300-£800 (fetched £1,250 April 1991); e. £8-£15.

COLES, J. fl. late 18th century
Stipple engraver of decorative subjects after his contemporaries.
Pl. for H.W. Bunbury's Illustrations to Shakespeare, *1792-4, 16½ x 19in/42 x 48cm, e. £40-£80 prd. in col.*
'The School Mistress', after F. Wheatley, 1794, £100-£200 prd. in col.

COLIBERT, Nicholas 1750-1806
French line and stipple engraver of decorative subjects and portraits after his contemporaries and his own designs. Born in Paris, he came to

London, aged about thirty, and worked there till his death. He engraved small ovals in the style of F. Bartolozzi (q.v.) and some bookplates.
'Les Jeunes Anglais' and 'Les Jeunes Hollandais', 1785, 7 x 8in/17.5 x 20.5cm, pair £250-£300 prd. in col.
Bookplates small value.

COLKETT, Samuel David 1800-1863
Norwich School painter and occasional etcher, engraver and lithographer of landscapes after his own designs and those of his contemporaries. Born in Norwich, he was a pupil of J. Stark (q.v.) and lived in London, Norwich, Great Yarmouth and Cambridge.
£10-£30.

COLLARD, W. fl. mid-19th century
Line engraver.
'Eight Views of Fountains Abbey', after J. Metcalf, and J.W. Carmichael, with J.W. Archer (q.v.), fo., e. £10-£30.

COLLEY, Thomas fl.1780-1783
Line engraver.
'De Estaing at Spa' (caricature), 9¼ x 13¾in/25 x 35cm, £40-£60.

COLLIER, John *see* **BOBBIN, Tim**

COLLINGS, James Kellaway
 fl. mid-19th century
Painter and occasional lithographer of architectural views.
Pl. for E. Christian's Architectural Illustrations of Skelton Church, Yorks., *1846, fo., e. £4-£8.*

COLLINS, James fl. early 18th century
Draughtsman and line engraver of topographical and architectural views.
'The North Prospect of Westminster Abbey', 18 x 24in/45.5 x 61cm, £100-£250.
Small bookplates small value.

COLLINS, William, R.A. 1788-1847
Well-known landscape and genre painter who also produced some etchings. Born in London, he travelled widely in Britain and on the Continent.
£15-£50.

COLLISON-MORLEY *see* **MORLEY, Lieut-Col.**

COLLYER, Joseph 1748-1827
Line and stipple engraver of portraits, decorative and military subjects, mainly after his contemporaries. Born in London, he was apprenticed to A. Walker (q.v.).
'His Majesty Reviewing the Armed Associations in Hyde Park on June 4th., 1799', 1801, 16¼ x 26in/41 x 66cm, stipple, £400-£600 prd. in col.
'The Volunteers of the City and County of Dublin', after F. Wheatley, 1784, 16¾ x 25in/42.5 x 63.5cm, line, £300-£500 col.
'Trains of Running Horses Taking Their Exercise on Warren Hill, near Newmarket', by J. Bodger (q.v.), portraits by J.C., 18½ x 27½in/47 x 70cm, line and aq., £400-£600.
'The Village Holiday', after D. Teniers, 19½ x 30in/49.5 x 76cm, line, £10-£25.
'Mrs. Fitzherbert', after J. Russell, 1793,

COLLYER, Joseph. 'Miss Farren', after J. Downman, 1797.

CONDE, John. 'Polindo and Albarosa', 1789, one of the artist's engravings after Richard Cosway.

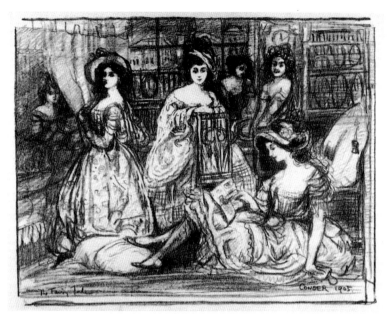

CONDER, Charles Edward. 'The Fairy Tale', 1905, lithograph printed in sanguine.

14 x 10in/35.5 x 25.5cm, stipple, £200-£300 col.
'Miss Farren', after J. Downman, 1797, 10¼ x 8¼in/27.5 x 21cm, stipple, £300-£500 prd. in col. Add more to last two if in fine contemporary frame.
Bookplates small value.

COLMAN, W. Gooding fl. early 19th century
Draughtsman and ?lithographer of architectural views.
Views of cathedrals, churches, etc., in northern France, *20 pl. incl. frontis., small fo., e. £5-£10.*

COMFORT, Arthur
fl. late 19th/early 20th century
Engraver of sentimental subjects, etc., after Old Master painters and his contemporaries.
£10-£30.

COMTE, Benjamin Rudolph c.1760-1843
Swiss etcher of topographical views. He went to London to study under J. Landseer (q.v.), and left for Lisbon about 1806.
'Grasmere Lake', after J. Laporte, 1795, 30¼ x 24½in/78 x 62cm, £80-£160 col.

CONDE, John fl. late 18th century
French-born stipple engraver of portraits and decorative subjects after his contemporaries. He is best known for his reproductions of Richard Cosway's paintings.
'Mrs. Fitzherbert', after R. Cosway, 1792, 12 x 8⅔in/30.5 x 22cm, £150-£300 prd. in col.
'Polindo and Albarosa', after R. Cosway, 1789, £50-£150 prd. in col.
'Docet Amor', 1801, 9½ x 6½in/24 x 16.5cm, £50-£150 prd. in col.

Add more if in fine contemporary frame.

CONDER, Charles Edward 1868-1909
Landscape and portrait painter and lithographer of figure subjects. Born in London, he was brought up in India and went to Australia in 1885 where he worked on the Illustrated Sydney News and studied painting. In 1890 he went to Paris and studied at Julian's. He settled in London in 1897. Apart from two very rare etchings, he produced thirty-three lithographs. These prints are drawn in a free and vigorous style which far surpasses that of his contemporaries and they possess the exuberance, gaiety, and mystery of such *fin de siècle* artists as Aubrey Beardsley. Impressions are frequently found printed in sanguine and sometimes on silk.

CONEY, John. One of the 'Views of English Abbeys and Cathedrals', 1815-29.

CONSTABLE, John. 'An Old Bridge at Salisbury' (Milford Bridge), c.1826.

COOK, Henry I. One of twenty-six plates from 'The Scenery of Central Italy: The Castle & Town of Lerici, Gulf of Spezzia'.

Etchings: 'Portrait of Mrs Conder' £200-£300; 'The Cloak' £200-£300.
'The Fairy Tale', 1905, litho. prd. in sanguine, £100-£200.
Bibl: Gibson, F., C.C. (catalogue of lithographs and etchings by Campbell Dodgson), London, 1913.

CONEY, John 1786-1833
Draughtsman, etcher and engraver of architectural views. Born in London, he was at first apprenticed to an architect. Later he was employed by J. D. Harding to draw and engrave a series of interior and exterior views of English abbeys and cathedrals.
'Views of English Abbeys and Cathedrals', 1815-29, e. £5-£10.
Views of Warwick Castle, 1815, e. £8-£12.
'Engravings of Ancient Cathedrals, Hotels de Ville and other Public Buildings of Celebrity', 1842, e. £5-£10.

CONSTABLE, John, R.A. 1776-1837
Celebrated English landscape painter who made a few rare etchings. Many of his paintings were engraved by others, particularly by D. Lucas (q.v.).
'Ruins of the West Window of Netley Abbey', c.1826, 5¼ x 7½in/13.5 x 19cm, £2,000- £3,000.
'An Old Bridge at Salisbury' (Milford Bridge), c.1826, 5¼ x 7½in/13.5 x 19cm, £2,000- £3,000.

COOK fl.1793
Line engraver of bookplates.
'Grand Cricket Match at Lord's', 1793, 4¼ x 6in/11 x 15cm, £30-£70.
Others small value.

COOK, Henry I fl. mid-19th century
Draughtsman and lithographer of topographical views.
'Recollections of a Tour in the Ionian Islands, Greece and Constantinople', 1853, 29 tt. pl., fo., e. £100-£250 col.
'The Scenery of Central Italy', 26 tt. pl., fo., e. £30-£80.

COOK, Henry II fl. early/mid-19th century
Line engraver of small bookplates, including portraits and decorative subjects after his contemporaries.
Small value.

COOK, Henry R. fl. early 19th century
Stipple and line engraver of portraits and decorative subjects after his contemporaries. He appears to have worked in London.
'St. Cecilia', after R. Westall, c.1802, 13½ x 16¾in/34 x 42.5cm, £40-£70 prd. in col.
'A Peasant Smoking', after R. Westall, c.1830, 12¾ x 10in/32 x 25.5cm, £150-£200 prd. in col.; pair with 'A Cottage Seamstress', by E. Scriven (q.v.), pair £400-£600 prd. in col.
'The Battle of Waterloo', after A. Sauerweid, 1819, a pair: 1 by H.R.C. and 1 by J. W. Cook (q.v.), 20½ x 30¼in/52 x 78cm, pair £200-£400.

COOK, J. fl. late 18th century
Line engraver of small bookplates and portraits.
Small value.

COOK, John W fl. early 19th century
Draughtsman and line engraver, mainly of small portrait plates.
Small value.

COOK, Thomas 1744-1818
Line engraver of portraits, decorative subjects and caricatures after his contemporaries. Born in London, he was a pupil of S.F. Ravenet (q.v.) and employed by John Boydell (q.v.) and others. He is probably best known for his copies of Hogarth's prints.
'Hogarth Re-engraved', 1795-1803, also 1812, fo., complete £400-£700; individual pl. e. £5-£15.
'The English Setter', after J. Milton, with Samuel Smith (q.v.), 17½ x 22¼in/44.5 x 56.5cm, £400-£600; pair to 'Spanish Pointer', by W. Woollett (q.v.) after G. Stubbs, pair £1,000-£2,000.

COOKE, Edward William, R.A. 1811-1880
Painter and etcher of marine subjects and architectural views. Born in London, the son of G. Cooke (q.v.), he engraved some botanical illustrations on wood when only nine (e.g. for Loudon's Encyclopaedia of Plants). About 1825 he sketched boats for Clarkson Stanfield and then, after studying architecture under A.C. Pugin for a short time, he produced his best known series of etchings: 'Shipping and Craft'. This was followed in 1830 by 'Coastal Scenery', and finally 'Old and New London Bridges', 1833. He then gave up etching for painting, travelling widely in the British Isles and on the Continent.
Early bookplates small value.
'Shipping and Craft', 1829, 50 pl., 1833, 65 pl., 'Coastal Scenery', 1830, 12 pl., e. £10-£25.
'London Bridges', 1833, 12 pl., e. £20-£50.

COOKE, George 1781-1834
Etcher and line engraver mainly of landscapes and topographical views after his contemporaries. Born in London, of German origins, he was apprenticed to J. Basire I (q.v.), was the brother of W.B. Cooke (q.v.) with whom he collaborated on several plates, and the father of E.W. Cooke (q.v.). Most of his plates were engraved for books.
'Views on the Thames', eng. with W.B. Cooke, 1811, 75 pl., e. £10-£30.
Pl. for Sir H.C. Englefield's and J. Webster's Isle of Wight, 1816, fo., e. £6-£12.
Pl. for J.M.W. Turner's Picturesque Views on the Southern Coast of England, 1814-26, 6 x 9in/15 x 23cm, proofs or early imp. e. £20-£60; later imp. small value.
Pl. for Engravings from the Pictures in the National Gallery, 1840, fo., small value.
'Haphazard', after B. Marshall, 1805, with W.B. Cooke, 18 x 24in/45.5 x 60.5cm, £300-£400.

COOKE, William Bernard 1778-1855
Line engraver mainly of landscape and topographical views after his contemporaries and his own designs. Born in London, of German origin, he was apprenticed to W. Angus (q.v.) and was the brother of G. Cooke (q.v.), with whom he collaborated on several plates. Most of his plates were engraved for books.
'Views on the Thames', eng. with G. Cooke, 1811, 75 pl., e. £10-£30.
Pl. for J.M.W. Turner's Picturesque Views on the Southern Coast of England, 1814-26, 9 x 6in/23 x 15cm, proofs or early imp. e. £20-£60; later imp. small value.
Pl. for W.C. Stanfield's Coast Scenery, e. £5-£15.
Pl. for Art Journal and similar publications small value.
'Haphazard', after B. Marshall, 1805, with G. Cooke, 18 x 24in/45.5 x 60.5cm, £300-£400.

COOKE, William John 1797-1865
Line engraver of small bookplates including landscapes and topographical views after his contemporaries. Born in Dublin, he moved with his parents to England in 1798. He was awarded the Gold Isis medal by the Society of Arts for his paper and demonstration on a method of engraving on steel. In 1840 he moved to Darmstadt where he died.
Pl. after W.H. Bartlett for Beattie's Switzerland, 1836, e. £5-£10.
Others small value.

COOMBES, Peter fl. early 18th century
Mezzotint engraver of portraits after his contemporaries.

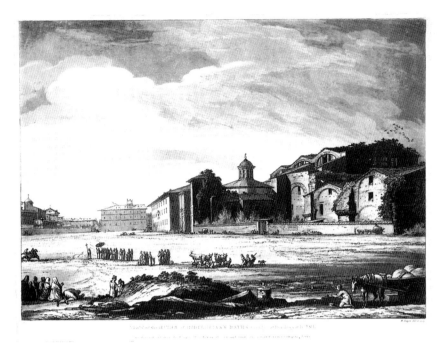

COOPER, Richard II. One of the plates from 'Views of Rome and Environs: View of the Ruins of Dioclesian's Baths and Adjacent Buildings at Rome', 1778-9.

COOPER, Robert. 'Miss Smithson as Miss Dorrillon', after G. Clint, 1822.

'Charles Moore', after J. Kerseboom, 14 x 10in/35.5 x 25.5cm, £40-£60.
CS lists 1 pl., noted above.

COOMBS, Joseph Ephenetus
fl. mid-19th century
Mezzotint engraver of portraits and sentimental subjects after his contemporaries and Old Master painters.
'The Fairy Well', after E. Corbould, 1855, 13½ x 20in/34 x 51cm, and other decorative subjects of similar size, £40-£100.
Add more if in fine contemporary frame.
Others small value.

COOPER, Abraham, R.A. 1787-1868
Eminent painter of sporting and battle subjects. While many of his works were engraved by professional engravers, he himself produced only a few etchings.
'Studies from Nature', 5 pl., e. £15-£50.

COOPER, ?J. or ?I.
fl. late 17th/early 18th century
Mezzotint engraver and publisher of portraits after his contemporaries.
£15-£40.
CS lists 6 HLs.

COOPER, Richard I c.1705-1764
Painter and line and mezzotint engraver of portraits. He studied under J. Pine (q.v.) and spent some years in Italy before settling in Edinburgh. He was the father of R. Cooper II (q.v.) and the master of R. Strange (q.v.).
£20-£60.
CS lists 3 pl.

COOPER, Richard II 1740-c.1814
Draughtsman, etcher, line, stipple and aquatint engraver of portraits, topographical views and decorative subjects, etc., after his contemporaries and his own designs; lithographer of landscapes after his own designs. Born in Edinburgh, the son of R. Cooper I (q.v.) who trained him initially, he

later went to Paris where he studied under J.P. LeBas. He was in Italy in the 1770s, sketching views, and from this period resulted the series of aquatints of 'Rome and its Environs'. In the 1780s he was drawing master at Eton. He was one of the first artists to experiment with lithography.
11 litho. are recorded in Man Cat., 1802-6: 3 publ. in Specimens of Polyautography, *e. £50-£80; on original mount £200-£400.*
'Step by Step', after A. Buck, 12 x 9in/30.5 x 23cm, stipple and aq., £150-£250 prd. in col.
'Love Wounded' and 'Love Healed', after S. Shelley, 1798, 9¼ x 7¾in/25 x 20cm, stipples, pair £200-£300 prd. in col.
'Children of Charles I with the Great Dog', after Van Dyck, 1762, 19 x 15½in/48 x 39cm, line, £15-£40.
'The Battle of Trafalgar and Death of Nelson', after W.M. Craig, 1806, 17 x 23in/43 x 58.5cm, £300-£500 prd. in col.
'The Meeting of Paris and Helen', after E.F. Burney, 8 x 5½in/20 x 14cm, stipple, £5-£12.
'The Procession of the Knights of the Garter', after A. Van Dyck, 1782, 18¼ x 55in/48 x 140cm, line, £40-£60.
'Views of Rome and Environs', 1778-9, 13½ x 20½in/34 x 52cm, aq., e. £70-£140.

COOPER, Robert fl. 1798-1826
Line engraver of portraits and book illustrations after various artists.
'Miss Smithson as Miss Dorrillon', after G. Clint, 1822, 13¼ x 9½in/33.5 x 24cm, and similar-sized portraits, £10-£30.
Small portraits and bookplates small value.

COOPER, Thomas George
fl. mid-/late 19th century
Painter of landscapes and rustic genre; occasional etcher and drypointer of animals. He was the son of T.S. Cooper (q.v.) and worked in London. He contributed plates to *The Etcher* and *The Portfolio*.
£4-£10.

COOPER, Thomas Sidney, R.A. 1803-1902
Painter and lithographer of cattle and sheep. Born in Canterbury, he went to the Continent in 1827 and taught in Brussels, where he was influenced by the animal painter Verboeckhoven as well as the 17th century Dutch landscape painters. He returned to London in 1831 where he settled for some years. After lithographing some plates for R. Bridgens' (q.v.) *West India Scenery,* and for D. Roberts' *Picturesque Sketches in Spain,* he produced his own studies of cattle. He later founded an art gallery and school in Canterbury where he died. Many of his

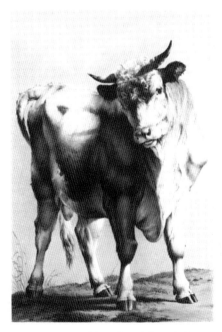

COOPER, Thomas Sidney. One of Cooper's famous studies of cattle.

COPE, Charles West. One of Cope's contributions to the Etching Club publications.

drawings and paintings were lithographed or engraved by others.
6 views of Canterbury, c.1820, obl. fo., e. £20-£50 col.
Pl. for R. Bridgens' West India Scenery, *1836, fo., e. £100-£200 col.*
Pl. for D. Roberts' Picturesque Sketches in Spain, *e. £30-£70 col.*
Studies of cattle, 2 series: 1836, 32 pl., c.1837, 40 tt. pl., fo., e. £15-£30; e. £50-£120 with contemporary col., v. rare.

COPE, Charles West, R.A. 1811-1890
Painter and etcher of figure subjects after his own designs and those of his contemporaries. Born in Leeds, he studied in London and Paris before travelling in Italy 1833-5. In 1843 he won a prize for his fresco decorations in the Houses of Parliament. He was a founder of the Etching Club and contributed plates to several of its publications, e.g. 'Goldsmith's Deserted Village', 1841. He also encouraged his friend S. Palmer (q.v.) to take up etching.
'The Life School of the Royal Academy' (his best known etching), 1868, and others £20-£50 (signed presentation proofs £40-£90).

COPLEY, John, A.R.E. 1875-1950
Painter, lithographer and etcher of figure subjects. Born in Manchester, he studied at the School of Art there and at the R.A. Schools. Having taken up lithography in 1907, he was Hon. Secretary of the Senefelder Club 1910-16 and won the chief award at the first International Exhibition of Lithographs at the Chicago Art Institute 1930. He lived in London. His lithographs, while often dark and gloomy with an air of suffering and despair, form a significant and underrated body of work in this medium.
'The Fall and Rise of His Imperial Majesty Jacques Demode, Emperor of the Sahara', 1909, fo., 22 litho. in one or more col., no copy has been on the market recently, but could fetch £1,500-£2,000.
Other prints £80-£200.
Bibl: Walker, R.A., 'The Lithographs of J.C.', *P.C.Q.*, 1926, XIII, p.273.

CORBOULD, George James 1786-1846
Line engraver of small bookplates after his contemporaries. He was the son of R. Corbould (q.v.) and a pupil of J. Heath (q.v.)
Small value.

CORBOULD, Henry 1787-1844
Historical painter and designer who made some lithographs after antique statues.
e. £30-£70.

CORBOULD, Richard 1757-1831
Book illustrator, portrait and landscape painter, who experimented with lithography.
'Landscape with Hunter and Wild Ducks', 1802, 7¼ x 11in/18.5 x 28cm; 'Old Trees with Old Man, Girl and Dog', 1802, 23.5 x 32.5cm, latter publ. in Specimens of Polyautography, *e. £80-£120; on original mount £200-£400.*
Man Cat.

CORBUTT, C. *see* PURCELL, R.

CORMACK, Mrs. Minnie b.1862
Irish mezzotint engraver of portraits after British 18th century painters, and portraits and decorative subjects after her contemporaries and her own designs. Born in Cork, she was a pupil of T.G. Appleton (q.v.) and worked in London.
'Sweet Peas', after E.J. Poynter, 1891, 22½ x 16in/57 x 41cm, £100-£200.
'Jessamine', after W. Etty, 1891, 10½ x 14½in/27 x 37cm, £30-£70.
Pl. after British 18th century painters £10-£40.
Add more if in fine contemporary frame.

CORNER, John fl. early 19th century
Line engraver of twenty-five portraits of celebrated painters, 1825.
Small value.

COPLEY, John. 'Paris Revisited', a plate from 'The Fall and Rise of His Imperial Majesty Jacques Demode, Emperor of the Sahara'.

CORMACK, Mrs. Minnie. 'Sweet Peas', after E.J. Poynter, 1891.

COSWAY, Maria Cecilia Louisa (née Hadfield) fl. late 18th century
Painter and occasional etcher. She married R. Cosway (q.v.) in 1781, but they later separated. Most of her plates are spirited copies of her husband's drawings.
'Lady Rubens with her Son Albert', after P.P. Rubens, and others, £10-£30.

COSWAY, Richard, R.A. 1740-1821
Well-known painter of portraits and miniatures. While many of his paintings were engraved by others, he etched only a few plates himself.
Pl. for Original Sketches from Nature by Various Masters, *1801 and other etchings, e. £40-£90.*
Bibl: Williamson, G.C., *R.C., his Wife and Pupils,* London, 1897; Daniell, F.B., *The Engraved Works of R.C.,* London, 1890.

COTMAN, John Joseph 1814-1878
Norwich School draughtsman, watercolourist and occasional etcher of landscapes. Born in Yarmouth, he was the second son of J.S. Cotman (q.v.) and lived and worked in and around Norwich.
£10-£30.

COTMAN, John Sell 1782-1842
Important draughtsman, watercolourist and etcher of landscapes, architectural views and marine subjects. Born in Norwich, he studied art at Dr. Munro's school in London and made several sketching tours to the West Country, Wales and, more importantly, to Yorkshire, between 1800 and 1806. He returned to Norwich in 1806 and joined the Norwich Society of which he became Secretary. From 1812 to 1824 he lived in Yarmouth and worked mainly for Dawson Turner providing drawings and etchings for his publications. It is from this period that the bulk of his etched work derives. In 1833 he was appointed Professor of Drawing at King's College, London, where he lived till his death. Possibly his most important series of plates resulted from his three visits to Normandy in 1817, 1818 and 1820: 'Architectural Antiquities of Normandy', 1822. He modelled himself as an

COSWAY, Maria Cecilia Louisa. 'Lady Rubens with her Son Albert', after P.P. Rubens.

COSWAY, Richard. One of the artist's few etchings.

etcher on Piranesi and, while his plates lack the melodrama and heavy chiaroscuro of the latter, his line is freer and simpler.

Early proof of soft-ground etching touched by artist, £150-£250; fine, early imp. of unpubl. or pre-publication pl. £60-£140.

'Etchings by J.S.C.', 1811, 24 pl., vol., early proof set £500-£800.

'Liber Studiorum', 1838, 48 pl., vol. £200-£400.

'Specimens of Norman and Gothic Architecture and the Castellated and Ecclesiastical Remains. . . . in Norfolk', 102 pl., vol. £300-£600.

Bibl: Rienaecker, V., *J.S.C.*, Leigh on Sea, 1953.

COTMAN, Miles Edmund　　　　1810-1858
Norwich School painter, etcher and lithographer of landscapes and marine subjects after his own designs and those of his father. Born in Norwich, he was the eldest son of J.S. Cotman (q.v.) and much influenced by him. In 1836 he went to London to assist his father who had been appointed Professor of Drawing at King's College, succeeding him on his death and only returning to

Norfolk towards the end of his life. He etched twenty-four plates, eleven being published by C. Muskett in 1845. The best of these are marine subjects, influenced by E.W. Cooke (q.v.).

'Facsimiles of Sketches by the Late J.S.C.', 1842, which reproduced his last drawings of Norfolk scenery, 12tt. pl., fo., etchings and litho., e. £15-£50.

Marine etchings e. £20-£60 (early working proof £60-£140; set of 'Eleven Original Etchings', publ. 1845, £250-£400).

Ref: Bolingbroke.

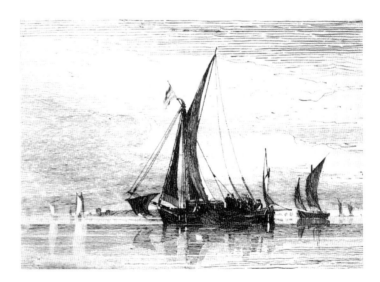

COTMAN, Miles Edmund. One of the artist's marine etchings.

COTMAN, John Sell. The title page to Cotman's first series of etchings, 1811.

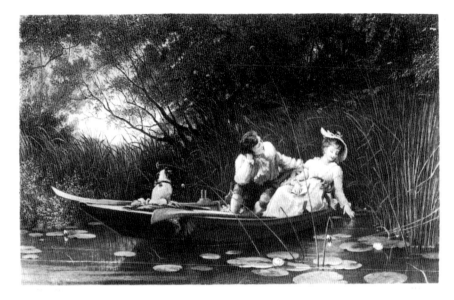

COUSEN, Charles. 'Simpletons', after S.L. Fildes.

COURTRY, Charles Jean Louis 1846-1897
French etcher of genre and sentimental subjects, etc., after Old Master painters and his contemporaries. He was born in and worked in Paris, apart from a period in London.
Single pl. £5-£15.
Bookplates small value.

COUSEN, Charles ?1813-1889
Line engraver of small landscape and topographical bookplates after his contemporaries. Born in Bradford, Yorkshire, the younger brother of J. Cousen (q.v.), he worked mainly on topographical views up to about 1850, after which he was employed continuously by Virtue to engrave landscape plates for the *Art Journal* and similar periodicals.
'Simpletons', after S.L. Fildes, small value.
American views £5-£15.
Swiss views £4-£10.
Pl. after J.M.W. Turner £3-£10 (early or proof imp. £20-£60).
Others small value.

COUSEN, John 1804-1880
Line engraver of landscape and topographical views mainly after his contemporaries. Born near Bradford, the elder brother of C. Cousen (q.v.), he was apprenticed to John Scott (q.v.) and worked in London, producing small plates for topographical works and the *Art Journal* and similar periodicals.
'Mercury and Horse', after J.M.W. Turner, 1842, 15½ x 18½in/39 x 47cm, £30-£70.
Other lge. pl. £10-£50.
Small bookplates after Turner, £3-£10 (early or proof imp. £20-£60).
American views £5-£15.
Swiss views £4-£8.
Other small bookplates small value.

COUSINS, Henry c.1809-1864
Mezzotint engraver of portraits and sentimental subjects after his contemporaries. He was the younger brother of S. Cousins (q.v.).
'Isambard K. Brunel', after J. C. Horsley, 1858, 16 x 13in/41 x 33cm, £40-£100.
'Queen Victoria' (WL on throne), 1839, after
G. Hayter, 26½ x 18¼in/67 x 48cm, £120-£200.
Other WL portraits and sentimental subjects £20-£60.
Other portraits £10-£30.
Add more if in fine contemporary frame.

COUSINS, Samuel, R.A. 1801-1887
Well-known mezzotint engraver of portraits and decorative subjects after his contemporaries and 18th century British artists. Born in Exeter, the elder brother of H. Cousins (q.v.), he was a pupil of and assistant to S.W. Reynolds (q.v.) and set up his own business in London in 1825. He was later to become the first engraver to be elected an R.A. He engraved plates after the foremost artists of his day including E. Landseer, J.E. Millais, F. Winterhalter, etc., and is probably the best remembered reproductive engraver of the time. In his engraving technique, he managed to retain some of the softness of 18th century mezzotints and avoid the hard-edged mechanical look of the Victorian period.
'A Piper and a Pair of Nutcrackers', after E. Landseer, 1865, 23 x 18¾in/58.5 x 46.5cm, £140-£200, and 'Collecting Apples', after J.E. Millais, 21½ x 15¾in/1882, 54.5 x 40cm, e. £120-£200.
'Queen Victoria', after A.E. Chalon, 1838, 31½ x 21in/80 x 53cm,
'The Return from Hawking', after E. Landseer, 1838, 24½ x 34¼in/62 x 88cm, and 'Pomona', after J.E. Millais, 1882, 21½ x 15¾in/54.5 x 40cm, e. £150-£250.
'Harriet, Countess Gower and Daughter', after T. Lawrence, 1832, 26¼ x 16¼in/68 x 42.5cm, £100-£160.
'The Red Boy' (Charles William Lambton), after T. Lawrence, 1827, 18¼ x 14in/46.5 x 35.5cm, £80-£120.
'The Royal Family', after F. Winterhalter, 28¾ x 34¼in/73 x 88.5cm, £300-£500, 'The Princes in the Tower', after J.E. Millais, 1879, 30 x 20in/72 x 50.5cm, e. £300-£500.
Add more if in fine contemporary frame.
Small portraits and bookplates small value.
Bibl: Pycroft, G., *A Memoir of S.C.,* London, 1887; Whitman, A.C., *S.C. Catalogue,* London, 1904.

COUTTS, William 1832-1894
Etcher of portraits. He was a member of the Junior Etching Club and later inherited an earldom.
Small value.

COVENTRY, J. fl. mid-19th century
Lithographer of small bookplates after his contemporaries.
Pl. for W. Kennedy's A Short Narrative of the Second Voyage of the Prince Albert, *1853, 8vo., tt., e. £5-£10.*

COWAN, J. fl. late 18th century
Line engraver of miscellaneous bookplates after his contemporaries.
Small value.

COWEN, William 1797-1861
Painter, etcher and ?lithographer of landscapes and topographical views. Born in Rotherham, Yorkshire, he was patronised by the Earl Fitzwilliam and travelled much on the Continent sketching. In 1840 he visited Corsica and, as a result, published a series of etchings in 1843.
e. £10-£30.

COWERN, Raymond Teague, R.A., R.W.S., R.E. b.1913
Painter and etcher of landscapes and figure subjects. Born in Birmingham, he studied at the R.C.A. and was a scholar at the British School in Rome. He lives in Brighton.
£20-£60.

COWHAM, Hilda d.1964
Magazine illustrator, writer of children's books and etcher of figure subjects. Born in London, she studied at Lambeth School of Art, was the first woman to draw for *Punch* and created the 'C Wham Kid'. Ballet and children are among the themes of her prints.
£20-£60.

COX, Arthur Leonard b.1879
London-born mezzotint engraver of portraits after British 18th century artists and his contemporaries.
£15-£50.

COUSINS, Samuel. 'A Piper and a Pair of Nutcrackers', after E. Landseer, 1865.

COZENS, Alexander. 'Castel Angelo', 1746, published 1801.

COZENS, John Robert. One of fourteen plates from 'Studies of Trees', 1789.

COX, David Sen. 1783-1859
Important watercolourist of landscapes, he also taught drawing for much of his career and published several drawing books; for *The Young Artist's Companion*, 1819-20, he executed forty soft-ground etchings, as well as a few lithographs for *Progressive Lessons*, 1823 and 1828. Many of his drawings were engraved by professional engravers.
e. £5-£15.

COX, Walter Alfred b.1862
Mezzotint engraver, photo-engraver and etcher of sentimental subjects and portraits after Old Master and British 18th century painters and his contemporaries, and topographical views of public schools, 1888-92, after F. Barrow, A.H. Wardlow, etc. He was a pupil of J. Ballin (q.v.).
Engravings: 'Coaching', after C. Aldin, 1906, 21 x 29½in/53.5 x 75cm, photogravure, £120-£260.
Portraits and sentimental subjects £10-£50.
Add more if in fine contemporary frame.
Etchings of public schools £30-£80; with sport in progress £60-£180.

COZENS, Alexander c.1717-1786
Early English watercolourist and successful drawing master who produced a few prints. His visit to Rome in 1746 resulted in one etching. He experimented with soft-ground etching, producing several pl. in the 1750s, depicting the Roman Campagna. His 'blot' landscapes, engraved in aquatint, were designed to teach people to construct landscape drawings out of blots. His son, J.R. Cozens (q.v.), also experimented with print-making.
'Castel Angelo', 1746, etching, contemporary imp. £300-£500; publ. in Original Sketches from Nature, in 1801, £150-£250.
Soft-ground etchings £100-£200.
'Blot' landscapes, c.1785, 16 aq., 9½ x 12½in/24 x 31.5cm, e. £100-£200.
Also a drawing book: 'Principles of Beauty Relative to the Human Head', 1778, fo., 19 pl., £400-£800.
Bibl: Oppé, A.P., *A. and J.R.C.*, 1952; Wilton, A., *The Art of A. and J.R.C.*, New Haven, 1980.

COZENS, John Robert 1752-1797
Important English watercolourist and son of A. Cozens (q.v.) who produced a few prints including the following two rare and important series:

'Views of Bath', 1773, 8 etchings with grey washes by the artist, 11 x 15in/28 x 38cm, e. £600-£900 (only one complete set seen, sold for £6,000 in 1978).
'Studies of Trees', 1789, 14 soft-ground etchings with aq. based on sketches made in Switzerland and Italy, e. £200-£400 (whole set has made £9,000).
Bibl: Oppé, A.P., *A. and J.R.C.*, 1952; Wilton, A., T*he Art of A. and J.R.C.*, New Haven, 1980.

CRABB fl. early 19th century
Line engraver of small topographical bookplates after his contemporaries.
Small value.

CRAFT, Percy Robert 1856-1934
London painter and etcher of landscapes and coastal scenes. He contributed plates to *English Etchings*.
£5-£15.

CRAIG, Edward Gordon 1872-1966
Important wood engraver of figure subjects, portraits, etc. While he produced only a very few etchings early in his career (e.g. *A Portfolio of Etchings*, c.1896), he engraved over 500 wood blocks, including many book illustrations. He also wrote several books on the theatre and designed stage sets.
12 etchings, Florence, 1907, edn. 30, set £500-£800.
8 wood eng. for Hamlet, published Weimar, Germany, 1930, set £700-£840 (special copy sold for $5,400 March 1993).
'Ellen Terry as Ophelia', touched with ink and wash, £200-£300.
'The Storm, King Lear', 1920, 6½ x 6¼in/16.5 x 16cm, £300-£500.
Working proofs of woodcuts and rare etchings £80-£200.
Various book illustrations £20-£80.

CRAIG, William Marshall c.1765-c.1834
Illustrator, watercolour and miniature painter who produced a few prints. He lived in Manchester before moving to London in 1791. He was one of the first designers of illustrations for wood engraving and many of his drawings were engraved by T. Bewick (q.v.) and his school.
'Pheasant Shooting II', from Orme's British Field Sports, *after S. Howitt, 1807-8, eng. with*

H. Merke (q.v.), 14½ x 19in/37 x 48.5cm, aq., £500-£1,000 col.
'Itinerant Traders of London in their Ordinary Costume', 1804, 31 etchings mostly by C., 5½ x 4½in/14 x 11cm, e. £20-£30 col.
Pl. for drawing books, soft-ground etchings, small value.

CRAWFORD, Susan Fletcher, A.R.E. d.1919
Glaswegian etcher.
£10-£30.

CRAWFORD, Thomas Hamilton 1860-1948
Painter of architectural views and mezzotint engraver of portraits after Old Master and British 18th century painters as well as his contemporaries. Born in Glasgow, he was a pupil of H. Herkomer (q.v.) and worked in London.
£15-£50.

CREED, Carey 1708-1775
Etcher.
Series of pl. depicting statues and busts at Wilton House, 1731, e. £5-£10 (copy made £1,200 October 1989).

CRESWICK, Thomas, R.A. 1811-1869
Painter and etcher of landscapes. Born in

CRAIG, Edward Gordon. One of eight wood engravings for Hamlet.

CRESWICK, Thomas. One of Creswick's best contributions to the Etching Club's publications.

Sheffield, he moved to London in 1828. He was a founder member of the Etching Club and contributed many plates to its publications. His lyrical and sensitive portrayals of the English countryside sometimes rival the etchings of S. Palmer (q.v.).
£15-£50.

CRISTALL, Joshua 1767-1847
Watercolourist who produced one lithograph and a few aquatints of figure subjects. Born in Cornwall, he was brought up near London and was a founder member and later President of the Old Watercolour Society.
'Apollo and the Muses', litho. 1816, 12 x 18in/30.5 x 45.5cm, £80-£120; £400-£600 col. by artist.
Aquatints e. £100-£200.

CROCKART, James fl. early 20th century
Etcher of architectural views.
£10-£30.

CROME, John 1768-1821
Major painter and etcher of landscapes. Born in Norwich, he spent most of his life in Norfolk, helping to found the Norwich Society in 1803. He was the guiding light of the Norwich School. His etchings were influenced by the Dutch 17th century landscape artists including Waterloo and Ruisdael. He produced thirty-three plates, including nine soft-ground, between 1809-13, but although he issued a prospectus in 1812 proposing their publication, the first edition was published by his widow in 1834: *Norfolk Picturesque Scenery*, thirty-one plates, sixty copies. In later editions the plates were much altered and diminished in quality.
Contemporary proofs, v. rare, e. £300-£900; imp. from Mrs. Crome's edn. e. £80-£300; later imp. e. £15-£60 (complete set of 31 pl. from Mrs. Crome's edn. fetched £2,700 June 1993).
Bibl: Theobald, H.S., *C.'s Etchings: a catalogue . . . ,* London, 1906.

CROME, John Berney 1794-1842
Painter of landscapes who retouched the etchings of his father, J. Crome (q.v.).
Small value.

CROMEK, Robert Hartley 1771-1812
Etcher and stipple engraver of decorative subjects, mainly small book illustrations, after his contemporaries. Born in Hull, he was a pupil of F. Bartolozzi (q.v.). Apart from his engraving work, he is known as a 'shifty speculator'. He died of consumption.
1 lge. pl., 'Canterbury Pilgrims', after T. Stothard, the rival to W. Blake's (q.v.) version, £100-£200.
Small bookplates small value.

CROOKE, W.P. fl. late 19th century
Etcher of architectural views in England and on the Continent. He worked in London and contributed plates to *The Etcher* and *English Etchings*.
£5-£15.

CROOME, C.J. fl. mid-19th century
Draughtsman and lithographer.
'The Duke of Grafton's Hounds Meeting at Shenley', 1840, 14 x 21½in/36 x 54.5cm, £300-£400 col.

CROSS, Thomas fl. mid-/late 17th century
Line engraver of portraits, often used as frontispieces to books. His work is very crude but the subjects are often interesting.
£5-£20.

CRISTALL, Joshua. 'Apollo and the Muses', 1816.

CROME, John. 'Composition – Sandy Wood', 1813, published by Mrs. Crome, 1834.

CROTCH, Dr. William 1775-1847
Amateur watercolourist and etcher of landscapes and architectural views. He was Professor of Music at Oxford and later the first principal of the Royal Academy of Music.
'Six Studies from Nature', 1809, obl. fo., soft-ground etchings, e. £10-£25.
'Six Etchings of the Ruins of the late Fire at Christ Church, Oxford', 1809, obl. fo., soft-ground etchings, set £200-£300.

CRUIKSHANK, George 1792-1878
Celebrated draughtsman and etcher of caricatures and humorous book illustrations. The son of I. Cruikshank and the younger brother of I.R. Cruikshank (qq.v.), he published his first etching when he was twelve. From 1811 to the 1820s he produced political and social satires which followed the tradition of J. Gillray and T. Rowlandson (qq.v.). Then, from about 1820, he started to produce small book illustrations as well, e.g. for E. Pierce's *Life in London*, 1821. Unlike the earlier coloured etchings, later plates from the 1830s, either etchings or wood engravings after the etchings for the works of Charles Dickens, Harrison Ainsworth, etc., were usually issued uncoloured and are worth little out of the book. From 1847, Cruikshank became more and more involved with the temperance movement and produced several propagandist works, e.g. 'The Bottle', and 'Triumph of Bacchus'.
Caricatures, 1811-1820s, depending on subject (i.e. more for social than political satires) mostly £50-£400 col. Little of quality has been available recently, so prices for good subjects in good condition at upper end of estimate and even more.
'A Scene in the Farce of "Lofty Prospects" as

performed . . . for the Benefit and amusement of John Bull', £300-£500 col.
'The Auction', £100-£200 col.
Pl. for Pierce's *Life in London, 1821, 8vo., and similar book illustrations from the 1820s, e. £15-£30 col.*

'The Bottle', 1847, the drawings reproduced by glyptography, vol. £80-£150.
'The Triumph of Bacchus', 1864, finished by C. Mottram (q.v.), 26¼ x 42½in/68 x 108cm, £100-£200, add more to latter if in fine contemporary frame.
Bibl: Reid, G.W., *A Descriptive Catalogue of the Works of G.C.*, 1871; Cohn, A.M., *G.C., a catalogue raisonné*, London, 1924; Patten, R. L., Biography in two vol.
Colour plate page 28.

CRUIKSHANK, Isaac 1756-1811
Scottish genre painter, book illustrator, draughtsman and etcher of caricatures. Born in Edinburgh, he was the father of G. Cruikshank and I.R. Cruikshank (qq.v.).
£50-£200 col.
Bibl: Marchmont, F., *The Three Cs*, 1897; Krumbhar, E.B., *I.C., A Catalogue Raisonné*, 1966.

CRUIKSHANK, Isaac Robert 1789-1856
Miniature painter, draughtsman and etcher of caricatures. Born in London, he was the son of I. Cruikshank and the elder brother of G. Cruikshank (qq.v.). He served in the merchant navy before becoming an artist. As well as the social and political satires, he also produced small bookplates, sometimes collaborating with his brother George, e.g. for E. Pierce's *Life in London.* His style is similar to and sometimes indistinguishable from that of G. Cruikshank, and on occasion he signed his plates 'Cruikshank' in order to pass them off as being by his more celebrated brother.
'Monstrosities of 1827' £100-£200 col.
'North East View of the Cricket Grounds at Darnall near Sheffield, Yorks.', 8½ x 12½in/21 x 31.5cm, aq., £200-£300 col.
'Football', etching aq. by G. Hunt, c.1825, 8¼ x 12½in/21 x 31.5cm, £150-£250 col.
'Going to a Fight' (panorama), 1819, 2½ x 156in/6.5 x 396cm, col. aq., £400-£800.
Caricatures generally £50-£200 col.

CRUIKSHANK, George. 'A Scene in the Farce of "Lofty Projects" as performed with great success for the benefit and amusement of John Bull – AnᵒD 1825'.

CUITT, George Jun. 'The Tower, Fountains Abbey'.

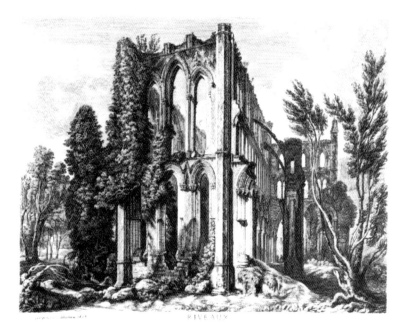

CUITT, George Jun. 'Riveaux', 1824, from *Cuitt's views of Yorkshire abbeys.*

Small bookplates, £15-£30 col.
Bibl: Marchmont, F., *The Three Cs.*, 1897.
Colour plate page 28.

CRUIKSHANK, Percy fl. mid-19th century
Designer and ?lithographer of humorous illustrations. He was the son of I.R. Cruikshank (q.v.).
'Comic History of the Russian War'
(panorama), c.1857, 5 x 96in/12.5 x 244cm,
£400-£600 col.
'Franco-Prussian War' (panorama), c.1871, 4¼
x 129in/12 x 327.5cm, £600-£1,000 col.
'Sunday Scenes in London', 1854, 12 pl., 4to., e.
£20-£50 col.

CUFF, R.P fl. mid-19th century
Line engraver of small bookplates including landscape and architectural views after his contemporaries.
Small value.

CUITT, George Jun. 1779-1854
Painter and etcher of landscapes and architectural views. Born in Richmond, Yorkshire, the son of George Cuitt Sen., a landscape and portrait painter, he left Yorkshire for Chester apparently because there was not enough work for the two of them, only returning after his father's death. His etchings of old buildings in Chester and ruined abbeys in Yorkshire are strongly influenced by Piranesi whom Cuitt greatly admired.
Views of old buildings in Chester and Yorkshire
abbeys, contemporary imp., e. £15-£50.
Reprints contained in Wanderings and Pencillings among the Ruins of Olden Times, *1848, fo., e. small value.*

CURREY, Esme, A.R.E. c.1883-1973
London painter, etcher and wood engraver of architectural views and portraits.
£15-£50.

CURRIE, Robert fl. late 19th century
Etcher of landscapes. He worked in Scotland and contributed plates to *English Etchings.*
Small value.

CURSITER, Stanley 1887-1976
Produced a few rare lithographs.
'A Nude', 1915, 8½ x 6in/21.5 x 15.5cm, e. £60-
£140.
'The Lighthouse', 1913, 15¼ x 9¾in/39 x 25cm,
e. £60-£140.

CURTIS, J. 1791-1862
Draughtsman and line engraver of small natural history plates. Born in Norwich, he died in London.
Small value individually.

CUTNER, Herbert 1881-1969
Writer on art and philosophy and etcher of genre subjects. Born in Hull, he lived in London and was the author of *Teach Yourself Etching*, 1947.
£15-£50.

DADLEY, J. c.1767-1807
Etcher and stipple engraver of small costume plates after his contemporaries. He worked in London for the publisher W. Miller.
Pl. for O. Dalvimart's Costume of Turkey, *1804, fo., 60 pl., e. £10-£20 col.*
Pl. for G.H. Mason's Costume of China, *1804, fo., 60 pl., e. £10-£20 col.*

DAGLISH, Eric Fitch, A.R.E. b. 1894
Watercolourist and wood engraver of ornithological subjects. Born in London, he later lived in Buckinghamshire. He illustrated several bird books.
£40-£90.

DALE, Mrs. Gertrude
fl. late 19th/early 20th century
London mezzotint engraver of sentimental subjects after her contemporaries.
£15-£50.

DALE, Henry Sheppard, A.R.E. 1852-1921
Painter and etcher of landscapes and architectural views mostly after his own designs. Born in Sheffield, he studied in London at the Slade and in Italy. He produced illustrations for *The Graphic* and for books on architecture as well as several sets of etched views including those of Venice, Glastonbury, Exeter, etc.
University and public school views e. £20-£60.
Other views e. £10-£30.
Other pl. small value.

DALGLIESH, Theodore Irving, R.E.
1855-1941
Coventry-born etcher of landscapes.
£15-£50.

DALLAS, A.C. fl.1920s/1930s
Wood engraver.
£10-£30.

DALTON, E. fl. mid-19th century
Lithographer of portraits after his contemporaries and his own designs.
£5-£10.

DALTON, Richard 1720-1791
Draughtsman, etcher and engraver of topographical views, antiquities, portraits after Old Master painters, etc. He studied in Rome and from 1749 travelled with Lord Charlemont to Sicily, Greece, Constantinople and Egypt. On his return he became Librarian and Keeper of Pictures to George III.
'Etchings of a Collection of Portraits by Holbein Found in the Cabinet of Queen Caroline', e. small value.
'A collection of Twenty Antique Statues Drawn After the Originals in Italy', e. small value.
'Antiquities and Views in Greece and Egypt with the Manners and Customs of the Present Inhabitants', R.D. drew all and eng. some, 1791, fo., e. £8-£20.

DALZIEL Brothers
Edward 1817-1905
George b.1815
John 1822-1869
Thomas Bolton Gilchrist Septimus 1823-1906
Wood engravers of book illustrations after their contemporaries. Their engraving technique was to cut the woodblocks on which the artist had drawn his illustration in pen and ink. Their most sought-after productions are the engravings after drawings by the Pre-Raphaelites, e.g. for *The Poems of Tennyson,* 1857, published by Moxon, *Parables of Our Lord,* 1863 and *The Arabian Nights,* 1865. Individual plates out of their books are of small value, unless they are proofs, usually found on India paper, and sometimes touched by the artist.
Proofs: Pre-Raphaelite illustrations £15-£40.
Others £8-£15.

DAMMAM, Benjamin Louis Auguste b.1835
French etcher of portraits after British and French contemporaries, Old Master painters and British 18th century artists.
Small value.

DANBY, Francis 1793-1861
Irish landscape painter who worked in England and Geneva and made a very few prints.
'View from Kingsweston Hill', litho., 1823, extremely rare, 9¼ x 14in/25 x 36cm, fetched £1,500 June 1993.

DANGERFIELD, Frederick
fl. mid-19th century
Lithographer.
'Scenes in Stratford-on-Avon', after P. Clarke, 2 pl., 6½ x 11in/16.5 x 28cm, e. £10-£25 prd. in col.

DANIEL, Henry fl. early 20th century
Etcher of architectural views.
£20-£60.

DANIELL, Rev. Edward Thomas 1804-1842
Norwich School watercolourist and etcher of landscapes. Born in London, he was brought up in Norfolk where he was taught drawing by J. Crome (q.v.). He was ordained in 1831 but became a full-time painter two years later. He died of fever on a sketching expedition to the Middle East.
£60-£120.
Ref: Bolingbroke.
Bibl: Binyon, L., *E.T.D., painter and etcher,* 1899; Dickes, W.F., *Norwich School of Painting,* 1905; Mallalieu, H., *The Norwich School,* 1975.

DANIELL, James c.1771-1814 or later
Mezzotint engraver of naval and decorative subjects after his contemporaries. He was also a publisher of prints and worked in London.
'Capt. Faulknor in the Zebra' and 'Capt. Trollope in the Glatton in the Attack on Fort Royal, Martinique', after H. Singleton, 1794, 26 x 24in/66 x 61cm, pair £1,000-£1,500 prd. in col.
'Death of Capt. Hood', after H. Singleton, 18 x 23in/45.5 x 58.5cm, £400-£600 prd. in col.
'A Lion', after J. Graham, 1792, 18¼ x 23¼in/48 x 60cm, £400-£600 (imp. prd. in col. fetched

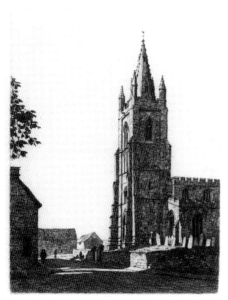

DANIEL, Henry. An architectural etching.

DANIELL, Edward Thomas. A typical etching.

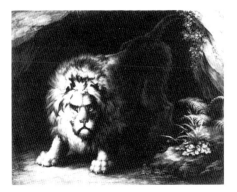

DANIELL, James. 'A Lion', after J. Graham, 1792.

Oct.1990 £2,800).
Religious, classical subjects, etc., £10-£20.

DANIELL, Samuel (1775-1811) *see*
DANIELL, William

DANIELL, Thomas, R.A. 1749-1840
Draughtsman, painter and aquatint engraver of
landscape, topographical and architectural
views. He was born in Chertsey. His best-
known work, and one of the most important
English colour plate books, is 'Oriental
Scenery' produced in collaboration with his
nephew William (q.v.). Published between
1795-1808, it was based on hundreds of
sketches made during their extensive travels on
the Indian sub-continent between 1786 and
1793. While William engraved most of the
plates for this work, Thomas both drew and
engraved the plates for the earlier 'Views in
Calcutta', which were engraved and published
in Calcutta.
*'River Landscape with Fishermen', c.1774, 14 x
11in/35.5 x 27.5cm and 'A Coastal Scene', two
very rare etchings after J.H. Mortimer, e. £100-
£200.*
'Oriental Scenery', see William Daniell below.
*'Views in Calcutta', 1786-8, 12 pl., obl. fo., e.
£300-£600 col.*

DANIELL, William, R.A. 1769-1837
Eminent draughtsman, watercolourist and
aquatint engraver of landscape, topographical
and architectural views, animal and marine
subjects and portraits. Born in Chertsey, he was
the nephew of T. Daniell (q.v.) and travelled
with him to India when aged sixteen. Apart
from 'Oriental Scenery', for which he spent
seven years engraving the plates, his most
important works are: 'Six Views of London' and
'Six Views of the London Docks', 1805, 'A
Voyage Round Great Britain', 1814-25, and
'Twelve Views of Windsor, Eton and Virginia
Water', c.1827. The plates for these works were
engraved after his own drawings, but he also
produced a large number of aquatints after his
contemporaries. While many of the latter are
not signed in the plate (e.g. S. Daniell's *Scenery
of Ceylon*), it is possible to attribute them to
William because his engraving technique is so
distinctive. ('African Scenery and Animals',
1804, is the only book where the plates are
described as having been drawn *and engraved*
by Samuel Daniell. However, it is generally
believed that they were in fact engraved by
William, who was giving his younger brother a
helping hand in his career.) William Daniell
made a major contribution to the English travel

DANIELL, Thomas. One of twelve plates from 'Views in Calcutta', 1786-8.

DANIELL, Thomas and William. A plate from 'Oriental Scenery: An Hindoo Temple, at Deo, in Bahar'.

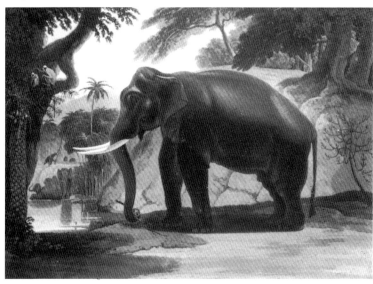

DANIELL, William. 'The Elephant', from S. Daniell's *Scenery of Ceylon*, 1808.

book. In the 1820s, he engraved some very fine marine subjects, usually found uncoloured and printed in dark blue.

'Oriental Scenery' depending on subject, e.g. interiors of temples £80-£120 col.; views of Calcutta £300-£500 col.; some of the best subjects up to £600 individually (set of 144 fetched £85,000 June 1994).

'Six Views of London' and *'Six Views of the London Docks'*, 1805, 19¼ x 33¼in/49 x 85cm, e. £800-£1,600 col. and £600-£1,000 col. respectively.

'A Voyage Round Great Britain', 1814-25, 308 pl., 4to., e. £20-£50 col. (complete set col. fetched £19,000 May 1992).

'Twelve Views of Windsor, Eton and Virginia Water', c.1827, obl. fo., e. £200-£400 col. (set fetched £6,200 Nov. 1992).

'African Scenery and Animals' (S. Daniell), 1804, 30 pl., fo., e. £300-£600 col.(set fetched £32,000 June 1993).

'Panoramic Sketch of Prince of Wales Island (now Penang, Malaysia)', after Capt. R. Smith, 1821, 10 pl., 20¼ x 29½in/51.5 x 75cm, set col. fetched £36,000 October 1989.

'Views of the Town of St. George in the Island of Grenada', c.1815, 15¼ x 22½in/39 x 57cm, pair £1,000-£2,000 col.

'The Longships Light-house off the Lands End, Cornwall', 1825, 16 x 22½in/41 x 57cm, £150-£250.

'Thomas Colledge, R.S.C. Surgeon to the British Factory in China, Attending at his Private Ophthalmic Infirmary in Macao', after G. Chinnery, 1834, 21½ x 20¾in/55 x 53cm, £300-£500.

Amongst other works, he executed plates for:
S. Davis' Views in Bootan, 1813, 7 pl., obl. fo., e. £150-£250 col.
R. Smirke's The Adventure of Hunch-Back, 1814, 17 pl., £5-£10.
S. Daniell's Scenery of Ceylon, 1808, obl. fo., e. £200-£300 col. (set of 12 fetched $13,000 June 1990), best subjects (as illustrated) up to £600 col.
W. Wood's Zoography, 1807, 60 pl., Royal 8vo., e. small value.
G. Dance's Profile Portraits, 1814, fo., soft-ground etchings, e. £4-£10.
Colour plate page 29.

DARCIS, J. Louis
fl. late 18th/early 19th century French stipple engraver of decorative and sporting subjects after his contemporaries. He was apparently born in Paris but was working in London c.1800.

'The Fruits of . . . Early Industry' and *'The Effects of Extravagance . . . '*, after G. Morland and H. Singleton, 1800, 25½ x 20in/64.5 x 51cm, 4 pl., set £900-£1,600 prd. in col.

DARLY (Darley), Matthew fl.1741-92
Draughtsman, etcher, engraver and publisher of caricatures after his own designs and those of amateur draughtsmen of the day. He kept a shop in the Strand which sold artists' materials and formed a partnership with his wife Mary. Since many of the plates are signed 'M. Darly', it is impossible to ascertain which one was the engraver. He is best known for his series of 'Macaroni' prints published between 1771 and 1773.

'Macaroni's Dressing Room', 9¾ x 13¾in/25 x 35cm, £100-160.
Other caricatures generally £20-£60.
Bookpl. small value.

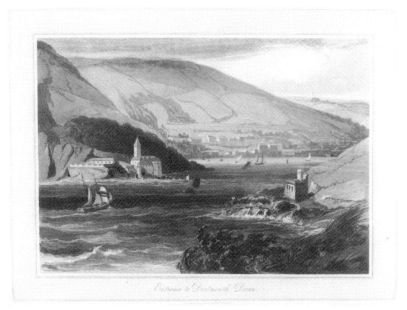

DANIELL, William. A plate from 'A Voyage Round Great Britain: Entrance to Dartmouth, Devon'.

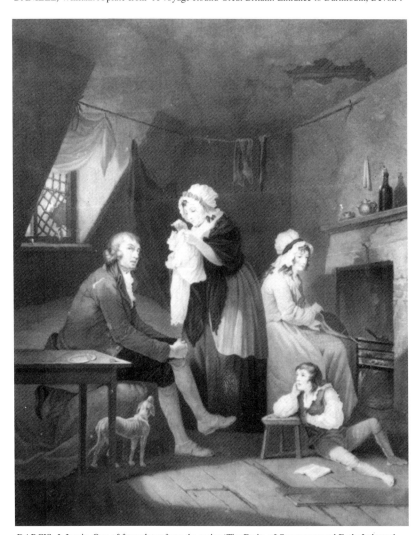

DARCIS, J. Louis. One of four plates from the series 'The Fruits of Oeconomy and Early Industry' and 'The Effects of Extravagance and Idleness', after G. Morland and H. Singleton, 1800. See also colour plate, page 30.

DAVY, Henry. A typical architectural view.

DAUM, Jan, A.R.E. fl.1920s
Etcher mainly of landscapes. He was of Dutch origin and lived in London and Sussex.
£15-£50.

DAVENPORT, Samuel 1783-1867
Line engraver of small portraits and book illustrations after his contemporaries. Born in Bedford, he moved with his family to London and was apprenticed to C. Warren (q.v.). He was one of the first to engrave on steel.
Small value.

DAVEY, (DAVY) Henry
fl. early/mid-19th century
Architect, draughtsman, etcher, lithographer and publisher of views around Ipswich where he worked. His etchings of architectural remains are in the style of J.S. Cotman (q.v.).
'Eastern Union Railway as Seen from the South Bank of the Cut through Sir Robert Harland's Wood, Wherstead, Suffolk, Looking Towards the River Orwell and Ipswich', 7 x 10½in/18 x 26.5cm, etching, £40-£60 col.
'Antiquities of Suffolk', 1827, 70 pl., e. £10-£20.

DAVEY, H.F. fl. late 19th century
Wood engraver of magazine illustrations.
Small value.

DAVEY, William Turner 1818-c.1890
Mixed-method engraver of sentimental and sporting subjects and portraits after his contemporaries. He was a pupil of C. Rolls (q.v.) and worked in London.
'Cerito (greyhound) with Catch', after R. Ansdell, 1856, 18 x 27½in/45.5 x 70cm, £300-£500.
'The Pytchley Hunt', after W. Barraud, 1852, 17 x 29in/43 x 73.5cm, £300-£600.
'Shooting Black Game', after R. Ansdell, 1852, 11¾in x 22¼in/30 x 57cm, £120-£250.
Sentimental subjects mostly £15-£40, but 'Eastward Ho!', and 'Home Again', after H. O'Neill, 1860-1, 32 x 22in/81.5 x 56cm, pair £300-£600.
'The Four Seasons', after W.H. Hopkins, 1865, 20¼ x 31in/51.5 x 79cm, e. £100-£150, set £600-£800.
'A Signal on the Horizon', after J.C. Hook, 1871, £100-£150.
Portraits £8-£25.
Add more if in fine contemporary frame.

DAVIES, S.T. fl. mid-19th century
Line engraver of small topographical bookplates after his contemporaries.
Swiss and American views £5-£10.
Others small value.

DAVIS, Herbert fl. mid-19th century
Mezzotint engraver of portraits and sporting subjects after his contemporaries.
'The Highland Drovers' Departure for the South', after E. Landseer, 1859, 25¾ x 35½in/65.5 x 90cm, £200-£400.
'Visc. R. Jocelyn', after F. Grant, 1857, 23¼ x 13¾in/59 x 35cm, £150-£300.
'Capt. S. Osborn', after S. Pearce, 1861, 9 x 11½in/23 x 29cm, £20-£50.
Pl. for J.F. Herring's British Horses, 1860, 15 x 11in/38 x 28cm, £120-£200.
Add more if in fine contemporary frame.

DAVIS, John Scarlett 1804-1844
Draughtsman and lithographer of landscapes, architectural views, portraits and figure studies. Born in Hereford, he studied at the R.A. and at the Louvre. He produced a few small etchings.
14 views of Bolton Abbey, 1829, obl. fo., e. £8-£12.
Small etchings, 1827, e. £5-£15.

DAVIS, William David Brockman, A.R.E.
b. 1892
Birmingham-born etcher, first of architectural views and later of finely-worked still-lifes of marine objects.
£40-£90.

DAVIS, William Henry fl. mid-19th century
Draughtsman and lithographer of large animal subjects, particularly prize oxen and sheep.
Livestock generally £300-£600 col.
'Portrait of a Horse in a Stable', £80-£160 col.

DAVISON, W fl. early 19th century
Northumberland publisher of crudely engraved caricatures and decorative subjects which bear no artist's or engraver's name.
£10-£40 col.

DAVY, H. *see* **DAVEY, H.**

DAWE, George, R.A. 1781-1829
Portrait painter who early in his career engraved a few mezzotints, mainly portraits, after his contemporaries. He was the son of P. Dawe (q.v.) who taught him to engrave, and the brother of H.E. Dawe (q.v.). He spent a large part of his career as Court Painter to the Tsar of Russia.
'A Lioness that Whelped in the Tower of London', after J. Graham, 1801, 24 x 18½in/61 x 47cm, £250-£400.
'Miss Searle, "The Innocent"', HL, after J. Reynolds, 15 x 11in/38 x 28cm, £40-£80.
'Benjamin West', HL, after A. Robertson, 14 x 9½in/35.5 x 24cm, £60-£140.
'James Northcote', after himself, 1803, 18 x 13¾in/46 x 35cm, £100-£150.
Other portraits: WLs £60-£120; HLs £15-£40. CS.

DAWE, Henry Edward 1790-1848
Painter and mezzotint engraver of portraits and decorative subjects after Old Master painters and his contemporaries. He was born in London, the son of P. Dawe (q.v.) who taught him engraving, and the brother of G. Dawe (q.v.), some of whose paintings he engraved.
'Genevieve' (Kemble playing to Miss O'Neill), after G. Dawe, 26¾ x 16¼in/68 x 42.5cm, £80-£120.
Other portraits £5-£20.
Pl. after Old Masters small value.
Decorative subjects, e.g. 'The Bee's Wing' and 'The Black Draught', after H. Sharp, 1824, 10½ x 8¼in/26.5 x 21cm, pair £40-£60.
Pl. for J.M.W. Turner's Liber Studiorum, £80-£200.
Pl. for G. Arnald's Picturesque Scenery on the River Meuse, 1835, fo., £20-£50.

DAWE, Philip c.1750-1809 or later
Mezzotint engraver of decorative subjects, caricatures and portraits after his contemporaries. He studied under H. Morland, was a friend of the latter's son, George, and

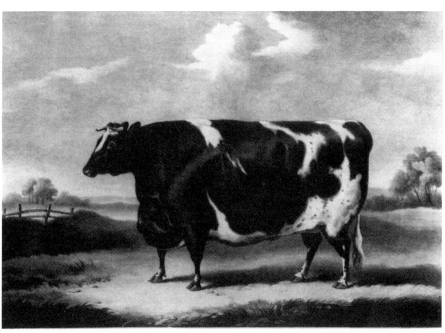

DAVIS, William Henry. One of this artist's livestock subjects.

engraved plates after both artists.
Caricatures £150-£350.
'Children Fishing' and 'Children Gathering Blackberries', after G. Morland, 19¼ x 14in/49 x 35.5cm, pair £900-£1,400 prd. in col.
'Connoisseur with Tired Boy', after H. Morland, 1773, 19¾ x 14in/50 x 35.5cm, and other domestic subjects after the same, £80-£200.
'Evening at Rest', after S. Gilpin and G. Barret, 1791, 17¼ x 21¼in/44 x 54cm, £200-£300 col.
'Lambert's Leap', after R. Pollard, 1786, 25½ x 18in/64.5 x 45.5cm, £80-£120.
'Sir Charles Hardy, Governor of New York', TQL, after T. Hudson, 12½ x 9¾in/32 x 25cm, £200-£400.
'John Carrick', after A.L. Brandt, 1785, 13¾ x 9¾in/35 x 25cm, £10-£25.
'Master Murray', after J. Graham, 1786, 20¼ x 14in/ 51.5 x 35.5cm, £140-£200 prd. in col.
CS.

DAWSON, Alfred fl. mid-late 19th century
Painter and etcher of landscapes and topographical views mainly after his own designs. He contributed plates to *The Portfolio.*
Small value.

DAWSON, Mrs. Lucy d.1958
Painter and etcher mainly of canine subjects. She illustrated several books on dogs.
£40-£90.

DAWSON, Montague J. 1894-1973
Painter of contemporary and period marine subjects. Born in Chiswick, he was the son of a sea captain and served in the Navy before turning to painting. He did not make prints himself but allowed publishers to reproduce his paintings in colour, signing individual impressions.
£150-£250.

DAWSON, Nelson, R.E. 1859-1941
Painter and etcher of marine subjects and coastal views. He was born in Lincolnshire and lived in London.
£30-£70.

DAY, William I 1764-1807
Amateur painter, geologist and ?aquatint engraver of landscapes and topographical views. He worked in London as a linen draper and made sketching tours with J. Webber (q.v.), by whom he was influenced. Later, he retired to Sussex.
Views in North Wales, 1810, 4 pl., 13¼ x 17¼in/33.5 x 44cm, e. £60-£80 col.

DAY, William II 1797-1845
Founder of a firm of lithographers and lithographic printers with L. Haghe (q.v.). After Day's death, it became known as Day & Son and later Vincent Brooks, Day & Son after a former employee bought it. Many mid-Victorian prints were lithographed by the firm and these are either signed by the professional lithographer himself or are anonymous: Day & Son lith.
For prices, refer to relevant lithographer. If anon. see price range under V. Brooks. Prices for many topographical pl. from books of fo. size will depend on place, and range from £10 to, for example, £100-£200 col. for South American or Australian views.

DAYES, Edward 1763-1804
Eminent watercolourist of landscapes and

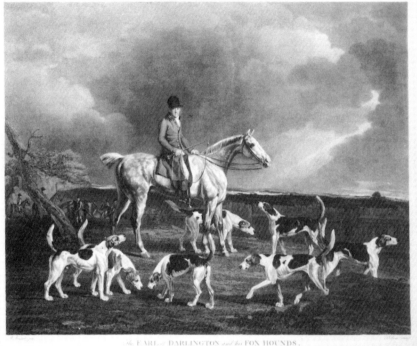

DEAN, John. 'The Earl of Darlington and Foxhounds', after B. Marshall.

topographical views, mezzotint and aquatint engraver of decorative subjects after his contemporaries. Born in London, he was a pupil of W. Pether (q.v.). Many of his watercolours were engraved. He committed suicide in 1804.
'Juvenile Navigation' and 'Children Nutting', after G. Morland, 1788, 17 x 22in/43 x 56cm, mezzo., pair £1,000-£1,600 prd. in col.
'A Visit to the Grandfather', after J.R. Smith, 1790, 22 x 16in/56 x 41cm, mezzo., £300-£500 prd. in col.

DEAKIN, A. fl. late 19th century
Etcher of landscapes. He contributed to *English Etchings.*
Small value.

DEAKINS, Cyril Edward, A.R.E. b.1916
Painter, etcher and wood engraver of landscapes. Born in Birmingham, he lived in London, Hertfordshire and Essex.
Small value.

DEAN, John 1754-1805 or soon after
Mezzotint and stipple engraver of portraits and decorative subjects after his contemporaries and Old Master painters. Born in London, he was a pupil of V. Green (q.v.).
'Cardplayers', after J. Opie, 1786, 16 x 21in/40.5 x 53.5cm, mezzo., £200-£400.
'Mrs. Hoppner (The Flower Girl)', HL, after J. Hoppner, 1785, 14 x 10in/35.5 x 25.5cm, mezzo., £60-£140.
'Elizabeth, Countess of Derby', almost WL, after G. Romney, 1780, 20 x 14in/51 x 35.5cm, mezzo., £300-£500.
'Valentine's Day', after G. Morland, 1787, 20 x 14in/51 x 35.5cm, mezzo., £300-£500 prd. in col.
'St. Anthony and the Infant Jesus', after Murillo, 14 x 20in/35.5 x 51cm, mezzo., £5-£15.
'The Earl of Darlington and Foxhounds', after

B. Marshall, 1805, 21¼ x 25¼in/54 x 64cm, stipple, £400-£700 prd. in col.
'James, Earl of Abercorn', WL, after T. Gainsborough, 1778, 24½ x 14¾in/62 x 37.5cm, mezzo., £150-£250.
'William Cantfield', HL, after J. Russell, 1777, 13½ x 10in/34 x 25.5cm, mezzo., £15-£40.
CS.

DEAN, T.A. fl. early 19th century
Line engraver of small bookplates, including portraits and decorative subjects after Old Master painters and his contemporaries.
Small value.

DEBAINES, Alfred Louis Brunet *see* **BRUNET-DEBAINES, A.L.**

DEBLOIS, Charles Theodore b.1851
French etcher of sentimental and genre subjects after his French and British contemporaries as well as after Old Master painters.
Small value.

DEEBLE, William fl. early/mid-19th century
Line engraver of small bookplates including landscapes and architectural views after his contemporaries.
Small value.

DEEVES, F. fl. late 18th century
Line engraver of bookplates after his contemporaries.
Small value.

DELAMOTTE, George Orleans fl. c.1830
Landscape painter and drawing master. He was the brother of W.A. Delamotte (q.v.) and the draughtsman and lithographer of 'Views of Magna Carta Island'.
'Magna Carta Island', c.1830, 7 pl., obl. 4to., e. £10-£12 col.

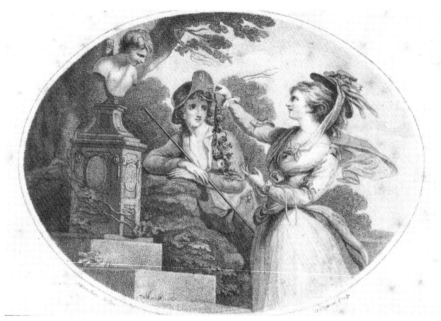

DELATRE, Jean Marie. 'May Day or the Happy Lovers', after Saunders, 1783.

DE LOUTHERBOURG, Philip Jacques. One of six plates from 'Première Suite de Soldats'.

DELAMOTTE, William Alfred 1775-1863
Watercolourist and etcher of landscapes and topographical views. Born in Weymouth, he studied under B. West (q.v.), and worked as a drawing master, firstly in Oxford and subsequently at the Royal Military Academy, living for many years around Sandhurst. He experimented with lithography, and the first two items below are examples of his early lithographs.
'Landscape with Small Stream, Cottage on Left', 1801, 6½ x 9½in/16.5 x 24cm, £100-£140; on original mount £200-£400.
'Resting, Men and Dogs Under a Big Tree', 1802, 9¼ x 12¾in/23.5 x 32.5cm, £100-£140; on original mount £200-£400.
'Studies of Trees', 1804-6, 18½ x 14in/47 x 35.5cm, soft-ground etchings, e. £30-£70; working proof of unpubl. pl. £100-£160.
'Twelve Views of the Overland Journey to India', after F. Broughton, ?1847, fo., tt. litho., e. £20-£30.
Man Cat.

DELATRE (Delattre), Jean Marie
1746-1845
French line, stipple and aquatint engraver of decorative subjects and portraits after his contemporaries. Born at Abbeville, he was brought to England by W.W. Ryland (q.v.) and became F. Bartolozzi's (q.v.) principal assistant, engraving round or oval 'furniture' prints after A. Kauffmann, F. Wheatley, W. Hamilton, etc.
'Sarah Bates', after Kauffmann, 1784, oval, 12¼ x 9¼in/31 x 25cm, £60-£120.
'May Day or The Happy Lovers', after Saunders, 1783, oval, 6 x 8in/15 x 20cm, £80-£160 prd. in col.
'Indiscretion' and 'Surprise', after F. Wheatley, eng. with Marcuard, 1789, 14½ x 12in/37 x 30.5cm, pair £250-£400 prd. in col.
'Necessity, Frugality, Choice, Penury', after P. Pasquin, 1796, 9 x 10¾in/23 x 27cm, aq., set £120-£160 col.
Add more if in fine contemporary frame.
Bookplates small value.

DELEGAL, James fl. late 18th century
Mezzotint engraver of portraits after his contemporaries. He seems to have worked in London. *£15-£50.*
CS lists 2 pl.

DELEU, F. fl. early 19th century
Etcher and line engraver of small bookplates after his contemporaries, mainly portraits.
Small value.

**DE LOUTHERBOURG, Philip Jacques
(James), R.A.** 1740-1812
Eminent French painter of battle and marine subjects and landscapes who etched and aquatinted a few plates. Born in Strasbourg, he came to England in 1771 where he worked for some years for David Garrick as a scene painter at Drury Lane and Covent Garden. He later settled in Chiswick. Many of his paintings were engraved by professionals.
Macaroni prints e. £60-£120.
'Fat Man with Dog', 3½ x 2¼in/9 x 6cm, aq., £60-£100.
'Maronites', 8¾ x 7in/22.5 x 17.5cm, 4 aq., e. £20-£60.
'Première Suite de Soldats', 6 etchings, 4¾ x 3½in/12 x 8.5cm, e. £40-£90.
Bibl: Portalis, R. and Beraldi, H., *Les Graveurs du Dix Huitième Siècle*, Paris.

DENT fl. mid-/late 18th century
Line engraver of small bookplates after his contemporaries.
Small value.

DENT, Robert Stanley Gonell, A.R.E. b.1909
Monmouth watercolourist and etcher of landscapes and rural subjects. He was a pupil of M. Osborne and R.S. Austin (qq.v.) at the R.C.A. and lived in Gloucestershire.
£30-£70.

DENT, William fl. late 18th century
Draughtsman and line engraver of caricatures.
£10-£30.

DENTON, Charles fl. mid-19th century
Draughtsman and lithographer of 'Abergavenny Steeple Chase'.
'Abergavenny Steeple Chase', 1853, 4 pl. 15¾ x 20½in/40 x 52cm, set £300-£500 col.

DESMAISON, Pierre Emile 1812-1880
French lithographer of portraits and decorative subjects after his French and English contemporaries as well as his own designs. He was born in Paris.
Small value.

DETMOLD, Edward Julius, A.R.E.
1883-1957
DETMOLD, Charles Maurice, A.R.E.
1883-1908
London illustrators and etchers of natural history subjects. Until Charles committed suicide in 1908, the twins worked closely together on etchings which were much influenced by Japanese colour prints, and also on illustrations to *Pictures from Birdland* and Kipling's *Jungle Book*. Edward stopped etching in 1910 but started again in the 1920s producing plates with an Oriental theme as well as bird and animal subjects. Apart from etching, he also worked in drypoint and *aquatint*.
Earlier bird and animal subjects £60-£200.
Later Oriental subjects £30-£100.
Prices increase further for good subjects in col. e.g. 'The Parrot' prd. in col., edn. of 12, 19 x 14½in/48 x 37cm, fetched £500 March 1990.
Bibl: Dodgson, C., 'C.M. and E.D.', *P.C.Q.*, 1922, IX, p.373.

DEVILLE, Maurice fl. late 19th century
French etcher of sporting and sentimental subjects after his contemporaries. Born at Bayonne, he was a pupil of T.N. Chauvel and L. Gaucherel (qq.v.).
Small value.

DE WILDE, Samuel fl. 1748-1832
Portrait painter who etched a few plates signed 'Paul'.
£10-£30.

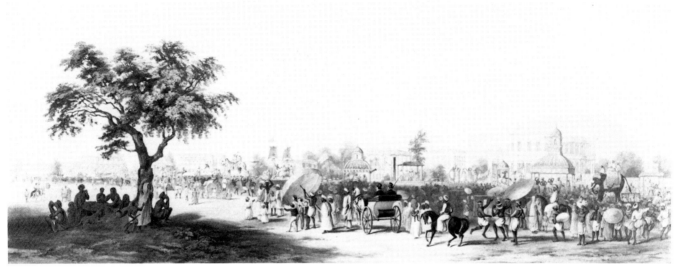

DICKINSON, Lowes Cato. A plate from Sir C. D'Oyley's *Views of Calcutta*, 1848, executed with W. Robert Dickinson.

DIBDIN, Ann fl.1803
Draughtswoman, etcher and aquatint engraver of illustrations to *The Professional Life of Mr. Dibdin* (autobiography of the famous dramatist and song writer and the illustrator's father).
Pl. for The Professional Life of Mr. Dibdin, *1803, 60 pl., 8vo., small value.*

DIBDIN, Thomas Coleman 1810-1893
Surrey-born draughtsman and lithographer of landscapes and architectural views after his own designs and those of his contemporaries.
Italian and English landscapes, after A.W. Callcott, 1847, 26 tt. pl., e. £15-£40.
Pl. for L.J. Wood's The Hall and Library of Lincoln's Inn, *c.1830, 7 tt. pl., obl. fo., e. £60-£100.*
Pl. for Capt. J.M. Carter's Select Views of the Rock and Fortress of Gibraltar, *1846, 14 tt. pl., fo., e. £80-£150.*
Pl. for J. Ferguson's Illustrations of the Rock Cut Temples of India, *1845, 19 tt. pl., fo., £10-£40.*
'Picturesque Illustrations of the Ancient Architecture of Hindoostan', 1848, fo., 23 pl., set £800-£1,200.

DICK, A. fl. early 19th century
Line engraver.
Pl. for P. and M.A. Nicholson's Cabinet Maker, *1826, 4to., small value.*

DICK, Thomas fl. mid-19th century
Etcher and mezzotint engraver.
'Going Out', after T. Black, 1859, 21 x 26in/53.5 x 66cm, £250-£400.
Add more if in fine contemporary frame.

DICKES, W. fl. mid-19th century
Illustrator and publisher who produced a few plates using the G. Baxter (q.v.) process.
Small value.

DICKINSON Bros. *see* **DICKINSON, W.R.**

DICKINSON, Lowes Cato 1819-1908
London painter and lithographer of portraits and sporting subjects after his contemporaries and 18th century painters. He was the son of Joseph Dickinson, a publisher of lithographs, and brother of W.R. Dickinson (q.v.), with whom he worked. He helped found the Working Men's College where he taught drawing with J. Ruskin and D.G. Rossetti. Several of his own paintings were engraved.
'John Booth' (huntsman and hounds), after J. Ferneley, £150-£250.
'Brunette' and 'Fairy' (horses), after E. Landseer, 1843, e. £100-£160.
'A View in Windsor Park' (Queen Victoria and Duchess of Kent driving), after J. Doyle, 1837, £150-£250.
Add more if in fine contemporary frame.
'Celebrated Opera Dancers of Her Majesty's Theatre', after A. Chalon, etc., c.1840, 28 pl., £8-£15.
'Helena, Lady Martin as Antigone', after W. Allan, 23¾ x 18in/60 x 46cm, £8-£15.
'Cardinal Wolsey', after R. W. Buss, 8 x 5in/20 x 13cm, £5-£15.
Pl. for R. R. McIan's Scottish Clans, *1845-7, fo., e. £20-£50 col.*
Pl. for Hon. Miss E. Eden's Portraits of the Princes and People of India, *24 pl., fo., £40-£70 col. (set col. fetched £6,000 in special Indian sale May 1995).*
Pl. for Sir C. D'Oyley's Views of Calcutta, *executed with W. R. Dickinson, 1848, 26 tt. pl., fo., e. £60-£120 col. (set col. fetched £3,500 May 1995).*

DICKINSON, William 1746-1823
Mezzotint and stipple engraver of portraits, decorative subjects and caricatures mainly after his contemporaries. Born in London, he began

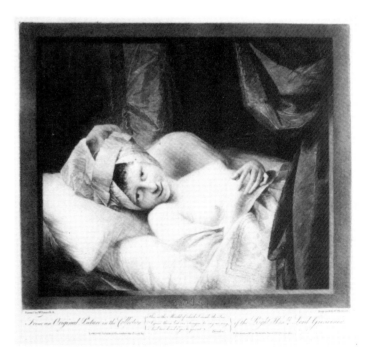

DICKINSON, William. 'Lydia', after M.W. Peters, 1776.

DICKINSON, William. 'Mrs. Pelham', after J. Reynolds, 1775.

DIGHTON, Denis. 'John Bellingham', 1812.

to publish his own works in 1773, setting up in partnership with T. Watson (q.v.) in 1779. After Watson's death, he concentrated more on publishing than engraving. He later moved to Paris where he produced some prints and eventually died.

Mezzotints:

'Mrs. Pelham', after J. Reynolds, 1775, 24¾ x 14¼in/63 x 38.5cm, £200-£400.

'W. Parsons and J. Moody as Varland and Major O'Flaherty', after J. Mortimer, 1776, 18 x 21¾in/45.5 x 55cm, £200-£400.

'William Preston', HL, after J. Stuart, 1789, £15-£40.

'Lord Robert Manners', WL, after J. Reynolds, 1783, 24½ x 15in/62 x 38cm, £80-£140.

'Lydia', after M. W. Peters, 1776, 9½ x 13in/24 x 33cm, £200-£300.

'The Farrier' and 'The Pedlar', after F. Wheatley, 19½ x 27in/49.5 x 68.5cm, pair £400-£600 col.

Stipples:

'The Propagation of a Lie' and 'A Long Minuet as Danced at Bath', two panoramas after H.W. Bunbury, 1787, 8½ x 68½in/21.5 x 174cm, e. £150-£250.

'Of Such is the Kingdom of God', after M.W. Peters, 1784, 22½ x 15¾in/57 x 40cm, £80-£120 prd. in col.

'Dinner, Symptoms of Eating and Drinking' and 'Breakfast, Symptoms of Drowsiness', after H.W. Bunbury, 1794, 14 x 17in/35.5 x 43cm, pair £400-£600 prd. in col.

'Billiards', after H.W. Bunbury, 1780, 10 x 14½in/25.5 x 37cm, £60-£100.

'The Country Club', after H.W. Bunbury, 1788, 13½ x 18½in/34.5 x 47cm, £30-£60.

'Patience in a Punt', no. 1 and no.2, 1792, 11¾ x 17in/30 x 43cm, pair £200-£400.

CS.

DICKINSON, W. Robert fl. mid-19th century
Lithographer of topographical views after his own designs and those of his contemporaries. He was the son of Joseph Dickinson, a publisher of lithographs, and brother of L.C. Dickinson (q.v.) with whom he worked under the name

Dickinson Bros., a firm of lithographers, printers and publishers.

'Views of St. Peter's Church, Brackley', W.R.D. drew all and litho. 3 of 5 pl., 1841, obl. fo., e. £8-£15 col.

'The Landing of H.M. the Queen in Alderney', after P.J. Naftel, by Dickinson & Co., 1854, 14½ x 22½in/37 x 57cm, £300-£500 col.

Pl. for Scotland Delineated, *after various artists, 1847-54, fo., tt. pl., e. £10-£20.*

Pl. for Sir C.D'Oyley's Views of Calcutta, *executed with L.C. Dickinson, 1848, 26 tt. pl., fo., e. £60-£120 col. (set col. fetched £3,500 May 1995).*

'Sketches in North America and the Oregon Territory', after Capt. H. Warre, 1848, obl. fo., set of 16 tt.pl.col. fetched £4,000 October 1988.

DICKSEE, Herbert Thomas, R.E. 1862-1942
London painter, etcher and mezzotint engraver of animal subjects, particularly lions, and genre and historical subjects after his own designs and those of his contemporaries. He was the brother of Frank Dicksee, several of whose works he engraved. He studied at the Slade School and later taught drawing at the City of London School.

Lge. pl. mostly £100-£300, but 'The Destroyers', 1904, 17½ x 28in/44.5 x 72.5cm fetched £450 Feb. 1996.

Smaller unsigned pl., e.g. for The Portfolio, *small value.*

DICKSEE, John Robert 1817-1905
London painter and lithographer of portraits and sentimental subjects after his own designs and those of his contemporaries.

'Outward Bound, The Quay of Dublin' and 'Homeward Bound, The Quay of New York', after T. Nichol, 1854, 12 x 7in/30.5 x 18cm, pair £150-£250 col.

Portraits £3-£12.

DICKSON, J. fl. mid-19th century
Lithographer of topographical views and portraits after his contemporaries and his own designs.

Pl. for J. LeCapelain's Panoramic Views of Rio

de Janeiro, *c.1848, 11 tt. pl., obl. fo., e. £100-£250 col.*

Portraits small value.

DIGBY, K. fl. early 19th century
Draughtsman and lithographer of crudely drawn architectural views in France.

Small value.

DIGHTON, Denis 1792-1827
Draughtsman, lithographer and etcher of figure subjects and costumes; the military plates after his own designs and the rest after his contemporaries. Born in London, a son of Robert Dighton (q.v.), he studied at the R.A. Schools and was patronised by the Prince of Wales who appointed him Military

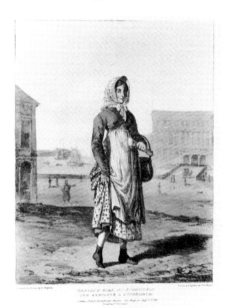

DIGHTON, Denis. 'Servant Girl at Stockholm', from Svedman's *Costume of Sweden*, 1823.

DIXON, Robert. One of thirty-six plates from 'Picturesque Norfolk Scenery: Cottage at Wymondham', 1810-11.

DIXON, John. 'Garrick as Richard III', after N. Dance, 1772.

DIGHTON, Richard. 'A Gentle Ride from Exeter'Change to Pimlico', 1812.

Draughtsman in 1815. He died in Brittany.
'New Costume of the British Cavalry', 1812-13, 4 pl., 9½ x 14½in/24 x 37cm, etchings, e. £80-£140 col.
'Heavy and Light Cavalry', 1825, 9½ x 9¼in/24 x 23.5cm, litho., e. £80-£140 col.
Pl. for K.V. Svedman's Costume of Sweden, *1823, 22 pl., fo., litho., e. £50-£100 col.*
Genre subjects, 1821, obl. 4to., litho., e. £8-£15 col.
Costume pl. and figures for Capt. A. de C. Brooke's A Winter in Lapland and Sweden, *1827, 4to., tt. litho., small value.*
A few portrait caricatures in the style of Robert Dighton, e. £20-£50 col.
'John Bellingham', 1812, £10-£20 col.
Bibl: Hake, H.M., 'Dighton Caricatures', *P.C.Q.*, 1926, XIII, pp. 136 ff. and 237 ff.

DIGHTON, Richard 1795-1880
London draughtsman and etcher of caricatures. He was the son of Robert Dighton (q.v.) and continued to produce portrait caricatures in the same style as his father after the latter's death in 1814 until 1828.
'A Gentle Ride from Exeter 'Change to Pimlico', 1812, £30-£60 col.
Boxers £60-£160.
Others £30-£100.
Bibl: Hake, H.M., 'Dighton Caricatures', *P.C.Q.*, 1926, XIII, pp. 136 ff. and 237 ff.

DIGHTON, Robert 1752-1814
Painter of portraits, caricatures and decorative subjects. He worked in London and many of his paintings were engraved anonymously in mezzotint and published by C. Bowles (q.v.). He started etching his own caricatures late in life and began his well-known series of humorous portraits in the 1790s. These were imitated and continued by his son Richard Dighton (q.v.). He achieved a certain notoriety when he was discovered to have taken some Rembrandt etchings from the British Museum. These impressions bear his collector's mark of a brush and palette.
£30-£100 col.
Bibl: Hake, H.M., 'Dighton Caricatures', *P.C.Q.*, 1926, XIII, pp. 136 ff. and 237 ff.
Rose, D., *Life, Times...of R.D....and...Sons*, 1981, Hove.

DIGHTON, T. fl. early 19th century
Lithographer of topographical views after his contemporaries.
Views of St. Leonard's, after 'J.B.', 1829, 11 pl. with V. Bartholomew, obl. 4to., e. £20-£30 col.

DIXON, Frederick Charles b.1902
Etcher of landscapes, townscapes and genre scenes.
'Off to the Wedding', 1928, 10 x 7¼in/25.5 x 18.5cm, and others mostly £80-£160.

DIXON, John c.1740-c.1801
Irish mezzotint engraver of portraits and decorative subjects after his contemporaries. He was born in and studied in Dublin but had moved to London by 1765. He later retired after marrying a rich woman.
WL portraits:
'Mary Duchess of Ancaster', after J. Reynolds, 24½ x 15in/62 x 38cm, £200-£400.
'William John Earl of Ancrum', after S. Gilpin and R. Cosway, 1773, 23¼ x 20¼ in/60 x 51.5cm, £100-£150.
'Omdut il Mulk, Nabob of Arcot', 1771, 24¼ x 20¼in/61.5 x 51.5cm, £200-£300.
'Garrick as Richard III', after N. Dance, 1772, 25 x 15¾in/63.5 x 40cm, £250-£350
HL portraits £15-£50.
'A Tigress', after G. Stubbs, 1773, 19 x 23in/48 x 58.5cm, £700-£1,400.
'Ludicrous Operator, or Blacksmith turned Tooth-Drawer', after J. Harris, 1768, 12½ x 10in/32 x 25.5cm, £200-£400.
'The Oracle Representing Britannia, Hibernia, Scotia and America Assembled to Consult the Oracle on the Present Situation of Public Affairs', after Dixon, 21 x 23in/53.5 x 58.5cm, v. rare, £400-£700.
CS.

DIXON, Robert 1780-1815
Norwich School painter and soft-ground etcher of landscapes and architectural views. He was born in Norwich where he painted scenes for the theatre and taught drawing.
'Picturesque Norfolk Scenery', 1810-11, 36 pl., e. £10-£25.

DOBBIE, Thomas fl. mid-19th century
Line engraver of small bookplates including architectural views, sporting subjects, etc., after his contemporaries.
Sporting subjects £5-£8.
Others small value.

DOBIE, James b.1849
Scottish etcher of genre subjects and period pieces after his contemporaries, particularly W. Dendy Sadler. He was born in Edinburgh.
Pl. after W. Dendy Sadler £20-£80.
Others £5-£20.

DODD, Francis. 'St. Martin's-in-the-Strand'.

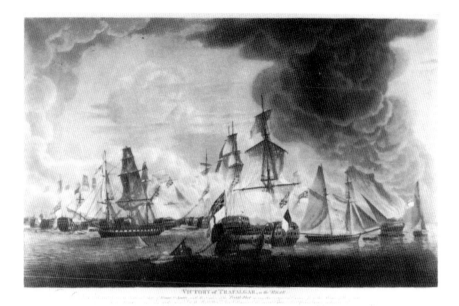

DODD, Robert. One of four aquatints from 'Victory of Trafalgar: In the Rear'.

DODD, Francis, R.A., R.W.S. 1874-1949
Painter and drypoint etcher mainly of architectural views and portraits. Born in Holyhead, he studied in Glasgow, travelled on the Continent and lived in Manchester and London. His architectural views were influenced by his friend, M. Bone (q.v.) and are close in style to those of H. Rushbury (q.v.).
'Strand with Sky', 1916, 13¾ x 10¼in/35 x 26cm, £200-£400.
Others £50-£150.
Bibl: Schwabe, R., 'F.D.', *P.C.Q.*, 1926, XIII, pp. 249 and 369.

DODD, Robert 1748-1816
Painter, etcher and aquatint engraver of marine and sporting subjects and topographical views after his own designs and those of his contemporaries. He often worked in conjunction with other engravers, aquatinting plates which they had etched or engraved in line, and he published many of his own prints.
'Duck, Partridge, Pheasant, Woodcock and Snipe Shooting', after J. Ibbetson, 1790, 12 x 14½in/30.5 x 37cm, e. £300-£400 col.
'A Mad Bull', after G. Morland, 1789, 13¼ x 16¾in/34 x 42.5cm, £120-£160 col.
'A Squadron Standing Along a Coast Under an Easy Sail' and 'A Squadron Under a Press of Sail Chasing to Windward', 1793, 17½ x 27½in/44.5 x 70cm, pair £800-£1,200 col.
'Grey Diomed', after Sartorius, 1792, 18 x 22in/45.5 x 56cm, £400-£600 col.
'British and American Steamships Under Way', 11 x 21in/28 x 53.5cm, rare, £500-£800 col.
'Battle of the Nile', 1799, 4 pl., 17½ x 28in/44.5 x 71cm, set £1,600-£2,600 col.
'Victory of Trafalgar', 4 aq., set £1,600-£2,600 col.
Other lge. marine subjects £400-£600 col.
London squares, after E. Dayes, eng. with R. Pollard (q.v.), 1789, 18 x 21¼in/45.5 x 55.5cm, e. £300-£500.
'Travellers Returning Home', after S. Rosa, c.1785, 19¼ x 25½in/49 x 65cm, £25-£35.
Pl. for Rev. J. Gardnor's Views Taken On and Near the River Rhine, 1788, 33 pl. etched by W. Ellis (q.v.), fo., e. £15-£50.

'Mutiny of the Bounty' after Dodd, 1790, 16 x 26in/40.5 x 66cm, £600-£1,000 prd. in col.

DOLBY, C.T. fl. mid-19th century
Lithographer of topographical views after his contemporaries.
'Linchden Abbey', after S. Prout, for Scotland Delineated, 1847-54, fo., £10-£20.

DOLBY, Edwin Thomas fl. mid-19th century
Draughtsman and lithographer of railway and naval subjects and architectural views after his own designs and those of his contemporaries. He lived in London.
'Views of the Abbey of Glastonbury', c.1830, 9 pl., fo., e. £6-£12.
'Iron Steam Yacht Peter Hoff', after T.S. Robins, 1850, 17¾ x 23in/45 x 58.5cm, £300-£500 col.
'The Lickey Inclined Plane' (Birmingham and Gloucester Railway), 14¼ x 15½in/37 x 39cm, tt. pl., £300-£400 col.
'Defford Bridge Designed to Carry the Birmingham and Gloucester Railway Over the River Avon, Worcestershire', 1839, 11¾ x 16¼in/30 x 41.5cm, tt. pl., £200-£350 col.
'Dolby's Sketches in the Baltic', 1854, fo., 17 pl., set £400-£800.

DOLBY, J. Edward Adolphus
fl. mid-19th century
Draughtsman and lithographer of landscapes and topographical views.
Six views of Eton College, c.1839, fo., tt. pl., set £200-£400.
'Prague Illustrated', 1845, fo., 9 tt. pl., e. £20-£50
Views in Italy, c.1840, 9¾ x 7¾in/24.5 x 20cm, e. £10-£20.

DOLLE, William fl. late 17th century
Line engraver of portraits after his contemporaries.
Small value.

DOO, George Thomas 1800-1886
Line and stipple engraver of portraits and historical and decorative subjects after his contemporaries and British 18th century and

Old Master painters. Born in London, he was a pupil of C. Heath (q.v.), and studied at the engraving schools in Paris. He was appointed Historical Engraver to William IV and later to Queen Victoria.
Larger pl., e.g. 'John Knox Preaching Before the Lords of the Congregation', after D. Wilkie, 1838, 21 x 28in/53.5 x 71cm, £30-£100.
Add more if in fine contemporary frame.
Smaller pl. and bookplates small value.

DORIGNY, Sir Nicholas 1657-1746
French line engraver of figure subjects after Old Master painters. Born in Paris, he originally trained as a lawyer, before turning to painting and later engraving. He was invited to England in 1711 to engrave Raphael's cartoons at Hampton Court. He completed the task in 1719 and was knighted for it by George I in 1720. He moved back to Paris in 1724, where he died.
'The History of Cupid and Psyche' and 'The Triumph of Galatea', after Raphael's frescoes in the Farnesina, 12 pl., 16¼ x 26½in/41.5 x 67cm, e. £200-£500 with contemporary gouache col.
Raphael cartoons, 7 pl., fo., e. £15-£50.

DOUGHTY, William c.1750-c.1780
Painter and mezzotint engraver mostly of portraits after his contemporaries. Born in York, he was a pupil of Sir J. Reynolds. He died in Lisbon where he was brought after being captured by the French and Spanish on his way to Bengal. Most of his prints are dated 1779 and were executed after his tuition under Reynolds.
'Samuel Johnson', after J. Reynolds, 1779, 18 x 13in/45.5 x 33cm, £60-£100.
Others £15-£50.
CS.

DOWD, James Henry 1883-1956
Painter and drypoint etcher of figure subjects, particularly children. He lived in London.
£30-£80.
Bibl: Macrae, A., 'An Etcher of Children at Play', *International Studio*, 1926, LXXXIV, p. 64.

DOWNMAN, John. 'Oriental Woman Holding a Torch', 1806.

DOWER, J. fl. early/mid-19th century
Aquatint engraver.
'Palermo, Island of Sicily, Polacca and Provision Boat in a Calm', after J. J. Baugean and G. Webster, 1831, 9¼ x 12¾in/23.5 x 32.5cm, £20-£40 col.

DOWNMAN, John 1750-1824
Well-known portrait painter who made one lithograph.
'Oriental Woman Holding a Torch', 1806, publ. in Specimens of Polyautography, 12½ x 9in/31.5 x 23cm, £200-£300; on original mount £300-£500.
Man Cat.

DOYLE, John ('H.B.') 1797-1868
Irish lithographer of portraits and caricatures. Born in Dublin, he studied under Gabrielli and the miniaturist W. Comerford, and came to London in 1821. After failing as a portrait painter, he began to lithograph and publish portraits of the famous as well as some sporting subjects. He is best known, though, as the caricaturist of 'H.B. Sketches', of which he produced 917 between 1829 and 1851. His caricatures are much inferior in imagery and execution compared to the earlier masters such as Gillray and Rowlandson and catered to Victorian restraint.
'H.B. Sketches': legal themes, e. £10-£30 col.; others £2-£10 col. and uncol.
'Life of the Race Horse', 1822-3, set of 9 pl., 10½ x 14¼in/27 x 36cm, e. £30-£50 (set fetched £1,600 May 1987).
'Mameluke, Winner of the Derby', 1827, 11 x 14in/28 x 35.5cm, £80-£150 col.
Bibl: Everitt's *English Caricaturists*, 1886, pp. 238-276.

D'OYLEY (D'Oyly), Sir Charles, Bt.
 1781-1845
Amateur draughtsman and lithographer of Indian scenes, customs and wild life. Born in Calcutta, he returned to India after being educated in England and had a distinguished career in the East India Company. He was taught drawing by George Chinnery and probably learnt lithography at the Asiatic Lithographic Press in Calcutta. He set up his Behar Amateur Lithographic Press in 1818 and published several 'Scrapbooks' containing his own lithographed drawings. He retired to England in 1838 and finally settled in Italy.
'The Feathered Game of Hindostan', 1828, 12 pl., 4to.; 'Oriental Ornithology', 1829, 12 pl., obl. fo.; both with birds drawn by C.W. Smith, former e. £50-£100 col. (set fetched $6,500 June 1989); latter e. £40-£80 col. (set fetched $3,500 June 1989).
Pl. for 'Scrapbooks' e. £2-£10.

DRAPENTIER (Drapentière), John
 fl. late 17th century
French etcher and line engraver of portraits and frontispieces. He worked in England and later became engraver to the Mint where he produced some commemorative medals.
'Battle of Beachy Head', 1690, 4 x 15¾in/10 x 40cm, £60-£100.
Others £5-£15.

DREVET, Pierre 1663-1738
French line engraver of portraits after his contemporaries. Born in Lyons, he was a pupil of G. Audran and died in Paris. He is included here for his few portraits of English Royalty and nobility.
English subjects £50-£150.
Bibl: Firmin-Didot, A., *Catalogue Raisonné of the Works of the Drevets*, Paris, 1876.

D'OYLEY, Charles. A typical plate for one of his 'Scrapbooks',

DRURY, Alfred Paul Dalou. 'Evening', 1925.

DRISCOLL, O.A. fl. mid-19th century
Lithographer.
Pl. for Costumes of the British Army, after W. Heath, 1840-54, 12¼ x 8½in/31 x 21.5cm, e. £70-£140 col.

DRUMMOND, Malcolm 1880-1945
Painter and etcher of figure subjects. Born in Berkshire, he studied at the Slade and the Westminster School of Art. He was a pupil of W. Sickert (q.v.) and was influenced by him. He joined the Camden Town Group in 1911.
£30-£80.

DRUMMOND, William fl. mid-19th century
Painter and lithographer of portraits.
Athenaeum portraits, 1836, small value.

DRURY, Alfred Paul Dalou, P.R.E. b.1903
Painter and etcher of portraits and rustic scenes. Born in London, he studied at Goldsmiths' College under E. J. Sullivan, M. Osborne and A.C.S. Anderson (qq.v.). His portraits show the influences of Dürer, Rembrandt and A. John (q.v.), while the rustic subjects look back to S. Palmer (q.v.).
Portraits £60-£100.
'Nicol's Farm', 1925, 4½ x 7¾in/11.5 x 19.5cm, £150-£300.
'Evening', 1925, 3 x 4in/7.5 x 10cm, £200-£400.
'September', 1928, 4¼ x 5in/10 x 13cm, £200-£400.
Bibl: 'The Etchings of Graham Sutherland and P. Drury', *P.C.Q.*, 1929, XVI, p.77.

DUBOSC (du Bosc), Claude
 fl. early/mid-18th century
French engraver of religious and military subjects, etc., after Old Master painters and his contemporaries. He came to England in 1712 to assist N. Dorigny (q.v.) in engraving Raphael's cartoons, but after a quarrel he left Dorigny's employ to produce reduced-size versions of this series for the printsellers. He imported other French engravers including B. Baron and H. Gravelot (qq.v.).
Pl. for Campaigns of the Duke of Marlborough, after A. Benoist, 1736-7, 30 pl., 7¼ x 6½in/18.5 x 16.5cm, e. £8-£15; after L. Laguerre, 21½ x 28½in/54.5 x 72cm, e. £100-£180.
'View of a Horse-Match Over the Long Course at Newmarket', after P. Tillemans, 18½ x 45in/47 x 114cm, £800-£1,200.
'Views of Lord Burlington's Garden at Chiswick' after J.M. Rysbrack, 17½ x 26in/45 x 66cm, e. £60-£140.
Raphael cartoons, 7 pl., e. £5-£10.
Small bookplates small value.

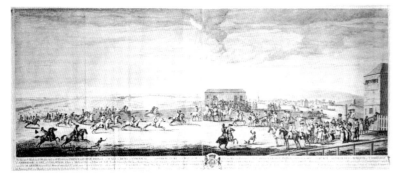

DUBOSC, Claude. 'View of a Horse-Match Over the Long Course at Newmarket', after P. Tillemans.

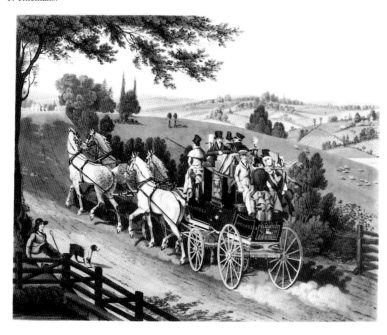

DUBOURG, Matthew. 'Stage Coach' (The Brighton Comet), after J. Pollard, 1822.

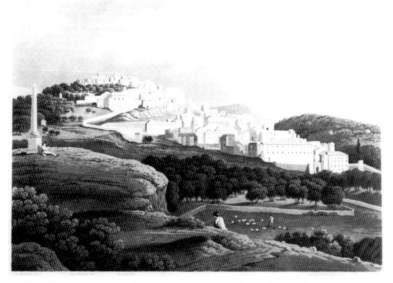

DUBOURG, Matthew. 'General View of the Town of Cora', from J.J. Middleton's *Grecian Remains in Italy*, 1812.

DUBOST, Antoine 1769-1825
French portrait and history painter who produced, in 1818, a series of lithographs after paintings he executed while in England in 1809.
'A View of Newmarket and the Life of the Race Horse', 1818, 11pl. and title page, 19½ x 26½in/49.5 x 67.5cm, e. £2,500-£4,000 (complete set has made £7,000).

DUBOURG, Matthew fl. early 19th century
Aquatint engraver of sporting and military subjects and topographical views after his contemporaries. He worked in London often in conjunction with John Clark (q.v.).
Pl. for J. Jenkins' Martial Achievements, after W. Heath, etched by Clark, 1814-15, 4to., e. £20-£35 col.
Pl. for Capt. T. Williamson's Foreign Field Sports, after various artists, 1814, 4to., e. £20-£35 col.
Pl. for Mornay's Picture of St. Petersburg, eng. with Clark, 1815, 20 pl., fo., views e. £60-£100 col.; vehicles e. £30-£70 col.
Pl. for J.J. Middleton's Grecian Remains in Italy, 1812, 23 pl., fo., e. £50-£80 col.
'Views of the Remains of Ancient Buildings in Rome...', 1820, fo., e. £30-£70 col.
Pl. for Lieut. W. Lyttleton's Views in the Island of Ceylon, 1819, 6 pl., lge. obl. fo., e. £150-£250 col.
'Royal Hunt in Windsor Park; George III Returning from Hunting', after J. Pollard, 1820, 15¼ x 21¼in/40 x 54cm, pair £800-£1,200 col.
'Panoramic View of British Horse Racing', after C. Tomson, with J. Pollard, 1816, 3½ x 243in/9 x 63cm, £800-£1,200 col.
'Foxhunting', after H. Alken, 1813, 4 pl. with J. Clark, 13½ x 17¼in/34 x 45cm, set £1,000-£1,600 col.
'Stage Coach' (The Brighton Comet), after J. Pollard, 1822, 15 x16¼in/38 x 42.5cm, £800-£1,200 col.
'Mail Coach', after J.L. Agasse, 1824, 14¼ x 16 in/37.5 x 42cm, £500-£700 col. Colour plate page 31.
'Storming of Monte Video on Feb. 3 1807', after Lieut. G. Robinson, eng. with Clark, 17 x 26in/43 x 66cm, £600-£1,000 col.
'London Stalls', after J. Pollard, 1822, 4 pl., 9 x 12in/23 x 30.5cm, set £600-£1,200 col. (see col. illustration page 31).
'Shooting', after J. Pollard, 1822, 4 pl., 10½ x 16in/26.5 x 40.5cm, set £1,500-£2,500 col.

DUDLEY, Thomas fl. late 17th century
Etcher and engraver of portraits and bookplates. He was a pupil and imitator of W. Hollar (q.v.).
Pl. for Life of Aesop, after F. Barlow, 1687, e. £8-£20.
Portraits £5-£15.

DUFF, John Robert Keitley, R.E. 1862-1938
Painter and etcher of landscapes and genre subjects. He studied under A. Legros (q.v.) at the Slade and lived in London.
£15-£50.

DUMEE, Ellis James c.1766-1794 or later
Stipple engraver of decorative subjects after his contemporaries. He was of French extraction and worked in London.
'The Fair Seducer', after G. Morland, £200-£300 prd. in col.
'The Love Dream' and 'The Love Letter', after R. Westall, 8½ x 9¼in/21.5 x 25cm, pair £100-£150 prd. in col.

DUNCAN, Andrew 1795-after 1845
Line engraver of small bookplates.
Small value.

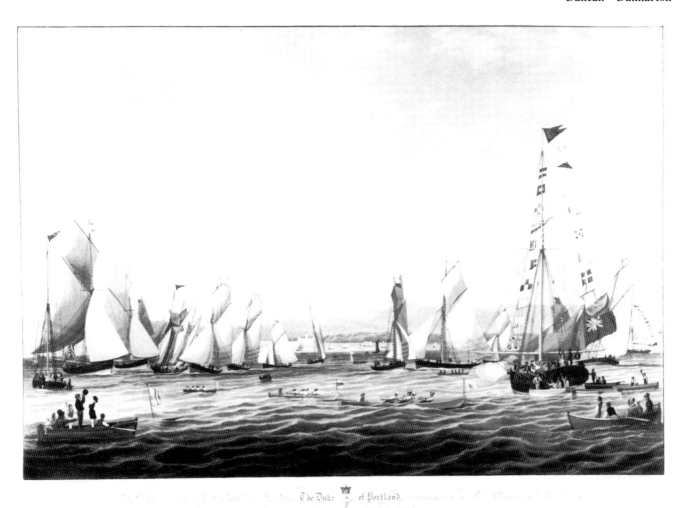

DUNCAN, Edward. 'Regatta of the Royal Northern Yacht Club', after W. Clark.

DUNCAN, Edward, R.W.S. 1803-1882
Watercolourist of landscapes, aquatint engraver and lithographer of marine and sporting subjects and topographical views after his contemporaries. He was apprenticed to R. Havell I (q.v.) from whom he learnt to engrave. From about 1825 he began to aquatint marine subjects after W.J. Huggins, whose daughter, Bertha, he married. It is for these large plates that he is best remembered as an engraver. From 1828, he also engraved sporting subjects particularly after J. Ferneley and C. Hancock. In the 1840s he gave up engraving to concentrate on his watercolour painting. He lived and worked in London.
'*The Nemesis Destroying the Chinese War Junks in Anson's Bay*', 1841, 12 x 18½in/30.5 x 47cm, £800-£1,200 col.
'*East India Co. Ship William Fairlie Leaving the Harbour of the Prince of Wales Island*', after W.J. Huggins, 1828, 19¼ x 26in/49 x 66cm, £800-£1,200 col.
'*The Lady Kennaway off Margate*', after W.J. Huggins, 1829, 17¼ x 26½in/45 x 67cm, £600-£1,000 col.
'*The Mary entering Valetta Harbour, Malta*', after W.J. Huggins, 1835, 18½ x 26in/47 x 66cm,

£500-£800 col.
'*Regatta of the Royal Northern Yacht Club*', after W. Clark, £600-£1,000 col.
'*The Right Sort*' and '*The Wrong Sort*', after H. Alken, 11 x 13in/28 x 33cm, pair £250-£350 col.
Portraits of racehorses, after J. Ferneley and C. Hancock, ave. size 15 x 20in/38 x 51cm, e. £400-£800 col.
'*Count Sandor's Exploits*', after J. Ferneley, 1833, 10 pl., 34 x 39½in/86 x 100cm, set £1,400-£2,000 col.
'*Returning from Ascot Races*', after C.H. Henderson, 1839, 19¼ x 35½in/49 x 90cm, £800-£1,200 col.
'*View of the London and Croydon Railway*', 1839, 2 versions: 18¾ x 26¾in/47.5 x 68cm, aq., £300-£500 col.; 11 x 19¼in/28 x 49cm, tt. litho., £60-£80 col.

DUNCOMB, E.C. fl. mid-19th century
Draughtsman and lithographer.
2 views of Guildford, 1837, 15 x 19in/38 x 48cm, e. £80-£200 col.

DUNKARTON, Robert 1744-by 1817
Mezzotint engraver of portraits, decorative and biblical subjects after his contemporaries and

Old Master painters. Born in London, he was a pupil of W. Pether (q.v.).
'*Wm. Lord Amherst, Col. St. James' Loyal Volunteers*', after Davis, 1805, 25½ x 16½in/65 x 42cm, £150-£250.
'*P. Colquhoun*', after S. Medley, 1802, 17¼ x 12½in/45 x 32cm, £80-£120 prd. in col.
'*The Sailor's Orphans*' and '*The Soldier's Widow*', after W. R. Bigg, 1800, 17½ x 23in/44.5 x 58.5cm, pair £800-£1,200 prd. in col.
'*The Harvest Man*' and '*The Weary Traveller*', after W. Artaud, 1806, 20¼ x 15¼in/ 53 x 40cm, pair £100-£150.
'*Jeremiah Hawkins with Hounds Finding*', after F.C. Turner, 22 x 25½in/56 x 65cm, £300-£400.
'*The Night-Blowing Cereus*', after P. Reinagle and W. Pether, 1800, 19 x 14¼in/48.5 x 36cm, mezzo., £900-£1,600 prd. in col.
'*James, Lord Lifford*', 25 x 17in/63.5 x 43cm, proof before letters, fetched £380 October 1994.
Pl. for J.M.W. Turner's Liber Studiorum, £80-£200.
Various male WLs £100-£250.
Various male HLs £15-£40.
Small portraits for books small value.
CS.
Colour plate page 32.

DUNSTALL, John fl. mid-17th century
Etcher and engraver of natural history subjects
and portraits. He lived in London and worked in
the style of *W. Hollar (q.v.).*
Pl. for A Book of Flowers, Fruits, Birds, Beasts,
Flys and Worms, *1662, title and 18 pl., 4to., e.
£20-£50.*
Portraits and frontis. £5-£15.

DUPONT, Felix fl. late 19th/early 20th century
French etcher and stipple engraver of decorative
subjects after his French and English
contemporaries as well as his own designs.
Born in Bordeaux, he studied in Paris.
Small value.

DUPONT, Gainsborough 1767-1797
Painter and mezzotint engraver of portraits after
T. Gainsborough whose nephew and pupil he
was. He died in London.
*'Col. St. Leger with Horse', 1783, 25¼ x
18in/65.5 x 45.5cm, £300-£500.
'George III and Queen Charlotte', 1790, 24¼ x
15in/63 x 38cm; 'Eldest Princesses of George
III', 1793, 26 x 18in/66 x 45.5cm, e. £150-£300.
'George Lord Rodney', 1788, 24½ x 15½in/62 x
39cm, £150-£300 (proof before letters fetched
£900 October 1994).
HLs £15-£50.*
CS.

DUTERREAU, Benjamin 1767-1851
French stipple engraver of decorative subjects
after his contemporaries. He worked in London
at the close of the century in the style of
F. Bartolozzi (q.v.).
*'The Squire's Door' and 'The Farmer's Door', after
G. Morland, 1790, pair £600-£1,000 prd. in col.
Pl. for H.W. Bunbury's* Illustrations to
Shakespeare, *1792-4, 16½ x 19in/42 x 48cm, e.
£40-£80 prd. in col.*

DUTTON, Thomas Goldsworth d.1891
Eminent draughtsman and lithographer of
shipping subjects after his own designs as well
as his contemporaries. He worked in London for
Day & Haghe (see William Day, 1797-1845).
His subjects included warships, yachts, P. & O.
steamships, clipper ships, naval engagements,
yachting races, etc. His lithographs were
usually printed with a tintstone and were issued
with or without hand colouring.
*'Naval Review at Spithead', after O.W. Brierly,
1853, 11½ x 31in/29 x 79cm, £200-£400 col.
'H.M.S. Forte at Rio de Janeiro', after Tupman,
1862, 17 x 22in/43 x 56cm, £600-£900 col.
'The Start for the Great Atlantic Race,
December 11th 1866', 16½ x 24½in/42 x 62.5cm,
tt. pl., £700-£1,000 col.
Pl. for O.W. Brierly's* The English and French
Fleets in the Baltic, *1854, fo., tt. pl., e. £150-£250.
Most other lge. yachting, naval and shipping
pl., col. or just tt., e. £400-£800.
Small yachting subjects, 7½ x 11in/19 x 28cm,
tt. pl., e. £140-£200 col.
'The New School 1855', after G.H. Andrews,*

DUNSTALL, John. A plate from *A Book of Flowers…*, 1662.

*1855, 21½ x 28½in/54.5 x 72.5cm, tt., £200-£400
col.; pair with 'The Old School', after Andrews
by R.C. Carrick (q.v.), 1755, pair £600-£1,000
col.*

DYCE, William 1806-1864
Eminent Scottish portrait and historical painter
who made a few rare etchings and drypoints.

*'An Old Woman', 1834, 18¼ x 9¼in/30 x
23.5cm, £300-£700.*

DYSON, William Henry 1883-1938
Australian newspaper cartoonist who produced
some etchings. He settled in England where he
drew for *The Daily Herald.*
£60-£140.

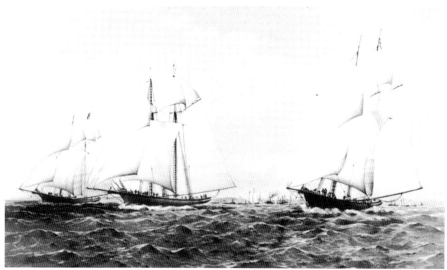

DUTTON, Thomas Goldsworth. 'The Start for the Great Atlantic Race, December 11th 1866'.

EARLE, Augustus fl. early/mid 19th century
Much travelled history and marine painter who produced the following:
'Sketches Illustrative of the Native Inhabitants and Islands of New Zealand', 60 litho., e. £50-£100 col.

EARLOM, Richard 1743-1822
Important mezzotint engraver of portraits, landscapes, and biblical, botanical and decorative subjects after his contemporaries and Old Master painters. Born in London, he was apprenticed to G.B. Cipriani and then worked for John Boydell (q.v.) from about 1765, his best known production for Boydell being the 'Liber Veritatis' after Claude Lorraine and plates for the Houghton Gallery. See also H. Birche.
'Sensibility' (Emma Hamilton), after G. Romney, 1789, 15 x 11½in/38 x 29cm, stipple, £500-£800 prd. in col.
'The Rabbit Seller', after J. Zoffany, 1774, 24 x 17in/ 61 x 43cm, mezzo., £200-£400.
'Roses', after Dr. R.J. Thornton, from Thornton's Temple of Flora, *1805, 19 x 14½in/148.5 x 37.5cm, mezzo., £2,000-£3,000 prd. in col.*
'Tulips', after P. Reinagle, 1798, 19 x 14in/48.5 x 35.5cm, mezzo., £1,400-£2,200 prd. in col.
'The Superb Lily', after P. Reinagle, from Thornton's Temple of Flora, *1799, £1,000-*

£1,600 prd. in col. and finished by hand.
'The Larder', after M. de Vos, 1775, 17¾ x 22½in/ 45 x 57cm, mezzo., £140-£180.
'The Four Markets', after F. Snyders and Long John, 1782, 16¼ x 22½in/41.5 x 58cm, mezzo., set £1,200-£2,400.
'Liber Veritatis', after Claude Lorraine, 1774-7, 2 vols., 200 pl., fo., mezzo., e. £15-£30; 1819, vol. 3, 100 pl., e. £10-£20.
'A Flower Piece' and 'A Fruit Piece', after J. Van Huysum, 1778 and 1781, 21¾ x 15½in/55 x 39.5cm, mezzo., pair £1,600-£2,400.
'A Concert of Birds', after M. di Fiori, 1778, 16¼ x 22¼in/41 x 56.5cm, mezzo., £200-£400.
Other pl. after Old Master painters from Houghton Gallery, mezzo., £20-£80.
'Col. Mordaunt's Cock Match', 1792; 'Embassy of Hyderbeck to Calcutta', 1800; 'Tiger Hunting in the East Indies', 1802, all after J. Zoffany, e. approx. 19 x 26in/48 x 66cm, e. £1,000-£2,000.
'The Exhibition of the Royal Academy of Painting in the Year 1771', after C. Brandoin, 1772, 18½ x 22in/47 x 56cm, mezzo., £500-£700 ('The Exhibition . . .' and 'The Pantheon', pair fetched £2,200 June 1991).
'The Forge', after J. Wright of Derby, 1773, 19 x 23½in/48 x 59.5cm, £1,500-£2,500.
'A Blacksmith's Shop', after J. Wright of Derby, similar size and subject to 'The Forge' fetched £3,200 June 1993.
'The Royal Academy', after J. Zoffany, 1773, 19¾ x 28¼in/50 x 72cm, £600-£900.
'John Kemble as Coriolanus', after F. Bourgeois, 1798, 19¼ x 23½in/49 x 60.5cm, £200-£350.
'Horatio Nelson' after W. Beechey, 1806, 20¼ x 14in/51.5 x 35.5cm, £100-£200.
'Lioness and Whelps', after J. Northcote, 1793, 19¾ x 25in/50.5 x 63.5cm, imp. prd. in col. and finished by hand fetched £900 April 1989.
Various HLs £20-£80.

CS.
Colour plates frontispiece and page 33.

EARTHROWL, Eliab George, A.R.E.
b.1878
London painter and etcher of landscapes.
£10-£30.

EASLING, J.C. fl. early 19th century
Mezzotint engraver of portraits and landscapes after his contemporaries. He was a pupil of C. Turner (q.v.).
'Wellington in India', after R. Home, 1813, 19¾ x 14½in/50 x 37cm, £70-£100.
'Sir T. Picton', after M. A. Shee, 1815, 12 x 9½in/30.5 x 24cm, £10-£15.
'The Student', 'The Idler', after Thomson, 12 x 10in/30.5 x 25.5cm, pair £150-£250.
Pl. for J.M.W. Turner's Liber Studiorum *£80-£200.*

EAST, Adam fl. early 19th century
Draughtsman and lithographer.
'Crack Hounds' £40-£60.

EAST, Sir Alfred, R.A., R.E. 1849-1913
Painter, etcher and aquatint engraver of landscapes. Born in Northamptonshire, he settled in London after having studied in Glasgow and Paris. He also travelled extensively abroad. His etchings are similar in style to those of F. Brangwyn (q.v.).
£30-£80.
Bibl: Newbolt, F., 'Etchings of A.E.', *Studio,* 1905, XXXIV, p.124.

EASTO, A. fl. early 19th century
Stipple engraver and etcher of portraits after his own designs and those of his contemporaries.
Wm Eales' (boxer), 1819, 10½ x 13½in/27 x 34cm, etching, £30-£50 col.

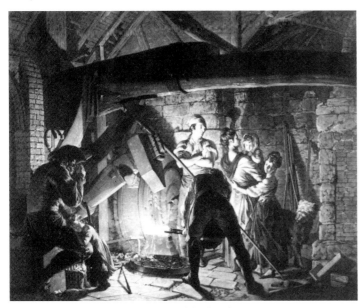

EARLOM, Richard. 'The Forge', after J. Wright of Derby, 1773.

EARLOM, Richard. 'A Flower Piece', pair with 'A Fruit Piece', after J. Van Huysum, 1778 and 1781.

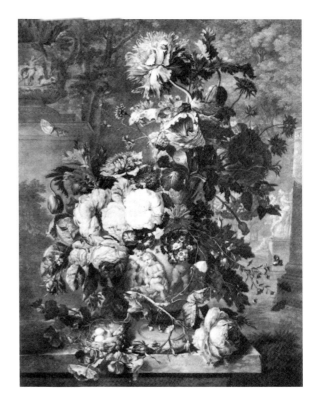

EAST, Alfred. A typical landscape.

EDWARDS, Edwin. Landscape dated 1867.

'Mary Ann Paton as Amazitti', after T. Wageman, 6½ x 4½in/16.5 x 12cm, stipple, £5-£10.
Others small value.

EDGE, J. fl. 1829-33
Aquatint engraver.
'Race for the Gold Cup at Ascot', after J. Pollard, 1829, 14 x 18in/35.5 x 45.5cm, £600-£900 col.

EDINGTON fl. early 19th century
Aquatint engraver.
'Panorama of Brighton', after H. Wild, 1833, 4½ x 160in/11.5 x 406.5cm, £600-£1,200 col.

EDWARDS, Edward, A.R.A. 1738-1806
Painter, furniture designer, decorator and art teacher who published fifty etchings in *A Collection of Views and Studies after Nature, with Other Subjects.* He was born in London where he lived most of his life. In 1788 he was appointed Professor of Perspective at the R.A. Schools. He coloured some of his etchings.
Pl. for A Collection of Views and Studies after Nature...*1790, 4to., £5-£10 col.*
Others small value.

EDWARDS, Edwin 1823-1879
Painter and etcher of landscapes and architectural views in England. Born in Framlingham, Suffolk, he practised law before

turning to painting and etching in 1861, and produced 371 dreary plates including his series 'Old Inns of England' which are of minor historical interest.
'Old Inns of England', 1873-81, 135 pl., depending on place e. £5-£25.
Landscapes £5-£10.

EDWARDS, George 1694-1773
Draughtsman and etcher of natural history subjects. Born in Stratford, Essex, he served an apprenticeship in London and visited Holland, Norway and France. He later became Librarian to the Royal College of Physicians and was also elected a Fellow both of the Royal Society and the Society of Arts. His major work was the *History of Birds,* 1743-51, from which loose plates are often found. He also collaborated with M. Darly (q.v.) on a *New Book of Chinese Designs,* 1754.
Natural history subjects e. £15-£50 col.
Chinese designs e. £15-£50.

EDWARDS, Samuel Arlent b.1861
Mezzotint engraver of portraits and sporting and decorative subjects after his contemporaries, British 18th century and Old Master painters.
'The Big Pack' (grouse driving), after A. Stuart Wortley, 1888, 14 x 23in/35.5 x 58.5cm, £150-£300.

'Eton' (from the Thames), after R. Gallon, 1887, 17 x 21½in/43 x 54.5cm, £100-£200.
Portraits and decorative subjects £10-£50 prd. in col.
Add more if in fine contemporary frame.
Pl. for The Library Edition of The Works of Sir Edwin Landseer *small value.*

EDWARDS, William Camden 1777-1855
Line engraver of small portrait plates and other book illustrations after his contemporaries. Born in Monmouthshire, he lived and worked in Suffolk.
Small value.

EDWARDS, W. Joseph fl. mid-19th century
Line, stipple and mezzotint engraver of portraits and historical and sentimental subjects after his contemporaries.
Lge. historical and sentimental subjects £30-£100.
Lge. portraits £10-£50.
Add more if in fine contemporary frame.
Others small value.

EDY, John William 1760-1817 or later
Danish aquatint engraver of topographical views and sporting, decorative and naval subjects after his contemporaries and his own designs. He worked in England.
'Views in North America', after G.B. Fisher,

EDINGTON. Section of a 'Panorama of Brighton', after H. Wild, 1833.

EDY, John William. 'View of Cambridge from the Castle Hill', after R. Harraden, 1798.

1795, 6 pl., 19 x 28 in/48.5 x 71cm, e. £1,000-£2,000 col.
'A Summer Evening Repast', after W. Burges, 1788, 16½ x 21½in/42 x 54.5cm, £150-£200 prd. in col.
'Views of Cambridge', after R. Harraden, 1798, 16½ x 21½in/42 x 55cm, e. £60-£140.
'Naval Battle off Cape St. Vincent', after R. Clevely, 1797, 18 x 27in/45.5 x 68.5cm, £300-£500 col.
'Winter Amusement in Hyde Park', after J.C. Ibbetson, etched by J. Tookey (q.v.), 1787, 12¼ x 15¼in/31 x 38.5cm, pair £600-£900 col.
'Views from Hampton on Thames', 1790, 18 x 24in/45.5 x 61cm, pair £700-£1,200 col.
Pl. for I.S. Roberts' Views in Ireland, 1795-6, obl. fo., e. £30-£70 col.
Pl. for Colebrooke's Twelve Views of Places in the Kingdom of Mysore, 1794, obl. fo., e. £30-£70.
Pl. for Boydell's Picturesque Scenery of Norway, 1820, 80 pl., fo., e. £15-£30 col.
'Race between Hambletonian and Diamond', after J.N. Sartorius, 1799, 13¾ x 20½in/35 x 53cm, pair £800-£1,500 col.

EGAN, James 1799-1842
Irish mezzotint engraver of portraits and historical and sentimental subjects after his contemporaries and his own designs. Born in Roscommon, he was a pupil of S.W. Reynolds (q.v.), and died in London.
The Groundslow Ploughing Match', 1840, 21 x 31in/53.5 x 78.5cm, £250-£400.
Lge. sentimental and historical subjects £20-£80.
Larger portraits £10-£40.
Add more if in fine contemporary frame.
Small pl. small value.

EGERTON, Daniel Thomas c.1800-1842
Draughtsman and aquatint engraver of caricatures, later lithographer of topographical views. He seems to have been born in London and was murdered in Mexico.
'Necessary Qualifications of a Man of Fashion', 1823, obl. 4to., 12 aq.; 'Fashionable Bores', 1824, obl. 4to., 12 aq., e. £20-£35 col.

'Views of Mexico', 1840, lge. fo., 12 litho., e. £400-£800 col. (complete set fetched £25,000 in 1986). Colour plate page 34.

EGINTON, Francis Jun. 1775-?1823
Glass painter, etcher, stipple and aquatint engraver of decorative subjects, portraits and topographical views after his contemporaries. He was born in Birmingham where he lived and worked; he died in Shropshire.
'The Shepherdess of the Alps', after W. Hamilton, 1792, 24¾ x 17in/63 x 43cm, £200-£400 prd. in col.
'Setting Out to the Fair' and 'The Fairings', after F. Wheatley, 1792, 23¼ x 18½in/59 x 47cm, stipple, pair £500-£800 prd. in col.
'Portrait of a Herefordshire Bull', after R. Lawrence, 1806, 37 x 46cm, £250-£400 col.
'The Departure of Aeneas from Carthage', after

EGINTON, Francis. 'The Shepherdess of the Alps', after W. Hamilton, 1792.

W. Hamilton, 1796, 23 x 16in/58.5 x 40.5cm, stipple, £20-£40.
Pl. for R.B. Wheler's Antiquities of Stratford-upon-Avon, 1806, 8vo., 8 sepia etchings and aq., e. small value.
Pl. for The New Bath Guide, 1807, 8vo., 12 stipples, e. £5-£15 col.
Portraits small value.

EGLETON, William Henry
 fl. mid-19th century
Stipple and mezzotint engraver of portraits and religious, historical and sentimental subjects after his contemporaries and Old Master painters, mainly small bookplates but also some larger plates. He worked in London.
'The Coronation Oath', after G. Hayter, 1851, 30½ x 20½in/77.5 x 52cm, £100-£250.
Other lge. pl. £30-£100.
Add more if in fine contemporary frame.
Small pl. small value.

EINSLIE, S. fl. late 18th/early 19th century
Miniature painter who engraved some portraits in mezzotint after his contemporaries. He worked in London.
'Anne, Countess of Aldborough', after J. Hoppner, 14 x 9½in/35.5 x 25cm; 'Edward, Earl of Aldborough', after T. Gainsborough, 1788, e. £15-£40.
CS lists 2 pl., noted above.

ELDER, William fl. late 17th century
Scottish engraver of small portraits and frontispieces. He died in London.
Small value.

ELLIOT, Dorothy M fl. early 20th century
Wood engraver. She was influenced by I. Macnab (q.v.).
£10-£30.

ELLIOT (Elliott), William 1727-1766
Line engraver, mainly of landscapes and topographical views after his contemporaries and 17th century painters, and also a few

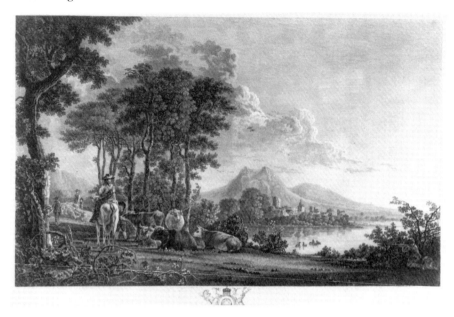

ELLIOT, William. Landscape engraving.

sporting plates after Thomas Smith of Derby. Born at Hampton Court, he worked in London.
'Breeding Horses', after T. Smith of Derby (pl. 1 'Cullen Arabian' with Smith), 1758, 6 pl., 15¼ x 21¼in/39 x 54cm, e. £200-£400.
'View of Kilgarren Castle, Wales', after R. Wilson, 1775, £50-£150.
'A View of the Great Cohoes Falls, on the Mohawk River', after P. Sandby, 14½ x 21in/37 x 53cm, £300-£600.
'A View of the Intendant's Palace, Quebec', after R. Short, 1761, 13½ x 19½in/34 x 50cm, £400-£700.
'Capture of Belleisle', after D. Serres and R. Short, 1777, from set of 7, 14½ x 20½in/36.5 x 52cm, e. £250-£350.
Landscapes after 17th century painters £50-£150.

ELLIOTT, Aileen Mary (Mrs. Beale) b.1896
Painter and etcher of landscapes and marine subjects. Born in Southampton, she was a pupil of W.P. Robins (q.v.).
£10-£30.

ELLIS, E.J. fl. 1920s/1930s
Wood engraver.
£10-£30.

ELLIS, Elizabeth fl. late 18th century
Etcher of landscapes after her contemporaries. She worked on several plates with her husband, W. Ellis (q.v.).
'A View near Henstead in Suffolk' and 'A House in Suffolk', after W. Woollett, 1797, 17 x 23in/43 x 58.5cm, pair £150-£300.

ELLIS, Tristram J., R.E. 1844-1922
Painter and etcher of landscapes and topographical views. Born in Great Malvern, he lived in London and travelled in Europe and the Middle East.
£30-£70.

ELLIS, William 1747-1810
Line and aquatint engraver of landscapes, topographical views and naval and decorative subjects after his contemporaries as well as his

own designs. Born in London, he was a pupil of and collaborated with W. Woollett (q.v.) on several plates. He also worked with his wife, Elizabeth Ellis (q.v.) on several plates.
'Views of the Ruins of the Principal Houses Destroyed During the Riots at Birmingham', 1791, 8 aq. after P.H. Witton, obl. 4to., e. £10-£20.
'Bulls', after E. Scott, 1799, 6 pl., 9½ x 12in/24 x 30.5cm, aq., e. £60-£120.
'The Fox Chase' and 'The Stag at Bay', after S. Howitt, with R. Pollard, 1802, 16½ x 26in/42 x 66cm, pair £800-£1,200 col.
Pl. for Rev. J. Gardnor's Views Taken On and Near the Rhine, *some eng. with Elizabeth Ellis, 1788, fo., e. £15-£50.*
'Campagna of London', c.1793, 28 pl., 4to., aq., e. £10-£25.
'Victory of the Nile', after W. Anderson, 4 pl. with F. Chesham (q.v.), 1799, 13¾ x 18in/35 x 45.5cm, aq. with eng., set £700-£1,400 col.
'The Seasons', after T. Hearne, 1784, 4 ovals, 13 x 14in/33 x 35.5cm, eng., set £200-£400.
'Robinson Crusoe and his Dog', after R. Pollard, 1800, 16 x 22in/40.5 x 56cm, aq., £80-£120 col.
'View of London from Greenwich', after T. Hearne; 'View of London from Wandsworth', after C. Tomkins, with Elizabeth Ellis, 1786, 18 x 21in/45.5 x 53.5cm, eng., e. £200-£400.
'View of the Cast Iron Bridge Near Coalbrook Dale, Salop', after R. Rooker, 14 x 18in/35.5 x 45.5cm, eng., £200-£400.

ELMES, William I
fl. late 18th/early 19th century
Line, stipple and aquatint engraver. Possibly the same artist as W. Elmes II (q.v.).
'Persian Cyclamen', after A. Pether for R. Thornton's Temple of Flora, *1799-1807, 20¼ x 16¼in/51.5 x 41cm, £300-£500 prd. in col.*

ELMES, William II fl. early 19th century
Draughtsman and etcher of a number of caricatures in the style of G. Cruikshank (q.v.), published between 1811 and 1816. Possibly the same artist as W. Elmes I (q.v.).
'The Yankey Torpedo', 10¾ x 16in/27 x 40.5cm,

£300-£400 col.
Others mostly £30-£90 col.

ELWES, Robert fl. 1854
Draughtsman and lithographer.
'A Sketcher's Tour Round the World', 1854, 8vo., e. £5-£15.

EMES, John fl. late 18th/early 19th century
Watercolourist of landscapes, line engraver of topographical views and naval subjects after his contemporaries. He was a pupil of W. Woollett (q.v.).
'Destruction of the Spanish Batteries before Gibraltar', after J. Jefferys, 1782, 18 x 27in/45.5 x 68.5cm, £200-£400.
Bookplates small value.

EMMERSON, Phyllis fl. 1920s
Lithographer of figure subjects.
£10-£30.

EMMETT, William fl. early 18th century
Mezzotint engraver of portraits after his contemporaries.
£15-£50.
CS lists 4 pl.

ENGLEHEART, Francis 1775-1849
Line engraver of decorative subjects and portraits after his contemporaries, mainly small bookplates but also a few larger plates. He was probably born in London, was a pupil of J. Collyer (q.v.) and assisted J. Heath (q.v.).
'The Only Daughter', after D. Wilkie, 1838, 16 x 21in/40.5 x 53.5cm, and similar-sized decorative subjects, £20-£80.
Add more if in fine contemporary frame.
Small bookplates small value.

ENGLEHEART, John H. fl. mid-19th century
Line engraver of small bookplates after his contemporaries, including landscapes, topographical views and historical and sporting subjects.
Sporting subjects £5-£10.
Others small value.

ENGLEHEART, Timothy Stansfield
1803-1879
Line engraver of small bookplates after his contemporaries, including landscapes, sporting subjects and portraits. He was the son and pupil of F. Engleheart (q.v.), and emigrated to Germany in 1840.
Sporting subjects £5-£10.
Others small value.

ENGLISH, Josias
c.1630-1718
Amateur etcher and line engraver in the style of W. Hollar (q.v.). He lived at Mortlake.
'Christ at Emmaus', after Titian, 9 x 11½in/23 x 29cm, etching and eng., £80-£140.
'Portrait of Wm. Dobson', 8¾ x 7in/22 x 18cm, £200-£300.
Others £5-£15.

ENSOM, William
1796-1832
Line engraver of small bookplates, including topographical views and portraits after his contemporaries and biblical subjects after Old Masters. He was born in and died in Wandsworth.
Small value.

ERXLEBEN, J.
fl. mid-19th century
Draughtsman and lithographer of portraits.
'J. Lidel' (musician), 1840, 10 x 7½in/25.5 x 19.5cm, £15-£30.
Others £10-£30.

ESCHAUZIER, Samuel
fl. 1830s
Draughtsman and lithographer of naval and military costumes. He seems to have worked mainly for the publisher W. Spooner. He often collaborated with L. Mansion (q.v.).
'Costume of the Royal Navy and Marines', with L. Mansion, c.1833, 15 pl., 11¼ x 10½in/30 x 26.5cm, e. £80-£160 col.
Pl. for Spooner's First Series, c.1830, 11 pl., 10 x 8in/25.5 x 20.5cm, e. £60-£120 col.
Pl. for Spooner's Large Series: Officers of the British Army, with L. Mansion, 1831, 6 pl., ave. 15½ x 12½in/39.5 x 32.5cm, £150-£250 col.
Pl. for Spooner's Small Oblong Series, c.1834, 17 pl., ave. 6½ x 8in/16.5 x 20.5cm, e. £50-£90 col.
Pl. for Spooner's Upright Series: Officers of the British Army, with L. Mansion, 1833-6, 60 pl.,

11½ x 9in/29 x 25cm, e. £140-£200 col.
(complete set col. fetched £15,000 May 1993).

ESPLENS, John and Charle
fl. early/mid-18th century
Mezzotint engravers and possibly publishers of portraits. They apparently worked in Edinburgh.
£15-£40.
CS lists 4 pl.

EVANS, Edmund
fl. mid-19th century
Wood engraver of small topographical bookplates after his contemporaries.
Small value.

EVANS, Edmund William
b.1858
Etcher of landscapes and architectural views after his contemporaries and occasionally after his own designs. He lived in London and is best known for his views of 'Public Schools' and 'Oxford and Cambridge Universities', after F. Barraud.
£30-£70.

EVANS, Merlyn Oliver
1910-1973
Welsh painter, etcher and aquatint and mezzotint engraver of surrealist and abstract subjects. Born in Cardiff, he studied at Glasgow School of Art and at the R.C.A. and was a pupil of Stanley W. Hayter.
Contemporary imp. £80-£200, 1970s reprints £20-£40.

EVANS, William
fl. late 18th/early19th century
Draughtsman, stipple and line engraver of portraits and decorative subjects after his contemporaries, mainly small bookplates. He worked in London.
'Grandmother's Blessing', after R. Smirke, 20 x 25¼in/51 x 64cm, £200-£300 prd. in col.
'Sir William Jones, Orientalist', after W. Devis, 1798, 9¼ x 7in/23.5 x 18cm, and portraits of similar or larger size, £5-£15.
Small bookplates and portraits small value.

EVE, George W., R.E.
1855-1914
Etcher of armorial ex-libris and certificates. He lived in London.
£5-£15.

EVELYN, John
1620-1706
Diarist, writer and amateur etcher. His plates include views of his house, Wotton, in Surrey and illustrations for his *Sculptura: The History and Art of Chalcography*, 1662, one of the earliest English books on the subject of engraving.
£10-£40.
(Special copy of 'Sculptura' has fetched £3,250).

EVERSHED, Arthur, R.E.
1836-1919
Painter and etcher of landscapes. Born in Sussex, he was a doctor who worked in Bedfordshire and London and contributed plates to the Etching Club, *The Etcher* and *English Etchings*.
£10-£30.

EVERY, George H.
1837-1910
Line and mezzotint engraver of portraits and sentimental subjects after British 18th century painters and his contemporaries. Born at Hendon, London.
Lge. sentimental pl. after J.E. Millais £80-£200; after other artists £30-£100.
Portraits £10-£50.
Add more if in fine contemporary frame.

EXLEY, James Robert Granville, R.E.
1878-1967
Painter and etcher of ornithological subjects, townscapes, portraits, etc. Born in Bradford, he taught at Cambridge and Hull.
£30-£80

EXSHAW, Charles
c.1710-1771
Irish mezzotint engraver of portraits after Old Master painters and his contemporaries. Born in Dublin, he came to London c.1758 after studying in Paris and Amsterdam and attempted unsuccessfully to set up a drawing school.
£15-£40
CS lists 4 pl., all portraits of Carle Vanloo's family.

EYLES, B.
fl. mid-19th century
Line engraver of small bookplates, including portraits and decorative subjects after his contemporaries.
Small value.

ERXLEBEN, J. 'J. Lidel', 1840.

ESCHAUZIER, Samuel. One of sixty plates from *Spooner's Upright Series: Officers of the British Army – 1st Life Guards*, with L. Mansion, 1833-6.

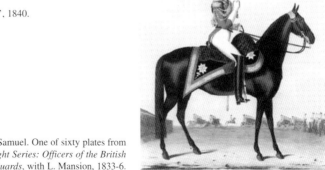

FABER, John I c.1660-1721

Dutch mezzotint engraver mainly of portraits after his own designs and those of his contemporaries. Born at The Hague, he came to London c.1687 or 1695 with his son, J. Faber II (q.v.). He established in 1707 a shop near the Savoy in the Strand, and spent some time in Oxford and Cambridge engraving the portraits of the founders of three colleges. He also worked as a miniaturist. He died in Bristol.
'Portraits of the Founders of Colleges at Oxford and Cambridge', 1712, and the 'Twelve Caesars', e. £5-£10.
Contemporary portraits, mostly HLs, £15-£50.
CS.

FABER, John II c.1695-1756

Well-known Dutch mezzotint engraver of portraits and decorative subjects after his contemporaries and Old Master painters. Born in Holland, he was the son and pupil of J. Faber I (q.v.) who brought him over to England c.1687 or 1695. He published most of his engravings himself from various addresses in and around the Strand. Immensely productive, he engraved portraits from the period of Kneller right up to the time of Reynolds, and was mainly responsible for preserving the continuity of mezzotint during that period.
'The Kit-Cat Club', after G. Kneller, 1735, 48 pl., 14 x 12½in/35.5 x 32.5cm, e. £10-£40 (complete set fetched $3,600 May 1993).
'George Graham' (clock-maker), after T. Hudson, 12¼ x 10in/31 x 25.5cm, £200-£300.
Domestic and genre subjects after P. Mercier, ave. 13 x 9in/33 x 23cm, £100-£200 ('Rural Life', after P. Mercier, set of four pl., fetched £1,650 May 1989).
WL female portraits, ave. 19¼ x 13½in/50 x 35cm, £100-£300.
WL male portraits £60-£160.
TQL male portraits mostly £30-£100.
HL male portraits mostly £15-£50.

FACIUS, Georg Sigmund c.1750-1814
FACIUS, Johann Gottlieb c.1750-c.1802

German stipple engravers of portraits and decorative, religious and mythological subjects after their contemporaries and Old Master painters. Born in Ratisbon, they studied in Brussels before coming to London in 1776 where they worked for John Boydell (q.v.), collaborating on many of their plates.
'Sir Thomas Musgrave, the Last British Commander of New York', after L.F. Abbott, 13½ x 11in/34 x 28cm, £300-£400.
'Mr. West and His Family', after B. West, July 1779, 22 x 26½in/56 x 68cm, £150-£250.
Other portraits £5-£15.
'The West Window of the Chapel, New College, Oxford', after J. Reynolds, 1785, 14 pl. (13 by Facius), e. £8-£15.
'The Golden Age', after B. West, 11½ x 12in/29.5 x 32.5cm, £80-£150.

FAED, James 1821-1911

Scottish painter and mezzotint engraver of portraits and sentimental subjects after his contemporaries. Born at Kirkcudbright, he was

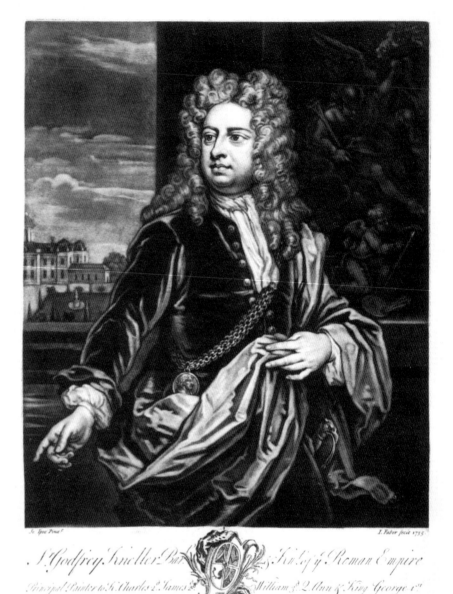

FABER, John II. 'Sir Godfrey Kneller', after a self-portrait by Kneller, 1735.

the brother of the painters John and Thomas Faed, several of whose works he engraved. He worked in London and Edinburgh.
'Sunday in the Backwoods', after W.H. Simmons, 1863, 26¼ x 34½in/68 x 87.5cm, £80-£200.
'The Last of the Clan', after W.H. Simmons, 1868, 28½ x 34½in/72.5 x 87.5cm, £120-£240.
'Mr and Mrs Wynn, with a Hunter and a Beagle in a landscape', after F. Grant, 31 x 26in/78.5 x 66cm, fetched £1,300 June 1990.
Add more if in fine contemporary frame.

FAGAN, Louis Alexander 1846-1903

Diplomat, art critic, amateur watercolourist and etcher of landscapes and occasional portraits. When he retired from the foreign service, he went to the British Museum, where he later became Assistant Director of Prints.
Small value.

FAHEY, James 1804-1885

London watercolourist, aquatint engraver and

etcher. Born in Paddington, he originally trained as an engraver under his uncle, John Swaine, before turning to painting. He was drawing master at Merchant Taylors' School for twenty-five years from 1856.
'Rural Chivalry', after C.H. Weigall, 1839, a series of six pl. showing fighting cocks, 8¼ x 11¼in/21 x 28.5cm, aq., set £300-£400 col.

FAIRBAIRN, John fl. late 18th century

Publisher of unsigned sporting and decorative prints. His publication line showed him to be 'Map, Chart & Printseller, No.146, Minories London'.
'Stag and Hare Hunting', set of four mezzo., 1794, 10 x 13in/25 x 35cm, fetched £800 May 1987.

FAIRCLOUGH, Wilfrid, R.E. b.1907

Painter, etcher and line engraver of landscapes and figure subjects. Born in Blackburn, he studied at the R.C.A. His 1930s work consists

FAIRCLOUGH, Wilfrid. A typical line engraving.

mostly of Italian subjects very much influenced by R.S. Austin (q.v.). He lives in Kingston, where he was Principal of the Art College, 1962-9.
£40-£90.

FAIRLAND, Thomas 1804-1852
London line engraver and lithographer of portraits and sporting, naval and decorative subjects after his contemporaries. He originally trained as an engraver under A. Warren and C. Heath (qq.v.), but soon turned to lithography at which he was much more successful.
'Grouse Shooting' and 'Partridge Shooting', after F.C. Turner, 1840, 11 x 13½in/28 x 35cm, pair £500-£700 col.
'Gone to Earth', after T. Woodward, 1845, 17¼ x 19½in/44 x 50cm, £200-£300 col.
'The Brighton Mails', after W.J. Shayer, 15¼ x 19½in/40 x 50cm, £400-£600 col.
'Transatlantic Steamship Liverpool', after

S. Walters, 1838, 16 x 20½in/40.5 x 52cm, £300-£500 col.
'The Recruit' and 'The Deserter', after R. Farrier, 1827, 12½ x 10½in/31.5 x 26.5cm, pair £40-£60 col.
'The East India Co.'s Frigate Memnon With a View of Cape Town', after Gunston, 16 x 21in/40.5 x 53.5cm, £500-£800 col.
'North Walsham Races', after G. Fenn, 14 x 17in/35.5 x 43cm, £200-£300 col.
'Eden' (a shorthorn bull), after R. Harrington, c.1834, 15¼ x 18in/39 x 47.5cm, £300-£400 col.
'Bachelor's Hall', after F.C. Turner, c.1835, 6 pl., 13½ x 18½in/34.5 x 47.5cm, litho., set £800-£1,200 col.

FAIRLEY, Dorothy M. b.1894
Painter, etcher and wood engraver. She lived in Sussex.
£15-£50.

FAITHORNE, William I c.1616-1691
Important early English line engraver mainly of portraits after his contemporaries and his own designs. He was a pupil of J. Payne (q.v.), and the publisher of his early prints was Robert Peake, a Royalist, with whom he went to Oxford where the King had set up court at the beginning of the Civil War. He was captured in 1645 after the siege of Basing House and imprisoned in London. At the end of the 1640s he obtained permission to go to France where he studied the work of French engravers such as Robert Nanteuil. When he returned to England, in 1650, he established himself as a printseller, dealing not only with English prints, including his own, but also Continental works. He retired in 1680.
More important subjects, e.g.: 'Charles I on Horseback With View of London', 1643, 'Charles II When a Youth, Scarf Thrown Over His Armour, the George Suspended by a Ribbon to His Side', 'Oliver Cromwell, Lord Protector, in Armour, Between Two Pillars', 1658, and 'John Milton' e. £100-£300.
Others mostly £10-£50.

FARINGTON, Joseph. 'View at Lynn', etching aquatinted by J.C. Stadler.

Bibl: Fagan, L., Descriptive Catalogue of the Works of W.F., 1888.

FAITHORNE, William II 1656-1710
Mezzotint engraver mainly of portraits after his contemporaries. He was the son and pupil of W. Faithorne I (q.v.).
'Elizabeth Cooper', after P. Lely, 13½ x 10in/34.5 x 25.5cm, £80-£140.
HLs mostly £15-£40.
TQLs mostly £30-£100.
CS.

FANSHAWE, Catherine Maria c.1775-c.1834
Poetess and amateur etcher of portraits and genre and historical subjects.
Small value.

FARINGTON, Joseph, R.A. 1747-1821
Landscape painter, etcher and aquatint engraver of landscapes. Most of his drawings were engraved by professional engravers, but he both drew and etched the plates for J. Boydell's History of the River Thames, and these were then aquatinted by J.C. Stadler (q.v.). He also worked on an album of experimental etchings c.1793 which includes outline etchings for the Thames set.
Pl. for Boydell's History of the River Thames, 1794-6, aq. by Stadler, 76 pl., fo., e. double page £100-£250 col., single £30-£70 col.
'Extensive Wooded Landscape with Woodmen Loading Cart in Foreground', 1790, 16¼ x 24in/42.5 x 61cm, soft-ground etching with aq. and etching, £60-£90.
'View at Lynn', etching aq. by Stadler, 9 x 10in/23 x 25.5cm, and other experimental pl. by the two, £80-£160 prd. in col.

FARLEIGH, John 1900-1965
Wood-engraver of figure subjects. Also book illustrator.
Separate, signed prints £30-£80; bookpl. small value

FARN, J. fl. late 18th/early 19th century
Line and stipple engraver of small bookplates, mainly portraits, after his contemporaries.
Small value.

FARNBOROUGH, Amelia Long, Baroness
 1772-1837
Amateur watercolourist, soft-ground etcher and lithographer of landscapes and architectural views. She was a pupil of T. Girtin (q.v.) and lived at Bromley Hill Place, Kent. Her pl. are signed 'A. Long'.
£15-£40.

FAIRLAND, Thomas. 'Bachelor's Hall', after F.C. Turner, c.1835, one from a set of six lithographs.

FARRELL, Frederick A. 'The Law Courts in the Strand'.

FARRELL, Frederick A. 1882-1935
Watercolourist and etcher of architectural views. He lived in Glasgow.
'The Law Courts in the Strand' and other London views £60-£120.
Others £30-£70.

FARR, Robert b.1832
Painter and etcher of landscapes, topographical views, illustrations to Greek plays, etc. He was born in Cambridge, and many of his views were taken in and around that city.
Cambridge views £10-£30.
Others small value.

FARRER, Thomas Charles 1839-1891
Painter and etcher of landscapes. Born in London, he taught himself to paint and etch in New York, returning to England in 1871.
'Eton College from the River', 1888; 'Oxford from the River', 1889, e. £20-£60.
Others £5-£15.

FAWLEY, D.M. fl. 1920s/1930s
Wood engraver.
£10-£30.

FEARNLEY, Thomas 1802-1842
Norwegian-born landscape painter who made a few etchings. Two of his plates were included

posthumously in one of the Etching Club's earliest *Etch'd Thoughts*, 1844.
Presentation proofs £40-£90.
Others £10-£30.

FELLOWS, William Dorset
fl. late 18th/early 19th century
Etcher and aquatint engraver of sporting subjects and topographical views after his contemporaries and occasionally after his own designs.
'Racing', after S. Howitt, 1792, 4 pl., 11 x 15in/28 x 38cm, set £1,400-£2,000 col.
'Shooting', after S.J.E. Jones, 2 pl., 14¼ x 17¼in/36 x 44cm, pair £500-£800 col.
'Horses Watering' and 'Horses Going to the Fair', after S.J.E. Jones, 14¼ x 17¼in/36 x 44cm, pair £400-£600 col.
'The Celebrated Trotting Mare', 1824, 12¼ x 16¼in/132.5 x 42.5cm, £80-£140 col.
Pl. for J.T. Smith's Antiquities of Westminster, *1807, 4to., small value.*

FERGUSON, James fl. mid-19th century
Lithographer of topographical views and military subjects after his contemporaries as well as his own designs. It seems that he worked for the Topographical Department of the War Office.
Pl. for Scotland Delineated, *after various artists, 1847-54, fo., £10-£20.*
'Dress of the British Army', 1866, 2 sets: Guards, Highlanders, each set 5 pl., 8¼ x 9¼in/21 x 24cm, e. pl. £70-£90 col.
'Review of the Volunteers at Edinburgh by H.M. The Queen', 1860, 15 x 32¼in/38 x 82cm, £250-£350 col.
'Engagements in Abyssinia', after Lt. Col. R. Baigrie, 1868, 2 pl., 10 x 14in/25.5 x 35.5cm, e. £80-£120.

FERGUSSON, John Duncan 1874-1961
Scottish painter of landscapes and figure studies who etched a few figure studies dating to the turn of the century. Born in Perthshire, he was influenced by the Glasgow School as well as by Manet and the Post-Impressionists. He worked in Paris and London before settling in Scotland.
£40-£90.

FERRIER, George Straton, R.E. d.1912
Scottish painter and etcher of landscapes and marine subjects. He was born in Edinburgh and contributed plates to *The Portfolio*.
£5-£15.

FIELD, R. fl. late 18th century
Mezzotint engraver of a few rare portraits after his contemporaries.
£15-£90.
CS lists 2 pl.

FIELDING, Haworth fl. mid-19th century
Lithographer.
Pl. for E. Sharpe's Architectural Parallels, *1848, fo., tt., small value.*

FIELDING, Newton Smith Limbard 1799-1856
Animal painter, etcher and aquatint engraver of sporting subjects and topographical views after his own designs and those of his contemporaries. Born in Huntingdon, he was the brother of the watercolourist Anthony Vandyke Copley Fielding and the engravers Thales and Theodore Fielding (qq.v.). He worked mainly in Paris where the family had a business, but also in London from time to time.
'Moving Accidents by Flood and Field', after F.C. Turner, 1836, 14½ x 17in/37 x 43cm, 4 aq., set £800-£1,500 col.

FIELDING, Newton Smith Limbard. 'a Swedish Brig'.

'*Red Deer Shooting*', *1838, 9 x 12in/23 x 30.5cm, 2 aq., pair £400-£600 col.*
'*Salmon Fishing,*' *8½ x 12in/22 x 30.5cm, 2 aq., pair £500-£800 col.*
'*Chantilly Races*', *after E. Lami, 1841, 18½ x 27in/47 x 68.5cm, aq., £1,000-£1,400 col.*
'*Cock Fighting*', *1853, 5¾ x 7½in/14.5 x 19.5cm, 6 aq., set £300-£400 col.*
Pl. for G. Petrie, A. Nicholl and H. O'Neill's Scenery of Ireland, *1835, 4to., e. £20-£50 col.*
2 pl. for T.T. Bury's Six Coloured Views on the London and Birmingham Railway, *1837, 4to., 2 aq., e. £100-£200 col.*
'*A Swedish Brig*', *after N.S.L.F., 6 x 8in/15 x 20.5cm, £15-£35 col.*

FIELDING, Thales 1793-1837

Landscape painter and aquatint engraver of topographical views after his contemporaries. Born in London, he was the brother of the watercolourist Anthony Vandyke Copley Fielding and the engravers Newton and Theodore Fielding (qq.v.). He worked in the family business in Paris early in his career and later settled in England, teaching drawing at the Royal Military Academy, Woolwich.
Pl. for Lefebvre-Durufle's Excursion Sur les Côtes et Dans les Ports de Normandie, *1823-5, fo., e. £20-£50.*
Pl. for G. de la Salle's Voyage Pittoresque en Sicile, *1822-6, lge. fo., e. £30-£80.*

FIELDING, Theodore Henry Adolphus
 1781-1851

Landscape painter and aquatint engraver of topographical views, sporting and coaching subjects after his contemporaries as well as after his own designs. He was the brother of Anthony Vandyke Copley Fielding and the engravers Newton and Thales Fielding (qq.v.). He worked in and around London, first at the family business in Newman Street; later he was Drawing Master at the Military Academy, Addiscombe. He also produced several books on drawing, painting and engraving.
Pl. for drawing books £1-£8.
Pl. for J. Johnson's Views in the West Indies, *1827-9, obl. fo., e. £400-£600 col.*
'*Views In and Near Bath*', *after B. Barker, 1824, 48 pl., fo., e. £15-£25 col.*
'*The Elephant and Castle on the Brighton Road*', *after J. Pollard, 1826, 23¾ x 31in/60.5 x 79cm, £2,000-£3,000 col. (a very fine imp. col. fetched £4,500 October 1993).*
'*The Leicestershire*' *(foxhunting), after H.T. Alken, 1827, 4 pl., 11¾ x 18½in/30 x 47.5cm, £1,000-£1,500 col.*
'*A Stanhope with a Favourite Horse*', *after J. Pollard, 1826, 11 x 16in/28 x 40.5cm, £400-£700 col.*

FIELDING, Thomas 1769-1793 or later

Stipple engraver of decorative, biblical and mythological subjects after his contemporaries. He enrolled at the R.A. Schools at the age of 21 and was the pupil of W.W. Ryland (q.v.); he did much work for the latter and consequently few of his plates bear his own name.
'*Theseus Finding his Father's Sword and Sandals*', *after A. Kauffmann, circle, 12in/30.5cm diam., £80-£160 prd. in col. or in sepia.*

FIESINGER, Gabriel 1723-1807

German stipple engraver of portraits and bookplates after his contemporaries. He worked in London from 1793.
'*Lord Hood*', *after J. Northcote,1793, £80-£120.*
Pl. for S. Lyson's Roman Antiquities at Woodchester, *1797, small value.*

FIELDING, Theodore Henry Adolphus. 'The Elephant and Castle on the Brighton Road', after J. Pollard, 1826.

FINDEN, Edward Francis 1791-1857

Line and stipple engraver of small bookplates and plates for the annuals after his contemporaries and Old Master painters, including landscapes, topographical views, portraits and decorative subjects. He was a pupil of J. Mitan and the brother of W. Finden (qq.v.) with whom he collaborated on many plates. He lived and worked in London.
Small value.

FINDEN, George C. fl. late 19th century

Line engraver of small bookplates and plates for the annuals, including portraits and decorative subjects after his contemporaries and some British 18th century artists. It is probable that he was related to E.F. and W. Finden (qq.v.). He worked in London.
Small value.

FINDEN, William 1787-1852

Line engraver of small bookplates after his contemporaries and Old Master painters. Born in London, he was a pupil of J. Mitan and the brother of G.C. Finden (qq.v.) with whom he collaborated on many plates. Later in life he engraved a few large plates mainly after Edwin Landseer and David Wilkie.

FINDEN, George C. 'Peg Woffington and Rich', after F. Smallfield. This is characteristic of the many small bookplates executed by the Finden family.

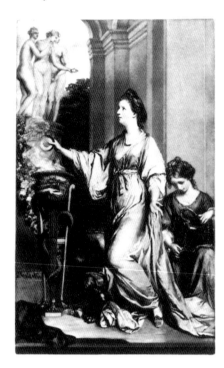

FISHER, Edward. 'Lady Sarah Bunbury, sacrificing to the Graces', after J. Reynolds.

Lge. pl. £50-£150.
Add more if in fine contemporary frame.
Others small value.

FINDLAY, J. fl. early 19th century
Draughtsman and aquatint engraver. Possibly the watercolourist who exhibited London views at the R.A. in 1827 and 1831.
'Confessions of an Oxonian', 1826, 36 pl., 12 mo., e. £5-£15 col.

FINLAYSON, John 1730-74
Mezzotint engraver of portraits after his contemporaries. He worked in London and all his plates bear dates from 1765 to 1773. John Boydell (q.v.) apparently reprinted his plates after his death without altering the publication lines.
'Samuel Foote and Thomas Weston as The President and Dr. Last', after J. Zoffany, 1769, 18 x 21in/45.5 x 55cm, £200-£300.
'Lord Romney', WL, after J. Reynolds, 1773, 24¼ x 15in/63 x 38cm, £80-£120.
'David Garrick as Kiteley', after J. Reynolds, 15 x 10in/38 x 27.5cm £140-£200.
Other HLs mostly £15-£40.
CS.

FINNIE, John, R.E. 1829-1907
Scottish painter, etcher and mezzotint engraver of landscapes. Born in Aberdeen, he was a pupil of W.B. Scott (q.v.) and worked mainly in England. He was President of the Liverpool Academy 1887-8.
Small value.

FIRTH, Marjorie fl. 1920s/1930s
Wood engraver.
£10-£30.

FISHER, Alfred Hugh, A.R.E. 1867-1945
Painter and etcher of figure subjects and architectural views. Born in London, he studied at the R.C.A. and travelled widely abroad.
£15-£40.

FISHER, Edward 1730-c.1785
Irish mezzotint engraver mainly of portraits after his contemporaries. He worked in London. His best plates are considered to be those after J. Reynolds who described him, however, as 'injudiciously exact'.
'Lady Sarah Bunbury, Sacrificing to the Graces', after J. Reynolds, 23½ x 14½in/59.5 x 37cm, £150-£250.
'John, Lord Ligonier' (equestrian portrait), after J. Reynolds, 23¼ x 18in/60.5 x 45.5cm, £300-£500.
'Garrick between Comedy and Tragedy', after J. Reynolds, 16 x 20in/40.5 x 51cm, £120-£180.'Benjamin Franklin of Philadelphia', after M. Chamberlain, 14¼ x 10½in/37.5 x 27.5cm, £300-£400.
'The Ladies Yorke', after J. Reynolds, c.1765, 20 x 14in/51 x 35.5cm, £200-£300.
'Lady Elizabeth Keppel', after J. Reynolds, 23½ x 14½in/59.5 x 37cm, £200-£300.
Male HLs £15-£40.

FISHER, Ida fl. early/mid-20th century
Linocut artist.
£50-£150.

FISHER, Jonathan d.1809
Irish painter and aquatint engraver of landscapes and topographical views. Born in Dublin, he settled in England, working from 1778 in the Stamp Office. While many of his drawings were engraved by others, he engraved the following:
'A Picturesque Tour of Killarney', 1789, 20 pl., obl. fo., e. £20-£50 sepia.
'Scenery of Ireland', 1795, 60 pl., obl. fo., e. £20-£50 sepia.

FISHER, Samuel fl. mid-19th century
Line engraver of small topographical bookplates after his contemporaries. Born in Birmingham, he was a pupil of W. Radclyffe (q.v.) and worked in London.
American and Swiss views £5-£15.
Others small value.

FITTON, Hedley. An architectural view.

FISHER, Thomas 1782-1836
Amateur artist and antiquary. Born in Rochester, he worked at the India Office and died in Stoke Newington. He experimented with etching and lithography, reproducing:
'A Series of Ancient . . . Paintings . . . , Discovered in the Summer of 1804 on the Walls of the Chapel of Trinity at Stratford on Avon' (depicting church brasses, classical fragments, etc.), sheet ave. 11¼ x 17½in/28.5 x 45cm, e. £5-£10.
'Monumental Remains & Antiquities in the County of Bedford, 1828, fo., 36 pl., special copy with hand-col. pl. fetched $1,500 June 1992.
Man Cat.

FITCH, Walter fl. mid-19th century
Draughtsman and lithographer of botanical plates for the works of Sir W.J. Hooker.
'Victoria Regina, or Illustrations of the Royal Water Lily', 1851, 4 pl., 22 x 29½in/55.5 x 75.5cm, e. £400-£800 col. (set fetched $9,500 June 1990).
'Illustrations of Himalayan Plants', after J.D.

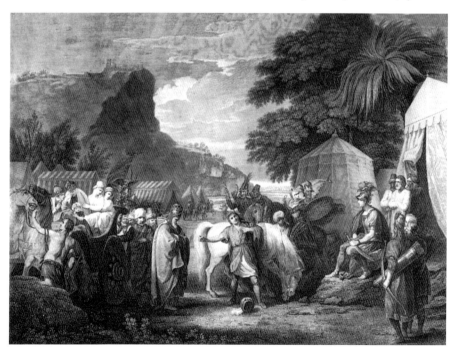

FITTLER, James. 'The Distress of Tigranes before Cyrus,...', after B. West, 1788. A typical 18th century historical engraving.

Hooker, 1855, 24 pl., 19¼ x 14½in/50 x 37cm, set £2,500-£4,000 col.

FITTLER, James, A.R.A. 1758-1835
Line engraver of naval and decorative subjects, portraits and topographical views, mainly after his contemporaries and occasionally after Old Master painters. Born in London, he studied at the R.A. and was appointed marine engraver to George III.
'North West View' and 'South West View of Windsor Castle', after G. Robertson, 1782-3, 19 x 23½in/48 x 60cm, pair £300-£500.
'Battle of the Nile', after P.J. de Loutherbourg, 1803, 20 x 30in/51 x 76cm, £250-£400.
'Rodney and de Grasse in the West Indies', after R. Paton, 1786, 18 x 26in/45.5 x 66cm, £200-£300.
'Victory of Cape St. Vincent', after Lieut. J. Brenton, 1798, 3 pl., 20 x 27in/51 x 68.5cm, set £600-£900.
'The Iron Bridge over the Severn', after G. Robertson, 14 x 20½in/35.5 x 52cm, £200-£400.
'View of Christ Church Gate, Oxford', 1800, 21¼ x 15½in/55 x 40cm, £100-£160.
'The Distress of Tigranes before Cyrus', after B. West, 1788, eng., £10-£20.
'Pedlars', after G. Morland, 1799, 8 x 10in/20.5 x 25.5cm, £10-£15.
'Views in Scotland', after J.C. Nattes, c.1820, 9 x 11in/23 x 28cm, e. £5-£15.
Pl. for H.L. Eveque's Campaign of the British Army in Portugal, *15½ x 21½in/39.5 x 54.5cm, e. £30-£70.*
Portraits £5-£15.
Small bookplates small value.

FITTON, Hedley, R.E. 1859-1929
Etcher mainly of architectural views. Born in Manchester, he worked both in Great Britain and on the Continent. He lived at Haslemere.
£40-£100.
Bibl: Dunthorne, R., *Catalogue of the Etchings of H.F., R.E.,* London, Rembrandt Gallery, 1911.

FLAMENG, Leopold Joseph 1831-1891
French etcher and engraver of portraits and biblical and decorative subjects after his own designs, his contemporaries and Old Master painters. Born in Brussels of French parents, he worked mainly in Paris. He is mentioned here for several plates executed after English artists and for some etchings which he contributed to *The Portfolio.*
'The Road to Ruin', after W.P. Frith, 5 pl., 17½ x 21in/44.5 x 53.5cm, set £70-£120.
'Death Crowning Innocence', after G.F. Watts, 1891, 19 x 12in/48.5 x 30.5cm, and similar sentimental subjects, £10-£50.
Add more if in fine contemporary frame.
'Portrait of F. Seymour Haden' £10-£25.
Other portraits £5-£15.
Pl. after Old Master painters small value.

FLETCHER, F. Morley b.1866
Painter and colour woodcut artist of landscapes and figure subjects. He was director of the School of Fine Art at Reading College, Oxford.
£40-£90.

FLETCHER, Henry
 fl. early/mid-18th century
Line engraver of natural history subjects, topographical views, etc., after his contemporaries. He worked in London and is best known for the following two sets:

FLETCHER, F. Morley. A woodcut landscape in colours.

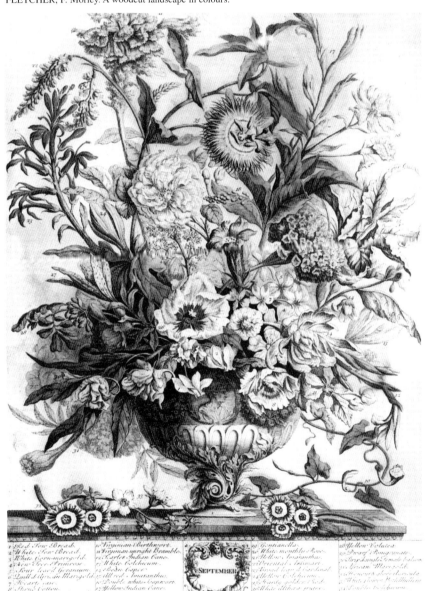
FLETCHER, Henry. 'The Months in Flowers: September', 1730.

FLIGHT, W. Claude. 'Paris Omnibus', c.1925.

FLINT, William Russell. 'Bagno della Marchesa'.

'The Months in Flowers', 1730, and 'The Months in Fruit', both sets of 12 pl. after P. Casteels, 16¾ x 12½in/42.5 x 32cm, e. pl. £500-£1,000 col. ('Months in Flowers' bound, i.e. all in consistently fine, fresh condition, with completely unfaded colours, fetched £18,000 April 1988).
Pl. for Icones Avium, after C. Collins, 1736, 12 pl., ave. 14½ x 18in/36.5 x 45.5cm, e. £200-£500 col.
Views of Venice after Canaletto £15-£40 col.
Bookplates small value.

FLIGHT, W. Claude 1881-1955
Important colour linocut artist. Born in London, he enrolled at Heatherley's in 1912 where he met C.R.W. Nevinson (q.v.). In 1922 he joined the Seven and Five Society whose members included Moore, Nicholson, Hepworth and others, but was later voted out. Flight probably learnt the technique of the linocut from seeing the work of the Viennese teacher Professor Franz Cizek, and he then taught linocutting at the New Grosvenor School of Modern Art. He treated modern day subjects, often involving movement and engineering, in a Futurist style, and was followed by a number of pupils, including E. Lawrence, C. Power, E. Mayo, L. Tschudi (qq.v.). He published some books on linocutting and printing in colours.
'Speed', c.1925/6, 8¾ x 11¼in/22 x 28.5cm, £3,500-£7,000.
'Paris Omnibus', c.1925, 10½ x 12¼in/26.5 x 31cm, £1,200-£2,400 prd. in col.
'Mother and Child', c.1929, 4¾ x 7½in/12 x 19cm, £600-£1,200.
'Brooklands', 12 x 10in/30.5 x 25.5cm, fetched £10,000; 'The Tube Staircase', 10 x 11¼in/25.5 x 29cm, £5,500; and 'Appy 'Ampstead', 13½ x 10¾in/34.5 x 27.5cm, £3,200, all in November 1989 at the peak of the market for these linocuts.

FLINT, Sir William Russell,
R.A., P.R.W.S., R.S.W., R.E. 1880-1969
Well-known Scottish watercolourist and drypoint etcher of figure subjects and landscapes. He was born in Edinburgh where he was educated and where he was apprenticed to a firm of lithographers. Coming to London in 1900, he worked as an illustrator for a medical journal and then for The Illustrated London News. Having studied watercolour painting in the evenings at Heatherley's, he turned to book illustration. He took up drypoint in 1928, after trying and rejecting etching. He worked extensively in Scotland and on the Continent. There is a considerable market in the so-called 'signed artist's proofs' (reproductions of his watercolours signed in pencil by himself).
Drypoints:
'The Shrimper', 9½ x 5in/24 x 12.5cm, £500-£900.
'Gleaming Sands', 13¼ x 8½in/34 x 22cm, £400-£700.
'Bagno della Marchesa' £250-£350.
Others mostly £150-£350.
Signed artist's proofs:
Without figures £120-£150.
With figures: nude/semi-nude women £400-£1,000 (the favourite subjects fetching the top prices are always changing); other figures £150-£250.
There have been large editions of some subjects published much more recently, i.e. long after the artist's death, and, therefore, not signed by him: I would recommend that buyers who are interested in artist's proofs only purchase the earlier signed ones.

FLOWER, John 1793-1861
Leicester draughtsman and lithographer of topographical views.
*'Views of Ancient Buildings in Leicester',
c.1830, 25 pl., fo., e. £5-£10.*

FOCILLON, Victor Louis 1849-1918
French etcher of landscapes and sentimental subjects, etc., after French and English contemporaries. He was born in Dijon and worked in Paris.
Small value.

FOGG, Anthony fl. 1792-1806
Stipple engraver of portraits and decorative and military subjects after his contemporaries. He worked in London until about 1805 when he moved to Reading.
*'Sir Sidney Smith at the Siege of St. Jean d'Acre, 1799', after W. Hamilton, 1802, 18½ x 23½in/47.5 x 60.5cm, £300-£500 prd. in col.
'The Blackberry Gatherer' and 'The Cowslip Gatherer', after W. Hamilton, 1802, pair £500-£700 prd. in col.
'Priam Supplicating Achilles for the Body of Hector', after J.S. Copley, 1799, £10-£25.
'The House of Commons in Sir Robert Walpole's Administration', after W. Hogarth and J. Thornhill, £40-£70.*

FOLLIE, William Stewart
fl. early/mid-20th century
Drypoint etcher of marine subjects. He imitated the style of W.L. Wyllie (q.v.).
£10-£30.

FONCE, Camille Arthur b.1867
French etcher of landscapes after his own designs as well as after his French and British contemporaries. Born at Briare, he was a pupil of M. Lalanne and A. Allongé and worked in France and England.
Small value.

FOOTET, Frederick Francis 1850-1935
Painter, etcher, lithographer, mezzotint engraver of landscapes after his own designs and those of his contemporaries. Born in Sheffield, he worked in London.
Small value.

FORD, F. fl. mid-19th century
Landscape painter and lithographer.
'Pool Valley During the Storm at Brighton', 1850, 12¾ x 19¼in/32.5 x 49cm, tt., £100-£150.

FORD, Michael fl. mid-18th century
Mezzotint engraver of portraits after his contemporaries and also his own designs. He was probably a pupil of J. Brooks (q.v.) to whose business as a printseller he succeeded c.1747. He was apparently lost at sea in 1758.
£15-£60.
CS.

FORD, Richard 1796-1858
Author of the *Handbook for Travellers in Spain*, amateur painter and etcher.
Small value.

FORES, S.W. fl. late 18th/early 19th century
Publisher and printseller, firstly of caricatures and later of sporting and other subjects. He founded the firm, Fores, in 1783.
*For prices refer to various etchers and engravers.
'Panorama of the Marriage Procession of Queen Victoria and Prince Albert', anon., 1840, 4½ x 240in/1.5 x 610cm, aq., £600-£1,200 col..*

FOX, Charles. 'The Poacher's Bothie', after E. Landseer, 1846.

Colour plate page 34.

FORREST, William 1805-1899
Scottish line engraver of small bookplates including landscapes, biblical and sentimental subjects after Old Master painters and his contemporaries. He seems to have worked in Edinburgh and London.
Small value.

FORREST, William S. fl. late 18th century
Painter, mezzotint engraver and lithographer of sporting subjects after his contemporaries as well as his own designs. He lived at Greenhithe, near London.
*'Salmon Spearing by Torchlight', a scene on the Tweed, after W. Simpson, 17 x 23in/43 x 58.5cm, £120-£200.
'Tom Hills on Gay Lass', litho., £100-£250.
Add more if in fine contemporary frame.*

FORRESTER, James 1729-1775
Irish painter and etcher of landscapes after his contemporaries and his own designs. Born in Dublin, where he studied, he went to live in Rome soon after 1752 and remained there for the rest of his life.
Views of Rome, after P. Stephens, etc., small value.

FOSTER, Myles Birket 1825-1899
Eminent watercolourist and illustrator who began his career as wood engraver of blocks for *The Illustrated London News*, etc., and produced several etchings mostly early in his career. Born in North Shields, he moved to London with his family in 1830. He was apprenticed to the wood engraver E. Landells (q.v.). At first he engraved the blocks himself but later, when he started his own business in 1846, he drew the illustrations on the blocks which were then engraved by other professionals. From about 1859, he concentrated on painting. He settled in Surrey.
*Milton's 'L'Allegro' and 'Il Penseroso', 1855, 30 etchings, e. £5-£10.
'Sheep Feeding', for The Etcher, 1880, £8-£15.
Wood eng. by or after M.B.F. small value, unless proofs, £8-£15.
Chromolitho. after M.B.F. £5-£15.*

FOUGERON, John fl. 1750-69
Line engraver.
'A View of the Bishop's House, Quebec', after R. Short, 1761, 13¾ x 19½in/35 x 50cm, £400-£700.

FOURDRINIER, Pierre fl. 1720-d.1758
French-born line engraver of architectural and topographical views, portraits, etc., after his

contemporaries. A member of a French refugee family, he studied in Amsterdam under B. Picart (q.v.) before settling in London in 1720.
*'Employment According to Age', after A. Watteau, 10¼ x 13½in/27.5 x 35cm, £20-£50.
'Portrait of Jonathan Swift', after C. Jervas, 11¼ x9½in/130 x 25cm, £30-£70.
'Mansion House', after Wale, 1754, 10½ x 16½in/26.5 x 42cm, £60-£120.
'The Plans . . . of Houghton' after I. Ware, 1735, 28 pl., fo. set £300-£400.
Small portraits and bookplates small value.*

FOWLER, J. fl. 1850
Lithographer of some of the architectural plans and elevations for H. Bowman's and J.S. Crowther's *Churches of the Middle Ages*, 1850.
Small value.

FOX, Augustus fl. mid-19th century
Line engraver of small bookplates, including portraits and figure subjects after his contemporaries.
Small value.

FOX, Charles fl. 1846
Etcher, mezzotint and line engraver, mostly of small bookplates including portraits, genre and sentimental subjects after his contemporaries. Born in Norfolk, he was apprenticed to W.C. Edwards and then worked for J. Burnet, engraving plates after D. Wilkie (qq.v.). Later he worked mainly for the Annuals.
*'The Poacher's Bothie', after E. Landseer, 1846, 18¾ x 23in/47.5 x 58.5cm, and others of similar size £150-£300.
Add more if in fine contemporary frame.
Bookplates small value.*

FOX, Charles Henry b.1860
Painter and etcher of landscapes. He lived at Kingston-on-Thames.
£8-£15.

FRAILING, George fl. late 18th century
Etcher and mezzotint engraver of decorative subjects after his contemporaries.
'The Woodman at Labour', after J. Barney, and 'The Woodman's Repast', after C. Turner, 1799, 20¼ x 17¼in/53 x 44cm, pair £300-£500 prd. in col.

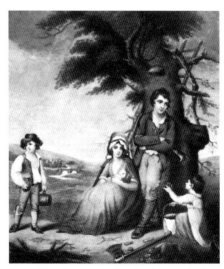

FRAILING, George. 'The Woodman's Repast', after C. Turner, pair with 'The Woodman at Labour', after J. Barney, 1799.

FRANCIA, Louis Thomas. A soft-ground etching printed on coloured paper, with white heightening added by hand.

FRANCIA, Louis Thomas 1772-1839
Watercolourist and soft-ground etcher of landscapes after his own designs and those of his contemporaries. Born in Calais, he came to England in 1795. He taught drawing from 1805 and returned to Calais in 1817, where he died.
'Studies of Landscape', after T. Gainsborough, J. Hoppner, etc., 1810, 7¼ x 9½in/18.5 x 24cm, e. £5-£10.
'Marine Studies', 1822, 4to., e. £5-£10.
'Progressive Lessons Tending to Elucidate the Character of Trees', 12 pl., 4to., e. £5-£10 col.

FRANK, William Arnee
 fl. early/mid-19th century
Draughtsman and lithographer.
'Ten Views in the Vicinity of Bristol', 1831, obl. 4to., e. £10-£25.

FRANKLAND, Sir Robert, 7th Bt.
 1784-1849
Amateur draughtsman, etcher and lithographer of sporting subjects, sometimes with a humorous slant. He lived at Thirkleby Park and was M.P. for Thirsk, Yorkshire, from 1815 to 1834. He signed his plates 'R.F.'
'Indispensable Accomplishments', 1811, 6 pl., 8¼ x 11½in/21 x 29cm, etchings, set £200-£300 col.
'Sketches of Deer Stalking in the Highlands', 1839, 10 pl., 10 x 14in/25.5 x 35.5cm, litho., set £300-£500.

FRASER, Claude Lovat 1890-1921
Illustrator, stage designer and colour woodcut artist. Born in London, he was a pupil of W. Sickert (q.v.). He was wounded in World War I.
£40-£90.

FREEBAIRN, Alfred Robert 1794-1846
Line engraver of small bookplates, mainly landscapes after his contemporaries. The son of the landscape painter Robert Freebairn, he studied at the R.A. Most of his work was executed for the Annuals.
Small value.

FREEDMAN, Barnett 1901-1958
Painter and lithographer of figure subjects, portraits and landscapes. Born in London, he studied at St. Martin's School of Art and at the R.C.A. He is best known as a designer of posters. He was an Official War Artist during World War II.
Posters and other large lithos £80-£250.
Smaller, separate prints £30-£80.
Small bookpl. small value.

FREEMAN, Samuel 1773-1857
Stipple and line engraver of portraits and decorative subjects after his contemporaries and Old Master painters. Born in London, he is believed to have been a pupil of F. Bartolozzi (q.v.). Most of his early work is in stipple and he is best known for his plates after Adam Buck, executed with the aquatinter J.C. Stadler (q.v.).
Pl. after A. Buck and W. Deroy £150-£250 prd. in col.
Add more if in fine contemporary frame.
Small bookplates small value.

FREEMAN, Samuel. 'My Tambourine', after A. Buck, 1811.

FREETH, H. Andrew, R.A., R.E. b.1912
Painter and etcher of portraits, genre subjects and landscapes. Born in Birmingham, he studied at the College of Art there and at the British School in Rome.
Portraits of celebrities £80-£200.
Others £50-£150.

FRENCH, William fl. mid-/late 19th century
Etcher and line engraver of historical subjects, etc., after his contemporaries. He contributed to the Annuals.
Small value.

FRESCHI, Andrea 1774-1815
Italian stipple engraver of portraits and decorative subjects after his English contemporaries and his own designs. Born in Bassano, he moved to London c. 1797.
'Lady Theodosia Cradock', after R. Cosway, £70-£140 prd. in col.
'Lady Charlotte Carr', after J. Bell, 10 x 6in/25.5 x 15cm, £5-£10.

FRANKLAND, Robert. One of six plates from 'Indispensable Accomplishments: Swishing at a Rasper', 1811.

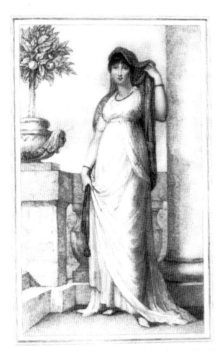

FRESCHI, A. 'Lady Theodosia Cradock', after R. Cosway.

FUSELI, Heinrich. 'Woman Sitting by a Window: Evening Thou Bringest All', c.1802.

'Mr. Kean as Richard III', 1814, 12½ x 8¼in/32 x 21cm, £50-£80 prd. in col.
'Awake' and 'Asleep', after Frood, 1809, 12 x 10in/30.5 x 25.5.cm, pair £250-£400 prd. in col.
Add more if in fine contemporary frame.

FROOD, Hester, A.R.E. 1882-1971
Painter and etcher of landscapes and architectural views. Born in New Zealand, she studied at Exeter and in Paris and lived in Devon. She was influenced by D. Y. Cameron (q.v.).
£40-£70.

FROST, D. fl. 1920s/1930s
Wood engraver.
£10-£30.

FROST, William Edward, R.A. 1810-1877
Eminent Victorian painter and occasional etcher of figure subjects, especially nymphs and mermaids.
£10-£30.

FRY, Roger 1866-1934
Painter, art critic, occasional lithographer and wood engraver. Born at Highgate, he took up art having studied science, and worked in W. Sickert's (q.v.) studio. He was Director of the Metropolitan Museum of Art, New York, 1905-10, and organised the first two shows of Post-Impressionist art in London, 1910-11 and 1912.
£20-£60.

FRY, William Thomas 1789-1843
Stipple and line engraver and lithographer of portraits and decorative subjects after his contemporaries and Old Master painters. He was one of the first engravers to work on steel plates. He produced mainly small bookplates.
Small value.

FRYE, Thomas 1710-1762
Important Irish mezzotint engraver of portraits after his own designs and those of his

contemporaries. Born in Dublin, he came to England at an early age and practised as a portrait painter before managing a china manufactory for fifteen years. He seems to have produced all of his prints in the two years before his death from consumption and gout. The series of life-size heads is interesting not only because of the unusual nature of the subject matter and its dramatic treatment, but also because few engravers at this time designed their own prints, merely reproducing the designs of other painters.
Portraits of ladies 'elegantly attired' and life-size heads after his own designs e. £600-£1,200.
'Queen Charlotte' and 'George III', both after T.F., former by T.F., latter by R. Purcell, 13¾ x 9½in/35 x 25cm, pair £300-£600.
Portraits after other artists £50-£150.

FULLER, Isaac 1606-1672
Portrait and historical painter who etched a few rare plates, including fifteen for *Un Libro*

FROST, William Edward. One of this famous painter's few etchings.

Designare, 1654, and some for *Iconologia, or Moral Emblems* by Caesar Ripa, published by P. Tempest, 1709.
£30-£80.

FULLER, S. & J. fl. early 19th century
Publishers of sporting and decorative subjects, costume plates, etc. Most of the plates published by them bear an artist's and engraver's name, but 'Modes de Paris' (costume plates), 4to., were engraved anonymously.
For prices see under various engravers.
Anon. small bookplates small value.

FULLWOOD, John 1854-1931
Painter and etcher of landscapes. Born in Birmingham, he lived at Twickenham.
£10-£30.

FUSELI (Fussli), John Henry, R.A. 1741-1825
Distinguished Swiss painter of figure and historical subjects and illustrator who worked in England after 1789 and was appointed Professor of Painting at the R.A. Many of his paintings were engraved by professionals. He experimented with lithography producing the following two works, both of which were published in *Specimens of Polyautography*:
'Woman Sitting By a Window', c.1802, 9¼ x 12¼in/23.5 x 31cm (one of the most successful early litho.), £300-£600; on original mount £1,200-£2,400.
'The Rape of Ganymed', 1804, 12¼ x 9¼in/31 x 23.5cm, £200-£300; on original mount £1,000-£1,600.
Man Cat.
Bibl: Weinglass, D.H. *Prints . . . by and after H.F.*, Aldershot, Scolar Press, 1994.

FYFE, Elizabeth 1899-1933
Etcher and line engraver of figure subjects particularly of a religious nature. Born in Sydney, Australia, she lived in London.
£20-£50.

G

GABAIN, Ethel Leontine 1883-1950
Painter, etcher and lithographer of figure subjects and portraits. Born at Le Havre, she studied at the Slade and Central Schools. She was married to J. Copley (q.v.) and was an Official War Artist during World War II.
Mostly £60-£180, but a few subjects more, e.g. 'Berceuse', 1915, 12¾ x 9½in/32.5 x 24cm, and 'Colombine à Paris', 1916, 18¾ x 12½in/47.5 x 32.5cm, £200-£400.
Illustrations to Jane Eyre, *1922, 22 pl., e. £5-£10.*
Bibl: Wright, H.J.D., 'The Lithographs of E.G.', *P.C.Q.*, 1923, X, p. 255.

GAINER, J. fl. late 18th century
Mezzotint engraver of portraits after his contemporaries.
£15-£40.
CS lists 2 pl.

GAINSBOROUGH, Thomas, R.A. 1727-1788
The most famous British 18th century portrait and landscape painter who produced a few etchings, soft-ground etchings and aquatints depicting landscapes with figures, cattle or wagons. Born at Sudbury, he came to London to study at first under Gravelot (q.v.), then at St. Martin's Lane Academy and finally under Francis Hayman. He lived in Ipswich, Bath and London. He was one of the few major painters of the period to experiment with printmaking, and his aquatints are much sought after for the painterliness of his engraving technique.
'The Gypsies', 18½ x 16¼in/47 x 41.5cm, etching before eng. added by J. Wood £1,000-£2,000; etching with eng. added £200-£300.
Aquatints:
Early states, before the Boydell edn., £3,000-£6,000; exceptional proofs up to £10,000 ('Repose', etching and aq., very rare, 8 x 10¼in/20.5 x 27.5cm, fetched £15,000 June 1995).
Imp. from Boydell edn., 1797, £1,000-£3,000; example illustrated here £1,800-£2,600.
'The Etched and Engraved Prints of T.G.', publ. 1971, by I. Bain, set of 11 reprints, red case, with text, obl. fo., £1,000-£2,000.
Bibl: Hayes, J., 'G. as a Printmaker', New Haven and London, 1971.

GALE, R.L. fl. mid-19th century
Lithographer of topographical views.
1 pl. for Narrative of a Journey to the Zoolu Country, *1836, 8vo., £5-£15.*
1 pl. for E. Hill's Views of Hawkstone Park, *c.1825, fo., £8-£12.*

GALLON, Robert 1845-1925
Painter and etcher of landscapes. He was the son of R.S. Gallon (q.v.) and lived in London.
£10-£30.

GALLON, Robert Samuel
fl. mid-19th century
Painter and lithographer of portraits after his own designs.
Small value.

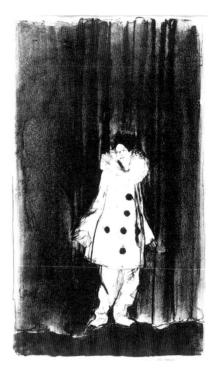

GABAIN, Ethel Leontine. 'Pierrot', 1916.

GAMMON, James fl. mid-17th century
Line engraver of portraits. He lived and worked in London.
£5-£15.

GANTZ, John fl. early 19th century
Draughtsman and lithographer of the following series:

'Indian Microcosm', publ. Madras 1827, 20 pl., obl. 4to., e. £20-£50 col. (set fetched £2,000 June 1993).

GARDINER, William Nelson 1766-1814
Irish etcher and stipple and line engraver of decorative subjects after his contemporaries. Born in Dublin, he came to London and worked for F. Bartolozzi (q.v.) and others. He returned to Dublin where he squandered his money before coming back to England. He committed suicide after various unsuccessful ventures, including bookselling.
2 pl. for 'The Months', after W. Hamilton (10 by F. Bartolozzi), 1793, 14 x 11in/35.5 x 28cm, stipples, e. £140-£200 prd. in col.
'The Tender Father' and 'The Relentless Father', after F. Wheatley, pair £400-£700 prd. in col.
'Volunteers and Yeomanry', 1803, 3 etchings, 10¼ x 8½in/27.5 x 22cm and smaller, e. £20-£50 col.
Pl. for H.W. Bunbury's Illustrations to Shakespeare, 1792-4, 16½ x 19in/42 x 48cm, £40-£80 prd. in col.
Small bookplates and portraits small value.

GARDNER, Thomas fl. early 18th century
Line engraver of small bookplates, e.g. for *The Book of Common Prayer*, 1735.
Small value.

GARDNER, William Biscombe 1847-1919
Painter of landscapes and wood engraver of illustrations for *The Graphic* and *The Illustrated London News*, including portraits and sentimental subjects after his contemporaries. He lived in London, Surrey and Tunbridge Wells.
Small value.

GARDNOR, Rev. John 1729-1808
Draughtsman and aquatint engraver of topographical views. He became Vicar of Battersea in 1778 and officiated at W. Blake's (q.v.) wedding in 1782.

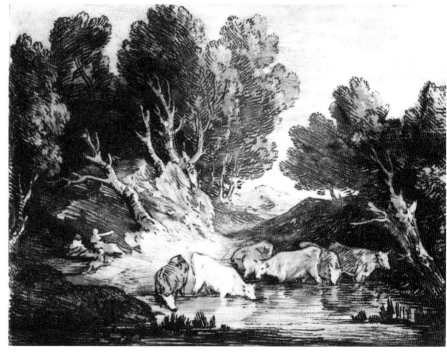

GAINSBOROUGH, Thomas. A typical aquatint engraving as published by J. Boydell, 1797.

*'Views Taken On and Near the River Rhine',
1788, 33 pl. after J.G. who eng. several, fo., e.
£15-£50; smaller version, 1791, 33 pl. mostly
eng. by J.G., small 4to., e. £10-£20 col.
Pl. for History of Monmouthshire, 1796, 33 pl.
after J.G., eng. by J.G. and J. Hill (q.v.), 4to.,
small value col.*

GARNER, Edith Mary b.1881
Painter and etcher of townscapes. Born near
Warwick, she studied at the Slade School and in
Paris, and was married to W. Lee-Hankey (q.v.).
£10-£30.

GARNER, Thomas 1789-1868
Birmingham line engraver of small bookplates
including portraits, decorative subjects and
topographical views mainly after his
contemporaries. He studied at the R.A. Schools,
was apprenticed to C. Heath (q.v.) and also
worked for W. Radclyffe (q.v.).
Small value.

GARNIER, Geoffrey Sneyd b.1889
Cornish painter, etcher and aquatint engraver of
coastal scenes and figure subjects. A pupil of
Stanhope Forbes, he lived and worked in
Newlyn, Cornwall.
£30-£70.

GARRARD, George, A.R.A. 1760-1825
Sculptor, painter and etcher of animal subjects
and portraits. He was a pupil of S. Gilpin (q.v.)
and studied at the R.A. Schools.
*'A Description of the Different Varieties of Oxen
Common to the British Isles' (his most
important prints), 1800, 52 pl., obl. fo., e. £30-
£60 col.
'Woburn Sheepshearing', after G.G., with M.N.
Bate, T. Morris and J.C. Stadler (qq.v.), 1811,
18½ x 30in/47 x 76cm, £400-£600.
Portraits £3-£8.*

GASCOYNE, George, R.E. fl. 1920s
Drypoint etcher of equine subjects, both
realistic and imaginary. He lived in Tunbridge
Wells. His prints seem to be rare.
£25-£60.

GASKELL, George Percival, R.E., R.S.A.
 1868-1934
Painter, etcher, aquatint and mezzotint engraver
of landscapes and coastal scenes. Born at
Shipley, Yorkshire, he lived in London where he
was headmaster at the Regent St. Polytechnic
School of Art for thirty years.
£30-£80.
Bibl: Salaman, M.C., 'Prints of P.G., R.E.,
R.S.A.', *Studio*, 1914, LXI, p. 238.

GATTY, Margaret 1809-1873
Authoress of children's books and amateur
etcher of landscapes. Born at Burnham, Essex,
she married a vicar and moved to Yorkshire.
£10-£30.

GAUCHEREL, Leon 1816-1886
French etcher of architectural views and
sentimental subjects after his own designs, Old
Master painters and his French and English
contemporaries. He was born in Paris where he
also lived.
Small value.

GAUCI, A. M. fl. mid-/late 19th century
Draughtsman and lithographer.
*'Lady Fragrant' (cow), 1870, 14¼ x 19½in/36 x
50cm, £200-£300 col.*

GARRARD, George. 'Woburn Sheepshearing', after Garrard, with M.N. Bate, J.C. Stadler and T. Morris, 1811.

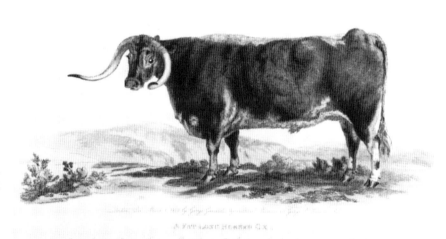

GARRARD, George. Plate from 'A Description of the Different Varieties of Oxen Common to the British
Isles: A Fat Long Horned Ox', 1800.

GAUCI, M. fl. early/mid-19th century
Lithographer of costumes, portraits and
topographical views after his contemporaries.
He was the father of P. and W. Gauci (qq.v.) and
worked in London.
*Pl. for E. Hull's Costume of the British Army,
1828-30, 72 pl., 4to., e. £30-£60 col.
Pl. for E. Hull's Costume of the British Navy,
1829, 17 or 12 pl., 4to., e. £20-£50 col.
Pl. for C. Macfarlane's Constantinople in 1828,
5 pl., 3 col. (views, costumes, etc.), 4to., e. £8-
£15 col.; double page pl. £100-£200 col.
Pl. for A Comparative View of the English
Racer and Saddle Horse, after various artists,
1836, 11½ x 8½in/29 x 22.5cm, e. £20-£50.
'The "'Age"' (coach), after C.C. Henderson,*
*11¼ x 19½in/28.5 x 49.5cm, £250-£400 col.
'Portrait of Henry Alken', 1823, 6½ x 5in/16.5 x
12.5cm, £20-£40.
Other portraits £5-£15.*

GAUCI, Paul fl. mid-19th century
Lithographer of topographical views after his
contemporaries. He was the son of M. and
brother of W. Gauci (qq.v.) with whom he
collaborated sometimes. He worked in London.
*'Lough Derg and the River Shannon', after
various artists, 1831, 5 pl., obl. 4to., e. £20-£40
col.
Pl. for R. Woodroffe's Views in Bath, c.1840, 18
pl., obl. 4to., e. £10-£25 col.
Pl. for Capt. I.S. Whitty's Views in the Vicinity*

GAUCI, Paul. 'Clovelly from the Pier', after H. Strong, from *Scenery in the North of Devon*. A typical British topographical view.

GAUCI, W. 'Door of the Hall of Ambassdors'. Plate for J.F. Lewis' *Sketches and Drawings of the Alhambra*, 1835.

of the City of Kingston, Jamaica, *1839, obl. fo., tt. pl., e. £80-£160.*
Pl. for C. Bentley's Twelve Views in the Interior of Guiana, *1840-1, 14½ x 20½in/37 x 53cm, tt. pl.,e. £150-£250 (set col. fetched £3,000 Dec. 1993).*
'Hayling Island Opposite the Isle of Wight', *after J.A. Borsley, 13 x 24½in/33 x 63cm, £200-£300 col.*
Portraits *£3-£15.*

GAUCI, W. fl. mid-19th century
Lithographer mainly of topographical views after his contemporaries. He was the son of M. and the brother of P. Gauci (qq.v.) with whom he collaborated sometimes. He worked in London.
'Punt Fishing', *after A.F. Roffe, 1867, 22½ x 34¼in/57 x 87cm, tt. pl., £600-£1,200 col.*
Pl. for Lieut. G.H.P. White's Four Views on the River Dart, *c.1830, fo., e. £15-£30.*
Pl. for W.A. Delamotte's Views of Oxford Colleges, Chapels and Gardens, *1845, fo., 25 tt. pl., e. £10-£25.*
Pl. for C. Stanfield's Sketches on the Moselle, the Rhine and the Meuse, *1838, fo., tt. pl., e. £40-£70.*
Pl. for J.F. Lewis' Sketches and Drawings of the Alhambra, *1835, fo., tt. pl., e. £25-£60.*
Pl. for Scenery in the North of Devon, *c.1837, obl. 4to., e. £10-£25 col.*
Channel Isles views, *after various artists, 1829-30, obl. fo., e. £50-£100.*

GAUGAIN, Thomas 1748-1810
French stipple engraver of decorative subjects and portraits after his contemporaries. Born at Abbeville, he came to England when very young and studied under R. Houston (q.v.). He lived for many years at 4 Little Compton St., Soho. He was one of the best stipple engravers of the period and produced a large number of engravings.
'Dancing Dogs' and 'Guinea Pigs', *after G. Morland, 1789-90, 22¼ x 16½in/56.5 x 42.5cm, pair £700-£1,100 prd. in col.*
'The Young Fortune Teller' and 'The Sheltered Lamb', *after R. Westall, 11¼ x 12¼in/28.5 x 31cm, pair £300-£500 prd. in col.*
'Country Girl of Tuscany', *after J. Northcote, 1794, 11½ x 9in/29 x 23cm, £60-£100 prd. in col.*
'An Airing in Hyde Park' and 'The Promenade in St. James's' by F.D. Soiron (q.v.), both after E. Dayes, *1793, 15¾ x 25½in/40 x 65cm, pair £2,000-£4,000 prd. in col.*
'Diligence' and 'Dissipation', *after J. Northcote, with T. Hellyer (q.v.), 1796, 10 pl., 19½ x 16in/49.5 x 40.5cm, e. £10-£20.*
'Lieut.-Col. Disbrowe', *after T. Barber, 1809, 12 x 10in/30.5 x 25.5cm, £5-£10.*
'Turnips and Carrots', *after F. Wheatley, from 'The Cries of London', 1793-7, 16½ x 13in/42 x 33cm, £250-£400 prd. in col.*
'Portraits of the Officers and Men Who Were Preserv'd From the Wreck of the Centaure', *after J. Northcote, 1796, 20¼ x 25½in/51.5 x 64cm, £300-£500 prd. in col.*

GAUJEAN, Eugène 1850-1900
French etcher and line engraver of genre, religious and sentimental subjects after his French and English contemporaries and Old Master painters. Born at Pau, Basses-Pyrénées, he worked in Paris and died at Andresy.
'Flora', *after E. Burne-Jones, 1894, 20 x 9¼in/51 x 23.5cm, £600-£1,200.*
'Flamma Vestalis', *after E. Burne-Jones, 1888,*

GAYWOOD, Richard. Portrait of George Monck, showing the influence of W. Hollar.

GAUGAIN, Thomas. 'An Airing in Hyde Park', pair with 'The Promenade in St. James's', by F.D. Soiron, both after E. Dayes, 1793.

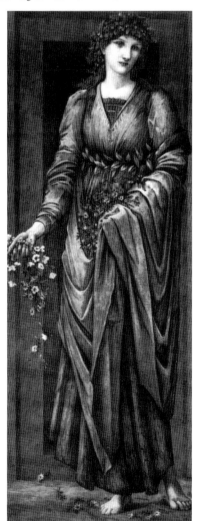

GAUJEAN, Eugène. 'Flora', after E. Burne-Jones, 1894.

17 x 7in/43.5 x 18cm, £600-£1,200.
'Ecce Ancilla Domini' (The Annunciation), after D.G. Rossetti, 1880, 9 x 17½in/23 x 44.5cm, £600-£1,200.
Pl. after J.E. Millais £50-£150; after other contemporaries £10-£25; after Old Masters small value.

GAYMARD, Antoine fl. early 20th century
Stipple engraver of decorative subjects after 18th Cent. painters.
'The Months of the Year' after W. Hamilton, c.1900, 14 x 11in/36 x 30cm, set fetched £400 October 1994.

GAYWOOD, Richard fl. mid-17th century
Etcher of portraits, and animal, religious and decorative subjects mainly after his contemporaries, though sometimes after his own designs. He was a pupil of W. Hollar (q.v.) and much influenced by him, even copying some of his plates.
'The Four Seasons' e. £10-£20.
Portraits £5-£15.
Natural history subjects after F. Barlow £10-£25.

GEAR, J.W. fl. mid-19th century
Draughtsman and lithographer of portraits, mainly of actors and musicians.
'Mr. Young as Iago' £20-£50 col.
Others £15-£50 col.

GEDDES, Andrew, A.R.A. 1783-1844
Scottish painter and drypoint etcher of portraits and landscapes after his own designs and Old Master painters and landscapes. Born in Edinburgh, he studied at the R.A. Schools and practised in Edinburgh and London, making occasional trips to the Continent. He was greatly influenced by Rembrandt's etchings, of which he had a large collection.
Rare early states £100-£200.
Contemporary imp. £20-£40.
Reprints small value.
Bibl: Dodgson, C., *The Etchings of Sir David Wilkie and A.G.,* Print Collectors' Club, 1936.

GEIKIE, Walter, R.S.A. 1795-1837
Scottish painter of landscapes and genre who produced a volume of etchings in 1833. He was born in Edinburgh where he lived and worked.
'Etchings Illustrative of Scottish Character and Scenery',
e. £10-£20.

GELLER, William Overend fl. mid-19th century
Painter, etcher and line and mezzotint engraver of portraits and genre, historical and decorative subjects after his contemporaries, British 18th century painters and his own designs. He worked in London.
'John Wesley Preaching in the Gwennap Amphitheatre, Cornwall', after Geller, 1846, 16 x 22in/40.5 x 56cm, £100-£200.
'Rice Wynne with Hounds', after J. Pardon, 1838, 24½ x 18½in/62 x 47cm, £250-£400.
'Fruit Piece', after G. Lance, 1848, 26 x19in/66 x 48cm, £150-£250.
Other lge. pl. after contemporaries £10-£100.
Add more if in fine contemporary frame.
Others small value.

GEAR, J.W. 'Mr. Young as Iago'.

GEIKIE, Walter. Plate from 'Etchings Illustrative of Scottish Character and Scenery: A Canny Customer'.

GELLER, William Overend. 'Fruit Piece', after G. Lance, 1848.

GEORGE, B. fl. mid-19th century
Lithographer.
1 pl. for Lieut.-Col. C.J. Dixon's Sketch of Mairwara, *1850, 4to., tt. pl., small value.*

GEORGE, Sir Ernest, R.A., R.E. 1839-1922
Eminent London architect, amateur watercolourist and etcher of architectural views. He studied at the R.A. Schools and contributed plates to *The Portfolio.* Many of his etchings depict Continental subjects.
'Etchings on the Moselle', 1873, 20 pl., and others, e. £8-£20.

GERICAULT, Théodore 1791-1824
Important French painter and lithographer who is mentioned here for having visited England and executed a series of litho. of horses, published by Rodwell & Martin in 1821, 'The English Series'.
'The English Series', e. £1,000-£2,000.

GEREMIA, I. fl. early 19th century
Stipple engraver mainly of small bookplates including portraits and decorative subjects after his contemporaries.
'Maternal Instruction', after L. Schiavonetti, 1804, £100-£200 prd. in col.
Bookplates small value.

engravings of the period from World War One up to 1921 are the most sought after. Later he produced many illustrations for private press books and was director of the Golden Cockerel Press from 1924.
'Vanishing-line' prints £100-£300
Others mostly £50-£150.
Bibl: Empson, P., *The Wood Engravings of R.G.*, Dent, 1959.

GIBBON, Benjamin Phelps 1802-1851
Line and mixed-method engraver of portraits and animal subjects after his contemporaries. Born in Pembrokeshire, he was apprenticed to J.H. Robinson and E. Scriven (qq.v.). He died in London.
'Roebuck and Rough Hounds', after E. Landseer, 1849, 17 x 21¼in/43 x 54cm, £200-£400.

GESSNER, Conrad 1764-1826
Swiss painter of equine and military subjects who produced some early lithographs while staying in England, 1796-1804.
£200-£400; mounted on original support sheet £400-£700.
Man Cat. lists 14 pl., 2 publ. in *Specimens of Polyautography.*

GETHIN, Percy Francis 1874-1916
Irish painter, draughtsman, etcher and lithographer of figure subjects and architectural views. Born at Holywell, Sligo, he studied at the R.C.A., Westminster School of Art and in Paris. He was killed in the Battle of the Somme.
£40-£100.
Bibl: Wright, H.J.L., 'Etchings and Lithographs of P.G.F.', *P.C.Q.,* 1927, XIV, p. 69.

GIBBINGS, Robert John 1889-1958
Eminent Irish wood engraver and occasional line engraver and etcher of landscapes, architectural views, marine and figure subjects. Born in Cork, Eire, he studied at the Slade and Central Schools. His 'vanishing-line' wood

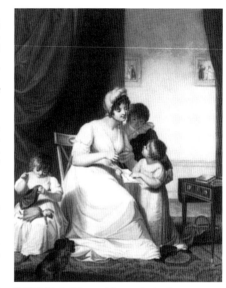

GEREMIA, I. 'Maternal Instruction', after L. Schiavonetti, 1804.

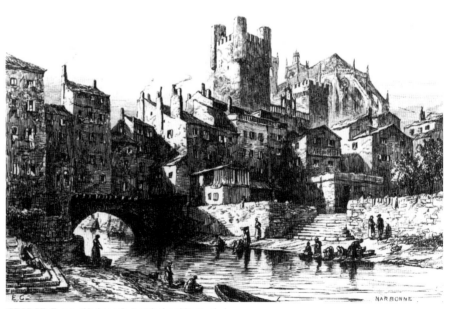

GEORGE, Ernest. 'Narbonne'. A typical architectural view.

GIBBON, Benjamin Phelps. 'The Shepherd's Grave', after E. Landseer, 1838.

GILES, John West. 'Four Prize Wethers', after H. Strafford.

'The Shepherd's Grave', after E. Landseer, 1838, 13½ x 14½in/34.5 x 37.5cm, £120-£200.
Lge. pl. after other artists £30-£100.
Add more if in fine contemporary frame.
Portraits and bookplates small value.

GIBBS, Evelyn, A.R.E. b.1905
Painter, etcher and line engraver of landscapes. She was born in Liverpool where she studied at the School of Art. Later she studied at the R.C.A. and at the British School in Rome. She lived in Nottingham and then in London.
£20-£50.

GIFFORD, George fl. mid-17th century
Line engraver of small portraits.
Small value.

GILBERT, Achille Isidore 1828-1899
French painter, etcher of portraits and decorative subjects after his French and English contemporaries and Old Master painters. He was born in Paris.
Lge. pl. £5-£15.
Others small value.

GILBERT, Edward
 fl. late 19th/early 20th century
Mezzotint and photo-engraver of sentimental, religious and sporting subjects after his contemporaries.
Sporting pl. £20-£60.
Add more if in fine contemporary frame.
Others small value.

GILES, James fl. mid-19th century
Line engraver of small bookplates including landscapes and topographical views after his contemporaries.
Small value.

GILES, John West fl. mid-19th century
Painter and lithographer of sporting, animal and decorative subjects, topographical views and military costumes after his contemporaries as well as his own designs. He worked in Aberdeen and London.
'Fox Hunting', after J.F. Herring, 1854, 4 pl., 22½ x 33½in/57 x 85cm, set £600-£1,200 col.
'The Coxeter Coat' (print shows undertaking in 1811 to prove possibility of manufacturing cloth

from wool and making it into a coat in a day), 21¼ x 29¼in/54 x 74.5cm, £500-£1,000 col.
'Hunter's Annual' (equestrian portraits), after R.B. Davis, 1838-9, 14¼ x 17½in/36 x 45cm, e. £300-£500 col.
'Windsor, Staines and South Western Railway Bridge over the Thames at Richmond', 1848, 15¼ x 22in/39 x 56cm, £200-£400 col.
'Kennel Scenes', after R.B. Davis, 1837, 14½ x 18½in/37 x 47.5cm, 4 tt. pl., e. £20-£40.
'Scenery and Reminiscences of Ceylon', after J. Deschamps, 1845, 12¾ x 18½in/32.5 x 47.5cm, 12 tt. pl., e. £60-£120 col. (set col. fetched £1,900 June 1987).
'The Castle Howard Oxen', after H. Strafford, 19¾ x 25¼in/50 x 64.5cm, £300-£500.
'Portrait of a Leicester Wether', after J. Barwick, c.1840, 16 x 19¾in/40.5 x 50.5cm, £300-£500.

'Four Prize Wethers', after H. Stafford, £300-£500.
Pl. for G.F. Angas' South Australia Illustrated, 1846-7, fo., 62 tt. pl., e. £100-£200 col. (set col. fetched £14,000 October 1988).
Pl. for Ackermann's Costumes of the British Army, after H. Martens, etc., 1840-54, 12 x 9in/30.5 x 23cm, e. £70-£130 col.
Pl. for T.S. Cooper's Cattle Subjects, fo., e. £20-£40.
Colour plate page 35.

GILES, William 1872-1939
Painter, etcher and line engraver of landscapes and bird subjects. Born at Reading, he studied at the R.C.A. and lived in London. He printed his plates in colours and was President of the Society of Graver Printers in Colour.
£60-£140.

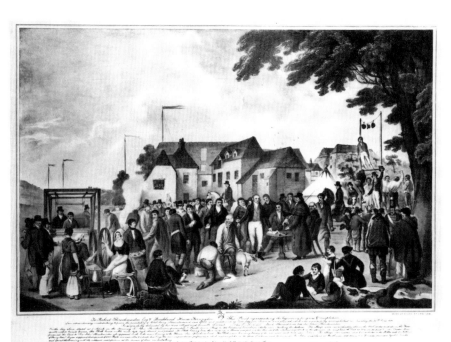

GILES, John West. 'The Coxeter Coat'.

GILL, Arthur Eric Rowton. 'Mother and Child', a typical wood engraving.

GILKS, Thomas fl. mid-19th century
Lithographer of small bookplates including topographical views after his contemporaries.
Pl. for C. Masson's Narrative of Various Journeys in Balochistan, Afghanistan, the Punjab and Kalat, *1844, 8vo., 6 tt. pl., e. £5-£15.*
Pl. for L.S. Costello's Bearn and the Pyrenees, *1844, 8vo., 2 tt. pl., small value.*

GILL, Arthur Eric Rowton 1882-1940
Calligrapher, typographical designer, sculptor and distinguished wood engraver of figure subjects and portraits. Born in Brighton, he studied at Chichester School of Art. He lived at Ditchling in Sussex, Abergavenny, and High Wycombe, Buckinghamshire. He was a lay member of the order of St. Dominic and many of the subjects of his prints are of a religious nature.
Generally separate, signed prints £100-£300.
'Mother and Child', wood eng., £120-£240.
Proofs for book illustrations mostly £50-£150
Some subjects, more erotic than religious, e.g.
'Eve', 1926, 9½ x 4¾in/24 x 12cm, £600-£1,200.
Bibl: Physick, J.F., *The Engraved Work of E.G.,* 1963.

GILLBANK, Henry fl. early 19th century
Mezzotint engraver of decorative and historical subjects after his contemporaries.
'Rustic Hours', after F. Wheatley, 1800, 4 pl., 19¼ x 23¼in/49 x 59cm, e. £500-£800 prd. in col.
'The Rapacious Steward' and 'The Benevolent Heir', after W.R. Bigg, 17½ x 22in/44.5 x 56cm, pair £600-£1,200 prd. in col.
'Lord Nelson Mortally Wounded at . . . Trafalgar', after M. Brown, 1806, 14¼ x 16in/36.5 x 41cm, £50-£80.
'Jane Shore Doing Penance', after H. Singleton, 1817, 20 x 24in/51 x 61cm, £10-£20.

GILLER, William C. b.1805
Line and mezzotint engraver of portraits and sporting, historical and sentimental subjects after his contemporaries. He was born in London where he worked.
'The Meet at Badminton', after Barraud, 1847, 17 x 29½in/43 x 75cm, and other lge. sporting

pl., £200-£400.
'Painter, a Retriever', after A. Cooper, 1827, 12 x 9½in/30.5 x 24cm, and other sporting pl. of similar size, £20-£50.
'A Strawyard, Winter' and 'A Kentish Farm Yard', after J.F. Herring, 1862, 25¼ x 35½in/65.5 x 90cm, pair £400-£600.
Other lge. sentimental and historical pl. £30-£100.
Add more if in fine contemporary frame.
Others £5-£10.

GILLETT, Edward Frank 1874-1927
Suffolk painter, illustrator and drypoint etcher of landscapes and sporting, rural and genre subjects.
£30-£80.

GILLRAY, James 1756-1815
Important draughtsman, etcher, aquatint and stipple engraver of caricatures mainly after his own designs but also after sketches by amateurs. He was born in Chelsea and, after an apprenticeship to a lettering engraver, he studied drawing at the R.A. Schools and learnt stipple engraving from W.W. Ryland and F. Bartolozzi (qq.v.). He produced several serious plates in this medium after his own designs and after paintings by J. Northcote while establishing his reputation as a caricaturist. His earliest political satires date from 1780. By the end of 1791 all of his caricatures were published by Mrs. Hannah Humphrey with whom he lived for the rest of his life. His last print appeared in 1811, by which time he had become insane. He also produced one early lithograph: 'A Musical Family', 1804.
'A Musical Family', 1804, 8 x 6½in/20 x 16.5cm, litho., v. rare, £600-£1,200.
'Mendoza' (boxer), 17½ x 13½in/45.5 x 35cm, aq., £400-£800 in brown.
'Siège de la Colonne de Pompée - Science in the

Pillory', 1799, 21½ x 16¼in/54.5 x 41.5cm, £800-£1,400 col.
'Metallic Tractors', 1801, 9¾ x 12½in/24.5 x 31.5cm, £600-£1,000 col.
'The American Rattle-Snake', 1782, 10¼ x 14¼in/26 x 36cm, £600-£1,000 col.
'Shakespeare Sacrificed - or - The Offering to Avarice', 1789, 19¾ x 15in/50 x 38cm, £600-£1,000 col.
'Connoisseurs Examining a Collection of George Morland's', 1807, 15¼ x 12¼in/39 x 31cm, £400-£800 col.
'The Theatrical Bubble', 1805, 14¼ x 10¼in/36 x 26cm, £400-£800 col.
'The Reception of the Diplomatique and his Suite', 1792, 12½ x 15½in/32 x 39.5cm, £500-£1,000 col.
'A Peep at Christie's - or - Tally Ho', 1796, 14 x 9½in/35.5 x 24.5cm, £300-£500 col.
'The Gout', 1799, 10¼ x 14¼in/26 x 36cm, £800-£1,400 col.
'Sandwich-Carrots! dainty Sandwich-Carrots', 1796, 14 x 9½in/35.5 x 24.5cm, etching, £600-£1,200 col.
'The Plumb-pudding in Danger . . ., 1805, 10¼ x 14¼in/26 x 36cm, £1,000-£2,000 col.
'The Reception in Holland', 1799, 10¼ x 14¼in/26 x 36cm, £300-£600 col.
'National Conveniences', 1796, 14¼ x 10in/36 x 25.5cm, £600-£1,400 col.
'The Cow Pock - or - The Wonderful Effects of the New Inoculation', 1802, 9¾ x 13½in/24.5 x 35cm, £600-£1,200 col.
'Tiddy Doll - The Great French Gingerbread Baker Drawing Out a New Batch of Kings', 10 x 14½in/25.5 x 37cm, £300-£600 col.
'Delicious Dreams - Castles in the Air - Glorious Prospects', 1808, £100-£200 col.
Egyptian sketches, 1799, e. £50-£100 col.
'Habits of the New French Legislators', 1798, 12 pl., e. £40-£80 col.
Single portrait caricatures £60-£200 col.

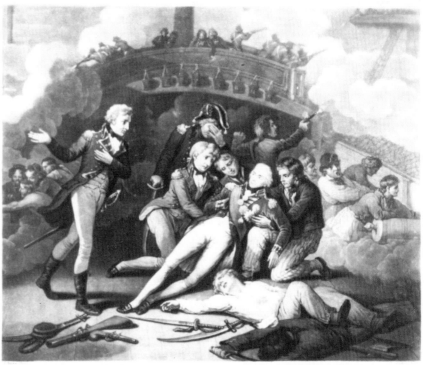

GILLBANK, Henry. 'Lord Nelson Mortally Wounded…at Trafalgar', after M. Brown, 1806.

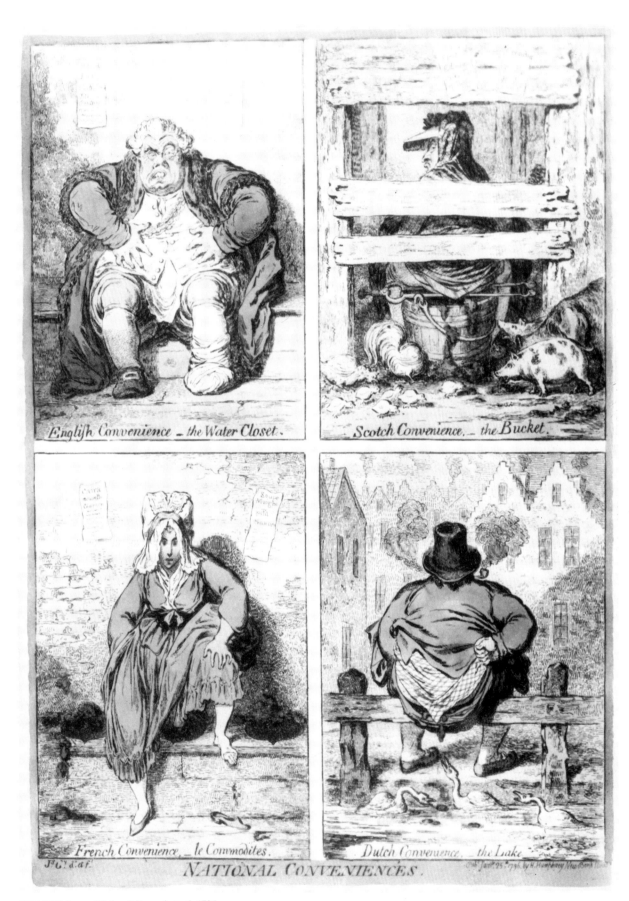

GILLRAY, James. 'National Conveniences', 1796.

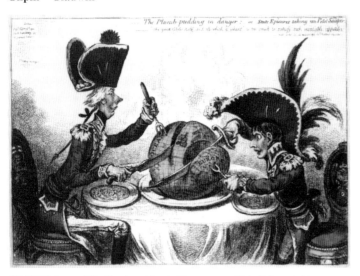

GILLRAY, James. 'The Plumb-pudding in Danger: – or – State Epicures taking un Petit Souper', 1805. Probably Gillray's most famous print.

GILPIN, Sawrey. One of eight plates from 'Characters of Horses: The Managed Horse', 1793.

'The Caricatures of G.', 1818, 85 pl. col. on 81 leaves, £1,200-£2,000.
'The Works of J.G.' publ. by H.G. Bohn, 1847, (582 pl. on 152 leaves, printed on two sides of the paper, all with numbers in upper right corners of plate), set £800-£1,200.
Bibl: Hill, D., *Mr. G. the Caricaturist*, 1965 Colour plates pages 35 and 36.

GILPIN, Sawrey, R.A. 1733-1807
Painter and etcher of animal subjects. Born in Carlisle, he was apprenticed to the marine painter Samuel Scott but later broke away to concentrate on animal painting. Many of his paintings were engraved by professionals. He himself produced just a few plates:
'Characters of Horses', 1761, 8 pl., 8 x 9½in/20.5 x 24cm, etchings, e. £20-£50, reprints 1793 e. £10-£20.
'Animals', 1793, 8 pl., 6¼ x 10in/17 x 25.5cm, soft-ground etchings, e. £15-£30.

GILPIN, Rev. William 1724-1804
Draughtsman and aquatint engraver of small landscape and topographical bookplates. Born near Carlisle, he was ordained in 1746. After working as a curate in Northumberland, he ran a boy's school in Surrey for thirty years before being appointed Vicar of Boldre in the New Forest where he remained for the rest of his life. He etched as a young man, and later made sketching tours up and down the country which resulted in several books for which he wrote the text as well as perhaps engraving some of the plates. These are usually found tinted and, rarely, coloured.
'Observations . . . on the Mountains and Lakes of Cumberland and Westmorland', 1786, 8vo., 30 tt. pl., £3-£8.
Others small value.

GINNER, Isaac Charles, A.R.A., R.W.S.
 1878-1952
Painter and wood engraver of architectural views and landscapes. Born in Cannes, France, where he was educated, he commenced an architecture course in Paris but gave it up to paint. He settled in London and was a founder member of the Camden Town Group. It appears that he made only eleven prints, all woodcuts, from 1919 to 1931. There were few impressions of the earlier ones, but editions of fifty of the later ones. He handcoloured some impressions.
'View Overlooking a Town with Cathedral', £300-£400 col. by artist.
Others £200-£500.

GIRARDET, Edouard Henri 1819-1880
GIRARDET, Paul 1821-1893
Swiss brothers who painted and engraved. They are mentioned here for having reproduced a few sentimental and decorative subjects after English artists.
£5-£15.

GIRARDET, Leon 1857-1895
French painter who also produced a few prints after English contemporaries.
'Salome', after E. Poynter, 25¼ x 34in/64 x 86.5cm, photo-eng., and other similar subjects of same size £80-£200.
'Sub Rosa', after J. Williams, 1891, mixed-method eng., £5-£8.
Add more if in fine contemporary frame.

GIRLING, Edmund 1796-1871
Painter and etcher of landscapes after his own

GINNER, Isaac Charles. 'View Overlooking a Town with Cathedral'.

designs as well as after Old Master painters and Norwich School artists. He was born in Yarmouth where he worked as a bank clerk.
Small value.

GIRLING, Richard 1799-1863
Draughtsman and etcher of landscapes after J. Crome (q.v.).
Small value.

GIRTIN, James fl. 1796-1819
Line engraver of dedications and plans for books.
Small value.

GIRTIN, Thomas 1775-1802
Notable watercolourist of landscapes and topographical views who died in his twenties. He is mentioned here for 'A Selection of Twenty of the Most Picturesque Views in Paris', 1803, obl. fo. These were drawn and etched in soft-ground by Girtin and aquatinted by F.C. Lewis I (q.v.). Proofs before the aquatint was added can be found, and some of these were handcoloured by the artist.
Soft-ground etchings before aq. added: e. £1,200-£2,400 col. by artist; e. £40-£80 uncol.
Soft-ground etchings with aq. added, e. £50-£100 prd. in sepia (fine set fetched £5,500 Oct. 1988).

GISBORNE, John fl. late 18th century
Mezzotint engraver of portraits and decorative subjects after his contemporaries.
'The Wood Girl', after J. Hoppner, 18 x 14in/45.5 x 35.5cm, £150-£300 prd. in col.
Portraits £5-£15.
CS lists 2 pl.

GIVEN, J. fl. mid-18th century
Line engraver.
'A Perspective View of the Camp near Winchester', 1760, £20-£30 col.

GLADWIN, George
 fl. early/mid-19th century
Line engraver of architectural plans and sections, mainly small bookplates, also some railway subjects.
Pl. for F.W. Simm's Public Works, 1838, fo., e. £5-£15.
Other small bookplates small value.

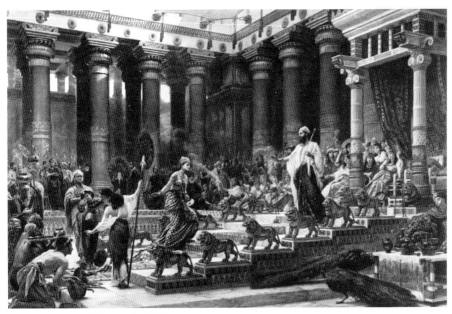

GIRARDET, Leon. 'Salome', after E. Poynter.

'Stephenson's Patent Locomotive Engine - Side Elevation', after C.F. Cheffins, 12 x 23½in/30.5 x 60.5cm, £80-£160.

GLEADAH, Joseph fl. 1815-36
Aquatint engraver of landscapes, topographical views, sporting subjects, costume plates and caricatures after his contemporaries.
Pl. for drawing books by J. Varley small value.
Pl. for R. Johnston's Travels Through Part of the Russian Empire, *1815, 4to., e. £5-£10 col.*
Pl. for H. Abbott's Antiquities of Rome, *1820, lge. fo., e. £10-£20 sepia.*
'Dance of Death', 12 pl., 8 x 5in/20 x 13cm, e. small value.
'Butter Cups and Daisies, A Sketch from Low Life' and 'Pinks and Tulips, A Sketch from High Life', drawn and etched by W. Heath (q.v.), aq. by Gleadah, 1822, 4¼ x 16½in/12 x 42cm, pair £150-£250.
Other caricatures £30-£70 col.
'Four-in-Hand', after J. Pollard, 1823, 15 x 16½in/38 x 42cm, £500-£800 col.
'Race for the Derby Stakes at Epsom', 1829, after J. Pollard, 14 x 18in/35.5 x 46cm, £400-£600 col.
Pl. for Fores' British Army, *after W. Heath, 1820-8, 21 pl., 14 x 19½in/35.5 x 24cm, e. £100-£160 col.*
'The Great Conquest between Spring and Langan', 1824, after J. Clement and J. Pitman, 18¼ x 24in/46.5 x 61cm, £700-£900 col.
'Bowling', after J. Clements, c.1830, 10 x 17½in/25.5 x 45cm, £300-£400 col.

GLOVER, George fl. mid-17th century
Line engraver of frontispieces and small portraits, mainly found in books.
£5-£15.

GODBY, James 1769-1818 or later
Etcher, stipple and occasionally aquatint engraver of portraits and sporting, decorative and religious subjects after his contemporaries and Old Master painters. He was possibly a pupil of J. Murphy (q.v.) and worked in London.
'The Dipping Well in Hyde Park', after F. Wheatley, and 'The Drinking Well in Hyde Park', after M. Spilsbury, 1802, 20 x 25¼in/51 x 64cm, stipples, pair £1,000-£1,600 prd. in col.
Pl. for Orme's Collection of British Field Sports, *after S. Howitt, etched by Godby, aq. by H. Merke (q.v.), 1807-8, 13¼ x 19in/33.5 x 48.5, e. £500-£1,000 col.*
'Christ in the Judgement Hall', after R. Smirke, 21 x 27in/53.5 x 68.5cm, £5-£15.
'Innocent Recreation' and 'Animal Affection', after W. Miller, 1799, 14 x 11in/35.5 x 28cm, pair £300-£500 prd. in col.
'Madame de Stael, née Necker', after F. Rehberg,

1814, 11 x 7½in/28 x 20cm, £30-£80.
Small portraits and bookplates small value.

GODDARD, John fl. mid-17th century
Line engraver of frontispieces and small portraits mostly found in books.
£3-£10.

GODEFROY, John 1769-1839
Line and stipple engraver of small portraits after his contemporaries. He was born in London, the son of a French engraver François Godefroy.
Small value.

GODFREY, John c.1817-d.1889
Line engraver of small bookplates including landscapes, architectural views, and historical and sentimental subjects after his contemporaries and Old Master painters. He contributed several plates to *The Art Journal*.
Small value.

GODFREY, Richard Bernard b.1728
Stipple and line engraver of portraits, antiquities and topographical views after his contemporaries, mainly small bookplates. He was born in London.
Small value.

GODSON, W. fl. 1756
Line engraver.
'Correct View of the Hessian Camp on Barton Farm near Winchester', 1756, £20-£30 col.

GOFF, Col. Robert Charles, R.E. 1837-1922
Irish amateur painter and etcher of landscapes and topographical views. A professional soldier, he joined the army when he was eighteen and retired from the Coldstream Guards in 1878. He settled in London and devoted himself to art. Later he lived in Hove, Florence and Switzerland.
£30-£70.

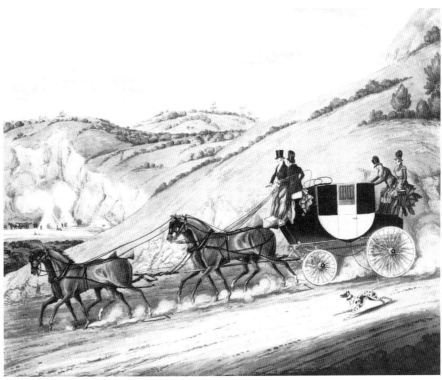

GLEADAH, Joseph. 'Four-in-Hand', after J. Pollard, 1823.

GOFF, Robert Charles. A typical etching.

GOLDAR, John 1729-1795
Line and aquatint engraver of portraits,
caricatures, naval and military subjects after his
contemporaries and Old Master painters. He
was born in Oxford.
*'The Recruiting Serjeant', after J. Collett, 1767,
15 x 20in/38 x 51cm, eng., and others after
Collett, £60-£100.*
*'Boors at Politics', after Heemskirk, 'Boors at
Cards', after D. Teniers, 13 x 10in/33 x 25.5,
eng., pair £30-£50.*
*'Rodney's Victory over de Grasse in the West
Indies', after Capt. Miller, 1795, 14¼ x
23½in/37.5 x 60cm, aq., pair £500-£700 col.*
Portraits and bookplates small value.

GOLDIE, Cyril R. 1872-1942
Etcher of classical landscapes with figures.
£30-£70.

GOLDING, Richard 1785-1865
London line engraver of portraits and figure
subjects mainly after his contemporaries. He
was apprenticed to J. Parker (q.v.).
Lge. pl. £10-£40.
Add more if in fine contemporary frame.
Small pl. small value.

GOLE, Jacob 1660-1737
Dutch mezzotint engraver of portraits and genre
subjects after his contemporaries. He is
mentioned here for having engraved a few
English portraits.
English portraits £15-£50.

GONSALVES, J.M. fl. early 19th century
Draughtsman and lithographer.
*'Views at Bombay', c.1831, 6 pl., fo., e. £60-£90
col.; extremely rare set fetched £4,000 in
special Indian sale May 1995.*

GOOCH, Thomas c.1750-1802 or later
Painter of horses, draughtsman and aquatint
engraver of the following set:
*'The Life and Death of a Racehorse', 1790, 6 ovals,
11¼ x 13¼in/8.5 x 33.5cm, set £600- £900 sepia.*

GOODALL, Edward 1795-1870
Line engraver of landscapes, topographical views
and historical and sentimental subjects after his
contemporaries and Old Master painters. Born in
Leeds, he taught himself to paint and engrave. He
is best known for his landscape engravings after
J.M.W. Turner who had seen a painting of
Goodall's at the R.A. in 1822, and on the strength
of it requested Goodall to undertake as many
plates after his (Turner's) own work as he could.
Later in his career, he reproduced several
paintings by his son, Frederick Goodall, R.A.
'The Piper', after F. Goodall, £10-£40.
Lge. single pl. after Turner £80-£250.

GOODALL, Edward. 'The Piper', after F. Goodall.

Other lge. pl. £10-£40.
Add more if in fine contemporary frame.
*Bookplates after Turner £20-£80 if proofs or
early imp.*
Other bookplates small value.

GOODEN, Stephen Frederick, R.A., R.E.
 1892-1955
Illustrator and line engraver of figure subjects,
birds and animals. Born in Rugby, he studied at
the Slade and produced a few, rare, etchings and
one lithograph before turning to line engraving.
Most of his work consisted of book illustrations,
including plates for *The Nonesuch Bible*, 1924,
and *La Fontaine's Fables*, 1929, as well as ex-
libris. He lived at Bishop's Stortford,
Hertfordshire and later in Buckinghamshire.
'Juno and the Peacock', 1929, £40-£60.
Early etchings and litho. £100-£300.
Ex-libris £5-£20.
Illustrations and single pl. £30-£80.
Rare early states up to £200.

GOODEVE, C. fl. mid-/late 19th century
Etcher and line engraver of figure subjects, etc. after
his contemporaries. He contributed to the Annuals.
Small value.

GOODNIGHT, Nicholas Charles fl. 1769-93
Line engraver mainly of bookplates after his
contemporaries. He also both drew and
engraved a few caricatures.
*'The Recruiting Serjeant, or Brown Bess Sooner
Than Bigg Belly'd Betty' (caricature), after
S. Collings, 1786, 8¾ x 7in/22 x 18cm, and other
caricatures, £30-£90.*
Bookplates small value.

GOODYEAR, Joseph 1797-1839
Line engraver of small bookplates including
decorative and sentimental subjects after his
contemporaries. Born in Birmingham, he
worked as a commercial engraver before being
apprenticed to C. Heath (q.v.). He died in
London.
Small value.

GOODEN, Stephen Frederick. 'Juno and the Peacock', 1929.

GORDON, Sir Henry fl. 1835
Draughtsman and etcher of topographical views.
Vol. of topographical views, 1835, 28 pl., obl. 4to., e. small value.

GOSSE, Sylvia Laura, R.E. 1881-1968
Painter, etcher, soft-ground etcher, aquatint engraver and lithographer of landscapes, architectural views and interiors with figures. Born in London, the younger daughter of Sir Edmund Gosse, she studied at the Westminster School of Art under W.R. Sickert (q.v.) and

taught at the latter's own school, 1909-14. While strongly influenced by Sickert, she achieved her own distinctive style in her etching.
'Portrait of Sir Edmund Gosse in His Study', 1911, 7 x 6in/18 x 15cm, £300-£500.
'Saying and Doings', 10 x 7in/25.5 x 18cm, £80-£200.
'The Iron Bedstead', 12 x 9in/30.5 x 23cm, £120-£200.
Landscapes and architectural views £60-£140.
Bibl: Stokes, H., 'The Etchings of S.G.', *P.C.Q.*, 1925, XII, p. 315.

GOSSE, Thomas 1756-1844
Mezzotint engraver of decorative subjects after his contemporaries. He gave up engraving c. 1802 for miniature painting. He died in London.
'Founding of the Settlement of Port Jackson at Botany Bay', and 'Transplanting of the Bread-Fruit Trees from Otaheite', 1796-77, 24 x 28in/61 x 71cm, rare pair, £1,600-£2,400 prd. in col.
'The Country Butcher', after G. Morland, 1802, 17¾ x 21½in/45 x 55cm, £400-£600 prd. in col.

GOULD, John 1804-1881
Important ornithological artist. Although he wrote the texts for most of his books, obtained the specimens and drew them crudely or had them drawn, and organised the publication and distribution of the books, he never lithographed any of the plates himself. Nonetheless, the 2,999 large folio prints he produced are still known as 'Gould's Plates'. His wife, Elizabeth, was the first lithographer to work for Gould on the publication *A Century of Birds*, 1831-2. Later lithographers include E. Lear (q.v.), H.C. Richter, W. Hart and J. Wolf (q.v.).
Pl. for The Birds of Europe, 1832-7, 448 pl. by E. Gould and E. Lear, fo.; The Birds of Asia, 1850-83, 530 pl. by H.C. Richter, J. Wolf and W. Hart, fo.; The Birds of Great Britain, 1862-73, 367 pl. mostly by H.C. Richter and W. Hart, fo., e. £60-£200 col.
Pl. for The Birds of Australia, 1840-69, 681 pl.

GOULD, John. 'Pandion Leucocephala', a typical lithograph from *The Birds of Australia*.

by E. Gould and H.C. Richter, fo., e. £80-£200 col.
Colour plate page 37.

GOULDING, Frederick 1842-1909
Better known as a master printer of etchings, he also etched several landscape plates and reproduced a few Pre-Raphaelite subjects. Amongst others, he printed plates by J.A.M. Whistler, F. Seymour Haden and A. Legros (qq.v.). In 1890, he was elected the first Master

GOSSE, Sylvia Laura. 'Portrait of Sir Edmund Gosse in his Study', 1911.

GOSSE, Thomas. 'The Country Butcher', after G. Morland, 1802.

GOUPY, Joseph. 'A Land Storm'; landscape after N. Poussin.

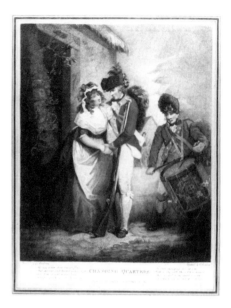

GRAHAM, George. 'Changing Quarters', pair with 'The Billeted Soldier', by J. Hogg, both after G. Morland, 1791.

Printer to the Royal Society of Painter-Etchers. He was born in London.
'A Christmas Carol', after D.G. Rossetti, 1867, 13½ x 11in/34 x 28cm, £400-£800.
Landscapes small value.

GOULDSMITH, Harriet (Mrs. Arnold)
1787-1863
Landscape painter who etched a few rare plates.
4 views of Claremont, 1819, obl. fo., e. £5-£15 col.

GOUPY, Joseph d.1763
French painter, etcher and line engraver of biblical and mythological subjects, landscapes, etc., after Old Master painters and his contemporaries. Born at Nevers, he came to London c.1725 and taught drawing to Frederick Prince of Wales and Prince George, later George III. He etched several plates after Salvator Rosa. He died in London.
'The True Representation and Character, etc.' (caricature of G.F. Handel), 1750, 18¼ x 12½in/46.5 x 31.5cm, £300-£400.
Lge. landscape pl. £50-£150.
Others £5-£15.

GOYDER, Alice Kirkby b.1875
Painter and etcher of landscapes and figure subjects. Born in Bradford, she lived in Suffolk.
£15-£50.

GRAF, C. fl. mid-19th century
Printer of lithographs who also executed a few lithographs himself. He worked for the lithographic printers Engelmann, Graf & Co. in London.
'Drum Major of the Royal Artillery', after A. Comer, c.1840, 11½ x 7½in/29 x 19cm, £50-£80 col.
Small portraits small value.

GRAF, G. fl. mid-19th century
Lithographer.
'Hastings from the Railway Station', 9 x 13in/23 x 33cm, tt. pl., £100-£150 col.

GRAF, J. fl. mid-19th century
Printer of lithographs and lithographer of topographical views after his contemporaries. He worked for the lithographic printers

Engelmann, Graf & Co. in London.
'Queen Victoria Proceeding in State to Westminster Abbey for Her Coronation', 1838, 13½ x 20½in/34.5 x 52cm, £200-£300 col., add more if in fine contemporary frame.
1 pl. for Scotland Delineated, 1847-54, lge. fo., tt. pl., £10-£20.

GRAHAM, George
fl. late 18th/early 19th century
Stipple and mezzotint engraver of decorative subjects and portraits after his contemporaries and Old Master painters. He lived in London.
'Changing Quarters' with 'The Billeted Soldier', by J. Hogg (q.v.), both after G. Morland, 1791, 13¼ x 10½in/35 x 26.5cm, stipples, pair £300-£500 prd. in col.
'War, or the Soldier's Farewell' with 'Peace, or the Soldier's Welcome Home', by J. Hogg (q.v.), both after G. add more if in fine contemporary frame. Morland, 1802, 13½ x 10½in/35 x 26.5cm, stipples, pair £400-£600 prd. in col.
'Adelaide', after R. Westall, oval, 8 x 6in/20.5 x 15cm, stipples, £100-£150 prd. in col.

Add more if in fine contemporary frame.
'Poverty', after J. Rising, 1791, 15½ x 13in/39.5 x 33cm, mezzo., £60-£80.
Portraits: mezzo. £15-£40; stipples £5-£15.
CS lists 4 pl.

GRAINGER, W. fl. late 18th/early 19th century
Line engraver of small bookplates including portraits and military subjects, etc., after his contemporaries and his own designs.
Small value.

GRANGER, B. fl. late 18th/early 19th century
Stipple engraver of portraits and decorative subjects after his contemporaries, Old Master painters and his own designs.
'Gypsy Fortune Teller' and 'The Wedding Day', after T. Stothard, 20 x 25in/51 x 63.5cm, pair £400-£700 prd. in col.
Bookplates and small portraits small value.

GRANT, Charles Jameson fl. mid-19th century
Draughtsman, etcher and lithographer of humorous subjects and caricatures. He was the

GRANGER, B. 'Gypsy Fortune Teller', pair with 'The Wedding Day', after T. Stothard.

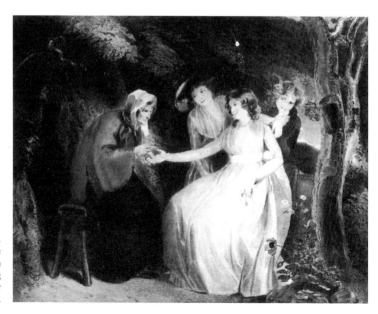

GRAY, Joseph. A typical landscape.

GREATBACH, W. 'Alpine Mastiffs Reanimating a Traveller', after E. Landseer, 1881.

main draughtsman of the satirical woodcuts which featured in the penny 'radical' papers.
'Political Alphabet', 1837, 26 pl., 4¾ x 4in/12 x 10cm, litho., set £80-£140 col.
'Bowl'd Out or the K-g and All England Against the Boroughmongers' (cricket subject), 1831, 8¾ x 13½in/22 x 35cm, litho., £200-£300 col.
Other caricatures of similar size £30-£70 col.

GRANT, Duncan James Corrowr b.1885
Painter and lithographer of portraits, landscapes and still life. Born in Inverness-shire, he studied at the Westminster School of Art and the Slade. He was associated with the Bloomsbury Group.
'Hanging out the Washing', 'The Washerwoman', in cols., 30½ x 22in/77 x 56cm, pair £300-£500.
Others generally £50-£150.

GRANT, James A., A.R.E. b.1887
Painter and drypoint etcher of portraits and figure subjects. Born in Liverpool, he studied in London and Paris settling in London.
£30-£70.

GRANT, John fl. mid-19th century
Draughtsman and aquatint engraver of military subjects after his own designs and those of his contemporaries.
'Royal Horse Artillery', after T.H. Jones, 1843, 11 x 16in/28 x 40.5cm; 'Royal Artillery Repository Exercises', 1844, 12 x 16in/30.5 x 40.5cm; 'Rocket Practice in the Marshes', 1845, 11¼ x 16¼in/28.5 x 41.5cm, e. £100-£200 col.

GRAVE, R. fl. mid-18th century
Line engraver of small bookplates and portraits after his contemporaries.
Small value.

**GRAVELOT, Hubert François
Bourguignon d'Anville** 1699-1773
French draughtsman and etcher of decorative subjects, portraits, caricatures, topographical views, etc., after his own designs and those of his contemporaries. Brought over to England in 1732 by C. du Bosc, to assist him on plates for B. Picart's 'Ceremonies' (1733-7), he stayed until 1745 before returning to France. He came back to England once more but settled finally in Paris. He ran a studio which produced many small book illustrations designed by himself and either etched by himself or by one of his pupils. He also taught drawing to, amongst

others, T. Gainsborough (q.v.). He was very largely responsible for introducing to England, through his work, the French rococo style of drawing.
'And has not Sawney too his Lord and Whore?' (caricature of Alexander Pope), 1742, 11¼ x 13½in/28.5 x 34.5cm, £300-£400.
'Monument of Wm. Shakespeare', after P. Scheemakers, 12 x 7½in/30.5 x 19cm, £10-£25.
Small bookplates small value.

GRAVES, Robert, A.R.A. 1798-1873
Line engraver of portraits and historical and sentimental subjects after his contemporaries, Old Master and British 18th century painters. Born in London, the grandson of printseller Robert Graves, and brother of print publisher Henry Graves, he was a pupil of J. Romney (q.v.).
'The Farm Yard', after J.F. Herring, 20 x 25¼in/51 x 65cm, £200-£400
'The Highland Whisky Still', after E. Landseer, 16½ x 21in/42 x 53.5cm, £200-£400.
'The Slide', after T. Webster, 1864, 18 x 29in/45.5 x 73.5cm, £80-£200.
Lge. historical subjects £30-£100.
'Lord Byron', after T. Philips, 1836, 12 x 9½in/30.5 x 25cm, £80-£160.
Other lge. portraits £10-£50.
Add more if in fine contemporary frame.
Bookplates and small portraits small value.

GRAVIER, Alexandre Louis 1834-1905
French etcher of sentimental subjects after his French and English contemporaries.
Small value.

GRAY, Andrew
 fl. late 18th/early 19th century
Engraver.
2 pl. for Boydell's Shakespeare, fo., £10-£25.

GRAY, Charles d.1845
Wood engraver of small bookplates after his contemporaries. He was born in Newcastle.
Small value.

GRAY, Joseph 1890-1962
Painter and etcher of landscapes and architectural views. Born in South Shields, he travelled widely on the Continent before World War I.
£15-£50.
Bibl: Salaman, M.C., 'Etchings of J.G.', *Studio*, 1926, XCII, p. 12.

GREATBACH, George fl. mid-19th century
Etcher and line engraver of military, sporting and sentimental subjects, portraits and landscapes after his contemporaries and Old Master painters.
'Daisy, Mr. William Pearce's Celebrated Trotting Pony', after R.N. Hind, 1859, 18 x 22in/46 x 56cm, etching, £150-£200 col., add more if in fine contemporary frame.
Bookplates small value.

GREATBACH, Joseph
 fl. mid-/late 19th century
Etcher and line engraver of sentimental and genre subjects after his contemporaries. He contributed to the Annuals.
Small value.

GREATBACH, William 1802-c.1885
Line engraver of portraits, and historical and sentimental subjects after his contemporaries and Old Master painters. He worked in London.
'The Waterloo Banquet at Apsley House', after W. Salter, 1836, 27¼ x 46in/69.5 x 116.5cm, £150-£300.
'Alpine Mastiffs Reanimating a Traveller', after E. Landseer, 1881, approx. 20 x 26in/51 x 66cm, £300-£500.
'The Musicians', after Coll, 1856, 16 x 21in/40.5 x 53.5cm, £30-£80.
Add more if in fine contemporary frame.
Small bookplates and pl. for the Annuals small value.

GREAVES, Walter 1846-1930
Painter and etcher of London and Thames views and figure subjects. The son of a Chelsea boat builder, he was originally a boatman who, with his brother, Henry, used to ferry J.A.M. Whistler (q.v.) across the Thames. They both eventually became his pupils.
'The Last Chelsea Regatta' (his best pl.), 10¼ x 21½in/26 x 55cm, £600-£1,200.
Rare early proofs of other pl. £60-£140.
Others £20-£60.

GREEN, Benjamin fl. late 18th century
Mezzotint engraver of animal subjects mostly after G. Stubbs, portraits and decorative subjects after other contemporaries, etcher and line engraver of landscapes and topographical views after his contemporaries. Born at Halesowen in Worcestershire, he lived and worked in London.
Pl. after G. Stubbs: mezzo. £800-£1,400;

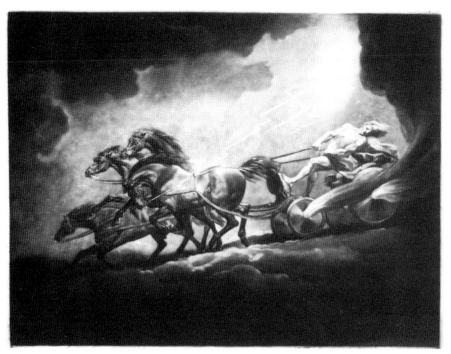

GREEN, Benjamin. 'Phaethon', after G. Stubbs, mezzotint.

occasional soft ground etchings £150-£300 ('Brood Mares', after S., 1768, 16 x 21¼in/40.5 x 55cm, fetched £1,600 May 1987).
'Gypsies Stealing a Child' and 'The Child Restored', after H. Singleton, 1801, 18 x 23in/45.5 x 58.5cm, mezzo., pair £600-£1,100 prd. in col.
'Miss Baldwin', after Kettle, 14¼ x 10½in/37.5 x 27.5cm, mezzo., £30-£70.
'Rachael of Covent Garden', after M. Laroon, soft-ground etching, small value.
Landscapes and topographical views £10-£50. CS lists 3 pl.

GREEN, C.F. fl. 1857
Draughtsman and lithographer.
'The Legend of Shakespeare's Crab Tree', 1857, 4to., 9 tt. pl., e. small value.

GREEN, James 1771-1834
Painter and line engraver of portraits after his contemporaries. Born at Leytonstone, in Essex, he studied under Thomas Martyn and at the R.A. Schools. He died in Bath.
Small value.

GREEN, Reginald H., A.R.E. 1884-1971
Etcher of landscapes and architectural views.
£30-£70.

GREEN, Roland 1896-1972
Painter and drypoint etcher of ornithological subjects. Born in Kent, he lived in Norfolk. He illustrated several books, both his own and those of others.
£15-£50.

GREEN, Valentine, A.R.A. 1739-1813
Prominent mezzotint engraver of portraits and historical subjects after his contemporaries. Born at Salford, Worcestershire, he was originally intended for a career at the Bar but, without the consent of his father, he became apprenticed to an obscure line engraver in Worcester. When he came to London in 1765, he turned to mezzotint. Over the next forty years he engraved nearly four hundred plates. In 1775 he was elected an A.R.A. and was appointed Mezzotinto Engraver to King George III. In 1789 he obtained from the Elector of Bavaria the exclusive privilege of engraving the pictures of the Dusseldorf, but was ruined when the city was besieged in 1798. On the foundation of the British Institution, in 1805, he accepted the office of Keeper, a post which he retained until his death.
Portraits: 'The Ladies Waldegrave', after J. Reynolds, 1781, 19¼ x 22½in/50 x 58cm (in the 1920s one of the most sought after English

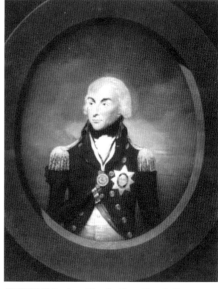

GREEN, Valentine. 'The Rt. Hon. Horatio Baron Nelson of the Nile, K.B.', after L.F. Abbott, 1801.

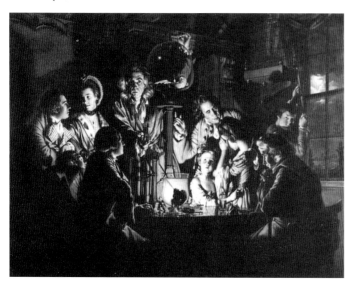

GREEN, Valentine. 'Philosopher Showing an Experiment on the Air Pump', after J. Wright of Derby, 1769.

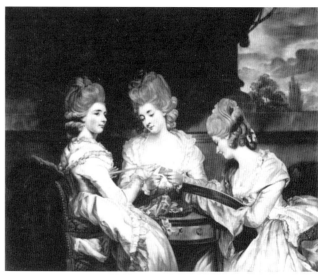

GREEN, Valentine. 'The Ladies Waldegrave', after J. Reynolds, 1781.

prints), £600-£1,200.
'Lady Elizabeth Delme and Children', after J. Reynolds, 24¼ x 15½in/61.5 x 40cm, and other female WLs, £200-£500.
'Lady Louisa Manners', after J. Reynolds, 24¼ x 15in/63 x 38cm, £200-£300.
'British Naval Victors', 1779, 24½ x 20in/62 x 51cm, £1,000-£1,500 prd. in col.
'William Innes' (golfer), after L.F. Abbott, 26 x 17in/66 x 43cm, £1,000-£3,000 (the original mezzotint is extremely rare; numerous late 19th Cent photo-engravings of this subject, prd. in col., have been seen in specialised golfing and sporting memorabilia auctions, sometimes catalogued as originals, often fetching a few hundred pounds).
'Archduke Charles of Austria', after P.J. de Loutherbourg, 1795, 14 x 10in/35.5 x 25.5cm, £600-£900 prd. in col.
'The Rt. Hon. Horatio Baron Nelson of the Nile, K.B.', after L.F. Abbott, 1801, £200-£400 prd. in col.
'Joshua Reynolds - Self-portrait', 19 x 15in/48 x 38cm, £100-£200.
'David Garrick', after T. Gainsborough, 1769, 24¼ x 15in/61.5 x 38cm, £200-£300.
'William Thomas', 1776, 7 x 5in/718 x 12.5cm, £5-£8.
Various male HLs, ave. 14 x 10in/35.5 x 25.5cm, £15-£40.
American portraits: 'George Washington', after J. Trumbull, 1781, and 'Henry Laurens', after J.S. Copley, 1782, both WLs, 25 x 16in/63.5 x 40.5cm, e. £500-£900.
Other male WLs mostly £80-£200.
Subjects:'A Youth Rescued from a Shark, Havannah Harbour', after J.S. Copley, 1779, 19¾ x 23½in/50 x 60.5cm, £400-£700.
'Regulus Returning to Carthage', after B. West, 1771, 25 x 34½in/63.5 x 88cm, and other historical (ancient history) subjects, £80-£140.
'Scene in a Country Town at the Time of a Race', after W. Mason, 1783, 17¾ x 23½in/45 x 60cm, etching and aq., £200-£300.
'A Philosopher Showing an Experiment on the Air Pump', after J. Wright of Derby, 1769, 19 x 23¼in/48.5 x 59cm, £3,000-£5,000.
C.S.
Bibl: Whitman, A. 'V.G.', London, 1902.

GREEN, William 1761-1823
Draughtsman, soft-ground etcher and aquatint engraver of landscapes and topographical views, mainly after his own designs but also after those of his contemporaries. Born in Manchester, he studied engraving in London and then went to live in Ambleside in the Lake District where he remained for the rest of his life. The scenery of the Lakes formed the subject of most of his drawings and prints which he also published himself.
'Seventy Eight Studies from Nature', 1809, obl. fo., soft-ground etchings, £15-£30 col.; £5-£10 uncol.
'Views in Kent', after J.G. Wood, 1800, 37 pl., obl. fo., aq., e. £10-£20 col.
'Sixty Small Prints of the Lakes', 1814, obl. fo., soft-ground etchings, £4-£8 col.; small value uncol.
'Scenery of the Lake District', 1808-30, lge. obl. fo., soft-ground etchings, e. £10-£20.
Views in the Lake District, 1820, 10 x 13¼in/25.5 x 33.5cm, aq., e. £15-£30 col.

GREEN, W.T. fl. mid-19th century
Wood engraver of bookplates.
Small value.

GREENAWAY, John 1818-1890
Wood engraver of illustrations for The Illustrated London News and Punch. He was the father of the children's book illustrator, Kate.
Small value.

GREENHEAD, Henry T. 1849-1926
Mezzotint engraver of portraits and decorative subjects mainly after British 18th century painters but also after his contemporaries. Born in Hampshire, he worked in London.
£10-£50.

GREENHILL, John 1649-1676
Portrait painter who etched one very rare portrait of his brother (1667).
£300-£600.

GREENWOOD, C. J. fl. mid-19th century
Lithographer of topographical views.
Most £5-£15.
'Hackney' (with railway), 10½ x 13½in/26.5 x 34.5cm, tt. pl., £100-£150 col.

GREENWOOD, John 1727-1792
American painter and mezzotint engraver of portraits and decorative and genre subjects after his contemporaries and Old Master painters. Born in Boston, Massachusetts, he worked there, in the Dutch East Indies and in Holland, before finally settling in London c.1763. In 1773 he ceased engraving and became a picture dealer and auctioneer.
'Lady with a Parrot', after G. Metsu, 14¼ x 10½in/36 x 27.5cm, £60-£80.
'The Card Players', after A. van Ostade, 1768, £10-£25.
'Miss Amelia Hone', after N. Hone, 1771, 14 x 10in/35.5 x 25.5cm, £40-£70.
'John Wesley', after N. Hone, 1770,15 x 11in/38 x 28cm, £80-£140.
'Rembrandt's Father', after Rembrandt, 1764, 13¾ x 9½in/35 x 25cm, £8-£15.
'Philip Sherard and William Tiffin', after N. Hone, 21¼ x 20in/55 x 51cm, £100-£200.
CS.

GREENWOOD, John Frederic, R.E.
 1885-1954
Yorkshire wood engraver, etcher and art teacher. Best known as an engraver of English landscapes, he contributed works to the Society of Wood Engravers' exhibitions.
£15-£40.

GREG, Barbara 1900-83
Wood engraver. Born in Cheshire, she studied at the Slade, Central School and Westminster School of Art. She married N. Janes (q.v.) and lived in London.
£15-£40.

GREIG, John fl. early/mid-19th century
Line engraver of small bookplates, including landscapes and topographical views after his contemporaries. He worked in London.
Small value.

GRIBELIN, Simon Jun. 1661-1733
Line engraver of decorative and religious subjects after his contemporaries and Old Master painters. He originally worked as an engraver of silver watch cases before turning to copperplate engraving.
Set of 7 small pl. after Raphael's cartoons, 1707, set £30-£50.
'A New Book of Ornaments: Useful to All Artists', 1704, 16 pl., e. £30-£70.
Pl. for R. Blome's The Gentleman's Recreation, after various artists, 1686, 4to., e. £20-£40.
Pl. for S. Hales's Vegetable Staticks, 1727, 8 vo. 19 pl., copy fetched £600 July 1994.
Other bookplates small value.

GRIEVE, A. R. fl. mid-19th century
Lithographer.
Pl. for J.H. Allen's A Pictorial Tour in the Mediterranean, 1843, fo., tt. pl., e. £8-£15.

GRIFFIER, Jan (John) 1645-1718
Dutch etcher of natural history subjects after Francis Barlow (q.v.). Born in Amsterdam, he came to London about 1667 and painted

GREEN, William. A plate from 'Scenery of the Lake District: Farm House at Glen Coin', 1808-30.

179

GRIGGS, Frederick Landseer Maur.
'The Almonry', 1925.

landscapes. After being shipwrecked on his return to Holland, he came back to London.
Etchings e. £10-£25.
CS attributes some mezzo., inscribed 'I.G.', to him, e. £15-£40.
'The Elephant and the Rhinoceros', after F. Barlow, rare mezzo., £300-£600.

GRIFFITHS, Henry d.1849
Line engraver of small bookplates including landscapes and topographical views after his contemporaries.
American and Swiss views £5-£10.
Others small value.

GRIGGS, Frederick Landseer Maur, R.A., R.E. 1876-1938
Distinguished etcher of landscapes and architectural views. He was born in Hitchin, Hertfordshire, where he lived until 1903, producing sixteen experimental etchings from 1896. While in Hitchin, he began to execute architect's drawings and book illustrations, and he is particularly remembered for his illustrations to the 'Highways and Byways' series. In 1903 he settled in Campden, Gloucestershire, where he remained for the rest of his life. His main oeuvre of fifty-seven plates dates from 1912 and, in the vast majority of them, medieval architecture, either real or imaginery, features prominently. His imagery reflects not only the influence of S. Palmer (q.v.) but also his own deep-seated nostalgia for 'Old England', and it is this which sets his etchings apart from the other architectural views of the 1920s and '30s. Griggs later installed a printing press at Dover's House where he lived, from 1921 and most proofs are stamped 'DHP' on the verso.

'The Almonry', 1925, 9 1/2 x 6 1/2in/24 x 16.5cm, £600-£900 (fetched £1,500 June 1988).
'St. Botolph's, Boston', 1924, 10 3/4 x 7 1/2in/27.5 x 19cm, £80-£120.
'The Coppice' (only 6 imp.), 1913, 6 x 7in/15 x 17.5cm, £800-£1,000.
'Lanterns of Sarras', 1932, £400-£600 (fetched £900 Dec. 1989).

'Laneham', 1923, 5 x 5in/12.5 x 12.5cm, £30-£50.
'Anglia Perdita', 1921, 9¾ x 7in/25 x 18cm, £300-£400.
'Castor', 1927, 5¼ x 4½in/13.5 x 12cm, £30-£50.
'The Cross Hands', 1930, 7¼ x 9½in/18.5 x 24cm, £120-£180.
'The Hitchin Etchings', 1897, 6 pl., set £300-£500.
Bibl: Comstock, F.A., *A Gothic Vision, F.L.G. and His Work,* Boston and Oxford, 1966.

GRIGNION, Charles Sen. 1717-1810
Etcher and line engraver of portraits, topographical views and historical and decorative subjects, etc., after his contemporaries. Born in London, he was a pupil of H.F.B. d'A. Gravelot (q.v.) and J.P. Le Bas.
'The Chaise Match Run on Newmarket Heath on Wednesday the 29th. of August 1750', after J. Seymour, 1751, 20¼ x 32½in/52.5 x 83cm, £300-£500.
'Garrick in the Character of Richard III', after W. Hogarth and eng. with W. Hogarth (q.v.), 1746, 15½ x 19½in/9.5 x 50cm, £60-£120.
Other lge. portraits £5-£15.
'A North View of Fort Royal in the Island of Guadeloupe, When in Possession of H.M. Forces in 1759', after Lieut. A. Campbell, 1764, 12¼ x 19½in/31 x 50cm, £250-£400.
'A View of the Canal, Chinese Building, Rotunda, &c. in Ranelagh Gardens', after Canaletto, 1752, 8¼ x 15½in/22.5 x 38.5cm, £50-£100 col.
Pl. for H.F.B. d'A. Gravelot's Male and Female Costumes, 1744-5, e. £30-£70.
Pl. for J. Gwin's L'Ecole des Armes (fencing), 1763, 10¼ x 15¼in/26 x 39cm, e. £30-£80.
Lge. anatomical illustrations, 1747, 21¼ x 15¼in/55 x 40cm, e. £60-£140.
Other small bookplates and portraits small value.

GRIMSTONE, Edward fl. mid-19th century
Painter and lithographer of portraits.
'David Livingstone' £25-£40.
Others £5-£15.

GROSS, Anthony. 'Fishing at Herne Bay Pier', etching and engraving with roulette, 1948.

GROZER, Joseph. 'Viscountess Duncannon', after J. Reynolds, 1785.

GROGAN, Joseph H. fl. 1810
Draughtsman and lithographer of rustic scenes.
3 pl., all dated 1810, e. £30-£50.
Man Cat. lists 3 pl., noted above.

GROGAN, Nathaniel 1740-1807
Irish painter and occasional aquatint engraver after his own designs.
'Views of Cork', 12 oval pl., set £1,000-£1,500.
'The Angry Schoolmaster' £300-£450.

GROOM, Mary Elizabeth 1903-58
Wood engraver. She was a pupil of C. Flight (q.v.).
£10-£30.

GROOM, Robert fl. mid-19th century
Lithographer of topographical views and portraits after his contemporaries.
Misc. English views: church interiors £3-£10; high street views £10-£30; country views £5-£15.
Portraits £3-£10.

GROSE, Francis 1731-91
Antiquary and artist who engraved some small caricatures of fellow members of the Society of Antiquaries.
£10-£20.

GROSS, Anthony b.1905
Painter, illustrator, etcher and occasional lithographer of landscapes and genre subjects. Born in London, he studied at the Slade and in Paris. He was an Official War Artist during World War II.
Etchings £80-£200; later etchings (1960s/70s) £100-£300.
Litho. posters publ. by J. Lyons £100-£200.
Ref: Reynolds.

GROVE, W. fl. mid-19th century
Draughtsman, etcher and aquatint engraver.
'Spithead and Portsmouth', 1845, 4 pl., 9 x 11in/23 x 30cm, etching with aq., e. £15-£20.

GROZER, Joseph fl. late 18th century
Mezzotint, stipple and aquatint engraver of sporting and decorative subjects and portraits after his contemporaries. He was born in London.
'Morning, or the Benevolent Sportsman' and 'Evening, or the Sportsman's Return', after G. Morland, 1795, 19½ x 24½in/49.5 x 63cm, mezzo., pair £1,400-£2,200 prd. in col.
'A Litter of Foxes', after C. Loraine Smith and G. Morland, 1797, 18 x 24in/145.5 x 61cm, mezzo., £100-£150.
'Boxing Match between Humphreys and Mendoza', after J. Einsle, 1788, 19 x 22in/48.5 x 56cm, stipple, £300-£600.
'Phoebus', after B. Stead, 1796, 18¼ x 21½in/46.5 x 54.5cm, aq., £300-£400 col.
'Delicate Embarrassment, or the Rival Friends', after G. Morland, 1796, 20 x 14in/51 x 35.5cm, mezzo., £400-£600 prd. in col.
'Abraham Newland of the Bank of England', after G. Romney, 1799, 19 x 14in/48 x 35.5cm, mezzo., £100-£150 prd. in col.
'Miss Wallis', after J. Graham, 1796, 24½ x 15in/62 x 38cm, mezzo., £200-£300.
'Viscountess Duncannon' after J. Reynolds, 1785, mezzo., £80-£160.
Male HLs, mezzo., £15-£40.
CS.

GRUEBER, Henry fl. early/mid-19th century
Draughtsman and lithographer.
'Six Lithographic Views of Seats in the Neighbourhood of Wrexham', North Wales, c.1828, fo., e. £10-£25 col.

GRUNER, L. fl. mid-19th century
Draughtsman and lithographer.
'Ornamental Designs . . . from Italian Monuments, Churches, etc.', fo., small value.

GUBBLE, V. fl. 1920s/1930s
Wood engraver.
£10-£30.

GUEST, H. (?R.) fl. mid-19th century
Aquatint engraver of sporting and military subjects after his contemporaries.
'Staghunting', after C. Hancock, with J. Harris, 1840, 19 x 26in/48.5 x 66cm, £400-£600 col.
Pl. for The Hunter's Annual (equestrian portraits), after R.B. Davis, 1841, 14¼ x 19in/35.5 x 48cm, e. £300-£500 col.
1 pl. for Ackermann's Military Incidents, 1842-4, 10 ¼ x 14in/26 x 35.5cm, £20-£30 col.

GULICH, John Percival 1865-1899
Illustrator and occasional etcher. Born in Wimbledon, he studied at Heatherley's and drew for periodicals.
£15-£50.

GULLAND, Elizabeth d.1934
Turn of the century painter and mezzotint engraver of portraits and sentimental subjects after British 18th century painters and her

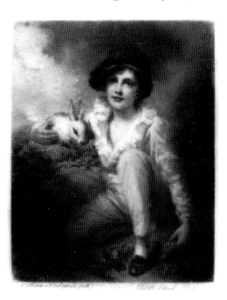

GULLAND, Elizabeth. A typical mezzotint.

contemporaries. Born in Edinburgh, she was a pupil of H. Herkomer (q.v.) and reproduced some of his works. She lived at Bushey, Hertfordshire.
£15-£50 prd. in col.

GULSTON, Elizabeth Bridgetta 1749-1780
Amateur etcher of portraits after her own designs and those of her contemporaries. She was married to Joseph Gulston, the print collector.
Small value.

GUNST, Pieter van c.1667-1724
Dutch line engraver mainly of portraits after his contemporaries. He was born in Amsterdam where he also died. He is mentioned here for his English portraits.
English portraits £15-£50.

GUTHRIE, James Joshua 1874-1952
Illustrator, printer, publisher and etcher. Born in Glasgow, he set up the Pear Tree Press and published his own books for which he etched the illustrations. He lived in Sussex.
£10-£30.

GUY, S.J. fl. mid-19th century
Lithographer of topographical views.
1 pl. for H.C. Trery's Sketches in Lowestoft, c.1852, fo., £5-£10.

GWIN, James 1700-1769
Draughtsman of illustrations for *L'Ecole des Armes*, 1763. He also engraved one of the plates.
1 pl. for L'Ecole des Armes, 1763, 47 pl, 10¼ x 15¼in/26 x 38.5cm, £30-£80.

GWYNNE-JONES, Allan 1892-1982
Painter and etcher of rural scenes. Educated at the Slade, he was also a writer on art and was Professor of Painting at the RCA 1920-30.
£80-£200.

HAAGENSEN, F.H. fl. 1920s
Norwegian etcher of marine and coastal subjects and London monuments.
£50-£150.

HACKER, Edward H. 1813-1905
Line, stipple and mezzotint engraver of sporting subjects, animals and equestrian portraits after his contemporaries.
'Will Long on Bertha with Three Favourite Hounds', and 'C. Davis on Traverser with Three Favourite Hounds', both after W. and H. Barraud, 1849, 17¼ x 20in/44 x 51cm, e. £150-£300.
Small sporting subjects £5-£10.
Other small bookplates and portraits small value.

HADEN, Sir Francis Seymour, P.R.E.
 1818-1910
Important etcher and mezzotint engraver of landscapes, marine subjects and portraits, occasionally after British painters, but mainly after his own designs. Born in London, he practised as a surgeon, etching in his spare time. He completed over 250 plates, most of them dating from 1858 when J.A.M. Whistler (q.v.) stayed with him in London. They had considerable influence on each other's work and together were regarded as the founders of the Modern Etching Movement. Haden was also very much influenced by Rembrandt, publishing a book on his etchings in 1879. He often worked on plates in the open air to achieve the maximum atmospheric effect. He founded the R.E. in 1880, and was its president until his death.
Mostly £50-£150 for signed imp.
'Shere Mill Pond', 7 x 13in/17.5 x 33cm, £200-£300.
'Sunset on the Thames', 5½ x 8½in/14 x 21.5cm, £160-£28.
'Hands Etching - "O Laborum"' 5½ x 8½in/14 x 21.5cm, £150-£200.
'A Sunset in Ireland', 1863, 5½ x 8½in/14 x 21.5cm, £400-£600.
'The Breaking Up of the Agamemnon', 7¼ x 16¼in/19.5 x 41.5cm, £200-£300.
'On the Test', 6 x 8in/15 x 22.5cm, £200-£300.
'The Towing Path', 5½ x 8½in/14 x 21.5cm, £200-£300.
'Brig at Anchor', 'Battersea Reach', 'Twickenham Church', 'Sonning Bank', all as publ. in books or periodicals in lge. edn., unsigned £20-£30.
Bibl: Schneiderman, R.S., *A Catalogue Raisonné of the Prints of Sir F.S.H.*, London, 1983.

HAGHE, C. d.1888
Lithographer of topographical views, sporting subjects and portraits after his contemporaries. He was the brother of L. Haghe (q.v.) with whom he collaborated on many projects.
'The Grey Mare', after S. Gilpin, c.1850, 16½ x 18½in/42 x 47.5cm, tt. pl., £20-£40.
'T. Thompson as Cincinnatus', after Haghe, £5-£15.

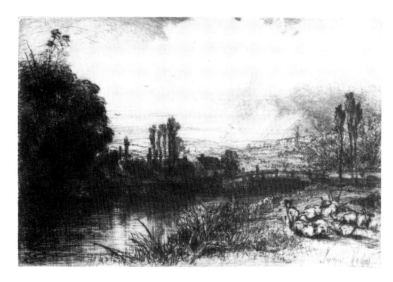

HADEN, Francis Seymour. 'On the Test'.

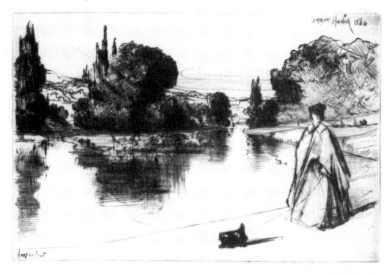

HADEN, Francis Seymour. 'The Towing Path'.

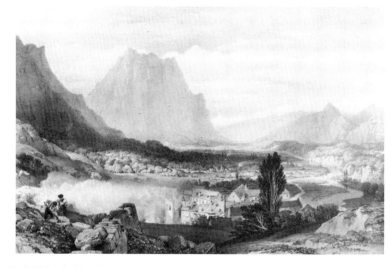

HAGHE, Louis. Plate from Lord Monson's *Views in the Dept. of the Isère:* 'Valley of the Isère…', 1840.

Pl. for W. Simpson's The Seat of War in the East, *1855-6, fo., tt. pl., e. £10-£30 col.*
Pl. for Lieut. W.H.J. Browne's Ten Coloured Views Taken During the Arctic Expedition of H.M.S. *Enterprise and H.M.S.* Investigator, *1850, fo., tt. pl., e. £40-£100 col.*

HAGHE, Louis 1806-1895
Belgian watercolourist and lithographer of landscapes and topographical and architectural views after his own designs and those of his contemporaries. Born at Tournay, he trained as a watercolourist and lithographer at an early age, and in 1823 went to England. He founded the firm of lithographers Day & Haghe with William Day (see William Day II). Of many topographical works for which he produced plates the most important was David Roberts' *Holy Land, Egypt and Nubia.* He gave up lithography in 1852 to take up watercolour painting.
Pl. for David Roberts' Holy Land, Egypt and Nubia, *1842-9, tt. pl., full pl. £150-£600 col.; full pl. £50-£200 uncol.; half pl. £100-£250 col.; half pl. £20-£60 uncol.; whole set in 6 vol., 248 pl., with original colouring, up to £100,000, £15,000 uncol. Note that pl. with original colouring (trimmed and mounted on card) very often foxed, uncol. pl. often seen with modern colouring (these have margins with printed titles below subject, half-pl. also have text on verso); pl. from 'Egypt and Nubia' generally more popular than 'Holy Land'.*
Pl. for Lord Monson's Views in the Dept. of the Isère, *1840, fo., e. £30-£60.*
Pl. for his own Sketches in Belgium and Germany, *1840, fo., tt. pl., e. £5-£20.*
Pl. for J. Le Capelain's The Queen's Visit to Jersey, *1847, fo., tt. pl., e. £30-£70.*
'The Destruction of Jerusalem by the Romans', after D. Roberts, 1850, 27¼ x 41¼in/69 x 105cm, £200-£400.
'Engagement between the Shannon and the Chesapeake', after J. Schetky, 1830, 4 pl., set £800-£1,500 col.
'Charge of 3rd Dragoon Guards upon the Rioters in Queen Sq., Bristol', after T.L. Rowbotham and W. Muller, 1831, 18½ x 22in/47 x 56cm, £80-£120 col.
'View of the River Lea Bridge and Stratford Viaduct as Now Constructing for the Eastern Counties Railway Company', 13 x 22¾in/33 x 58cm, £300-£400 col.
'The Royal Lodges in the Great Park, Windsor', after H.B. Ziegler, 8 pl., fo., e. £60-£100 col.
Views in Guernsey, after T. Compton and others, 1829-30, 10 pl., obl. fo., e. £30-£70.
Portraits £5-£20.
Colour plate page 37.

HÄHNISCH, Anton 1817-1897
Austrian portrait painter who drew and lithographed several British portraits on visits to the country.
Small value.

HAIG, Axel Hermann, R.E. 1835-1921
Swedish etcher of architectural views. Born on Gotland Island, he originally studied naval architecture. Later he came to London and worked for a number of architects. He produced several hundred large plates, many of them depicting cathedrals, both in Britain and on the Continent. He lived in Haslemere, Surrey.
'Mont St. Michel', 1889, 35 x 24½in/89 x 62cm, and 'Notre Dame from the Seine', 1900, 22 x 30¼in/56 x 78cm fetched £190 and £170 Feb. 1996

HAIG, Axel Hermann. A typical architectural view.

Generally £50-£150.
Bibl: Armstrong, E.A., *A.H.H. and His Work*, Fine Art Society, London, 1905.

HAIG, Henry fl. mid-19th century
Mezzotint and line engraver of portraits and bookplates after his contemporaries and Old Master painters.
Small value.

HAIG, J.E. fl. late 18th century
German mezzotint engraver of portraits after his contemporaries. One of a family of engravers, he worked in Augsburg and engraved a few English portraits.
English portraits £5-£15.

HAIG, Johann Gottfried 1730-1776
German mezzotint engraver of portraits and decorative subjects after his contemporaries. Born in Württemberg, one of a family of engravers, he was invited to London by John Boydell (q.v.) and engraved several plates before returning to Germany.
'Charles, Lord Camden', after J. Reynolds, 14 x 10in/35.5 x 25.5cm, £15-£40.
'Samuel Foote', after J. Zoffany, 1765, 17 x 20in/43 x 51cm, £60-£100.
'Rembrandt's Mother', after Rembrandt, 14 x 10in/35.5 x 25.5cm, £5-£10.
CS.

HAIG, Johann Jacob fl. mid-18th century
German mezzotint engraver of portraits after his contemporaries. One of a family of engravers, he worked in Augsburg and engraved a few English portraits.
English portraits £5-£15.

HAINES & SON fl. early 19th century
Publishers of decorative, allegorical and biblical subjects engraved anonymously in mezzotint.
'The Reapers' and 'The Haymakers', 1809, 10 x

13½in/25.5 x 34.5cm, pair £100-£150 col.
Mostly small value if uncol.

HAINES, William 1778-1848
Stipple engraver of small portrait plates after his contemporaries.
Small value.

HAIR, Thomas H. fl. 1839
Painter of north eastern landscapes and street scenes. In 1839, he published a series of etchings of coal mines.
'Old Locomotive Engine, Wylam Colliery', 1843, 6¾ x 9½in/17 x 24cm, £10-£25.

HAKEWILL, Jame 1778-1843
Architect and draughtsman of topographical and architectural views. He drew and also lithographed a series of views of the Zoological Gardens in Regent's Park.
'Views of the Zoological Gardens', 1831, 10 pl., 15¾ 13¼in/40 x 33.5cm, e. £60-£140 col.

HALFPENNY, John born c.1788
Etcher and aquatint engraver of portraits.
Small value.

HALFPENNY, Joseph 1748-1811
Drawing-master and watercolourist in York who etched sets of antiquarian pl.
'Gothic Ornaments in the Cathedral Church of York', 1795-1800, and 'Fragmenta Vetusta, or the Ancient Remains of Ancient Buildings in York', 1807, e. set £400-£600 in original wrappers (paper cover), otherwise small value.
Yorkshire Churches, 1816-17, e. £50-£60

HALL, Charles c.1720- d.1783
Line engraver of small portrait plates after his contemporaries and Old Master painters and bookplates depicting objects of antiquarian interest. He died in London.
Small value.

HALL, Edna Clarke, Lady b.1879
Draughtsman, etcher and lithographer of figure subjects. Born in Shipbourne, Kent, she studied at the Slade.
£10-£30.

HALL, Henry Bryan 1808-1884
Line and stipple engraver of portraits and biblical and decorative subjects after his contemporaries and Old Master painters, mostly small bookplates. Born in London, he was apprenticed to B. Smith, assisted H. Meyer, and then worked for H.T. Ryall (qq.v.) engraving the portraits for Ryall's 'The Coronation of Queen Victoria'. In 1850 he emigrated to America where he continued to engrave portraits, eventually setting up a firm with his sons.
'The Coronation of Queen Victoria', after G. Hayter, 1843, 23½ x 34in/59.5 x 86.5cm, £200-£300.
Add more if in fine contemporary frame.
Small portraits and bookplates small value.

HALL, John 1737-1797
Line engraver of historical and mythological subjects and portraits after his contemporaries. Born in Wivenhoe, near Colchester, he was a pupil of S. Ravenet (q.v.). On the death of W. Woollett (q.v.), he was appointed Historical Engraver to George III, presenting the latter on this occasion with 'The Battle of the Boyne', after B. West.
'The Battle of the Boyne', after B. West, 1781, 19 x 24½in/48.5 x 62cm, £150-£300.

HALL, John. 'The Battle of the Boyne', after B. West, 1781.

'William Penn's Treaty with the Indians', after B. West, 1775, 17 x 23½in/43 x 59.5cm, £150-£300.
'Lord Hawke, Admiral of the Fleet', after F. Cotes, 1793, 14 x 11in/35.5 x 28cm, £10-£25.
Pl. for L'Ecole des Armes, 1763, 47 pl, 10¼ x 15¼in/26 x 38.5cm, £30-£80; other bookplates and small portraits small value.

HALL, Oliver, R.A., R.E. 1869-1957
Painter and etcher of landscapes. Born in London, he studied at the R.C.A. and at other London schools. He sketched in Wales, the

HALL, Oliver. A typical landscape.

North Country and on the Continent and lived in Sussex and at Ulverston, Lancashire.
£30-£70.

HALL, Sidney fl. early 19th century
Line and stipple engraver of small architectural plates and portraits after his contemporaries.
Small value.

HALL, T. fl. early 19th century
Aquatint engraver of architectural views, sections and plans after his contemporaries.
Small value.

HAMBLE, Joseph R. c.1784-1814 or later
Aquatint engraver of topographical views and naval and sporting subjects after his contemporaries and his own designs. He often worked with John Clark (q.v.).
'A View of the Cape of Good Hope and The Battle Previous to the Surrender', after W.M. Craig, eng. with Clark, 1806, 20¼ x 25¼in/51.5 x 65.5cm, £500-£700 col.
Pl. for D. and J.T. Serres' Liber Nauticus, 1805-6, 24 pl., fo., e. £30-£80.
Pl. for Ackermann's History of Westminster Abbey, after A. Pugin etc., 1812, 4to., e. £5-£15 col.
Pl. for Capt. T. Williamson and S. Howitt's Oriental Field Sports, 1805-7, obl. fo., e. £150-£300 col., for 1819 edn. e. £80-£160 col.
English views, 1812, ave. 14 3/4 x 20in/37.5 x 51cm, e. £70-£150 col.

HAMBURGER, C. fl. mid-19th century
Lithographer of portraits.
'Sir Augustus Fraser, Col. of the Royal Horse Artillery and Director of the Royal Laboratory', c.1820, 20¼ x 16¾in/51.5 x 42.5cm, £15-£40.
'Sir Peter Laurie', after F. Cruikshank, 9 x 6½in/23 x 17cm, £3-£10.

HAMERTON, Philip Gilbert, R.E.
1834-1894
Art critic and minor etcher of landscapes. Born near Oldham, Lancashire, he came to London to study. Amongst the many articles and books he wrote, he is best remembered for Etching and Etchers, 1868 (and other editions), which did much to encourage the medium, and his own publication The Portfolio, 1870-92, to which he

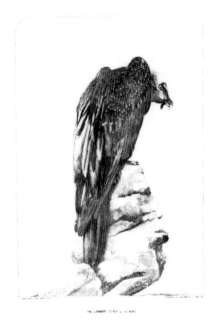

HANCOCK, John. Plate from 'A Fasciculus of
Eight Drawings on Stone of Groups of Birds:
The Laemmer-Geyer of the Alps', 1853.

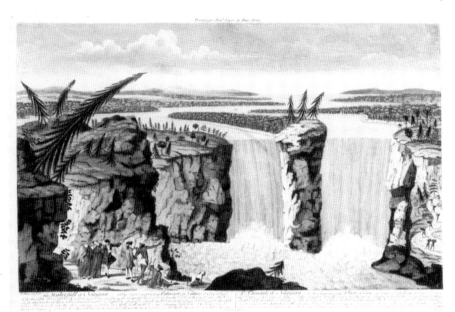

HANCOCK, Robert. 'The Waterfall of Niagara', engraving.

contributed several plates.
Small value.

HAMERTON (Hammerton), R.J.
fl. mid-19th century
Lithographer of small bookplates including
portraits, Oriental scenes and views, etc., after
his contemporaries and his own designs.
Pl. for Capt. C.R. Scott's Rambles in Egypt and
Candia, *1837, 5 pl., 8vo., small value.*

HAMILTON, John
fl. late 18th century
Amateur Irish draughtsman and etcher of
bookplates after his contemporaries. Born in
Dublin, he came to England as a young man.
Pl. for F. Grose's Ancient Arms and Armour,
1786, and other books, small value.

HANCOCK, John
fl. 1853
Draughtsman and lithographer of ornithological
subjects.
*'A Fasciculus of Eight Drawings on Stone of
Groups of Birds', 1853, 8 pl., fo., e. £10-£20
(copy with 8 col. and 8 uncol. fetched $1,100 in
Dec. 1989).*

HANCOCK, Robert
1730-1817
Stipple, line and mezzotint engraver of
portraits, topographical views, sporting and
decorative subjects after his contemporaries.
Born at Burslem, Staffordshire, he studied
engraving under S. Ravenet (q.v.) but worked at
first in a porcelain manufactory in Battersea. In
1756 he became draughtsman and engraver to
the Worcester porcelain works. Later he turned
to mezzotint engraving.
*'The Waterfall of Niagara', 10¼ x 15¼in/26 x
40cm, eng., £200-£400 col.*
*'Crop', after F. Sartorius, 1794, 9¾ x 13¾in/25 x
35cm, eng., £120-£180 col.*
*'Lady Chambers', after J. Reynolds, 5¾ x
4½in/14.5 x 11.5cm, mezzo., £5-£15.*
*'R. Lovett', after J. Wright, 14 x 10in/35.5 x
25.5cm, mezzo., £20-£40.*
Small bookplates (line and stipples) small value.
CS.

HANDASYDE, Charles
fl. mid-/late 18th century
Miniature and enamel painter who engraved
four small portraits of himself.
Self-portraits, 1 etching and 3 mezzo., e. £10-£40.
CS.

HANDFORD, Alfred Sidney
b.1858
Etcher, mezzotint and mixed-method engraver
of landscapes and sentimental subjects after
19th century British artists and his
contemporaries.
£10-£50.

HANFSTAENGL, Franz Seraph
1804-1877
German lithographer and photo-engraver of
portraits, sporting and sentimental subjects, etc.,
after his contemporaries, especially British
artists, and religious subjects, etc., after Old
Master painters. Born in Bavaria, he studied in
Munich and practised lithography (reproducing
a series of paintings in the Dresden Gallery),
before turning to photo-engraving after its
invention. His first works in that medium were
reproductions of paintings in Munich Gallery.
Golfing subjects £150-£300.
*Football, cricket, polo, rowing, fishing subjects
£60-£160.*
Fox-hunting and shooting subjects £20-£60.
Boer War subjects £15-£40.
*'Thomas Gordon, General in Greek Service',
after Krazeiser, £160-£240.*
*'King Cophetua and the Beggar Maid', after
E. Burne-Jones, 1893, 29½ x 14¼in/74.5 x 36cm,
£400-£800.*
Add more if in fine contemporary frame.
*Other sentimental and decorative subjects and
pl. after Old Master painters small value.*

HANHART, Michael & N.
fl. mid-/late 19th century
Firm of lithographers and lithographic printers.
*'The Whitehaven Races', after J. Rook, 1852,
10¼ x 14¼in/27.5 x 37.5cm, £120-£180 col.*
*'London Scottish Volunteer Rifle Corps', after
H. Fleuss, 18 x 11½in/45.5 x 29cm, £80-£120 col.*
Pl. for T.W.J. Connolly's Royal Engineers, *after
G.B. Campion, 4¾ x 7¼in/12 x 18.5cm, e. £10-*
£25 col.
*'Royal Military Academy, Woolwich' and
'Cricket Match, Royal Military Academy,
Woolwich', after Prof. W. Paris, 1888, 11 x
17½in/28 x 44.5cm, pair £300-£500 col.*
*'Royal Mail Steam Packet Trent', after
W. Jefferson, 13 x 17½in/33 x 45cm, £300-£500.*
*'The Months in Flowers' after H. Brooke, 15¼ x
12½in/40 x 32cm, set £1,200-£1,800 col.*
Pl. for W.R. Snow's Sketches of Chinese Life
and Character, *c.1840, 18 tt. pl., fo., e. £30-£50
col.*
*Pl. for H. Alken's Sketches, The Stable, The
Road, The Field, 1854, 6 pl., 9 x 13½in/23 x
34.5cm, e. £20-£40 col.*

HANKEY, William Lee-, R.W.S., R.E.
1869-1952
Painter and etcher of figure subjects, portraits
and landscapes. Born in Chester, he studied at
the School of Art there, at the R.C.A. and in

HANKEY, William Lee-. 'Mother and Child',
etching.

HARDING, James Duffield. One of twenty-six lithotints from 'The Park and The Forest: Sycamore', 1841.

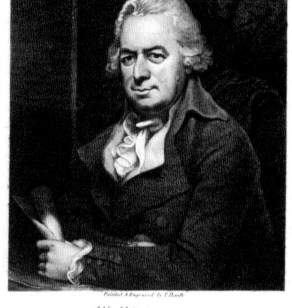

HARDY, Thomas. 'W. Cramer', 1794.

Paris. He lived in London and taught etching at Goldsmiths' College. Many of his prints depict women and children.
£15-£40.
'Denise', 1918, 8 x 5in/20 x 12.5cm, £150-£300.
Others mostly £80-£200.
Bibl: Hardie, M., *The Etched Work of W.L.-H., R.E., 1904-20,* London, 1921.

HANLON, William fl. late 18th/early 19th century
Draughtsman and etcher of political and social satires.
£20-£60 col.

HARDIE, Martin, R.E., R.S.W. 1875-1952
Watercolourist, etcher and drypointer of landscapes. Born in London, he studied etching under F. Short (q.v.), by whom he was influenced. He was Keeper of the Departments of Painting, Engraving, Illustration and Design at the Victoria and Albert Museum, 1921-35, and wrote several books on art.
£40-£100.
Bibl: Laver, J., 'The Etchings and Drypoints of M.H.', *P.C.Q.,* 1937, XXIV; 'Catalogue of the Etchings and Drypoints of M.H., C.B.E., R.E.', *P.C.Q.,* 1938, XXV.
Hardie, M., 'J.M. *Catalogue Raisonné* 1902-24', London, 1925.

HARDING, Edward 1776-1796
Stipple and line engraver mainly of small bookplates, particularly portraits after his contemporaries, Old Master painters as well as his own designs. He was the son of Sylvester H. (q.v.) and seems to have worked in London.
'The Costume of the Russian Empire', 73 pl., e.

£6-£10 col.
Others mostly small value.

HARDING, George Perfect d.1853
Miniaturist, watercolourist and lithographer of small portraits after Old Masters, British 18th century painters, his contemporaries and his own designs. A son of Samuel Harding (q.v.), he died in Lambeth.
Small value.

HARDING, James Duffield 1797-1863
Watercolourist, engraver and lithographer of landscapes and topographical views after his own designs and those of his contemporaries. Born in Deptford, he studied under S. Prout (q.v.) and was apprenticed to J. Pye I (q.v.) to learn engraving. But it was to the development of the medium of lithography that he made major contributions. Working with C. Hullmandel (q.v.), the printer, he produced the first important topographical book in which the lithographs were printed with a tintstone, i.e. half-tone (*Sketches at Home and Abroad*). In 1841 the next project appeared: *The Park and the Forest* contained twenty-six 'lithotints' which reproduced wash drawings by using a brush on the stone instead of a crayon.
'Sketches at Home and Abroad', 1836, 50 tt. pl., fo., set £600-£1,000 (set fetched £1,800 Feb. 1990).
'The Park and the Forest', 1841, 26 pl., fo., lithotints, set £500-£800.
Views in Europe, 10½ x 15in/26.5 x 38cm, tt. pl., e. £15-£30.
Pl. for Britannia Delineata, 1822-3, obl. fo., e. £25-£50.
Pl. for A. de Capell Brooke's Winter Sketches in

Lapland, *1826, fo., tt. pl., e. £10-£30.*
Pl. for A Series of Subjects From the Works of the late R.P. Bonington, *1829-30, 4to., small value.*
Pl. for C.S. Hardinge's Recollections of India, *1847, fo., 26 tt. pl., e. £100-£200 col.*

HARDING, John Wells c.1764-1812 or later
Stipple and aquatint engraver of decorative subjects, architectural views, etc., after his contemporaries.
Stipples after A. Kauffmann £50-£150, add more if in fine contemporary frame.
'A Party Billeted upon Cottagers', 1812, by and after Harding, 13¼ x 10½in/33.5 x 26.5cm, aq., £60-£80 col.
Pl. for J. Gandy's Designs for Cottages, Cottage Farms and other Rural Buildings, *1805, small value.*

HARDING, Samuel fl. late 18th/early 19th century
Line and stipple engraver of small portraits and bookplates after Old Master painters, his own designs and those of his contemporaries. He was a son of S. Harding (q.v.).
Small value.

HARDING, Sylvester 1748-1808
Miniaturist, etcher, line and stipple engraver of small portraits after his own designs and Old Master painters. Born in Newcastle under Lyme, he came to London after having worked with some strolling players and started painting miniatures. He was responsible for several publications.
Small value.

HARDY, F.J. fl. mid-19th century
Lithographer.
*'The Curragh Camp Headquarters', c.1850, by
and after Hardy, 6¾ x 9¼in/17 x 23.5cm, £10-
£25.*

HARDY, Heywood, R.E. 1842-1933
Sporting, animal and genre painter and etcher of
animal subjects. Born in Chichester, he settled
in London, later returning to Sussex. He
contributed plates to *The Portfolio* and to *The
Etcher.*
*Signed proofs £30-£70; unsigned imp. from The
Portfolio and The Etcher £10-£30.*

HARDY, J. fl. late 18th century
Stipple engraver of portraits after his
contemporaries.
£2-£8.

HARDY, Thomas 1757-c.1805
Portrait painter and occasional stipple and
mezzotint engraver of portraits and some
decorative subjects after his contemporaries as
well as his own designs.
Stipples: 'W. Cramer', 1794, £5-£8.
Others £1-£8.
*Mezzo.: 'Thomas Peter Legh, Col. of the Third
Regt. of the Lancashire Light Dragoons', after
J. Cranke, 26 x 18in/66 x 45.5cm, £80-£120.*
Others £15-£70.
CS.

HARGRAVE, Edward fl. mid-19th century
Engraver of small bookplates including
portraits.
Small value.

HARLAND, T.W. fl. early 19th century
Painter and stipple engraver of portraits, mainly
small bookplates after his own designs.
Small value.

HARLEY, George 1791-1871
Draughtsman and lithographer of landscapes
and topographical views after his own designs
and those of his contemporaries. He was also a
drawing master.
*'English Scenery', 1820, 4 pl. (Hastings,
Leicestershire and Vauxhall), obl. fo., e. £15-
£40 col.*
*'Four Views in the Isle of Wight', after
W. Varley, 1823, obl. 4to., e. £10-£30 col.*

HARRADEN, James fl. early 19th century
Aquatint engraver of 'Views of Cambridge'
after R. Harraden (q.v.). He was possibly a son
of the latter.
*'Views of Cambridge', after R. Harraden, 1800,
obl. 4to., e. £10-£30.*
*Also 'View of Gibraltar from the Devil's Tongue
Battery', by J.B.H. after H.A. Barker, 1808, 21¼
x 28½in/55 x 72.5cm, £200-£400 col.*

HARRADEN, Richard 1756-1838
Draughtsman and aquatint engraver of
landscapes and topographical views. Born in
London, he worked in Paris and London before
moving to Cambridge in 1798, where he drew a
number of views engraved by others. He had a
son Richard Bankes Harraden (1778-1862) who
was a draughtsman and aquatint engraver. Many
plates are just signed 'Harraden' and could be
by either father or son.
*Pl. for F.W. Blagdon's A Brief History of
Ancient and Modern India, 1802-5, fo., e. £40-
£90 col.*
Pl. for T. Girtin's A Selection of Twenty of the

Most Picturesque Views in Paris, *1803, see
Girtin for prices.*
*'The Fall of the Staubbach in the Valley of the
Lauterbrunnen', after K.H. Digby, 1817, 14¼ x
19½in/37.5 x 50cm, £250-£400 col.*

HARRAL, Alfred and Horace
fl. mid-19th century
Wood engravers of plates for *The Illustrated
London News*, etc.
Small value.

HARRIS, Henry Hotham 1805-1865
Birmingham artist and lithographer.
*'The Gathering of the Unions on New Hall,
Birmingham', 1832, 16 x 22in/41 x 56cm, litho.,
£250-£350.*

HARRIS, John I fl. early/mid-18th century
Etcher and line engraver of architectural views,
naval subjects, maps, etc., after his
contemporaries.
*'The Revolt of the Fleet', after T. Baston, 16½ x
18½in/42 x 47cm, £120-£200.*
*'South West Prospect of Manchester and
Salford', 18¾ x 49in/47.5 x 124.5cm, £300-
£500.*
*'A View on the Pont Neuf', after H.W. Bunbury,
1771, 16 x 24in/40.5 x 61cm, £80-£160.*
*'Cathedral Churches in England and Wales',
obl. fo., e. £10-£40.*
*'South West Prospect of the Duke of
Marlborough's House in St. James's Park', after
J. Lightbody, 19 x 23in/48 x 58.5cm, £100-£200.*
Small bookplates small value.

HARRIS, John II d.1834
Illustrator and watercolourist who lithographed
some portraits of Freemasons.
*'Augustus Frederick, Duke of Sussex, as Grand
Master of the Masons', 1833, 19½ x 14in/49.5 x*

35.5cm, £20-£50.
Portrait vignettes of other masons small value.

HARRIS, John III 1811-1865
Aquatint engraver of sporting and military
subjects after his contemporaries. He was born
in London, some say the son of J. Harris II
(q.v.), others the son of a cabinet maker, and
lived there all his life working mainly for the
publishers Ackermann and Fores.
*'Fores's National Sports: Foxhunting', after
J.F. Herring, 1852, 4 pl., 24¾ x 45in/63 x
114 .5cm, set £2,500-£3,500 col.*
*'Fores's National Sports: Racing', after J.F.
Herring, with C. Quentery (q.v.), 1856, 4 pl., 24
x 44½in/61 x 113cm, set £2,600-£4,000 col.*
*'Fores's Stables Scenes', after J.F. Herring,
1846, 4 pl., 21 x 29 1/2in/53.5 x 75cm, set £600-
£1,000 col.*
*'Fox Hunting', after J.F. Herring, 1854, 4 pl.,
17½ x 30¼in/44.5 x 78cm, set £1,500-£2,500 col.
Add more if in fine contemporary frame.*
*'Fores's Hunting Casualties', after H.T. Alken,
1850, 6 pl., 10½ x 13¼in/26.5 x 33.5cm, set
£350-£450 col.*
*'Doncaster Races', after J. Pollard, 1837, 4 pl.,
14½ x 25in/37.5 x 63.5cm, set £3,000-£4,000
col.*
*'Richard Knight, Huntsman to the Pytchley
Hunt', 6 x 5in/15 x 12.5cm, £10-£20 col.*
*'Fores's Contrasts' (railway subjects), after
H.T. Alken, 1852, 3 pl., 15¾ x 23½in/40 x
59.5cm, set £500-£700 col.*
*'Duke of Wellington', after H. de Daubrawa,
1844, 17 x 20½in/43 x 52.5cm, £40-£80 col.*
*'The Derby Day Tits and Trampers on the Road
to Epsom', after J. Pollard, 1842, 9¾ x 14in/25
x 35.5cm, £200-£400 col.*
*'The First Steeple-Chace on Record', after H.T.
Alken, 1839, 4 pl., 10½ x 14½in/26.5 x 37cm,
first issue Ackermann, set £1,500-£2,500 col.;*

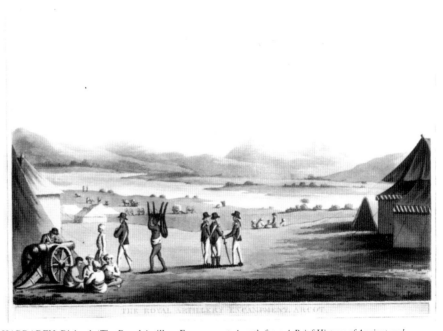

HARRADEN, Richard. 'The Royal Artillery Encampment, Arcot', from *A Brief History of Ancient and
Modern India.*

HARRIS, John I. Plate from 'Cathedral Churches in England and Wales: The South Prospect of the Cathedral Church of St. Mary Lincoln'.

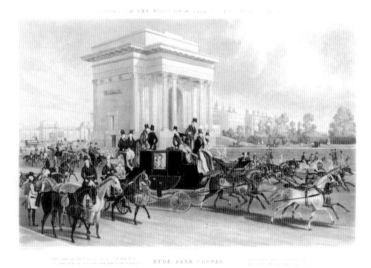

HARRIS, John III. One of four plates from 'Scenes on the Road, or a Trip to Epsom and Back: Hyde Park Corner', after J. Pollard, 1838.

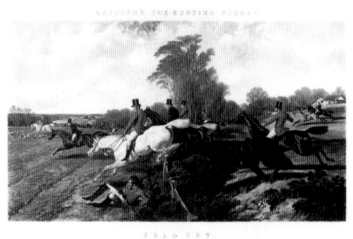

HARRIS, John III. One of four plates from 'Fox Hunting: Full Cry', after J.F. Herring, 1854.

reissues Ben Brooks, set £100-£250 col.
'The Everingham Short Horned Prize Cow', after W.H. Davis, 1843, 19 x 24¼in/48 x 61.5cm, £300-£400 col.
'Car-Travelling in Southern Ireland', 1836, after M.A. Hayes, 6 pl., 8 x 13in/20.5 x 33cm, set £500-£800 col.
3 pl. for T.T. Bury's Six Coloured Views on the London and Birmingham, 1837, 4to., rare, e. £100-£200 col.
'Fores's Coaching Incidents', after C.C. Henderson, 6 pl., 12¼ x 23¼in/32.5 x 59cm, e. £150-£250 col.
'Costumes of the British Army', after H. Martens, 1855, 14½ x 9¾in/37 x 25cm, e. £80-£150 col.
'Celebrated Engagements of the Sikh Wars', after H. Martens, 1848-9, 20½ x 27in/52 x 68.5cm, e. £150-£250 col.
'The Conference at Block Drift, Kaffir Land, Jan. 30th 1846', after H. Martens, £400-£600 col.
'Ackermann's Chobham Scenes', after H. Martens, 1853-4, 6 x 9in/15 x 22.5cm, e. £30-£50; ave. 22 x 30½in/55.5 x 77.5cm, e. £300-£500 col.
'Fores's Celebrated Winners', after J.F. Herring, e. £400-£600 col.
'Scenes on the Road, or a Trip to Epsom and Back', after J. Pollard, 1838, 4 pl., 16 x 22in/40.5 x 56cm, set £3,000-£5,000 col. (set col. fetched £7,800 Oct. 1988).
Colour plates pages 38 and 39.

HARRIS, Moses b.1731
Draughtsman, etcher, engraver and publisher of entomological and botanical plates. He was born in London.
Pl. for The Aurelian, 1766, e. £30-£100 col.
Self portrait, 1780, 8 x 6in/20.5 x 15cm, £30-£70.

HART, W. see GOULD, J.

HARTLEY, Alfred, R.E. 1855-1933
Painter, etcher and aquatint engraver of landscapes and genre subjects. Born in Hertfordshire, he studied at the R.C.A. and Westminster School of Art and lived in London and Wales.
£15-£40.

HARTNELL, N. fl. 1840
Lithographer.
'Lithographic Views of Military Operations in Canada', after Lord C. Beauclerk, 1840, 6 pl., 7 x 10½in/18 x 26.5cm, e. £60-£90 col. (set col. fetched £1,500 Feb. 1991).

HARTRICK, Archibald Standish, R.W.S.
 1864-1950
Painter, lithographer and occasional etcher of genre subjects and landscapes. Born in southern India, he studied under A. Legros (q.v.) at the Slade and in Paris. He was a founder member and Vice-President of the Senefelder Club. He lived in Gloucestershire and London.
'Women's Work', for The Great War: Britain's Efforts and Ideals Shown in a Series of Lithographic Prints, 6 pl., fo., e. £40-£70.
Others £40-£90.

HARVEY, Herbert Johnson 1884-1924
Painter and etcher of portraits and figure subjects. He was born in and lived in London.
£10-£30.
Bibl: Laver, J., 'Etchings of H.J.H.', Bookman's Journal, 1927, XV, p. 42.

HARVEY, Thomas 1748-1820
Draughtsman and soft-ground etcher of a book of animal studies and landscapes.
Animal studies and landscapes, 32 pl., 11¼ x 8in/28.5 x 20.5cm, e. £4-£10.

HARVEY, William 1796-1866
Wood engraver mainly of book illustrations after his contemporaries. Born in Newcastle upon Tyne, he was apprenticed to T. Bewick (q.v.) and engraved many of the plates for the latter's *Fables*, 1818. In 1817 he went to London.
'The Assassination of L.S. Dentatus', after B.R. Hayon, 1821, 18 x 11½in/46 x 29cm, £20-£50. Bookpl. small value.

HASSALL, Joan, R.E. b.1906
Painter and wood engraver of landscapes. She studied at the R.A. Schools and at the L.C.C. School of Photo-engraving and Lithography. She lives in London.
£60-£120.
Bibl: McLean, R., *The Wood Engravings of J.H.*, Oxford University Press, London, 1960.

HASSELL, John 1767-1825
Draughtsman and aquatint engraver mainly of small topographical bookplates, but also some larger sporting, naval and decorative subjects after his contemporaries as well as his own designs. He lived and worked in London. He also worked as a drawing master and wrote several books on drawing and watercolour painting, e.g. *Aqua Pictura*, 1813.
'Fox Hunting', after T. Hand, 1801, 4 pl., 11 x 15in/28 x 38cm, set £1,000-£1,600 col.
'The High-Mettled Racer', drawn and etched by T. Rowlandson, aq. by Hassell, 1789, 4 pl., 10¼ x 14in/26 x 35.5cm, set £1,500-£2,500 col.
'H.M.S. Sloop The Little Bell and American Frigate President after the Action of May 11, 1811', after J. Cartwright, £400-£600 col.
'Hue and Cry after a Highwayman', after F.G. Byron, 26 x 13in/66 x 115cm, £250-£350 col.
'Views of Willesdon Church and Acton Town, Middlesex', 2 pl. after M. Hollogen, 1790, 13½ x 16in/134.5 x 41.5cm, pair col. fetched £520 June 1987.
'Beauties of Antiquity', 1807, 52 pl., 8vo., small value.
'Tour of the Grand Junction Canal', 1819, 24 pl., 8vo., e. £10-£20 col.
Pl. for J.C. Ibbetson's Guide to Bath, Bristol and Hot Wells and the River Avon 1793, 16 pl., 4to., e. £10-£20 col.
Pl. for R. Harraden's Views of Cambridge 1800, obl. 4to., e. £10-£30.

HASTINGS, Capt. Thomas
fl. early 19th century
Amateur etcher of landscapes. He was the Collector of Customs in Liverpool.
'Vestiges of Antiquity, or a Series of Etchings of Canterbury', 1813, small value.
'Etchings from the Works of Richard Wilson', 1825, small value.
'The British Archer, or Tracts on Archery', 1831, e. £5-£10.

HAUGHTON, Moses Jun. 1772-1848
Miniaturist, etcher and line engraver. The son of M. Haughton Sen., he was a pupil of G. Stubbs (q.v.) and studied at the R.S.A. Schools.
'Eight Principal Motions in the Attack and Defence as Practised in the Hungarian Sword Exercise', after R. Lawrence, 1797, 4 pl. each

HAVELL, Daniel. 'South East View of St. Paul's Cathedral', after J. Gendall, 1818.

with 2 figs., e. £10-£30 col.
Small portraits small value.

HAVELL fl. early 19th century
Aquatint engraver of small bookplates, including Welsh customs and views after his contemporaries. He may have been the same engraver as one of the following Havells.
£4-£8 col.

HAVELL, Daniel b.1785
Aquatint engraver of topographical views, military and genre subjects after his contemporaries. Born in Berkshire, he was the son of a painter, Thomas, and possibly the nephew of R. Havell I (q.v.) with whom he collaborated on a number of plates. He seems to have worked in London.
'South East View of St. Paul's Cathedral', after J. Gendall, 1818, 16¾ x 21in/42.5 x 53cm, and other London views of similar size, £500-£1,000 col.
Amongst other works he engraved plates for:
E.G. Vidal's Picturesque Illustrations of Buenos Ayres and Monte Video, 1820, 24 pl., lge. 4to., e. £100-£200 col.

Baron J.I. von Gerning's A Picturesque Tour along the Rhine, after C.G. Schultz, 1820, fo., e. £50-£100 col.
J. Gendall's Six Views of Hastings, 1822, obl. 4to., e. £15-£35 col.
R. Ackermann's Oxford and Cambridge, 1814, e. £20-£60 col.
R. Ackermann's Public Schools, 1816, e. £20-£60 col.
J. Hassell's Picturesque Rides and Walks, 1817/8, small 8vo, small value.
J. Jenkins' Martial Achievements, after W. Heath, 1815, 4to., e. £20-£35 col.
H. Haseler's Picturesque Views on the River Exe, 1819, fo., e. £40-£70 col.

HAVELL, Frederick James 1810-1840
Etcher and line engraver mainly of small bookplates including landscapes and topographical views after his contemporaries and Old Master painters. Born in Reading, the son of a drawing master Luke Havell, he was a brother of William Havell (q.v.) the landscape artist, and worked in London. He engraved one aquatint 'The Blenheim leaving the Star Hotel, Oxford', after G. Havell.

HAVELL, Frederick James. 'Greenwich Hospital', after W. and F.J. Havell.

HAVELL, Robert I and II. One of twelve plates from 'A Series of Views of the Public Buildings and Bridges in London: A View of London Bridge and Custom House', 1820/1.

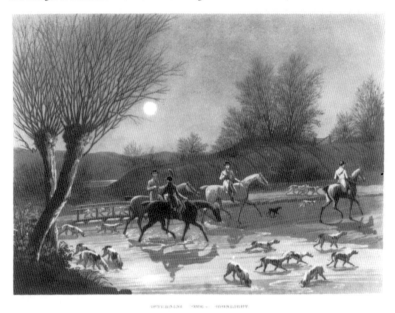

HAVELL, Robert I and II. One of four plates from 'A Celebrated Fox Hunt: Returning Home by Moonlight', after J. Pollard, 1817.

'The Blenheim Leaving the Star Hotel, Oxford', after G. Havell, 1831, 13 x 19¼in/33 x 49cm, £300-£500 col.
'Greenwich Hospital', after W. and F.J. Havell, 9 x 17in/23 x 43cm, £60-£140.
Small bookplates £1-£5.

HAVELL, Robert I 1769-1832
Prominent aquatint engraver of topographical views, and sporting, transport and military subects after his contemporaries as well as his own designs. Born in Berkshire, he was possibly the brother of a drawing master, Luke, and therefore the uncle of W. Havell and D. Havell (qq.v.). He worked in London, often collaborating with either D. Havell or his son, R. Havell II (q.v.). He also published many of his own prints.

Amongst numerous works are the following:
'A Celebrated Fox Hunt', with son, after J. Pollard, 1817, 4 pl., 13¼ x 18in/33.5 x 46cm, set £2,500-£3,500 col.
Coaching subjects after his own designs, all approx. 8¾ x 13½in/22 x 35cm, e. £200-£500 col.
'The Lioness Attacking the Horse of the Exeter Mail Coach', after J. Pollard, 1817, 9½ x 14½in/24 x 37cm, £250-£400.
Most other coaching subjects after J. Pollard, 1815/7, approx. 12¼ x 16¼in/31 x 41cm, e. £600-£1,100 col.
'View of the Liverpool and Manchester Railway Taken at Newton', after E. Calvert, 1825, 11¾ x 15in/30 x 38cm, £120-£180 col.
Pl. for W. Havell's Picturesque Views of the Thames, 1818, 12 pl., obl. fo., e. £300-£600 col.

(set made £11,000 in May 1992).
Miscellaneous books on architecture, 4to., e. small value.
With D. Havell pl. for:
H. Salt's Twenty Four Views of St. Helena, the Cape, India, etc., 1809, obl. fo., Abyssinian £100-£150 col.; others, mostly Indian, £200-£500 col. (set made £12,500 April 1994).
G. Walker's Costume of Yorkshire, 1813/4, fo., 41 pl., £30-£60 col.
With son:
Pl. for Views of the Noblemen's and Gentlemen's Seats, after various artists, 1814/23, fo., e. £10-£20 col.
'A Series of Views of the Public Buildings and Bridges in London', 1820/1, 12 pl., obl. fo., e. £200-£500 col. (set made $40,000 in Oct. 1988).
'South West View of Hobart Town, Van Diemen's Land', after G.W. Evans, 1820, 11¼ x 21¼in/30 x 54cm, £1,500-£2,500 col.
Views of 'The Artillery Barracks' and 'The Royal Military Academy, Woolwich', after Maj. Cockburn, 1816, 16 x 23in/41 x 58.5cm, pair £600-£1,000 col.
'George IV's Visit to Dublin', after J.L. Reilly and J.P. Haverty, 1821, 18 x 26in/45.5 x 66cm, pair £400-£700 col.
'The Descent of Mr. Livingston on the Coast of Baldoyle, Co. Dublin', after T.J. Mulvaney, c.1822, 15¼ x 20in/40 x 51cm, £400-£500.

HAVELL, Robert II 1793-1878
Prominent engraver of topographical views, and military, sporting, coaching and natural history subjects after his contemporaries as well as his own designs. Born in Reading, he was the son of R. Havell I (q.v.) with whom he collaborated on numerous plates. He lived and worked in London. His most celebrated engravings were the plates for J.J. Audubon's Birds of America. Amongst numerous works are the following:
Pl. for Audubon's Birds of America, 1827-38, 435 pl., elephant fo., prices range widely from £600 for the smallest and least interesting, to £50,000 for the largest and most sought-after subjects (e.g. 'Flamingo' and 'Great Blue Heron', two of the largest and most sought-after subjects); lge. subjects mostly in the four figure range; complete set fetched $3,700,000 April 1992.
'Panoramic View of New York (from the North River)', after Havell and J. Pringle, 1840, 8½ x 32in/22 x 81cm, imp. col. fetched £4,500 April 1990.
'Panorama of London', 1822, 3¼ x 169in/8 x 429cm, £600-£1,200 col.
Pl. for J.B. Fraser's Views of Calcutta, 1824/6, fo., e. £100-£250 col.
'Sketches of Brightelmstone', 1824, 12 pl., 12mo., small value.
'Coaching Scenes During the Severe Winter of 1836/7', after H. Alken, 6 pl., 8¾ x 11½in./22 x 29cm, e. £100-£200 col.
'The Reading and Telegraph Coaches, Meeting Near Salt Hill with a Distant View of Eton and Windsor', 1835, 12½ x 19½in/31.5 x 50cm, £600-£1,100 col.
Colour plates pages 40, 41 and 42.

HAVELL, William 1782-1857
Landscape watercolourist who produced two early lithographs. Born in Reading, he was the son of Luke Havell, a drawing master, the cousin of D. Havell (q.v.) and possibly the nephew of R. Havell I (q.v.).
'Study of Trees and Shrubs with Seated Figure', 1804, 12¼ x 8½in/31 x 22cm, 'Landscape with

HAVELL, William. 'Study of Trees and Shrubs with Seated Figure', 1804.

Trees' and 'Girl Crossing Footbridge', 1804, 12¼ x 9in/31 x 23cm, latter 2 publ. in Specimens of Polyautography, *e. £80-£120; when on original mounts e. £300-£400.*
Man Cat.

HAWARD, Francis, A.R.A. 1759-1797
Engraver, at first in mezzotint, later in line and stipple, of portraits and allegorical subjects after his contemporaries. He was born in London and studied at the R.A. Schools. He was elected Associate Engraver of the R.A. and was appointed Engraver to the Prince of Wales. He died in Lambeth.
'Master Bunbury', after J. Reynolds, 1786, 15 x 11in/38 x 28cm, mezzo., £40-£80.
'H.R.H. George, Prince of Wales', after J. Reynolds, 1793, 17 x 19½in/43 x 49.5cm., stipple, £60-£140.
'Mrs. Siddons as the Tragic Muse', after J. Reynolds, 1787, 19¾ x 16in/50 x 40.5cm, line, £50-£80.
'Charles, 2nd Earl Cornwallis', after D. Gardner, 1784, 5¾ x 4½in/14.5 x 11.5cm., stipple, small value.
 CS lists 3 pl.

HAWKESWORTH, John fl. mid-19th century
Line engraver of small bookplates including architectural outlines and plans and portraits after his contemporaries.
Small value.

HAWKINS, Benjamin Waterhouse
 fl. mid-19th century
Lithographer of portraits and figure and animal subjects after his contemporaries.
Pl. for Lieut. R.F. Burton's Falconry in the Valley of the Indus, *1852, 8vo., e. small value.*
Pl. for G.F. Angas' South Australia Illustrated, *1846/7, fo., e. £100-£200 col. (set col. fetched £14,000 Oct. 1988), and for* The New Zealanders Illustrated, *1846/7, fo., e. £40-£70 col.*
Animals at Knowsley and small portraits small value.

HAWKINS, George I fl. early 19th century
Aquatint engraver of architectural and

HAWARD, Francis. 'H.R.H. George, Prince of Wales', after J. Reynolds, 1793.

HAWKINS, George I. 'The Royal Military Academy', pair with 'The Artillery Barracks, Woolwich', both after R.W. Lucas, 1821.

topographical views after his contemporaries.
Views of Rugby School, approx. 10 x 12in/25.5 x 30.5cm, e. £40-£90 col.
Views of 'The Artillery Barracks' and 'The Royal Military Academy, Woolwich', after R.W. Lucas, 1821, fo., pair £200-£400 col.

HAWKINS, George II 1809-1852
Draughtsman and lithographer of architectural and topographical views and marine and engineering subjects after his own designs and those of his contemporaries. He worked for Day & Son, and died in Camden Town.

HAWKINS, George II. 'Bath from Beacon Hill', pair with 'Bath from Beechey Hill', both after J. Syer.

'The Britannia Tubular Bridge over the Menai Straits', 1850, 17½ x 24½in/44.5 x 62.5cm, £200-£300 prd. in col.
'H.M.S. Pandora, Falmouth Packet', after N.M. Condy, 1843, 13¼ x 16in/33.5 x 40.5cm, £250-£400 col.
2 views of Scarborough, 1 after H.B. Carter, 1 after W. R. Beverley, 1845, 11½ x 13¼in/29 x 35cm., tt. pl., pair £150-£250.
'South West of Canterbury Cathedral', after L.L. Raze, 1844, 20¼ x 25¼in/51.5 x 64.5cm, tt. pl., £80-£140.
'Building for the Great Exhibition', 1851, London, 18¼ x 43½in/46.5 x 111cm, tt. pl., £300-£400.
'Bath from Beechey Hill' and 'Bath from Beacon Hill', after J. Syer, 11½ x 16¼in/29 x 42.5cm, tt. pl., pair £200-£300 col.
Pl. for H. Bowman and J.S. Crowther's Churches of the Middle Ages, *1850, fo., tt. pl., small value.*
Pl. for W. Richardson's Monastic Ruins of Yorkshire, *1843, tt. pl., e. £240-£80 col.*
Pl. for P.J. Naftel's Sketches in Guernsey, *obl. fo., tt. pl., e. £50-£100.*
Pl. for F. Egerton's Views in Palestine and Lebanon, *c. 1845, obl. fo., 13 tt pl., e. £50-£100 col.*

HAY, Alexander fl. early/mid-19th century
Scottish mezzotint engraver of portraits after his contemporaries and Old Master painters.
'James Law', after H. Raeburn, 11¼ x 9¼in/28.5 x 23.5cm, £8-£15.
'Frances, Countess of Mar', after G. Kneller, 5½ x 4½in/14 x 11.5cm, £3-£6.

HAY, Frederick Rudolph b.1784
Line engraver of small bookplates including landscapes and topographical views after his contemporaries.
Small value.

HAY, James Hamilton 1874-1916
Painter and etcher of landscapes. He lived in Liverpool and later in London.
£15-£40.
Bibl: Marriott, C., 'The Drypoints of J.H.H.', *P.C.Q.*, 1927, XIV.

HAYDON, Benjamin Robert
 fl. late 19th century
Painter who made the following etching and lithographed a few large heads from his picture of the Reform Banquet.
'Christina Rossetti', 10 x 7in/25.4 x 18cm, £10-£30.
Litho. £10-£20.

HAYES, Gertrude Ellen, A.R.E. 1872-1956
Painter and etcher of architectural views. Born in London, she studied at the R.C.A. and lived in Kenilworth and later in Nottingham.
£15-£40.

HAYES, William fl. late 18th century
Draughtsman and etcher of ornithological subjects. He worked in the Menagerie at Osterley, Middlesex. He coloured his plates himself.
'Portraits of Rare and Curious Birds with their Descriptions from the Menagerie of Osterley Park', 11¼ x 16¼in/30 x 41cm, e. £10-£35 col.
Pl. for the Natural History of British Birds, *1775, lge. fo., e. £50-£150 col.*

HAYLLAR, Algernon Victor
 fl. late 19th century
Mezzotint engraver of landscapes and sentimental subjects after his contemporaries. He worked in Oxfordshire.
Small value.

HAYNES, E. Leslie
 fl. late 19th/early 20th century
Mezzotint engraver of portraits and decorative subjects after Old Master and British 18th century painters as well as his contemporaries.
£15-£50 prd. in col.
Others small value.

HAYNES, John fl. mid-18th century
Draughtsman and line engraver of topographical and architectural views. He was born in York.
Pl. for T. Gent's History of Kingston and Hull *and for Drake's* Eboracum, *1736, small value.*
Lge. plan of the City of York, 1748, £80-£160.

HAYNES, Joseph 1760-1829
Etcher of portraits and figure subjects after his contemporaries and early/mid-18th century painters. Born in Shrewsbury, he was a pupil of J.H. Mortimer (q.v.) and etched some of his master's works. He later worked as a drawing master at Shrewsbury and Chester.
Pl. after Mortimer £10-£30.
Pl. after W. Hogarth small value.

HAYNESWORTH, William
 fl. mid-/late 17th century
Line engraver of portraits. He worked in London.
'Richard Cromwell', 8½ x 7in/21.5 x 18cm, £5-£15.
Others small value.

HAYTER, Sir George 1792-1871
Well-known portrait and historical painter who produced a few etchings mainly in the 1820s and taught Queen Victoria and Prince Albert (qq.v.) to etch in 1840.
Self-portrait, 1824, 5½ x 5in/14 x 12.5cm, £70-£140.
Others £20-£60.
Bibl: Alexander, D. 'G.H., A Printmaker of the 1820s,' *Print Quarterly*, 1985, II, pp. 218-229.

HAYTER, John fl. early/mid-19th century
Draughtsman and lithographer.
'Carl Maria von Weber Leading at Covent Garden Theatre in . . . Der Freischutz', 1826, £20-£40.
'Sketches of Mme. Pasta', 1827, fo., e. £10-£25.

HAYTER, John. 'Carl Maria von Weber Leading at Covent Garden Theatre in his Celebrated Opera of *Der Freischutz*', 1826.

HEATH, Charles. 'Hercules Slaying the Hydra', after R.L. West, lithograph.

HAZARD, James 1748-1787
Amateur etcher who died in Brussels where he had published his *Recueils de Dessins de Différentes Ecoles, Fidèlement Gravées par M. Hazard.*
Small value.

HEARNE, Thomas 1744-1817
Topographical draughtsman. Born near Malmesbury, he was apprenticed to W. Woollett (q.v.) and assisted him in many of his works. After leaving Woollett, however, he gave up engraving to concentrate on producing drawings to be engraved by others, especially W. Byrne (q.v.). He did one lithograph for *Specimens of Polyautography.*
'Old Tree, a Castle in the Distance on the Right', publ. in Specimens of Polyautography, *1803, 8½ x 11½in/21.5 x 29cm, £200-£300; on original mount £500-£800.*
Man Cat.

HEATH, Charles 1758-1848
Line engraver of landscapes, topographical views, portraits and decorative and military subjects after his contemporaries as well as Old Master painters. He was the illegitimate son and pupil of J. Heath (q.v.) and specialised in small book illustrations, in particular plates for the Annuals, starting his own, *The Keepsake*, in 1827. He ran a workshop, employing a number of assistants, though all the plates had his name on them. He also produced some early lithographs after his own designs and those of his contemporaries.
Lithographs:
'Hercules Slaying the Hydra', after R.L. West, 9½ x 5½in/24 x 14cm, £300-£500.
'Head of an Oriental Wearing a Turban', after J.H. Mortimer, 10½ x 8in/26.5 x 20cm, £300-£500.
'Apollo as a Warrior', 1804, 12½ x 9¼in/32 x 23.5cm, £250-£350; on original mount £400-£600.
Engravings:
Pl. for H.L. Eveque's Campaign of the British Army in Portugal, *1812/5, 15½ x 21½in/39.5 x 54.5cm, eng., e. £30-£80.*
'View of the Thames from Richmond Hill', 1823, 17½ x 24in/44.5 x 61cm, £100-£200.
'Puck', after S. Reynolds, 1827, 10¼ x 14½in/27.5 x 37cm, £20-£50.
Pl. for J.M.W. Turner's Picturesque Views in England and Wales, *1827-38, e. £8-£15.*
Other small bookplates and portraits small value.
Man Cat.

HEATH, Frederick Augustus 1810-1878
Line engraver of small bookplates, including portraits, historical and decorative subjects after his contemporaries. He was a son of C. Heath (q.v.) and worked in his father's workshop. He engraved the design for the first postage stamp, the penny black, in 1839.
Small value.

HEATH, Henry fl. early 19th century
Draughtsman, etcher and lithographer mainly of caricatures after his own designs. He was the brother of W. Heath (q.v.) whose style he imitated closely. His plates are usually signed HH.
'I'd be a Butterfly. The Wish Granted', £80-£160 col.
'The Impudent Challenge' and 'The Sharp Reply' after J. Pollard, 8¾ x 12in/22 x 30.5cm, pair £70-£140 col.
Caricatures e. £50-£150 col.

HEATH, James 1757-1834
Etcher, line and stipple engraver of portraits, and decorative, military and naval subjects after his contemporaries and Old Master painters. He was born in London, where he died, and was the father of C. Heath (q.v.). He restored W. Hogarth's (q.v.) plates for a further printing in 1822.
'Hogarth Restored', 119 pl., fo., vol. £600-£1,200; individual pl. £8-£20.
'The Death of Major Pierson and the Defeat of the French Troops in the Market Place of St. Heliers', after J.S. Copley, 1796, 22½ x 30½in/57 x 77.5cm, £200-£400.

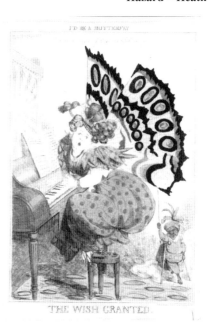

HEATH, Henry. 'I'd be a Butterfly. The Wish Granted'.

'The Death of Lord Viscount Nelson', after B. West, 1811, £100-£150.
'The Riot in Broad Street', after F. Wheatley, 1790, 19 x 24¼in/48 x 61.5cm,, £100-£250.
'Archery', after J. Slater, 1789, 17 x 23¾in/43 x 60.5cm, £300-£600.
'Gen. Washington', after Stuart, 1800, 19 x 13in/148 x 33cm, £200-£300.
Bookplates and small portraits small value.

HEATH, R.H. fl. early 19th century
Engraver of decorative subjects after his contemporaries.
'The Disabled Soldier', after G. Morland, 1806, 12½ x 9¼in/32 x 23.5cm, £80-£100 prd. in col.

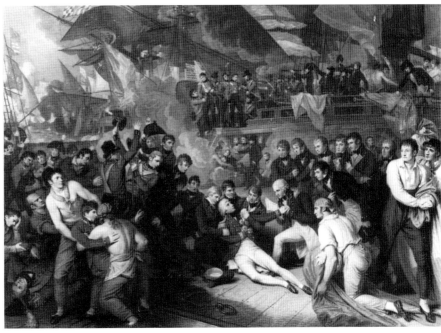

HEATH, James. 'The Death of Lord Viscount Nelson', after B. West, 1811.

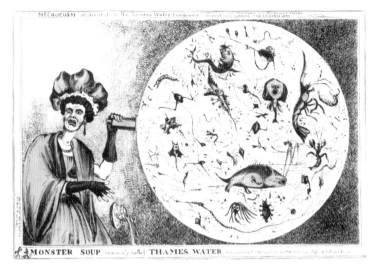

HEATH, William. 'Monster Soup commonly called Thames Water', signed in the plate with the figure of Paul Pry (lower left corner).

HEATH, William 1795-1840
Draughtsman, etcher and lithographer of caricatures and military subjects mainly after his own designs. He was the brother of H. Heath (q.v.). Many of his prints were signed with the figure of Paul Pry, a popular stage character of the day, but as this was constantly plagiarised he reverted to his own name.
'The Battle of Waterloo', etched by W.H., aq. by R. Reeve, 1817, 16¼ x 22in/42.5 x 55.5cm, £140-£200 col.
'The Wars of Wellington', 1819, 30 pl. etched by W.H., aq. by J.C. Stadler, 4to., £10-£25 col.

'Military Costume of the British Cavalry', 1820, 10 x 8in/25.5 x 20cm, 18 aq., e. £60-£80 col.
'Foreign Military Costume', 1823, 10¼ x 13½in/26 x 34.5cm, etchings, e. £10-£25 col.
'British Royal Artillery', c.1840, 9 x 14½in/23 x 37cm, 4 litho., e. £80-£120 col.
'Lumps of Pudding', after H.W. Bunbury, 1811, 13¾ x 97in/35 x 246.5cm, £200-£300.
'Butter Cups and Daisies: A Sketch from Low Life', and 'Pinks and Tulips: A Sketch from High Life', drawn and etched by Heath, aq. by J. Gleadah (q.v.), 1822, 4¾ x 16½in/12 x 42cm,

pair £150-£250 col.
'Sporting in the Scottish Isles', 1835, 4 pl., 9 x 12½in/23 x 32cm, set £500-£900 col.
'Monster Soup . . . ', £100-£200 col.
Other caricatures, depending on subject, mainly £80-£250 col.

HEAVISIDE, T. fl. mid-19th century
Wood engraver of small bookplates and vignettes including portraits after his contemporaries.
Small value.

HECKEL, August fl. late 18th century
German draughtsman and etcher of topographical views.
Views in Kew, Richmond and Twickenham, 1770, 6 x 9½in/15.5 x 24cm, e. £20-£40.

HEIDELOFF, Nicolaus Innocentius Wilhelm von 1761-1837
German draughtsman and aquatint engraver who worked in Paris and fled to London after the Revolution. He engraved and published *The Gallery of Fashion*. These costume plates are considered to be the finest of the period.
Pl. for The Gallery of Fashion, 1794-1802, 217pl., 4to., e. £20-£50 col.

HEINS, D. fl. mid-18th century
German painter and mezzotint engraver of portraits. He came to England c.1730 and lived in Norwich where he painted portraits of several members of the corporation.
£20-£50.
CS.

HELLYER, Thomas. One of three plates from 'Battle of the Nile', after Capt. J. Weir, 1800.

HEINS, John Theodore 1732-1771
Miniature and portrait painter, drypoint etcher and engraver of miscellaneous subjects after his own designs and those of his contemporaries. The son of D. Heins (q.v.), he was born in Norwich and died in Chelsea. He etched in the style of T. Worlidge (q.v.).
Small value.

HELLYER, Thomas fl. late 18th/early 19th century
Stipple, line and aquatint engraver of decorative, genre and naval subjects after his contemporaries. Little is known about him, but he collaborated with T. Gaugain (q.v.) on several plates.
'A Boy Mending his Nets' and 'The Little Domestic', after R. Westall, 1802, 24 x 13in/61 x 33cm, stipples, pair £300-£500 prd. in col.
'Diligence and Dissipation', after J. Northcote, 1797, 10 pl. with Gaugain, 18 x 21in/46 x 53.5cm, stipples, e. £10-£20.
'The Stray'd Favourite Restored', after W.R. Bigg, with Gaugain, 1798, 17 x 24½in/43 x 62.5cm, stipples, £500-£700 prd. in col.
'Battle of the Nile', after Capt. J. Weir, 1800, 3 pl., 19 x 28½in/49 x 72.5cm, aq., set £500-£700.

HENDERSON, Charles Cooper 1803-1877
Well-known sporting and coaching painter who produced one set of prints entitled 'Road Scrapings'.
'Road Scrapings', 12 etchings, 8 x 11¼in/20 x 30cm, e. £15-£40.

HENDERSON, J. fl. mid-19th century
Lithographer.
Pl. for J. Hay's Views of Aberdeen, 1840, 6 tt. pl., fo., £15-£35 col.

HENDERSON, William fl. late 19th/early 20th century
Mezzotint engraver of portraits and sentimental subjects after British and French 18th century painters and his contemporaries.
£10-£40.

HENNING, John Jun. fl. mid-19th century
Lithographer.
1 pl. for R.R. McIan's Scottish Clans, 1845-7, fo., £20-£50 col.

HENSHALL, J. fl. mid-19th century
Line engraver of landscapes, architectural views and furniture designs after his contemporaries.
Small value.

HERBERT, John Rogers 1810-90
Historical painter who made a few etchings; he contributed to the publications of the Etching Club.
£5-£15.

HERDMAN, William Gawin 1805-1882
Liverpudlian art master, draughtsman and lithographer of local topographical views.
'Ancient Liverpool', 1843 and 1853, 2 sets both fo., 49 and 48 tt. pl., e. £5-£20.
'Views of Fleetwood on Wyre in the County of Lancaster', 1838, obl. fo., title and 7 pl., set col. fetched £2,800 Oct. 1988.

HERDMAN-SMITH, Robert b.1879
Painter and etcher of architectural views. Born in Liverpool, he lived at Looe, Cornwall.
Mostly £20-£60; but 'The Blue Parakeet' prd. in col., 7 x 5in/17.5 x 12.5cm, £60-£140.

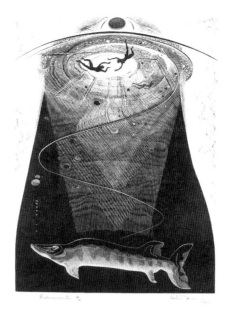
HERMES, Gertrude. 'Undercurrent', 1938.

HERKOMER, Sir Hubert von, R.A., R.W.S., R.E. 1849-1914
Portrait, genre and historical painter, etcher and engraver of genre subjects and portraits after his contemporaries as well as his own designs. Born in Bavaria, he settled in Southampton in 1857 and studied art at the R.C.A. He founded and directed the Herkomer School of Art at Bushey, Hertfordshire., 1883-1904, and was Slade Professor of Art at Oxford, 1885-94. He also wrote on and experimented with printmaking techniques, inventing the 'Herkotype', a combination of monotype and photogravure.
'Benjamin Disraeli, Earl of Beaconsfield', after J.E. Millais, 1881, 23½ x 17½in/60.5 x 44.5cm, imp. signed by artist and engraver fetched £400 May 1987.
Pl. after Millais generally £80-£160.
Portraits of Seymour Haden, Wagner and

HERKOMER, Hubert von. 'The Babes in the Wood'.

Tennyson £30-£80.
'The Babes in the Wood' and others £10-£50.
Bibl: Roeper, A., 'H. v. H. und sein Graphisches Werk', *Der Kunsthandel,* 1909.

HERMES, Gertrude Anna Bertha, R.A., R.E. 1901-1983
Sculptor, wood engraver of figure subjects and landscapes. Born in Kent, she studied at Beckenham School of Art and Leon Underwood's School of Painting and Sculpture. She was married to B. Hughes-Stanton (q.v.) from 1926 to 1933 and they influenced each other's work strongly during this period. She lived in London.
Mostly £80-£250; some small book illustrations, signed proofs, £20-£40.
Ref: Russell., J. *The Wood Engravings of G.H.* 1993, Aldershot.

HERRING, John Frederick Sen. 1795-1865
Eminent sporting and coaching painter who made one lithograph. Many of his paintings were reproduced by professional engravers and lithographers.
'Dunsinane, the Property of His Majesty', 11¼ x 15¼in/30 x 40cm, £150-£300.

HERTOCKS, Abraham fl. mid-17th century
Line engraver of portraits and frontispieces.
Small value.

HERVE, C.S. fl. mid-19th century
Lithographer of portraits after his own designs and those of his contemporaries.
Small value.

HESELTINE, John Postle, R.E. 1843-1929
Amateur etcher of landscapes. Born in Norfolk, he lived in London, where he served as Director of the National Gallery. He collected prints and paintings.
£8-£20.

HESELTINE, W. fl. late 18th/early 19th century
Stipple engraver of decorative subjects after his contemporaries. He was a pupil of M. Bovi (q.v.).
'The Constancy of Portia', after Delaire, 1802, 21½ x 16in/54.5 x 40.5cm, £100-£150 prd. in col.

HESLOP, Arthur 1881-1955
Painter and etcher of marine subjects and landscapes. Born in Newcastle, he studied at Armstrong College there, later becoming Master of Engraving and Design.
£15-£50.

HESS, Charles fl. late-18th century
Stipple engraver of portraits.
'Rubens and his First Wife', after P.P. Rubens, 1797, 26¼ x 18in/66.5 x 46cm, £40-£70.

HESTER, Edward Gilbert c.1843-1903
Line, mezzotint and aquatint engraver of sporting and sentimental subjects after his contemporaries. He worked in London.
Aquatints:
'Punchestown, Conyngham Cup, 1872', after J. Sturgess, 1874, 4 pl., 21¼ x 33¾in/54 x 86cm, set £800-£1,200 col.
'Fores's Hunting Incidents', pl. I-IV after W.B. Hopkins, with H. Papprill (q.v.), 1876-78, 4pl., 20¼ x 27in/51.5 x 68.5cm, set £700-£1,000.
'Dodson's Hunting Incidents', after T.N.H. Walsh, 1878/9, 4 pl., 12 x 17½in/30 x 45cm, set

HESTER, Edward Gibert. 'Scene in Ancient Egypt', after E. Long.

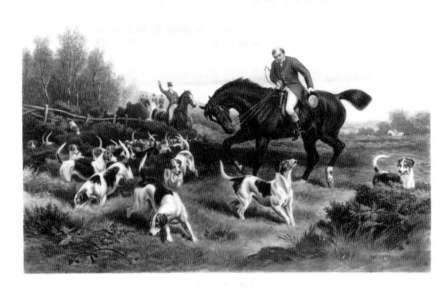

HESTER, Edward Gilbert. One of four plates from 'Fores's Hunting Incidents: A Check', after W.B. Hopkins with H. Papprill, 1876-78.

£300-£500 col.
'First at the Fence' and 'Taking the Lead', after C.B. Barber, 1869/70, 27½ x 20in/70 x 51cm, pair £300-£450 col.
'Shotover', after E. Gilbert, 1882, 15 x 19½in/38 x 50cm, and similar portraits of racehorses after H. Hall, £200-£400 col.
'The British Army', after O. Norie, 1879, 21¼ x 33in/54 x 84cm, £300-£500 col.
Line, mezzotints and mixed-method engravings:
Sporting subjects £80-£250.
'Scene in Ancient Egypt', after E. Long, and other sentimental subjects, £10-£40.
Add more if in fine contemporary frame.

HESTER, E.M. fl. late 19th/early 20th century
Mezzotint and photo-engraver of sporting and sentimental subjects after his contemporaries.
Portraits of racehorses, after A.C. Havell, photo-eng., £50-£100 col.
Others £3-£10.

HESTER, Robert Wallace b.1866
Etcher, aquatint and photo-engraver of sporting and sentimental subjects and portraits and topographical views after his contemporaries as well as 18th century painters. He was the son and pupil of E.G. Hester (q.v.).
Sporting subjects £80-£250.
Views of Oxford colleges and public schools £30-£90.
Others small value.

HEWETSON, J. fl. mid-19th century
Architect and landscape gardener who drew and lithographed views of mansions in Hampshire.
'Mansions in Hampshire', c.1830, 25 pl., fo., e. £10-£30 col.

HEYDEMANN, William fl. late 19th/early 20th century
Etcher of sentimental subjects after his contemporaries.
£10-£30.

HIBBART, William fl. mid-/late18th century
Painter and etcher of small portraits and frontispieces after his own designs and those of his contemporaries. He lived in Bath and etched in a style similar to T. Worlidge (q.v.).
Small value.

HIBBERT, John fl. early 19th century
Etcher and stipple engraver.

'The Prize Ox at the Bath and West of England Society', 1803, 9¼ x 12½in/23.5 x 32cm, £300-£400 prd. in col.

HICKS, Robert fl. early/mid-19th century
Stipple engraver of small portraits after his contemporaries.
Small value.

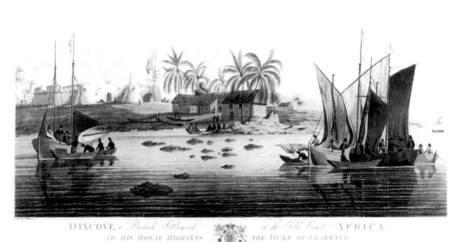

HILL, John. 'Dixcove, A British Settlement on the Gold Coast, Africa', a plate from G. Webster's Views of English and Dutch Settlements on the Gold Coast, 1806.

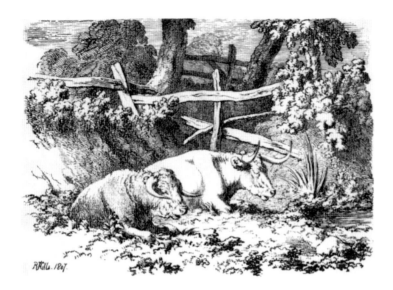

HILLS, Robert. 'Cattle Resting', 1807, lithograph on original mount.

HIGHAM, Thomas 1796-1844
Line engraver of small bookplates including landscapes and architectural views after his contemporaries.
Small value.

HILL, David Octavius, R.S.A. 1802-1870
Landscape painter and celebrated early photographer who produced two sets of lithographs
'Sketches in Perthshire', c.1821, 30 pl., obl. fo., e. £15-£35 col. (set uncol. fetched $1,800 June 1992).
'Views of the Opening of the Glasgow and Garnkirk Railway', 1832, 4 pl., fo., e. £200-£300 col. (uncol. set fetched £1,800 July 1981).

HILL, John 1770-1850
Aquatint engraver of topographical views, costumes and marine subjects after his contemporaries. He worked in London from about 1800 to 1814, and finally emigrated to the United States where he died.
'A View of the Highgate Archway', after A.C. Pugin, 19¼ x 23¾in/50 x 60.5cm, £500-£800 col.
'A View of the Cross of the Black Friars, Hereford', after E. Dayes, 1814, 14¼ x 18¼in/36 x 46.5cm, £80-£140 col.
'Views in Ireland', after T. Walmsley, 1800-1, 9¼ x 11½in/24.5 x 29.5cm, e. £40-£80 col.
'Military Costumes', after J.A. Atkinson, 1807-9, 8½ x 6¼in/21.5 x 16cm, e. £30-£60 col.
Pl. for P.J. de Loutherbourg's Picturesque Scenery of Great Britain *(views of Ramsgate, Margate, etc.), 15½ x 21¼in/39 x 55.5cm, e. £50-£150 col.*
Pl. for W.H. Pyne's Microcosm, *etched for Pyne, aq. by Hill, 1808, 121 pl. in sepia, obl. fo., e. small value.*
Pl. for Microcosm of London, *after T. Rowlandson and A.C. Pugin, 1808-10, 4to., Law Courts £30-£80 col.; others £20-£60 col.*
Pl. for Ackermann's Cambridge, *1814, 4to., e. £20-£60 col.*

Pl. for J. Nattes' Views of Bath, *1806, 28 pl., 11½ x 14½in/29 x 37.5cm, e. £100-£200 col.*
Pl. for W.G. Wall's Hudson River Portfolio, *17¼ x 24¼in/45 x 63cm, e. £2,000-£4,000 col.*
Pl. for G. Webster's Views of English and Dutch Settlements on the Gold Coast, *1806, 4 pl., 17¼ x 22¼in/45 x 56.5cm, e. £200-£300 col. (set col. fetched £1,600 Oct. 1988).*

Pl. for R. Freebairn's Six Select Views in Italy, *1802, fo., e. £80-£120 col.*

HILL, Vernon 1887-1953
Sculptor, etcher and engraver of figure subjects, mostly of an allegorical nature. Born in Halifax, he lived in Hampshire.
'Sweeping Flame', 1929, 13¼ x 6½in/33.5 x 16.5cm etch., £200-£300.
Others mostly £50-£150.

HILLS, Robert 1769-1844
Painter and etcher of animals. Born in Islington, he seems to have taught himself to paint and etch. He was the first Secretary, and later Treasurer, of the Old Water Colour Society. All his plates were etched around the turn of the century and he also produced one early lithograph at this time.
Etchings e. £5-£15.
'Cattle Resting', 1807, 9 x 12½in/23 x 32cm, litho., £150-£250; on original mount £300-£500.
Man Cat.

HIMELY, Sigismund 1801-1872
Swiss aquatint engraver of sporting and coaching subjects after his English contemporaries, and topographical views after his Swiss contemporaries. He was taught engraving by Thales Fielding (q.v.) in Paris. Many of the sporting and coaching plates were copied from aquatints by English engravers. His Swiss views are beyond the scope of this book.
'Royal Mails Starting from the Post Office', after S.J.E. Jones, 14¼ x 17¼in/36 x 44cm, £300-£400 col.
'Stag Hunting', 4 pl., 2 after R.B. Davis, 1 after W.P. Hodges, 1 after D. Wolstenholme, 12¼ x 16¼in/32.5 x 42.5cm, set £800-£1,200 col.
'Shooting', after D. Wolstenholme, 4 pl., 12½ x 15¼in/31.5 x 38.5cm, set £700-£1,200 col.
'Trolling for Pike', after J. Pollard, 1831, 15½ x 18¼in/39 x 46.5cm, £300-£400 col.

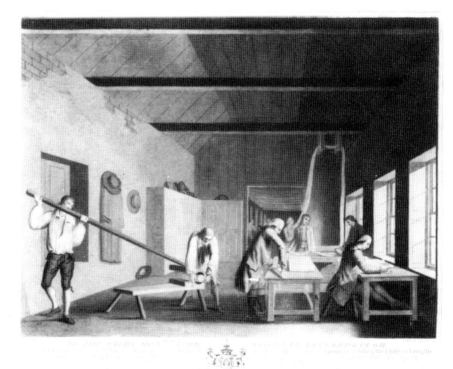

HINCKS, William. One of twelve plates from 'The Irish Linen Industry: A Perspective View of a Lapping Room with the Measuring, Crisping or Folding the Cloth in Lengths', 1783.

HIRST, Norman. A typical portrait.

HINCKS, William fl. late 18th century
Irish painter and stipple engraver of portraits
and genre subjects mainly after his own designs.
Born at Waterford, he was apprenticed to a
blacksmith but taught himself to paint and
engrave. He came to London in the 1780s.
*'The Irish Linen Industry' (his most famous
prints), after his own designs, 1783, 12 pl., 13¼
x 16¼in/33.5 x 41.5cm, set £3,000-£5,000.
Portraits £5-£20.*

HINE, Mrs. Victoria S., A.R.E. 1840-1926
Painter and etcher of landscapes. Born in
Norwich, she was the daughter of S. Colkett
(q.v.) and lived in Suffolk.
Small value.

HIRST, Norman, A.R.E b.1862
Mezzotint engraver of portraits, sentimental
subjects and landscapes after British 18th, 19th
and 20th century painters, as well as
occasionally after his own designs. He lived in
Sussex and Dorset.
£10-£40.

HISLOP, Andrew Healey 1887-1954
Scottish painter and etcher. He lived in
Edinburgh and taught at the College of Art
there.
£10-£30.

HIXON, R. fl. early 19th century
Aquatint engraver and publisher of sporting and
coaching subjects.
*'Sir John' (racehorse), 13 x 16¼in/33 x 41.5cm,
£200-£300 col.
'A Tandem' and 'A Barouche', 1812, 9½ x
16¼in/24 x 41.5cm, pair £250-£350 col.*

HOARE, William, R.A. 1706-1792
Portrait painter who etched a few small plates,
mainly portraits, for his own amusement. He
had a successful practice in Bath.
Small value.

HODGES, Charles Howard 1764-1837
Portrait painter and mezzotint engraver of
portraits, decorative and religious subjects after
his contemporaries. Born in London, he was
probably a pupil of John Raphael Smith (q.v.).
He worked as a print dealer between

Amsterdam and London from 1788, and finally
emigrated to Holland in 1794 where he
remained for the rest of his life engraving many
Dutch portraits.
*'Children Spouting Comedy' and 'Children
Spouting Tragedy', after R.M. Paye, 1790, 17¼
x 21¼in/44 x 55.5cm, pair £300-£500.
'The Shipbuilder' after Rembrandt, 17 x
22in/43.5 x 56cm, £80-£120.
'The Amorous Sportsman', after F. Wheatley,
1786, 17¼ x 21½in/44 x 55cm, £300-£400.
'Mambrino', after G. Stubbs, 1788, 14½ x
18¼in/37 x 46.5cm, £600-£1,200.
'Hebe' (Mrs. Musters), after J. Reynolds, 1785,
23¼ x 14¼in/60.5 x 37.5cm, £250-£400.
'William Wilberforce', after J. Rising, 1792, 20
x 13¾in/51 x 35cm, £100-£200.
Other male WLs £40-£100.
Various female HLs £30-£80.
Various male HLs £15-£40.
CS.*

HODGES, William, R.A. 1744-1797
Painter of landscapes and allegorical subjects,
draughtsman and aquatint engraver of 'Select
Views in India'. Born in London, he was a pupil
of Richard Wilson and was appointed
draughtsman on Captain Cook's second voyage
to the South Seas, 1772-5. He left for India in
1778, returning to England in 1783. He was one
of the first English artists to bring back views of
India. He killed himself after failing in business.
*'Select Views in India', 1785-8, 48 pl., fo., e.
£60-£120 prd. in sepia.
'A View of the Town of Fonchial (sic), the
Capital of Madeira', 1787, 15 x 24in/38 x 61cm,
£300-£400.
'A Dissertation on the Prototypes of
Architecture', with 2 lge. Indian views, drawn
and etched by H., engraved by J. Browne (q.v.),
1787, fetched £650 March 1989.*

HODGETTS, R.M. fl. mid-19th century
Stipple engraver of portraits after his
contemporaries.
Small value.

HODGES, Charles Howard. 'Hebe' (Mrs. Musters),
after J. Reynolds, 1785.

HODGETTS, Thomas fl. early 19th century
Landscape painter and mezzotint engraver of
portraits and landscapes after his
contemporaries. He lived and worked in
London.
*'George IV' and 'Thomas, Lord Lyndoch', both
after T. Lawrence, 1829, both approx. 23¼ x
15¼in/60.5 x 40cm, £50-£90 and £40-£60.
Pl. for J.M.W. Turner's Liber Studiorum £80-
£200.*

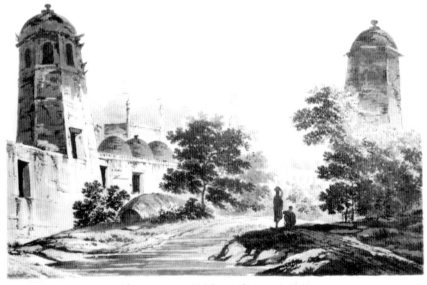

HODGES, William. One of forty-eight plates from 'Select Views in India: A View of the Cuttera built by
Jaffier Cawn at Muxadavad', 1785-8.

HODGKINSON fl. early 19th century
Engraver.
'A View of the British Army on the Peace Establishment in the Year 1803', after C. de Bosse, 1803, 24½ x 19in/62 x 48.5cm, £200-£300 col.

HODGSON, David 1798-1864
Norwich School painter and etcher and lithographer of architectural views after his own designs as well as after his contemporaries. The son of an architectural painter, he was a pupil of J. Crome (q.v.) and taught drawing at Norwich Grammar School.
Various views in and around Norwich £10-£30.

HODGSON, E.S. fl. late 19th century
Etcher of public school views.
Small value.

HODSON, Samuel John, R.W.S. 1836-1908
Painter and lithographer of portraits, architectural views and sentimental and genre subjects after his contemporaries and his own designs. Born in London, he studied at Leigh's Academy and the R.A. Schools. He produced chromolithograph supplements for *The Graphic*.
'The Metropolitan Railway - Interior of King's Cross Station', 20½ x 28¼in/52 x 72cm, and 'Interior of Charing Cross Station', 23 x 31⅓in/58.5 x 80cm, e. £200-£400.
Others small value.

HOFFAY, A. fl. mid-19th century
Lithographer.
Pl. for Lieut. J.E. Alexander's Travels from India to England, 1827, 4to., e. £10-£20 col.

HOGARTH, William 1697-1764
The most important and the best-known English engraver of the 18th century, Hogarth had served an apprenticeship under the silver-plate

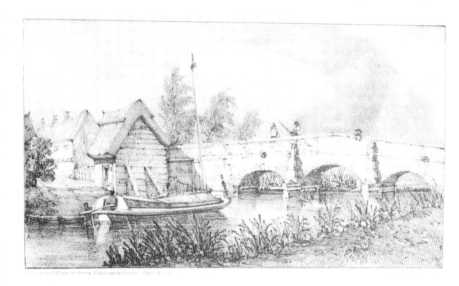

HODGSON, David. 'St. Olaves', one of the artist's views near Norwich, after F. Stone & Son.

engraver Elias Gamble and did not produce his first print, a little engraver's tradecard, until 1720. During the next decade, he engraved several successful satires and his large illustrations to Butler's *Hudibras*, 1725-6, as well as making a considerable reputation painting conversation pieces. It was, however, the exhibition of the six paintings of the 'Harlot's Progress' and the corresponding publication of engravings therefrom which displayed Hogarth's radically different approach to the art of printmaking. He intended to convey the serious moral purpose of his subject to the widest possible audience, as well as to profit himself not only from the sale of the paintings but also, more substantially, from the sale of the prints. Vertue noted that 1,400 or 1,500 sets were subscribed for while the prints were being engraved and that 1,240 sets were printed. They were immediately pirated, prompting Hogarth to agitate for the passing of the Engravers' Copyright Act whereby the copyright of the artist's design was protected for fourteen years.

His next famous series, 'A Rake's Progress', appeared after the enactment of the law in 1735. For 'Marriage-à-la-Mode', 1745, Hogarth employed the French engravers Ravenet, Scotin

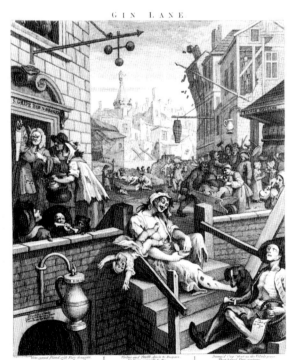

HOGARTH, William. 'Gin Lane', pair with 'Beer Street', 1750-1.

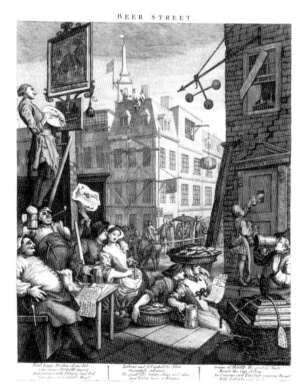

HOGARTH, William. 'Beer Street', pair with 'Gin Lane', 1750-1.

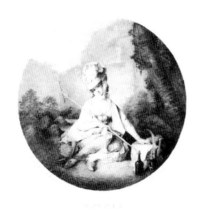

HOGG, Jacob. 'Sophia', after M.W. Peters, 1785.

and Baron (qq.v.) to give these expensive plates intended for an educated audience a delicacy and grace which his own workmanlike but functional style could not. Hogarth executed his last plate, 'Tailpiece', or 'Bathos' in 1764.

After his death, his wife, Jane, who had inherited all the plates, continued to sell prints at the original prices as well as whole collections. When she died in 1789, the plates passed to her cousin, Mary Lewis, who sold them to J. Boydell (q.v.) for a lifetime annuity of £250. Boydell published three editions: 1790, containing 103 plates, another with 107 and the third edition of 1795 with 110. The plates were bought at Boydell's sale in 1818 by the publishers Baldwin, Cradock & Joy and further editions were issued under the title *The Works of William Hogarth, from the Original Plates Restored by James Heath, Esq., R.A.; With the Addition of Many Subjects not before Collected*; they continued to be printed through the century. The enormous number of impressions taken from the plates over a period exceeding one hundred years helps to explain why Hogarth's prints appear to be cheaper today than they should be. Also, unless the prints are found in the original albums, the condition of those which were framed is likely to be poor. The following prices are for good 18th century impressions; fine impressions from early states could be worth two or three times as much.
12 lge. illustrations for Butler's Hudibras, *1725-6, and* Industry and Idleness, *1747, 12 pl., e. set £250-£400.*
'A Harlot's Progress', 1732, 6 pl.; 'A Rake's Progress', 1735, 8 pl.; 'The Four Times of Day', 1738; 'Marriage-à-la-Mode', 1745, 6 pl.; and 4 prints of an election, 1755-58, e. set £600-£1,400.
'Before' and 'After', 1736, 'Beer Street' and 'Gin Lane', 1750-1, e. pair £400-£800.
'The Four Stages of Cruelty', 1750-1, set £200-£300.
Separate pl. and portraits generally £50-£150, but 'Southwark Fair' fetched £1,500 June 1995.
Complete Mrs. Hogarth collection £6,000-£10,000; album of 83 pl. with Auvergne watermarks (mid 18th century) fetched £6,400 April 1989.
Complete Boydell collection £3,000-£5,000.
Complete Hogarth Restored collection £600-£1,200.
See also T. Cook.
Paulson, R: H's Graphic Works. 2 vols., 1989 (3rd rev. ed.)

HOGG, Jacob (James)　　fl. late 18th century
Etcher and stipple engraver of decorative and historical subjects after his contemporaries.
'John Howard, Esq., Visiting and Relieving the Miseries of a Prison', after F. Wheatley, 1790, 18 x 23in/45.5 x 58.5cm, £20-£50.
'Sophia', after Rev. M.W. Peters, 1785, 16 x 14in/40.5 x 35.5cm, £250-£400 prd. in col.
'Henry and Jessy', after F. Wheatley, with F. Jukes (q.v.), 1786, 22½ x 16½in/57 x 42cm, etching and aq., £80-£140 col.
'The Billeted Soldier', and 'Changing Quarters', by G. Graham (q.v.), both after G. Morland, 1791, 13¾ x 10½in/35 x 26.5cm, pair £400-£600 prd. in col.

HOLE, Henry　　d.1820
Wood engraver of small bookplates. He was a pupil of T. Bewick (q.v.) and assisted him on *British Birds*. He lived and worked in Liverpool.
Small value.

HOLE, William Brassey, R.S.A., R.E.
　　　　　　　　　　　　　1846-1917
Scottish painter, and etcher of landscapes and sentimental subjects after early 19th century painters, his contemporaries and his own designs. Born in Salisbury, he lived in Edinburgh. He contributed plates to *The Portfolio*.
Rare signed imp. £10-£30, unsigned small value.

HOLL, Benjamin　　1808-1884
Stipple engraver of portraits after his contemporaries and Old Master painters. The son of W. Holl I (q.v.), he was the brother of C., F. and W(II) Holl (qq.v.).
Small value.

HOLL, Charles　　1820-1882
Stipple engraver of portraits after his contemporaries and Old Master painters. Born in London, the son of W. Holl I (q.v.), he was the brother of B., F. and W(II) Holl (qq.v.).
Small value.

HOLL, Francis, A.R.A.　　1815-1884
Line, stipple and mixed-method engraver of portraits and sentimental and genre subjects after his contemporaries. He was born in Camden Town, London. The son and pupil of W. Holl I (q.v.), he was the brother of B., C. and W(II) Holl (qq.v.) and is probably the best known member of this family of engravers. He was engaged for twenty-five years engraving pictures in Queen Victoria's collection.
'The Coming of Age in the Olden Time', after W.P. Frith, 1852, 24¼ x 36½in/63 x 93cm, £80-£200.
'The Railway Station', 1866, 25½ x 47¼in/64.5 x 121.5cm, £300-£600.
Add more if in fine contemporary frame.
Portraits and bookplates small value.

HOLL, William I　　1771-1838
Stipple engraver of portraits, decorative subjects, statuary, etc. after his contemporaries and Old Master painters. He was the father of B., C., F. and W(II) Holl (qq.v.) and was a pupil of B. Smith (q.v.). He died in London.
'The Boar that Killed Adonis Brought Before Venus', after R. Westall, 1802, 26 x 20in/66 x 51cm, £150-£250 prd. in col.
Portraits and bookplates small value.

HOLL, William II　　1807-1871
Stipple, line and mezzotint engraver of portraits

and sentimental and genre subjects after his contemporaries. Born at Plaistow, Essex, the son and pupil of W. Holl I (q.v.), he was the brother of B., C., and F. Holl (qq.v.).
'Merry Making in the Olden Time', after W.P. Frith, 1849, 21 x 34in/53.5 x 86.5cm, £80-£200.
'Brougham Horse' and 'Cavalry Horse', from British Horses series, after J. Herring, 1860, 15 x 11in/38 x 28cm, e. £100-£200.
'Garibaldi', after T.J. Barker, 1862, 33¾ x 23¾in/86 x 60.5cm, £80-£200.
Add more if in fine contemporary frame.
Small portraits and bookplates small value.

HOLLAND, W.T.　　fl. mid-19th century
Mezzotint engraver of portraits and sentimental subjects after his contemporaries.
'Sir Richard Sutton', after J. Reynolds, 4¼ x 4in/12 x 10cm, small value.
'Resignation', after T. Brooks, 1804, 17½ x 24in/44.5 x 61cm, and other lge. pl., £30-£80.
Add more if in fine contemporary frame.

HOLLAR, Wenceslaus (Wenzel)　　1607-1677
Important Bohemian etcher of portraits, architectural and topographical views and decorative and natural history subjects after his own designs and those of his contemporaries. Born in Prague, he worked mainly in Germany before coming to England in 1636 with Thomas Howard, Earl of Arundel, for whom he worked, etching plates of the latter's art and natural history collections. As a Royalist, he was in exile in Antwerp from 1644 to 1652, continuing to etch plates from sketches he had made in England. When he returned, he worked for publishers who exploited his talents mercilessly until his death in penury.
His contribution to British art is twofold: firstly as the major topographical draughtsman of his day (he was appointed Scenographus Regius by Charles II in 1666) his influence was widespread. Second, his neat and precise etching style has been admired by practitioners of the medium and collectors right up to the present day.
Pl. for F. Barlow's Severall Wayes of Hunting,

HOLLAR, Wenceslaus. 'The Seasons: Summer'.

HOLLAR, Wenceslaus. One of four plates from 'English Views: Tothill Fields'.

Hawking and Fishing, *1671, 12 pl., 7 x 9in/18 x 23cm, e. £30-£60.*
'*. . . Prospect of the Famous City of London . . . before the Fire' and 'Another Prospect . . . after the . . . Destruction by Fire', 1666, on one plate, 9 x 26in/23 x 66.5cm, £500-£1,000.*
'*Westminster from the River', 'Lambeth Palace from the River', 'Whitehall from the River' and 'Westminster Hall', second (final) state, set £800-£1,200.*
'*English Views', 4 pl., 3¾ x 6½in/9.5 x 17cm, set of good to fine imp. in good condition £400-£600.*
'*The Seasons', 10¼ x 7in/ 26 x 18cm, second (final) state, 4 pl., set of good imp. in good condition £1,000-£1,500.*
'*A Stag Lying', after A. Dürer, second (final) state, £80-£120.*
'*The Chalice' £300-£400.*
'*A Group of Muffs and Articles of Dress on a Table' £1,500-£3,000.*
'*Muscarum Scarabe, Vermiumque Variæ Figuræ . . .' (Flies, Beetles, Worms, etc.), set of 12 fetched £8,000 Dec. 1994.*
32 etchings of 'Shells' fetched £36,000 Nov. 1989.
Hind. A.M., *W.H. and His Views of London and Windsor in the 17th Century*, London, 1922; Parthey, G., *W.H.: Beschreibendes/Verzeichniss Seiner Kupferstiche*, Berlin, 1853, reprint Amsterdam, 1963; Pennington, R., *A Descriptive Catalogue of the Etched Work of W.H. 1607-77*, Cambridge University Press, 1982.

HOLLINGS, J.F. fl. mid-19th century
Lithographer of topographical views after his contemporaries.
'*Sketches in Leicestershire', 1842, fo., 24 tt. pl., e. £6-£12.*

HOLLINS, Thomas fl. early 19th century
Draughtsman and etcher of 'A View of the High Street, Birmingham'. He was probably related to the Birmingham artists, William and John Hollins.
'*A View of the High Street, Birmingham', aq. by J.C. Stadler (q.v.), 23 x 31½in/58.5 x 80cm, £600-£1,200 col.*

HOLLIS, George 1793-1842
Etcher, stipple and line engraver of landscapes and topographical views mainly after his own designs. Born in Oxford, he was a pupil of G. Cooke (q.v.) whose style he imitated.

'*St. Mark's Square, Venice: Juliet and Her Nurse', after J.M.W. Turner, 1842, 16½ x 22¼in/42 x 56.5cm, £200-£300, add more if in fine contemporary frame.*
Illustrations of Oxford, after various artists, 1835/9, e. £20-£50.
Pl. for H. de Cort's Six Views in Chudleigh, 1818, fo., e. £5-£10.
Portraits and small bookplates small value.

HOLLIS, Thomas 1818-1843
Stipple and line engraver mainly of small portraits after Old Master painters and his contemporaries. Born at Walworth in London, he was the son of G. Hollis (q.v.).
Small value.

HOLLIS, W. fl. mid-19th century
Stipple engraver of small portraits after his contemporaries and Old Master painters.
Small value.

HOLLOWAY, Charles Edward 1838-1897
Painter and etcher of landscapes and marine subjects after his own designs and those of his contemporaries and early 19th century painters. Born at Christchurch, Hampshire, he studied in London at Leigh's School. He died in London.
£10-£30.

HOLLOWAY, Edgar b.1914
Painter and etcher of portraits and figure subjects. He studied at the Slade and lives in Sussex.
Self-portrait, edn. 50, 10 x 12in/25 x 30cm, £150-£250.
Others mostly £30-£100.

HOLLOWAY, Thomas 1748-1827
Line engraver of portraits and figure subjects after his contemporaries and Old Master painters. Born in London, he was apprenticed to a seal engraver, studied at the R.A., and then worked mainly as an engraver of small bookplates. He was appointed Historical Engraver to George III. He died in Norwich.
Mostly small value, but 2 mezzo. portraits e. £15-£50.
CS lists 2 portraits, noted above.

HOLLYER, Christopher C. fl. mid-late 19th century
Mezzotint engraver of animal and sentimental

subjects after his contemporaries.
'*The Sheep Farm', after T.S. Cooper, 1872, 20 x 34in/51 x 86.5cm, £60-£140.*
'*A Brown Study' (donkey), after W. Huggins, 1872, 20 x 16in/51 x 40.5cm, £30-£80.*
'*Alexander and Diogenes', after E. Landseer, 1873, 13½ x 17½in/34.5 x 45cm, £40-£100.*
Add more if in fine contemporary frame.

HOLLYER, Frederick fl. mid-/late 19th century
Mezzotint engraver of sentimental and genre subjects after his contemporaries. He also photographed many important Victorian paintings.
'*The Shepherd's Chief Mourner' and 'The Shepherd's Grave', both after E. Landseer, 1869, 20¼ x 23⅛in/51.5 x 59.5cm, e. £120-£200.*
Add more if in fine contemporary frame.

HOLLYER, Samuel 1826-1919
Line, stipple and mezzotint engraver of portraits, landscapes and genre subjects after his contemporaries.
'*The Keeper's Home', after T. Faed, 1861, 20 x 26½in/51 x 67.5cm, £60-£140.*
Add more if in fine contemporary frame.
Portraits and bookplates small value.

HOLMES, James 1777-1860
Watercolourist and occasional stipple engraver and lithographer of portraits after his contemporaries and his own designs. Trained as an engraver, he became a distinguished watercolour painter and was President of the Society of British Artists in 1829.
'*George IV', after his own painting, eng. £15-£30.*
'*Duke of Clarence', after his own painting, litho. £10-£20.*
Small value.

HOLMES, Sir John Charles, R.W.S. 1868-1936
Painter and etcher of landscapes. He is better known as an art historian. Born in Preston,

HOLROYD, Charles. A typical landscape etching.

HOOK, James Clarke. A contribution to the Etching Club.

Lancashire, he was Slade Professor at Oxford, 1904-10, Director of the National Portrait Gallery, 1909-10, and of the National Gallery, 1916-28.
Small Value.

HOLMES, Kenneth b.1902
Etcher of landscapes and architectural views. Born in Shipton, Yorkshire, he was Principal of Leicester College of Art, 1931-56, and lived in Richmond.
£20-£50.

HOLMES, P. fl. late 17th century
Line engraver of bookplates.
Small value.

HOLROYD, Sir Charles, R.E. 1861-1917
Painter, etcher and occasional lithographer of landscapes, architectural views and figure subjects. Born in Leeds, he studied at the Slade under A. Legros (q.v.) and was influenced by both him and his friend W. Strang (q.v.). He later became Keeper of the Tate Gallery, 1897-1906 and then Director of the National Gallery, 1906-16.
£20-£50.
Bibl: Dodgson, C., 'Sir C.H.'s Etchings', *P.C.Q.*, 1923, X, p.309.

HONE, Nathaniel, R.A. 1717-1784
Irish miniaturist and painter of portraits and decorative subjects, who etched and engraved in mezzotint a few of his own designs. Born in Dublin, he settled in London, after having studied in Italy, and practised as an itinerant portrait painter around England. He was a founder member of the R.A.
'Elisa Gambarini', 1748, 8¼ x 10¾in/21 x 27.5cm, £15-£40.
'Francis Grose and Theo. Forrest as Monks', 1772, 14¼ x 18in/36 x 45.5cm, £60-£120.
'Portrait of the Artist', 14 x 9¾in/35.5 x 25cm, £60-£120.
CS lists 3 pl., noted above.

HOOD, Thomas 1799-1855
Poet, humorist and comic illustrator who

studied engraving under H. Lekeux (q.v.) but later turned to writing and drawing.
Small value.

HOOK, James? 1772-1828
Amateur etcher of a few caricatures executed in his youth. He was later Dean of Worcester, 1825.
£10-£30 col.

HOOK, James Clarke, R.A. 1819-1907
Genre, historical, landscape and coastal scene painter who etched several plates and contributed to the Etching Club.
£10-£30.

HOOPER, John fl. mid-/late 19th century
Wood engraver of book illustrations.
Small value.

HOOPER, Luther 1849-1932
Landscape painter who produced several lithographs and the occasional etching.
Small value.

HOOPER, W.H. fl. mid-/late 19th century
Wood engraver of book illustrations after his contemporaries.
Pl. after Burne-Jones for The Tale of Cupid and Psyche, *e. £60-£140.*
Others small value.

HOPPNER, John, R.A. 1758-1810
Well-known portrait painter who produced a very few prints.
CS lists 2 mezzo.: *'Peasant Girl', 1785, 14 x 10¼in/35.5 x 25.5cm; 'Peasant Boy', 14 x 9in/35.5 x 23cm, e. £60-£120.*
Etchings £15-£40.

HOPWOOD, James I c.1752-1819
Line, stipple and aquatint engraver of portraits, decorative subjects and costume plates after his contemporaries. He took up engraving at the age of forty-five in order to support his large family.
Pl. for A. Robertson's London Volunteers, *13½ x 10¼in/34.5 x 26cm, and smaller, e. £40-£70 col.*
'Uniform of the Artillery Division', after J. Green, aq. by J. Hill, 1804, 13¼ x 11in/35 x 28cm, £100-£160 col.
'The Quadrangular Passion Flower', after P. Henderson, from Thornton's Temple of Flora, *1802, 21¼ x 16in/55.5 x 41cm, £400-£700 prd. in col.*
Small portraits and bookplates small value.

HOPWOOD, James II b.1795
Stipple engraver of small portraits and bookplates after his contemporaries. He was the son of J. Hopwood I (q.v.).
Small value.

HOPPNER, John. One of the artist's few etchings.

HOPWOOD, William 1784-1853
Painter, illustrator, stipple and line engraver of small portraits after his contemporaries.
Small value.

HORNER, John fl. mid-19th century
Draughtsman and lithographer of Halifax views. He was probably a native of the town.
'Buildings in Halifax', 1835, 20 pl., obl. fo., e. £15-£30.
'View of Halifax from the South East', 1822, 12½ x 18 1/4in/32 x 46.5cm, £60-£100.

HORSBURGH, John 1791-1869
Scottish line engraver of small bookplates, including portraits, historical subjects, landscape and topographical views after his contemporaries. Born at Prestonpans, he was a pupil of R. Scott (q.v.). Later in life he worked as a pastor in the Scottish Baptist Church. He died in Edinburgh.
Small value.

HORSLEY, John Callcott, R.A. 1817-1903
Victorian painter who contributed etchings to the Etching Club.
£10-£30.

HOUBRAKEN, Jacobus 1698-1780
Dutch line engraver mainly of portraits after his contemporaries and Old Master painters. He is mentioned here for the following series published by A. Pond and C. Knapton (qq.v.):
'The Heads of the Illustrious Persons of Great Britain', 1743-52, fo., e. £10-£20.
Bibl: Ver Huell, A., *J.H. et Son Oeuvre,* Arnhem, 1875 and 1877.

HOUGHTON, Richard fl. late 18th century
Line engraver of genre subjects after his contemporaries.
'The Politicians', after E. Penny, 1794.
'I Saw a Smith With His Hammer Thus', after E. Penny, 1771, e. £10-£20.

HOUSTON, George, R.S.A., R.S.W.
 1869-1947
Scottish painter and etcher of landscapes. He was born in Ayrshire and lived and worked in Scotland.
£10-£30.

HOUSTON, Richard 1721-1775
Irish mezzotint engraver of portraits, decorative and sporting subjects after his contemporaries and Old Master painters. He studied in Dublin under J. Brooks (q.v.) and then settled in London, establishing himself at Charing Cross. He was apparently a dissipated character and was confined to the Fleet Prison for many years by the publisher R. Sayer (q.v.), who had advanced him money. He was released in 1760 on the accession of George III. He died in London.
'Lion and Lioness', after G. Stubbs, 1773, 14 x 19in/35.5 x 48.5cm, £800-£1,600.
'Portraits of Celebrated Racehorses', after J. Seymour and T. Spencer, enclosed within decorative cartouches, 1755-6, 12 pl., 11½ x 13½in/29 x 34.5cm, e. £150-£300.
'Warter' (racehorse), after J.N. Sartorius, 9¼ x 13½in/23.5 x 34.5cm, £120-£220.
'A Race Over the Beacon Course at Newmarket', after F. Sartorius, 9¼ x 14in/25 x 35.5cm, £250-£350.
'Miss Powell', after C. Read, 1769, 19½ x 14½in/49.5 x 36.5cm, £60-£100.
'Harriet Powell as Leonora', after J. Reynolds,

HORNER, John. One of twenty plates from 'Buildings in Halifax: Old Building in the Wool Shops', 1835.

OLD BUILDING in THE WOOL SHOPS, HALIFAX.
Taken down 1833

1771, 20 x 14in/51 x 35.5cm, £80-£120.
'John, Marquis of Granby', WL, after G. Penn, 1769, 19¾ x 17in/50 x 43cm, £80-£120.
'Mary, Duchess of Ancaster', HL, after J. Reynolds, 1756, 13 x 9in/33 x 23cm, £20-£50.
'Queen Charlotte', after J. Zoffany, 1772, 21 x 15½in/53.5 x 40cm, £80-£140.
'Catherine Wodhull', after J. Zoffany, 1772, 19¼ x 14in/50 x 35.5cm, £200-£300.
'The Death of Wolfe', after E. Penny, 1772, 17 x 19½in/43 x 50cm, £300-£500.
Various male TQLs £20-£80.
Various male HLs £15-£40.
'The Five Senses', after F. Hayman, 1753, 13¼ x 9½in/135 x 25cm, set £600-£1,200.
'The Four Elements', after P. Mercier, 1756, 13¾ x 10in/35 x 25.5cm, set £500-£800.
Domestic subjects after P. Mercier, etc., ave. 13¾ x 9½in/35 x 25cm, e. £60-£140.
CS.

HOUSTON, Robert, R.S.W. b.1891
Scottish landscape painter who engraved an aquatint after J.L. Agasse.
'The Last Stage on the Portsmouth Road', after J.L. Agasse, 1930, 16¼ x 21½in/41 x 55.5cm, £60-£120 prd. in col.

HOW, J. fl. mid-19th century
Line engraver of small bookplates including landscapes and topographical views after his contemporaries.
Pl. for Tombleson's Views on the Rhine, 1832, and other German views, e. £5-£10.
Others small value.

HOW, R. fl. mid-18th century
Mezzotint engraver.
'Bay Malton Beating King Herod, Turf and Askham', after F. Sartorius, 1769, 13¼ x 17½in/33.5 x 45cm, £200-£400.

HOWARD, Frank fl. mid-19th century

Lithographer.
Pl. for Capt. W.C. Harris' Portraits of the Game and Wild Animals of Southern Africa, 1840-2, fo., 30 pl., £100-£200 col.

HOWARD, T. fl. mid-19th century
Line engraver of small bookplates including landscapes and architectural views after his contemporaries.
Pl. for Tombleson's Views on the Rhine, 1832, and other German views e. £5-£10.
Others small value.

HOWARD, William fl. late 17th century
Line engraver. He was a pupil of W. Hollar (q.v.).
Small value.

HOWARTH, Albany E., A.R.E. 1872-1936
Watercolourist, etcher and drypoint etcher of landscapes and architectural views. He worked in England and on the Continent and lived in Watford.
£15-£50.
Bibl: Colnaghi, P. and D., and Obach, *Catalogue of Original Etchings, Drypoints and Mezzotints by A.E.H.,* London, 1912.

HOWELL, Samuel fl. mid-19th century
Draughtsman and lithographer.
'Fourteen Lithographic Views of Knaresborough in Yorkshire', c.1838, 14 pl., obl. fo., e. £10-£20.

HOWISON (Howieson), William, A.R.S.A.
 1798-1850
Scottish stipple and line engraver of portraits and genre and sentimental subjects after his contemporaries. Born in Edinburgh, he was apprenticed to A. Wilson. He is best known for his engraving of 'The Curlers', after G. Harvey. He died in Edinburgh.
'The Curlers', after G. Harvey, 11½ x 30in/9 x

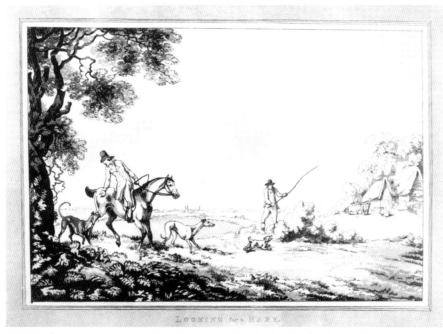

HOWITT, Samuel. One of six plates from 'Shooting and Coursing: Looking for a hare', 1791.

76cm, £80-£200.
'School Scailin', after G. Harvey, 1849, 15¼ x 26½in/40 x 67.5cm, £40-£100.
Add more if in fine contemporary frame.
Small bookplates and portraits small value.

HOWITT, Samuel c.1756-1822
Well-known painter, etcher and aquatint engraver of sporting and animal subjects. He lived and worked in London and was married to the sister of T. Rowlandson (q.v.), by whom he was most influenced. Many of his drawings, including those for the two famous series 'British Field Sports' and 'Oriental Field Sports', were engraved by professional aquatinters such as H. Merke (q.v.).
'Royal Menagerie, Exeter Change, the Strand, London', 1813, 9¾ x 19in/24.5 x 48.5cm, etching and eng., £200-£300.
'Shooting and Coursing', 1791, 6 etchings with aq., set £800-£1,400.
'Fox Hunting', 1794, 6 pl., 10 x 14in/25.5 x 35.5cm, aq., set £1,500-£2,000 col.
'The British Sportsman', 1799/1800, 72 pl., 4to., etchings, e. £10-£20.
'Groups of Animals', 1811, 44pl., 4to., e. £4-£10.

HOWITT, Samuel. A plate from 'The British Sportsman: The Greyhound', 1798-1800.

HOWLETT, Bartholomew 1767-1827
Draughtsman and line engraver of topographical and architectural views after his contemporaries, and antiquarian subjects. Born in Lincolnshire, he was a pupil of J. Heath (q.v.) and died at Newington a poor man.
'Views in the County of Lincoln', after various artists, 1805, 8½ x 11¼in/21.5 x 28.5cm, e. £10-£20.
Pl. for Stothard's Monumental Effigies, 1817, and other antiquarian subjects, small value.

HOYTON, Edward Bouverie b.1900
Etcher and line engraver mainly of landscapes. Born in London, he studied at Goldsmiths' College, London, under M. Osborne and A.C.S. Anderson (qq.v.), and was Principal of the College of Art (1941-65) at Penzance.
£60-£140.

HUARD, L. fl. mid-19th century
Draughtsman and lithographer of military subjects.
'The Battle of Inkermann: The Brigade of Guards Under the Duke of Cambridge', 1854, 17½ x 23¼in/44.5 x 59cm, £80-£140 col.
'The Review in the Park at Windsor', 1855, 12 x 18½in/30.5 x 47cm, £60-£100 col.
Music covers e. £3-£10 col.

HUBERT, F fl. early 19th century
Line engraver.
'Battle of Algeciras', after Capt. J. Brenton, 1802, aq. by J.C. Stadler (q.v.), 20½ x 26½in/52 x 67cm, £250-£400 col.

HUDSON, Henry 1765-95
Mezzotint engraver of portraits and decorative and religious subjects after his contemporaries and Old Master painters. He seems to have lived in London.
'The Comforts of Industry' and 'The Miseries of Idleness', after G. Morland, 1790, 12¼ x 15in/31 x 38cm, pair £300-£600 prd. in col.
'David and Bathsheba', after Castelli, £5-£15.
'A Man Rescued from an Alligator', 1786, 20 x 24in/51 x 61cm, £150-£300.
'Sir William Hamilton', WL, after J. Reynolds, 1782, 24¼ x 14¼in/61.5 x 37.5cm, £300-£400.
Various male HLs £15-£50.
CS.

HUFFAM, A.M. (?A.W.) fl. mid-19th century
Mezzotint engraver of portraits after his contemporaries. He was presumably related to T.W. Huffam (q.v.).
£10-£30

HUFFAM, T.W. fl. mid-19th century
Line, mezzotint and aquatint engraver of sporting, genre and sentimental subjects and portraits after his contemporaries and Old Master painters.
'Fox Hunting', after J.F. Herring, 1846, 4 pl., 2 by J.R. Mackrell (q.v.), 21½ x 30in/54.5 x 76cm, aq., set £1,000-£2,000 col.
'The Royal Mail Coach', after J.F. Herring, 1841, 22½ x 30½in/57.5 x 77.5cm, aq., £400-£700 col.
'The Start (Just Off)', after J.A. Fitzgerald, 20¼ x 22¼in/51.5 x 58cm, aq., £60-£100 col.
'The Travelled Monkey', after E. Landseer, 1859, 15¼ x 18¼in/38.5 x 46.5cm, line and mezzo., £60-£120.
'The Afternoon's Nap', after J.M. Wright, 1847, 27 x 22in/68.5 x 56cm, mezzo., £40-£100.
Add more if in fine contemporary frame.
Pl. after Old Masters and small portraits small value.

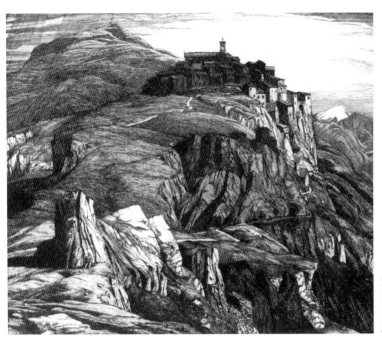

HOYTON, Edward Bouverie. A landscape etching.

1928, 10 pl., edn. 12, set £1,600-£2,000.
'Horizon' v. rare proof impression prd. in cols.,
1935, 13 x 9½in/33 x 24cm, £300-£400.
Others £120-£300.
Bibl: Eustace, K., *The Wood Engravings of
Gertrude Hermes and B.H–S.*, 1995.

HULETT, James d.1771
Line engraver of portraits and historical and
scientific subjects, etc., after his contemporaries
and Old Master painters. He worked in London,
mainly for the booksellers, and died in
Clerkenwell.
Small value.

HULL, Edward fl. early/mid-19th century
Draughtsman, etcher and lithographer of
sporting subjects, military costumes and
caricatures.
'Life of Dick Turpin', 1834, 6 pl., 12¼ x

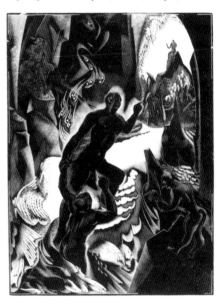

HUGHES-STANTON, Blair Rowlands. One of ten
plates from 'Pilgrim's Progress: The River of Death',
with Gertrude Hermes, 1928.

HUGHES, Hugh (?Henry) 1790-1863
Wood engraver of small bookplates. Born in
Wales, he died at Great Malvern.
Small value.

HUGHES, S.G. 1793-1825
Aquatint engraver of railway subjects and
topographical views after his contemporaries.
'Travelling on the Liverpool and Manchester
Railway', after I. Shaw, 1831, 4 subjects on 2
pl., 9½ x 25½in/24 x 64.5cm, set £600- £1,200
col.
'View of the Intersection Bridge on the Line of
the St. Helens and Runcorn Gap Railway
Crossing the Liverpool and Manchester
Railway' 1832, 13¼ x 19¾in/33.5 x 50cm, £300-
£500 col.
Pl. for T.T. Bury's Coloured Views on the
Liverpool and Manchester Railway, e. £80-
£200 col.

Topographical views: e.g. Ireland e. £20-£50
col.; India e. £10-£25 col.
Colour plate page 43.

HUGHES, William 1793-1825
Wood engraver of small bookplates. Born in
Liverpool, he died in Lambeth.
Small value.

HUGHES-STANTON, Blair Rowlands b.1902
Wood engraver of figure subjects and abstract
compositions. Born in London, the son of the
painter Sir Herbert Hughes- Stanton, he studied
at the Byam Shaw, R.A. and Leon Underwood's
Schools. He was married to G. Hermes (q.v.)
from 1926 to 1933 and they influenced each
other's work strongly at this period. He lived in
London and later in Essex, and illustrated a
number of private press and other books.
'Pilgrim's Progress', with Gertrude Hermes,

15¼in/31 x 38.5cm, litho., set £300-£500 col.
'Coursing, Hampton Court Park', 2 pl., 9 x
12½in/23 x 32.5cm, litho., pair £250-£350 col.
'Cavalry Costumes', 1817, 4 pl. 12 x 8½in/30.5
x 21.5cm, etchings, e. £60-£100 col.
'A Fit of the Blues, or the Turn of Christmas'
(caricature), 1834, 5¾ x 7in/14.5 x 18cm, £10-
£25 col.
'Tilbury Fort, The Time o' Day, 1820, 11¼ x
15¼in/30 x 40cm. litho., e. £70-£100 col.
'Foxhunting', 1823, 8 pl., 13½ x 18¼in/34.5 x
46.5cm, litho., set £1,000-£1,600 col.
'Foxhunting at Melton Mowbray', 1835, 6 pl.,
9¾ x 11¼in/25 x 28.5cm, litho., set £600- £1,000
col.
'Sir Henry Dymoke', after A. Cooper, litho., £8-£15.

HULLAND, William T. fl. mid-19th century
Mixed-method engraver of sentimental subjects
and portraits after his contemporaries and
British 18th century painters.
'The Roll Call', after Elizabeth Thompson
(Lady Butler), 1882, 15 x 30in/38 x 76cm, £120-
£250, add more if in fine contemporary frame.
Small portraits and pl. for The Art Journal *small
value.*

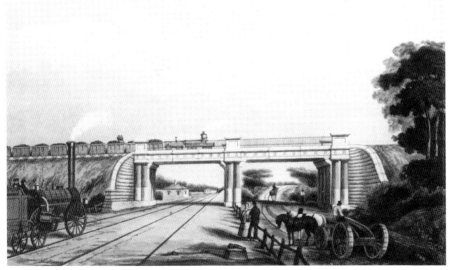

HUGHES, S.G. 'View of the Intersection Bridge on the Line of the St. Helens and Runcorn Gap Railway…',
1832.

HULLMANDEL, Charles Joseph. 'Les Rochers, from the Mail', a typical landscape.

HULLMANDEL, Charles Joseph 1789-1850
Draughtsman and lithographer of landscapes and topographical views after his own designs and those of his contemporaries. Born in London, the son of a German musician, he was one of the first practising lithographers in England, producing his first plate in 1818. He is, however, best known as a printer of lithographs. He decided to learn how to print on stone when he discovered in 1818 that the existing firm of printers was not up to the task of printing his lithographic sketches of Italy. Soon he was doing work not only for the best English artists such as J. Ward and W. Westall, but also for Continental painters. Géricault's famous 'English Series' was printed on Hullmandel's press. Hullmandel is also credited with most of the major developments in the medium over the next twenty years, including the 'brush style' in 1831, the 'stump style' and the 'tinted style' in 1835, and finally the 'lithotint' process in 1841.
'Les Rochers, from the Mail', £15-£35.
'Twenty-four Views of Italy', 1818, obl. 4to., e. £12-£25.
Pl. for Britannia Depicta, *1822/3: Kent, obl. fo., e. £30-£60*
Pl. for Major J. Cockburn's Views to Illustrate the Route of Mont Cenis, *1822, 50 pl., fo., e. £12-£25.*

HULME, Frederick William 1816-1884
Figure and landscape painter who lithographed some architectural and topographical views after his contemporaries.
Pl. for S.C. Hall's Baronial Halls, *1848, fo., small value.*
1 pl. for G.F. Angas' Views of the Gold Regions of Australia, *1851, fo., £100-£200 col.*

HUMBLE, T. fl. early 19th century
Line engraver of small portraits.
Small value.

HUMPHREY, William c.1740-c.1810
Mezzotint engraver of portraits, decorative subjects and caricatures after his contemporaries and Old Master painters. He was also a publisher and printseller.
'Modern Head-dress, or Folly of 1772', 13¼ x 9½in/35 x 24.5cm, and other caricatures, £200-£300.
'Temptation', after G. Morland, 1790, 20 x 13¾in/50.5 x 35cm, £150-£250.
'Abelard and Eloisa', after R. Cosway, 1774, 9 x 7in/23 x 18cm, £40-£70.
'Man with Books', after Rembrandt, 1765, 14 x 10in/35.5 x 25.5cm, £10-£25.
'Mme. du Barry', after B. Wilson, 1770, 15½ x 10¾in/39.5 x 27.5cm, £120-£180.
Various male HLs £15-£40.
CS.

HUMPHRYS (Humphreys), William
1794-1865
Irish line engraver of portraits and sporting and sentimental subjects after his contemporaries and Old Master painters. Born in Dublin, he originally worked in America engraving bank notes and stamps as well as small bookplates. He then worked in England from about 1822, producing plates mainly for the Annuals as well as a few stamps and some larger plates before returning to America in 1843.
'The Meet at Melton', after F. Grant, 17 x 28½in/43 x 72.5cm, £300-£500, add more if in fine contemporary frame.
Small bookplates and pl. for the Annuals small value.

HUNSLEY, William fl. mid-19th century
Draughtsman and lithographer of Indian military costumes and topographical views. He worked for the East India Company as a draughtsman in Madras where his plates were printed and published.
'Costumes of the Madras Army', 1841, 40 pl., 14 x 10in/35.5 x 25.5cm, e. £30-£80 col.
'Church, Main Guard and Artillery Barracks, St. Thomas' Mount, from the Parade Ground, Madras', 16½ x 9½in/42 x 25cm, £80-£160 col.

HUNT, Charles I b.1806
Eminent aquatint engraver of sporting, transport and animal subjects and topographical views after his contemporaries and his own designs. The father of C. Hunt II (q.v.) he was possibly a brother of G. Hunt (q.v.) with whom he collaborated on several plates early in his career. He lived and worked in London engraving after all the best-known sporting artists of the day.
St. Leger and Derby winners, after J.F. Herring and later H. Hall, ave. 15 x 20in/38 x 51cm, e. £400-£800 col.
'Fox Hunting', 4 lge. pl., set £1,000-£1,500 col.
'The Young English Fox Hunter', after F.C. Turner, 1841, 4 pl., 15¾ x 23¾in/40 x 60.5cm, set £1,000-£1,600 col.
'Grand Stand Ascot', after J.F. Herring, 1839, 27½ x 31½in/70 x 80.5cm, £800-£1,200 col.
'Newton Races', after C. Towne, 1832, 23½ x 31½in/59.5 x 80cm, £800-£1,200 col.

HUNT, Charles I. One of six plates from 'Epsom: Saddling in the Warren', after J. Pollard, 1836.

HUNT, Charles I. One of six plates from 'Epsom: The Race Over', after J. Pollard, 1836.

'Epsom Races', after J. Pollard, 1834, 2 pl. with R.W. Smart (q.v.), 14 x 24½in/35.5 x 62.5cm, pair £1,000-£1,600 col.
'Epsom', after J. Pollard, 1836, 6 pl., 11¾ x 18¼in/30 x 46.5cm, set £4,000-£6,000 col.
'St. Alban's Grand Steeple Chase', after J. Pollard, 1832, 6 pl., 3 with G. Hunt (q.v.), 3 by H. Pyall and C. Bentley (qq.v.), 11¼ x 16½in/30 x 42cm, set £2,500-£4,000 col.
'The Last Grand Steeplechase at the Hippodrome, Kensington', after S.H. Alken, 15½ x 22in/39.5 x 56cm, set £1,600-£2,600 col.
'H.M. Steam Frigate Geyser off Mt. Edgecumbe', after W.A. Knell, 15½ x 23½in/39.5 x 59.5cm, £400-£600 col.
'Royal Mails Starting from the General Post Office, Lombard Street', after S.J.E. Jones, 1827, 29 x 17in/73.5 x 43cm, £700-£1,000 col.
'The Enterprise Steam Omnibus', after W. Summers, 14½ x 18in/37 x 45.5cm, £600-£900 col.
'Unrivalled Lincolnshire Heifer with Two Extraordinary Sheep', after W. Beetham, 19¼ x 25½in/50 x 64.5cm, £600-£900 col.
'Views of Brighton', after G.B. Campion, 1838, 3 pl., obl. fo., e. £100-£200 col.
Pl. for Lieut. J.H. Caddy's Scenery of the Windward and Leeward Islands, 1837, obl. fo., e. £40-£60 col.
Colour plate page 44.

HUNT, Charles II b.1830
Aquatint engraver of sporting subjects after his own designs and those of his contemporaries. Born in London, he was the son of C. Hunt I (q.v.) with whom he collaborated on many plates.
'McQueen's Steeple Chasing', after B. Herring, 1873, 4 pl. with C. Hunt I, 13½ x 23¼in/34.5 x 59cm, set £600-£1,000 col.
Portraits of racehorses, after and with C. Hunt I, e. £300-£600 col.

HUNT, E.H. fl. late 19th century
Aquatint engraver of sporting subjects after his own designs and those of his contemporaries. He was probably related to G. and C. (I and II) Hunt (qq.v.).

'Dead Heat for the Derby', after R. Powell, 1884, 21¼ x 28¾in/54 x 73cm, £400-£700 col.

HUNT, F.C. fl. early/mid-19th century
Etcher and aquatint engraver of caricatures after his own designs and those of his contemporaries.
'Botheration', 14 x 18in/35.5 x 20.5cm, £60-£100 col.
'An Old Maid's Skull Phrenologised', after E.F. Lambert, 14 x 8in/35.5 x 20.5cm, £120-£180 col.

HUNT, George fl. early/mid-19th century
Eminent aquatint engraver of sporting, transport and military subjects, topographical views and caricatures after his contemporaries. He was possibly a brother of C. Hunt I (q.v.) with whom he collaborated on several plates. He lived and worked in London, engraving many of the most famous sporting and coaching pictures of the day.
'Fores's Coaching Recollections', after C.C. Henderson, 6 pl., 21 x 28½in/53.5 x 72.5cm, set £1,400-£2,000 col.
'Foxhunting' and 'Shooting', after H. Alken, 1823 and 1824, 4 pl. e. set, 13 x 18½in/33 x 47cm, sets respectively £700-£1,200 and £1,000-£1,600 col.
'Fly Fishing' and 'Trolling for Pike', after J. Pollard, 16¼ x 20in/41 x 51cm, pair £2,000-£3,000 col.
'The View of the Worcester Race Course and Grand Stand', drawn and etched by H.B. Ziegler, 1823, 12½ x 22¾in/31.5 x 58cm, £1,000-£2,000 col.
'Stage' and 'Wagon', after M. Egerton, 1824, ave. 9½ x 17¼in/24 x 44cm, pair £200-£400 col.
'Approach to Christmas', after J. Pollard, 14¼ x 20½in/37.5 x 52cm, £2,500-£4,000 col.

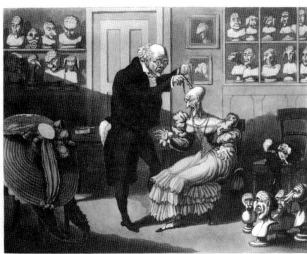

HUNT, F.C. 'An Old Maid's Skull Phrenologised', after E.F. Lambert.

AN OLD MAID'S SKULL PHRENOLOGISED.

'View on the River Thames, Showing Goding's New Lion Ale Brewery, the Wharfs, Shot Factories and the Lambeth End of Waterloo Bridge', after F.C. Turner, 1836, 18¼ x 26 ¾in/ 47.5 x 68cm, £600-£1,000 col.
'A View on the Highgate Road', after J. Pollard, 16 x 20¼in/40.5 x 51.5cm, £800-£1,400 col.
'Celebrated Trotting Horse Tom Thumb', with C. Hunt I, 1829, 13¾ x 17¼in/35 x 44cm, £300-£500 col.
'Mortar Battery at Woolwich', after T. Jones, 1847, 14 x 19½in/35.5 x 49.5cm, £150-£250 col.
'Football', drawn and etched by R. Cruikshank, 9½ x 13½in/24 x 34.5cm, £100-£160 col.
'Trimming a Horse', after G. Gratton, and 'What's his Age?', with C. Hunt I, 21 x 15½in/53.5 x 39.5cm, pair £400-£600 col.
'Hornsea, Winner of the Goodwood Cup, 1836', after F.C. Turner, and other similar portraits of racehorses. £400-£800 col.
Pl. for C. and R. Sickelmore's Views of Brighton, c.1827, obl. fo., e. £60-£100 col.
Pl. for Lieut. J. Moore's Rangoon Views and Combined Operations in the Birman Empire, 1825-6, fo., e. £60-£140 col.
Pl. for Lieut. H. Chamberlain's Views and Costumes of the City and Neighbourhood of Rio de Janeiro, 1822, fo., e. £250-£400 col., set of 36 pl. col. fetched £15,000 1994.
Colour plate page 45.

HUNT, George Sidney b.1856
Mezzotint engraver of portraits and sentimental subjects after his contemporaries. He executed several plates for the Library Edition of *The Works of Sir Edwin Landseer*.
Small value.

HUNT, J.B. fl. mid-/late 19th century
Line, stipple, mezzotint and mixed-method engraver of historical and sentimental subjects and portraits after his contemporaries. He seems to have worked in London.
'Eos' (dog), after E. Landseer, 1877, 13¼ x 17½in/34 x 44.5cm, £160-£300.
Lge. sentimental and historical subjects £20-£80. Add more if in fine contemporary frame.
Small portraits and bookplates small value.

HUNT, John fl. early 19th century
Draughtsman and etcher.
Pl. for British Ornithology, 1815-22, 5¼ x 8in/13.5 x 20.5cm, e. £10-£20 col.

HUNT, Thomas Williams fl. mid-19th century

HUNT, William Holman. 'A Day in the Country', 1865.

HUNT, George. 'Trolling for Pike', pair with 'Fly Fishing', after J. Pollard.

Line and stipple engraver of small bookplates, including portraits and sentimental subjects after his contemporaries and British 18th century painters.
Small value.

HUNT, William Holman 1827-1910
Famous Pre-Raphaelite painter who contributed four etchings to the Etching Club, and two to the magazine 'The Germ'.
'The Abundance of Egypt' and 'The Desolation of Egypt', 1857, pair £60-£100, as published by the Etching Club, early proofs e. £100-£250.
'A Day in the Country', 5¼ x 8½in/14.5 x 21.5cm, 1865, £80-£140.
'The Father's Leave Taking', 1879, £100-£200.
'Portrait of W. Howes Hunt', 3¾ x 2¾in/9.5 x 7cm, £40-£70.
Two subjects for '"The Germ', 1850, 8 x 4¾in/20 x 12cm fetched £750 April 1990.

HUNTER fl. late 18th century
Line engraver.
'A South East View of the Cast Iron Bridge Over the River Wear at Sunderland, Co. Durham', after R. Johnson, 13¾ x 16½in/35 x 42cm, £150-£300.

HUNTER, Colin, A.R.A., R.E. 1841-1900
Scottish painter and etcher of marine and coastal subjects. Born in Glasgow, he came to London in 1872 after working in Scotland.
£15-£40.

HUNTER, Frederick fl. late 19th century
Mezzotint engraver and etcher of portraits and architectural views after his contemporaries.
'Cricket at Rugby', after J. Brooks, £100-£200.
Public school views generally, after F. Barraud, e. £30-£90.
Others small value.

HUNTER, James Brownley b.1855
Scottish mezzotint and photo-engraver of portraits after Old Master painters and his contemporaries. He was born in Edinburgh where he worked.
Small value.

HUTCHINS, C. fl. mid-19th century
Draughtsman and lithographer. He worked in Liverpool.
'Victoria Bowling Green, Welsh-pool and the Montgomeryshire Yeomanry Cavalry', c.1850, 13 x 19½in/33 x 49.5cm, £100-£200 col.
'Wreck of the Convict Ship Waterloo, Cape of Good Hope', after C.S. Hext, 1842, 12 x 16in/30.5 x 41cm, fetched £2,600 Oct. 1989.
Views in Australia and Tasmania, after C.S. Hext, c.1845, 7 pl., sheets 9½ x 12in/24.5 x 31cm, 3 sets sold Oct. 1989 fetched £2,600, £3,800, £4,500.

HUTCHINSON, J.R. fl. late 19th century
Painter and etcher of architectural views.
Small value.

HUTCHISSON fl. mid-19th century
Draughtsman and lithographer.
'The Campaign in Bhurtpore', 16 pl., 12½ x 16in/32 x 40.5cm, e. £20-£50 col.

HUTH, Frederick fl. late 19th/early 20th century
Scottish and etcher of portraits and sentimental subjects after hs contemporaries and 18th century painters. He worked in Edinburgh.
Small value.

IBBETSON, Julius Caesar. One of his 'Etchings of Figures', 1816.

IBBETSON, Julius Caesar 1759-1817
Yorkshire landscape and figure painter who produced two folios of etchings towards the end of his life.
'Etchings of Cattle', 6 pl., and 'Etchings of Figures', 8 pl., both 1816, fo., e. pl. £10-£30.

ILLINGWORTH, Adeline, A.R.E. 1858-1942
London etcher of architectural views.
£15-£40.

ILLMAN, T. fl. early 19th century
Etcher and stipple engraver of small portraits and bookplates after his contemporaries.
Pl. for Foxchase, *a poem, c.1813, 8 x 11½in/20.5 x 29cm, e.£5-£15.*
Portraits and other bookplates small value.

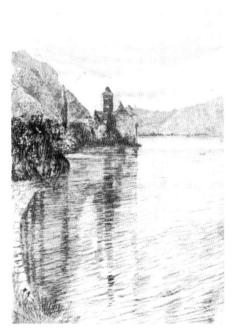

INCHBOLD, John William. A typical etching.

INCHBOLD, John William 1830-1888
Victorian landscape painter who etched a few plates. He contributed plates to *The Portfolio* and illustrated his own book *Mountain and Vale*, 1885, with twenty-one etchings.
£8-£20.

INGALTON, William fl. early 19th century
Draughtsman and lithographer of topographical views.
Views of Eton and Windsor, 1821, 11¼ x 10½in/30 x 27cm, e. £20-£60.

INGREY, C. fl. mid-19th century
Draughtsman and lithographer.
'View of the Opening of the Bodmin and

Wadebridge Railway - the Train Passing over Pendevey Bridge', 11¼ x 34½in/30 x 88cm, £400-£700 col.
Portrait of William Cobbett small value.

IRELAND, Samuel d.1800
Art dealer and collector, author, draughtsman, etcher and aquatint engraver of landscapes, topographical views and portraits after his contemporaries and his own designs. After having worked as a weaver in Spitalfields, he became a dealer in prints and drawings and amassed a large collection of prints and books. He etched and engraved plates for his own publications. He was the father of W.H. Ireland, the forger of Shakespearian documents.

'Picturesque Tour Through Holland, Brabant and Part of France', 1790, 45 pl., fo., e. £5-£10 sepia.
'Picturesque Views on the River Thames', 1792, 52 pl., fo., e. £5-£15 sepia.
'Picturesque Views of the Inns of Court', 1800, 21 pl., fo., e. £20-£60 col.

ISAACS, John R. fl. mid-19th century
Liverpudlian lithographer and publisher of shipping subjects after his contemporaries.
'Packet Ship Shackamaxon', after C.P. Williams, 21 x 28in/53.5 x 71cm, tt., £250-£400 col.
'Clipper Ship Lightning', 15¼ x 21½in/38.5 x 55cm, £150-£250 col.

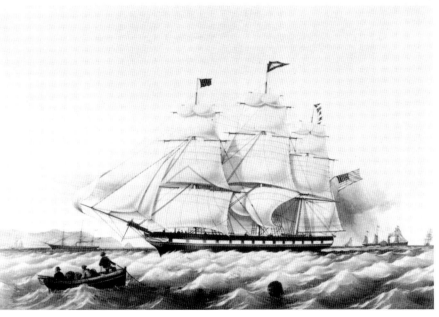

ISAACS, John R. 'Packet Ship *Shackamaxon*', after C.P. Williams.

JACKSON, F.E. fl. mid-19th century
Draughtsman and lithographer of portraits.
Small value.

JACKSON, J.G. fl. mid-19th century
Lithographer.
Pl. for P.F. Robinson's Designs for Farm Buildings and Ornamental Villas, 1830, 4to., small value.

JACKSON, John 1801-1848
Wood engraver of small bookplates after his contemporaries. Born in Northumberland, he was a pupil of C. Armstrong and T. Bewick (qq.v.). He later worked in London engraving illustrations mainly for children's books.
Small value.

JACKSON, John Baptist c.1700-c.1770
Important chiaroscuro and colour woodcut artist. He seems to have spent his early years in London and was perhaps a pupil of E. Kirkall (q.v.). About 1725, he moved to Paris where he worked for J.M. Papillon producing book decorations. He then went to Italy in 1731 and settled in Venice. It was there that he executed the large woodcuts after Venetian masters for which he is famous. These were printed from at least two, and as many as seven, blocks and they form an important contribution to the development of colour printing. He returned to London in 1745 where various projects, such as manufacturing wallpapers, failed to take off and he ended up as a drawing master.
'Titani, Vecelli, Pauli, Caliari, Jacobo Robusti et Jacobo de Ponte. Opera Selectiora . . .', 24 pl. after Venetian painters, 1745, ave. 21 x 15in/53.5 x 38cm, e. £100-£300, set £6,000-£9,000.

Landscapes after M. Ricci, 1744, 6 pl., 16½ x 22¾in/42 x 58cm, e. £1,000-£2,000.
Kainen, J., 'J.B.J.', *Smithsonian Institution*, 1962.
Colour plate page 46.

JACKSON, John Richardson 1819-1877
Line and mezzotint engraver of portraits and sentimental and sporting subjects after his contemporaries, Old Master and British 18th century painters. Born at Portsmouth, he studied under R. Graves (q.v.).
'Robert Stephenson', after J. Lucas, 1846, 17 x 13¼in/43 x 33.5cm, £40-£100.
'1st Marquis Anglesey', after T. Lawrence, 1845, 12¼ x 7½in/31 x 19cm, £10-£30.
'Lady Ann Fitzpatrick', after J. Reynolds, 1875, 13½ x 11in/34.5 x 28cm, £6-£20.
'Robert Keate', after J.P. Knight, 17½ x 13¾in/44.5 x 35cm, £16-£30.
'The Four Eldest Daughters of Queen Victoria', after F. Winterhalter, 1851, 15 x 18½in/38 x 47cm, £40-£100.
'Otter and Salmon', after E. Landseer, 1847, 22 x 34½in/56 x 87.5cm, £200-£400.
Add more if in fine contemporary frame.

JACKSON, J.T. fl. mid-19th century
Line engraver of small bookplates including landscapes, architectural views and military subjects after his contemporaries.
German views £5-£10.
Others small value.

JACKSON, Michael fl. late 18th century
Mezzotint engraver of portraits after his contemporaries and Old Master painters. He was probably Irish and appears to have worked in London.
'Spranger Barry', after J. Gwinn, 1753, 13½ x 9½in/34.5 x 24cm, £40-£80.
'Nancy Dawson', 14 x 9¾in/35.5 x 25cm, £50-£90.
'Old Man', after Rembrandt, 11½ x 8in/29 x 20.5cm, £5-£15.
'Mrs. Woffington', after J. Lewis, 13 x 9in/133 x 23cm, £30-£60.
CS lists 4 pl., noted above.

JACOBE, Johann 1733-1797
German line and mezzotint engraver who is

mentioned here for some mezzotint portraits after J. Reynolds and G. Romney which he executed during a visit to London, 1779-80, when he was taught to engrave in this medium.
'Omai Otaheita', WL, 1780, 25 x 15in/63.5 x 38cm; 'Miss Meyer as Hebe', WL, 1780, 22¼ x 15in//58 x 38cm; 'Hon. Mary Monckton', WL, 1781, 24¼ x 15in/63 x 38cm, all after J. Reynolds, e. £200-£400; ('Omai Otaheita' fetched £500 Oct. 1988).
'Life Drawing in the Royal Academy', after Quadal, 24 x 30in/61 x 76cm, £300-£600.
Various HLs £15-£40.

JACOMB-HOOD, George Percy, R.E.
1857-1929
Painter, illustrator, etcher and occasional lithographer of figure subjects and townscapes. Born at Redhill, he studied at the Slade under A. Legros (q.v.) and Edward Poynter and drew for *The Illustrated London News* and *The Graphic*, travelling to Greece and India for the latter. He lived in London.
£10-£40.

JACQUET, Achille 1846-1908
French etcher and line engraver of portraits and sentimental subjects after his French and British contemporaries and Old Master painters. He was the brother of Jules Jacquet (q.v.).
Egyptian scene, after E. Long, 1888, £20-£40.
Others mostly small value.

JACQUET, Jules 1841-1913
French etcher and line engraver of sentimental subjects after his French and British contemporaries and Old Master painters. He was the brother of Achille Jacquet (q.v.).
Pl. after Meissonier £30-£70.
Others small value.

JAMES, Clifford R. 1920s
Mezzotint engraver of portraits after British 18th century and late Victorian painters.
£10-£40.

JAMES, George P. fl. early 20th century
Mezzotint engraver of decorative subjects after British 18th century painters.
£25-£60 prd. in col.

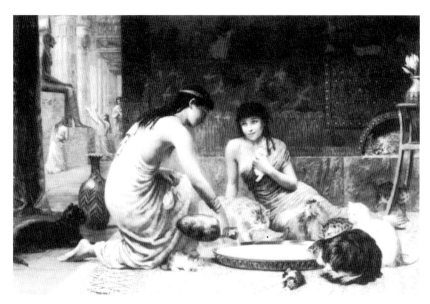

JACQUET, Achille. Egyptian scene, after E. Long, 1888.

JAMES, H.G. fl. early 19th century
Draughtsman and lithographer. He seems to
have been a native of Manchester.
*'Views of Old Halls, Buildings &c., in
Manchester and the Neighbourhood', 1825, 36
pl., small fo., e. £10-£30.*

JAMES, Hon. Walter John 1869-1932
(Lord Northbourne), R.E.
Painter and etcher of marine subjects and
landscapes. Born in London, he studied at the
R.C.A. and was taught etching by F. Short
(q.v.). He lived in Kent and Northumberland.
£15-£40.
Bibl: Salaman, M.C., 'Pictures and Etchings of
the Hon. W.J.', *Studio*, 1911, LIV, p.103.

JAMESON, Alexander fl. early 18th century
Engraver working in Edinburgh.
Small value.

JANES, Norman Thomas, R.W.S., R.E.
b.1892
Painter, etcher and wood engraver of
architectural views, landscapes and portraits.
Born in Surrey, he studied at the Slade, the
Central School of Arts and Crafts and the
R.C.A., and lived in London.
*'Liverpool Street', wood. eng., £60-£140.
Others £40-£140.*

JASINSKI, Felix 1862-1901
Polish etcher and line engraver of sentimental,
religious and mythological subjects and
portraits after Old Master painters and his
contemporaries. Born at Zabkow, he emigrated
to France and lived and worked in Paris. His
best plates are his reproductions of Pre-
Raphaelite pictures, and the following four are
all after E. Burne-Jones:
*'The Golden Stairs', 1894, 27½ x 13½in/70 x
34.5cm, £800-£1,600.
'The Mirror of Venus', 1896, 16 x 23½in/40.5 x
59.5cm, £700-£1,400.
'The Annunciation', 1897, 23¼ x 11in/59 x
28cm, £600-£1,200.
'Love Among the Ruins', 1899, 17 x 22½in/43.5
x 57.5cm, £600-£1,200.
'Primavera' after Botticelli, 1892, 19½ x
26in/49.5 x 66cm, £300-£500.
Others mostly small value.*

JEAKES, Joseph fl. early 19th century
Aquatint engraver of naval engagements,
topographical views and sporting subjects after
his contemporaries and his own designs. He
worked in London.
*'Battle of Trafalgar', after T. Whitcombe, 17 x
27¾in/43 x 70.5cm, £400-£600 col.
'Action between the Shannon and the
Chesapeake', after T. Whitcombe, 15 x 21in/38
x 53.5cm, £500-£800 col.
'Capture of the Diamond', after J.T. Serres, 14½
x 22¼in/37 x 56.5cm, £300-£500 col.
'Foxhunting: Morning, Noon, Evening and
Night', after D. Wolstenholme, with J. Clark
(q.v.), 1811, 4 pl., 14½ x 18½in/36.5 x 47cm, set
£1,200-£1,800 col.
'View of Kingston, Jamaica', 1814, 20¼ x
35in/52.5 x 89cm, £800-£1,200 col.
'Five Views of Hythe, Sandgate and
Folkestone', after Jeakes, 1816, small 4to., e.
£20-£50 col.
'Athens, South View of the Acropolis', after
Priaux, 1804, 18 x 24¾in/46 x 63cm, £500-£700
col.
Views of Rio de Janeiro, after T. Sydenham, 8 x
13¼in/20.5 x 34cm, e. £150-£250 col.*

JANES, Norman Thomas. 'Liverpool Street', wood engraving.

JASINSKI, Felix. 'The Mirror of Venus', after E. Burne-Jones, 1896.

JEENS, Charles Henry. 'Leaving Home', after F. Holl.

Painted by R.Cosway
ABELARD and ELOISA.
Engraved by I. Jehner

JEHNER, Isaac.
'Abelard and
Eloisa', after
R. Cosway, 1787.

Pl. for J. Jenkin's Naval Achievements, *after T. Whitcombe, 1817, 4to., e. £50-£80 col.*
Pl. for J.J. Middleton's Grecian Remains in Italy, *1812, fo., e. £50-£80 col.*
Small bookplates, inc. English views, uncol., small value.

JEAVONS, Thomas c.1800-1867
Line engraver of small bookplates, including landscapes and topographical views after his contemporaries.
Swiss views £5-£10.
Others small value.

JEENS, Charles Henry 1827-1879
Line and stipple engraver mainly of small bookplates, including portraits and figure subjects after his contemporaries and Old Master painters, and antiquities. Born in Gloucestershire, he was a pupil of J. Brain and W. Greatbach (q.v.).
Lge. pl. £10-£50.
Add more if in fine contemporary frame.
'Leaving Home', after F. Holl, and other small pl., £5-£15.

JEFFERYS, J. fl. mid-18th century
Line engraver.
'A Perspective View of the Battle Fought Near Lake George, on the 8th. Sept. 1755, Between

2,000 English With 250 Mohawks . . . and 2,500 French and Indians', after S. Blodgett, 1756, 11¼ x 20½in/28.5 x 52cm, £400-£600.

JEHNER (Jenner), Isaac b.1750
Mezzotint engraver of portraits and decorative subjects after his contemporaries. Born in Westminster, he was the son of a German gunsmith who brought the art of silver-plating to England. Subsequently, he changed his name to Jenner. He worked as an assistant to W. Pether (q.v.) and later settled in Exeter.
'Dionysius, the Areopagite', after J. Reynolds, oval, 10 x 8in/25.5 x 20.5cm, £20-£50.
'Abelard and Eloisa', after R. Cosway, 1787, 14 x 9½in/35.5 x 24.5cm, £50-£80.
'William Henry, Marquis of Titchfield', WL, after J. Reynolds, 1777, 19¼ x 13½in/50 x 35cm, £120-£180.
'Hon. Augustus Keppel', HL, after Scott, 1779, 10½ x 8in/26:5 x 20.5cm, and other HLs of similar size, £15-£40.
CS.

JENKINS, Elizabeth T. fl. mid-20th century
Colour linocut artist in the school of W.C. Flight (q.v.).
£150-£300.

JENKINS, J. I fl. late 18th century

Line and stipple engraver of decorative and genre subjects after his contemporaries. He worked in London.
Pl. after A. Kauffmann, ovals, roundels £100-£200 prd. in sepia or in col.
'Country Race Course, with Horses Preparing to Start', and 'With Horses Running', after W. Mason with F. Jukes (q.v.), 1780, 20 x 26¼in/51 x 68cm, pair £600-£900 col.

JENKINS, J. II early/mid-19th century
Stipple engraver of small portraits and bookplates after his contemporaries and Old Master painters.
Small value.

JENNER, J. see JEHNER, I.

JENNER, Thomas d.1673
Line engraver mainly of portraits. He worked in London and was also a map and printseller.
'The Soverayne of the Seas, Builte in the Yeare 1637', £200-£400.
Portraits £3-£10.

JERRARD, P. fl. mid-19th century
Lithographer and publisher.
Ornithological subjects after W. Dexter, 9 x 13in/23 x 33cm, e. £15-£30 col.

JERVAS, Charles 1670-1739
Irish painter who produced a few etchings. He was a pupil of Sir Godfrey Kneller and died in London.
'Dean Swift', after Jervas, £40-£80.
Others small value.

JEWETT, Thomas Orlando Sheldon
 1799-1869
Wood engraver of small bookplates. Born in Derbyshire, he was brought up near Rotherham, Yorkshire, worked for a time in Oxford and eventually settled in London.
Small value.

JOHN, Augustus Edwin, R.A. 1878-1961
Important British painter, etcher and lithographer of portraits and figure subjects. Born at Tenby, Wales, he studied at the Slade. He produced most of his etchings in the first decade of the century and the majority of these plates are portraits, strongly influenced by Rembrandt. The lithographs, which are all figure subjects, came later.
Etchings:
'A Man Seated by a Camp Fire', 4¼ x 6in/10.5 x 15.5cm, £250-£400.
'A Girl's Head - F', before 1914, 6¾ x 5½in/17 x 14cm, £300-£450.
'The Hawker's Van', 1904-5, 6¼ x 8in/16 x 20.5cm, 'Jacob Epstein, No. 2', 5 x 4in/12.5 x 10cm, £300-£600.
'Les Femmes Damnées', 1906, £80-£140.
'Fruit Sellers - C', 4½ x 3¼in/11.5 x 9.5cm, £250-£400.
'Nude Girl with Knee on Couch', 6½ x 3½in/16.5 x 9.5cm, £120-£200.
'Old Man in Fur Cloak', 1902, 4¼ x 3¼in/11 x 8cm, £150-£250.
'Self Portrait',c.1901, edn. 50 prd. 1919, 6 x 4in/15 x 10cm, £400-£700.
'Self Portrait in a Black Gown', 6½ x 3¼in/16.5 x 9.5cm fetched £1,300 Feb. 1990.
'William Butler Yeats', 1907, 7 x 5in/18 x 12.5cm, fetched £1,450 April 1993.
Lithographs:
£100-£250.
Bibl: Dodgson, C., 'Additions to the Catalogue of the Etchings by A.J., R.A.', *P.C.Q.* 1931,

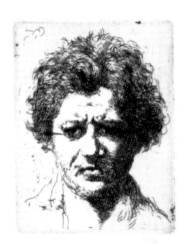

JOHN, Augustus Edwin. 'Jacob Epstein No.2'.

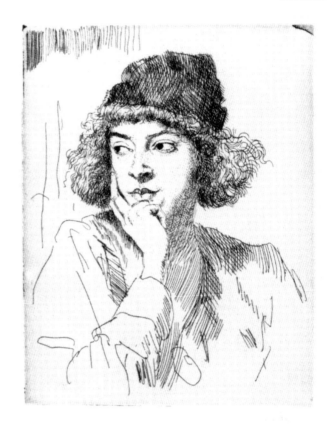

JOHN, Augustus Edwin. 'A Girl's Head – F'. before 1914.

XVIII, pp.271-87; Dodgson, C., *A Catalogue of Etchings by A.J., 1901-1914*, London, 1920.

JOHNSON fl. mid-18th century
Mezzotint engraver of portraits and decorative subjects after his contemporaries.
Male portraits £15-£40.
Female portraits and decorative subjects £30-£100.

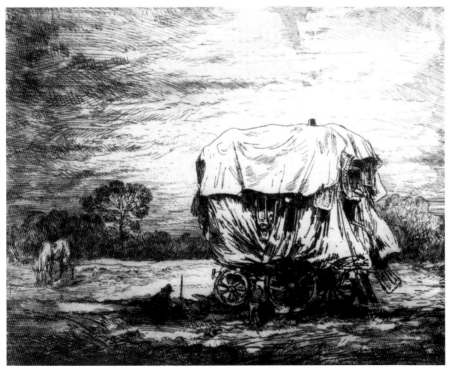

JOHN, Augustus Edwin. 'The Hawker's Van', 1904-5.

JOHNSON, G. fl. mid-18th century
Mezzotint engraver of portraits after his contemporaries, all dated 1744-5.
'William, Duke of Cumberland', 15 x 10½in/38 x 26.5cm, £60-£80
1QLs £15-£40.
CS lists 3 pl.

JOHNSON, James d.1811
Scottish engraver and publisher, mainly dealing as a music seller in Edinburgh. He was a friend of the poet Robbie Burns and published a large number of his lyrics.
Small value.

JOHNSON, John fl. late 18th century
Wood engraver of small bookplates. He was a cousin of R. Johnson (q.v.) and apprentice of T. Bewick (q.v.) for whom he engraved several plates.
Small value.

JOHNSON, Robert 1770-1796
Watercolourist who trained as a line engraver. Born in Northumberland, he was apprenticed to T. Bewick (q.v.) and R. Beilby in Newcastle and produced several drawings for Bewick's books. After his apprenticeship he turned to watercolour painting full-time.
Small value.

JOHNSON, T. fl. mid-19th century
Wood engraver of book illustrations including portraits after his contemporaries.
Small value.

JOHNSON, Thomas 1708-1767
Mezzotint engraver of portraits after his contemporaries. Born at Boston, Lincolnshire,

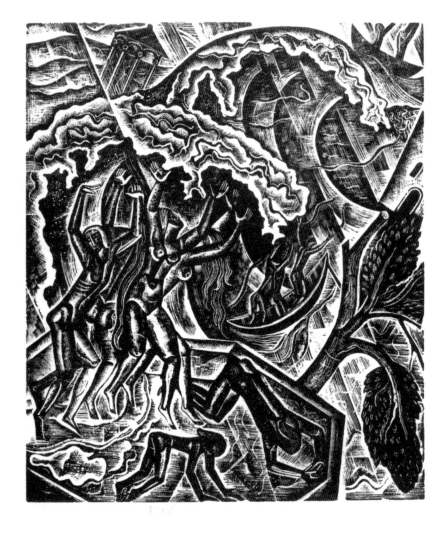

JONES, David Michael. Illustration to *Deluge*, wood engraving.

he worked mainly in London. Some have argued that Thomas Johnson was a pseudonym for J. Faber I (q.v.) but the question is unlikely to be settled.
Various HLs £15-£40.
CS.

JOHNSTON, Andrew fl. early 18th century
Mezzotint engraver of portraits after his contemporaries.
£15-£40.
CS lists 4pl.

JOHNSTONE, J.M. fl. mid-19th century
Wood engraver of book illustrations including portraits after his contemporaries.
Small value.

JOHNSTONE, William fl. late 19th century
Scottish engraver of genre and sentimental subjects after his contemporaries.
Small value.

JONES, David Michael 1895-1974
Painter, poet, illustrator, etcher and wood engraver of figure subjects. Born at Brockley, Kent, he studied at Camberwell and Westminster Schools of Art and worked with

A.E.R. Gill (q.v.) at Ditchling 1922-4. His most important line engravings are the set of eight illustrations to the *Ancient Mariner*, but he is better remembered for his wood engravings.
Illustrations to the Ancient Mariner, *8pl., set (edn. 400, pl. unsigned) £400-£600.*
Illustration to 'The Chester Play of the Deluge', wood eng., individual signed proofs £100-£200, set (edn. 80, pl. unsigned) £400-£600.
Other wood eng. e. £100-£250 signed.

JONES, Frederick fl. mid-19th century
Lithographer of military and railway subjects and topographical views after his contemporaries and his own designs. He worked mainly for Day & Son (see William Day II) in London.
'View of the Mansions Erected and Erecting at Kensington Gore', c.1851, 19 x 28¾in/48.5 x 73cm, tt. pl., £200-£400.
Pl. for W. Simpson's Seat of War in the East, *1855-6, fo., tt. pl., e. £10-£30 col.*
Pl. for Lieut. Mecham's Sketches and Incidents of the Siege of Lucknow, *1858, fo., tt. pl., £5-£15.*
Pl. for W. Hickman's Sketches on the Nipisaguit, New Brunswick, Canada, *1860, fo., tt. pl., e. £100-£150 col.*

'South Devon Railway: View of Landslip between Dawlish and Teignmouth', 1852, 13¾ x 17in/35 x 43.5cm, tt. pl., £400-£600 col.
'Bridges in India', 9½ x 14½in/24 x 34cm, e. £50-£80

JONES, John c.1745-1797
Mezzotint and stipple engraver of portraits and decorative subjects after his contemporaries. He was born in and worked in London. He was appointed Engraver to the Prince of Wales and the Duke of York.
'Tregonwell Frampton, the Father of the Turf', after J. Wootton, 1791, 21½ x 14in/54.5 x 35.5cm, £150-£300, fetched £480 April 1990.
'Charles James Fox', after J. Reynolds, 1784, 18 x 14in/45.5 x 35.5cm, £40-£70.
'Emma' (Lady Hamilton), after G. Romney, 1785, 15¼ x 11in/38.5 x 28cm, stipple, £400-£600, prd. in col.
'Black Monday, or the Departure for School' and 'Dulce Domum, or the Return from School', after W.R. Bigg, 1790, 18 x 23¾in/45.5 x 60.5cm, pair £1,000-£1,600 prd. in col., fetched £2,200 Oct. 1994.
'Marlborough Theatricals', after J. Roberts, 1788, 3pl., 18 x 14¼in/45.5 x 36cm, set £200-£300.
'Mr. Tattersall', after T. Beach, 1787, 20 x 13¾in/50.5 x 35cm, £100-£150.
'Sir Edward Vernon', after J. Reynolds, 25¼ x 15½in/64 x 39.5cm, £80-£120.
Various HLs, mezzo., £15-£50.
'The Young Fortune Teller' (Lord Henry and Lady Charlotte Spencer), and 'Robinetta', both after J. Reynolds, 1789 and 1787 respectively, 15 x 10¾in/38 x 27.5cm, e. £200-£400 prd. in col.
'The Infant Cottager', after H. Singleton, 1799, 15¼ x 11in/38.5 x 28cm, £200-£300, prd. in col.
'Lady Caroline Price', after J. Reynolds, 1788, 15 x 10½in/38 x 27.5cm, £100-£200.
'Giovanna Bacelli', after T. Gainsborough, 1784, 21 x 14in/53.5 x 35.5cm, fetched £620 April 1994.
'Edward Burke' after G. Romney, proof before letters, £380 Oct. 1994.
CS.

JONES, Owen Carter b.1809
Architect, interior designer and topographical draughtsman who lithographed a few bookplates after architectural drawings by himself and others.
Small value.

JONES, R. fl. early 19th century
Stipple engraver of small portraits.
Small value.

JONES, Sydney Robert Fleming 1881-1966
Watercolourist and etcher of architectural views, especially of London, Oxford and Cambridge. Born in Birmingham, where he studied at the School of Fine Art, he lived in London and later in Berkshire. He published several books on the English countryside.
£15-£50.

JONES, Thomas fl. early/mid-19th century
Draughtsman and etcher of caricatures and portraits of boxers.
Caricatures, boxing portraits £30-£90 col.

JONNARD, P. fl. late 19th century
Wood engraver of book illustrations, including portraits, after his contemporaries.
Small value.

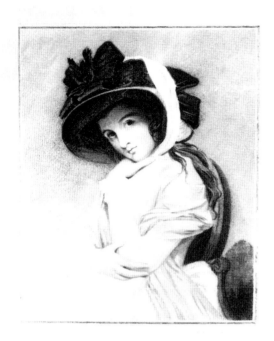

EMMA.

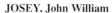

JONES, John. 'Emma' (Lady Hamilton), after G. Romney, 1785, stipple.

JOSEY, John William b.1866

Mezzotint and line engraver of animal and sentimental subjects after his contemporaries. The son of R. Josey (q.v.), he worked in London.

Pl. for The Works of Sir Edwin Landseer, *1881-91, fo., small value.*

JOSEY, Richard d.1906

Mezzotint engraver of portraits and sentimental subjects after British 18th century painters and his contemporaries. He worked in London and in Buckinghamshire and was the father of J.W. Josey (q.v.)

'After the Battle' (Tel-el-Kebir), after E. Thompson (Lady Butler), 1888, 19 x 39½in/48.5 x 100.5cm, £200-£400.

'The Departure of the Mayflower for England', after A.W. Bayes, 1884, 18¾ x 34¾in/47.5 x 88.5cm, £60-£140.

'With the Blue and Buff - Going Away', after A.C. Sealy and A.H. Wardlow, 1890, 17 x 28in/43 x 71cm, £150-£250.

'Dreamland', after C. Barber, 1885, 16½ x 22½in/42 x 58cm, £40-£100.

'Lady Jane Grey in the Tower', after A. Barzaghi-Cattaneo, 1887, 30¾ x 12¼in/78 x 31cm, £150-£250.

'Fred Archer', after R. Corder, 1884, 12¾ x 10¾in/32.5 x 27.5cm, £40-£100.

'Sir George Jessel', after J. Collier, 15½ x 12¼in/39.5 x 31cm, £20-£60.

'Portrait of Thomas Carlyle', after J.A.M. Whistler, 1878, 19 x 15¾in/48.5 x 40cm, signed by artist and engraver £200-£300.

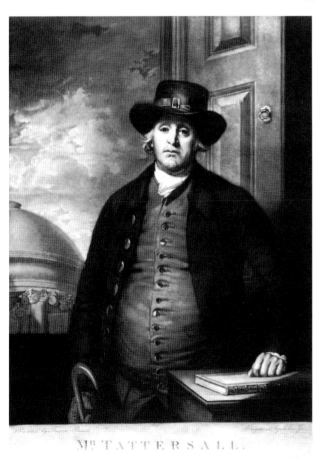

M⁅ TATTERSALL.

JONES, John. 'Mr. Tattersall', after T. Beach, 1787.

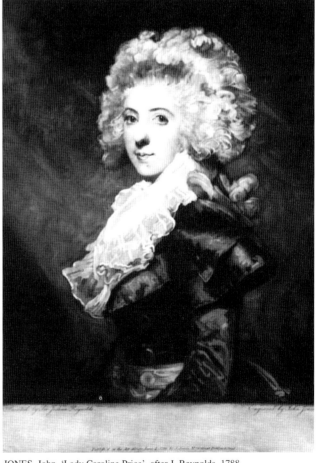

JONES, John. 'Lady Caroline Price', after J. Reynolds, 1788.

INNOCENT REVENGE.

JOSEY, Richard. 'Lady Jane Grey in the Tower', after A. Barzaghi-Cattaneo, 1887.

JOSI, Christian. 'Innocent Revenge', pair with 'Innocent Mischief', after R. Westall, 1795.

Add more if in fine contemporary frame.
Pl. for the Library Edition of The Works of Sir Edwin
Landseer, *1881-91, fo., small value.*
Small portraits small value.

JOSI, Christian d.1828
Dutch art dealer and print collector, stipple engraver of decorative subjects and portraits after his contemporaries. Born at Utrecht, he came to London on a travelling scholarship in 1791 and worked for five years under John Raphael Smith (q.v.), studying also under F. Bartolozzi (q.v.). He then returned to Holland, giving up engraving due to poor health, and becoming instead a printseller and art dealer. He visited collections all over Europe and finally settled in London in 1819 with his family.
'Innocent Mischief' and 'Innocent Revenge', after R. Westall, 1795, 16½ x 12¾in/42 x 32.5cm, pair £400-£700 prd. in col.
'Peasant's Repast', and 'Labourer's Luncheon', after G. Morland, 1816, 12 x 15in/30.5 x 38cm, pair £250-£400 prd. in col.

'Maria Cosway', after R. Cosway, 1797, 10 x 7in/25.5 x 18cm, crayon manner eng., £40-£100.
Small bookplates small value.

JOUBERT, Jean Ferdinand 1810-1884
French line and mezzotint engraver of portraits, sentimental subjects and landscapes after his French and British contemporaries and Old Master painters. Born in Paris, where he studied, he came to England in 1850.
'The Playground', after T. Webster, 1858, 18 x 36in/45.5 x 91.5cm, £40-£100.
'Francis Quartly of Molland, Devon, with his North Devon Cattle', after T. Mogford, 23½ x 19in/60 x 48.5cm, £400-£700.
'Henry Pownall', after E.U. Eddis, 21¼ x 13½in/55 x 34.5cm, £20-£60.
'Atalanta's Race', after E.J. Poynter, 1881, 12½ x 36in/32 x 91.5cm, £100-£200.
'Water Lily', after E.U. Eddis, 1850, 14 x 18½in/35.5 x 47cm, £20-£60.
'Nelson at Prayer, on Going into Battle at Trafalgar', after T.J. Barker, 1854, 17½ x

13½in/44.5 x 34.5cm, £20-£60.
Add more if in fine contemporary frame.
Bookplates, small portraits, and pl. after Old Masters, etc., small value.

JOWETT, Ellen fl. early 20th century
Mezzotint engraver of portraits mainly after British late 18th and early 19th century painters. Born in Yorkshire, she was a pupil of J.B. Pratt and F. Short (qq.v.)
£10-£40.

JUDKINS, Elizabeth fl. late 18th century
Mezzotint engraver of portraits after her contemporaries. She worked in London and was probably a pupil of J. Watson (q.v.).
'Harriet Powell as Leonora', after J. Reynolds, 1770, 14 x 10in/35.5 x 25.5cm, and other female portraits of similar size, £60-£140.
Smaller size portraits £10-£40.
Bibl: Goodwin, G., *British Mezzotinters: Thomas Watson, James Watson and E.J.,* London, 1904.
CS.

216

JUKES, Francis 1745-1812

Prominent aquatint engraver of sporting and marine subjects, topographical views, landscapes, caricatures, etc., after his contemporaries. Born at Martley, Worcestershire, he worked in London, often collaborating with other engravers, especially R. Pollard (q.v.).

'Portraits of a Two-year-old Ram' and a 'Two-year-old Ewe of the New Leicestershire Kind', after J. Boultbee, June 1802, 18¾ x 23½in/47.5 x 60cm, e. £800-£1,500 col.

'The Pytchley Hunt', after C. Loraine Smith, 1790, 8 pl., 8 x 9½in/20.5 x 24cm, set £600-£1,000 col.

'Country Race Course: with Horses Preparing to Start' and 'With Horses Running', after W. Mason, with J. Jenkins I (q.v.), 1780, 20 x 26¾in/51 x 68cm, pair £600-£900 col.

'Highflyer' (racehorse), after S. Gilpin, 1788, 15¼ x 20in/39 x 50.5cm, £400-£600 col.

'St. Preux and Julia' and 'Henry and Jessy', after F. Wheatley, with R. Pollard and J. Hogg (q.v.), 1786, 22½ x 16½in/57 x 42cm, pair £140-£200 col.

'The Attempt to Assassinate the King', after R. Smirke, with R. Pollard, 1786, 17½ x 21½in/44.5 x 54.5cm, £20-£50.

'A Visit to the Uncle' and 'A Visit to the Aunt', drawn and etched by T. Rowlandson, 1794, 8 x 9½in/20 x 24.5cm, pair £250-£400 col.

'Courtship' and 'Matrimony', after W. Williams, 1787, 17¼ x 13½in/43.5 x 34.5cm, pair £400-£600 col.

'Vauxhall', after T. Rowlandson (q.v.), with R. Pollard (q.v.), 1785, 19 x 35in/48.5 x 89cm, £800-£1,200 col.

London squares, after E. Dayes, with R. Pollard (q.v.), 1787, 18 x 21¾in/45.5 x 55.5cm, e. £300-£500.

'Design of the East Front of the New Building for the University of Edinburgh', after R. Adam, 1791, 12¼ x 21¼in/31 x 54cm, £100-£200 col.

'View of the Brielle in Holland', after S. Hutchinson, 16¾ x 19¾in/42.5 x 50cm, £250-£400 col.

'Views in the South Pacific', after J. Cleveley's drawings executed on Capt. Cook's third voyage, publ. 1788, 4 pl., 19 x 24in/48.5 x 61cm, set £4,000-£6,000 col.

'Mount Vernon in Virginia, the Seat of the Late Lt.-Gen. George Washington', and 'New York from Holbuck Ferry House', after A. Robertson, 1800, 18 x 26in/45.5 x 66cm, pair £3,000-£5,000 col.

Views in Ireland, after T. Walmsley, 1800-1, 9¾ x 11½in/24.5 x 29.5cm, e. £50-£80 col.

Pl. for E. Dayes' Views on the River Wye, 1797-1802, obl. fo., e. £40-£70 col.

Pl. for A. Campbell's A Journey to Scotland, 1802, 4to., tt. pl., small value.

Pl. for P. Sandby's A New Drawing Book, 1779, with V. Green (q.v.), 8¾ x 10¾in/22 x 27.5cm, £15-£25.

JUNE, John fl. mid-18th century

Line engraver of sporting subjects, caricatures, costumes, etc., after his contemporaries.

Portraits of racehorses, after F. Sartorius, 1770, 7 x 10¾in/18 x 27.5cm, e.£80-£150.

'Cavalry Costumes', 1762-88, ave. 6 x 5½in/15 x 14cm, £15-£40.

'British Resentment or the French Fairly Coopt at Louisbourg', after L. Boitard, 1755, 10 x 13¼in/25.5 x 33.5cm, £40-£80.

'The Months of the Year', 1749, 8 x 5¼in/20 x 13.5cm, set £300-£500.

Bookplates and portraits small value.

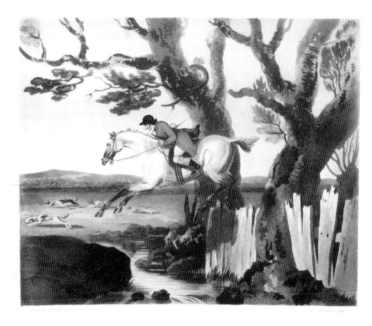

JUKES, Francis. One of eight plates from 'The Pytchley Hunt', after C. Loraine Smith. 1790.

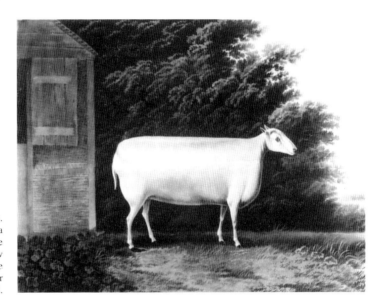

JUKES, Francis. 'Portrait of a Two-year-old Ewe of the New Leicestershire Kind', after J. Boultbee, 1802.

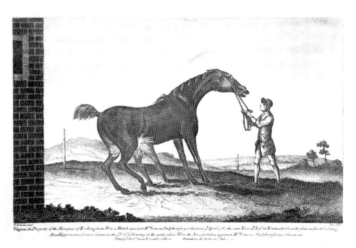

JUNE, John. 'Pilgrim', after F. Sartorius, 1770.

KAPP, Edmond Xavier　　　1890-1980
London caricaturist, painter and lithographer of portraits. His early work was strongly influenced by Max Beerbohm. In 1960 he turned to painting exclusively abstract compositions.
£60-£140.

KAUFFER, Edward McKnight　　d.1954
American poster artist, illustrator, wood engraver and lithographer of figure subjects, still life and landscapes. Born at Montana, U.S.A., he moved to London in 1914 after studying in Chicago, Munich and Paris, and turned to full-time poster designing and print making in the 1920s.
'Actors Prefer Shell', 1933, 29½ x 44in/75 x 112cm, £1,200-£1,800 prd. in col.
'Eno's Fruit Salad', 1924, 29½ x 19½in/75 x 49.5cm, £1,200-£1,800 prd. in col.
'London Underground', 1932, 39¼ x 24½in/99.5 x 62cm, several different subjects, generally from £300-£7,000, but 'Underground Power' very rare and sought after £10,000-£15,000.

KAUFFMANN, Maria Anna
Angelica Catherina, R.A.　　1741-1807
Swiss painter of portraits, genre, allegorical, classical and mythological subjects. Coming to England in 1766, she was nominated one of the original members of the R.A. on its foundation in 1768. She left London in 1781 and eventually settled in Rome. While she executed the designs for many 'furniture prints', often roundels or ovals engraved by professionals in stipple (see F. Bartolozzi), she herself etched nearly forty plates after Old Master painters and her own designs; these were mainly classical and biblical subjects. Many were reprinted by J. Boydell.
'Young Woman, Seated, Pensive', after Kauffmann, 8 x 6½in/20 x 16.5cm, £200-£400.
'Calliopeia and Homer', after A. Zucchi, 1781, 9 x 7in/23 x 17.5cm, £80-£200.
'The Bearded Old Man', 5 x 3½in/12.5 x 9cm, £100-£200.
Early proofs of early etchings have been fetching between DM 900 and DM 1,800 in Germany.
Boydell reprints mainly £30-£80.
Bibl: Andresen, Boerner.
Alexander, D. 'Chronological Checklist of Singly Issued English Prints after A.K.' in ed. W.W. Rowarth, A.K., London, Reaktion Books, 1992

KAY, John　　　1742-1826
Scottish miniature painter, draughtsman and etcher of portrait caricatures. Born at Dalkeith, he originally worked for a barber until a pension from a benefactor enabled him to set himself up as a printseller and artist. From 1784 he started etching caricatures of Edinburgh characters, producing over nine hundred. These were collected as 'Kay's Edinburgh Portraits', 1837-8.
Contemporary imp. £5-£15.
Later reprints small value.

KAUFFMANN, Maria Anna Angelica Catherine. 'Calliopeia and Homer', after A. Zucchi. 1781, as published by J. Boydell.

KEARNAN, T.　　　fl. mid-19th century
Line engraver of small bookplates, mainly architectural views after his contemporaries.
Small value.

KEARNEY, W.H.　　　fl. mid-19th century
Lithographer of portraits after his contemporaries, and of monumental effigies.
Small value.

KEATING, George　　　1762-1842
Irish stipple and mezzotint engraver of portraits and decorative subjects after his contemporaries. He was a pupil of W. Dickinson (q.v.) and worked in London. He had his own shop near Piccadilly before entering his father's book-selling business in Golden Square.
'Duchess of Devonshire with Lady Georgiana Cavendish', after J. Reynolds, 1787, 12½ x 15½in/32 x 39.5cm, mezzo., £200-£400.
'A Party Angling', after G. Morland, companion to 'Anglers' Repast', by William Ward (q.v.) after the same, 1789, 18 x 22in/46 x 56cm, mezzo., pair £800-£1,200.
'The Deserter Series', after G. Morland, 1791, 4 pl., 20 x 17in/51 x 43cm, set £1,000-£2,000

prd. in col.
'The Cottage Door' and 'The School Door', after F. Wheatley, 1798, 13¾ x 10¼in/35 x 26cm, stipples, pair £500-£800 prd. in col.
'Rustic Benevolence' and 'Rustic Sympathy', after F. Wheatley, 1797, 20 x 25¼in/51 x 64cm, stipples, pair £600-£1,200 prd. in col.
'The Settling Family Attacked by Savages', companion to 'The Settling Family Secure and Happy', by J. Murphy, after H. Singleton, 1805, 25¼ x 20¼in/65.5 x 51.5cm, mezzo., pair £600-£900 prd. in col.
'Children Playing at Soldiers', after G. Morland, 1798, 17¼ x 21¼in/45 x 55.5cm, mezzo., £200-£300.
'Faith, Hope and Charity', after J. Nixon, mezzo., £40-£60.
'Henrietta, Countess of Stamford', after G. Romney, 1793, 18 x 13in/45.5 x 33cm, mezzo., £150-£200.
'Baron Nelson of the Nile', after H. Singleton, 1798, 18 x 12¼in/45.5 x 32.5cm, imp. prd. in col. in elaborate period frame, fetched £2,000 April 1989.
Various HLs, mezzo., £15-£40.
CS.

KEENE, Charles Samuel 1823-1891
Illustrator, humorous draughtsman and etcher of portraits, landscapes and figure subjects. Born in North London, he taught himself to draw and his illustrations appeared in many books and periodicals from 1842. He is best known as a *Punch* cartoonist. He produced about thirty etchings, mainly in the period 1855-70, and was a member of the Junior Etching Club.
Contemporary imp. £30-£80.
Reprints as published in Twenty-one Etchings *by C. Keene, 1903, fo., e.£10-£30, set fetched £300 April 1996.*

KELIHER, J. fl. late 19th century
Lithographer.
'Uniforms of the Volunteers', after R. Benham, 1892-4, 8½ x 5¼in/21.5 x 13.5cm, chromolitho., e. £5-£15.

KELL, C.F. fl. mid-19th century
Draughtsman and lithographer of architectural views and portraits after his contemporaries. He appears to have been a member of a lithography firm in Holborn.
'The London Central Poultry and Provision Market', after H. Jones, 19 x 29½in/48.5 x 75cm, £150-£300.
Bookplates small value.

KELLAWAY fl. early 19th century
Stipple engraver of small bookplates including portraits.
Small value.

KELSALL, W. fl. mid-19th century
Line engraver of small bookplates including landscapes and architectural views after his contemporaries.
Small value.

KENNERLEY fl. early 19th century
Stipple engraver of small bookplates, including portraits after his contemporaries.
Small value.

KENNINGTON, Eric Henry, R.A. 1888-1960
Painter, sculptor and lithographer of portraits. Born in London, the son of T.B. Kennington (q.v.),

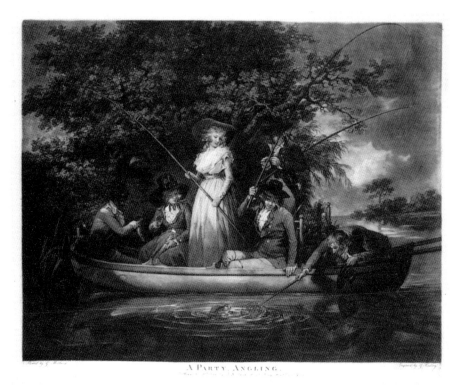

KEATING, George. 'A Party Angling', pair with 'Anglers' Repast', by William Ward, both after G. Morland, 1789.

KENNINGTON, Eric Henry. One of six plates from 'Making Soldiers', 1917.

he studied at Lambeth School of Art and at the City and Guilds School. After being wounded in World War I he was appointed an Official War Artist, a post which he again took up in World War II.
'Making Soldiers', 1917, 6 pl. 18¼ x 14in/46.5 x 35.5cm, set £400-£700.

KENNINGTON, Thomas Benjamin 1856-1910
Painter and etcher of genre subjects and portraits. Born at Grimsby, he studied at the Liverpool College of Art, the R.C.A. and in Paris. He was the father of E.H. Kennington (q.v.) and died in London.
Small value.

KENNION, Edward I 1744-1809
Painter, etcher and aquatint engraver of landscapes. Born in Liverpool, he participated in the capture of Cuba and went into business in London before working as a drawing master and writing instruction books.
Pl. for Elements of Landscape and Picturesque Beauty, *1790, and* An Essay on Trees in Landscapes, *1815, 50 pl., fo., e. £3-£8.*

KENNION, Edward II fl. mid-19th century
Line engraver of small bookplates including landscapes and architectural views after his contemporaries.
Small value.

KENT, William 1684-1748
Well-known Palladian architect who made a very few rare etchings.
£100-£300.

KERNOT, James Harfield fl. mid-19th century
Line engraver of small topographical bookplates including landscapes and topographical views after his contemporaries.
Swiss views £5-£10.
Others small value.

KERR, Henry Wright, R.S.A., R.S.W.
1857-1936
Scottish painter and etcher of portraits and figure subjects. Born in Edinburgh, he studied at the R.S.A. Schools there and worked mainly in Scotland.
Small value.

KERR, Lord Mark fl. early 19th century
Amateur draughtsman and lithographer of grotesque animals and semi-humans.
'The Raven Queen in Her Walking Dress', and other pl., £5-£15.

KERR, Lord Mark. 'The Raven Queen in Her Walking Dress'.

KIDD, Joseph Bartholomew. Plate 32 for 'West Indian Scenery Illustrations: Town of Bath', 1838-40.

KEULEMANS, J.G. fl. mid-19th century
Lithographer of ornithological subjects and topographical views after his contemporaries.
Ornithological pl. after J. Gould £60-£200 col.
Pl. for Capt. W. Kerner's Sketches in the Sudan, 1885, obl. 4to., tt. pl., small value.

KIDD, Joseph Bartholomew, R.S.A.
 1808-1889
Scottish landscape draughtsman who both drew and lithographed West Indian Scenery Illustrations. Born in Edinburgh, he moved to London and later became a drawing master at Greenwich.
Pl. for West Indian Scenery Illustrations, *drawn and litho. by Kidd*, 1838-40, fo., 50 pl., e. £100-£200 col.
West Indies' views, after W.J. Kidd, 1846, 15¼ x 19½in/39 x 49.5cm, tt. pl., e. £60-£100.

KILBURN, William fl. late 18th century
Draughtsman and etcher of botanical subjects.
'Flora Londiniensis', 1777-98, 10½ x 8½in/27 x 22cm, e. £15-£25 col.

KILLINGBECK, Benjamin fl. late 18th century
Etcher, stipple and mezzotint engraver of portraits and animal subjects after his

contemporaries and his own designs.
'Richard, Lord Howe', 1782, 25 x 15¼in/63.5 x 38.5cm, mezzo., £100-£150.
'Charles James Fox', after Killingbeck, 1780, 4¼ x 4½in/12 x 11.5cm, mezzo., £10-£15.
Stipples small value.
CS lists 3 pl., inc. 2 noted above.

KING, Daniel fl. mid-17th century
Draughtsman and etcher of architectural views after his own designs and those of his contemporaries. Born in Chester, he was originally apprenticed to a painter. He moved to London in 1656 where he drew and etched plates in the style of W. Hollar (q.v.), contributing to Dugdale's *Monasticon Anglicanum*, 1655, and producing his own *The Cathedral and Conventual Churches of England and Wales.*
£10-£30.

KING, George fl. early 18th century
Line engraver of bookplates and portraits.
Small value.

KING, Giles fl. mid-18th century
Irish line engraver of some topographical views after W. Jones, and mezzotint engraver of a portrait of Thomas Carter. Born in England, he

settled in Dublin where he practised for many years.
'Thomas Carter', 1745, 14¼ x 10¼in/36 x 26cm, £20-£50.
Views near Dublin, after W. Jones, 1744-5, 4 pl., e. £100-£200.
Bookplates small value.
CS lists the portrait noted above.

KING, J. fl. late 18th century
Etcher of landscapes and topographical views after his contemporaries.
'View of Brading, Isle of Wight', after S. Barth, 1797, 18 x 24in/45.5 x 61cm, £200-£300 col.
'The Rise of the River Dee', after J. Laporte, 1794, 18 x 24½in/45.5 x 62cm, £200-£300 col.

KING, Thomas d.1845
Line engraver of antiquarian subjects and portraits.
Small value.

KINGSBURY, Henry fl. late 18th century
Mezzotint engraver of portraits and sporting and decorative subjects after his contemporaries, Old Master painters and his own designs. He worked in London.
'Daniel Mendoza' (boxer), after J. Robineau, 1789, 22¼ x 17in/58 x 43cm, £200-£400.

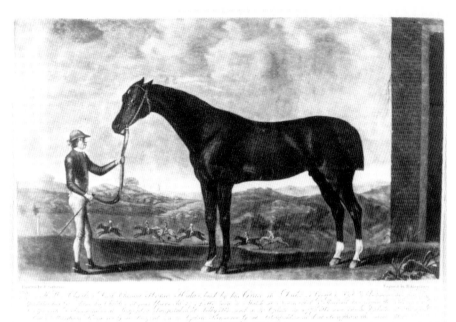

KINGSBURY, Henry. 'Hylas', after F. Sartorius, 1788.

'Linnaeus in Lapland', after Hoffman, 19 x 14in/48.5 x 35.5cm, £100-£160 prd. in col.
'Bacchus, Ceres and Venus', after J. Jordaens, 1780, 9 x 14in/23 x 35.5cm, £10-£20.
'Anthony Webster as Comus', after F. Wheatley, 1781, 19¼ x 14½in/50 x 36.5cm, £60-£140.

'Hylas' (racehorse), after F. Sartorius, 1788, 9¾ x 14¾in/24.5 x 35cm, £150-£300.
'Mrs. Waller', after J. Downman, 1783, 11¾ x 9in/30 x 23cm, £30-£50.
Various male HLs £15-£40.
CS.

KINNEBROOK, W. fl. mid-19th century
Lithographer.
1 pl. for R.R. McIan's Scottish Clans, *1845-7, fo., £20-£50 col.*

KINNERSLEY, T. fl. early 19th century
Line and stipple engraver of small bookplates including portraits after his contemporaries.
Small value.

KIP, Johannes 1653-1722
Dutch etcher and line engraver of topographical views after his contemporaries and his own designs. Born in Amsterdam, he came to England after the Revolution of 1688, and his best work was after the topographical draughtsman Leonard Knyff for *Britannia Illustrata*. He died in Westminster.
Pl. for Britannia Illustrata, *1707-26, fo., e. £50-£150.*
'A Prospect of the City of London, Westminster and St. James's Park', 12pl., 51¼ x 84¼in/130 x 214cm, set £1,200-£2,500.
'The City of Bristol', after H. Blandel, 1717, £300-£500.
'The Royal Hospital at Chelsey', after L. Knyff, 1707, 21¼ x 35in/54 x 89cm, and lge. view of Greenwich Hospital e. £100-£200.
Small bookplates small value.

KIRK, Thomas d.1797
Painter, etcher and stipple engraver of portraits, decorative subjects and military costume plates after his contemporaries. He was a pupil of R. Cosway (q.v.). He died in London.
'Music' and 'Painting', after A. Kauffmann, circles, e. £100-£200 prd. in col. or in sepia.
'Third Regiment of Foot Guards', after E. Dayes, 1792, 6 subjects on 3 pl., e. pl. 12¼ x

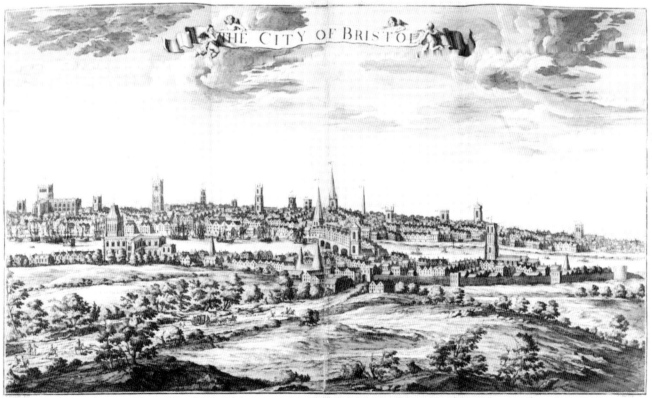

KIP, Johannes. 'The City of Bristol', after H. Blandel, 1717.

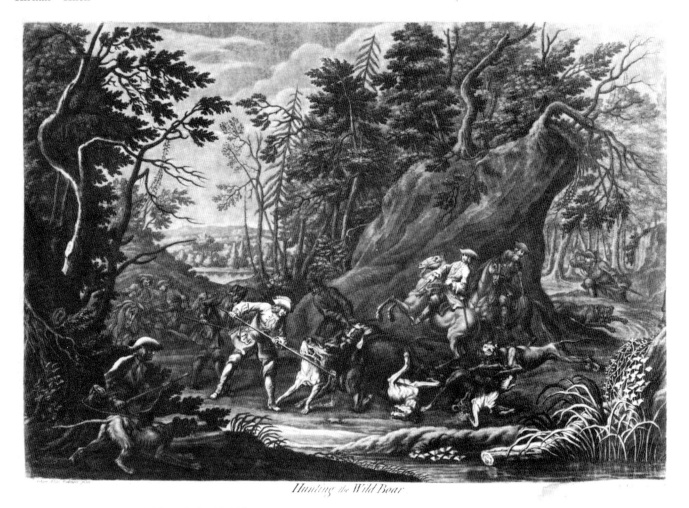

KIRKALL, Elisha. 'Hunting the Wild Boar', after J.E. Ridinger.

13½in/32.5 x 34.5cm, e. pl. £200-£400 col.
'Penelope Boothby' after J. Reynolds, 1796,
approx. 6 x 4in/15 x 10cm, small value.

KIRKALL, Elisha c.1682-1742
Etcher, line and mezzotint engraver of portraits
and biblical, mythological, marine and sporting
subjects after Old Masters and his
contemporaries. Born in Sheffield, he came to
work in London, at first on bookplates, then
developing a method of colour printing using
colours from woodblocks over an etched and
mezzotinted plate. He produced twelve 'chiaro
obscuro' prints after Italian Old Master
drawings between 1722 and 1724. He also used
to print many of his mezzotints using one or
more coloured inks on the plate.
'Sea Pieces', after W. van de Velde, c.1720, 14
mezzo., 17¼ x 12¼in/44 x 31cm, e. £500- £800
prd. in green.
Chiaroscuro prints prd. from metal cut in white
line and two woodblocks, varying sizes, £50-£300.
Pl. for A Catalogue of Trees, Shrubs, Plants and
Flowers, 1730, 4to., e. £30-£60 prd. in col.
'Hunting the Wild Boar', after J.E. Ridinger, 14
x 19½in/35.5 x 49.5cm, £80-£150.
'Francesco Bernardi', after J. Goupy, 12½ x
8½in/32 x 22cm, £20-£60.
Small portraits, bookplates and eng. small
value.
CS lists the portrait noted above.

KIRKLEY, Caroline fl. late 18th century
Mezzotint engraver of portraits after her
contemporaries.
'J. Reynolds', after J. Reynolds, 1795, 14¼ x
11in/37.5 x 28cm, £60-£90.
CS lists 1 pl., noted above.

KIRKPATRICK, Ethel
 fl. late 19th/early 20th century
Painter and colour woodcut engraver of
landscapes, marine and ornithological subjects.
She studied at the R.A. Schools and at the Central
School of Arts and Crafts and lived in Middlesex.
£50-£150.

KIRKWOOD, James fl. mid-19th century
Irish etcher and engraver of portraits and
topographical views after his contemporaries. A
pupil of C. Heath (q.v.), he often collaborated
with his son John, working in Dublin and
Edinburgh.
Portraits small value.
Pl. for Dublin and Kingston Railway Companion,
1834, e. £10-£20.

KIRKWOOD, John *see* **KIRKWOOD, James**

KIRTLAND, G. fl. late 18th century
Etcher and publisher.
'A View of Ramsgate from the East Pier Head',
after E. Dorrell, 1798, 13 x 19in/33 x 48cm,
£80-£140.

KITCHIN, T. fl. mid-18th century
Line engraver of maps and small bookplates
including portraits after his contemporaries and
Old Master painters.
Small bookplates small value.

KLINKICHT, M. fl. late 19th century
Wood engraver of book and magazine
illustrations including portraits after
photographs. He engraved supplements to *The
Illustrated London News.*
Small value.

KNAPTON, Charles fl. mid-18th century
Etcher of imitations of Old Master drawings.
Between 1732 and 1736, he collaborated with
A. Pond (q.v.) to produce seventy plates, mainly
landscapes, many overprinted with a tinted
woodblock to imitate wash drawings. After
1736 he turned to publishing landscape
engravings with Pond.
£5-£15.

KNELL, William Adolphus c.1805-1875
Marine painter who also engraved a few plates
in aquatint. Several of his own paintings were
engraved by professionals.
'The Capture of St. Jean d'Acre', after
F.K. Hawkins, 1841, 10 x 20½in/25.5 x 52cm,
£250-£400 col.

KNIGHT, Charles I 1743-c.1826

Stipple engraver of portraits and decorative, historical and sporting subjects after his contemporaries. He is said to have been a pupil of F. Bartolozzi (q.v.).

'The Favourite Rabbit' and 'Tom and his Pidgeons', after J. Russell, 1792, 14 x 10¾in/35.5 x 27.5cm, pair £300-£500 prd. in col.

'The Landlord's Family' and 'The Tenant's Family', after T. Stothard, 20¼ x 16¾in/53 x 42.5cm, pair £500-£800 prd. in col.

'British Plenty' and 'Scarcity in India', after H. Singleton, 20 x 16in/51 x 40.5cm, pair £800-£1,400 prd. in col.

'The Elopement' and 'The Tired Soldier', after J. Opie, 1806, 25½ x 19¼in/64.5 x 49cm, pair £500-£800 prd. in col.

'Palemon and Lavinia', after A. Kauffmann, oval, £50-£150 prd. in red.

Pl. for H.W. Bunbury's Illustrations to Shakespeare, e. £40-£80 prd. in col.

'Lady Hamilton as a Bacchante', after G. Romney, 15 x 11½in/38 x 29cm, £400-£600 prd. in col.

'Foxhunting', after T. Hand, 1808, aq. by H. Merke, 19¾ x 26¼in/50 x 66.5cm, £400-£600 col.

'Tragic Readings' and 'Comic Readings', after R. Boyne, 17 x 21in/43 x 53.5cm, pair £400-£700 prd. in col.

'A Barber's Shop', after H.W. Bunbury, 1803, £200-£300 prd. in col.

'John, 4th Duke of Atholl', after J. Hoppner, 1811, 22¼ x 14¾in/56.5 x 37.5cm, £15-£35.

'Sir Nathaniel Dance', after G. Dance, 1804, 3 x 2½in/7.5 x 6.5cm, £10-£25 prd. in col.

Small portraits in black small value.

Colour plate page 47.

KNIGHT, Charles II fl. mid-19th century

Line, stipple, mezzotint and mixed-method engraver of portraits and historical and sentimental subjects after his contemporaries.

'Approach of the Muse', after E. Hopley, 1861, 13¼ x 7½in/33.5 x 19.5cm, £10-£20.

'Charles I Presenting the Bible to Bishop Juxon on the Morning of his Execution', after S. Blackburn, 1855, 20¼ x 25½in/51.5 x 65cm, £30-£90.

'Naval Heroes', after D. Cooper, 1858, 21¼ x 35in/55 x 89cm, £200-£400.

'Tigers at Play' and 'Feline Affection', after B. Bradley, 1878, 17 x 24in/43 x 61cm, pair £150-£300.

Add more if in fine contemporary frame.

KNIGHT, J. fl. mid-19th century

Line and mezzotint engraver of figure subjects and animals after his contemporaries. He may be the same person as T. or T.W. Knight.

'Hunter' and 'Park Hack', after J.F. Herring, 1860, 14½ x 11½in/37 x 29cm, from British Horses Series, e. £80-£160.

Small bookplates small value.

KNIGHT, John William Buxton, R.E. 1842-1908

Painter, etcher and mezzotint engraver of landscapes. Born at Sevenoaks, Kent, he taught himself to paint. He worked mainly in Kent and contributed plates to The Etcher and English Etchings.

Small value.

KNIGHT, Joseph I, R.E. 1838-1909

Painter, mezzotint engraver and etcher of landscapes. Born in Manchester, he taught himself to paint. He moved to London in 1871 and in 1875 finally settled near Conway in North Wales.

£5-£15.

KNIGHT, Joseph II 1870-1952

Painter and etcher of landscapes. Born in Bolton, he studied in Paris and was Headmaster of Bury School of Art in Lancashire.

£15-£40.

KNIGHT, Dame Laura, R.A., R.W.S., R.E. 1877-1970

Painter, etcher, aquatint, mezzotint and wood engraver of figure subjects and landscapes. Born in Derbyshire, she studied at Nottingham School of Art and at the R.C.A. She married Harold Knight in 1903 and lived in Yorkshire, Cornwall and London. Life in the theatre, circus and music hall formed the subject matter for her best known prints, and her use and combination of all the etching and engraving methods show her interest in technique.

'Some holiday', 13¾ x 9¾in/35 x 25cm, aq., £400-£600.

'The Sleeping Darkie', woodcut, £60-£120.

'The Bare-back Rider', 9¾ x 5in/25 x 12.5cm, etching, £400-£700.

'At the Footlights', aq., £200-£400.

'The Southern Blonde', mezzo., £120-£200.

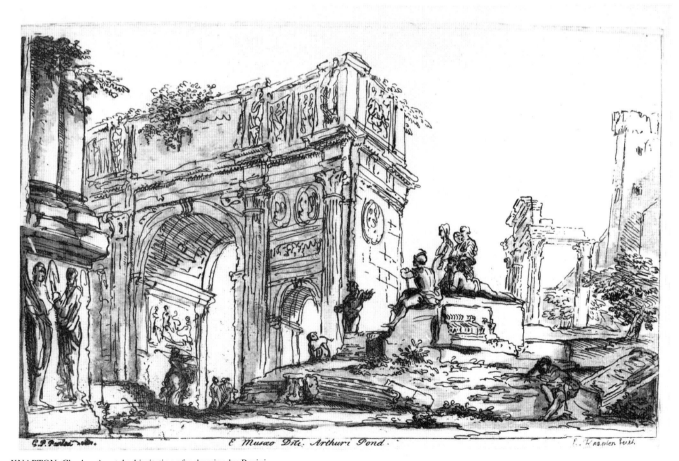

KNAPTON, Charles. An etched imitation of a drawing by Panini.

KNIGHT, Dame Laura. 'Some Holiday', aquatint.

Bibl: Bolling, G.F. and Withington, V.E., *The Graphic Works of L.K.*, 1993, Aldershot.

KNIGHT, T. fl. mid-19th century
Mezzotint engraver. He may be the same person as J. Knight or T.W. Knight (qq.v.).
'A Sailor Boy's Dream of Home', after T. Brooks, 1860, 29½ x 22¼in/75 x 56.5cm, £40-£100.
Add more if in fine contemporary frame.

KNIGHT, T.W. fl. mid-19th century
Line engraver of small bookplates after his contemporaries and British 18th century painters including portraits and figure subjects. He may be

the same person as J. or T. Knight (q.v.).
Small value.

KOMJATI, Julius, A.R.E. 1894-1958
Hungarian etcher of figure subjects and landscapes. He is mentioned here because he visited London in the 1920s on a travelling scholarship to study the graphic arts and a number of his etchings were published there. He was a pupil of M. Osborne (q.v.). The subjects of many of his plates were based on his war time experiences when he was captured by the Romanians.
£60-£140.
Bibl: Salaman, M.C., 'The Etchings of J.K.', *P.C.Q.*, 1933, XX, p.247.

KRAMER, Jacob 1892-1962
Painter and lithographer of portraits and figure subjects. Born in the Ukraine, he came to England in 1900 when his parents settled in Leeds. He studied at the Slade.
'The Philosopher', 18 x 11¾in/45.5 x 30cm, £200-£300.
'Head of Epstein', 22¾ x 17¾in/58 x 45cm, £300-£400.
'Self-Portrait', c.1931, 15¼ x 10¾in/39 x 27.5cm, £140-£200.
'(Vorticist Figure)', 16¼ x 9¾in/41.4 x 25cm, fetched £1,300 Oct. 1987.
Others mostly £30-£80.
Ref: Grose.

KRATKE, Charles Louis 1848-1921
Parisian painter and etcher of landscapes and figure subjects after his French contemporaries, early 19th century English painters and his own work.
£10-£30.

KYTE, Francis fl. early/mid-18th century
Mezzotint engraver of portraits and religious subjects after Old Master painters and his contemporaries. In 1725 he was pilloried for

KYTE, Francis. 'Mr. John Sturges', after J. Vanderbank, 1733.

forging coins and then Latinised his name to Milvus.
'John Gay', after W. Aikman, 13¼ x 10in/35 x 25.5cm, £20-£50.
'Mr. John Sturges', after J. Vanderbank, 1733, £40-£80.
Other male HLs £15-£40.
'Henrietta, Countess of Godolphin', after G. Kneller, 13¼ x 9¾in/33.5 x 25cm, £30-£70.
'Worthies of Britain, 6 pl., e. pl. with 4 ovals, 14 x 10in/35.5 x 25.5cm, set £200-£300.
CS.

LABY, A fl. mid-19th century
Lithographer of portraits and military and genre subjects after his contemporaries and his own designs.
Pl. for Capt. G.F. Atkinson's Campaign in India, *1859, fo., tt., £8-£15.*
Pl. for Capt. G.F. Atkinson's Curry and Rice, *1860, 4to., tt., £3-£8.*
'Views of Niagara Falls', after Maj. H. Davis, with J. Needham (q.v.), 1848., elephant fo., chromolitho., e. £200-£400.
Portraits small value.

LA CAVE, F. Morellon fl. mid-18th century
Line engraver of small bookplates and portraits after his contemporaries and 17th century painters.
Small value.

LA CAVE, Peter fl. late 18th/early 19th century
Watercolourist of landscapes and rustic scenes who etched a few plates.
2 views of Cheltenham, 15 x 24in/38 x 61cm, pair £300-£400 col. by artist.

LACEY, Edward Hill b.1892
Drypoint etcher and aquatint engraver of portraits and figure subjects. Born in Bradford, he lived in London.
£20-£60.

LACEY, Samuel fl. mid-19th century
Line engraver of small bookplates after his contemporaries including landscapes and topographical views.
Swiss, German and American views e. £5-£10.
Others small value.

LACEY, W. fl. mid-19th century
Line engraver of small bookplates after his

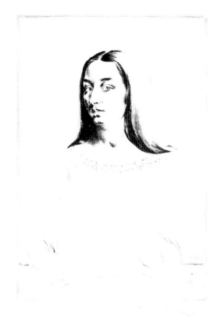

LACEY, Edward Hill. Portrait, 1927.

contemporaries including landscapes and topographical views.
German views £5-£10.
Others small value.

LACK, Henry Martyn, R.E. 1909-1980
Etcher of landscapes and architectural views. He studied at Leicester College of Art and at the R.C.A. where he taught in the Engraving School, 1947-53. He later lived in Hastings.
£30-£70.

LACOUR, Octave L. fl. late 19th century
Painter and etcher of portraits and figure subjects after his contemporaries and early 19th century painters. He worked in and near London.
Small value.

LADBROOKE, John Berney 1803-1879
Norwich School painter and occasional lithographer of landscapes and topographical views. Born in Norwich, he was a pupil of his uncle, J. Crome (q.v.) and spent most of his life in Norfolk.
'Select Views of Norfolk and its Environs', 1820-22, e. £5-£15.

LADBROOKE, Robert 1770-1842
Landscape painter, draughtsman and lithographer of architectural views. Born in Norwich, he was a friend of J. Crome (q.v.) and married his sister-in-law. In 1803 he founded the Norwich Society with Crome, but later quarrelled with him and put on alternative exhibitions before rejoining the Society in the 1820s. He lithographed and published his views of Norfolk Churches in five vols.
£5-£15.

LAGUILLERMIE, Frederick Auguste b.1841
French painter and etcher of portraits, genre subjects, illustrations, etc., after Old Master painters, British 18th century artists and his French and English contemporaries.
Pl. after J.E. Millais £15-£50.
'Coronation of Edward VII', after E.A. Abbey, 1906, 22½ x 36⅞in/57 x 93.5cm, £100-£300.
Add more if in fine contemporary frame.
Others small value.

LAHEE, J. fl. early 19th century
Lithographer.
'Gamekeepers and Poachers' and 'Wild Fowl Shooting', after H. Alken, 1822, 9¼ x 5½in/23.5 x 14cm, pair £100-£200 col.

LAING, Frank, A.R.E. b.1862
Scottish painter and etcher of landscapes and architectural views. He was a friend and follower of J.A.M. Whistler (q.v.).
£40-£100.

LAING, John Joseph 1830-1862
Scottish wood engraver of book illustrations after his contemporaries. He was born in and worked in Glasgow, later moving to London.
Small value.

LAKE, W. fl. mid-19th century
Lithographer.
'Prince Albert Reviewing the Bands of the Royal Artillery and Coldstream Guards', 9¼ x 7½in/25 x 19.5cm, £20-£30 col.

LACK, Henry Martyn. A typical landscape.

LADBROOKE, John Berney. 'Bramerton Church', 1822. from 'Select Views of Norfolk and its Environs'.

LALAUZE, Adolphe. 'A Love Story', after F. Dicksee, 1884.

LANCASTER, Percy. 'Print Connoisseurs'.

LALAUZE, Adolphe 1838-1906
French painter and etcher of portraits and
sentimental subjects after Old Master painters
and his French and British contemporaries.
*'A Love Story', after F. Dicksee, 1884, 15 x
20½in/38 x 52cm, £30-£90.*
Add more if in fine contemporary frame.
Pl. after Meissonier £20-£80.
Portraits and pl. after Old Masters small value.

LAMB, H. fl. mid-19th century
Draughtsman, lithographer and publisher of
topographical views. He worked in Malvern and
Cheltenham.
*5 views of Cheltenham, c.1830, obl. fo., e. £20-
£40.*
*'Sketches of Malvern and its Vicinity', c.1820,
obl. 4to., £15-£35 col.*

LAMBERT, Mark 1781-1855
Wood engraver of book illustrations. He was an
assistant of T. Bewick (q.v.) and died in
Newcastle.
Small value.

LAMBORN (Lamborne), Peter Spendelove
1722-1774
Miniaturist, draughtsman and etcher mainly of
small bookplates including architectural views
and portraits. Born in London, he worked in
Cambridge where he died.
*'View of Trinity College Bridge . . . Cambridge',
16 x 24in/40.5 x 61cm, £80-£160.*
Small bookplates small value.

LAMY, P. fl. mid-18th century
Line engraver of topographical views after his
contemporaries. He appears to have worked in
London.
*'Perspective Views of Villages, Country Houses
and Gardens on Either Side of the River Vecht
Between Utrecht and Muyden', after C. Bruin,
10 pl., 7½ x 10½in/19 x 25.5cm, e. £50-£150 col.*

LANCASTER, Percy, A.R.E. 1878-1951
Landscape painter, etcher of figure subjects and
landscapes. Born in Manchester, he originally
trained as an architect before turning to art. He
lived and worked in Southport.
'Print Connoisseurs' and others £20-£60.

LANDELLS, Ebenezer 1808-1860
Wood engraver of illustrations for newspapers
and periodicals. Born in Newcastle, he was a
pupil of T. Bewick (q.v.) and lived and worked
in London.
Small value.

LANDER, Edgar Longley b.1883
Watercolourist and etcher of figure subjects. He
lived in London.
£6-£12.

LANDON, C.P fl. mid-18th century
Line engraver of small bookplates including
portraits.
Small value.

LANDSEER, Sir Edwin Henry, R.A.
1802-1873
Famous Victorian animal and portrait painter
who made a number of prints mostly early in his
career. Many of his paintings and drawings
were reproduced by professional engravers and
lithographers, including his father J. Landseer
and his brother T. Landseer (qq.v.).
*2 groups of etchings mainly of animals, 1809
(aged 7) to 1812, and 1822 to 1826, e. £30-
£100.*
*'A Norwich Terrier', 1842, 6 x 4½in/15 x
11.5cm, extremely rare pl. made for Queen
Victoria when L. was teaching her etching,
£150-£300*
2 litho. after Count d'Orsay, 1843, e. £50-£80.

LANDSEER, H. fl. early 19th century
Stipple engraver of portraits after his
contemporaries.
*'Francis, 1st Marquis of Hastings (when Earl of
Moira) as Grand Master of Free Masons', after
J. Hoppner, 1804, 18½ x 15in/47 x 38cm, £15-£30.*
*'Mrs Mullens', after W.M. Craig, 1807, 11½ x
8in/29 x 20.5cm, £40-£70 prd. in col.*
Small bookplates and vignettes small value.

LANDSEER, John, A.R.A. 1769-1852
Painter, line, stipple and aquatint engraver,
mainly of small bookplates including
landscapes, topographical views and figure
subjects after his contemporaries and Old
Master painters. Born in Lincoln, he was

apprenticed to W. Byrne (q.v.), and was the
father of E. Landseer and T. Landseer (qq.v.).
He spent much time fighting to gain recognition
for engravers from the R.A. He died in London.
*'The China Limodoron', after P. Henderson,
from R. Thornton's* Temple of Flora, *1802, 21 x
16in/53.5 x 40.5cm, £300-£500 prd. in col.*
*Pl. after J.M.W. Turner, when proofs or early
imp., £20-£80.*
*Other bookplates and small portraits small
value.*

LANDSEER, Thomas, A.R.A. 1795-1880
Etcher, line, mezzotint and mixed-method
engraver of animal and figure subjects, portraits
and landscapes after his contemporaries and his
own designs. Born in London, he was the son
and pupil of J. Landseer (q.v.), and the elder
brother of E. Landseer (q.v.) many of whose
paintings he engraved. His first plate, 'A Bull',
was etched in 1811 after a drawing by his
brother aged nine, and he engraved the majority
of Edwin's most famous paintings, including
'Dignity and Impudence', 'Laying Down the
Law', 'The Monarch of the Glen', 'The Stag at
Bay'.
*'Monkeyana, or Men in Miniature', after his
own drawings, 1827, 24 pl., 8 x 6¼in/20 x 16cm,
e. £10-£20.*
*'Celebrated Short Horned Cow Bracelet', after
P. Forster, c. 1843, 16 x 19½in/40.5 x 50cm,
£400-£700.*
*'Princess Alice', after E. Landseer, 1845, 10¼ x
9¼in/27.5 x 23.5cm, £10-£20.*
*'Jacob Bell', after E. Landseer, 1869, 14¼ x
11in/36 x 28cm, £10-£20.*
*'A British Boar' and 'A French Hog', after
E. Landseer, 1818, 12½ x 18in/32 x 45.5cm, pair
£500-£800 col.*
*'Queen Victoria on a White Horse', after
E. Landseer, 1875, 28 x21in/71 x 53.5cm, £150-
£300.*
'The Lost Sheep', after E. Landseer, £100-£200.
*'The Stag at Bay', after E. Landseer, 1848, 20½
x 36½in/52 x 92.5cm, £400-£600.*
*'The Monarch of the Glen', after E. Landseer,
1852, 28¾ x 27¼in/73 x 70.5cm, £600-£800.*
*'Three Members of the Temperance Society',
after J.F. Herring, 1847, 24 x 32in/61 x 81.5cm,
£200-£400.*

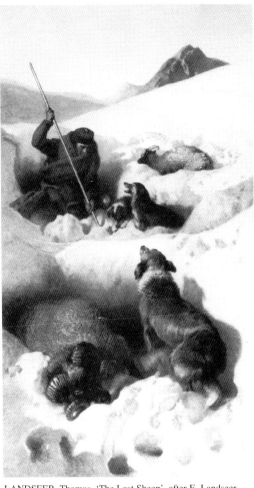

LANDSEER, Thomas. 'The Lost Sheep', after E. Landseer.

LANE, Theodore. 'An Old Friend with a New Face or the Baron in Disguise', 1821.

Add more to last 5 titles if in fine contemporary frame.
Small bookplates and pl. for the Annuals small value.

LANE, Richard James, A.R.A. 1800-1872
Prolific Victorian lithographer of portraits and figure subjects after his contemporaries and Old Master painters as well as his own designs. Born in Hereford he was a pupil of C. Heath (q.v.). He did several portraits of the Royal Family and was appointed Lithographer to Queen Victoria in 1837 and to Prince Albert in 1840. He died in Kensington.
'Mlle. Taglioni' (dancer), after A.E. Chalon, 1834, 14¼ x 9in/37.5 x 23cm, £300-£400 col.
'Prince of Wales on the Moors', after W.L. Price, with J.H. Lynch (q.v.), 1858, 20¼ x 14in/52.5 x 35.5cm, £80-£200.
Other lge. pl. £20-£100.
Add more if in fine contemporary frame.
Vignettes and small portraits small value.
Pl. after Old Masters small value.

LANE, Theodore 1800-1828
Portrait painter, miniaturist, etcher of caricatures and humorous subjects. Born in Middlesex, he was apprenticed to J.C. Barrow. His best known prints are a series of caricatures relating to the trial of Queen Caroline. He was killed when he fell through a skylight in Gray's Inn Road.
'An Old Friend with a New Face or the Baron
in Disguise', 1821, and other political caricatures mostly e. £40-£100 col.
'Masquerade, Argyll Rooms', 1826, etching aq. by G. Hunt (q.v.), 11¼ x 18¼in/30 x 46.5cm, and other large caricatures, £200-£400.
'Rackets', etching aq. by G. Hunt, 8¼ x 12¼in/22 x 31cm, £200-£400 col.
Pl. for P. Egan's Anecdotes, *1827, 8vo., e. £10-£20 col.*

LANE, William 1746-1819
Portrait painter who engraved a few stipples after his contemporaries.
'Mrs. Abington', after R. Cosway, 1790, 4¾ x 3in/12 x 7.5cm, £20-£50 prd. in col.
'Hon. Mrs. Spencer', after J. Reynolds, 1819, 6¼ x 7¼in/16 x 18.5cm, £50-£90 prd. in col.
Add more if in fine contemporary frame.

LANGLEY, Thomas d.1751
Line engraver mainly of bookplates including architectural views, antiquities, etc.
Small value.

LANGMAID, Rowland 1897-1956
Painter and etcher of marine subjects. He was a pupil of and imitator of W.L. Wyllie (q.v.). He served in the Royal Navy and lived in London.
London views £40-£90.
Others £15-£50.

LAPORTE, John 1761-1839
Draughtsman, etcher and aquatint engraver of
landscapes and topographical views after his own drawings and those of his contemporaries. He was drawing master at Addiscombe Military Academy and published several drawing books. He died in London.
Views of Irish Scenery, 1812-16, 24 pl., aq., e. £20-£50 col.
'Six Views in Dumfriesshire', after Rev. J. Wilkinson, 1812, obl. fo., soft-ground etchings, e. £15-£40 col.
Pl. for Laporte's Sketch Book, *1829, 24 pl., obl. 4to., etchings, e. small value.*
Pl. for T. Gainsborough's English Scenery, *1819, fo., soft- ground etchings, e. £5-£10 col.; small value uncol.*
(Man seated under tree, two cows standing), c.1804, 11½ x 15¼in/29.5 x 39cm, rare unrecorded early litho. £100-£200.

LARKINS, William Martin, A.R.E. b.1901
Painter and etcher of architectural views and occasional genre subjects. Born in London, he studied at Goldsmiths' College Art School and was a pupil of E.J. Sullivan and M. Osborne (qq.v.).
£80-£200.
Bibl: Laver, J., 'The Etched Work of W.M.L.', *Bookman's Journal*, 1926, XIV, p.157; Cooke, G., *Etchings of the East End in the 1920s and Other Scenes*, Robin Garton, 1979.

LAROON, Marcellus, the Elder 1653-1702
Dutch portrait and historical painter who engraved

LARKINS, W.M. Bush House, Aldwych.

LAURIE, Robert. 'A North View of Hanover Square', 1794, engraving.

Master painters. He was born in London where he lived and worked. He invented a method of printing mezzotints in colours for which he received a premium from the Society of Arts in 1776. He also published prints in partnership with James Whittle, having taken over Robert Sayer's firm at the Golden Buck in Fleet Street. Their main line of business was in topographical views, which were often unsigned by the engraver.

'The Full' and 'The Wane of the Honeymoon', after F. Wheatley, 1789, 18 x 24in/45.5 x 61cm, pair £400-£600.
'The Lion and Horse', after G. Stubbs, 1791, 18 x 22¼in/45.5 x 55.5cm, £800-£1,600.
'The Frighten'd Horse', after G. Stubbs, 1788, mezzo., £800-£1,600.
'The Flemish Rat Catcher', after A.van Ostade, 18 x 14in/45.5 x 35.5cm, £10-£20.
'The Rival Milliners', after J. Collet, 9¾ x 13¼in/25 x 33.5cm, £100-£300.
'Arthur Wentworth of Bulmer, near Castle Howard, Yorkshire', after N. Drake, 10¼ x 14in/27.5 x 35.5cm, £60-£100.
'Hawk and Prey', after S. Elmer, 1803, 20 x 13¾in/50.5 x 35cm, £200-£300.
'Mr. Shutter, Mr. Quick and Mrs. Green, in She Stoops to Conquer', after T. Parkinson, 1776, 17¾ x 22in/45 x 55.5cm, £100-£250.
'Elizabeth, Duchess of Brandoin . . . ', after C. Read, 1771, 18 x 14in/45.5 x 35.5cm, £40-£90.
'Queen Charlotte', 1774, 19¼ x 14in/50 x 35.5cm, £100-£200.
'David Garrick', after T. Parkinson, 1779, 22¾ x 17¾in/57.5 x 45cm, £200-£300.
'Actors', after R. Dighton, 1779, 12 pl., 6 x 4½in/15 x 11.5cm, set £400-£600.
Various male HLs £15-£40.
Topographical views publ. by Laurie & Whittle, depending on place interest, 'A North View of Hanover Square', 1794, eng., £80-£160 col., others mostly £40-£200 col.
'A View of the Taking of Quebec, Sept. 13th, 1759, Showing the Manner of Debarking the English Forces', 1797, 12½ x 18½in/32 x 47cm, £200-£300 col.
CS.

LAVRIN, Nora (Nora Fry) b.1897
Illustrator and etcher of landscapes and genre subjects. She studied at Liverpool School of Art and in Paris and was married to a Yugoslavian, Jango, whose books she illustrated. Many of her prints are of Yugoslavian scenes.
£30-£90.

LAW, David, R.E. 1831-1901
Painter and etcher of landscapes after his own designs, those of his contemporaries and early 19th century painters. Born in Edinburgh, he was apprenticed to G. Aikman (q.v.) and worked in the Ordnance Survey Office in Southampton for twenty years before turning to painting and etching full time. He died in Worthing.
Small value.

LAWRANSON, William fl. mid-18th century
Irish mezzotint engraver of portraits after his own designs. The son of a portrait painter.
'Thomas Lawranson' (artist's father), 6¼ x 4¼in/16 x 12cm, £10-£40.
'William Smith as Iachimo in Cymbeline', 1772, 20¼ x 15in/52.5 x 38cm, £100-£200.

LAWRENCE, Edith 1890-1973
Colour linocut artist in the school of W.C. Flight (q.v.).
£50-£150.

a few mezzotints for English printsellers. Born at The Hague, he died in Richmond. He is best known as the draughtsman of the 'Cries of London' · engraved by J. Savage (q.v.).
£100-£200.

LASCELLES, Thomas W. fl. late 19th century
Mezzotint engraver after his contemporaries.
'The Nest', after H. Caffieri, 1889, 13 x 9½in/33 x 24cm, small value.

LASINIO, C. fl. early 19th century
Mezzotint engraver of small portraits after his contemporaries.
Portraits approx. 6¼ x 5in/16 x 12.5cm, e. £10-£20 prd. in col.

LAURIE, C. fl. late 19th century
Etcher of small portraits and vignettes.
Small value.

LAURIE, (Lawrie, Lowry), Robert
fl. late 18th/early 19th century
Mezzotint engraver of portraits, caricatures, decorative, religious, classical and sporting subjects after his contemporaries and Old

LAWRIE, R. *see* **Laurie, Robert**

LEACH, Bernard Howell b.1887
Well-known potter who produced a few
etchings early in his career. After studying
pottery in Japan and working there for ten years,
he settled in St. Ives, Cornwall in 1920.
£30-£90.

LEAR, Edward 1812-1888
Important painter, draughtsman and etcher of
ornithological subjects, landscapes and
topographical views. Born in Highgate,
London, he was already producing natural
history drawings by the age of fifteen. He not
only contributed bird plates to the publications
of J. Gould (q.v.), as well as drawing the
illustrations for Lord Derby's *Knowsley
Menagerie*, 1856, but also produced his own
famous illustrations of parrots.
Later, he became exclusively a landscape painter
and topographical draughtsman, having begun
extensive travels abroad in the early 1830s. Much
of this work consists of Mediterranean views, but
he also visited Egypt, the Holy Land, India and
Ceylon. From the 1850s he returned to England
rarely, and died in San Remo. He is also well-
known for his *Book of Nonsense*.
*Illustrations of parrots, 1830-2, 42 pl., fo., e.
£300-£700 col. (set col. fetched $210,000 June
1989).*
'Birds of Europe', 1832-7, e. £60-£130 col.
*'Illustrated Excursions in Italy', 1846, 4to.,
tt.pl., e. £10-£20.*
*'Views in Rome and its Environs', 1841, 26 pl.,
fo., £20-£50.*
*'Views in the Seven Ionian Islands', 1863, 20
pl., fo., e. £50-£90.*

LEBLOND, Abraham 1819-1894
LEBLOND, Robert 1816-1863
Brothers who established a firm of engravers
and printers in Walbrook, London (Leblond &
Co.) c.1840, and in 1849 became G. Baxter's
(q.v.) principal licensees, copying many of the
latter's prints. They are best known for the set of
their 'Thirty-two Ovals'.
Ovals e.£30-£80.
Needle-box prints small value.
Copies of Baxter's prints £5-£15.
Bibl: Courtney Lewis, C.T., *The Leblond Book*,
1920.
Colour plate page 48.

LEBRETON, Louis d.1866
French painter, draughtsman and lithographer
of marine subjects who worked in London for
several years.
*'Engagement between the Kearsage and the
Alabama', £500-£800 col.*
*'The First French Paddle Steamer, Aubes,
Crossing to America', £200-£300 col.*
'View of Sacramento, California', 1850, £500-£800.
Others mostly £20-£50 col.

LE COEUR, H. fl. late 18th century
Stipple and line engraver of small bookplates
including portraits after his contemporaries.
Small value.

LE CONTE, John fl. mid-19th century
Stipple, line and mezzotint engraver of
portraits, sporting and sentimental subjects after
his contemporaries and Old Master painters. He
appears to have worked in Edinburgh.
*'The Curling Match of the Royal Caledonian
Curling Club at Linlithgow', after C. Lees,
1858, 22½ x 37¼in/57 x 94.5cm, £200-£400.*

LAURIE, Robert. 'The Frighten'd Horse', after G. Stubbs, 1788, mezzotint.

LEAR, Edward. One of twenty plates from 'Views in the Seven Ionian Islands: View from the Castle Hill, looking towards Monte Skopo-Zante', 1863.

*'Preparing for the Promised Land', after
W. Macduff, 9½ x 11in/24 x 28cm, £10-£30.*
*'James Watt', after J. McDonald, 1858, 17 x
13in/43 x 33cm, £20-£40.*
Add more if in fine contemporary frame.
Small portraits and bookplates small value.

LEE, John d.1804
Wood engraver of book illustrations who
worked in London.
Small value.

LEE, Rupert Godfrey 1887-1959
Sculptor, painter and woodcut engraver of
animal subjects. Born in Bombay, he studied at
the R.A. Schools and at the Slade. He lived in
Sussex and Spain.
£20-£50.

LEE, Sydney, R.A., R.W.S., R.E. 1866-1949
Painter, etcher, wood and aquatint engraver of
landscapes and townscapes. Born in

LEGROS, Alphonse. A typical landscape etching.

LEIGHTON, Clare Veronica Hope. 'Cutting'.

Manchester, he studied at the School of Art there and also in Paris. He worked extensively in Europe and lived in London.
Venetian scene, 1927, wood eng., and others £30-£70.

LEECH, John 1817-1864
Illustrator, painter, etcher and lithographer of humorous subjects, especially hunting scenes. Born in London, he originally trained as a doctor before making a career of illustration. He is best-known for his work for *Punch* as well as his illustrations to R.S. Surtees' *Jorrocks* books. He died in Kensington.
'Sketches in Oil', 1865-6, 16¼ x 24¼in/41.5 x 63cm, chromolitho. mounted on card with titles in facsimile prd. below, e.£60-£180.
'The Rising Generation', 12 pl., litho., set £150-£250 col.
Etched pl. for Surtees' Jorrocks books, e. £10-£25 col.
Other bookplates small value.

LEE-HANKEY, William *see*
HANKEY, William Lee-

LEEPER, Reginald Mervyn Charles b.1897
Irish-born painter and etcher of landscapes. He studied at Chelsea Polytechnic and in Paris and worked in London and France.
£30-£70.

LEGAT, Francis 1755-1809
Line engraver of decorative and historical subjects and portraits after his contemporaries. Born in Scotland, he was a pupil of A. Runciman (q.v.) and in 1780 came to London where he worked for J. Boydell (q.v.). He was later appointed Engraver to the Prince of Wales.
Pl. for Boydell's Shakespeare e. £10-£25.
'The Death of Gen. Sir Ralph Abercrombie', after T. Stothard, 19 x 24in/48.5 x 61cm, £80-£140.

LEGOUX, Louis fl. 1789-1808
Stipple engraver of small bookplates including

portraits after his contemporaries. He was a pupil of F. Bartolozzi (q.v.).
Small value.

LEGROS, Professor Alphonse, R.E.
 1837-1911
French painter, lithographer and etcher of portraits, figure subjects and landscapes. Born in Dijon, he settled in England in 1863 and taught etching at the R.C.A., later becoming Professor of Art at the Slade, 1876-92. He produced over seven hundred plates, mostly landscapes which are often monotonous; his portraits can be of greater interest.
Mainly e. £20-£60 for signed imp.; collection of 189 plates sold for £11,000 June 1989.
Some publ. in The Studio *in lge. edn. £8-£20.*
'Ridley, Legros, Madame Edwards and Edwards at Sunbury', 6½ x 9½in/16.5 x 24cm, £60-£90.

LEIGHTON BROS. fl. mid-19th century
Chromolithographers.
'The Rifle Contest, Wimbledon', 1864, 16¼ x 23½in/42.5 x 59.5cm, £80-£140.
'British Troops on the March, Canada', 1862, 12½ x 17¼in/32 x 44cm, £60-£120.

LEIGHTON, Clare Veronica Hope, R.E.
 1900-89
Painter, illustrator and wood engraver of rural subjects, animals and portraits. Born in London, she studied at Brighton School of Art and at the Slade. She later emigrated to the U.S.
'Cutting' and others generally £60-£140, but some subjects executed in the U.S., e.g. 'Stoking' and 'Breadline, New York' have fetched prices in the region of $600 to $800.

LEIGHTON, Frederic, Lord 1830-1896
Famous Victorian painter of neo-classical subjects. While many of his works were reproduced by professional engravers, he executed a few etchings himself.
'Pastorale', 1867, 7¾ x 4in/19.5 x 10.5cm, as publ. in Gazette des Beaux-Arts, *£60-£140.*

LEIGHTON, George C. fl. mid-19th century
Wood engraver, mainly of book and magazine illustrations.
'Panorama of London', after R. Sandeman, 1849, 5½ x 264in/14 x 670.5cm, £200-£400.
Others small value.

LEKEUX, Henry 1787-1868
Line engraver of small bookplates including landscapes, architectural views, antiquities, etc., after his contemporaries. Born in London, he was the brother of J. Lekeux (q.v.) and was apprenticed to J. Basire II (q.v).
Small value.

LEKEUX, John 1783-1846
Line engraver of small bookplates including architectural views and antiquities after his contemporaries. Born in London, he was the brother of H. Lekeux and the father of J.H. Lekeux (qq.v.). He originally worked as an engraver on pewter and was then apprenticed to J. Basire II (q.v.).
Small value.

LEKEUX, John Henry 1812-1896
Line engraver of small bookplates including architectural and topographical views after his contemporaries. Born in London, he was the son of J. Lekeux (q.v.) and a pupil of J. Basire II (q.v.). He designed and patented a process for printing steel engravings with one or more tints.
Small value.

LEMON, Henry fl. 1847-80
Line engraver of portraits and genre and sentimental subjects after his contemporaries. He worked in London.
'Football', after T. Webster, 1864, 15½ x 35¼in/39.5 x 91cm, £200-£400.
'Punch and Judy', after T. Webster, 1859, 22 x 45in/56 x 114.5cm, £60-£140.
'The Beaconsfield Cabinet', after C. Merter, 1874, 40 x 52in/101.5 x 132cm, £150-£300.
'Edward, Prince of Wales, on Horseback', 1863, 22½ x 25in/57 x 63.5cm, £100-£200.

'Queen Victoria Riding', after Count d'Orsay, 1849, 29¼ x 21¼in/74.5 x 54cm, £150-£300. Add more if in fine contemporary frame. Small portraits, bookplates and pl. for The Art Journal *small value.*

LENEY, William S. 1769-1831
Stipple and aquatint engraver of portraits, decorative subjects and topographical views after his contemporaries, Old Master painters and his own designs. Born in London, he is said to have been a pupil of P.W. Tomkins (q.v.). In 1805 he emigrated to New York where he engraved banknotes before retiring to Canada.
'Going to the Mill' and 'Breaking the Ice', after R. Westall, 1803, 22 x 26½in/55.5 x 67cm, stipple, pair £500-£800 prd. in col.
'Tameing the Shrew', after H.W. Bunbury, 1793, stipple, £40-£80 prd. in col.
Pl. for Boydell's Shakespeare, *stipple, £10-£25.*
'Patterson Falls, New Jersey', 15¼ x 19½in/38.5 x 50cm, aq., £800-£1,600 col.
Small portraits and bookplates small value.

LENS, Andrew Benjamin
fl. mid-18th century
Miniaturist and line engraver. He was the son of B. Lens II (q.v.).
'Grenadier Exercise', after B. Lens, 1744, 19 pl., e. £5-£15.

LENS, Bernard I 1659-1725
Mezzotint engraver of portraits, landscapes and biblical, mythological and decorative subjects after his contemporaries and his own designs. He was born in and died in London. He was the father of B. Lens II (q.v.).
'Fireworks Displays Given on the Return of William III from his Irish Campaign', £100-£250.
'Isabella, Duchess of Grafton', after G. Kneller, 16¼ x 10in/42.5 x 25.5cm, and other female WLs of similar size, £200-£400.
'William III', 16¼ x 10in/42.5 x 25.5cm, and other male WLs of similar size, £60-£140.
'Sir Cloudesley Shovel', after M. Dahl, 13¼ x 10¼in/35 x 26cm, and other male HLs of similar size, £20-£60.
Small pl. £5-£20.
CS.

LENS, Bernard II 1682-1740
Miniaturist, watercolourist, etcher and line engraver of portraits and bookplates. He was the son and pupil of B. Lens I (q.v.).
Pl. for the 'Grenadier's Exercise', 1735, 17 pl., e. £5-£15.
Others small value.

LEPETIT, A. fl. mid-19th century
Line engraver of small bookplates including landscapes and topographical views after his contemporaries.
Small value.

LEPETIT, William fl. mid-19th century
Line engraver of small bookplates including landscapes and topographical views after his contemporaries.
German and Swiss views e. £5-£10.
Others small value.

LERPINIERE, Daniel c.1745-85
Etcher and line engraver of landscapes and religious, decorative, naval and sporting subjects after his contemporaries and Old Master painters. Born in England of French extraction, he was a pupil of F. Vivares (q.v.)

LENEY, William S. 'Tameing the Shrew', after H.W. Bunbury, 1793, stipple.

LERPINIERE, Daniel. 'A South View of London and Westminster from Denmark Hill', pair with 'View of Highgate', both after G. Robertson, 1779.

and worked in London, mainly for J. Boydell (q.v.).
'Views in the Island of Jamaica', after G. Robertson, 1778, 16 x 20½in/40.5 x 52cm, e. £200-£500.
'The Relief of Gibraltar', after R. Paton, 1784, 19½ x 26¼in/49.5 x 66.5cm, £150-£250.

'Engagement between Serapis and Bon Homme Richard', after R. Paton, 1780, 17½ x 23in/44.5 x 58.5cm, £200-£350.
'A Hunting Piece', after J. Wootton, 1788, 19 x 23¾in/48 x 60.5cm, £300-£500.
'View of London and Westminster from Denmark Hill' and 'View of Highgate', after

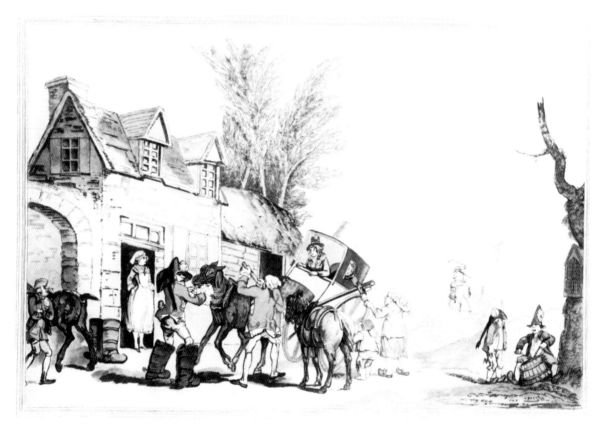

LEWIS, Frederick Christian I. One of six plates from 'Travelling in France: Changing Horses near Clermont', after F.G. Byron, 1801-3.

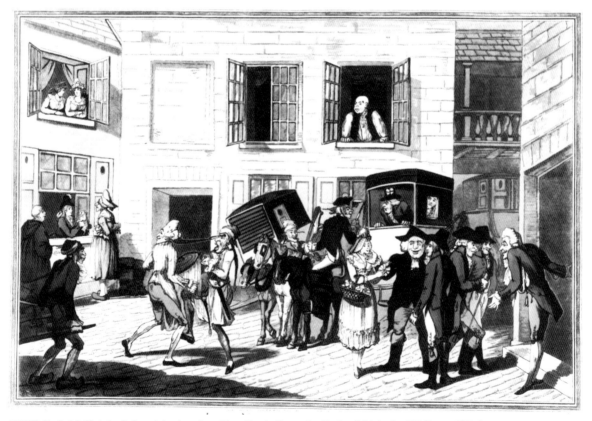

LEWIS, Frederick Christian I. One of six plates from 'Travelling in France: Inn Yard at Calais', after F.G. Byron, 1801-3.

G. Robertson, 1779, 17 x 23in/43 x 58.5cm, pair £600-£1,200.
Landscapes and decorative subjects after contemporaries and Old Masters £20-£80.

LESLIE, Cecil Mary b.1900-1980
Painter, sculptor and aquatint engraver of figure subjects with an art deco flavour. She studied at the London School of Photolithography and Engraving and at the Central School of Arts and Crafts. She also taught aquatint engraving at the Grosvenor School of Modern Art. She lived in Surrey and Norfolk.
£30-£90.

LESSORE, Theresa 1884-1945
Painter and etcher of genre subjects, landscapes, etc. She studied at the Slade and was the third wife of W. Sickert (q.v.) whose etching style she imitated closely.
£50-£150.

LEWIN, John William fl. late 18th century
Draughtsman and etcher of natural history subjects. He was the brother of W. Lewin (q.v.).
Small value.

LEWIN, William d.1795
Draughtsman and etcher of natural history subjects. He was the brother of J.W. Lewin (q.v.). He died in London.
'The Birds of Great Britain Accurately Figured', 1789-95 and 1795-1801, fo., 336 pl. (inc. 58 of eggs), e. £10-£30 col. (set col. fetched $23,000 June 1989).
'The Insects of Great Britain', 1795, e. £10-£30 col.
'Birds of New South Wales', 1813, 18 pl., 4to, set col. fetched $360,000 June 1989.

LEWIS, Arthur James 1825-1901
Painter and etcher of landscapes. He was a member of the Junior Etching Club.
£5-£15.

LEWIS, Charles George 1808-1880
Prominent etcher, line and mezzotint engraver of sporting, animal, genre and historical subjects and portraits after his contemporaries and Old Master painters. Born in Enfield, Middlesex, he was the son and pupil of F.C. Lewis I and the brother of J.F. Lewis (qq.v.). He died in Sussex.
'The Melton Breakfast', after F. Grant, 1839, 18½ x 28½in/47 x 72.5cm, £300-£500.
'The Waterloo Heroes at Apsley House', after J.P. Knight, 1847, 22 x 35¼in/56 x 89.5cm, £200-£400.
'The Relief of Lucknow', after T.J. Barker, 1857, 30 x 52in/76 x 132cm, £200-£400.
'Eton, Montem, The School Yard' and 'The Playing Fields', after W. Evans, 1852, 27¼ x 33½in/69 x 85.5cm, pair £500-£800.
'The Cheshire Hunt', after H. Calvert, 19 x 31½in/48.5 x 80cm, £400-£700.
'A View in Smithfield', after J.L. Agasse, with F.C. Lewis, 20 x 24in/51 x 61cm, line and aq., £700-£1,200 col.
'The Intellect and Valour of Britain', after T.J. Barker, 1864, 28¾ x 42¼in/73 x 107.5cm, £40-£100.
Pl. after R. Bonheur £10-£40.
Lge. pl. after E. Landseer £150-£300.
Add more if in fine contemporary frame.
Small portraits small value.

LEWIS, Frederick Christian I 1779-1856
Landscape painter, etcher and prominent

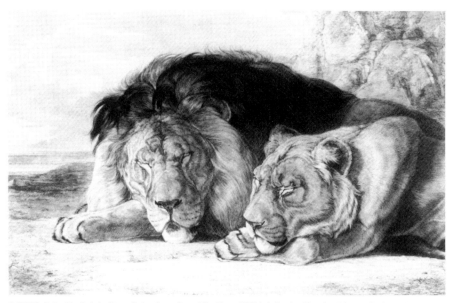

LEWIS, John Frederick. One of six plates from 'Studies of Wild Animals: Sleeping Lion and Lioness', 1825, etching with mezzotint.

aquatint and stipple engraver of sporting subjects, landscapes, topographical views, portraits, etc., after his contemporaries, Old Master painters and his own designs. Born in London, he was a pupil of J.C. Stadler (q.v.) and studied at the R.A. Schools. After meeting T. Girtin (q.v.) he aquatinted the latter's etched views of Paris (1803). He contributed plates to J.M.W. Turner's *Liber Studiorum* and worked for several members of the Royal Family. He also both drew and engraved several Devon views. He was the father of C.G. Lewis and J.F. Lewis (qq.v.).
Stipples:
'Cottage Industry' (Lady L. Russell), after E. Landseer, 1833, 11 x 8in/28 x 20.5cm, £80-£140 prd. in col.
Small portraits and bookplates small value.
Aquatints:
Pl. for Ackermann's History of Westminster Abbey, *1812, 4to., e. £10-£25 col.*
Pl. for the University of Oxford, *1814, 4to., e. £20-£60 col.*
Pl. for J.T. Smith's Antiquities of Westminster, *1807, 4to., small value.*
'Imitations of Claude Lorraine', 1837, fo., e. £10-£20 prd. in sepia.
Pl. for T. Girtin's Selection of Twenty of the Most Picturesque Views in Paris, *1803, obl. fo., e. £50-£100. Pl for his own 'Scenery of the River Dart', 1821, 36 pl., fo., etchings, e. £10-£30 col, prd. in sepia.*
Pl. for E. Dodwell's Views in Greece, *1819-21, fo., e. £140-£200 col. (complete set col. fetched £7,000 June 1993).*
Pl. for J.B. Fraser's Views of Calcutta, *1824-6, fo., e. £100-£250 col.*
Pl. for G. Heriot's Travels in the Canadas, *1807, fo., £20-£30.*
'Travelling in France', after F.G. Byron, 1801-3, 6 pl., 19¼ x 27½in/50 x 70cm, set £1,200-£1,800 col.
'Mail Coach', after J.L. Agasse, 1820, 38 x 43cm, £400-£600 col.
'The Quorn Hunt', after H. T. Alken, 1835, 8 pl., 16½ x 23½in/42 x 60cm, set £4,000-£8,000 col.; later reprints: set £300-£900 col.
'Mundig, Winner of the Derby', after C. Hancock, 1835, 15¼ x 19¼in/38.5 x 49cm,

and similar racehorse portraits, £300-£700 col.
'Red Grouse', after P. Reinagle, with G. Maile (q.v.), 1808, 14¼ x 20¼in/37.5 x 51.5cm, £300-£500 col.
Pl. for J. Wallis' London Volunteers, *after J. Green 1801-5, 13½ x 11in/34.5 x 28cm, e. £100-£160 col.*
'The Battle of Kirkee, 5th. Nov., 1816', after J.M. Wright, 16¾ x 30in/42.5 x 76cm, £200-£300 col.
'North East View of the Chapel and Hall of New College, Oxford', drawn and etched by J.C. Buckler, 1806, 18¼ x 24½in/46.5 x 62.5cm, £100-£250 col.
'The Sacred Egyptian Bean', after P. Henderson, with T. Burke (q.v.), 1804, 21¼ x 17in/54 x 43cm, aq. and stipple, £500-£800 prd. in col. and finished by hand.
Colour plate page 49.

LEWIS, Frederick Christian II
 fl. mid-19th century
Mezzotint engraver. He was presumably the son of F.C. Lewis I (q.v.).
'Sir Thomas H. Maddock', after F.C.L. II, 26½ x 17¼in/67.5 x 44cm, £30-£100.
Add more if in fine contemporary frame.

LEWIS, George Robert 1782-1871
Painter and aquatint engraver of military subjects, portraits, landscapes and architectural views after his contemporaries and his own designs. Born in London, he was the younger brother of F.C. Lewis I (q.v.) with whom he collaborated on some plates.
'The Duke of Cumberland's Sharpshooters in Ambush', after P. Reinagle, with F.C. Lewis I and G. Maile (qq.v.), 1808, 11¼ x 15in/28.5 x 38cm, £300-£500 col.
'The Battle of the Pyrenees, 28th July, 1813', after J.M. Wright with H. Moses (q.v.), 19¼ x 26½in/49 x 67.5cm, £200-£400 col.

LEWIS, John Frederick, R.A. 1805-1876
Well-known Orientalist painter, draughtsman, etcher and mezzotint engraver of animal subjects, lithographer of topographical views mainly after his own designs. Born in London, he was the son of F.C. Lewis I (q.v.). At the

LINDSAY, Lionel Arthur. 'The Evening Ride', drypoint etching.

LINDSAY, Norman Alfred William. 'The Duke in Picardy', etching.

beginning of his career, he made studies of the animals at the Royal Menagerie, Exeter Change, and these resulted in 'Studies of Wild Animals', 1825. His etchings of domestic subjects were published in 1826. He made his first sketching tour abroad in 1827 and in the 1830s produced all his topographical lithographs before devoting himself entirely to painting.
'Studies of Wild Animals', 1825, 6 etchings with mezzo., fo., set £400-£700.
Domestic subjects, 1826, 12 etchings, fo., set £100-£250.
'Sketches and Drawings of the Alhambra' (only 8 pl. litho. by J.F.L.), 1835, fo., tt. pl.; 'Sketches of Spain and Spanish Character', 1836, fo., tt. pl.; 'Illustrations of Constantinople', after Coke Smyth, 1838, fo., tt. pl., e. £20-£60; 'Sketches of Spain and Spanish Character' fetched £8,500 Dec.1989.

LEYDE, Otto Theodore 1835-1897
German painter, lithographer and etcher of portraits and genre subjects after his British contemporaries and his own designs. He settled in Edinburgh in 1854 where he worked as a librarian.
Small value.

LHUILLIER, Victor Gustave 1844-1889
French etcher of sentimental subjects and portraits after British 18th century painters, his contemporaries and his own designs. He worked in London.
Small value.

LIGHTFOOT, Peter 1805-1885
Line and stipple engraver of portraits and historical and sentimental subjects after his contemporaries and British 18th century and Old Master painters. He worked in London.
Lge. pl. after contemporaries £50-£150.
Other lge. pl. £10-£40.
Add more if in fine contemporary frame.
Small bookplates small value.

LIND, J. fl. late 18th/early 19th century
Line engraver of portrait silhouettes.
Small value.

LINDSAY, Sir Lionel Arthur 1874-1961
Australian painter, cartoonist, etcher, aquatint and mezzotint engraver of landscapes and architectural views, wood engraver of ornithogical subjects. Born in Victoria, the brother of N. Lindsay (q.v.), he studied at the National Gallery School, Melbourne. He drew cartoons for the *Sydney Evening News* from 1903-26 and worked in Europe, North Africa and India 1926-35.
'The Evening Ride', drypoint etching, £100-£160.
Australian subjects £100-£200.
Others £60-£140.
Bibl: Smith, U., *Etchings and Drypoints: L.L.*, Sydney, 1949.
Ref: Mendelssohn.

LINDSAY, Norman Alfred William
 1879-1969
Australian painter, etcher and aquatint engraver of figure subjects, particularly with fantasy or erotic themes. Born in Victoria, the brother of L. Lindsay (q.v.), he was the cartoonist for the *Sydney Bulletin* and lived in New South Wales. He hand-coloured some impressions of his prints.
'The Duke in Picardy', etching, £800-£1,400 col.
Others £500-£1,400.

LINNELL, John. 'Saul, the Beauty of Israel is Slain', after J. Varley, mezzotint.

LINES, Vincent Henry, R.W.S. 1909-1968
Painter, lithographer and occasional etcher of
landscapes, architectural views and figure
subjects. Born in London, he was a pupil of A.S.
Hartrick (q.v.) at the Central School of Arts and
Crafts and also studied at the R.C.A. He lived in
Hastings.
£10-£30.

LINNELL, John 1792-1882
Well-known landscape and portrait painter,
etcher, mezzotint engraver and lithographer of
landscapes, portraits and figure subjects. Born
in Bloomsbury, he studied at the R.A. Schools
and was a pupil of B. West (q.v.) and J. Varley
(q.v.). He was a patron of W. Blake and father-
in-law of S. Palmer (qq.v.). He produced most
of his prints early in his career and later
concentrated on painting.
*'Michelangelo's Paintings in the Sistine
Chapel', 1835, 42 pl., obl. fo., mezzo., e. small
value.*
*'Panel of the Upright Judges', after H. and
J. van Eyck, 20¾ x 9in/52.5 x 22.5cm, etching,
£40-£90.*
*'The Journey to Emmaus', 1839, 34.5 x 46cm,
etching and mezzo., £200-£400.*
*'Saul, the Beauty of Israel is Slain', after
J. Varley, 19¾ x 25½in/50 x 65cm, mezzo., £150-
£300.*
Portraits £50-£150.
Landscape etchings £100-£300.

LINTON, H.D. fl. mid /late 19th century
Wood engraver of portraits after photographs.
He was probably related to W.J. Linton (q.v.).
Small value.

LINTON, William James b.1812
Wood engraver of portraits and figure subjects
after his contemporaries and his own designs.
Born in London, he was apprenticed to G.W.
Bonner (q.v.) and then worked on plates for
books and periodicals including *The Illustrated
London News*, his most famous illustrations
being of Tennyson's poems after drawings by
the Pre-Raphaelites, published by Moxon in
1857. In 1866 he emigrated to the U.S.

*Pl. after Pre-Raphaelites, proof imp., £10-£50.
Others small value.*

LISNEY, Charles fl. early 19th century
Draughtsman and line engraver.
*'Wandsworth Volunteer', 8¼ x 6½in/22 x
16.5cm, £40-£70 col.*

LITTEN, Sidney Mackenzie 1887-1949
Etcher and mezzotint engraver of landscapes
and architectural views, designs and portraits
after Victorian painters. He was a pupil of
F. Short (q.v.) at the R.C.A. and lived in
London, later becoming Senior Master at St.
Martin's School of Art.

LINNELL,
John. 'Sheep
resting', 1818,
etching.

LITTEN, Sidney Mackenzie. 'Venetian Gondolas', etching.

'Venetian Gondolas', etching, £40-£70. Others £30-£80.

LIVENS, Horace Mann 1862-1936
Painter and etcher of landscapes, architectural views, poultry, etc. Born in Croydon, he studied at the School of Art there and in Belgium and France. He died at Harrow.
£40-£100.

LIVESAY, Richard d.1826
Portrait painter and drawing master who etched a few plates. He was a pupil of and assistant to B. West (q.v.) and taught drawing to the children of George III at Windsor, and later at the Royal Naval College, Portsmouth, where he died.
'The Royal Review in Hatfield Park of the Volunteer Cavalry and Infantry, with the Militia, of the County of Herts.', aq. by J.C. Stadler, 1802, 18 x 26in/45.5 x 67.5cm, £500-£800 col.
'Isle of Wight Volunteers Receiving the Island Banner at Carisbrooke Castle', aq. by J. Wells, 1799, 15¾ x 23½in/40 x 59.5cm, £300-£500.
'An Account of the Peregrination of Hogarth and Others', after W. Hogarth, 1782, 9 pl., with aq. by R.L., e. small value.

LIZARS, D. fl. late 18th century
Line engraver of bookplates after his contemporaries. He was the father of W.H. Lizars (q.v.) with whom he collaborated.
Small value.

LIZARS, William Home 1788-1859
Scottish genre painter, etcher and line and aquatint engraver of topographical views, decorative, historical and natural history subjects and portraits after his contemporaries. Born in Edinburgh, he was the son of D. Lizars (q.v.) and studied at the Trustees's Academy. On the death of his father, in order to support his brothers and sisters, he was forced to abandon painting and take up engraving, starting by producing banknotes. He engraved the first ten plates for J.J. Audubon's *Birds of America*. However, when work was halted by a strike of colourists in his shop, Audubon transferred the project to the shop of R. Havell II (q.v.).
Pl. for Audubon's Birds of America: 'Wild Turkey . . . Male', sheet 38 x 25in/96.5 x 63.5cm, up to £30,000 col.; 'Wild Turkey . . . Female', sheet 25½ x 38/65 x 96.5cm, £16,000-£24,000 col.; others £600-£2,400 col.
Pl. for W. Jardine's Illustrations of the British Salmonidae, 1839-41, 12 pl., fo., e. £100-£300 col.
Pl. for P.J. Selby's British Ornithology (British Birds in their Full Natural Size), 1819-34, 21¾ x

15¾in/55 x 40cm and smaller, e. £60-£200 col.
'National Work, British Domestic Animals', after J. Howe, 1829-31, 14 pl., 12¾ x 16½in/32.5 x 42cm, eng., e. £40-£80 col.
'King George IV's Visit to Leith', 1822, 9 x 21½in/23 x 55cm, aq., pair £200-£400 col.
'Annals of Sporting', after W. Howe, 14 pl., 10 x 15½in/25.5 x 39.5cm, eng., e. £40-£80 col.
'A Comparative View of the Lengths of the Principal Rivers of Scotland', £5-£10 col.
Pl. for Naturalist's Library, after T. Pennant, 6¼ x 3¾in/16 x 9.5cm, and other small bookplates, e. £1-£10,
Colour plate page 50.

LOCK, Anton b.1893
Painter, etcher and wood engraver of landscapes and animal subjects. He was a pupil of W. Sickert (q.v.) at the Westminster School of Art.
£15-£40.

LOCKLEY, David fl. early 18th century
Line engraver of architectural views, portraits and figure subjects after his contemporaries. He worked in London.
'The Bloody Sentence of the Jews', after Franciscus Franck, 24 x 42in/61 x 106.5cm, £80-£160.

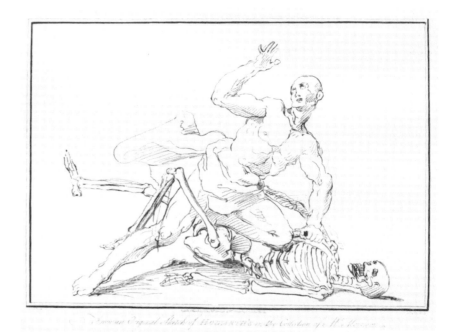

LIVESAY, Richard. Etching after W. Hogarth from 'An Account of the Peregrination of Hogarth and Others', 1782.

LIZARS, William Home. 'The Capybara, or Water Hog', after A. Mosses, coloured etching. One of this artist's many small bookplates.

LOGGAN, David. 'Christ's College, Cambridge', 1688, engraving.

'View of Dunkirk', 1712, 19 x 22in/48.5 x 60cm, £60-£140.
'New Church in the Strand', lge. pl., £80-£200.
'George I', 12¾ x 9in/32.5 x 23cm, £15-£25.

LODGE, John fl. mid-/late 18th century
Line engraver of small bookplates after his contemporaries.
Small value.

LODGE, William 1649-1689
Draughtsman, etcher and line engraver of portraits and topographical views. Born in Leeds, he studied law before attending Lord Fauconberg in his embassy to Venice. He translated and illustrated G. Barri's *Viaggio Pittoresco*, 1679, and drew rare shells and fossils for Dr M. Lister. He died in Leeds.
'The Prospects of Two Most Remarkable Towns in the North for the Clothing Trade' (Leeds and Wakefield), on one sheet, £400-£700.
'The Ancient and Loyal City of York', 8 x 20in/20.5 x 51cm, £80-£160.
'The Monument for the Great Fire of London', £20-£60.

LOGGAN, David d.1693
German draughtsman and line engraver of topographical views, mezzotint engraver of portraits mainly after his own designs. Born in Danzig, he studied under Simon van der Passe and Hendrik Hondius and came to England early in his career. After working in London, he went to Oxford and was appointed engraver to the University. There he produced his two most famous series of prints, 'Oxonia Illustrata', 1675, forty plates and then 'Cantabrigia Illustrata', 1688, thirty plates. He died in London.
'Prospect of Cambridge from the West', after D.L. by J. Kip (q.v.), from Cantabrigia Illustrata, 18¼ x 23½in/46.5 x 59.5cm, £200-£400.
Views of individual Oxford and Cambridge colleges £50-£150.
'Habitus Academicorum Oxoniae Doctore usque ad Servientem', costume pl., e. £8-£15.
Portraits:
'Allestree, Dolben and Fell', after P. Lely, 12½ x 14½in/31.5 x 36.5cm, £200-£400.
Others £10-£50.
CS.

LOMBART, Pierre 1620-1681
French line engraver of portraits and religious subjects after his contemporaries and Old Master painters. Born in Paris, he came to England in 1640 and resided in London for twenty years before returning to France shortly after the Restoration. He died in Paris.
'The Headless Horseman', after A.Van Dyck, 21¾ x 14in/55 x 35.5cm, depending on state £100-£300.
'The Countesses', after A. Van Dyck, ave. 12½ x 9¼in/32 x 23.5cm, e. £20-£50.
Pl. for A. Van Dyck's Iconographia e. £20-£50.

LONG, M.H. fl. mid-19th century
Lithographer of landscapes after his contemporaries, particularly M. Birket Foster (q.v.).
Small value.

LONG, Sydney, A.R.E. 1878-1955
Painter, etcher and aquatint engraver of landscapes, rustic scenes, birds, etc. Born in New South Wales, he studied in Australia and London. He returned to Australia in 1925 and

LORD, Elyse Ashe. A typical colour print.

settled in Sydney.
£60-£140.

LONGMATE, Barak I 1737-1793
Line engraver mainly of heraldry. Born in
Westminster, he edited Collins' *Peerage*, 1779-
84.
Small value.

LONGMATE, Barak II 1768-1836
Line and aquatint engraver of bookplates
including portraits after his contemporaries. He
was the son of Barak Longmate I (q.v.).
Small value.

LORD, Elyse Ashe c.1895-d.1971
Painter and drypoint etcher of figure subjects
and flowers in a pseudo-Chinese style. Her

prints are found hand-coloured or printed in
colours from woodblocks or in a combination of
both.
*£100-£200, in original Japanese-style lacquer
frame £200-£400.*
Bibl: Salaman, M.C., *E.L.*, Masters of the
Colour Print Series, *Studio*, London, 1927.

LORETTE, Thinot fl. mid-19th century
Lithographer of sporting subjects after his
contemporaries.
Shooting', after C.H. Weigall, 6 x 8½in/15 x
21.5cm, £30-£70 col.
'Rifle Practice' (Rifle Volunteers), c.1860, 6 x
8½in/15 x 21.5cm, £30-£70 col.
'Cricketing' (Lord's Match of Gentlemen and
Players), 9¾ x 13¼in/24.5 x 33.5cm, £150-£300
col.

LOUND, Thomas 1803-1861
Amateur painter and occasional etcher of
landscapes. A Norwich brewer, he took lessons
from J.S. Cotman (q.v.). He joined the Norwich
Society in 1820.
£30-£80.
Ref: Bolingbroke.

LOWENSTAM, Leopold 1842-1898
Dutch etcher and line engraver of sentimental
subjects and portraits after his contemporaries
and his own designs. Born in Amsterdam, he
came to London in 1873, where he reproduced
paintings by Victorian artists, becoming best
known for his reproductions of classical
subjects by L. Alma-Tadema.
Pl. after Alma-Tadema £100-£300.
Pl. after other artists and original pl. £20-£60.

LOWRY, Joseph Wilson 1803-1879
Line engraver mainly of small bookplates
including landscapes, topographical views and
scientific illustrations after his contemporaries.
He was the son and pupil of Wilson Lowry
(q.v.).
'View of Melbourne - Port Philip 1843', after
W. F. E. Liardet, 1844, 8½ x 20in/22 x 51cm,
imp. with later colouring, damages, fetched
£800 April 1990.
Small bookplates small value.

LOWRY, Laurence Stephen, R.A. 1887-1976
Celebrated painter and lithographer of Northern
townscapes and industrial scenes. Born in
Manchester, he studied at the School of Art
there as well as in Salford. He lived near
Manchester most of his life. His prints divide
into two groups: original lithographs, printed in
black and beige, and colour reproductions of his
paintings. Impressions from both groups should
be signed and numbered in pencil and are
known as 'signed artist's proofs'.
*Litho: £300-£400 (complete set of 14 fetched
£3,000 June 1995).*
*Colour reproductions: 'Going to the Match',
£500-£700; others range from £120 to £300-
£400 for larger industrial subjects.*

LOWRY, R. *see* **Laurie, Robert**

LOWRY, Wilson 1762-1824
Line engraver of architectural views,
landscapes, scientific and technical illustrations
and portraits after his contemporaries and his
own designs. Born at Whitehaven, Cumberland,
he was apprenticed to an engraver called Ross
in Worcester where his family had moved. He
moved to London in 1780. He is credited with
the invention of a device for hatching on plates
and was one of the earliest engravers to use
steel.
'A View of the British Army on the Peace
Establishment in the Year 1803', after C. de
Bosset, 1803, 24½ x 19in/62 x 48.5cm, £200-
£300.
'A Courtyard, Dublin', after J. Malton, 20¼ x
25¼in/51.5 x 64cm, £150-£300.
'An Iron Work, for Casting of Cannon, and a
Boring Mill, Taken from the Madeley Side of the
River Severn', after G. Robertson, 1788, 16 x
23¼in/40.5 x 59cm, £200-£400.
'A View of Kenwood, in Middlesex', after
G. Robertson, 1781, 15¾ x 21½in/40 x 54.5cm,
£150-£300.
Pl. for W. Wilkins' The Antiquities of Magna
Graecia, *1807, fo., e. £5-£10.*
Small bookplates small value.

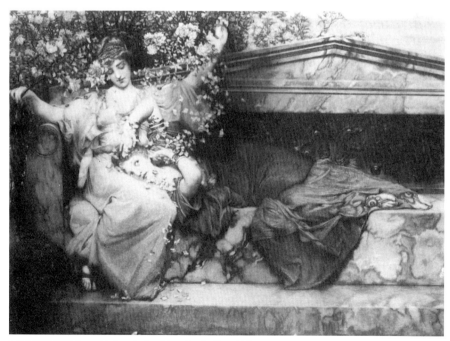

LOWENSTAM, Leopold. A typical etching after L. Alma-Tadema.

LOWRY, Wilson. 'An Iron Work, for Casting of Cannon, and a Boring Mill, Taken from the Madeley Side of the River Severn', after G. Robertson, 1788.

LUCAS, Alfred fl. mid-19th century
Line, stipple and mezzotint engraver of portraits
and sporting and sentimental subjects after his
contemporaries. He worked in London.
*'Deer Stalking', after R. Ansdell, 1857, 14 x
26in/35.5 x 66cm, and other lge. sporting
subjects, £150-£300.*
*'The Pets', after E. Landseer, 1877, 22 x
17½in/56 x 44.5cm, and others after Landseer of
similar size, £120-£250.*
*Lge. sentimental subjects after E. Landseer
£60-£160; after others £20-£60.*
Add more if in fine contemporary frame.
Others small value.

LUCAS, David 1802-1881
Mezzotint engraver of landscapes, architectural
views, portraits and figure subjects after his
contemporaries and 18th century painters. A
pupil of S.W. Reynolds (q.v.), he is best known
for his reproductions of J. Constable's (q.v.)
paintings, and his most important work was the
series of mezzotint engravings of Constable's
'Various Subjects of Landscape Characteristic
of English Scenery'.
*Pl. from Constables' 'Various Subjects . . .',
1833, 22 pl., obl. fo.,: e. £30-£100, though up to
£5,000 if early proof before completion or
worked on extensively by artist, e.g. 'Hadleigh
Castle' progress proof, fetched £4,700 Dec.
1991; 'Stoke-by-Nayland', progress proof,
worked on by C. with white chalk and Indian
ink, fetched £2,500 June 1995; complete set,
from first edn. in original parts, fetched £7,500*

LUCAS, David. 'The Rainbow, Salisbury', large plate after J. Constable, touched proof.

LUMSDEN, Ernest Stephen. 'The Preacher', 1921.

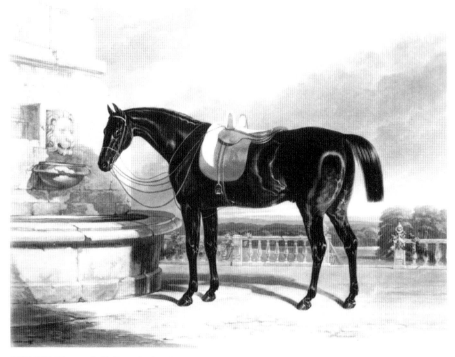

LUPTON, Thomas Goff. 'Tartar', after W. Barraud, 1839.

June 1994; from later edn. published by Bohn, pl. have number in upper right corner of border, e. small value.
'Salisbury Cathedral', 7 x 9¾in/17.5 x 25cm, *early proof of unpublished pl., extensively worked on by artist, has made £9,500.*
Lge. pl. after Constable £150-£300; if early and/or touched proof £300-£1,000; 'The Rainbow, Salisbury', 23¾ x 28⅛in/60.5 x 71.5cm, *progress proof, touched by C., fetched £8,500 Dec. 1991.*
Lge. pl. after others £60-£140.
Add more if in fine contemporary frame.

Larger portraits, i.e. approx. 15 x 12in/38 x 30.5cm, £10-£30.
'Portrait of J. Constable', after C.R. Leslie, *1843, 6½ x 5in/16.5 x 12.5cm, £10-£30.*
Other small portraits small value.
Bibli: Shirley, A., *The Published Mezzotints of D.L. after John Constable RA*, 1930.

LUCAS, Horatio Joseph 1839-1873
Painter and etcher of architectural views. He lived and worked in London.
Small value.

LUCAS, James Seymour fl. mid-19th century
Line and mezzotint engraver of landscapes and biblical and historical subjects after his contemporaries and 18th century painters. He worked in London.
£10-£40.

LUCAS, John 1807-1874
Painter, mezzotint and mixed-method engraver of portraits, genre subjects, etc., after his own designs, his contemporaries and 18th century British painters. Born in London, he was the pupil of S.W. Reynolds (q.v.) and the painter William Etty.
'The Duke of Wellington', 1841, 29¾ x 20in/75.5 x 51cm, £120-£250.
Other portraits £20-£80.
Add more if in fine contemporary frame.

LUCAS, Richard Cockle
 fl. mid-19th century
Hampshire sculptor who experimented with printmaking, producing etchings, drypoints and 'native-prints'. The results were not very successful.
Small value.

LUMLEY, George d.1768
Amateur mezzotint engraver of portraits. Born in York, he worked as a solicitor there. F. Place (q.v.), a friend of his, taught him to engrave in mezzotint and his portraits all seem to be of local worthies.
£10-£50.
CS.

LUMSDEN, Ernest Stephen
 fl. early/mid-20th century
Painter and etcher of landscapes, architectural views and portraits. Born in London, he studied at Reading and in Paris and travelled widely abroad, his travels providing the material for most of his etchings, particularly those of India. He lived in Edinburgh.
'The Preacher', 1921, and others mostly £30-£90, but 'Portrait of James McBey', 1920, 9¾ x 11½in/25 x 29.5cm, £60-£140.
Bibl: Lumsden E.S., 'Chronological List of Etchings by E.S.L', *P.C.Q.*, 1936, pp.219-38.

LUPTON, Thomas Goff 1791-1873
Mezzotint engraver of landscapes, topographical views, portraits and animal and sporting subjects after his contemporaries. Born at Clerkenwell, he was a pupil of G. Clint (q.v.) and also worked for S.W. Reynolds (q.v.). He introduced steel plates for engraving, having discovered that many more good impressions could be taken off them than off copper plates. He was awarded the Isis Medal by the Society of Arts in 1822. He died in London.
'Ancient Jerusalem', after W. Linton, 1837, 23½ x 31¾in/60 x 81cm, £250-£400.
'The Meet at Blagdon', after J.W. Snow, 1840, 22 x 32in/56 x 81.5cm, £200-£400.
'Tartar', after W. Barraud, 1839, £250-£400.
'Fleur-de-Lis' (horse), after A. Cooper, 1828, 18 x 21¾in/45.5 x 55.5cm, £250-£400.
'Blanchard, Liston and Mathews in Love, Law and Physic', 1831, 17½ x 14in/44.5 x 35.5cm, £30-£80.
'The Poacher Detected', 1831, companion to 'The Poacher's Snare', by J. Stewart, 1830, both after W. Kidd, pair £500-£800 prd. in col.
'J.S. Munden, Comedian', after G. Clint, 1822, the first-ever engraved steel pl., £60-£100.
'Thomas Waring', after A. Cooper, 21¼ x 25½in/55 x 64.5cm, £150-£300.

LUPTON, Thomas Goff. 'Solway Moss', after J.M.W. Turner, 1816, from Turner's *Liber Studiorum*.

LYDON, A.J. 'Sezincote', from *Country Seats of the Noblemen of Great Britain and Ireland*.

'*The Hero (Duke of Wellington) and his Horse on the Field of Waterloo, Twenty Years after the Battle', 1843, 25½ x 30in/64.5 x 76.5cm, £200-£300.*
Most other portraits: HLs £5-£20; WLs £10-£50.
Pl. for J.M.W. Turner's Liber Studiorum, *e. £80-£200.*
Pl. for J.M.W. Turner's The Rivers of England and Wales, *if early proofs or imp., e. £30-£90.*
Pl. for Rev. E. Bury's Three Sanctuaries of Tuscany, Valombroga . . ., *1833, 8 x 10in/20 x 25.5cm, e. £10-£20.*

LUTTEREL (Luttrel), Edward
fl. late17th/early 18th century
Irish draughtsman and mezzotint engraver of portraits. Born in Dublin, he came to London at an early age to study law but turned to art instead. He collaborated with I. Beckett (q.v.) and the two were among the earliest mezzotint engravers.
'*Madam Helyot', 12 x 9in/30.5 x 23cm, £100-£200.*
'*Francis Higgins', 13¼ x 9¾in/33.5 x 25cm, and other male portraits of this size, £20-£60.*
'*Keay Nabee and Keay Abi', 6½ x 8in/16.5 x 20.5cm, £20-£60.*
Small portraits £10-£25.
CS.

LYDON, A.J.
fl. mid-19th century
Wood engraver of topographical views which were printed in colours from several blocks.
Pl. for County Seats of the Noblemen of Great Britain and Ireland, *4to., small value.*

LYNCH, James Henry
fl. mid-19th century
Painter and lithographer of portraits, military costumes and topographical views after his contemporaries and his own designs. He worked in London.
Pl. for Ackermann's British Army, *ave. 12 x 9½in/30.5 x 24cm, e. £80-£140 col.*
'*Spooner's Oblong Series: The British Army', after M.A. Hayes, 1840-4, 53 pl., 9 x 13in/23 x 33cm, e. £80-£140 col.*
'*Lord Robert and Lord Charles Manners', after J. Ferneley, 1843, 15¼ x 22½in/40 x 57cm, £200-£400.*
'*Prince of Wales on the Moors', after W.L. Price, with R.J. Lane (q.v.), 1858, 20¼ x 14in/52.5 x 35.5cm, £60-£120.*
Other lge. portraits £10-£40.
Add more if in fine contemporary frame.
Small portraits and vignettes small value.
Pl. for Lieut. G. Abbott's Views of the Forts of Bhurtpore and Weire, *1827, fo., e. £5-£15.*

MACARDELL, James fl. mid-18th century
Irish draughtsman, mezzotint engraver of
portraits and decorative, historical and religious
subjects after his contemporaries and Old
Master painters. Born in Dublin, he was a pupil
of J. Brooks (q.v.) with whom he moved to
London in 1746. Joshua Reynolds spoke of
being 'immortalised' by him. He died in
Hampstead.
*'The Tribute Money', after Rembrandt, 15 x
20in/38 x 51cm, £10-£20.*
*'The Seasons', 4 pl., 2 by R. Houston, 14½ x
10in/37 x 25.5cm, set £500-£700.*
*'The Interior of a Flour Mill', after
J.I. Richards, £100-£160.*
*'Employment', after Longhi, and 'Pride', after
Cuyp, 13¾ x 9¾in/35 x 25cm, pair £100-£200.*
*'Mary, Lady Coke', after A. Ramsay, 19¾ x
14in/50.5 x 35.5cm, and other female WLs of
similar size, £200-£400.*
*'Benjamin Franklin', after B. Wilson, 14 x
9¾in/35.5 x 25cm, £300-£500.*
*'David Garrick and Mrs. Cibber', after
J. Zoffany, 1764, 18 x 21½in/46 x 55cm, £200-
£300.*
*'Sir Philip Honeywood', after B. Dandridge,
19¾ x 14in/50.5 x 35.5cm, £80-£150.*
*'Mr. Garrick in Hamlet', after B. Wilson, 1754,
18 x 16½in/45.5 x 42cm, £50-£80.*
*Other male HLs or TQLs, ave. 14 x 12in/35.5 x
30.5cm, £15-£60.*

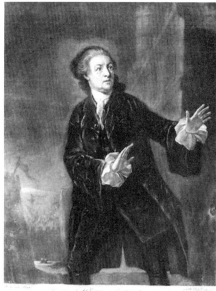

MACARDELL, James. 'Mr. Garrick in *Hamlet*',
after B. Wilson, 1754.

*Female HLs or TQLs, ave. 14 x 12in/35.5 x
30.5cm, £30-£120.*
CS.
Bibl: Goodwin, G. 'J.M.', London, 1903.

MACARTHY, C.V. fl. mid-19th century
Liverpudlian lithographer.
*'The Camp at Crosby', after J. Prior, c.1875, 8½
x 14in/21.5 x 35.5cm, £60-£90 col.*

**MACBETH, Robert Walker,
R.A., R.W.S., R.E.** 1848-1910
Scottish painter and etcher of sentimental and
genre subjects, landscapes and portraits after his

own designs, those of his contemporaries and
Old Master painters. Born in Glasgow, he went
to London in 1871 and worked for *The Graphic.*
*'Le Chant d'Amour', after E. Burne-Jones,
1896, £700-£1,200.*
*'The Cloister or the World', after A. Hacker,
1900, 23½ x 17½in/60 x 44.5cm, £40-£100.*
*'His First Love', after F. Dicksee, 18 x
24in/45.5 x 61cm, £40-£100.*
Pl. after J.E. Millais and G. Pinwell £40-£100.
Add more if in fine contemporary frame.
Others small value.

MACBETH-RAEBURN, Henry, R.A., R.E.
1860-1947
Scottish painter, mezzotint engraver of portraits
after late 18th and early 19th century British
painters, etcher of sentimental subjects,
landscapes and architectural views after his
contemporaries and his own designs. He was
the brother of R.W. Macbeth (q.v.) and took the
name Raeburn to distinguish himself. He
studied at the R.S.A. Schools and in Paris and
worked in Scotland and London.
Mezzo. portraits £80-£200 prd. in col.
Others £15-£40.

McBEY, James 1883-1959
Prominent Scottish painter and etcher of
landscapes, architectural views, figure subjects
and portraits. Born in Aberdeenshire, he taught
himself to etch while working for an Aberdeen
bank. In 1910 he left the bank and went to
London where he had his first exhibition in
1911. His travels abroad during subsequent
years to the Continent, North Africa and the
Middle East, formed the subject matter for
many of his prints. He was appointed Official
War Artist to the Palestine Expeditionary Force
1917-18, and this trip resulted in several well-
known prints including his most famous 'Dawn:
Camel Patrol'. Some consider his etchings of
Venice to be his best works, though these have
also been described as 'poor man's Whistlers'.
He later lived in the U.S.A. and Tangiers.

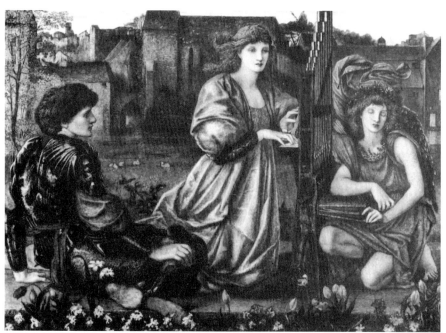

MACBETH, Robert Walker. 'Le Chant d'Amour', after E. Burne-Jones, 1896.

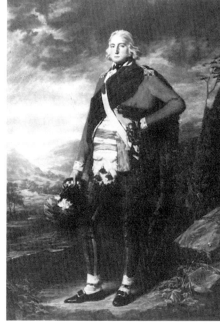

MACBETH-RAEBURN, Henry. A typical mezzotint
portrait after Sir Henry Raeburn.

'Dawn: Camel Patrol' £1,000-£2,000.
Other Middle East campaign etchings £150-£400.
Venice prints: 'Venetian Night', 1930, 10¾ x 16¾in/27.5 x 42.5cm, £1,000-£1,600, 'The Deserted Palace, Venice', 1928, and others £300-£800.
Moroccan subjects £100-£300.
New York subjects £200-£500.
Portraits £60-£140.
Bibl: Hardie, M., *J.M. Catalogue Raisonné 1902-24,* London, 1925; Carter, C., *Etchings and Dry Points from 1924 by J.M.* (a supplement to the catalogue by M. Hardie), Aberdeen Art Gallery, 1962; *The Early Life of J.M.: An Autobiography 1883-1911,* ed. N. Barker, Oxford University Press, 1977.

McCABE, E.F. fl. mid-19th century
Line engraver of topographical views after his contemporaries.
Pl. for R.B. Harraden's Cantabrigia Depicta, *1809, obl. 4to., e. £10-£25.*
Others small value.

McCLATCHIE, A. fl. mid-19th century
Line engraver of small bookplates including topographical views after his contemporaries.
German views £5-£10.
Others small value.

McCLEARY fl. early 19th century
Irish publisher of caricatures. His address was at 32 Nassau Street, Dublin, and most of the prints which he published were copies of English caricatures by J. Gillray (q.v.) etc.
£30-£70 col.

McCORMICK, Arthur David 1860-1943
Irish landscape painter and etcher of sentimental subjects after his own designs and those of his contemporaries. Born at Coleraine, he studied at the R.C.A. and lived in London.
Small value.

McCULLOCH, G. fl. mid 19th century
Lithographer of military subjects after his contemporaries and his own designs. He worked for Day & Son in London.
'The Volunteer, 1803', and 'The Volunteer, 1860', after J. Absolon, 1860, 13 x 10in/33 x 25.5cm, pair £100-£160 col.
'The Volunteer Reviews, Windsor and Edinburgh', 1881, 12½ x 19½in/32 x 49.5cm, e. £80-£150 col.
Pl. for C. Bossoli's War in Italy, *1859-60, 8vo., small value.*
Pl. for Capt. G.F. Atkinson's The Campaign in India, *1859, fo., tt. pl., e. £8-£15.*
Pl. for Capt. G.F. Atkinson's Curry and Rice, *4to., tt. pl., e. £3-£8.*

MACDONALD *see* **MACLURE, A.**

MACDUFF, Archibald *see* **BARRY, James**

MACFARLANE, W.H. fl. mid-/late 19th century
Scottish draughtsman and lithographer of military subjects and portraits. He worked in Edinburgh.
'Royal Volunteer Review as Seen from St. Anthony's Chapel, Holyrood Park, 7th August, 1860', 11 x 19¼in/28 x 49cm, tt. pl., £60-£120.
'Royal Review of Scottish Volunteers, Queen's Park, Edinburgh, 25th August, 1881', 20 x 36¾in/51 x 93.5cm, £200-£400 col.
'Thomas Chalmers, D.D.', 11¼ x 8½in/28.5 x 22cm, and similar subjects, £10-£20.

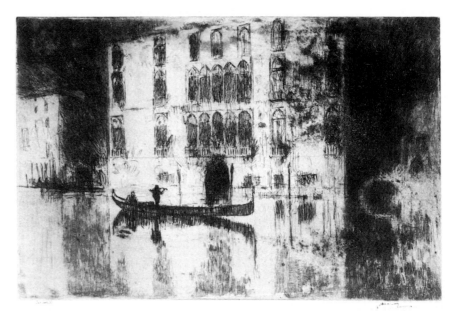
McBEY, James. 'Venetian Night', 1930.

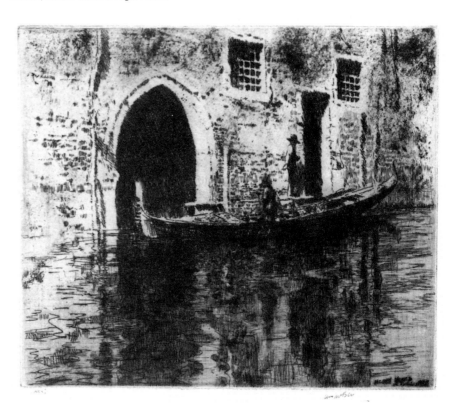
McBEY, James. 'The Deserted Palace, Venice', 1928.

McGAHEY, John fl. mid-19th century
Liverpudlian draughtsman, lithographer and publisher of topographical views, military and sporting subjects, etc., after his own designs and those of his contemporaries.
'The Celebrated Greyhounds', after J. Armstrong, 1870, 17 x 23½in/43.5 x 60cm, £200-£300 prd. in col.
'Model View of Chester Castle', c.1845, 10¾ x 15¾in/27.5 x 40cm, £30-£60 col.
'Grand Volunteer Field Day, Sefton Park,

Liverpool, 5th October, 1867', 10½ x 19in/26.5 x 48.5cm, £100-£150 col.
Views of Liverpool, 5 x 7in/12.5 x 18cm, tt. pl., e.£20-£60.

McIAN, Robert Ronald fl. mid-19th century
Draughtsman and lithographer of costume plates.
'Scottish Clans', 1845-7, 72pl., 13½ x 9¼in/34.5 x 23.5cm, e. £20-£50 col.

McGAHEY, John. 'Custom House, Liverpool'.

MACKRELL, James. 'The Straw Yard, Evening', pair with 'The Straw Yard, Morning', after W.J. Shayer, 1847-8.

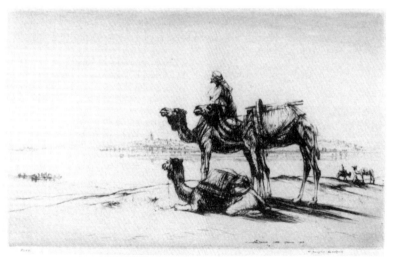

MACLEOD, William Douglas. 'Salte, Morocco', 1928.

McINNES, E. fl. mid-19th century
Mezzotint engraver of portraits after his contemporaries and early 19th century painters.
Pl. after T. Lawrence, 1839-44, 8¼ x 6½in/21 x 17cm, e. £3-£8.

McINTOSH, J. fl. late 18th century
Scottish mezzotint engraver of portraits after his contemporaries.
'William, 19th Earl of Sutherland, Colonel of a Highland Regt.', after A. Ramsay, 1779, 15¼ x 10in/38.5 x 25.5cm, £20-£40.
CS lists 1 pl., noted above.

MACKENZIE, Frederick 1787-1854
Painter, draughtsman, etcher and aquatint engraver of architectural views. Exhibited at the Old Watercolour Society. His treatise on *Etchings of Landscape* was published in 1825.
'Views of the Abbeys and Castle of Yorkshire' with W. Westall (q.v.), 1819-1820, 9¾ x 13in/25 x 33cm, e. £10-£30.

MACKENZIE, James Hamilton, R.S.W., A.R.E. 1875-1926
Scottish painter and etcher of architectural views. Born in Glasgow, he went to the School of Art there.
£15-£40.
Bibl: Taylor E.A., 'J.H.M., Painter and Etcher', *Studio*, 1920, LXXVIII, p.148.

MACKENZIE, K. fl. early 19th century
Stipple engraver of small bookplates including portraits after his contemporaries.
Small value.

MACKIE, Helen Madeleine d.1957
Painter of architectural views and illustrator who produced a few lithographs. She studied at Lambeth School of Art and lived in London.
'Waterloo Station: In Peace-time', and 'In War-time', 1943, 31½ x 47¼in/80 x 120cm, pair £300-£500 prd. in col.

MACKLEY, George b.1900
Wood-engraver of landscapes and rustic scenes.
£30-£70.
Ref: Gresham.

MACKLIN, Thomas
fl. late 18th/early 19th century
Line and stipple engraver of decorative subjects after his contemporaries. He worked in London and is better known as a print publisher than as an engraver.
'Peleus and Thetis', after A. Kauffmann, 1786, oval, 15 x 12in/38 x 30.5cm, £50-£150.

MACKRELL, James fl. mid-19th century
Aquatint engraver of sporting subjects after his contemporaries. He worked in London.
'Foxhunting', after J.F. Herring, 1846, 4 pl., 2 by T.W. Huffam (q.v.), 21½ x 30in/54.5 x 76cm, set £1,000-£2,000 col.
'Coronation' (racehorse), after F.C. Turner, 1841, 21½ x 26in/54.5 x 66cm, £300-£500 col.
'The Straw Yard, Morning' and 'Evening', after W.J. Shayer, former by C. Hunt I (q.v.), 1847-8, 21 x 27in/53 x 69cm, pair £700-£1,200 col.
'Moore's Tally Ho! to the Sports - The Noble Tips', after F.C. Turner, with G. Hunt (q.v.), 1842/3, 4 pl., 17 x 24in/43 x 61cm, set £1,200-£1,800 col.

MACLACHLAN, Thomas Hope 1845-1897
Painter and etcher of landscapes. Born in Darlington, he was called to the Bar before

turning to painting and etching.
Small value.

MACLEOD, William Douglas 1892-1963
Scottish painter and etcher of landscapes. Born in Renfrewshire, he studied at the Glasgow School of Art and then worked as a cartoonist for the *Glasgow Evening News,* 1920-30. His visits to the Continent and North Africa provided the subject matter for many of his prints which show the strong influence of J. McBey (q.v.).
'Salte, Morocco', 1928, and others generally £30-£70.

MACLISE, Daniel 1806-1870
Historical painter who executed a series of lithographic portrait caricatures of fashionable figures, signed 'AC' (Alfred Croquis), for 'Fraser's Magazine', 1833-1836.
Proofs e. £10-£30.

MACLURE, Andrew fl. mid-19th century
Lithographer of military and marine subjects, topographical views and portraits after his own designs and those of his contemporaries. He set up a firm of lithographers, lithographic printers and publishers with a MacDonald and a MacGregor.
'Royal Thames Yacht Club, Ocean Match from Nore to Dover', after C.R. Rickett, 17 x 26¾in/43 x 68cm, tt. pl., £600-£900 col.
'Destruction of the Emigrant Ship Ocean Monarch', *after Prince de Joinville, 1848, 14¼ x 18½in/36 x 47cm, tt. pl., £100-£160 col.*
'Bridge Erected over the London and Bath Road, Near Reading, for the Reading, Guildford and Reigate Railway', 14 x 18in/35.5 x 46cm, tt. pl., £250-£450 col.
'Crimean War Battles', 1854, ave. 17½ x 24in/44.5 x 61cm, e. £60-£120 col.
'The First Shot at Wimbledon', 1860, 8¼ x 14¾in/21 x 37.5cm, £80-£140 col.
'Funeral of the Duke of Wellington', 1853, 2pl., 11 x 16in/28 x 40.5cm, pair £80-£120 col.
Pl. for J. Dunlop's Mooltan During and After the Siege, *1849, fo., tt. pl., e. £6-£12.*
Pl. for Illustrations of the Principles of Toleration in Scotland, *after D.O. Hill and J. Drummond, 1846, fo., tt. pl., small value.*
Pl. for M. Bruce's Views of Hong Kong, *1846, fo., tt. pl., e. £200-£400 col.*
Pl. for G.L. Hall's Views of Rio de Janeiro, *tt. pl., e. £100-£200.*
Portraits and pl. for The Whitehall Review *small value.*

McNAB, Allan b.1901
Etcher and line engraver of landscapes and architectural views. Born in Southampton, he worked on the Continent and around the Mediterranean.
£20-£50.

McNAB, Iain, R.E. 1890-1967
Painter, wood engraver and etcher of figure subjects and landscapes. Born in the Philippines, the son of a banker, he studied at the Glasgow School of Art and at Heatherley's in London. He was later principal at the latter school and also at the New Grosvenor School of Modern Art. He lived in London.
'Drying Sails, Lake Garda', 1938, 8½ x 7½in/21.5 x 19cm, £150-£250.
Others mostly £60-£160.
Bibl: Garret A., *Wood Engravings and Drawings of I.M. of Barachastlain,* Midas Books, 1973.

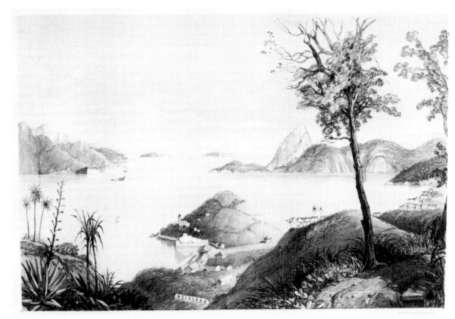

MACLURE, Andrew. 'Entrance to the Bay', from *Views of Rio de Janeiro* after G.L. Hall.

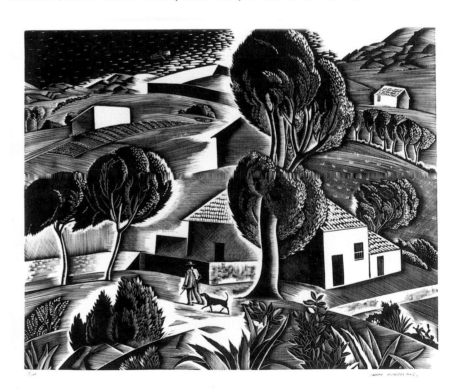

McNAB, Iain. 'Corsican Landscape', 1931.

MACWHIRTER, John, R.A. 1839-1911
Scottish painter and etcher of landscapes. Born near Edinburgh, he was apprenticed to a bookseller before studying at the Trustees's Academy. He then moved to London. He contributed plates to *The Portfolio.*
£4-£10.

MADDAN, David fl. late18th century
Mezzotint engraver.
'Curious American Bog-Plants', after

P. Reinagle, 1812, 10¾ x 7¼in/27.5 x 18.5cm, £20-£50 prd in cols.

MADDOCKS (Maddox), W.
 fl. early 19th century
Stipple engraver of small bookplates including portraits after his contemporaries.
Pl. for reduced-size version of Thornton's Temple of Flora: *'Group of Carnations', 1812, etching and aq., £30-£50 col.*
Others small value.

MADELEY, G.E. 'City of London School', after J.B. Bunning.

MADELEY, G.E. fl. mid-19th century
Lithographer of military subjects and costumes, topographical views, caricatures and portraits after his contemporaries and his own designs.
'42nd Royal Highlanders and 72nd Highlanders', 6½ x 9in/16.5 x 23cm, £60-£120 col.
'Ceremony of Presenting New Colours to the 93rd Highland Regiment', after H. Martens, 1834, 14¼ x 19½in/37.5 x 49.5cm, £150- £200 col.
'City of London School', after J.B. Bunning, 14¼ x 19½in/37.5 x 49.5cm, £100-£160 col.
Pl. for C.H. Smith's Six Views of Singapore and Macao, 1840, small fo., e. £100-£200 col.
Pl. for Capt. W.R. King's Campaigning in Kaffirland, 1853, 3¾ x 6½in/9.5 x 17cm, tt. pl., e. £5-£15.
Caricatures e. £20-£60 col.
Small portraits and vignettes small value.

MAGUIRE, H.C. fl. mid-19th century
Draughtsman and lithographer of music covers and portraits after his contemporaries.
Small value.

MAGUIRE, Thomas Herbert 1821-1895
History and portrait painter, lithographer of portraits after his own designs and those of his contemporaries. He was born in London. He produced the series 'Ipswich Museum Portraits'.
'Ipswich Museum Portraits', 1851, e. £4-£10.

MAILE, George fl. early 19th century
Etcher and stipple, aquatint and mezzotint engraver of sporting subjects, portraits and topographical views after his contemporaries and his own designs. He seems to have lived and worked in London.
'The Sportsman', after B. Marshall and L. Clennel, 1824, 10½ x 7½in/26.5 x 19cm, mezzo., £300-£500 prd. in col.
'Red Grouse', after P. Reinagle, with F.C.

Lewis, 1808, 14¼ x 20¼in/37.5 x 51.5cm, aq., £300-£500 col.
'Windsor Castle', after J. Barrow, companion to 'Mrs. Q.', after H. Villiers, by W. Blake (q.v.), stipples, pair £1,000-£2,000 prd. in col.
'Fox Hunting', 'Hare Hunting', 'Stag Hunting', 'Coursing', after S. Alken with T. Sutherland (q.v.), 7 x 36½in/18 x 92.5cm, 4 aq., set £1,500-£2,500 col.
'Maj. Gen. The Hon. Sir William Ponsonby, Lt. Col. of the Fifth Dragoon Guards', after Maile, 1817, 14¼ x 13in/37.5 x 33cm, stipple, £15-£25.
'Portrait of Rubens' and 'Helena, His Second Wife', after P.P. Rubens, 1817, 17¼ x 12¾in/44 x 32.5cm, mezzo., pair £150-£250 prd. in col.

MAILE, George. 'The Sportsman', after B. Marshall and L. Clennel, 1824.

'Elizabeth, Marchioness of Huntley', 11½ x 9in/29 x23cm, stipple, £100-£150 prd. in col.
'Henrietta Constance Smithson', after C.M. Dubufe, 13¾ x 11¼in/35 x 28.5cm, mezzo., £30-£50.
'Isaak Walton', after J. Huysmans, 4¼ x 3¼in/11 x 8.5cm, mezzo., £5-£15.
Pl. for E.E. Vidal's Picturesque Illustrations of Buenos Ayres and Monte Video, eng. with others, 1820, lge. 4to., aq., e. £100-£200 col.

MAJOR, Thomas, A.R.A. 1720-1799
Etcher and line engraver of portraits, decorative and sporting subjects, landscapes and topographical views after his contemporaries and Old Master painters. He went to Paris in 1745 and was imprisoned by the French in retaliation for the imprisonment of French soldiers taken at the battle of Culloden. While there, he studied under J.P. Le Bas and engraved several plates after Wouvermans, Berchem and Claude. Later, after he had returned to England, he became Seal Engraver to the King, retaining the post for forty years. He died in London.
'Le Manège', after P. Wouvermans, and other lge. pl. executed in France after 17th and early 18th century Continental artists e. £50-£150.
'Frances, Lady Carteret', after F. Zincke, 1755, 12¼ x 8¼in/31 x 21cm, £10-£20.
'William Huggins', after W. Hogarth, roundel, diam. 2¾in/7cm, small value.
Self portrait, 11 x 8.5cm, £20-£50.
'Return from a Course on Lambourne Downs', after J. Seymour, fo., £100-£200.
'A View of Landguard Fort', after T. Gainsborough, 1754, fo., £60-£120.

MALCHAIR, John Baptiste 1731-1812
French draughtsman who came to England in 1754 and taught drawing and playing the violin, becoming Leader of the Band in Oxford in 1759. He etched a few landscapes, architectural views and the odd portrait.
'Godstow Abbey', 1772, £20-£50.
'Mr. Philips, Oxford Musician', after T. Dashwood, 5 x 6½in/2.5 x 17cm, outline, £10-£30.

MALET, Guy 1900-1973
Wood-engraver of landscapes. A pupil of I. Macnab (q.v.) at the Grosvenor School of Modern Art, and a lifelong friend of his.
£20-£50.

MALGO, Simon fl. early 19th century
Mezzotint engraver of portraits and decorative subjects after his contemporaries.
'Sir Francis Willoughby', 9¼ x 7¼/23.5 x 18.5cm, £15-£30.
'Princess de Lamballe' and 'Marie Antoinette', both after A. Hickel, 1793 and 1794, 25 x 23in/63.5 x 58.4cm, e. £200-£400.
'Morland's Ass', after G. Morland, 1804, 11¼ x 12½in/28.5 x 31cm, £200-£300 prd. in col.
CS lists 3 pl., noted above.

MALTON, James c.1766-1803
Draughtsman and aquatint engraver of architectural and topographical views mainly after his own designs. He was the son of an architectural draughtsman, Thomas Malton Sen., and the brother of T. Malton Jun. (q.v.). When in Dublin, where he worked for three years for the architect James J. Gandon, he made some drawings of the town which he engraved and published in London. He died in London.
'Views in the City of Dublin', c.1791-9, 25 pl.,

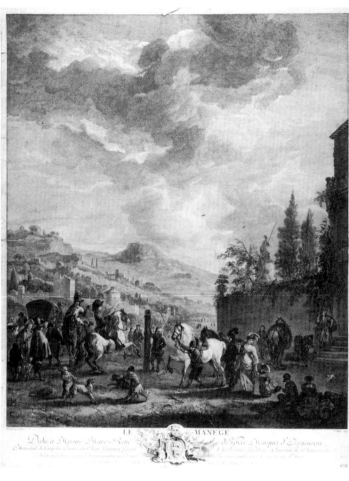

MAJOR, Thomas. 'Le Manège', after P. Wouvermans.

obl. fo., 1st. edn. prd. in sepia, 2nd edn. col., e. £100-£200.
4 views in Devon, after F. Keenan, 1800, fo., e. £20-£50 col.
'An Essay on British Cottage Architecture', 1798, 21 pl., 4to., e. small value.

MALTON, Thomas Jun. 1748-1804
Teacher of perspective, draughtsman, etcher and aquatint engraver of architectural and topographical views after his own designs and caricatures after T. Rowlandson (q.v.). Born in London, the son of an architectural draughtsman Thomas Malton Sen. and the brother of J. Malton (q.v.), he worked in Dublin for three years for the architect John Gandon and studied at the R.A. Schools.
'A Picturesque Tour Through the Cities of London and Westminster', 1792-1801, 100 pl., fo., e. £50-£100 col. (often found with later colouring).
Views of Bath, 1774-88, 12 pl., 16¼ x 22¼in/41 x 56.5cm, e. £200-£500.
Views of Cambridge, 1798-1800, 8 pl., 16 x 22½in/40.5 x 57.5cm, e. £150-£250.
Views of Oxford, 1802, 24 aq. and 6 etchings, fo., aq., e. £30-£60; etchings e. £10-£30.
'A Field Day in Hyde Park', after and etched by T. Rowlandson, 1789, 15¾ x 22¼in/40 x 58cm, £600-£1,000 col.
'English Barracks' and 'French Barracks', after and etched by T. Rowlandson, 1788, 16½ x 21½in/42 x 54.5cm, pair £1,200-£2,000 col.
'Inn Yard on Fire', after and etched by T. Rowlandson, 13¼ x 17¾in/33.5 x 45cm, £300-£600 col.

Julian, travelled on the Continent and in North Africa. He lived in London.
£20-£50.

MANSELL, F. fl. mid-19th century
Line engraver of small bookplates, including architectural views after contemporaries, biblical subjects after Old Master painters, etc.
Small value.

MANSION, Leon fl. mid-19th century
Draughtsman and lithographer of military, naval and fancy costumes. He collaborated with S. Eschauzier (q.v.).
'Fancy Ball Dress', 30 pl., 10½ x 8¼in/26.5 x 21cm, e. £10-£20.
'Costume of the Royal Navy and Marines', c.1833, ave. 11¼ x 10¼in/30 x 26cm, e. £80-£160 col.
Pl. for Spooner's Large Series: Officers of the British Army, with S. Eschauzier, 1831, 6 pl., ave. 15½ x 12½in/39 x 32cm, e. £150-£250 col.
Pl. for Spooner's Upright Series: Officers of the British Army, with S. Eschauzier, 1833-6, 60 pl., ave. 11½ x 9¾in/29 x 25cm, e. £140-£200 (complete set col. fetched £15,000 May 1993).
See illustration under S. Eschauzier.

MANSKIRCH, Franz Joseph 1770-1827
German landscape and figure painter who worked in England at the end of the 18th century and beginning of the 19th century and produced a drawing book for the publisher R. Ackermann.
Pl. for drawing book, obl. fo., soft-ground etchings with aq., e. small value.

MANWARING, Robert fl. mid-18th century
Cabinet maker who engraved a few mezzotint portraits after his contemporaries.
'Matthew Henry', after G. Vertue, 5 x 4½in/12.5 x 11.5cm, £5-£15.
'Martin Madan', 12½ x 10in/32 x 25.5cm, £10-£30.
CS lists 2 pl., noted above.

MANNING, William Westley, A.R.E. 1868-1954
Painter, etcher and aquatint engraver of landscapes. He studied in Paris at the Académie

CHARLEMONT-HOUSE. DUBLIN.

MALTON, James. One of twenty-five plates from 'Views in the City of Dublin: Charlemont-House', 1793.

MALTON, Thomas. 'West Front of the Abbey Church at Bath', 1788, from the set of twelve views of Bath.

MARCHI, Giuseppe Filippo Liberati 1735-1808
Italian painter and mezzotint engraver of portraits after his contemporaries. Born in Rome, he was brought to England in 1752 by Joshua Reynolds and was employed to prepare his palette and paint the draperies in his pictures. Having failed as a portrait painter in his own right, he turned to engraving.
'Mrs. Bouverie and Mrs Crewe', after Reynolds, 1770, 20 x 17½in/51 x 44.5cm, £200-£400.
'King Lear', after Reynolds, 14 x 10in/35.5 x 25.5cm, £60-£120.
'Miss Cholmondeley', after Reynolds, 1768, 19 x 14in/48 x 35.5cm, £200-£300.
'Samuel Dyer', after Reynolds, 1773, 18 x 16in/45.5 x 40.5cm, £15-£40.
'Oliver Goldsmith', after Reynolds, 1770, 18 x 13in/45.5 x 33cm, £40-£80.
'John Moody as Foigard', after J. Zoffany, 20 x 14in/51 x 35.5cm, £100-£200.
CS.

MARCUARD, Robert Samuel 1751-1792
Stipple engraver of decorative subjects and portraits after his contemporaries. He was a pupil and follower of F. Bartolozzi (q.v.).
'Contemplating Philosopher', after F. Bartolozzi, 1788, £100-£200 prd. in sepia or in col.
Other decorative subjects: ovals and circles after various artists, £50-£150 prd. in sepia or in col.
'Adm. Augustus Keppel', after J. Ceracchi, 1782, 4¾ x 3¾in/12 x 9.5cm, £5-£10.
'Portrait of Bartolozzi', after J. Reynolds, 1784, 9½ x 8in/24 x 20.5cm, £100-£200 prd. in col.

MARKS, Henry Stacey, R.A., R.W.S.
1829-1898
Well-known painter of ornithological and genre subjects, etcher of figure subjects. He was a member of the Junior Etching Club.
£10-£30.

MARLOW, William. 'A View at Florence', one of the rare set of six Italian views, 1765, published 1795.

MARKS, J.L. fl. early 19th century
Draughtsman and etcher of caricatures and military costumes. He was also a publisher of prints.
'Military Costumes', 1821, 8 x 9in/20.5 x 23cm, e. £20-£50 col.
Caricatures e. £30-£70 col.

MARKS, Sydney fl. mid-19th century
Mezzotint engraver and publisher of portraits. His address was at 88 Charlotte Street, Fitzroy Square, London.
'Lt. W.G.D. Massys', c.1856, 11½ x 13¼in/29 x 33.5cm, £10-£25.

MARLOW, M. fl. late 17th century
Line engraver of portraits and frontispieces who worked for the booksellers.
Small value.

CONTEMPLATING PHILOSOPHER.

MARCUARD, Robert Samuel. 'Contemplating Philosopher', after F. Bartolozzi, 1788.

MARLOW, William 1740-1813
Painter and occasional etcher of landscapes and topographical views. Born in Southwark, he was a pupil of Samuel Scott and studied at St. Martin's Academy. Apart from visiting the Continent in the period 1765-8, during which he etched some Italian views, he painted English views, especially on the Thames. Several of his paintings were engraved by professionals. He died in Twickenham.
Italian views, 1765, publ. 1795, 6 pl., set £500-£1,000.

MARPLES, George, A.R.E. 1869-1939
Painter and etcher of ornithological subjects. Born in Derby, he studied at the School of Art there, at the R.C.A. and in Paris. He was Principal of Huddersfield, Hull and Liverpool Schools of Art.
£30-£80.

MARR, Charles fl. mid-19th century
Line engraver of small bookplates including genre and decorative subjects and portraits after his contemporaries and Old Master painters. He was one of the first engravers to use steel plates.
Small value.

MARRIOT, Frederick, R.E. 1860-1941
Painter and etcher of landscapes and architectural views. Born in Stoke-on-Trent, he studied at the R.C.A. After working as a designer, he taught design at Blackheath and was Headmaster of Onslow College Art School and of Goldsmiths' Institute. Visits to the Continent provided the subject matter for many of his etchings.
£30-£70.

MARSHALL, Herbert Menzies, R.W.S., A.R.E. 1841-1913
Architect, painter and etcher of landscapes and architectural views. Born in Leeds, he studied at the R.A. Schools and was later Professor of Landscape Painting at Queen's College, London. He contributed plates to *English Etchings*.
£5-£10.

MARSTON, Freda 1895-1949
Painter and etcher of landscapes. Born in London, she studied at The Regent Street Polytechnic and was a pupil of Terrick Williams. She lived in Sussex.
£10-£30.

MARTEN, John fl. early 19th century
Draughtsman and lithographer of topographical views. He was the son of the artist John Marten of Canterbury, and he worked there as well as in Hastings.
'Hastings Delineated', c.1825, 6 pl., obl. 4to., e. £15-£40 col.
'Shakespeare's Cliff, Dover', £10-£30.

MARTIN, Alfred 1814-1872
Mezzotint engraver of biblical and other subjects, after his father, J. Martin (q.v.).
'Christ Walking on the Sea', after J. Martin, 1835, 5¼ x 9in/13.5 x 23cm, £10-£20.
'Sadak in Search of the Waters of Oblivion', after J. Martin, 1841, 16¼ x 12½in/41.5 x 32cm, £80-£150.

MARTIN, David 1736-1798
Scottish painter, line and mezzotint engraver of portraits after his contemporaries, Old Master painters and his own designs. Born at Anstruther, Fifeshire, he was a pupil of Allan Ramsay with whom he went to Rome. In 1775 he settled in Edinburgh where he was appointed Chief Painter to the Prince of Wales. He moved to London after marrying a wealthy lady but returned to Edinburgh on her death.
'David Hume', after A. Ramsay, 1767, 15½ x 11¼in/39.5 x 28.5cm, £20-£60.
'J.J. Rousseau', after A. Ramsay, 1766, 13½ x 11in/34.5 x 28cm, mezzo., £30-£80.
'William, Earl of Bath', after A. Ramsay, 1753, 10¼ x 8½in/26 x 22cm, line, £8-£15.
'William, Earl of Mansfield', after Martin, 1775, 24¼ x 17in/61.5 x 43cm, line, £12-£25.
'Rembrandt', after the painter, 5½ x 4½in/14 x 11.5cm, mezzo., £10-£20.
'Lady Frances Manners', after Martin, 20 x 18¼in/51 x 46.5cm, mezzo., £100-£160.
CS.

MARTIN, Dorothy Freeborn b.1875
Welsh miniaturist, painter and etcher of landscapes. She studied at the Slade and lived in London.
£10-£30.

MARTIN, Elias, A.R.A. 1739-1811
Swedish landscape, portrait and figure painter,

etcher and engraver of decorative subjects and portraits mainly after his own designs. Born in Stockholm, he came to London in 1768 and studied at the R.A. Schools. He remained in England until 1780 and then went back to Sweden, returning to England once more in 1788 when he stayed for three years. He died in Stockholm.
'A Daughter's Education from Cradle to Marriage Contemplation', 1776, 6 ovals, approx. 8 x 5in/20.5 x 12.5cm, set £400-£700 prd. in red.
'Henrietta Maria', after A. Van Dyck, 1774, 5 x 3¾in/12.5 x 9.5cm, £4-£8.
'A Family Concert' (The Fitzpatrick Family), 16 x 19¼in/40.5 x 49cm, £100-£200 prd. in red.
'Sir John Smith', 1773, 11¾ x 7½in/30 x 19.5cm, £8-£15.

MARTIN, Henri b.1809
French etcher of landscapes and marine subjects after his Continental and British contemporaries.
£5-£10.

MARTIN, John 1789-1854
Well-known painter, etcher and mezzotint engraver of landscapes, historical and biblical subjects. Born at Haydon Bridge, near Hexham, he was apprenticed to a coach painter and then to a china painter with whom he went to London in 1806. His first etchings date from 1816, and these prints, as well as his 'Views of Sezincote House', reveal his interest in architecture and perspective which was to dominate many of his later prints, particularly the large plates. He produced the bulk of his mezzotints in the 1820s and 1830s, and made full use of the medium to

MARTEN, John. 'Shakespeare's Cliff, Dover'.

MARTIN, John. 'View of a Classical City', 1816, etching.

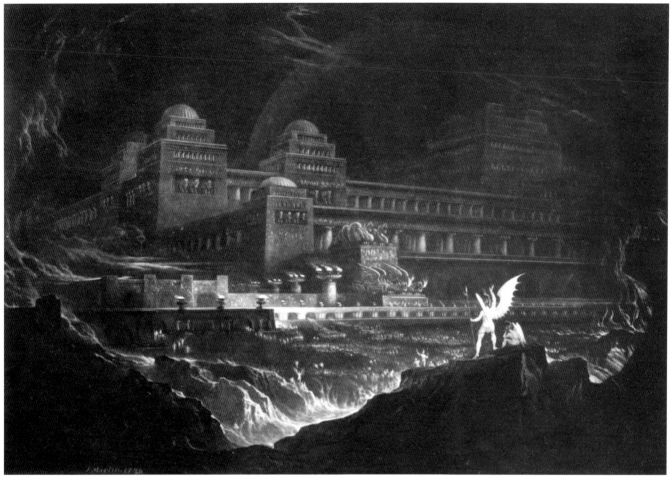

MARTIN, John. One from the set of twenty-four larger mezzotint illustrations for *Paradise Lost*.

achieve the chiaroscuro effects of his apocalyptic visions. His use of steel plates made possible very large editions. His most famous series was the set of twenty-four illustrations to John Milton's *Paradise Lost*. He died in the Isle of Man.

Studies of trees, early etchings, e. £300-£600.

'View of a Classical City', 1816, 7¼ x 9¾in/18.5 x 25cm, etching, £500-£1,000.

'Views of Sezincot House', c.1818, 10 etchings aq. by F.C. Lewis (q.v.), obl. fo., set £4,000-£8,000.

'Pandemonium', with J.P. Quilley (q.v.), 1832, 18¾ x 27¾in/47.5 x 70.5cm, mezzo., £500-£1,000.

'The Deluge', 1828, 23½ x 32in/60 x 81cm, mezzo. with etching, £600-£1,200, proof before all letters, fetched £6,500 June 1993.

'The Flight into Egypt', 14¼ x 19in/36 x 48.5cm, rare, £800-£1,400.

Other lge. pl. £600-£1,400.

Illustrations to Paradise Lost, *1827, 24 pl., larger pl., 10 x 14in/25.5 x 36cm, set £2,500-£4,000.*

Illustrations of the Bible, *C. Tilt edn., 1838, 20 pl., fo., set £800-£1,600; rare early proof set £3,000-£5,000.*

Bibl: Balston, T., *J.M. 1789-1854, Illustrator and Pamphleteer,* London, 1934.

Refs: J. D. Wees & M. J. Campbell, *Darkness Visible,* Williamstown, 1986.

M. J. Campbell, *John Martin - Visionary Printmaker,* 1992.

MARTIN, R. fl. mid-19th century
Lithographer of topographical views, costumes, portraits, etc., after his own designs, his contemporaries and Old Master painters.

'Robert Davies', 15¼ x 11¼in/38.5 x 28.5cm, £8-£15.

'London Bridge at Different Periods', 8 pl., obl. fo., set £500-£1,000 col.

Pl. for The Cyclopaedia of British Costumes, *fo., e. £5-£15 col.*

MARTINDALE, Percy Henry 1869-1943
Mezzotint engraver of portraits and landscapes after British 18th century painters and his contemporaries. He was a pupil of J.B. Pratt (q.v.) and lived in Woodchester in Gloucestershire.

£30-£70 prd. in col.

MARTINI, Pietro Antonio 1739-1797
Italian etcher and line engraver of decorative, genre and religious subjects after his contemporaries. He seems to have been born in Parma but worked in London for some years.

'The Exhibition of the Royal Academy, 1787', and 'King George III at the Royal Academy', both after J.H. Ramberg, 1788, both 15 x21in/38 x 53.5cm, e. £140-£180; a fine pair has fetched £1,000.

'Le Repos en Egypte', after Vernet, 14¼ x 9¼in/37.5 x 23.5cm, £8-£15.

'La Petite Toilette', after Moreau, 11 x 9in/28 x 23cm, £30-£60.

MARTYN, Ethel King, R.E.
 c.1865-1930 or later
Portrait painter and etcher of fairy subjects. She lived in Kensington.

£25-£80.

MARTYN, John fl. 1794-d.1828
Irish line and stipple engraver of portraits after his contemporaries. He lived and worked in Dublin, claiming to have been trained in London.

Small value.

MARVY, Louis fl. mid-19th century
French line and mezzotint engraver of landscapes after his contemporaries and 18th century painters. He fled the Revolution in 1848 and took refuge in England, where he was assisted by the writer Thackeray, an old friend of the family.

Sketches after English landscape painters, 1850, 4to., e. small value.

'Ten Mezzo-tinto Engravings from Original Drawings by Caroline Courtenay Boyle', fo., small value.

MASON, Abraham John b.1794
Wood engraver of book illustrations after his contemporaries. A pupil of A.R. Branston (q.v.), he set up his own business in 1821, and in 1829 went to New York where he was elected Associate of the Academy and Professor of Engraving.

Bookplates small value.

MASON, Frank H. 1876-1965
Painter and drypoint etcher of marine and railway subjects. Born in County Durham, he served as a Lieutenant in the R.N.V.R. in World War I and lived in Scarborough.
£20-£50.

MASON, James 1710-c.1785
Etcher and line engraver of landscapes, topographical views and naval and military subjects after his contemporaries and 17th century painters. He seems to have lived and worked in London, engraving several plates for J. Boydell (q.v.), and sometimes collaborating with P.C. Canot and F. Vivares (qq.v.).
Views in the island of Jamaica, after G. Robertson, 1778, 16 x 20½in/40.5 x 52cm, e. £200-£500.
'Part of the Town and Harbour of Halifax, Nova Scotia', after D. Serres, 15¾ x 21in/40 x 53cm, £400-£700.
'A Cataract on the River Dee, which Divides the Counties of York and Durham', after T. Smith, 15¾ x 21¾in/39 x 55.5cm, £80-£200.
'Lake of Killarney from Near Dunmow Castle', after J. Fisher, 1770, 16¼ x 21in/41 x 53cm, £80-£200.
'View of Plymouth Fort' and 'Mount Edgcumbe', after G. Lambert and S. Scott, 1755, 15 x 24in/38 x 61cm, e. £60-£140.
Landscape pl. after 17th century painters, £50-£150.
'The Reduction of Havannah', after D. Serres, 1766, 12 pl. with P. Canot, 17¾ x 25¼in/45 x 65.5cm, e. £200-£300.
Bookplates small value.

MASON, T. fl. mid-19th century
Lithographer.
'Views of South Devon Railway', 10¼ x 14½in/26 x 37cm, e. £100-£200 col.

MASSE, Pierre Augustin
fl. late 19th century
French etcher of sentimental and historical subjects after his contemporaries. Born at Blois, he was a pupil of E. Boilvin (q.v.) and worked in London for several years.
£5-£15.

MASSOL fl. early 19th century
Stipple engraver of small bookplates including portraits.
Small value.

MATHAM, T. fl. mid-17th century
Line engraver of bookplates and portraits after his contemporaries.
Small value.

MATHEY-DORET, Emile Armand b.1854
French etcher of portraits, genre and decorative subjects after 17th, 18th and 19th century

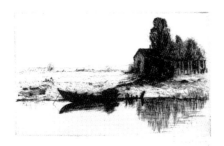

MATHIESON, John George. Landscape etching.

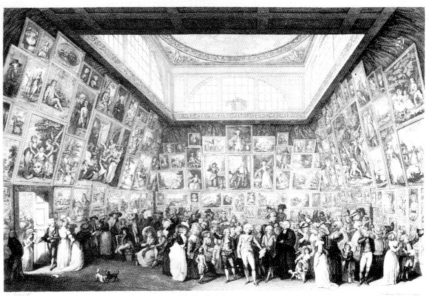

MARTINI, Pietro Antonio. 'The Exhibition of the Royal Academy, 1787', after J.H. Ramberg, 1788.

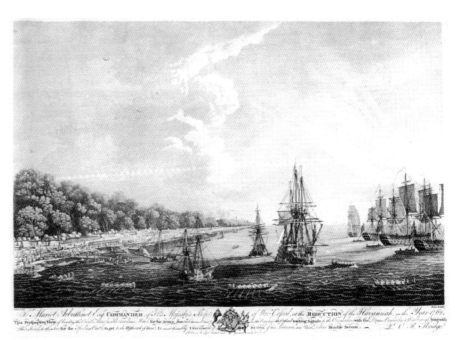

MASON, James. 'The Reduction of Havannah', one of twelve plates after D. Serres, 1766.

British and French painters and his contemporaries. Born in Besançon of Swiss parents, he was a pupil of Lehman and C. Waltner (q.v.).
£5-£15.

MATHIESON, John George
fl. early 20th century
Scottish painter and etcher of landscapes. He lived and worked in Stirling.
£10-£30.

MATTHEWS, Henry fl. mid-19th century
Draughtsman and lithographer.
'Royal East India Volunteers Receiving their

Colours', c.1860, 14 x 21in/35.5 x 53.5cm, chromolitho., £80-£140.

MAURER, John fl. early/mid-18th century
Draughtsman, etcher and line engraver, mainly of topographical views. He is believed to have been of Swiss origin and to have worked in London from 1713 to 1761.
'A Perspective View of ye Royal Palace of Somerset next ye River', 1742, and other London views £80-£200 col.
Others views mostly £50-£150 col.
'Monument of William Shakespeare', after P. Scheemakers, 1742, 13½ x 8½in/34.5 x 22cm, £10-£20

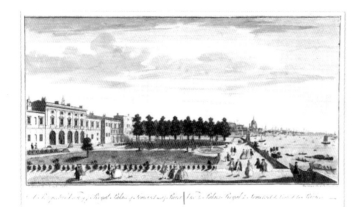

MAURER, John. 'A Perspective View of ye Royal Palace of Somerset next ye River', 1742.

MAXWELL, Tom. A typical architectural view.

MAZELL, P. 'The Grosvenor Arabian', after G. Stubbs.

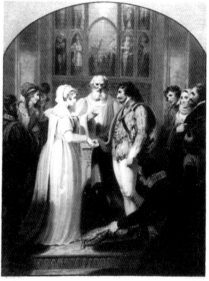

MEADOWS, Robert Mitchell. 'Marriage', one of a set of four with 'Baptism', 'Confirmation' and 'Sacrament', all after R. Westall, 1806.

MAXWELL, Tom fl. early 20th century
Scottish etcher of landscapes and architectural views.
£20-£50.

MAY, William Holmes 1839-1920
Surrey painter and etcher of landscapes. He contributed plates to *English Etchings*.
Small value.

MAYALL, fl. late 18th century
Etcher of bookplates.
Small value.

MAYO, Eileen fl. mid-20th century
Colour linocut artist in the school of W.C. Flight (q.v.).
'Turkish Bath' and 'The Plunge', 1928, pair £500-£700.

MAZELL, Peter 1735-1805 or later
Etcher and line engraver of portraits, animal and ornithological subjects, etc., after his contemporaries.

'Firefighting' £60-£120.
'The Grosvenor Arabian' (racehorse), after G. Stubbs, 16¼ x 19¼in/41.5 x 49cm, £1,000-£2,000.
'George III at Review', after D. Morier, 21¼ x 17¾ in/55 x 45cm, £80-£160.
Pl. for Pennant's British Zoology, *after P. Paillou, 1761-6, 16¼ x 12½in/41.5 x 32cm, e. £70-£150 col.*
'Upper Lake of Killarney from Turk Mountain', after J. Fisher, 1770, 16 x 21in/41 x 53cm, £80-£200.
Small portraits and bookplates small value.

MEADOWS, Robert Mitchell 1763-1812
Stipple engraver of decorative, sporting and genre subjects and portraits after his contemporaries. He was born in and worked in London.
'Baptism', 'Confirmation', 'Sacrament', and 'Marriage', after R. Westall, 1806, 4 pl., 22½ x 17in/57 x 43cm, set £600-£1,000 prd. in col.
'A Storm in Harvest', and 'Reapers', after R. Westall, 1802 and 1805, 21¼ x 28½in/54 x 72.5cm, pair £600-£900 prd. in col.
'Francis, Duke of Leeds', after T. Lawrence, 24 x 15¼in/61 x 38.5cm, £10-£20.
'Mr. Kemble as Coriolanus', after T. Lawrence, 1805, 33 x 19½in/84 x 49.5cm, £60-£120.
'Fox Breaking Cover', after P. Reinagle, aq. by F.C. Lewis,
1807, 14¾ x 20¼in/37.5 x 51.5cm, £400-£600 col.
Small portraits and bookplates small value.

MEDLAND, Thomas 1755-1822
Draughtsman, line, stipple and aquatint engraver of landscapes, topographical views, sporting, botanical and drawing at the East India College based first at Hertford and later Haileybury.
'The Battle of the Glorious First of June, 1794', after R. Cleveley, a pair, one by B.T. Pouncy (q.v.), 17 x 22½in/43 x 57cm, line eng., pair £400-£700.
'The Aloe', after P. Reinagle, 1798, from

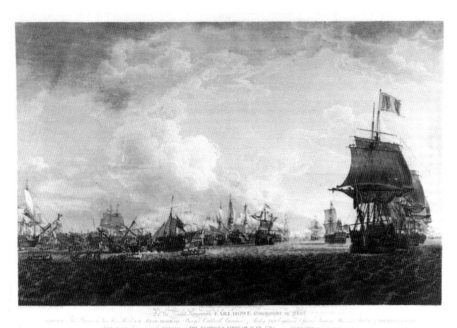

MEDLAND, Thomas. 'The Aloe', after P. Reinagle, 1798, aquatint.

MEDLAND, Thomas. 'The Battle of the Glorious First of June, 1794', after R. Cleveley, line engraving. One of a pair, the companion by B.T. Pouncy is on page 280.

R. Thornton's Temple of Flora, *18½ x 15½in/47 x 39cm, £300-£500 prd. in col.*
'Richard Badham Thornhill', 1804, 8¾ x 6½in/22 x 16.5cm, aq., £10-£15 col.
'George Cartwright', after W. Hilton, 1792, 8 x 6 ½in/20.5 x 16.5cm, line, small value.
Pl. for R.B. Thornhill's Shooting Directory, *after J. West, 1804, 11¼ x 9in/28.5 x 23cm, aq., e. £30-£50 col.*
Pl. for Capt. C. Gold's Oriental Drawings, *1806, 4to., aq., e. £7-£14 col.*
Pl. for J. Farington's Views of the Lakes, *1789, obl. fo., line, e. £15-£30.*
Pl. for E. Harding's Shakespeare Illustrated, *1793, small value.*
Pl. for The Naval Chronicle, *after N. Pocock, 1805, ave. 4½ x 7½in/11.5 x 19cm, aq., £8-£16 col.*

MEDWORTH, Frank Charles b.1892
Painter, etcher and wood engraver of religious, genre and figure subjects. Born in London, he studied at the R.C.A. and was a finalist in the Rome Scholarship in Engraving.
£10-£30.

MELVILLE, H. fl. mid-19th century
Line engraver of small bookplates, including landscapes, topographical views, etc., after his contemporaries.
Small value.

MENPES, Mortimer L., R.E. 1860-1938
Painter, illustrator, etcher and drypointer of portraits, figure and genre subjects and

architectural views. Born in Australia, he came to England and studied under J.A.M. Whistler (q.v.). He travelled extensively on the Continent, North Africa, the Far East and Mexico, and his travels provided him with the subject matter for most of his prints. He later lived at Pangbourne, Berkshire.
'White Ducks, - or The Five Faces of Whistler', 7 x 6in/17.5 x 15cm, and other portraits of Whistler, e. £200-£400.
Other portraits, figure subjects, views and genre scenes mostly £40-£100.

MERIGOT, J. fl. late 18th/early 19th century
Aquatint engraver of topographical views after his contemporaries. He was probably of French origins, and apparently worked in Paris before

MENPES, Mortimer L. 'White Ducks - or The Five Faces of Whistler'.

MERIGOT, J. 'View of the Bridge across Cabaritta River…', from the series of six views in Jamaica, 1800.

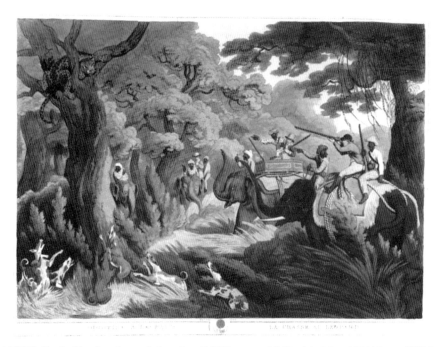

MERKE, Henri. 'Shooting a Leopard', from Capt. T. Williamson and S. Howitt's *Oriental Field Sports*, 1805-7.

coming to London.
*Views in Jamaica, after L. Belanger, 1800, 6 pl.,
22¼ x 30½in/56.5 x 77.5cm, e. £1,000-£2,000
col.*
*'The Funeral Procession of Lord Nelson on
January 6, 1806', after Pugin, 4 pl., fo., set
£600-£900 col.*
*'Views of Stockholm from the Island of
Langholm' and 'The Castle of Drottingholm',
after E. Martin, 1802, 18¼ x 23½in/47.5 x 60cm,
pair £1,000-£2,000 col.*
*'A Romantic Landscape with Pyramids and
Mountains', after R.A. Riddell, 1808, 36½ x
52in/93 x 132cm, £400-£700 col.*
*'Views and Ruins in Rome', 1797-9, 62 pl., fo.,
tt., e. £10-£30.*
Pl. for J.C. Nattes' Tour of Oxford, *1805, fo., e.
£50-£100 col.*
Pl. for J. Stoddart's Picturesque Views in
Scotland, *1801, 8vo., e. small value.*

MERKE, Henri

fl. late 18th/early 19th century
Swiss aquatint engraver of sporting and genre
subjects and costume plates after his
contemporaries. He was apparently born in
Zurich and worked in London.
*'Inside' and 'Outside of a Cottage in
Buckinghamshire', after E. Orme, 1807, with
C. Knight I (q.v.), fo., pair £80-£140 col.*
*'Fox Hunting', after T. Hand, 1808, with
C. Knight, 19¼ x 26¼in/50 x 66.5cm, £400-£700
col.*
*'The Wreck of the Lady Burges, East India
Ship', after J. Sartorius, 1806, 21 x 27½in/53 x
70cm, £200-£350 col.*
Pl. for Ackermann's Royal Navy, *etched by
T. Rowlandson, 1799, 10 pl., 11½ x 8½in/29 x
22cm, e. £30-£70 col.*
Pl. for Orme's Collection of British Field
Sports, *after S. Howitt, with various eng., 1807-
8, 14½ x 19in/37 x 48.5cm, e. £500-£1,000 col.
(set of 20 fetched £16,500 Oct. 1988).*
Pl. for Capt. T. Williamson's Foreign Field
Sports, *after various artists, 1814, 4to., e. £15-
£30 col.*

Pl. for Capt. T. Williamson and S. Howitt's
Oriental Field Sports, *1805-7, obl. fo., e. £150-
£300 col., for 1819 edn. e. £80-£160 col.*
Pl. for J. Hunter's Scenery of Mysore, *1805, fo.,
e. £20-£50 col.*
Colour plate page 51.

MERRITT, Anna Massey Lea, A.R.E.
1844-1930
American painter and etcher of portraits. Born
in Philadelphia, she settled in England after
travelling in Europe.
£15-£30.

METZ, Conrad Martin 1755-1827
German draughtsman, etcher and stipple
engraver of portraits, decorative and
mythological subjects after Old Master painters,
his contemporaries and his own designs. Born
in Bonn, he studied in London under
F. Bartolozzi (q.v.) and taught drawing for some
time before leaving for Rome in 1802.
*'Children Playing', 'Angling', etc., after Metz,
1800, 4 pl., 13 x 9in/33 x 23cm, set £400-£800
prd. in col. or in sepia.*
Pl. for Imitations of Original Drawings *by Hans
Holbein, most by Bartolozzi, 1792, fo., e. £40-
£90 prd. in col.*
Others small value.

MEYER, Henry 1782-1847
Painter, line, stipple, mezzotint and aquatint
engraver of portraits and decorative subjects
after his contemporaries. Born in London, he
was a nephew of the painter John Hoppner, and
studied under F. Bartolozzi (q.v.).
*'Lady Hamilton as Nature', after G. Romney,
12½ x 9¾in/32 x 25cm, mezzo., £500-£800 prd.
in col.*
*'The Cottage Door' and 'The Roadside', after
W. Owen, 1814, 20¼ x 14¼in/53 x 37.5cm,
mezzo., pair £600-£1,000 prd. in col.*
*'The Proposal' and 'Congratulations', after
G.H. Harlow, 14¼ x 9¾in/36 x 25cm, stipples,
pair £250-£400 prd. in col.*
*'Father's Delight', after W. Derby, 1811, 11½ x
8¼in/29 x 21cm, stipple, £150-£250 prd. in col.*
*'Equestrian Match Against Time', after
J. Meyer, 9½ x 13½in/24 x 34.5cm, aq., £80-£140
col.*
*'Alexander Adair', after H. Edridge, 18¼ x
13¼in/46.5 x 33.5cm, stipple, £20-£40 partly
prd. in col.*
*'Guiseppe Ambrogetti', after J. Partridge, 16¼ x
13¼in/42.5 x 35cm, mezzo., £20-£40.*
*'Lord Hawkesbury', after J. Hoppner, 1808,
12¼ x 9¾in/31 x 25cm, mezzo., £10-£25.*
Pl. for J. Wallis' London Volunteers, *1807, after
J. Green, with F.C. Lewis I (q.v.), 13½ x*

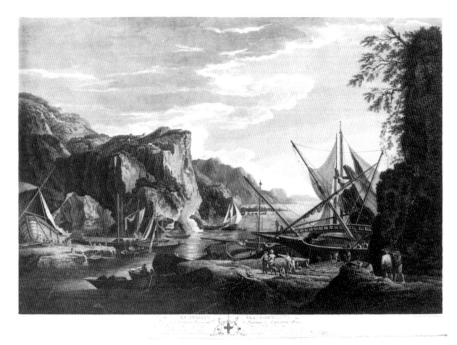

MIDDIMAN, Samuel. 'An Italian Sea-Port', after S. Rosa, 1800.

*11in/34.5 x 28cm, aq., e. £100-£160 col.
Small portraits and bookplates small value.*

MEYER, Henry Leonard fl. mid-19th century
Draughtsman and lithographer of ornithological subjects.
'Coloured Illustrations of British Birds and their Eggs', fo. edn. pl. 15 x 11in/38 x 28.5cm, e. £10-£30 col.; 8vo. edn. approx. 430 pl., 1842-5, vol. 600-£1,000 col., fetched £1,700 April 1989.
'Game Birds and their Localities', 6 pl., 8¼ x 11¼in/22 x 28.5cm, e. £80-£160 col., set col. has fetched $5,500 June 1989.

MICHEL, Jean Baptiste d.1804
French line and stipple engraver of decorative subjects after his contemporaries and Old Master painters. Born in Paris, he later worked in London where he died.
'Peasants with Fruit and Flowers', after W. Peters, 1786, 12 x 13in/30.5 x 33cm, stipple, £200-£400 prd. in col.
Pl. after Old Masters small value.

MIDDIMAN, Samuel 1750-1831
Etcher and line engraver of landscapes, topographical views and figure subjects after contemporaries, Old Master painters and his own designs. He was a pupil of F. Bartolozzi, W. Byrne and W. Woollett (qq.v.). He died in London.
'Select Views in Great Britain', 1784-92, after various artists, obl. 4to., e. £5-£15.
Pl. for Boydell's Shakespeare, *fo., e. £10-£25.*
Lge. landscapes after Old Master painters and contemporaries £50-£150.

MIDDLEMIST, C. fl. early 19th century
Stipple engraver of small portraits after his contemporaries.
Small value.

MIDDLETON, Charles
 fl. late 18th/early 19th century
Draughtsman and line engraver of architectural views. He was architect to the court of George III.

MIDDLETON, John. A typical landscape study.

'Picturesque and Architectural Views for Cottages, Farm Houses and Country Villas', 1793, fo., e. small value.

MIDDLETON, John 1828-1856
Painter and etcher of landscapes. Born in Norwich, he studied under H. Bright, J.B. Ladbrooke and J. Stannard (q.v.) and was a follower of the Norwich School. The only published issue of his etchings were: 'Nine Etchings by J. M.', in 1852. He died of consumption.
£40-£90.
Ref: Bolingbroke.

MIGNON, Abel Justin b.1861
French etcher.
'Spring', after E. Burne-Jones, 1900, 21 x 14½in/53.5 x 37cm, £600-£1,200.
Others small value.

MILLAIS, Sir John Everett, P.R.A.
 1829-1896
Famous Pre-Raphaelite painter, illustrator and etcher of sentimental and genre subjects. He was a member of the Etching Club and the Junior Etching Club and contributed plates to their publications. Many of his paintings were reproduced by professional engravers.
'The Baby-House', 5½ x 7¼in/14 x 18.5cm, £80-£160.
'Happy Springtime', 1860, £100-£200.
'Going to the Park', 1863, 7¼ x 5¼in/18.5 x 13.5cm, £70-£140.
'Summer Indolence', 1861, 6¼ x 9½in/16 x 24cm, £80-£160.

MILLAIS, John Everett. 'St. Agnes of Intercession', 1850.

MIGNON, Abel Justin. 'Spring', after E. Burne-Jones, 1900.

'St. Agnes of Intercession', 1850, 5¾ x 8¾in/14.5 x 22.5cm, v.rare, fetched £2,800 December 1985.

MILLAIS, John Guille 1865-1931
Draughtsman and lithographer of ornithological and animal subjects. Born in London, he was the son of J.E. Millais (q.v.). He travelled all over the world making sketches, and published several books.
'Grouse', 1890, 8¾ x 9½in/22.5 x 24.5cm, chromolitho., £30-£70.

MILLER, Andrew d.1763
Mezzotint engraver of portraits after his contemporaries. Born in London, he was a pupil of J. Faber I (q.v.) and moved to Dublin c.1740 where he remained for the rest of his life, engraving portraits of several Irishmen.
'Jonathan Swift', after F. Bindon, 14 x 10in/35.5 x 25.5cm, £100-£160.
Other Irish portraits: WLs £80-£200; HLs £40-£100.
'William, Duke of Cumberland' (on horseback), 1746, 20¼ x 14in/51.5 x 35.5cm, £100-£160.
English HLs £15-£50.
CS.

MILLER, Frederick
fl. late 19th/early 20th century
Etcher, mezzotint and mixed-method engraver of sentimental subjects and portraits after his contemporaries.
£10-£30, £20-£60 prd. in col.

MILLER, J.G. fl. late 18th century
Line engraver. Probably related to John Miller (q.v.).
'The Battle of Bunker's Hill', after J. Trumbull, 1798, 20 x 30in/51 x 76cm, £300-£500.

MILLER, John (Johann Sebastian Müller) b.1715
German painter, draughtsman and line engraver of landscapes, topographical views, portraits, botanical illustrations and sporting and historical subjects after his own designs, Old Master painters and his contemporaries. Born in Nuremberg, he came to England in 1744 and, as well as drawing and engraving, published several botanical books, the best known being *Illustrations to the Sexual System of Linnaeus*, 1776.
'Costumes of Highlanders', 1743-6, 6½ x 9¼in/16.5 x 23.5cm, e. £8-£15.
'Atlas' (racehorse), after W. Shaw, 1761, 12½ x 15¾in/31.5 x 40cm, £100-£200.
'The Continence of Scipio', after A. Van Dyck, 1766, 23 x 17½in/58.5 x 44.5cm, £10-£20.
Views of Roman ruins, after G.P. Panini, 6 pl., 19 x 24in/48.5 x 61cm, e. £80-£160.
London views, 28 x 40cm, £40-£100.
Most pl. after Old Masters, small portraits and bookplates small value.

MILLER, John Douglas b.1860
Mezzotint engraver of decorative and sentimental subjects and portraits after his contemporaries. He was born in Hadley.
'The Lady of Shalott', after W. Holman Hunt, 1909, 27¾ x 21¼in/70.5 x 54cm, £250-£400.
'Letty', after F. Leighton, 1888, 13 x 11in/33 x 28cm, £20-£50.
'The First Whispers of Love', after W. Bouguereau, 21¼ x 12½in/55.5 x 32cm, £70-£140.
'Summer Slumber', after F. Leighton, 16 x 21¾in/40.5 x 55.5cm, £140-£200.
'The Lady . . .' and 'Summer . . .', pair fetched £1,100 Oct. 1988.

MILLER, John Douglas. 'The First Whispers of Love', after W. Bouguereau.

Add more if in fine contemporary frame. Portraits small value.

MILLER, John Frederick
fl. late 18th century
Topographical painter, draughtsman and etcher of natural history subjects. The son of J. Miller (q.v.), he was draughtsman on Banks' Iceland expedition in 1777.
'Cimelia Physica', 1796, fo., e. £30-£90 col.

MILLER, William 1796-1882
Scottish line engraver of landscapes, topographical views and biblical and historical subjects after his contemporaries. Born in Edinburgh, he was first apprenticed to an engraver there and then went to London in 1819 to study under G. Cooke (q.v.), returning home in 1821. He was elected an Honorary Member of the R.S.A. in 1862.
Lge. pl. after J.M.W. Turner £100-£250.
Add more if in fine contemporary frame.
Bookplates after Turner if proofs or early imp. £5-£15.
Other bookplates small value.

MILLS, Alfred 1776-1833
Wood engraver of book illustrations. He died at Walworth.
Small value.

MILLS, Arthur Stewart Hunt, R.E.
1897-1968
Etcher and wood engraver. Born in Portsmouth, he trained at Goldsmiths' College after receiving an M.A. at Oxford. He lived in Hertfordshire and later Hampshire.
£10-£30.

MILLS, Isaac, fl. early 19th century
Etcher and line engraver of small bookplates

including portraits and topographical views after his contemporaries and his own designs.
Small value.

MILN, Robert fl. early 18th century
Scottish line engraver of bookplates.
Small value.

MILNER, Elizabeth Eleanor d.1953
Mezzotint engraver of portraits after 18th century painters and sentimental subjects after her contemporaries. Born in Stockton-on-Tees, she studied at Lambeth and St. John's Wood Schools of Art as well as at the R.A. Schools. She was also a pupil of H. Herkomer (q.v.) at Bushey, Hertfordshire, where she lived for the rest of her life.
£20-£60 prd. in col.
£10-£30 b. & w.

MILTON, Thomas c.1743-1827
Line and aquatint engraver of landscapes, topographical views, portraits and military costumes after his own designs and those of his contemporaries. The son of a marine painter, he may have been a pupil of W. Woollett (q.v.). He worked in London, later in Dublin and died in Bristol.
Pl. for L. Mayer's Views in Egypt, Palestine and Other Parts of the Ottoman Empire, 1804, fo., aq., £10-£30 col.
'Military Uniforms', after J. Smith, 1808, 13 x 10in/33 x 25.5cm, aq., £30-£60 col.
'The Seats and Demesnes . . . of Ireland', after W. Ashford and others, 1783-93, 24 pl., set £700-£1,200.
Other bookplates, small portraits, and all line eng. small value.

MILTON, William d.1790
Line engraver of bookplates. He died at Lambeth.
Small value.

MINASI, Giacomo
fl. late 18th/early 19th century
Stipple and chalk-manner engraver of portraits and decorative subjects after his contemporaries and Old Master painters. He was probably a pupil of F. Bartolozzi (q.v.), and appears to have worked in London. See also Minasi, J.A.
'A Lady with a Young Girl', after R. Cosway, 13¾ x 9½in/35 x 24cm, £60-£140 prd. in sepia or in col.
'Cupids Sporting', after D. Beauclerk, 4 pl., set £200-£400 prd. in sepia or in col.
'Mary Whitefoord and Her Son', after R. Cosway, 1806, 17½ x 14½in/44.5 x 37cm, £60-£140 prd. in sepia or in col.
Add more if in fine contemporary frame.
'Salvator Mundi', 20 x 15in/51 x 38cm, £4-£10.
'Thomas, Baron Wentworth', after H. Holbein, 7 x 6in/18 x 15cm, small value.
'The Marquis of Wellington', after A. Aglio, 1803, 17 x 12½in/43 x 32cm, £15-£40.

MINASI, James Anthony 1776-1865
Stipple engraver and lithographer of portraits after his own designs, his contemporaries and Old Master painters. There are prints signed Anthony, I.A. or I.; it is possible that there were two engravers, Anthony and James. He/they were probably pupils of F.Bartolozzi (q.v.).
Small value.

MITAN, James 1776-1822
Etcher, line and aquatint engraver of landscapes, architectural views, military

subjects, etc., after his contemporaries. Born in London, he was a pupil of J.S. Agar and T. Cheesman (qq.v.) and also studied at the R.A. Schools. He was employed by both the Admiralty and the Freemasons and died in London. He was the brother of S. Mitan (q.v.) and some plates without initial could be by either engraver.

'The Pavilion and Steyne at Brighton, with the Promenade, The Prince of Wales Riding', after G.T. Cracklow and W.M. Craig, 1806, 18¼ x 28¼in/47.5 x 72cm, aq., £150-£300.
'The Battle of Bunker's Hill', after J. Trumbull, 1808, 15 x 20in/38 x 51cm, £200-£400.
'The Battle of Alexandria', after Lt. Willermin, with C. Turner, 1804, 21½ x 28in/54.5 x 71cm, £400-£600 prd. in col.
'Inspection of the Honble. Artillery Company', after E. Dayes, 1803, with W. Pickett (q.v.), 24 x 30in/61 x 76cm, etching and aq., £500-£800 col.
'Sir William Sidney Smith at Acre', after R.K. Porter, with A. Cardon (q.v.), 1800, 14¼ x 8¼in/37.5 x 21cm, £10-£20.
Small portraits and bookplates small value.

MITAN, Samuel 1786-1843
Etcher, line and aquatint engraver of military subjects and topographical views after his contemporaries. He was the brother and pupil of J. Mitan (q.v.); some plates are signed without initial and could be by either engraver.
'Loyal London Volunteers', after W.M. Craig, 10¼ x 14½in/26 x 37cm, aq., £100-£160 col.
'Flying Artillery', drawn and etched by T. Rowlandson (q.v.), 1798, 11¼ x 17¼in/30 x 45cm, £200-£300 col.
'The London Volunteer Cavalry and Flying Cavalry as Reviewed in Hyde Park', after C. Cranmer, 1805, 18½ x 19¼in/47 x 49cm, £300-£500 col.
Pl. for Kelly's Battle of Waterloo, after G. Jones, 1817, 4to., e.£3-£8.
Other small bookplates small value.

MITCHELL, Edward fl. late 18th/early 19th century
Edinburgh line and stipple engraver of landscapes, topographical views, portraits, genre and decorative subjects after Old Master painters and his contemporaries.
'Old Parish Church', after J. Summers, 12 x 17¼in/30.5 x 44cm, £5-£15.
'The Death of Abercrombie', 1805, 23 x 25in/58.5 x 63.5cm, £120-£200 prd. in col.
'Henry Johnston, the Actor, as Douglas', after H. Singleton, 1806, 17 x 14in/43 x 35.5cm, £15-£40.
'John Bruce', after H. Raeburn, 10¼ x 8in/26 x 20.5cm, £4-£8.
'Adamo Van Noort', after van Dyck, 9¼ x 7in/23.5 x 18cm, small value.
'Cymon and Iphigenia', after H. Singleton, 1809, 11½ x 14¼in/29 x 37.5cm, £50-£150 prd. in sepia or col.
Small portraits and bookplates small value.

MITCHELL, James 1791-1852
Line engraver of genre and sentimental subjects after his contemporaries. The father of R. Mitchell (q.v.), he contributed plates to the Annuals and died in London.
Small value.

MITCHELL, Robert 1820-1873
Line and mezzotint engraver of sentimental subjects after his contemporaries. He was the son of J. Mitchell (q.v.). He died in Bromley, Kent.

'Tapageur, a Fashionable Member of the Canine Society', after E. Landseer, 1852, 19 x 24½in/48.5 x 62cm, £150-£300.
'Christ Walking on the Sea', after R.S. Lauder, 1854, 26¼ x 18¼in/68 x 46.5cm, £15-£30.
'The Happy Mothers' and 'The Startled Twins', after R. Ansdell, 1850, 17½ x 23¼in/44.5 x 60.5cm, pair £200-£500.
Add more if in fine contemporary frame.

MOFFAT, James 1775-1815
Topographer, draughtsman, etcher and aquatint engraver of caricatures. He lived in Calcutta from 1789 and produced some cartoons satirising life in Bengal.
'Views in India and China', etching with aq., 1804, 19½ x 24in/49.5 x 61cm, obl. fo., e. £100-£200 (18 pl. fetched £5,000 May 1995).
Caricatures £30-£80 col.

MOLLISON, J. fl. early/mid-19th century
Stipple engraver of small bookplates including portraits after his contemporaries and Old Master painters.
Small value.

MONGIN, Augustin 1843-1911
French etcher of genre and sentimental subjects and portraits after his French and British contemporaries and Old Master painters as well as his own designs.
Small value.

MONK, William, R.E. 1863-1937
Painter and etcher of architectural and topographical views. Born in Chester, he studied at the Antwerp Academy and lived in London.
Views of Eton, Winchester and Harrow £15-£40; New York and London £20-£50.
London Almanacks £12-£25.
Bibl: Hockney, A., 'The Etchings of W.M., R.E.', *P.C.Q.*, 1937, XXIV, p.308-17.

MONKHOUSE, William 1813-96
Lithographer and lithographic printer in York. He gave up lithography for photography in 1864.
'Vale of Kirkham, Yorkshire' (showing the York and Midland Railway, Scarborough Branch), after C. Taylor, 15 x 22in/38 x 56cm, tt. pl., £150-£250 col.
'View of Free Town, Sierra Leone', 12½ x 19½in/32 x 50cm, £200-£400 col.

MONTGOMERIE, William Hugh Canning b.1881
Etcher of landscapes and architectural views. Born in Edinburgh, he studied at the Slade. His etchings of Scotland show the influence of D.Y. Cameron (q.v.).
£15-£40.

MOODY, C. fl. mid-19th century
Lithographer.
'The Prize Heifer, Flower', after B. Hubbard, 14¼ x 21in/37.5 x 53cm, £300-£500 col.

MOORE, George Belton 1806-1875
Landscape and topographical draughtsman and lithographer of architectural views after his contemporaries.
Pl. for H.G. Knight's The Ecclesiastical Architecture of Italy, 1843, fo., e. £10-£25.
Pl. for O. Jones and J. Goury's Views on the Nile from Cairo to the Second Cataract, 1843, fo., tt. pl., e. £15-£40.

MOORE, Henry, R.A. 1831-1895
Marine painter, etcher of landscapes and animal subjects. Born in York, he was the son of a portrait painter and brother of the artist Albert Moore. He studied at the R.A. Schools, was a member of the Junior Etching Club and contributed to *The Portfolio*. He died in Kent.
£10-£30.

MOORE, Henry Spencer, O.M. 1898-1986
Important sculptor, draughtsman, etcher and lithographer of figure subjects. Born at Castleford, Yorkshire, he studied at Leeds College of Art and at the R.C.A. as well as on the Continent. He taught at the R.C.A. and the Chelsea School of Art and was an Official War Artist in the last war. He lived in Much Hadham, Hertfordshire.
Early prints, e.g. 'Figures in Settings', 1949, signed and numbered from edn. of 75, 22½ x 16in/57 x 40.5cm, £6,000-£9,000 (fetched £10,500 Oct. 1989).
Standing figures, colograph prd. in col., 1949, signed and numbered from edn. of 75, 14¼ x 18½in/37.5 x 47cm, £4,500-£7,000 (fetched £9,000 Oct. 1989).
'Seated Figures', litho. prd. in col., 1957, signed and numbered from the edn, of 200, fetched £3,700 June 1995.
Sculptural objects, 1949, edn. of 3,000, 19½ x 30in/49.5 x 76cm, litho., £300-£500 prd. in col.
Later prints, most from 1960s, 1970s and 1980s, £400-£1,600, but etchings of sheep, 1972, signed and numbered from edn. of 80, ave. 7½ x 10in/19 x 25.5cm, e.£1,000-£2,000.

MOORE, J. fl. mid-19th century
Stipple and line engraver of small bookplates including portraits after daguerrotypes and earlier paintings.
Small value.

MOORE, James fl. late 18th century
Mezzotint and line engraver of portraits and decorative subjects after Old Master painters and his contemporaries.
'Rev. George Whitfield', after Jenkin, 13¾ x 9¾in/35 x 25cm, £10-£35.
CS lists 1pl., noted above.

MOORE, Samuel fl. late 17th/early 18th century
Amateur draughtsman and engraver. He worked in the Custom House, London.
'Coronation Procession of King William III and Queen Mary', £50-£150.
Others mostly small value.

MOORE, Thomas Sturge 1870-1944
Poet, illustrator and wood engraver of figure subjects, particularly with a mythological theme. He illustrated books published by Vale Unicorn and Eragny Presses and lived in London.
'Metamorphosis of Pan and Other Woodcuts', 1895, 10 pl., edn. of 12, set £300-£600.
Others mostly £20-£60.

MORGAN, Henry I fl. mid-19th century
Irish landscape painter, draughtsman and lithographer of topographical views.
'Views of Cork', c.1850, fo., e. £60-£120 col.

MORGAN, Henry II fl. mid-19th century
Line and mixed-method engraver of genre and historical subjects after his contemporaries.
'The First Easter Dawn', after J.K. Thomson, 13¾ x 23in/35 x 58.5cm, £20-£70.

MOORE, Henry. 'Figures in Settings', 1949, lithograph printed in colours.

Add more if in fine contemporary frame.
Small bookplates small value.

MORGAN, Thomas fl. mid-19th century
Liverpudlian lithographer and publisher.
'Review at Aintree', 9 x 17½in/23 x 44.5cm,
£80-£140 col.

MORGAN, William Evan Charles b.1903
Line engraver and drypoint etcher of landscapes and figure subjects. Born in London, he studied at the Slade and won the Prix de Rome, 1924, for engraving.
£50-£150.

MORIN, E. fl. mid-19th century
Lithographer of military and equine subjects after his contemporaries.
Pl. for W. Simpson's Seat of War in the East, *1855-6, fo., e. £10-£30 col.*
Pl. for Mrs. Stirling Clarke's The Habit and the Horse: A Treatise on Female Equitation, *1857, 8¼ x 6in/21 x 15cm, tt. pl., small value.*
'Cavalry Charge at Balaclava', after Morin, 1854, 18 x 24¾in/45.5 x 63cm, £200-£400 col.

MORLAND, George 1763-1804
Well-known painter of rustic genre and sporting and decorative subjects. While many of his paintings were engraved by professionals, he himself etched only a very few plates.
'Morning' and 'Evening', drawn and etched by Morland, aq. by S. Alken (q.v.), 1792, 17¼ x 22¼in/45 x 56.5cm, pair £500-£700 col.

MORLEY, Lieut.-Col. Collison- d.1915
Amateur etcher of figure subjects. A professional soldier, he was a pupil of L. Taylor (q.v.) and was killed in World War I.
'Boiling up the Billy' (Australian subject), £60-£120.
Others £10-£30.

MORLEY, Harry, A.R.A., R.E. 1881-1943
Painter and line engraver of figure subjects, often with a classical theme. Born in Leicester, he originally studied architecture at the R.C.A. but left his articles to take up painting. His prints were influenced by R.S. Austin (q.v.) who had suggested that he take up engraving in 1928. He lived in London.
£20-£50.

MORRIS, M. fl. late 19th century
Etcher of landscapes and figure subjects after his/her contemporaries.
Small value.

MORRIS, Richard fl. mid-19th century
Draughtsman and aquatint engraver of a panorama of Regents Park. He was the author of *Essays on Landscape Gardening.*
'Regents' Park Panorama', 1831, 4½ x 224in/11.5 x 570cm, £600-£1,200 col.

MORRIS, Thomas fl. late 18th century
Etcher and line engraver of landscapes, architectural views and sporting and genre subjects after his contemporaries. He was apparently a pupil of W. Woollett (q.v.) and worked in London for J. Boydell (q.v.) and other publishers.
'View of Ludgate Hill' and 'View of the Monument', after W. Marlow, 1795, 22¼ x 17in/56.5 x 43cm, e. £200-£400.
'Hawking', after S. Gilpin, 1780, 18¼ x 21½in/46.5 x 55.5cm, £250-£450.
'Foxhunting', after S. Gilpin and G. Barret, 1783, 14¾ x 20¼in/37.5 x 51.5cm, £250-£450.
'Mares and Foals', after G. Garrard (q.v.), 1793, 13¼ x 18in/33.5 x 46cm, £100-£200.
'Woburn Sheepshearing', after G. Garrard, with M.N. Bate, J.C. Stadler and G. Garrard (qq.v), 18½ x 30in/47 x 76cm, £400-£600.
'A Light Horse Volunteer', after G. Garrard, c.1820, 11 x 9in/28 x 23cm, £15-£30.
Bookplates small value.

MORRIS, William 1834-1896
Important designer and leader of the Arts and Crafts Movement. As a wood-engraver, he produced a number of book illustrations. He is best known for the blocks he engraved after drawings by E. Burne-Jones for 'The Tale of Cupid and Psyche'; this was never published, and only a few proof sets were printed in the 1880s.
These proofs e. £100-£300.

MORRISON, James
 fl. early/mid-19th century
Line engraver of small portrait bookplates after his contemporaries.
Small value.

MORRISON, W. fl. mid-19th century
Line engraver of historical and allegorical subjects after his contemporaries.
£4-£10.

MORTIMER, John Hamilton, R.A.
 1741-1777
Painter of historical subjects and portraits, draughtsman and etcher of dramatic figure subjects including sea monsters, banditti and Shakespearian heads, mainly after his own designs. Born in Eastbourne, he studied under several painters including Joshua Reynolds and won a premium of 100 guineas given by the Society of Encouragement of Arts, Manufacturers and Commerce for the best historical picture: 'St. Paul Converting the Britons'. He lived and worked in London and retired to Aylesbury.
Heads of Shakespearian characters, 1775-6, contemporary imp. e. £100-£150; reprints e. £30-£80.
Banditti and other subjects £30-£80.

MORTON, Edward fl. mid-19th century
Lithographer of portraits and topographical views after his contemporaries.
Portraits small value.
Pl. for Capt. P.M. Taylor's Sketches in the Deccan, *1837, fo., tt. pl., e. £5-£15.*

MORTON, Henry fl. 1807-25
Draughtsman, etcher and aquatint engraver of
landscapes and topographical views after his
own designs and those of his contemporaries.
Views of Hastings, 1817, obl. to., e. £15-£35 col.
Pl. for G.F. Robson's Scenery of the Grampian
Mountains, *1814, fo., e. £15-£35 col.*

MOSES, Henry 1782-1870
Draughtsman, etcher and line engraver of
classical subjects (mostly in outline) after
antiquities and his contemporaries, battle scenes
after his contemporaries, and marine subjects
after his own designs. Born in London, he died
in Cowley, Middlesex.
'The Cruise of the Experimental Squadron',
1830, 6 pl., 4 x 7in/10 x 18cm, set £120-£180.
'Battle of the Pyrenees, 28th July, 1813', after
J.M. Wright, aq. by G. R. Lewis (q.v.), 19¼ x
26½in/49 x 67.5cm, £200-£400.
'The Marine Sketch Book', 1826, 26 pl., obl.
8vo., and other small marine subjects e. £5-£15.
Classical subjects and other book illustrations
£4-£10.

MOSLEY, Charles fl. 1737-53
London etcher and line engraver of portraits,
genre and naval subjects, etc., after his own
designs, Old Master painters and his con-
temporaries. He assisted W. Hogarth (q.v.) in
engraving 'The Gate of Calais', but most of his
work consisted of bookplates.
'Attack on Carthagena, 1741', after H. Gravelot,
11½ x 14½in/29 x 37cm, £50-£80.
'Catherine Clive as Mrs. Riot in Garrick's
Lethe', 11¾ x 8½in/30 x 22cm, £15-£30.
'Nicholas Sanderson', after J. Vanderbank, 8¼ x
8½in/21 x 21.5cm, small value.
'An Exact Perspective View of Dunmow . . . with
a Representation of the Ceremony and
Procession . . . ', after D. Ogborne, 1751, 15¼ x
22¼in/38.5 x 56.5cm, £80-£160.
'The Gate of Calais, or O the Roast Beef of Old
England', after and with W. Hogarth (q.v.),
1749, 15 x 18in/38 x 45.5cm, £100-£200.
Bookplates small value.

MOSS, William fl. 1777
Draughtsman and etcher.
2 views of Somerset House, 1777, aq. by
F. Jukes (q.v.), 20 x 28¼in/50.5 x 71.5cm, pair
£400-£600 prd. in sepia.

MOSSMAN, W fl. mid-19th century
Line engraver of small bookplates including

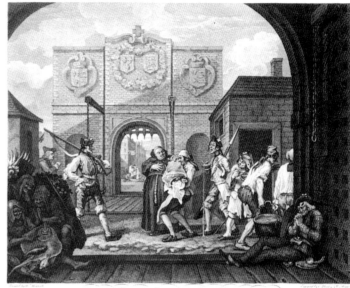

MOSLEY,
Charles. 'The
Gate of Calais,
or O the Roast
Beef of Old
England', after
and with
W. Hogarth,
1749.

landscapes and topographical views after his
contemporaries.
Small value.

MOTE, William Henry fl. mid-19th century
Line engraver of portraits, landscapes, religious
and sentimental subjects, etc., after Old Master
painters and his contemporaries. He worked in
London, mainly on small bookplates.
Small value.

MOTE, W.T. fl. mid-19th century
Line and stipple engraver of small bookplates
including portraits after his contemporaries and
Old Master painters.
Small value.

MOTTRAM, Charles 1806-1876
Major line and mixed-method engraver of
biblical, sporting, historical, sentimental and
animal subjects after his contemporaries. He
was responsible for many of the best-known
large Victorian engravings. He died in London.
'The Great Day of his Wrath', 'The Plains of
Heaven', 'The Last Judgement', after J. Martin,

1856, 28 x 41¼in/71 x 106cm, and slightly
smaller, e. £600-£1,200 col.; e. £300-£400 uncol.
'The Scapegoat', after W. Holman Hunt, 1861,
24½ x 36¼in/62 x 92cm, £400-£600.
'Jerusalem in Her Grandeur' and 'Jerusalem in
Her Fall', after H.C. Selous, 1860, 25 x
38in/63.5 x 96.5cm, pair £400-£700.
'The Worship of Bacchus', after G. Cruikshank,
26¾ x 42½in/68 x 108cm, £150-£300.
'The Ashdown Coursing Meeting', after
S. Pearce, 1872, 16 x 40in/40.5 x 101.5cm,
£300-£500.
'J. Morell with Horse and Hounds', after
F. Grant, 1855, 20½ x 28¼in/52 x 73cm, £300-
£600.
'The Morning Before' and 'The Evening After
the Battle', after T. Jones Barker, 1865, 22 x
28½in/56 x 72.5cm, pair £300-£500.
'Boeufs Bretons', after R. Bonheur, 1862, 22½ x
33½in/57 x 85cm, and similar lge. sentimental
subjects, £20-£60.
Pl. for E. Landseer's Her Majesty's Pets, *1874-*
6, ave. 13 x 17in/33 x 43cm, £20-£60.
'Boston', after J. W. Hill, 1857, 28¼ x
41½in/73.5 x 105.5cm, imp. with (?) later
colouring, fetched £1,600 April 1990.
Add more if in fine contemporary frame.
Small bookplates small value.

MULLER, Johann Sebastian *see* **MILLER,
John**

MULLER, Louis Jean b.1864
French etcher of sentimental subjects after his
French and British contemporaries and Old
Master painters. Born in Paris, he was a pupil of
E. Boilvin and A. Lalauze (qq.v.).
Small value.

MULLOCK, J.F. fl. mid-19th century
Draughtsman and lithographer.
'The Attack of the Chartists on the Westgate
Hotel', 1839, 7¾ x 10¼in/19.5 x 26cm, £70-
£120.

MUNCASTER, Claude Grahame, R.W.S.
 1903-1974
Painter, etcher and wood engraver of landscapes

MOTTRAM,
Charles. 'The
Scapegoat', after
W. Holman
Hunt, 1861.

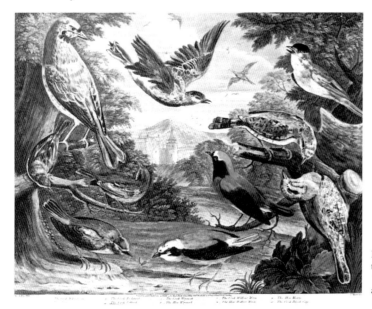

MYNDE, J. One of twelve plates from 'Icones Avium', after C. Collins, 1736.

and marine subjects. Born in Sussex, he was the son of O. Hall (q.v.) but changed his name by deed poll.
£30-£70.

MUNN, Paul Sandby 1773-1845
Draughtsman and lithographer of landscapes. A close friend and sketching companion of J. S. Cotman, he exhibited his watercolours at the RA and the Watercolour Society. He made two (possibly three) lithographs, one in 1807 (for *Specimens of Polyautography*) and another c.1808. Between 1810 and 1814, he produced some brief *Sketch Books* and sets of *Etchings*, intended as progressive lessons for art students. As Michael Campbell points out, these *Etchings* were not etchings at all, but were, in fact, pen-lithographs.
'*Etchings of Landscape, No.7*', 1813, 4 pl., 8¼ x 11¾in/21 x 30cm, set £80-£160.
Lithos of 1807 and c.1808, £30-£80.

MUNNINGS, Sir Alfred James, P.R.A., R.W.S. 1878-1959
Famous painter of sporting subjects, horses, landscapes and portraits, he produced a very few etchings. Born in Suffolk, he studied at Norwich School of Art and in Paris. He lived in Dedham, Essex. Unlike his drawing and painting, his etchings are rather scratchy and not very good. There is, however, a big market in colour reproductions of his paintings signed in pencil by the artist, the so-called 'signed artist's proofs'.
Etchings £20-£40.
Signed artist's proofs: sporting subjects £500-£1,200; others £200-£400 (note that, due to defects in the colour printing used at the time, many signed artist's proofs have turned green over the years and would fetch much less).

MURPHY, John
fl. late 18th/early 19th century
Irish mezzotint and stipple engraver of portraits, biblical, historical and animal and genre subjects after his contemporaries, Old Master painters and his own designs. Born in Ireland, he worked in London as a publisher of prints as well as an engraver.

'*The Encampment at Brighton*' and '*The Departure from Brighton*', after F. Wheatley, 21 x 26in/53.5 x 66cm, pair, £800-£1,400 prd. in col.
'*Titian's Son and Nurse*', after Titian, 1778, 18¼ x 14in/46.5 x 35.5cm, £8-£15.
'*The Settling Family Secure and Happy*', companion to '*The Settling Family Attacked by Savages*', by G. Keating (q.v.), both after H. Singleton, 1805, 25¼ x 20¼in/65.5 x 51.5cm, pair £600-£900 prd. in col.
'*A Porcupine and Dogs*', after S.F. Snyders, 1798, 18¼ x 24in/47.5 x 61cm, £150-£300 prd. in col.
'*The Cyclops at Their Forge*', after L. Giordano, 1788, 19¼ x 13¾in/50 x 35cm, £30-£70.
'*A Tigress*', after G. Stubbs, 1798, 19 x 24in/48.5 x 61cm, £600-£1,200.
'*A Tyger*', after J. Northcote, 1790, 18¼ x 23¾in/48 x 60.5cm, imp. prd. in col. and finished by hand fetched £2,800 April 1989.
'*Major Money Rescued From His Balloon*', after J. Reinagle, 1789, 24 x 18in/61 x 45.5cm, £500-£800.
'*Caroline, Princess of Wales*', after T. Stothard, 1795, 21¼ x 14¾in/55 x 37.5cm, £200-£400.
'*The Royal Family*', after T. Stothard, 1794, 20¼ x 26in/51.5 x 66cm, £200-£400.
'*Peter Beckford*', 1793, 19¼ x 13¾in/50 x 35cm, £100-£200.
Various male HLs £15-£40.
CS.

MURRAY, Charles 1894-1954
Scottish painter, etcher and wood engraver of landscapes, figure subjects, etc. Born in Aberdeen, he studied at Glasgow School of Art as well as in Rome and died in London.
£10-£30.

MURRAY, Charles Oliver, R.E. 1842-1923
Scottish etcher of landscapes, architectural views, historical and sentimental subjects and portraits after his own designs, 18th century British painters and his contemporaries. Born in Roxburghshire, he studied at the Edinburgh School of Design and at the R.S.A. Schools. He worked in London and lived in South Croydon.

'*Golf*', after W.G. Stevenson, 1892, 14¼ x 24¼in/37.5 x 63cm, £800-£1,400.
Classical subjects after L. Alma-Tadema, 1904, 21¼ x 16¼in/54 x 41cm, e. £100-£300.
'*Partridge Driving*', after C. Whymper, 1887, 14 x 21½in/35.5 x 55cm, and other sporting subjects of similar size, £150-£300.
Add more if in fine contemporary frame.
Views of public schools and Oxford and Cambridge colleges £30-£90.
Small bookplates and portraits small value.

MURRAY, G. fl. late 18th/early 19th century
Line and stipple engraver of small bookplates including portraits after his contemporaries.
Small value.

MURRAY, J. (?James) G., A.R.E.
fl. late 19th/early 20th century
Scottish etcher of landscapes and architectural views.
Small value.

MURRAY, John George fl. mid-19th century
Line and mezzotint engraver of historical subjects and portraits after his contemporaries. He worked in London.
'*View of the Interior of the House of Peers During the Trial of Queen Caroline, 1820*', after G. Hayter with James Bromley and J. Porter (qq.v), 1832, 22¼ x 34½in/58 x 87.5cm, £200-£300.
'*Pillage and Destruction of Basing House*', after G. Landseer, 1840, 22 x 28in/56 x 71cm, £40-£100.
'*King John Signing Magna Carta*', after A.W. Devis, 1833, 27 x 38in/68.5 x 96.5cm, £40-£100.
'*Lord Brougham*', after R. Bowyer, 1831, 17 x 14in/43 x 35.5cm, £15-£30.
'*John Clow*', after J.W. Gordon, 12¼ x 9¼in/31 x 25cm, £12-£25.
'*Duke of Wellington*', after T. Lawrence, with W. Bromley, 1825, 19¼ x 14in/49 x 35.5cm, £20-£50.
Add more if in fine contemporary frame.

MURRAY, William Staite
fl. early/mid-20th century
Eminent potter who produced a few drypoints. Born in London, he lived at Bray, Berkshire.
£30-£70.

MYERS, H. fl. early/mid-19th century
Mezzotint engraver.
'*Elizabeth Russell with a Tambourine*', after W. Owen, 13¼ x 9¼in/35 x 25cm, £30-£70.

MYERS, Simeon fl. late 19th century
Etcher of landscapes after his own designs and those of his contemporaries. He contributed plates to *The Portfolio*.
Small value.

MYNDE, J. fl. mid-18th century
Line engraver of portraits, landscapes, ornithological subjects, etc., after his contemporaries.
'*Icones Avium*', after C. Collins, 1736, 12 pl., approx. 14½ x 18in/36.5 x 45.5 cm, e.£400-£700 col.
'*A Ship of the First Rate at Anchor*', 13½ x 16in/34 x 41cm, £100-£200.
Illustrations to Don Quixote, after C.A. Coypel, 1725, small value.
Portraits small value.

N

NARBETH, W. A. fl. early 20th century
Etcher of topographical views and biblical subjects.
£20-£50.

NASH, John Frederick fl. mid-19th century
Wood engraver of book and magazine illustrations including sporting and military subjects after his contemporaries.
'The Relief of Ekowse, 31 March, 1879', 13¾ x 39¾in/35 x 101cm, supplement to The Graphic, *and others of similar size, £10-£30.*
Others small value.

NASH, John Northcote, R.A. 1893-1977
Painter and wood engraver of landscapes and still life. Born in London, he was the brother of P. Nash (q.v.). He taught at Ruskin School, Oxford 1922-7 and at the R.C.A. 1934-40 and 1945-57. He was also appointed an Official War Artist in 1918 and 1940. He lived near Colchester in Essex.
Litho. posters publ. by J. Lyons, approx. 24½ x 31in/62 x 79cm, e. £200-£400 prd. in col.
Wood eng. £80-£160.

NASH, Joseph 1809-1878
Draughtsman and lithographer of architectural views after his own designs and those of his contemporaries. Born in Great Marlow, Buckinghamshire, he was a pupil of Augustus Pugin, the architectural draughtsman. As well as producing architectural prints, including his well-known 'Mansions of England in the Olden Time', he drew illustrations for poems and novels. He died in Bayswater, London.
'Mansions of England in the Olden Time', 1839-48, fo., 106 tt. pl., e. small value, but £10-£25 col.
'Views of The Great Exhibition', after Nash, 1854, fo., 55 chromolitho., e.£20-£50.
'Windsor Castle', after Nash, 1848, fo., 25 chromolitho., e. £15-£40, set col. and mounted fetched £2,800 Sept 1992.
Pl. for J.B. Pyne's Windsor with its Surrounding Scenery, *c.1839, fo., tt. pl., e. £40-£70 col.*
Pl. for D. Wilkie's Sketches in Turkey, Syria and Egypt, *1843, lge. 4to., tt. pl., e. £60-£140 col.*

NASH, Paul 1889-1946
Painter, illustrator, theatrical designer, wood engraver and lithographer of landscapes, still life and abstract compositions. Born in London, he was the brother of J.N. Nash (q.v.). He studied at Chelsea Polytechnic and at the Slade and was appointed an Official War Artist in 1917 (after having been injured at Ypres) and again in 1940-45. He taught at Oxford 1920-3 and at the R.C.A. 1924-5 and 1938-40. He died in Hampshire. His most sought-after prints are the lithographs depicting the devastation on the Western Front during World War I, but his later wood engravings are perhaps some of the more interesting exercises in this medium in the 1920s.
'Void of War', 1918, litho., £1,000-£3,000.
'A Shell Bursting, Passchendaele', 1917, 10¼ x 14¼in/26 x 36cm, and other litho. of war scenes, £1,000-£3,000.
'The Sluice', 1920, 14¼ x 16¼in/36 x 41.5cm, litho., £400-£600.
'Abstracts Nos. 1 and 2', 4 x 2in/10 x 5cm and 9 x 7.5cm, wood eng., e. £100-£200.
'Winter', 1921, wood eng., £400-£700.
'Black Poplar Pond', 1922, 6 x 4¼in/15 x 11cm, wood eng., £400-£700.
'Raider on the Moors', litho. poster in col., produced during World War II, 15¼ x 22½in/39 x 57cm, £400-£700
Ref: Postan

NAUMANN, P. fl. mid-19th century
Wood engraver of magazine illustrations after his contemporaries. He worked for *The Illustrated London News.*
Small value.

NEAGLE, John d.1822
Line engraver of portraits and sporting, biblical and genre subjects after his contemporaries and

NASH, Joseph. A plate from 'Mansions of England in the Olden Time: Charlecote, Warwickshire'.

Old Master painters. Born in London, he later emigrated to the U.S. where he died.
'Foxhunting', after J.N. Sartorius, with J. Peltro (q.v.), 1795, 4 pl., 17½ x 24in/44.5 x 61cm, set £800-£1,600.
'Thanksgiving Service at St. Paul's Cathedral', after E. Dayes, 1793, 19 x 27½in/48.5 x 70cm, £30-£70.
'Nelson Wounded at Tenerife', after R. Westall, 1809, 8¼ x 7in/21 x 18cm, £10-£20.
Portraits and bookplates small value.

NEALE, Thomas fl. mid-17th century
Line engraver of small bookplates after his contemporaries and Old Master painters
Small value.

NEAVE, David S. b.1879
Painter and etcher of landscapes. He lived in Scotland and later London.
Small value.

NASH, Paul. 'Void of War', 1918, lithograph.

NASH, Paul. 'Winter', 1921, wood engraving.

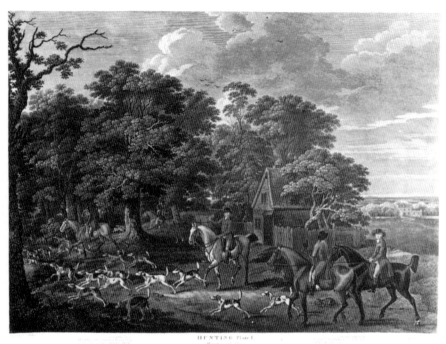

NEAGLE, John. One of four plates from 'Fox Hunting: Brushing into Cover', after J.N. Sartorius, 1795.

NEEDHAM, Joseph fl. mid-19th century
Landscape painter, lithographer of landscapes, architectural views, naval and military subjects after his contemporaries. He worked in London for Day & Son (see W. Day II).
Views in Ceylon, after Capt. O'Brien, tt. pl., e. £25-£40.
Views of Niagara Falls, after Maj. H. Davis, with A. Laby, 1848, elephant fo., chromolitho., e. £200-£400.
'Royal Albert Bridge at Saltash', after C.A. Scott, 12½ x 18½in/32 x 47cm, tt. pl., £150-£250 col.
'Turning the First Sod of The Portsmouth Railway', after W. Adams, 12¼ x 15¼in/31 x 39cm, £100-£200 prd. in col.
Pl. for Lieut. Mecham's Sketches and Incidents
of the Siege of Lucknow, *1858, fo., tt. pl., £5-£8.*
Pl. for W. Simpson's Seat of War in the East, 1855-6, fo., e. £10-£30 col.
Pl. for J.P. Lawson's Scotland Delineated, 1847-54, fo., tt. pl., e. £10-£20.
Pl. for O.W. Brierly's English and French Fleets in the Baltic, 1855, lge. fo., tt. pl., e. £80-£150.
Pl. for J.C. Schetky's A Cruise in Scotch Waters, c.1849, fo., 29 tt. pl., e. £10-£25 col.
Pl. for Ouseby's South America, fo., 26 tt. pl., e. £200-£300 col.

NEELE, Samuel John 1758-1824
Line engraver of bookplates after his contemporaries including topographical views, military subjects, portraits, etc.

Pl. for J. Taylor's Art of Defence on Foot with the Broadsword and Sabre, *11 pl., 8½ x 13in/21.5 x 33cm, and smaller, £5-£15.*
Others small value.

NESBIT, Charlton 1775-1838
Wood engraver mainly of small bookplates, including ornithological, religious and animal subjects, topographical views, illustrations to poems, etc., after his contemporaries. Born in Durham, he was apprenticed to R. Beilby and T. Bewick (q.v.) producing tail pieces for the latter's *British Birds.* He lived in London and Swalwell.
Small value.

NESS, John Alexander, A.R.E. d.1931
Scottish etcher of landscapes and architectural views. Born in Glasgow, he studied at the School of Art there and lived in Nottinghamshire.
£4-£8.

NEVINSON, Christopher Richard Wynne, A.R.A. 1889-1946
Important Vorticist painter, etcher, wood and mezzotint engraver and lithographer of figure and genre subjects, landscapes and townscapes. Born in Hampstead, London, he studied at St. John's Wood School of Art and at the Slade as well as in Paris. He was much influenced in his early works by Cubism and Futurism, and prints from the period up to 1920 are much sought after, particularly the war subjects which were based on his experiences on the Western Front in the Red Cross and the R.A.M.C. He was also appointed an Official War Artist in 1917. He lived in London.
'Building Aircraft', 1917, 6 pl., 16 x 11¼in/40.5 x 30cm, litho., e. £1,000-£2,000, set fetched £20,000 June 1987.
'Southwark', 8¼ x 6in/22.5 x 15cm, mezzo., £1,200-£1,800.
'London from Parliament Hill', 9¾ x 13½in/25 x 35cm, drypoint, £600-£1,000.
'Brooklyn Bridge', 9¼ x 7in/24.5 x 17.5cm, drypoint, £1,200-£1,800.
'Looking Down into Wall Street, New York', 1919, 19¼ x 13¼in/49 x 35cm, litho., £1,200-£1,800.
'Portrait of Dame Edith Sitwell', 1927, 7½ x

NEVINSON, Christopher Richard Wynne. 'French Troops Resting', 1916, drypoint.

NEVINSON, Christopher Richard Wynne. One of six plates from 'Building Aircraft: Banking at 4,000 Feet', 1917. lithograph.

6in/19 x 15cm, drypoint, £1,600-£3,000.
'A Picnic', 10 x 14in/25.5 x 35.5cm, drypoint,
£300-£400.
'Reliefs at Dawn', 1918, 10¼ x 14in/27.5 x
35.5cm., litho., £1,200-£1,800.
'French Troops Resting', 1916, 8¼ x 10¼in/21 x
26cm, drypoint, £3,000-£4,500; fetched £3,600
December 1985.
'Wind', 1918, 5 x 7in/12.5 x 18cm, mezzo.,
£1,200-£1,800.
'Le Port', 1919, 20 x 15¼in/50.5 x 39cm, £600-
£1,000.
'Quartier Latin' (rue Vallet), 13¼ x 11½in/35 x
29cm, drypoint, £300-£500.
Ref: List of etchings and drypoints in an
appendix of Guichard.

NEWBOLT, Sir Francis George, A.R.E.
1863-1940
Amateur painter and etcher of landscapes. Born
in Bilston, he studied at the Slade but made a
career as a lawyer and scientist. He also wrote
some books on etching. He lived in London and
Devon.
£10-£30.

NEWMAN, John & Co. fl. mid-19th century
London firm of engravers, lithographers and
publishers of topographical views after their
own designs and those of their contemporaries.
2 views of Plymouth, 1835, 9½ x 11½in/24 x
29cm, litho., pair £80-£120 col.
4 views of Bournemouth, c.1850, obl. 4to.,
litho., e. £20-£50 col.
Views of Killarney, obl. fo., tt. litho., e. £20-£50.
'Panorama of Weymouth and Melcombe Regis',
9¼ x 33¼in/23.5 x 84.5cm, tt. litho., £100-£200.
'Gumlin Viaduct, on the Newport, Abergavenny
and Hereford Extension to Taff Vale', 14½ x
17in/36.5 x 43.5cm, tt. litho., £200-£400 col.
'Malvern from the Link Railway Station', 7½ x
10¼in/19 x 26cm, tt. litho., £40-£80.
Small eng. bookplates small value.

NEWNHAM, George Simon
Harcourt, Viscount 1736-1809
Amateur draughtsman and etcher who executed
some views of his home.
'Views of the Ruins of Stanton Harcourt',
1763/4, 16¼ x 20½in/42.5 x 52.5cm, e. £20-£40.

NEWTON, Eric Ernest 1893-1965
Art historian and critic who produced a few
etchings and engravings.
£10-£25.

NEWTON, I.H. fl. early 19th century
Draughtsman and aquatint engraver.
Pl. for Capt. H. Cox's Journal of a Residence in
the Burmhan Empire, 1821, 8vo., e. small value.
NEWTON, James fl. late 18th century
Line and stipple engraver of portraits and
decorative subjects after his contemporaries and
Old Master painters.
'Georgiana, Duchess of Devonshire', after
D. Beauclerk, 6½ x 7¼in/16.5 x 18.5cm, £30-£70
prd. in sepia or in col.
Other portraits small value.
'The Herdsman', after F. Zuccarelli, 1794, 15¼
x 20½in/38.5 x 52cm, £20-£40.
'The Spartan Boy', after N. Hone, 7 x 4in/18 x
10cm, £20-£40 prd. in col.

NEWTON, R. fl. early/mid-19th century
Line engraver of portraits after his
contemporaries.
Small value.

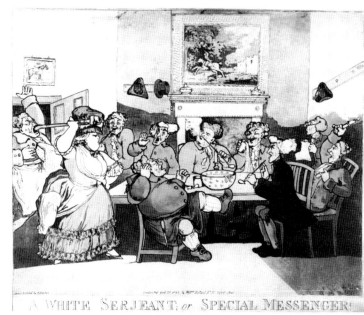

NEWTON,
Richard. 'A
White Serjeant:
or Special
Messenger',
1794.

NEWTON, Richard 1777-1798
Miniaturist, draughtsman, etcher and aquatint
engraver of caricatures. He died in London at
the early age of twenty-one having, in his short
career, produced a large number of
extraordinarily inventive caricatures.
'Progress of an Irishman', 1794, 15½ x
20½in/39.5 x 52cm, £60-£120 col.
'Sturdy Beggars Collecting for the Emigrant
French Clergy', 1792, 16 x 21in/40.5 x 53.5cm,
£30-£70 col.
'A Scots Concert', 1796, 15¼ x 20½in/39 x
52cm, £250-£400 col.
'A White Serjeant; or Special Messenger',
1794, £100-£200 col.
Pl. for L. Sterne's Sentimental Journey, 1795, 12
pl., 8vo., e. small value.

NEWTON, Sir William John 1785-1869
Miniature painter and line engraver of portraits

NICHOLSON, Ben. 'Pisa', 1951.

after his contemporaries. He was appointed
Miniature Painter in Ordinary to William IV and
Queen Adelaide and later to Queen Victoria. He
was born in and lived in London.
Small value.

NEWTON, W.S. fl. late 18th/early 19th century
Line engraver of small bookplates after his
contemporaries.
Small value.

NIBBS, Richard Henry 1816-1893
Musician turned landscape and marine painter,
who drew and lithographed some views of
Brighton, where he settled.
'Viaduct of the London, Brighton and South
Coast Railway', 1846, 9¾ x 13in/24.5 x 33cm, tt.
pl., £80-£140 col.
Others £30-£70.

NICHOLLS, Sutton
fl. early/mid-18th century
Draughtsman, etcher and line engraver of
architectural views and antiquities. He worked
mainly for the booksellers and is best known for
'Prospects of the Most Considerable Building
about London', 1725, and for the metropolitan
views for Stow's Survey. He lived in London.
Lge. London views £150-£300.
Portraits and small bookplates small value.

NICHOLS, William fl. early 19th century
Stipple engraver of portraits and sporting
subjects after his contemporaries and Old
Master painters.
Shooting and hunting subjects after P. Reinagle,
with other aq. eng., 1807-10, ave. 15 x 20in/38
x 51cm, e. £300-£500 col.
'Sarah Siddons', after T. Lawrence, 1810, 11 x
9¼in/28 x 23.5cm, £30-70 prd. in col.
Other portraits and bookplates small value.

NICHOLSON, Ben 1894-1982
Important painter, etcher and engraver of
abstract and architectural compositions. Born in
Buckinghamshire, the eldest son of
W. Nicholson (q.v.), he studied briefly at the
Slade. His second wife was the sculptor Barbara

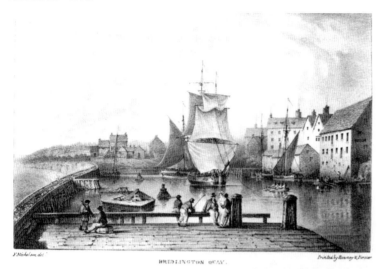

BRIDLINGTON QUAY.

F.Nicholson del. Printed by Rowney & Forster

NICHOLSON,
Francis.
'Bridlington Quay'
is typical of
Nicholson's
topographical views.

NICHOLSON,
William Newzam
Prior. A plate from
'An Alphabet: P for
Publican', 1898,
hand-coloured wood
engraving.

Hepworth. He lived in St. Ives, Cornwall and later in Switzerland. Most of his prints were produced in the 1960s.
'Abstract with Red Circle', linocut prd. in black, with red gouache handcolouring, 1937, 5¼ x 7in/13.5 x 18.5cm, one of only about three imp. fetched £4,500 June 1991.
1960s etchings generally £800-£2,200, up to £5,000 or £6,000 if hand-col.
Colour plate page 52.

NICHOLSON, Francis 1753-1844
Drawing master, painter and lithographer of landscapes and topographical views. He was born in Yorkshire where he spent most of his life, apart from some periods in London and sketching tours in Scotland. His lithographs date from the 1820s and mostly consist of views of Scarborough and Scotland, and plates for drawing and sketch books.
'Bridlington Quay' £20-£30.
Views of Scarborough, 1822-4, and Scotland, 1828, fo., e. £10-£35.
Pl. for drawing and sketch books £5-£15.

NICHOLSON, George 1787-1878
Watercolourist, etcher and lithographer of topographical views. He was the nephew of F. Nicholson (q.v.).
Views in the Highlands, 1802, 6 litho., fo., e. £10-£25.
'Six Etchings of Roche Abbey, Yorkshire', 1824, fo., e. £8-£16.
'Eight Select Views of Caernarvon', 1827, fo., litho., e. £15-£30 col.

NICHOLSON, Isaac 1789-1848
Wood engraver of small bookplates including historical and religious subjects. Born in Cumberland, he was an apprentice of T. Bewick (q.v.).
Small value.

NICHOLSON, T.E. fl. mid-19th century
Line engraver of small bookplates including historical and genre subjects after British 18th century painters and his contemporaries.
Small value.

NICHOLSON, Sir William
Newzam Prior 1872-1949
Well-known designer and lithographer of posters and wood engraver of portraits, and

genre, rustic and sporting subjects. Born in Newark-on-Trent, he studied at H. von Herkomer's (q.v.) school at Bushey, Hertfordshire, and in Paris. He designed lithographic posters with J. Pryde (q.v.) under the name of J. & W. Beggarstaff. His famous series of wood engravings such as 'An Alphabet' and 'London Types' were the result of commissions from W. Heinemann, the publisher, undertaken at a time when he was impecunious. These plates were also lithographed for the cheaper editions. He died in Berkshire.
'An Alphabet', 1898: hand-col. wood eng. e. £150-£400; litho. set £300-£500.
Portraits: 'J.M. Whistler', 'Sarah Bernhardt' and 'Queen Victoria', hand-col. wood eng. e. £800-£2,000; litho. e. £50-£150, ('Queen Victoria' fetched £2,500 Dec.1991).
Other portraits: hand-col. wood eng. e. £150-£500; litho. e. £15-£80.
Note: hand-col. wood-eng. mounted on cardboard which is prone to crumble.
Lge. posters see Pryde, J.F.
Views of Oxford, reproductions signed by artist, e. £8-£20.

NICOLSON, John, A.R.E. 1891-1951
London painter, etcher and lithographer of landscapes and rustic scenes. He studied at St. Martin's School of Art.
£30-£80.

NIGHTINGALE, Charles Thrupp b.1878
Illustrator, wood-engraver of figure subjects, including mythological themes.
£30-£80.

NINHAM, Henry 1793-1874
Norwich painter and etcher of landscapes and architectural views. He was acquainted with J.S. Cotman and E.T. Daniell (qq.v.).
Lifetime proof imp., £20-£50, posthumous reprints from 'Fifteen Etchings by the late H. N.' published in 1875, e. £10-£20.

NIXON, Job, R.W.S., R.E. 1891-1938
Painter, etcher and line engraver of landscapes, architectural views and genre subjects. Born in Stoke-on-Trent, he studied at Burslem School of Art, the R.C.A. and at the Slade. He worked in the U.K., in France and in Italy and lived in London.

'An Italian Fiesta', 1921, 26¼ x 27¼in/68 x 69cm, £200-£400.
Others £50-£150.

NIXON, John d.1818
Amateur landscape painter, draughtsman and etcher of caricatures. An Irish merchant working in the City of London, he went on sketching tours every summer all over England as well as visiting Ireland, Scotland and the Continent. Some of his caricatures were engraved by T. Rowlandson (q.v.). He died on the Isle of Wight.
Caricatures £30-£80 col.
'Bacchus with lion and tiger', 1817, 6½ x 10¼in/16.5 x 27.5cm, very rare, £100-£200

NOBLE, George
 fl. late 18th/early 19th century
Line engraver of small portraits and bookplates after his contemporaries and Old Master painters. He was the brother of S. Noble (q.v.).
Small value.

NOBLE, John 1797-1879
Line engraver of portraits after his contemporaries.
Small value.

NOBLE, Samuel 1779-1853
Line engraver of landscapes and architectural views after his contemporaries and his own designs. Born in London, the brother of G. Noble (q.v.), he later gave up a successful engraving career to become a minister in the New Church.
Small value.

NODDER, Frederick P. d.1800
Painter and line engraver of botanical subjects. Born in London, he was created Botanical Painter to the King in 1788.
Pl. for T. Martyn's Flora Rustica, after Nodder, 1792-4, 8vo., and similar works, small value.

NOEL, Mrs. Amelia
 fl. late 18th/early 19th century
Drawing mistress, draughtswoman and etcher of landscapes and topographical views.
Views in Kent, 1797, 24 pl., obl. 4to., e. £8-£15 col., but a special copy with 18 pl. has made £1,900.

NOEL, Leon fl. mid-19th century
French lithographer of portraits after his
contemporaries, including several of the British
Royal Family.
*'Queen Victoria and her Family', after F.X.
Winterhalter, 27½ x 34in/70 x 86.5cm, £300-£500.
'The Prince of Wales and Prince Alfred', after
F.X. Winterhalter, 1849, 25 x 18in/63.5 x
45.5cm, £60-£140.
Others mostly £20-£80.
Add more if in fine contemporary frame.
Vignettes small value.*

NOOTH, W. Wright fl. late 19th century
London etcher of sentimental subjects after his
contemporaries and Old Master painters.
Small value.

NORMAN, H. fl. early 20th century
Mezzotint engraver of portraits after British
18th and early 19th century painters.
£20-£60 prd. in col.

NORRIS, Charles 1779-1858
Draughtsman and etcher of architectural views.
Born in London, he was educated at Eton and
Oxford and settled in Wales, at first in
Pembrokeshire and later at Tenby. He turned to
art after serving in the army.
Etchings of Tenby, 1812, e. £10-£20.

NORSWORTHY, L. fl. early 20th century
Mezzotint engraver of landscapes and river and
coastal scenes after his contemporaries.
£10-£30 prd. in col.

NORTHCOTE, James, R.A. 1746-1831
Eminent historical and animal painter who
produced a very few etchings.
£100-£250.

NORTON, Christopher fl. mid-18th century
Line engraver of landscapes and marine and
rustic subjects after his contemporaries and 17th
century painters. He was born in Paris, where he
spent his early career. He then came to England
with P.C. Canot (q.v.) and studied under him at
the St. Martin's Lane Academy.
£10-£30.

NOYCE, E. fl. early/mid-19th century
Lithographer of topographical views after his

NIXON, Job. 'Subiaco', 1926.

contemporaries. He was a pupil of J.B. Malchair
(q.v.).
*'Six Views of Windsor Castle', after
S. Scarthwaite, 1835, fo., e. £30-£50 col.*

NUGENT, Thomas fl. 1785-98
Irish-born stipple engraver of portraits and
decorative subjects after his contemporaries.
*'Fetching Water' (Mrs. Sheridan and child),
after J. Hoppner, 24½ x 17in/62.5 x 43cm, £200-
£300 prd. in col.
Small portraits and bookplates small value.*

NUTTER, William 1754-1802
Prominent stipple engraver of portraits and
decorative and historical subjects after his
contemporaries. He was a pupil of John Raphael
Smith (q.v.) and F. Bartolozzi (q.v.) and died in
London.
*'Sunday Morning', and 'Saturday Evening',
after W.R. Bigg, 1793, 18 x 23in/45.5 x 58.5cm,
pair £800-£1,400 prd. in col.*

*'The Absent Father or the Sorrows of War', after
H. Singleton, and 'The Parent Restored or the
Blessings of Peace', after W.R. Bigg, 1797, 16½ x
12½in/42 x 32cm, pair £400-£600 prd. in col.
'The Fair Moralist', after J.R. Smith, 1805, 15 x
12¼in/38 x 31cm, £100-£160 prd. in col.
'The Burial of General Fraser', after
J. Graham, 1794, 18½ x 23½in/47 x 60cm, £100-
£200 prd. in col.
'Mrs. Elizabeth Hartley as a Bacchante', after
J. Reynolds, 1801, 22½ x 17½in/57.5 x 44.5cm,
£250-£400 prd. in col.
'The Right Honble. Lady Beauchamp', after
J. Reynolds, 1790, 11¼ x 8½in/28.5 x 22cm,
£150-£250 prd. in col.
Small portraits and bookplates small value.*

NUTTING, Joseph d.1722
Line engraver of portraits after his own designs
and those of his contemporaries. He worked
mainly for the booksellers.
Small value.

NUTTER, William.
'The Burial of Gen.
Fraser', after
J. Graham, 1794.

NUTTER, William.
'Mrs. Elizabeth
Hartley as a
Bacchante', after
J. Reynolds, 1801.

OAKES, John Wright, A.R.A. 1820-1887
Painter and etcher of landscapes. Born in
Cheshire, he studied at the Mechanics' Institute
in Liverpool where he lived until 1859 before
settling in London. He was a member of the
Junior Etching Club and contributed plates to its
publications.
Small value.

OAKMAN, John 1748-1793
Wood engraver of illustrations for children's
books. Born in London, he was apprenticed to a
map engraver, kept a shop selling caricatures
and wrote disreputable novels.
Small value.

O'CONNOR, M. fl. mid-19th century
Draughtsman and lithographer of portraits.
£3-£10.

O'DRISCOLL, A. fl. mid-19th century
Irish landscape and portrait painter, and
lithographer of military costumes after his
contemporaries.
£60-£140 col.

OGBORNE, John 1755-1837
Stipple engraver of portraits and decorative
subjects, mainly after his contemporaries. Born
at Chelmsford, he was a pupil of F. Bartolozzi
(q.v.). He later aquatinted a few topographical
views. He died in London.
*'Sunshine' and 'Rain', after W.R. Bigg, 1792, 14½
x 11¾in/37 x 30cm, pair £300-£500 prd. in col.*
*'Mrs. Jordan as the Romp', and 'Mrs. Jordan as
the Country Girl', after G. Romney, 1788, 12¼ x
10in/31 x 25.5cm, pair £250-£400 prd. in col.*
*'The Harvest Girl' and 'The Angler' (latter
actually signed Mary Ogborne, presumably
J.O.'s wife), both after W.R. Bigg, 1787, 9¼ x
7in/23.5 x 17.5cm, pair £300-£500 prd. in col.*
*'Caroline and Lindorf', after T. Stothard, 10½ x
13in/26.5 x 33cm, £30-£60 prd. in col.*
*'Prince Arthur Giving Welcome to the Archduke
of Austria', after W. Hamilton, 1795, 12½ x
14¾in/32 x 37.5cm, £30-£60.*
*'Charles, Earl Camden', after G. Dance, 1794,
12¼ x 9¾in/31 x 25cm, £7-£15.*
Pl. for J. Boydell's Shakespeare, fo., £10-£25.
Pl. for T. Landemann's Observations on

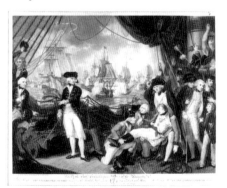

ORME, Daniel. 'The Victory of the Glorious First of
June, 1794', after M. Brown, stipple.

OGBORNE, John.
'The Angler', pair
with 'The Harvest
Girl', after W. Bigg,
1787.

Portugal, 1818, fo., aq., e. £6-£12 col.
Small portraits and bookplates small value.

OKEY, Samuel fl. mid-18th century
Mezzotint engraver mainly of portraits after his
contemporaries and Old Master painters. He
lived in London, emigrating to Rhode Island,
U.S.A., in 1771.
*'Samuel Adams' (American revolutionary), after
J. Mitchell, 1775, 13 x 9in/33 x 23cm, £800-£1,200.*
Other American portraits £600-£900.
English portraits and decorative subjects £30-£90.

O'NEILL, George Bernard 1828-1917
Genre painter who was a member of the Etching
Club and executed several plates.
£10-£30 (signed presentation proofs £40-£90).

ORME, Daniel b.1765
Miniaturist, line, stipple and aquatint engraver
of decorative, military and naval subjects after
his contemporaries. Born in Manchester, he
worked in London.
*Lge. decorative subjects after Morland etc.,
stipples, £300-£500 prd. in col.*
*'The Reception by Marquis Cornwallis of the
Princely Hostages, the Sons of Tippoo Sultan',
1799, 23 x 22⅞in/58.5 x 58cm, imp. prd. in col.
fetched £1,400 May 1995 in special Indian sale.*
*'The Victory of the Glorious First of June, 1794',
after M. Brown, stipple, £200-£300 prd. in col.*
Lge. naval subjects, aq., £200-£400 col.
Small portraits and bookplates small value.

OSBORNE, Malcolm, R.A., P.R.E. 1880-1963
Etcher of portraits, landscapes and townscapes.
Born in Somerset, he was a pupil of F. Short
(q.v.) at South Kensington, succeeding him in
1924 as Head of the Etching and Engraving
School there.
'Sir Frank Short' £150-£300.
'Mrs. Heberden' £80-£160.
'Sir Cuthbert Cartwright Grundy' £40-£90.
Landscapes and townscapes £50-£150.
Bibl: Salaman, M.C. 'Etchings of M.O.,
A.R.A., R.E.', *P.C.Q.*, 1925, XII, p.285.

OTTLEY, William Young 1771-1836
Amateur painter and connoisseur who made a
few engravings when young.
*A series of aq. pl. of the Old Testament subjects,
1797,
9¼ x 7in/23.5 x 18cm, e. £10-£20.*

OUTRIM (Outram), John fl. mid-19th century
Line engraver of sentimental, genre and biblical
subjects after his contemporaries. He worked in
London.

O'NEILL, George
Bernard. A typical
contribution to the
Etching Club
publications.

*'The Mountain Top' (highlander and eagle),
after E. Landseer, 1856, 20 x 15in/51 x 38cm,
£50-£150.*
*'Highland Lassie Crossing the Stream', after
E. Landseer, 1864, 28 x 21in/71 x 53.5cm, £150-
£300.*
Add more if in fine contemporary frame.
*'Rustic Civility', after W. Collins, 4 x 3in/10 x
7.5cm, small value.*

OVEREND, William Heysham 1851-1898
Marine painter, book and magazine illustrator
who etched a few plates.
Small value.

OVERTON, T. fl. early 19th century
Line and stipple engraver of portraits and
bookplates after his contemporaries.
Small value.

OWEN, Rev. Edward Pryce 1788-1863
Amateur painter, draughtsman and etcher of
landscapes and architectural views. He was
Vicar of Wellington and Rector of Eyton-upon-
the-Wildmoors, Shropshire. He travelled widely
throughout Europe making drawings from
which he later produced oils and etchings.
Small value.

OWEN, S., T. and W. fl. mid-19th century
Line engravers of small architectural bookplates
after their contemporaries.
Small value.

OSBORNE, Malcolm. 'Sir Cuthbert Cartwright
Grundy'.

PALMER, Samuel. 'Harvest Under a Crescent Moon', the artist's only wood engraving, from the edition of fifty printed in 1932.

PACKER, Thomas fl. mid-19th century
Draughtsman and lithographer of military subjects, portraits and topographical views after his own designs and those of his contemporaries.
'*The Bombardment of Sebastopol*', 1855, 16¼ x 26⅛in/42.5 x 68cm, £100-£200 col.
'*The Battle of Inkermann*', 1854, 11 x 17½in/28 x 44.5cm, £80-£140 col.
'*Her Majesty's Distribution of the Crimean Medals to the Heroes of Alma, Balaklava and Inkermann on the Parade Ground, St. James' Park*', 1855, 18¼ x 23¼in/46.5 x 59cm, £100-£200 col.
'*The Palace of Industry and International Exhibition in the Champs Elysées*' and '*Grand Entrance and Vestibule of the Palace of Industry, Paris*', 1855, 13 x 20¼in/33 x 51.5cm, tt. pl., pair £150-£250.
Portraits, music covers and songsheets £5-£15 col.

PAGE, J. fl. late 18th century
Line engraver of small portraits and bookplates after his contemporaries and Old Master painters.

Small value.

PAGE, R. I fl. early 19th century
Draughtsman and aquatint and stipple engraver of small portraits and costume plates.
'*London Volunteers*', c. 1804-5, 4 pl., ave. 15¼ x 12in/38.5 x 30.5cm, aq., e. £60-£120 col.
Small portraits and stipples small value.

PAGE, R. II fl. mid-19th century
Line and stipple engraver of small bookplates including portraits after his contemporaries, British 18th century and Old Master painters.
Small value.

PAGE, W.T. fl. mid-19th century
Stipple engraver of small portraits after his contemporaries. He was perhaps a son of R. Page II (q.v.).
Small value.

PALMER, Frances F. fl. mid-19th century
Draughtswoman and lithographer. She emigrated with her family to the U.S., where she became one of the principal lithographers for the firm of Currier & Ives.
Pl. for J.F. Holling's Sketches in Leicestershire, *1846, fo., tt. pl., e. £10-£25.*

PALMER, Samuel, R.W.S. 1805-1881
Important painter and etcher of landscapes and rustic scenes. Apart from producing one wood engraving in the style of W. Blake's (q.v.) 'Illustrations to Virgil's Eclogues' during the 1820s, he made no further prints until he took up etching in 1850. The medium appears to have appealed to him greatly and his etchings, which recall the earlier Shoreham period, are much revered and influenced many etchers of subsequent generations.
'*The Lonely Tower*', the rarest of his etchings, £2,000-£3,000 (signed imp. fetched £3,800 June 1995).
'*The Bellman*', contemporary imp., edn. 60 with remarque, £2,500-£4,000, fetched £4,000 June 1995; from posthumous edn. of 1926 £1,000-£1,600.
'*Christmas . . .*', superb imp. fetched £2,800 Dec. 1991.
'*The Sleeping Shepherd . . .*' as publ., fetched £800 June 1994.
'*The Skylark*', fifth state of eight, signed and inscribed, fetched £1,800 June 1995.
'*Willow*', contemporary imp. £300-£500; from posthumous edn. of 1926 £250-£350.
'*Herdsman's Cottage*, publ. in several books, £200-£400.
'*Harvest Under a Crescent Moon*', his only wood-eng., c.1826, posthumous edn. of 50 publ. 1932, £1,400-£2,200, fetched £2,600 Dec. 1992.
Bibl: Alexander, R.G., *A Catalogue of the Etchings of S.P.*, London, Print Collectors' Club, 1937; Lister, R., *S.P. and his Etchings*, London, Faber & Faber, 1969.

PAPENDICK, G.E. fl. early 19th century
Draughtsman and lithographer.
Views of Kew Gardens, c. 1820, 24 pl., 8vo., e.£8-£20 col.

PAPPRILL, Henry A. b.1816
Aquatint engraver of sporting, military, coaching and naval subjects after his contemporaries. He worked in London.
'*Review of the Queen's Own Regt. of Yeomanry Cavalry*', after W.I. Pringle, 1839, 15½ x 23⅜in/39.5 x 59.5cm, £250-£450 col.
'*The Capture of Amoy*', after Capt. R.B. Crawford, 1844, 3 pl., 9½ x 21⅛in/24 x 55cm, set £400-£700 col.
'*The Jolly Old Squire*', after J. Pollard, 1840, 4 pl., 15 x 21in/38 x 53cm, set £800-£1,200 col.
'*Racing*', after G.H. Laporte, 1860, 2 pl., 12¼ x 22¼in/31 x 56.5cm, pair £500-£800 col.
'*Fores' Coaching Recollections*', after C. Cooper Henderson, 1874, 5 pl., 8 x 11¼in/20 x 30cm, e. £100-£200 col.
'*H.M. Steam Frigate Cyclops*', after W.A. Knell, 1857, 19½ x 24in/49.5 x 61cm, £300-£500 col.
'*Coursing*', after G.H. Laporte, 1860, 15½ x 24¼in/39 x 63cm, pair £300-£500 col.
'*Down Hill, the Skid*', and '*Up Hill, Spring'Em*', after W.J. Shayer, 1867, 19½ x 23⅜in/49.5 x 60cm, pair £400-£700 col.

PARISET, D.P. b.1740
French stipple engraver of small portraits after his contemporaries. He came to England in 1769 and worked for W.W. Ryland and F. Bartolozzi (qq.v.).
Small value.

PARK, George Harrison fl. late 19th century
Etcher of landscapes.
Small value.

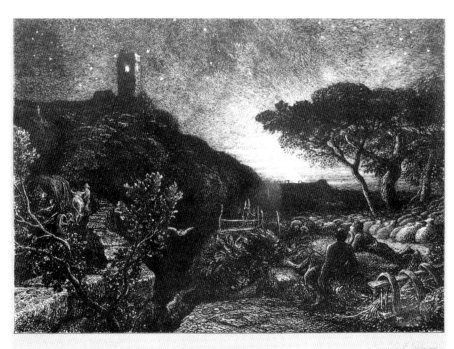

PALMER, Samuel. 'The Lonely Tower', the artist's rarest and most sought-after etching.

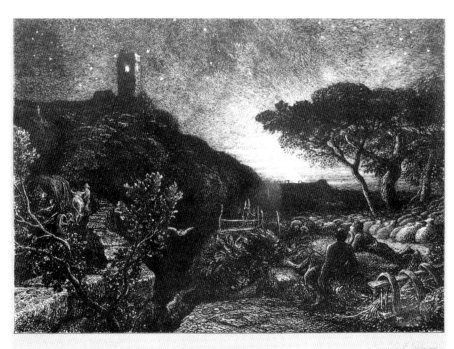

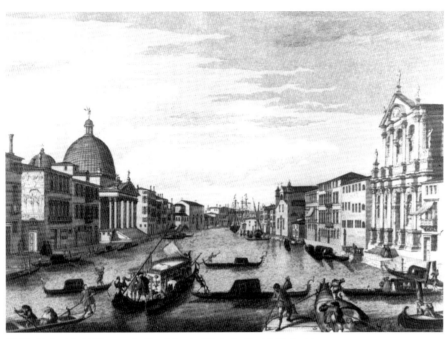

PARR, Nathaniel. 'A View on the Grand Canal of Venice', after M. Marieschi.

PARK, Thomas b.1760
Mezzotint engraver of portraits and decorative subjects after his contemporaries. He was born in Middlesex. He gave up engraving in 1797 to devote himself to literary and antiquarian pursuits.
'Mrs. Jordan as the Comic Muse', after J. Hoppner, 1787, 27½ x 15in/70 x 38cm, £250-£400.
'Lord Henry Fitzgerald', after J. Hoppner, 1789, 15 x 10¾in/38 x 27.5cm, £30-£60.
'J.G. Holman with Miss Brunton as Romeo and Juliet', after M. Brown, 1787, 25¾ x 18in/65.5 x 45.5cm, £200-£300.
'William Hayes', after J. Cornish, 1787, 11¼ x 9in/30 x 23cm, £15-£35.
CS.

PARKER, Agnes Miller, R.E. 1895-1980
Scottish painter, book illustrator and wood engraver of figure and animal subjects. Born in Ayrshire, she studied at the School of Art in Glasgow, where she continued to live before moving to the Isle of Arran.
£50-£150.

PARKER, G. fl. mid-19th century
Stipple engraver of small portraits and bookplates after his contemporaries.
Small value.

PARKER, James 1750-1805
Stipple and line engraver of portraits, historical and decorative subjects, etc., after his contemporaries. Born in London, he was apprenticed to J. Basire I (q.v.) and studied alongside W. Blake (q.v.) with whom he started up a print shop in 1784. This failed, however, three years later and he was then obliged to earn his living from engraving. He died in London.
'The Revolution of 1688', after J. Northcote, 1790, 17 x 24in/43 x 61cm, £30-£80.
'Mary Ann Hodges', after O. Humphrey, 1798, 8 x 5in/20.5 x 12.5cm, stipple, £5-£15.
Pl. for Boydell's Shakespeare £10-£25.
Small portraits and bookplates small value.

PARKES, Robert Bowyer b.1830
Mezzotint engraver of portraits mainly after 18th century British painters and genre and sentimental subjects after his contemporaries. He worked in London.
Lge. pl., approx. 18 x 25in/45.5 x 63.5cm, £20-£60; small pl. small value.

PARKYNS, George Isham
 fl. late 18th/early 19th century
Antiquary, amateur draughtsman and aquatint engraver of architectural views after his own designs and those of his contemporaries. He was born in and lived in Nottingham and travelled throughout Britain as well as on the Continent and in North America. He died in Cambridge.
'Monastic and Baronial Remains', 1816, 99 pl., 8vo., e. small value.
Pl. for J.C. Barrow's Picturesque Views of Churches, 1791-2, 12 pl., fo., e. £40-£80.

PARR, Nathaniel fl. mid-18th century
Etcher and line engraver of topographical views, sporting subjects and portraits after his contemporaries. He was probably related to Remi Parr (q.v.), and plates signed without initial could be by either engraver.
'A View on the Grand Canal of Venice', after M. Marieschi, £60-£120 col.
Portraits of racehorses, after J. Seymour, 1741-54, 11¾ x 11¾in/30 x 30cm, e. £150-£300.
'Representation of the Most Considerable Actions in the Siege of a Place', after J. Rigaud, 6 pl., set £150-£250 col.
Views of Oxford Colleges, after W. Williams, with W.H. Toms, e. £30-£80.
Portraits and bookplates small value.

PARR, Remi b.1723
Etcher and line engraver of topographical views, portraits and naval and decorative subjects after his contemporaries. He was born in Rochester, but studied in London where he appears to have lived and worked. He was probably related to N. Parr (q.v.), and plates signed without initial could be by either engraver.
'A Gentleman on a Manag'd Horse - riding out with a Lady', after J. Seymour, 1743, £150-£300 col.
Views of Vienna, after J.E.F. van Ert, etc.,7½ x 10in/19 x 25.5cm, £60-£120 col.
Views in and near Florence, after G. Zocchi, 1750, 11½ x 16¼in/29 x 42.5cm, e. £60-£120 col.
'A General Engagement', after F. Swaine, 11½ x 16in/129.5 x 40.5cm, £70-£120 col.
'Engagement between the Nottingham and the Mars', after P. Monamy and F. Swaine, 10¼ x 15in/26 x 38cm, £200-£300 col.
'The Seasons', after N. Lancret, 4 pl., 9 x 15in/23 x 38cm, set £400-£700 col.
Portraits and bookplates small value.

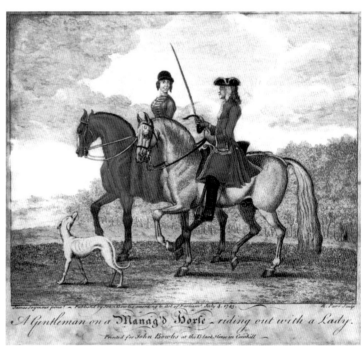

PARR, Remi. 'A Gentleman on a Manag'd Horse - riding out with a Lady', after J. Seymour, 1743.

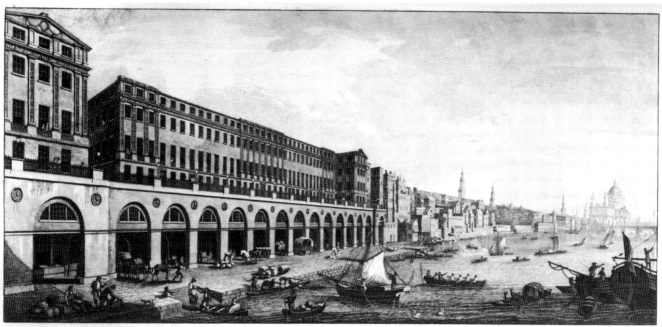

PASTORINI, Benedetto. 'View of the South Front of the New Buildings, called Adelphi'.

PARR, Richard
fl. mid-19th century
Line engraver of small bookplates including sporting and animal subjects after his contemporaries.
Small value.

PARROTT, William
1813-1869
Draughtsman and lithographer of topographical and architectural views mainly after his own designs. Born at Overley, he was a pupil of J. Pye II (q.v.) and travelled often to the Continent.
'London from the Thames', c.1840, 8½ x 16¼in/21.5 x 41.5cm, 12 tt pl., e. £200-£400 col.
'Panorama of Bermuda', after S. Halliwell, c.1850, 9 x 236in/23 x 600cm, £2,000-£4,000 col.
'Views of the Bermudas', 13 tt pl. (making 3 panoramas), e. pl. 19 x 18¼in/25.5 x 46.5cm, extremely rare set fetched £28,000 Oct. 1988.
Views of Georgetown, ?Demerara, after E.A. Goodall, 1844, obl. fo., 3 tt. pl., e. £200-£300 col.
'The Battle of Solebay, 1672', after W. van de Velde, 8½ x 13¼in/21.5 x 33.5cm, £10-£20.

PASS, J.
fl. late 18th/early 19th century
Line engraver of topographical and architectural views, naval subjects, portraits, etc., after his contemporaries.
Pl. for W. Alexander's Views in China, 1796, fo., e. £5-£15.
'Camelopardus, or Giraffe', 9½ x 7½in/24.5 x 19cm, £20-£30.
Portraits and small bookplates small value.

PASTORINI, Benedetto
c.1746-1839
Italian etcher, line, aquatint and stipple engraver of portraits, decorative subjects, topographical views and caricatures after his contemporaries and his own designs. He worked in London at the end of the 18th and the beginning of the 19th century.

'A Pair of Politicians Waiting for the Extraordinary Gazette', 1788, aq., £100-£200 prd. in sepia.
'Gaulterus and Griselda' and 'Griselda Returning to her Father', after Rigaud, 1784, 12 x 9in/30.5 x 23cm, stipples, pair £200-£400 prd. in sepia or in col.
'View of the South Front of the New Buildings, called Adelphi', 17 x 32½in/43 x 82.5cm, line, £100-£600.
'Elizabeth Billington', after J. Reynolds, 1803, 24 x 16½in/61 x 42cm, stipple, £40-£100.
Small portraits small value.

PATCH, Thomas. Self portrait, 1768.

PATCH, Thomas
d.1782
Landscape and portrait painter, etcher and line and aquatint engraver of religious subjects after Old Master painters, and caricatures and portraits after his own designs. After studying art in England, he went to Italy where he became a student in Rome. Having fallen foul of the Roman church authorities, however, he left Rome and settled in Florence in 1755. His caricatures of Italians are in the manner of P.L. Ghezzi.
'Life of Fra Bartolomeo', 1772, 24 pl., fo., e. small value.
Pl. after Old Master painters small value.
Self portrait, 1768, £150-£300 col.
Other caricatures £50-£150 col.
Small portraits small value.

PATERSON, George
fl. mid-19th century
Etcher, line and mezzotint engraver of sporting and genre subjects after his contemporaries. He worked in Glasgow and perhaps also in London.
'Grouse Shooting', after R. Ansdell, 1857, 14 x26in/35.5 x 66cm, £200-£400.
'An English Farmyard' and 'A Glimpse of an English Homestead', after J.F. Herring, 1856 and 1854, 22½ x 34in/57 x 86.5cm, pair £400-£700.
Add more if in fine contemporary frame.
'Postman's Horse', 'Scotch Cart Horse', from British Horses, after J.F. Herring, 1860, 11½ x 14¼in/29 x 37.5cm, e. £120-£180.
Small bookplates small value.

PATERSON, J.S.
fl. early 19th century
Scottish draughtsman and lithographer of landscapes and topographical views. He was teacher of drawing at Montrose Academy.
'Scenery in Angus and Mearns', c.1824, 6 pl., obl. fo., e. £10-£20 col.

PATERSON, Robert
fl. late 19th century
Etcher of landscapes and genre subjects after his contemporaries.
Small value.

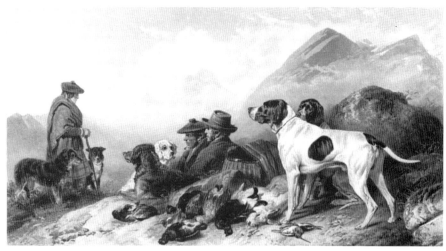

PATERSON, George. 'Grouse Shooting', after R. Ansdell, 1857.

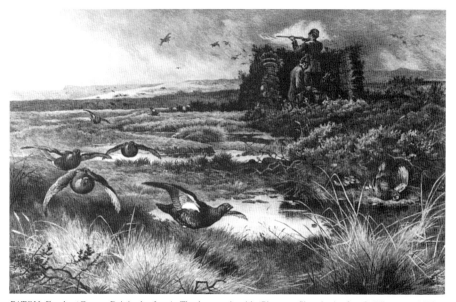

PATON, Frank. 'Grouse Driving', after A. Thorburn, pair with 'Pheasant Shooting', after C. Whymper, 1889.

PATRICK, James McIntosh. A typical architectural view.

PATON, Frank 1856-1909
Painter and etcher of animal, sporting and genre subjects after his own designs and those of his contemporaries. Born in London, he worked there and in Essex, living in Gravesend.
'Grouse Driving', after A. Thorburn, and 'Pheasant Shooting', after C. Whymper, 1889, 12½ x 20in/32 x 51cm, pair £200-£400.
'English Fishing', after C. Whymper, 1891, 6 pl., 6¼ x 9½in/17 x 24cm, set £150-£300.
Others of similar size £15-£40.

PATON, Hugh, A.R.E. 1853-1927
Scottish painter and etcher of landscapes. Born in Glasgow he taught himself to etch. He lived in Cheshire.
£10-£30.

PATRICK, James McIntosh, A.R.E. b.1907
Scottish painter and etcher of landscapes and architectural views. Born in Dundee, he studied at the Glasgow School of Art and in Paris. His subjects are taken from the Highlands and the South of France.
£30-£70.

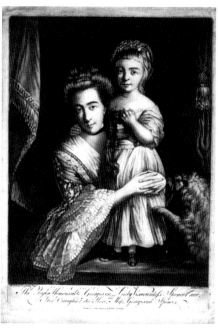

PAUL, J.S. 'Georgiana, Lady Spencer, and Daughter', after J. Reynolds, 1771, smaller version.

PAUL, J.S. fl. late 18th century
Mezzotint engraver of portraits and decorative subjects after his contemporaries and Old Master painters.
'Nymphs a'Bathing', after J. Vernet, 1770, 18½ x 22in/47 x 56cm, £70-£140.
'Georgiana, Lady Spencer, and Daughter', after J. Reynolds, 1771, 20 x 14in/51 x 35.5cm, £150-£250; smaller version, 5¼ x 4½in/14.5 x 11.5cm, £15-£35.
'Sir William Parsons', 1777, 9¼ x 7½in/25 x 19.5cm, £5-£15.
CS.

PAULUSSEN, R.
 fl. late 19th/early 20th century
Photo-engraver of portraits and genre and sporting subjects after his contemporaries.
Small value.

PAYNE, Albert Henry 1812-1902
Line engraver of small bookplates after his contemporaries, including landscapes, architectural views, scientific and industrial subjects and portraits. Born in London, he moved to Leipzig in 1838 where he set himself up in business and remained for the rest of his life.
German views e. £5-£10.
Others small value.

PAYNE, Charles Johnson 'Snaffles'
Painter and draughtsman of humorous sporting and military subjects. Reproductions of many of his paintings were printed, and there is a considerable market for signed impressions; often the artist would add additional remarques or sketches in the margins in chalk, pencil or watercolour.
£200-£1,000.

PAYNE, G.T. fl. mid-19th century
Line and mezzotint engraver of portraits and sporting and historical subjects after his contemporaries. He worked in London.
'The Amesbury Coursing Meeting', after W. and H. Barraud, 1850, 18½ x 36½in/47 x 92.5cm, and other sporting subjects of similar size, £300-£600.
Add more if in fine contemporary frame.
'Charles Green, the Aeronaut', after J. Hollins, 1838, £120-£240.
'Queen Victoria', after S. Bendixen, 14½ x 11¼in/37 x 28.5cm, £120-£180 prd. in col.
Other portraits and historical subjects £10-£50.

PAYNE, John fl. mid-17th century
Line engraver of portraits and frontispieces after his contemporaries and his own designs. A pupil of Simon van de Pass, he died in London.
Small value.

PAYNE, William
fl. late 18th/early 19th century
Drawing master, landscape and topographical draughtsman who etched some views of his native Plymouth.
6 views of Plymouth, obl. 4to., e. £20-£50 col.
Views in Devonshire, 1826, 16 pl., aq., 5 x 6½in/13 x 16.5cm, e. £30-£80 col.

PAYRAU, Jules Simon
fl. late 19th/early 20th century
French etcher and stipple engraver of portraits and sentimental and decorative subjects after 18th century British painters and his French and British contemporaries.
'The Garden of the Hesperides', after E. Burne-Jones, 1901, 26¼ x 21½in/66.5 x 54.5cm, and similar after the same, £600-£1,000.
Ovals after J. Downman, etc. £80-£200 prd. in col., in 18th century-style frame.
Others small value.

PEAK (Peake), James fl. mid-18th century
Etcher and line engraver of landscapes, topographical views and mythological, genre and naval subjects after his contemporaries, Old Master painters and his own designs. He was born in London and worked there, often for J. Boydell (q.v.).
'The Capture of the Island of Dominica', after Lieut. A. Campbell, 12¼ x 19½in/31 x 50cm, £250-£400.
'A Design to Represent the Beginning and Completion of an American Settlement or Farm', after P. Sandby, 1761, 14½ x 21in/36.5 x 53cm, £300-£500.

Lge. landscape pl. after Claude Lorraine, Richard Wilson, etc., £50-£150.
Small bookplates small value.

PEGRAM, Frederick. A typical figure study.

PEAKE, Richard Brinsley fl. early 19th century
Draughtsman and etcher.
'French Characteristic Costumes', 1816, 19 pl. with aq. by R. Havell I (q.v.), 4to., e.£10-£25 col.

PEAKE, Sir Robert d.1667
Printseller and line engraver of portraits. During the Civil War, he fought for Charles I and was besieged in Basing House with W. Faithorne I and W. Hollar (qq.v.), both of whom he assisted with their plates. On their surrender, Peake was exiled by Cromwell. With the Restoration, he returned and was appointed vice-president and leader of the Honourable Artillery Company under James, Duke of York.
£10-£30.

PEARCE, Charles Maresco 1874-1964
Painter and etcher of architectural views and figure subjects. After being apprenticed to the architect, E. George (q.v.), he studied at the Chelsea School of Art under A. John (q.v.) and William Orpen. His etchings show the influence of another teacher, W. Sickert (q.v.). He lived in London and Sussex.
£40-£90.

PEARD, John Whitehead 1811-1880
Draughtsman and lithographer of topographical views. A West Countryman, he was the son of an admiral and fought in Garibaldi's army in Italy.
'Five Views of the Environs of Gibraltar', c.1840, fo., tt. pl., e. £30-£80.

PEARSON, James d.1805
Irish stained-glass designer who engraved a few

sporting aquatints after his contemporaries. He trained in Bristol and died in London.
'Wild Duck Shooting', after S.B. Casse, 14½ x 18in/37 x 46cm, £300-£500 col.

PEDRO, Francesco del 1749-1806
Italian draughtsman and line engraver of decorative and historical subjects after his Continental and British contemporaries. Born in Udine, he worked in Venice where he died.
'The Taking of Seringapatam' and 'The Delivery of the Sons of Tippoo as Hostages to Lord Cornwallis', after H. Singleton and M. Brown, 1804-5, 11½ x 16in/29 x 40.5cm, e. £15-£30.

PEGRAM, Frederick 1870-1937
Genre painter, magazine and newspaper illustrator, etcher of portraits and figure subjects. He was born in London, where he worked for the *Pall Mall Gazette* and other publications.
£50-£90.

PEIRSON, J. *see* **PIERSON, J.**

PELHAM, Peter 1695-1751
Painter and mezzotint engraver of portraits after 17th century painters, his contemporaries and his own designs. Born in Chichester, he emigrated to America in 1726 and died in Boston. His portrait of Cotton Mather, 1728, is possibly the first American graphic work.
American portraits, not often found in the U.K., £300-£1,400.
English portraits £15-£50.
CS.

PELLEW, Claughton
fl. early/mid-20th century
Painter and wood engraver of landscapes and figure subjects. Born in Cornwall, he studied at the Slade and lived in Norfolk.
£30-£70

PELTRO, John 1760-1808
Line engraver of sporting and naval subjects after his contemporaries. He died at Hendon.
'Foxhunting', after J.N. Sartorius, 1795, 4 pl. with J. Neagle (q.v.), 17½ x 24in/44.5 x 61cm, set £800-£1,200.
'The Pearl Captures the Esperance', after R. Dodd, 1782, 12 x 17½in/30.5 x 44.5cm, £150-£250.
'The Action between the Monmouth and the Heros, after D. Serres, 1786, 17¼ x 24in/44 x 61cm, £200-£300.
Bookplates small value.

PENNELL, Joseph, R.E. 1858-1926
American book illustrator, etcher and lithographer of architectural and topographical views. He was born in Philadelphia, where he was educated, and he worked in England and on the Continent as well as in North and Central America. He wrote *The Life of James M'Neill Whistler*, 1907, and several other books and was first President of the Senefelder Club.
View of the Acropolis, Athens, litho., £200-£300.
Views of the Panama Canal, litho., e. £50-£100.
'Times Building, New York', litho., £200-£300.
Signed etchings generally £100-£300, but unusually fine imp. up to £700-£800.
Etchings and litho. publ. in The Studio, *unsigned, e. £8-£20.*
Bibl: Wuerth, L.A., *Catalogue of the Etchings of J.P.*, Boston, 1928.

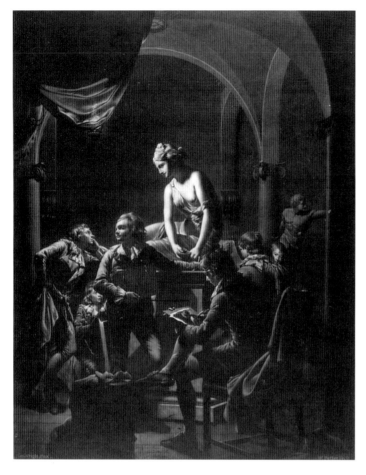

PETHER, William. 'The Drawing Academy', after J. Wright of Derby.

PENNY, C. fl. early 19th century
Stipple engraver of small portraits and bookplates after his contemporaries, 18th century painters and his own designs.
Small value.

PENNY, Edward, R.A. fl. late 18th century
Painter and stipple engraver of decorative subjects.
'The Respectful Lover', 'The Disconsolate Lover', 'The Jovial Lover', 1796, 9½ x 7in/24 x 17.5cm, and similar subjects, e. £40-£100.

PENNY, William
fl. late 18th/early 19th century
Scottish line engraver of small bookplates after his contemporaries. He lived near Edinburgh.
Small value.

PENSTONE, E. fl. mid-18th century
Line engraver.
'A Light Dragoon of the 15th. Reg.', 1760, 10½ x 8½in/26.5 x 21.5cm, £20-£50 col.

PENSTONE, John Jewel fl. mid/late 19th century
Painter and line engraver of small portraits and bookplates after his contemporaries and his own designs.
Small value.

PERCIVAL, Harold b.1868
Painter and etcher of marine and figure subjects.
Small value.

PERIAM, G.A. fl. mid-19th century
Line engraver of small bookplates including portraits and religious, historical and genre subjects after his contemporaries. He emigrated to Mexico in 1853.
Small value.

PERRY, Francis d.1765
Etcher and line engraver of small bookplates including portraits, topographical views, coins, medals, antiquities, etc. Born in Abingdon, Berkshire, he was originally apprenticed to a hosier before studying painting and then engraving.
Small value.

PETER, Robert Charles, A.R.E.
b.1888-?1980
Painter, etcher and mezzotint engraver of landscapes and animal, rustic and allegorical subjects after his own designs, and sporting subjects after 18th century British painters. Born in London, he was a fellow student of E. Blampied (q.v.) who influenced his etchings.
Sporting subjects after B. Marshall £80-£140 prd. in col.
Others £30-£70.

PETHER, William 1738-1821
Prominent mezzotint engraver of portraits and decorative, religious and genre subjects after his contemporaries, Old Master painters and his own designs. Born in Carlisle, he moved to London where he became a pupil of T. Frye (q.v.) with whom he formed a brief partnership in 1761. His career was apparently marred by his inability to concentrate. He eventually died in obscurity in Bristol having eked out his last years as a drawing master.

'The Orrery', after J. Wright of Derby, 1768, 19 x 23in/48.5 x 58.5cm, £3,500-£7,000.
'The Drawing Academy', after J. Wright of Derby, £2,400-£4,800.
'The Farrier's Shop', after J. Wright of Derby, 1771, 19¼ x 13¾in/50 x 35cm, £2,000-£3,500, fine imp. fetched £4,000 June 1993.
Drawing from 'The Gladiator', after J. Wright of Derby, 1769, 19 x 22in/48.5 x 56cm, £2,000-£3,500, fine imp. fetched £4,200 June 1993.
'The Alchemist', after J. Wright of Derby, fetched £4,800 June 1993.
'William Pether', 14¼ x 10¼in/36 x 27.5cm, £60-£140.
'Benjamin West', after W. Lawrenson, 18 x 13in/45.5 x 33cm, £60-£140.
'Master Ashton', after J. Wright of Derby, 1770, 19¼ x 13¾in/50 x 35cm, £150-£250.
'Gimcrack' (racehorse), after G. Stubbs, 1766, 16 x 18in/40.5 x 45.5cm, £600-£1,200.
'The Soldier's Return', after J.H. Ramberg, 1785, 18¼ x 27¾in/46.5 x 70.5cm, £300-£500 prd. in col.
'George III', after T. Frye, 1762, 24¼ x 16¾in/61.5 x 42.5cm, £100-£200.
'Helena Forman, Rubens' Wife', after P.P. Rubens, 1769, 20¼ x 14¼in/51.5 x 36cm, £30-£70.
'John Greenwood', 6½ x 5in/16.5 x 12.5cm, £5-£10.
CS.

PETITJEAN, François
fl. late 19th/early 20th century
French etcher and mezzotint engraver of sentimental and decorative subjects after Old Master and 19th century painters and his contemporaries.
'Ophelia', after J.E. Millais, 1922, 13½ x 21in/34 x 53cm, £300-£500 prd. in col.
Other lge. pl.£15-£50 prd.in col.
Others small value.

PETTIE, John, R.A. 1839-1893
Well-known history and genre painter who etched a few plates and contributed to the Etching Club.
Small value.

PETTIT, John fl. late 18th century
Stipple engraver of caricatures after his contemporaries.
'A Private Rehearsal of June Shore', after J. Nixon, 1790, £80-£160 col.
'Old Maids at a Cat's Funeral', after F.G. Byron, 1789, 11½ x 23½in/29 x 59.5cm, £150-£300 prd. in col.

PHILLIBROWN, T. fl. mid-19th century
Stipple engraver and lithographer of portraits.
Small value.

PHILLIPS, Alfred H. fl. late 19th century
Etcher, painter and mezzotint engraver of genre and sentimental subjects after his contemporaries. He lived in London.
'Coaching', after W.J. Shayer, 1890, 8¾ x 12¼in/ 22.5 x 32.5cm, pair £30-£70.
Others small value.

PHILLIPS, Charles 1737-?1780
Etcher and mezzotint, stipple and line engraver of portraits and figure subjects after Old Master painters and his contemporaries.
'David Garrick', after P.J. de Loutherbourg, 11½ x 16in/29 x 40.5cm, etching, £15-£40.
'Lydia Hone', after N. Hone, 1771, 15 x 12in/38 x 30.5cm, mezzo., £30-£80.
'Nelly O'Brien', after J. Reynolds, 1770, 16¼ x 13in/41.5 x 33cm, mezzo., £60-£140.
CS lists 6 pl.

PHILLIPS, George Henry
fl. mid-19th century
Miniaturist, painter, etcher and line and mezzotint engraver of portraits and religious, sentimental and sporting subjects after his contemporaries. He worked in London.
'The Cricket Match between Sussex and Kent at Brighton', after W. Drummond and C. Basebe, 1849, 23 x 36in/ 58.5 x 91.5cm, £300-£600.
'Cottage Piety', after T. Webster, 1836, 20 x 16in/51 x 40.5cm, £30-£80.
'The Opening of the Sixth Seal', after F. Danby, 1844, 19½ x 27¼in/49.5 x 69cm, £400-£600.
'John, Earl of Westmorland', after G. Sanders, 1827, 23¾ x 16in/60.5 x 40.5cm, £40-£100.
Add more if in fine contemporary frame.
'Lady Dover and Child', after T. Lawrence, 1838, 11 x 8in/28 x 20.5cm, £15-£30.
'Hon. Maria Anne Ashley', after T. Lawrence, 1842, 8 x 6in/20.5 x 15cm, £10-£20.
'Enoch Durant', after J. Wood, 12 x 9¼in/30.5 x 23.5cm, £10-£20.

PHILLIPS, James
fl. late 18th century
Engraver of the following:
'Cubeer Birr, the Great Banyan Tree', 'The Caves of Elephanta', after J. Wales, 15 x 28in/38 x 71cm, pair £400-£700.

PHILLIPS, John
fl. mid-19th century
Draughtsman, etcher and aquatint engraver of the following series:
'Characteristic Sketches of the London Clubs', 1829, 4 pl., obl. fo., e.£150-£300 col.

PHILLIPS, Samuel
fl. late 18th/early 19th century
Stipple engraver.
'Taste in High Life', after W. Hogarth, 1808, 15¼ x 18¼in/39 x 46.5cm, £30-£70.

PHILLIPS, Watt
fl. mid-19th century
Draughtsman and etcher of humorous cartoon strips and panoramas.
'M.P.', c.1840, 15 col. pl. on 11 sheets, obl. 4to., set £150-£250; small value individually.

PHYSICK, W.
fl. mid-19th century
Lithographer, perhaps a native of Manchester.
'The Steam Ship President', after N.J. Kempe, 1840, 10¼ x 13¾in/26 x 35cm, tt. pl., £70-£140.

PICART, Bernard
1673-1733
French miniaturist, line and mezzotint engraver of portraits and historical, classical and religious subjects after Old Master painters and his contemporaries. He is mentioned here for several portraits of Englishmen after Van Dyck, Kneller, etc.
Portraits of Englishmen £5-£15.

PICART, Charles
fl. late 18th/early 19th century
Stipple and line engraver of portraits after his contemporaries. He lived and worked in London, producing mainly small bookplates but also a few larger plates.
'George John, Duke of Dorset', after C. Robertson, 16 x 12½in/40.5 x 32cm, £10-£20.
'Miss Foote as Marie Darlington in A Roland for an Oliver', after G. Clint, 1822, 14½ x 11in/37 x 28cm, £30-£80 prd. in col.
Small bookplates small value.

PICKEN, Andrew
1815-1845
Draughtsman and lithographer of landscapes, topographical and architectural views and portraits after his contemporaries and his own

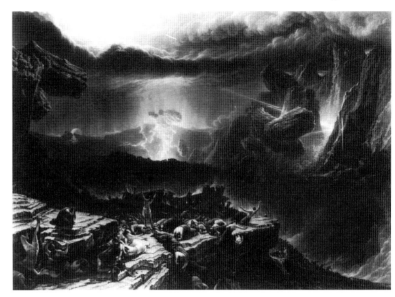
PHILLIPS, George Henry. 'The Opening of the Sixth Seal', after F. Danby, 1844.

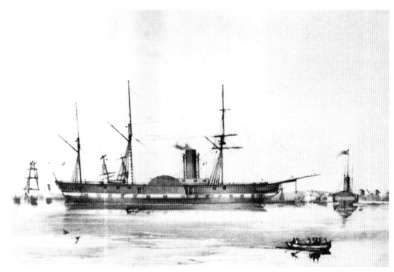
PHYSICK, W. 'The Steam Ship President', after N.J. Kempe, 1840.

PICKEN, Andrew. One of ten plates from 'Madeira Illustrated: Ravine of St. Jorge', 1840.

PICKEN, Thomas. 'View of the Harbour, St. George's, Grenada, W.I.', after Capt. H. Turner, 1852.

designs. The brother of T. Picken (q.v.), he was a pupil of L. Haghe (q.v.). He lived and worked mainly in London, where he died.
'View of the Remains of St. Stephen's Chapel on the Morning after the Fire of 16 Oct. 1834', after J. Taylor Jun., 15¼ x 16½in/39 x 42cm, £80-£140 col.
'Madeira Illustrated', after Picken, 1840, 10 tt. pl. incl. title, fo., set £500-£800, fetched £900 May 1993.
Pl. for Clarkson Stanfield's Sketches on the Moselle, the Rhine and the Meuse, *1838, fo., tt. pl., e. £40-£70.*
Small portraits and bookplates small value.

PICKEN, Thomas d.1870
Painter and lithographer of landscapes, topographical views and naval and military subjects after his contemporaries and his own designs. He worked in London but later apparently emigrated to Australia. He was the brother of A. Picken, (q.v.).

PIERSON, John. 'The Gamekeeper', pair with 'The Milkmaid'.

'View of the Harbour of St. George's, Grenada, W.I.', after Capt. H. Turner, 1852, tt. pl., £300-£400 col.
'Sydney Harbour' and *'Sydney Cove, N.S.W.',* both after O.W. Brierly, 1853, 13 x 19½in/33 x 49.5cm, tt. pl., pair £1,200-£1,800 col.
'Final Destruction of Bomarsund', after O.W. Brierly, 1854, 13¼ x 22½in/33.5 x 57cm, tt. pl., £80-£140.
'Royal Military Academy, Woolwich' and *'Royal Horse Artillery Review',* after W. Ranwell, c.1840, 15½ x 26¾in/39.5 x 68cm, pair £400-£600 col.
Pl. for W. Simpson's Seat of War in the East, *1855-6, fo., e. £10-£30 col.*
Pl. for E. Walker's Views of the Principal Buildings in London, *1852, 12½ x 16¼ in/31.5 x 41cm, tt. pl., e. £200-£400.*
Pl. for J. LeCapelain's The Queen's Visit to Jersey, *1847, fo., e. £30-£70.*
'Panoramic View of Liverpool from the River Mersey', after J. Butler and S. Walters, 1853, 18 x 41in/45.5 x 104cm, tt. pl., £300-£500.
'Views of Sheffield', after W. Ibitt, 1855, 18¼ x 28in/46.5 x 71cm, tt. pl., pair £300-£600 col.
'Douglas, Isle of Man, with the Monas Queen Starting for Liverpool', after S. Walters, 12¼ x 25½in/32.5 x 64.5cm, tt. pl., £300-£400.

PICKETT, W fl. late 18th/early 19th century
Draughtsman and aquatint engraver of landscapes, architectural views and naval and military subjects after his contemporaries and his own designs.
2 views of Bury St. Edmunds, 1806, 12½ x 15½in/32 x 39.5cm, pair £150-£250 col.
'Inspection of the Honble. Artillery Company', after E. Dayes, with J. Mitan (q.v.), 1803, 24 x 30in/61 x 76cm, £500-£800 col.
'Presentation of a Sword to Lieut. Col. Wilson (Queen's Royal Volunteers)', after Pickett, 9¾ x 12½in/25 x 32cm, £70-£120 col.
Pl. for P.J. de Loutherbourg's Picturesque Scenery of England and Wales, *1805, fo., e. £30-£70 col.*
6 views of Margate, 1797, after Pickett, obl. 4to., e. £20-£50.
'Battle of Cape St. Vincent', after J. Clark, 1806, 3¼ x 9¼in/8 x 23.5cm, and other pl. from Orme's Graphic History of Lord Nelson, e. £8-£15.
Pl. for W. Barber's Farm Buildings, *c.1805, 4to., e. small value.*

PICOT, Victor Marie 1744-1802/5
French etcher, line and stipple engraver of landscapes, topographical views, historical, mythological and decorative subjects and portraits after his contemporaries. Born at Montières, he came to England in 1766 with W.W. Ryland (q.v.), and later lived with F. Ravenet (q.v.) whose only daughter he married. He died at Amiens.
'D'Eon de Beaumont Fencing with M. de St. George', after Robineau, 1789, 15¼ x 18½in/40 x 47cm, stipple, £100-£200.
'Elizabeth West', after B. West, 1781, 7½ x 6in/19 x 15cm, line, £100-£150 prd. in col.
2 views of Hampstead Heath, after P.J. de Loutherbourg, 16 x 21in/40.5 x 53.5cm, line, pair £400-£600.
'Queen Margaret and the Robber', after Barralet, 1785, 14½ x 20in/37 x 51cm, stipple, £50-£150.
'Maternal Care', after C. Monnet, 1777, 13 x 10in/33 x 25.5cm, stipple in red, £50-£150.

PIERCY, Ralph 1862-1894
Etcher and mezzotint engraver of landscapes, architectural views, portraits and figure subjects after his contemporaries.
Small value.

PIERSON (Peirson), John
 fl. late 18th/early 19th century
Draughtsman and stipple engraver of sporting, decorative and religious subjects after his own designs and those of his contemporaries.
'Prudence', 'Temperance', 'Fortitude' and *'Virtue',* after H.C. Richter, with P. Roberts (q.v.), 1798, 15¾ x 11¾in/40 x 30cm, set £300-£500 prd. in col.
'Gay Shepherd's Week', after Pierson, 1798, 7 pl., 6¾ x 8½in/17 x 21.5cm, set £600-£1,000 prd. in col.
'The Gamekeeper' and *'The Milkmaid',* after J.P., 16 x 12in/40.5 x 30.5cm, pair £300-£500 prd. in col.
'The Holy Family' and *'The Annunciation',* 1800, 15 x 11in/38 x 28cm, pair £40-£80 prd. in col.

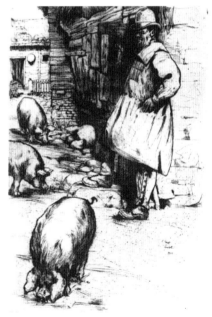

PIMLOTT, Philip. A typical rustic scene.

PILOTELL, Georges Labadie, called
1844-1918
French caricaturist and drypoint etcher of portraits. Born at Poitiers, he fled to London after the surrender of the Paris Commune in 1871. He died in London.
£10-£30.

PIMLOTT, Philip, A.R.E.
fl. late 19th/early 20th century
Etcher of landscapes and rustic scenes.
£10-£30.

PINE, John
1690-1756
Line engraver, mainly of bookplates, but best known for the three series listed here, particularly the first. He also ran a printshop in St. Martin's Lane in London and was a friend of W. Hogarth (q.v.) who introduced his portrait in 'Oh! the Roast Beef of Old England' as the Friar.
'The Tapestry Hangings of the House of Lords Representing the Several Engagements between the English and Spanish Fleets in 1588', 1739, 10 pl. with 6 charts of the sea coast of England and a general chart of Great Britain, set £2,000-£3,000 prd. in col. (fetched £3,500 Nov. 1988).
'Procession and Ceremonies Observed at the Installation of the Knights of the Bath, June 17, 1725, 20 pl. and additional pl. of the 'Arms of the Four Knights Companions of the Bath', c.1732, 22¼ x 16¾in/56.5 x 42.5cm, set £300-£500.
'Plan of London, Westminster and Southwark', 1746, 24 sheets and key, £500-£1,000.
Bookplates small value.

PINKERTON, Eustace
fl. late 19th/early 20th century
Etcher and mezzotint engraver of portraits after his contemporaries, 18th century painters and his own designs.
£10-£25.

PIPER, Elizabeth, A.R.E.
fl. late 19th/early 20th century
Painter and etcher of landscapes and architectural views. She studied at the Clifton School of Art and at the R.C.A., and lived at Stanmore, Middlesex.
£10-£30.

PIPER, John
b.1903-1992
Designer, painter and lithographer of landscapes

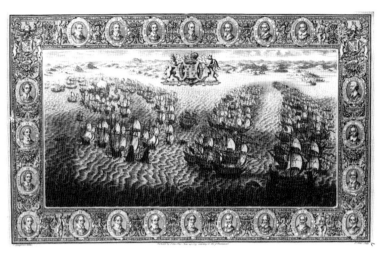
PINE, John. One of seven charts from 'The Tapestry Hangings of the House of Lords Representing the Several Engagements between the English and Spanish Fleets in 1588', 1739.

PIPER, John. 'The Royal Pavilion'. One of the 'Brighton Aquatints', 1939.

and architectural views. Born at Epsom, Surrey, he studied at Richmond and Kingston Schools of Art and at the R.C.A. He was an Official War Artist in World War II. He lived at Henley-on-Thames, Oxfordshire.
'Brighton Aquatints', 1939, 12 unsigned pl. 8¾ x 11½in/22.5 x 29cm, edn. 200, set £200-£400, 55 proofs hand-coloured by J. P. and Sir John Betjeman, set £400-£600.
Lithos prd. in col. mostly £300-£600.
Ref: O. Levinson.

PIRANESI, Giovanni Battista
1720-78
Famous Italian etcher and engraver of architectural views who was commissioned by the architect, Robert Milne, to etch a drawing by Milne of Blackfriars Bridge which the latter had designed.
'View of Blackfriars Bridge' £200-£400

PIROLI, Tomaso
1750-1824
Roman line and stipple engraver. He is mentioned here for his outline engravings after John Flaxman to illustrate Homer and other early classical authors, as well as after F. Rehberg to depict Emma Hamilton's *Attitudes*. *These pl. small value individually.*

PISSARRO, Lucien
1863-1944
Painter and wood engraver of landscapes and townscapes and rustic scenes. Born in Paris, he was the son of Camille Pissarro, under whom he studied. He came to London in 1890, and moved to Epping in 1893 where he set up the Eragny Press, designing and publishing books there until 1914. He became a British subject in 1916. He was the father of O.C. Pissarro (q.v.).

PIROLI, Tomaso. Outline engraving after John Flaxman.

PLATT, John Edgar. 'Red Chestnut'.

Mostly £50-£150, but up to £500 for imp. prd. in col., signed and numbered.
'Travaux des Champs', after C. Pissarro, 1893, 6 pl., 3in/7.5cm col., sheets 11¼ x 9¼in/30 x 23.5 cm, set (de luxe edn. of 25) £3,000-£5,000.

PISSARRO, Orovida Camille 1893-1968
Painter, etcher and aquatint engraver mainly of animal subjects. The daughter and pupil of L. Pissarro (q.v.), she was born at Epping, Essex, and lived in London. She taught herself to etch, working in a style strongly influenced by Oriental miniatures. She signed herself 'Orovida'.
'Marsh Deer', 1917, 4 x 8in/10 x 20cm, £60-£120.
'Strategy', 1929, 11½ x 9¼in/29.5 x 23.5cm, £120-£200.
'Stampede', 1930, 7 x 10¾in/17.5 x 27.5cm, £250-£400.
'Zebra Drinking', 1947, 12¼ x 8½in/31 x 22cm, £200-£300.

PITMAN, John fl. early/mid-19th century
Painter, draughtsman and lithographer of animal subjects. He worked at Worcester.
'The Madresfield Heifer', 15¼ x 18¼in/39 x 46.5cm, £150-£250.
'Nimrod' (racehorse), 16 x 20in/40.5 x 51cm, £140-£200.

PLACE, Francis 1647-1728
Amateur painter, draughtsman and etcher of landscapes and architectural views after his own designs and animal subjects after his contemporaries, and mezzotint engraver mainly of portraits after his own designs and those of contemporaries. Born in Yorkshire, he was serving as a clerk to an attorney in London when plague broke out in 1665, which gave him the opportunity to turn to art.
It is probable that W. Hollar (q.v.) encouraged

him to take up etching and he was one of the first mezzotint engravers to practise in England. Until 1675 he seems to have worked mainly in London; after that date he lived and worked in his native Yorkshire.
Etched landscapes £50-£100.
Natural history pl. £10-£25.
Mezzo. portraits: 'Countess of Middleton', after P. Lely, 11¼ x 8½in/30 x 22cm, £60-£140; various HLs, depending on size and subject, £10-£60. CS lists 14 portraits.
Bibl: Tyler, R. 'F.P.', exhibition catalogue, York City Art Gallery, 1971.

PLACE, M. fl. late 18th/early 19th century
Stipple engraver of decorative subjects and portraits after his contemporaries.
'The Child Lost', after M. Spilsbury, and 'The Child Restored', after L. Cosse, 1805, 17 x 23in/43 x 58.5cm, pair £250-£400 prd. in col.
'Duke of Wellington when Viscount Wellesley', after Raria, 1811, 8¼ x 6½in/21 x 17cm, £10-£20.
'The Volunteer Corps of the City of London' and 'The Volunteer Corps of the City of Westminster', after R.K. Porter, 12 x 14in/30.5 x 35.5cm, pair £250-£400 prd. in col.

PLATT, John Edgar 1886-1967
Colour-woodcut artist of landscapes and animal and figure subjects. Born in Staffordshire, he studied at the R.C.A. He was President of the Society of Graver Printers in Colour for many years and was Principal of Leicester School of Art from 1923. He modelled the technique and style of his plates on Japanese woodblock prints.
'The Scrum', 10 x 15¼in/25.5 x 38.5cm, £100-£200.
'The Plough', triptych, overall size 8¼ x 44¼in/21 x 112.5cm, £200-£400.

'Red Chestnut', and others £80-£200.

PLATT, John Gerald, A.R.E. b.1892
Painter, etcher and wood engraver of landscapes and figure subjects. Born at Bolton, Lancashire, he studied art in Newcastle and in Leicester as well as at the R.C.A. He was Principal of Harrow Technical and Art School from 1930 to 1947, and later Principal of Hornsey School of Arts and Crafts.
£15-£40.

PLATT, William
 fl. late 18th/early 19th century
Line and stipple engraver of portraits and book-plates after his contemporaries and Old Master painters. He studied at the R.A. Schools.
'Cambria in a Country Dance', after A. Buck, aq. by J.C. Stadler (q.v.), £100-£160 col.
Small portraits and bookplates small value.

PLAW, John fl. late 18th century
Architect, draughtsman and aquatint engraver of architectural designs.
Small value.

PLAYTER, Charles Gauthier d.1809
Stipple engraver of portraits and figure subjects after his contemporaries. He died in Lewisham.
Pl. for Boydell's Shakespeare £10-£25.
Others mostly small value.

PLOSCZCZYNSKI, N. fl. mid-19th century
Lithographer of portraits and sporting and military subjects after his contemporaries. He appears to have been of Polish descent.
'Young Reed', after W. Bromley, 17¼ x 14in/44 x 35.5cm, £100-£150.
'The Eleven of England', after N. Felix, 1847, 19 x 24in/48 x 61cm, £1,200-£2,000 col.
'The Two Elevens of the University and Town of

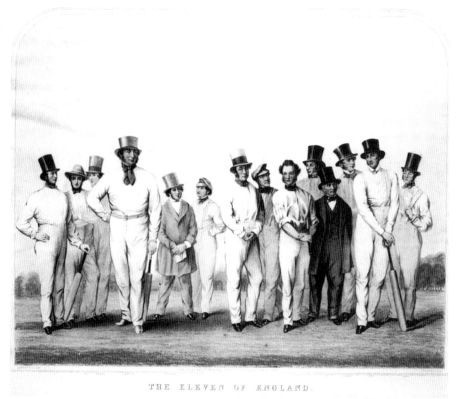

PLOSCZCZYNSKI, N. 'The Eleven of England', after N. Felix, 1847.

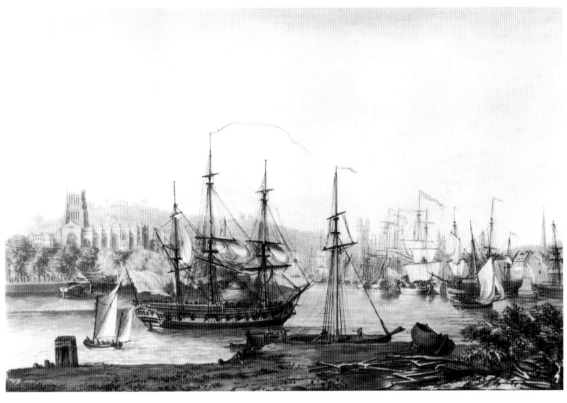

POCOCK, Nicholas. One of the Bristol views hand-coloured by the artist.

Cambridge', after N. Felix, 1847, 42 x 39in/106.5 x 99cm, tt. pl., £1,000-£1,600 col.
'Hertfordshire Militia and Essex Cavalry and Artillery Field Day', after F.W. Woodhouse, 1853, 8 pl., fo., set £400-£700 col.
'The 8th (The Royal Irish) Hussars, Chobham', after A. de Prades, 12 x 17¾in/30.5 x 45cm, £120-£180 col.
'Banquet Given by the Reformers of Marylebone', after C. Compton, 1847, 17¼ x 31¼in/44 x 79.5cm, £100-£150.
Small portraits and music covers small value.

POCOCK, Nicholas 1741-1821
Eminent shipping painter who etched a few marine subjects, and etched and aquatinted several views of his native Bristol.
Bristol views, 1780s, ave. 11½ x 16½in/29 x 42cm, hand-col. imp. by the artist, e. £300-£500.
'Action between H.M. Frigate San Fiorenzo and La Piëdmontaise, near the Island of Ceylon', etched by N. Pocock, aq. by W. Bennett (q.v.), 1809, 18 x 23½in/45.5 x 60.5cm, £300-£500 col.

POCOCK, Rose fl. mid-19th century
Draughtswoman and lithographer of West Country views.
'Scenery in Western Somersetshire', after Miss Sweeting, c.1840, 12 tt. pl., obl. 4to., set £150-£300.
'The Longleat Views', c.1840, 6 tt. pl., set £200-£300.

POLLARD, James 1797-1867
Famous painter and aquatint engraver of coaching and sporting subjects after his own designs and those of his contemporaries. Born in Islington, he was the son of R. Pollard (q.v.) who taught him to paint and engrave and brought him into his publishing business, renaming it R. Pollard & Sons in 1819. Over the next ten years, he both painted and engraved in

POCOCK, Rose. One of twelve plates from 'Scenery in Western Somersetshire: Dunster', c.1840.

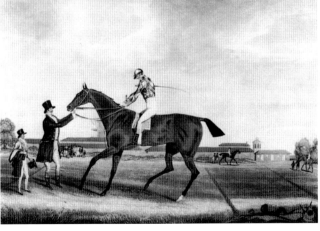

POLLARD, James. 'Memnon', 1825. A typical racehorse portrait.

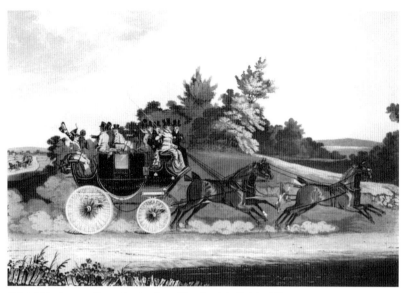

POLLARD, James. 'Stage Coach - Opposition Coach in Sight', 1829.

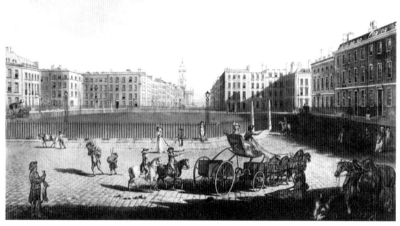

POLLARD, Robert. 'Hanover Square', after E. Dayes, with F. Jukes and R. Dodd, from the set of four views of London squares, 1787-9.

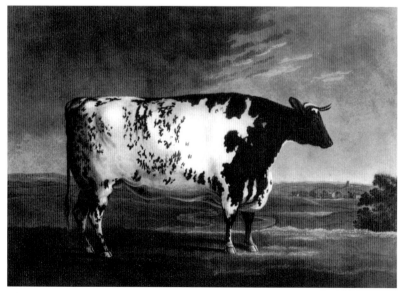

POLLARD, Robert. 'The Ketton Ox', after G. Cuitt, 1801, aquatint.

aquatint, using a style of grain which is immediately discernible from that of the other engravers who reproduced his paintings. After 1830 he did little engraving but concentrated on painting. He died in Chelsea.

'Shooting', 1812-17, 12 pl., 9½ x 14½in/24 x 37cm, e. £500-£800 col.

'Cricket Match', 1824, 4½ x 16in/11.5 x 40.5cm, £800-£1,200 col.

'Caught in the Act', 1825, 17½ x 20in/44.5 x 50.5cm, £100-£150 col.

'Coursing in Hatfield Park', 1824, 12¼ x 19in/31 x 48cm, pair £600-£1,000 col.

'Coursing at Epsom', after J.N. Sartorius, 1821, 4 pl., 16¾ x 20in/42.5 x 51cm, set £1,400-£2,000 col.

'Racing at Newmarket', 1823-5, 4 pl., 8½ x 18in/21.5 x 46cm, set £2,400-£3,200 col.

'Barouche', 1812, 8¼ x 11¼in/21 x 30cm, £200-£400 col.

'Stage Coach', 1826, 9¼ x 15½in/23.5 x 40cm, aq., £400-£700 col.

Coaching scenes, 1820s, ave. 12 x 17½in/30.5 x 44.5cm, £600-£1,200 col.

'Moses', 1822, 14½ x 18½in/37 x 47cm, 'Memnon', 1825, and similar racehorse portraits from the 1820s, £600-£1,200 col.

'New General Post Office', 1829, 13¾ x 25¼in/35 x 65.5cm, £1,000-£1,500 col.

Bibl: Selway N.C., *The Golden Age of Coaching*, 1972.

Colour plate page 53.

POLLARD, Robert 1755-1838

Etcher, line, ?aquatint and occasionally mezzotint engraver of naval, sporting, decorative and historical subjects, portraits and architectural views after his contemporaries. Born in Newcastle, he was originally apprenticed to a silversmith. He came to London in 1774, and studied painting and drawing under Richard Wilson, and etching under I. Taylor I (q.v.). He set up his own engraving and publishing business in Islington in 1781. While he executed the etching and line engraving in his prints, the aquatint ground always seems to have been laid on by other engravers, particularly by F. Jukes (q.v.). He was the father of J. Pollard (q.v.), whom he taught to paint and engrave, subsequently bringing him into his business.

Naval subjects: line eng. e. £200-£300; aq. e. £300-£500 col.

London Squares, after E. Dayes, aq. with F. Jukes and R. Dodd (qq.v.), 1787-9, 18 x 21¾in/45.5 x 55.5cm, e. £300-£500.

'The Choir of St. Paul's, April 23', 1789, after E. Dayes, 18 x 27in/46 x 69cm, £80-£150.

'Fox Hunting' after R. Pollard, with F. Jukes, 1806-7, 4 pl., 15 x 20in/38 x 51cm, aq., set £1,600-£2,200 col.

'The West End of Town' and 'The East End of Town', after H. Singleton, 1793, 17½ x 21¾in/44.5 x 55.5cm, aq., pair £600-£1,000.

'The Ketton Ox', after G. Cuitt, 1801, 16 x 21in/40.5 x 53cm, aq., £300-£600 col.

'Vauxhall', after T. Rowlandson, aq. by F. Jukes, 1785, 21¼ x 30¼in/54 x 78cm, aq., £800-£1,200 col.

'Foxhound Modish' and 'Pointer Dash', after S. Gilpin, with F. Jukes, 1788, 15¼ x 20½in/38.5 x 52.5cm, aq., e. £150-£250.

'Boy Playing at Marbles' and 'Boys Playing at Peg Top', after R.M. Paye, 1780, 16¼ x 21in/41.5 x 53.5cm, pair £200-£400.

'Aglaia' and 'Euphrosyne', both 1787, 10 x 5¾in/25.5 x 14.5cm, e. £20-£50.

'Infantile Sports', 1791, 17 x 13in/43 x 33cm,

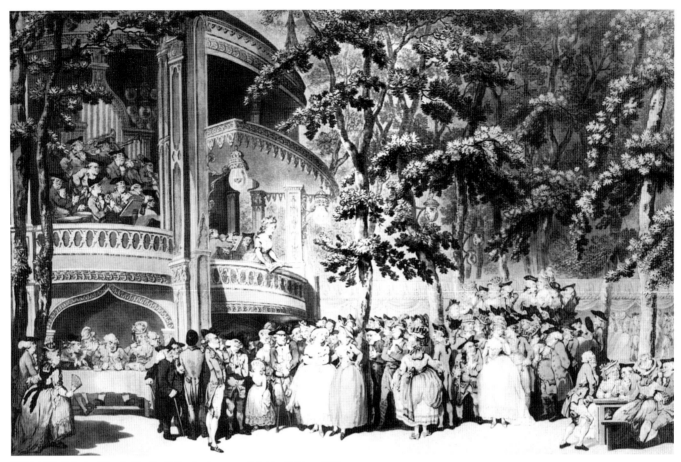

POLLARD, Robert. 'Vauxhall', after T. Rowlandson, aquatinted by F. Jukes, 1785.

£50-£100.
Small portraits and bookplates small value.
CS lists 3 mezzo.: 'Aglaia', 'Euphrosyne' and 'Infantile Sports'.

POND, Arthur d.1758
Painter, etcher and line engraver of portraits and caricatures after his own designs and those of his contemporaries. He studied at the Vanderbank Academy in 1720 and went to Rome in the mid-1720s, returning to become a portraitist in crayons. He is best known, however, for his 'Imitations of the Italian Masters', 1734-5, produced in collaboration with C. Knapton (q.v.), using etched plates with tones printed from woodblocks. He also produced two sets of prints after Italian caricatures between 1736 and 1742 and ran a business with Knapton publishing engravings after 17th and 18th century landscape painters and other works. After the 'Imitations' project, he turned to etching caricatures after P.L. Ghezzi and other Italians.
Pl. for 'Imitations of the Italian Masters', e. £5-£15.
'Self-portrait', 1751, 7¼ x 6in/18.5 x 15cm, £50-£70.
Other portraits small value.
Caricatures £5-£20.

POOLE, William
 fl. late 18th/early 19th century
Stipple and aquatint engraver of costume plates after his contemporaries.

POND, Arthur. A typical etched 'Imitation of an Old Master', after Claude Lorraine.

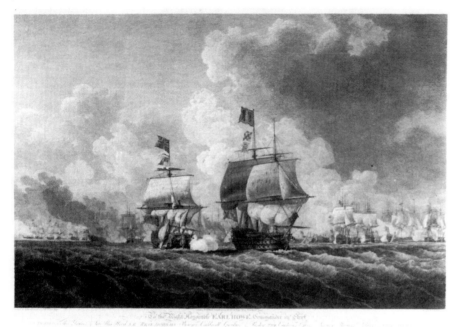

POUNCY, Benjamin Thomas. 'The Battle of the Glorious First of June, 1794', after R. Cleveley. One of a pair, the companion by T. Medland is on page 253.

Pl. for Bertrand de Moleville's Costume of the Hereditary States of the House of Austria, *1804, fo., e. £10-£30 col.*
Pl. for O. Dalvimart's The Costume of Turkey, *fo., stipple, e. £10-£20 col.*

POPE, Clara Maria
fl. early/mid-19th century
Botanical draughtswoman who executed one rare lithograph herself, although many of her drawings were engraved by professionals.
'Moss Roses in a Chinese Vase', after S. Curtis, 1832, 20½ x 16in/52 x 40.5cm, £400-£600 col.

PORTBURY, Edward J.
1795-1885
Line engraver of small bookplates including figure subjects and portraits after his contemporaries.
Small value.

PORTER, John
fl. mid-19th century
Mezzotint engraver of portraits and genre, and historical and animal subjects after his contemporaries. He worked in London.
'The Chillington Oxen', after L. Beattie, 1838, 15 x 20in/38 x 51cm, £300-£500.
'View of the Interior of the House of Peers During the Trial of Queen Caroline, 1820',

after G. Hayter, with J. Bromley and J.G. Murray, 1832, 22¾ x 34¼in/58 x 87cm, £150-£250.
Larger portraits £15-£60.
Add more if in fine contemporary frame.
Small portraits small value.

PORTER, Sir Robert Ker
1777-1842
Eminent historical painter, who is mentioned here for an early lithograph which he executed in 1803.
'Charge', 2 edn.: 1803 and 1806, 9 x 12¾in/23 x 32.5cm, £100-£200; on original mount £200-£400.
Man Cat.

PORTER, Samuel
fl. early 19th century
Line engraver of architectural outlines after his contemporaries.
Small value.

POSSELWHITE, J.
1798-1884
Line and stipple engraver of portraits after his contemporaries and Old Master painters. Most of his work consists of small bookplates. He died in London.
Small value.

POTT, Constance Mary, R.E.
b.1862
Etcher and aquatint engraver of landscapes and architectural views. She studied at the R.C.A. and was a pupil of F. Short (q.v.), in whose department she subsequently taught etching and printmaking techniques. She lived in London.
London views £40-£90.
Others £20-£50.

POTTER, Charles
b.1904
Aquatint engraver of industrial views.
£30-£70.

POULTER, D.J.
fl. mid-/late 19th century
Painter and etcher of landscapes. He worked in London and contributed plates to *English Etchings.*
Small value.

POUNCY (Pouncey), Benjamin Thomas
d.1799
Watercolourist, etcher and line engraver of landscapes, topographical views and naval and military subjects after his contemporaries. He was taught to engrave by his father Edward and his brother-in-law, W. Woollett (q.v.), whose style he imitated. He became Deputy Librarian at Lambeth where he died.
'The Battle of the Glorious First of June, 1794', after R. Cleveley, 1794, a pair, one by T. Medland (q.v.), 17 x 22½in/43 x 57cm, pair £400-£700.
'The Sortie Made by the Garrison of Gibraltar, 27 Nov. 1781', after A.C. de Poggi, 1792, 24 x 39in/61 x 99cm, £250-£350.
Views of *'Plymouth', 'St. Nicholas Isle', 'Catwater'* and *'The Citadel', after W. Hay, 1780-2, 4 pl., ovals 9¾ x 11in/25 x 28cm, set £150-£300.*
'Athens in its Flourishing State' and 'Athens in its Present State of Ruin', after R. Wilson and R. Willett, 18 x 24in/45.5 x 61cm, pair £500-£900.
Various landscape eng. £50-£150.

POUND, D.J.
fl. mid-19th century
Line engraver of small bookplates including portraits and figure subjects after contemporary painters and photographers.
Small value.

POWELL, John. One of 'Six views on Clapham Common: View from the Nine-Elms', 1825.

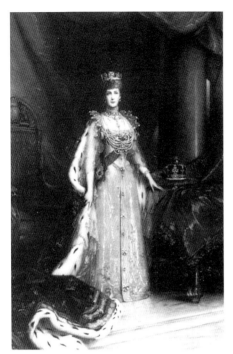

PRATT, Joseph Bishop. 'Queen Alexandra', 1908.

POWELL, Sir Francis, P.R.S.W., R.W.S.
1833-1934
Marine and landscape painter who produced a few etchings. Born in Manchester, where he studied art, he was a member of the Junior Etching Club and contributed to its publications. He died at Dunoon in Scotland.
Small value.

POWELL, John 1780-1834
Painter, etcher and lithographer of landscapes and topographical views. He was a drawing master and first President of the New Watercolour Society
'*Six Views on Clapham Common*', *1825, obl. fo., litho., e. £60-£120, set col. fetched £1,200 April 1995.*
'*Views in Egypt*', *1810, 24 pl., aq. and soft-ground etchings, 20¼ x 26½in/52.5 x 67cm and smaller, etchings, e. £10-£40, set fetched £320 April 1996.*

POWER, Cyril L. b.1872
Architect and important colour linocut artist of figures in movement, particularly being conveyed in modern vehicles, executed in a Futurist style. Born in Kensington, London, he lectured and wrote on architecture before and after World War I. About 1918, he met S. Andrews (q.v.) and they exhibited together in Bury St Edmunds and shared a studio in Hammersmith. In 1925 they helped I. McNab and W.C. Flight (qq.v.) to set up the New Grosvenor School of Modern Art and were taught linocutting by Flight. From 1929 the collaboration of Power and Andrews extended to poster design, primarily for the London Underground. He died in London.
'*The Eight*', *£2,000-£3,000, fetched £2,900 June 1994.*
The Tube Staircase', *18¼ x 11½in/46.5 x 29cm, £1,200-£1,800, fetched £1,700 June 1994.*
'*The Merry Go Round*', *13 x 13in/33 x 33cm, £1,000-£1,600.*
'*The Exam Room*', *11¼ x 16in/30 x 40.5cm,*

£600-£900.
'*The Carcase*', *11 x 9½in/28 x 24cm, £400-£600.*
'*Elmer's Mill*', *8¾ x 12in/22.5 x 30.5cm, monotype, £80-£120.*
Colour plates pages 54 and 55.

POWIS, William Henry 1808-1833
Wood engraver of small bookplates.
Small value.

POWLE, George fl. late 18th century
Miniaturist, etcher and mezzotint engraver of portraits after his own designs and his contemporaries. He was a pupil and follower of T. Worlidge (q.v.).
Etchings small value.
'*Elizabeth Worlidge*', *8¼ x 6¾in/21 x 17cm, mezzo., £8-£20.*
CS lists 1 pl., noted above.

PRANKER, Robert fl. mid-18th century
Line engraver of small bookplates.
Small value.

PRATT, Joseph Bishop 1854-1910
Mezzotint and mixed-method engraver of portraits, landscapes, sporting, sentimental and decorative subjects after his contemporaries and 18th century British painters. Born in London, the son of a mezzotint printer, he was apprenticed to D. Lucas (q.v.).
'*Foxhunting*', *after T. Blinks, 1887, 4 pl., 21½ x 31½in/54.5 x 80cm, set £600-£1,000.*
Other lge. sporting subjects £80-£200.
'*Queen Alexandra*', *1908, £40-£80.*
Other lge. pl. £20-£80.
Add more if in fine contemporary frame.
Pl. for the Library Edition of The Works of Sir Edwin Landseer, *and other small pl., small value.*

PRATT, Stanley Claude 1882-1914
Line and mezzotint engraver of sentimental and occasional sporting subjects after his contemporaries. He was the son of J.B. Pratt (q.v.).
Small value.

PRATTENT, Thomas
fl. late 18th/early 19th century
Topographical draughtsman, line engraver of small bookplates, including portraits, landscapes and topographical views after his own designs and those of his contemporaries. He was also the engraver of the following aquatint:
'*Phenomena, the Celebrated Trotting Mare*', *after J. Barenger, 1813, 20¼ x 25¼in/51.5 x 64cm, £250-£400 col.*
Bookplates small value.

PRESBURY, George fl. mid-19th century
Line engraver of small bookplates including landscapes, topographical views, religious and genre subjects, mainly after his contemporaries.
Small value.

PRESTEL, Catherina Maria 1739-1794
German etcher and aquatint engraver of landscapes, topographical views and rustic scenes after her own designs, those of her contemporaries and Old Master painters. Born at Grunenbach, Bavaria, she was the pupil of and wife of Johann Gottlieb Prestel. After separating from him in 1786, she came to England and practised as an engraver in London until her death. Impressions from her plates are usually found printed in brown or a grey-greenish colour.
'*Mercury Soothing Argus to Sleep*', *after S. Rosa, £80-£140.*
'*A Country Girl in London*' *and* '*A Country Girl at Home*', *after G. Morland, pair £200-£400 col.*
'*A View of the Black-lead Mine in Cumberland*', *after P.J. de Loutherbourg, £250-£400.*
Various landscapes with figures after Dutch and Italian Old Masters, T. Gainsborough, etc., £80-£200.

PRESTON, Thomas
fl. early/mid-18th century
Etcher and mezzotint engraver of portraits. He was apparently in the army and Town Mayor of Gibraltar.
'*Admiral Robert Blake*', *14 x 9½in/35.5 x 24cm,*

PRESTEL, Catherina Maria. 'Mercury Soothing Argus to Sleep', after S. Rosa.

PROUT, Samuel. One of fifty plates from 'Facsimiles of Sketches Made in Flanders and Germany: Munich', c.1830.

mezzo., £15-£40.
'James Nayler, the Quaker', 8 x 6¼in/20.5 x 16cm, mezzo., £10-£30.
'Self portrait', 7½ x 6½in/19 x 16.5cm, etching, £8-£20.
CS lists 3 pl.

PRIEST, Alfred 1810-1850
Norwich School painter and etcher of landscapes and marine subjects after his own designs and those of his contemporaries. Born in Norwich, he was a pupil of H. Ninham and J. Stark (qq.v.). He moved to London in his twenties and lived there until 1848, when he returned to Norwich a sick man.
£8-£20.

PRIOR, Thomas Abiel 1809-1886
Line and occasional mezzotint engraver mainly of landscapes and architectural views after his contemporaries. Born in London, he made his reputation from engraving J.M.W. Turner's painting of Heidelberg Castle, and it is for his engravings after Turner that he is best known. Prior later settled in Calais where he taught drawing in the local schools and where he eventually died.
Lge. pl. after Turner £150-£300.
'Crossing the Bridge', after E. Landseer, 1881, 11½ x 38in/29 x 96.5cm, £150-£300.
Add more if in fine contemporary frame.
Bookplates: American views £5-£10; others small value.

PRISCOTT, T. fl. early 19th century
Etcher, line and stipple engraver of small portraits after his contemporaries and 18th century painters.
'Charles George Dyer, printseller', 10¼ x 7in/26 x 18cm, soft-ground etching, £8-£15.
Others small value.

PRITCHARD fl. early/mid-18th century
Etcher and line engraver.
'A View of his Grace the Duke of Kingston's House at Thoresby with his Grace and Attendants Going a'Setting', after P. Tillemans, 12½ x 17¾in/32 x 45cm, £250-£400.

PROPERT, John Lumsden, R.E. 1834-1902
London physician, connoisseur, etcher and mezzotint engraver of landscapes and architectural views, mainly after his own designs. He contributed plates to *The Etcher* and *The Portfolio*.
Small value.

PROSSER, H. fl. mid-19th century
Lithographer.
'North Camp, Aldershot', 7¾ x 10½in/19.5 x 26.5cm, £20-£40 col.

PROUD, W. fl. mid-18th century
Line engraver of small bookplates and portraits after his contemporaries and Old Master painters.
Small value.

PROUT, John Skinner 1806-1876
Draughtsman and lithographer of landscapes and architectural views. Born in Plymouth, he taught himself to draw. He was the nephew of S. Prout (q.v.) by whom he was influenced. He lived in Bristol most of his life but died in London.
'Antiquities of Chester', c.1840, fo., tt. pl., e. £10-£25.
'Antiquities of York', c.1840, fo., tt. pl., e. £10-£25.
'The Castles and Abbeys of Monmouthshire', 1838, 13½ x 11in/34.5 x 28cm, 29 tt pl., e. £8-£20.

PROUT, Samuel 1783-1852
Famous watercolourist, draughtsman, soft-ground etcher and lithographer of landscapes, marine subjects and architectural views. Early in his career, he etched in soft-ground a series of studies of coastal and shipping scenes. Later, his many Continental sketching tours resulted in his lithographed architectural views. He also produced several drawing books. Many of his drawings were engraved by professionals.
Pl. for drawing books £3-£10 uncol.; £8-£20 col.
'Sketches in France, Switzerland and Italy', 1839, fo., tt. pl.: Swiss views e. £150-£250 col.; others e. £60-£100 col. (set col. fetched £5,200 Dec. 1989).
'Sketches in the Thames Estuary and on the South Coast', 1814, obl. fo., soft-ground

etchings, e. £20-£50.
'Illustrations of the Rhine', 1822-6, 28 pl., fo.,
e. £150-£250 col., set uncol. £300-£500.
'Facsimiles of Sketches Made in Flanders and
Germany', c.1830, 50 pl., fo., set £1,800-
£2,200.

PRYDE, James Ferrier 1866-1941
Painter, designer and lithographer of posters.
Born in Edinburgh, he studied at the R.S.A.
Schools and in Paris. He designed lithographic
posters with his brother-in-law, W. Nicholson
(q.v.), under the name 'J. & W. Beggarstaff'. He
lived in London. Twelve posters under the
Beggarstaff name are recorded, all of which are
rare.
'Rowntree's Elect Cocoa', c.1896, 40¼ x
30in/102 x 76.5cm, and others, £1,000-£10,000,
depending on rarity and condition.

PURCELL, E. fl. early 19th century
Lithographer of sporting and genre subjects,
costumes and caricatures after his
contemporaries.
'Sporting Sketches', after H. Alken, 1824, 16
pl., obl. 4to., e. £30-£70 col.
Pl. for A. Orlowski's Lithographic Costumes of
Russia and Persia, 1821, obl. fo., e. £15-£50 col.
Caricatures £20-£60 col.

PURCELL, Richard (Corbutt, C.)
 fl. 1744-66
Irish mezzotint engraver of portraits, decorative
subjects and caricatures after his
contemporaries and Old Master painters. Born
in Dublin, he studied there under J. Brooks
(q.v.) before coming to London where he led a
dissolute life. It is possible that he used his
pseudonym of 'C. Corbutt' to conceal his
identity as a copyist of other engravers' plates.
Domestic subjects: 'Lady writing', etc., after
P. Mercier, £100-£200.
'The Prodigal Son', after LeClerc, 6 pl., 9¾ x
13¾in/25 x 35cm, set £400-£700 col.
'The Seasons', after R. Pyle, copies of the set by
R. Houston, 12½ x 10in/32 x 25.5cm, set £200-
£300.
'A Flemish Conversation', after Brouwer, £10-£20.
Portraits engraved in Dublin v. rare: 'William
III with Schomberg', after G. Kneller, 1750;
'William III on Horseback', after J. Wyck, 1748,
13¾ x 19in/35 x 48cm, e. £300-£400.
Other Dublin portraits £80-£200.
WL female portraits £80-£200.
Various HLs £10-£40.
CS

PURSER, ?T. or ?W. fl. mid-19th century
Lithographer.
Pl. for Illustrations to Prinsep's Journal of a
Voyage from Calcutta to Van Diemen's Land,
1833, 4to., e. £5-£15.

PYALL, Charlotte b.1800
Aquatint engraver of sporting subjects after her
contemporaries. She was the wife of H. Pyall
(q.v.) and lived with him in Southwark, London.
'Ascot Races', after J. Pollard, 1834, 18 x
26½in/45.5 x 67.5cm, £900-£1,400 col.

PYALL, Henry 1795-1833
Aquatint engraver of sporting, coaching and
railway subjects and topographical views after
his contemporaries. He lived and worked in
London and ran a publishing firm with G. Hunt
(q.v.).
'London and Bath New Steam Carriage', after
G. Morton, 11¼ x 15¾in/28.5 x 40cm, £600-

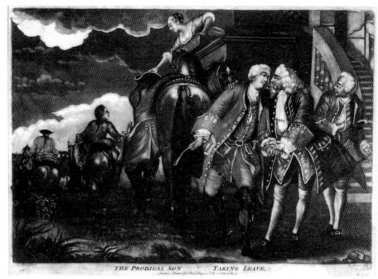

PURCELL,
Richard. One
of six plates
from 'The
Prodigal Son:
Taking Leave',
after LeClerc.

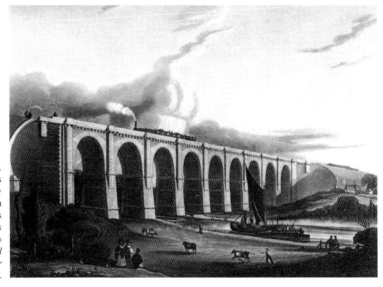

PYALL, Henry.
'Viaduct across
the Sankey
Valley', from
T.T. Bury's
Coloured Views
on the
Liverpool and
Manchester
Railway, 1833.

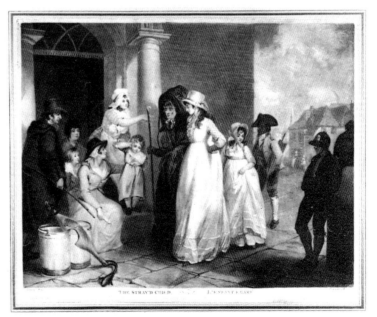

PYM, B. 'The
Stray'd Child',
pair with 'The
Stray'd Child
Restored', by
J. Young, both
after J. Ward,
1798.

£900 col.
'Shooting', after G. Jones, 1825, 2 pl., 8½ x 11in/21.5 x 28cm, pair £250-£400 col.
'Fishing', after G. Jones, 1831-3, 4 pl., 5¼ x 11½in/13 x 29cm, set £300-£500 col.
'Bessie Bedlam', after J.F. Herring, 1828, 12¼ x 17¼in/31 x 44cm, £300-£500 col.
'A North East View of the New General Post Office', after J. Pollard, 1832, 14¼ x 22¾in/37.5 x 58cm, £800-£1,400 col.
'Mail Coach Behind Time' and 'Stage Wagon', after H. Walter, 1827, 17 x 20½in/43 x 52.5cm, pair £600-£1,000 col.
'Battle of Navarin', after J.T. Lee, 2 pl. with R. Smart (q.v.), 21¼ x 24¾in/54 x 63cm, pair £1,200-£1,800 uncol.; £2,000-£3,000 col.
Pl. for The Cambrian Mountains, *after various artists, 1851, fo., e. £5-£10 col.*
Pl. for Lieut. J. Moore's Rangoon Views and Combined Operations in the Birman Empire, *1825-6, fo., e. £80-£160 col.*
Pl. for T.T. Bury's Coloured Views on the Liverpool and Manchester Railway, *1833, 4to., e. £100-£200 col.*

PYE, Charles 1777-1864
Line engraver of small bookplates including portraits and figure subjects after his contemporaries and Old Master painters. He

was the brother of J. Pye II (q.v.). He died in Leamington.
Small value.

PYE, John I b.1746
Line engraver of landscapes and topographical views after his contemporaries and 17th century painters. He entered the R.A. Schools in 1777.
Lge. pl. £50-£150.
Small bookplates small value.

PYE, John II 1782-1874
Line engraver of landscapes and topographical views after his contemporaries. Born in Birmingham, he came to London in 1801 and became J. Heath's (q.v.) assistant. He is best known for his engravings after J.M.W. Turner's works. He died in London.
'High Street, Oxford', after J.M.W. Turner, 1812, 20 x 28in/51 x 71cm, and other lge. pl. after Turner £150-£300.
Add more if in fine contemporary frame.
Bookplates after Turner, if proofs or early imp., £20-£60, later imp small value.
Small bookplates and pl. for the Annuals small value.

PYM, B. fl. late 18th/early 19th century
Mezzotint engraver of decorative subjects and

portraits after his contemporaries. It appears that he worked in London and was also a miniaturist.
'The Gypsy Boy', after J. Reynolds, 1799, 15 x 12in/38 x 30.5cm, £20-£50.
'The Stray'd Child' and 'The Stray'd Child Restored', both after J. Ward, latter by J. Young (q.v.), 1798, 19 x 24in/48.5 x 61cm, pair £500-£800 prd. in col.
'Erasmus Darwin', after S.J. Arnold, 1801, 12¼ x 10¼in/32.5 x 27.5cm, £15-£40.
'Henry James Pye', after S.J. Arnold, 1801, 13 x 10¼in/33 x 27.5cm, £10-£15.

PYNE, William Henry 1769-1843
London landscape painter, art critic, publisher, draughtsman and etcher of figure subjects, costumes and landscapes. His best known engraved work is 'Microcosm', which he worked on from 1802 to 1807 and which was intended as a guide to drawing figures in landscape. He spent most of his last years in the King's Bench Debtors' Prison.
'Microcosm', 120 etchings aq. by J. Hill (q.v.), 1808, obl. fo., e. small value; vol. £500-£700.
'Costume of Great Britain', 1819-20, fo., etchings with aq., e. £10-£30 col.
Etchings of rustic figures, 1815, 60 pl., small 4to., e. small value.

QUENTERY, Charles C. fl. mid-19th century
Aquatint engraver of sporting subjects after his contemporaries. He assisted J. Harris III (q.v.) on several of his plates but appears to have engraved none of his own.
'Foxhunting', after J.F. Herring, 1854, 4 pl., 17½ x 30¾in/44.5 x 78cm, set £1,200-£1,800 col.
'Fores's National Sports: Racing', after J.F. Herring, with J. Harris III (q.v.), 1856, 4 pl., 24 x 44½ in/61 x 113cm, set £2,600-£4,000 col.
'Saucebox' (racehorse), 1856, 24 x 30in/61 x 76cm, £300-£500 col.

QUILLEY, John P. fl. mid-19th century
Line and mezzotint engraver of portraits, landscapes and figure subjects after his contemporaries. He worked in London.
'Departure of the Israelites from Egypt', after D. Roberts, 1832, 23½ x 31½in/60 x 80cm, fetched £450 June 1996.
'Robert Lindley, Violin Player', after W. Davison, 17½ x 13¾in/44.5 x 35cm, £60-£140.
'Thomas Assheton Smith', after W. Beechey, with S.W. Reynolds, 17¼ x 13¾in/44 x 35cm, £20-£50.
'R.P. Bonington', after M. Carpenter, 1831, 8½ x 7in/21.5 x 18cm, £15-£30.

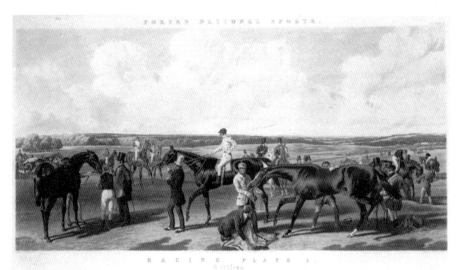

QUENTERY, Charles C. One of four plates from 'Fores's National Sports: Racing. Plate 1 Saddling', after J.F. Herring, with J. Harris III, 1856.

RADCLIFF fl. early 19th century
Line engraver of small bookplates.
Small value.

RADCLYFFE, Charles Walter 1817-1903
Landscape painter, draughtsman and lithographer of architectural views. Born in Birmingham, where he lived and worked, he was the son of W. Radclyffe and the brother of E. Radclyffe (qq.v.). He is best known for his Public School views.
'Views in Birmingham and Its Vicinity', c.1840, 8 pl., fo., e. £50-£100 col.
'Picturesque Antiquities in the County of Hereford', c.1845, fo., 32 tt. pl., e. £5-£15.
Views of public schools, 1843-6, fo., tt. pl., e. £30-£50 col.

RADCLYFFE, Edward 1810-1863
Etcher and line and mezzotint engraver of landscapes, topographical views and figure subjects after his contemporaries. The son and pupil of W. Radclyffe and the brother of C.W. Radclyffe (qq.v.), he was born in Birmingham and went to London c.1830 to work as an engraver.
'An Incident in the Life of Burns', after J. Absolon, 1850, 17 x 23in/43 x 58.5cm, mezzo., and other lge. mezzo £40-£100.
Add more if in fine contemporary frame.
Small mezzo. £8-£20.
American views £5-£10.
Others small value.

RAVERAT, Gwendolen Mary. 'London Snow'.

RAIMBACH, Abraham. 'The Rent Day', after D. Wilkie, 1817.

RADCLYFFE, William 1783-1855
Line engraver mainly of landscapes and topographical views after his contemporaries. Born in Birmingham, he went to drawing school there and was apprenticed to a writing engraver. He lived and worked in the city where he later founded the Academy of Arts. He was the father of C.W. Radclyffe and E. Radclyffe (qq.v.).
'The Durham Cow', after R. Lawrence, 1812, 13 x 18in/33 x 45.5cm, £150-£250.
Others small value.

RADDON, William fl. early/mid-19th century
Line engraver of portraits and genre subjects after his contemporaries and Old Master painters. He worked in London, mainly as an engraver of bookplates.
'Thomas Telford, Civil Engineer', after S. Lane, 1831, 13¼ x 10¼in/33.5 x 27.5cm, £15-£40.
Small portraits and bookplates small value.

RAIMBACH, Abraham 1766-1843
Line engraver of genre, sentimental and historical subjects after his contemporaries. Born in London, of a Swiss father, he was apprenticed to J. Hall (q.v.) and studied at the R.A. Schools. He is best known for his large plates after D. Wilkie (q.v.), though he also engraved many bookplates. He died in Greenwich.
Lge. pl. after D. Wilkie, e.g. 'The Rent Day', 1817, and 'Blind Man's Buff', 1822, approx. 16½ x 24½in/42 x 62cm, £40-£120.
Add more if in fine contemporary frame.
Bookplates small value.

RAINGER, W.A. fl. mid-19th century
Mezzotint engraver of portraits after Joshua Reynolds.
Small value.

RAJON, Paul Adolphe d.1888
French painter, etcher and lithographer of portraits and sentimental subjects after his contemporaries, British 18th century and Old Master painters and his own designs. He came to England and worked in London for a few

years after the Franco-Prussian War, 1870-1. He contributed several plates to *The Portfolio*.
Portrait of J.A.M. Whistler, litho., £80-£160.
Others small value.

RAMAGE fl. mid-19th century
Lithographer of portraits, military subjects, etc.
'Rifle Volunteer Brigade', c.1860, 10 x 7in/25.5 x 18cm, £15-£30.
Others small value.

RANSON, Thomas Frazer 1784-1828
Line engraver of portraits and bookplates after his contemporaries and his own designs. He was born in Sunderland and was apprenticed to an engraver in Newcastle.
Small value.

RAVENET, Simon François 1706-1774
French etcher and line engraver of portraits, caricatures, landscapes, genre and animal subjects after his contemporaries. Born in Paris, he was a pupil of J.P. LeBas and was brought to England apparently by W. Hogarth (q.v.) to engrave Plates 4 and 5 of his 'Marriage-à-la-Mode'. He settled in London c.1750.
Views of the Lake District, after W. Bellers, 15¼ x 21¼in/40 x 54cm, e. £150-£250.
Other lge. landscapes £50-£150.
Studies of horses, after P. Tillemans, 1753, 8 pl., 5¼ x 7in/13.5 x 18cm, e. £30-£70.
'Charles, Earl Camden', after J. Reynolds, 1766, 18 x 13½in/45.5 x 34.5cm, £8-£16.
'Garrick and Mrs. Bellamy as Romeo and Juliet', after B. Wilson, 1765, 15½ x 20½in/39.5 x 52cm, £80-£160.
Small portraits and bookplates small value.

RAVENHILL fl. late 18th/early 19th century
Line engraver of bookplates, including architectural views, antiquities, etc.
Small value.

RAVERAT, Gwendolen Mary, R.E.
1885-1957
Wood engraver of landscapes and figure subjects. The daughter of Sir George Darwin,

RAVILIOUS, Eric William. One of ten plates from 'Submariners'.

Professor of Astronomy at Cambridge, she studied at the Slade. She lived in London and later in Cambridge and illustrated several books as well as engraving separate plates.
£150-£400.

RAVILIOUS, Eric William 1903-1942
Painter, designer, book illustrator, wood engraver and lithographer of landscapes and figure subjects. Born in London, he studied at Eastbourne School of Art and at the R.C.A. He was an Official War Artist during World War II

and went missing, presumed dead, on an aeroplane patrol in 1942.
'Submariners', 10 pl., 10¾ x 12½in/27.5 x 32cm, litho., e.pl. £600-£1,400 in col.
Litho. posters e. £300-£600.
Wood eng. e. £60-£200.
'High Street' book with 23 lithos, 22 in cols., 1938, £400-£600.

RAWLE, Samuel 1771-1860
Painter, etcher and line engraver of landscapes, topographical views, naval subjects and

portraits after his contemporaries and his own designs. Born in Somerset, he was apprenticed to T. Bonnor (q.v.) and settled in London where he died. Most of his work consists of bookplates.
Pl. for J. Jenkins' Naval Achievements, *after T. Whitcombe, etched by S.R., aq. by various eng., 1817, 4to., e. £50-£80 col.*
'Panorama of Rome', c.1840, 17¼ x 141in/44 x 358cm, aq., £600-£1,200 col.
'View of Grand Cairo', after H. Salt, etched by S.R., aq. by D. Havell (q.v.), fo., £200-£400 col.
Small bookplates and portraits small value.

RAWLINS, J. Thomas fl. mid-19th century
Draughtsman, etcher and occasional lithographer of sporting subjects after his contemporaries.
Pl. for Nimrod's Memoirs of the Late John Mytton, *after H. Alken, aq. by E. Duncan (q.v.), 1837, 4to., e. £8-£15 col.*
'The Cadets' Races, Royal Military College, Sandhurst', after Lieut. Petley, 1837, 11½ x 16½in/29 x 42cm, litho., £50-£150 col.

RAY-JONES, R fl. early/mid 20th century
Etcher of portraits and figure subjects.
£30-£70.

READ, Arthur Rigden b.1879
Wood engraver of landscapes, genre and figure subjects. Born in London, he lived in Winchelsea, Sussex.
£10-£30.

READ, David Charles 1790-1851
Drawing master, draughtsman and etcher of landscapes and portraits mainly after his own designs. Born in Hampshire, he was apprenticed to J. Scott (q.v.). He lived and worked at Salisbury for most of his life after 1820, publishing four series of prints in 1828, 1832, 1840 and 1845. His etchings were influenced by those of Rembrandt.
£10-£30.

READ, Richard fl. late 18th century
Stipple and mezzotint engraver of portraits and decorative, religious and historical subjects after his contemporaries and Old Master painters. He was born in London and died there. He was a pupil of J. Caldwall (q.v.).
'Hope Nursing Love in the Forest of Arcadia', after R. Cosway, stipple, £80-£160 prd. in sepia or in col.
'Anne Cargill', after J. Russell, 1778, 7¼ x 5¾in/18.5 x 14.5cm, stipple, £10-£25.
'Love Vanquished', after W. Beechey, stipple, £200-£400 prd. in col.
Add more if in fine contemporary frame.
'Rev. J. Herries', after D. Martin, 1776, 13 x 10¾in/33 x 27.5cm, mezzo., £15-£30.
'Dutch Lady', after Rembrandt, 1776, 10½ x 8in/26.5 x 20.5cm, mezzo., £8-£15.
CS lists the 2 mezzo. noted above.

READ, W. fl. mid-19th century
Line and stipple engraver of portraits, landscapes and topographical views after his contemporaries. His work consists mostly of small bookplates.
Small value.

READING, Burnet c.1757-1820 or later
Stipple engraver of portraits and decorative subjects after his contemporaries. He came from Colchester and worked in London. Most of his work consists of small bookplates.

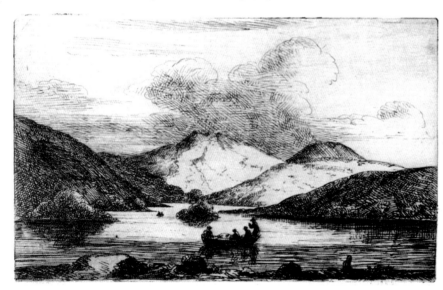

READ, David Charles. A typical landscape.

Portraits of American Statesman and Members of Congress, 13 pl. after P. E. du Simitiere, 1783, 6½ x 5½in/16.5 x 14.5cm, e. £100-£200. Small bookplates small value.

RECORD, James c.1746-1794 or later
Line engraver of small bookplates and portraits after his contemporaries and Old Master painters.
Small value.

REDAWAY, James C.
 fl. early/mid-19th century
Line and aquatint engraver of small bookplates including landscapes, topographical views and military subjects after his contemporaries.
Cavalry prints, after W. Heath, 1819, 4¾ x 6½in/12 x 16.5cm, aq., e. £10-£20 col.
Others small value.

REDGRAVE, Richard, R.A. 1804-1888
London history and genre painter, etcher of landscapes and rustic scenes with figures. He was a founder of and contributor to the Etching Club.
£10-£30.

READ, Richard. 'Hope Nursing Love in the Forest of Arcadia', after R. Cosway, stipple.

REEVE, Augustus William b.1807
Aquatint engraver of sporting, marine and military subjects after his contemporaries. Born in London, he was the son, and probably the pupil, of R. Reeve, and the brother of R.G. Reeve (qq.v.) with whom he engraved most of his plates.
'The Great Western', after J. Walter, with R.G.R., 1840, 21¾ x 29in/55.5 x 73.5cm, £500-£700 col.
'Bombardment of St. Jean d'Acre', after Lieut. J.F. Warre, with R.G.R., 1841, 2 pl., 16¼ x 25½in/41.5 x 65cm, pair £400-£600 col.
1 pl. for 'The Last Grand Steeplechase at the Hippodrome, Kensington', with R.G.R., after S.H. Alken, 15½ x 22in/ 39.5 x 56cm, set £1,600-£2,600 col.
Pl. for L. Rawstorne's Gamonia or the Art of Preserving Game, 1837, 8vo., e. £10-£20 col.

REEVE, Richard 1780-c.1835
Aquatint engraver of sporting subjects after his

contemporaries. He studied at the R.A. Schools and lived and worked in London. He was the father of R.G. Reeve and A.W. Reeve (qq.v.). Some of the later plates signed 'R.' or 'Richard Reeve' may be by father or son.
'Fox Hunting', after D. Wolstenholme, 1806, 4 pl., 16½ x 20½in/142 x 52cm, set £1,400- £2,200 col.
'Stag Hunting', after D. Wolstenholme, 1808, 4 pl., 11 x 13in/28 x 33cm, set £800-£1,200 col.
'Coursing', after D. Wolstenholme, 4 pl., set £1,000-£1,600 col.
'Locomotive Engine and Train of the Birmingham and Liverpool Railroad', after S. Bourne, with R.W. Smart (q.v.), 1825, 8 x 24½in/20 x 62.5cm, £300-£450 col.
'A Sporting Tandem Going to Cover', and 'A Sporting Tandem at Cover', after H. Alken, 1825, 8¾ x 13in/22.5 x 33cm, pair £300-£500 col.
Pl. for W.H. Pyne's Royal Residences, 1819, 4to, e. £20-£50 col.
Colour plate page 56.

REEVE, Richard Gilson 1803-1889
Aquatint engraver of sporting, coaching and naval subjects, landscapes and topographical views after his contemporaries. Born in London, he was the son, and probably the pupil of, R. Reeve, and the brother of A.W. Reeve (qq.v.).
'Fox Hunting', after H. Alken, 1835, 4 pl., 10½ x 14½in/26.5 x 37cm, set £1,000-£1,500 col.
'One Mile from Gretna' and 'A False Alarm on the Road to Gretna', after C.B. Newhouse, 13¼ x 16¾in/33.5 x 42.5cm, pair £400-£700 col.; reprints, pair £100-£150.
'The Chase of the Roebuck' and 'The Death of the Roebuck', after W.P. Hodges, 1834, 12¾ x 20¼in/32.5 x 51.5cm, pair £400-£700 col.
'The Shooting Season', after R.B. Davis, 1836, 6 pl., 14 x 17½in/35.5 x 44.5cm, set £1,800-

REDGRAVE, Richard. One of the artist's contributions to the Etching Club.

£2,600 col.
'Ascot Heath Races', after F.C. Turner, 1837, 17¼ x 25¾in/44 x 65.5cm, £800-£1,200 col.
'Procession of King George IV to Ascot Heath Races', after J. Pollard, 10 x 39½in/25.5 x 100.5cm, £1,000-£1,600 col.
'Shooting', after H. Alken, 1813, 4 pl., 16¼ x 20in/41 x 50.5cm, set £1,500-£2,000 col.
'The Royal Mail's Departure from The General Post Office (by day)', after J. Pollard, 1830, 16¾ x 24in/42.5 x 61cm, £800-£1,400 col.
'Cattle Market, Smithfield', after J. Pollard, 1831, 18 x 27¼in/6 x 69cm, £1,000-£1,600 col.
'The Adventures of Knutsford Race Course' (apparently eng. when he was 12 years old,

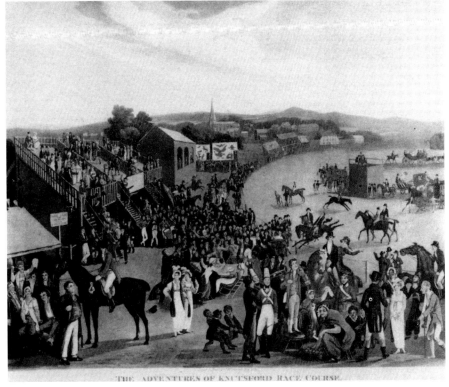

REEVE, Richard Gilson. 'The Adventures of Knutsford Race Course', after E. Hazelhurst, 1815.

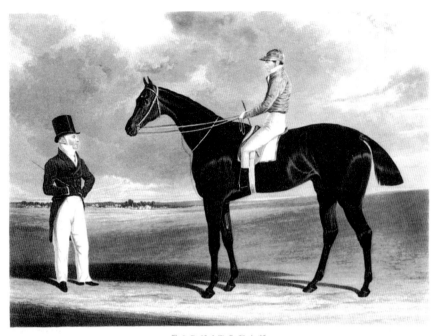

REEVE, Richard Gilson. 'Birmingham, the Winner of the Great St. Leger Stakes at Doncaster, 1830', after J.F. Herring, 1831.

perhaps by his father), after E. Hazlehurst, 1815, 24½ x 28½in/62.5 x 72.5cm, £1,000-£1,500 col.
Fishing subjects, after J. Pollard, 2 pairs, 1831 and 1833, 13½ x 17½in/34.5 x 44.5cm, e. pair £1,200-£1,800 col.
'Tarrare, Winner of the St. Leger, 1826', after J.F. Herring, 15¼ x 20½in/40 x 52cm, and other racehorse portraits of similar size, £400-£800 col.
'The Great Western', after J. Walter, with A.W.R., 1840, 21¼ x 29in/55.5 x 73.5cm, £500-£700 col.
'Bombardment of St. Jean d'Acre', after Lieut. J.F. Warre, with A.W.R., 1841, 2 pl., 16¼ x 25½in/41.5 x 65cm, pair £400-£600 col.
'Scenes on the Road', after C.B. Newhouse, 1834, 18 pl., 10½ x 14½in/27 x 37cm, e. £80-£140 col.
'West View of Syston Park', after T. Kearman, 14½ x 25½in/37 x 64.5cm, £150-£250 col.
'The Battle of Waterloo', after W. Heath, 1817, 18¼ x 23½in/47.5 x 59.5cm, £300-£400 col.
Pl. for J. Johnson's Views in the West Indies, *1827-9, obl. fo., e. £400-£600 col.*
Pl. for Ackermann's Oxford, *1814,* Cambridge, *and W.H. Pyne's* Royal Residences, *1819, all 4to., e. £20-£60 col.*
Pl. for Capt. R.M. Grindlay's Scenery . . . of India, *1826-30, 40., e. £40-£90 col.*
Pl. for D. Cox's Drawing Books, *fo., e. £10-£20.*
Colour plate page 56.

REINAGLE, George Philip 1802-1835
London painter and lithographer of marine subjects and topographical views. He was the son of the painter R.R. Reinagle
'Napier's Defeat of the Miguelite Squadron, July 5, 1833' (at which G.P.R. was present), 3 pl., 13 x 22in/33 x 56cm, set £250-£450.
'H.M. Brig. Black-Joke . . . engaging the

Spanish Slave Brig. Maranerito . . . , 1831', 15 x 19in/38 x 48cm, £200-£300 col.
12 views of Tenby, 1832, fo., e. £10-£20.
Pl. for Illustrations to Prinsep's Journal of a Voyage from Calcutta to Van Diemen's Land, *1833, 4to., e. £5-£15.*

REINAGLE, Philip, A.R.A. 1749-1833
Portrait, animal and landscape painter who engraved one mezzotint portrait of Thomas Pinto, the violinist.
'Thomas Pinto', 1777, 13¼ x 9⅞in/35 x 25cm, £30-£80.
CS lists 1 pl., noted above.

RENISON, William fl. 1920s
Painter and drypoint etcher of landscapes and architectural views. Born in Glasgow, he lived in London.
£15-£40.

RENOLDSON, M. fl. mid-/late 18th century
Line engraver of bookplates.
Small value.

RENTON, B. J. fl. early 19th century
Lithographer, about whom nothing is known except that he was an early exponent of the medium.
'Holy Family Resting on the Flight'; 'Country Cottage with Labourer', 1809, 8½ x 12¼in/21.5 x 31cm, £30-£80.
Man Cat.

REYNOLDS, George fl. mid-19th century
Guernsey draughtsman and lithographer.
'Laying the First Stone of the New Harbour, Saint Peter Port, Guernsey, on the 24th Aug...1853', 21½ x 31½in/54.5 x 80cm, £300-£500 col.

REYNOLDS, Samuel William I 1773-1835
Landscape painter, well-known mezzotint engraver and etcher of portraits, animals, historical, sporting and decorative subjects, landscapes and topographical views after his contemporaries and Old Master painters. Born in London, he studied at the R.A. Schools where he was a pupil of W. Hodges and J.R. Smith (qq.v.). He was not related to Sir Joshua

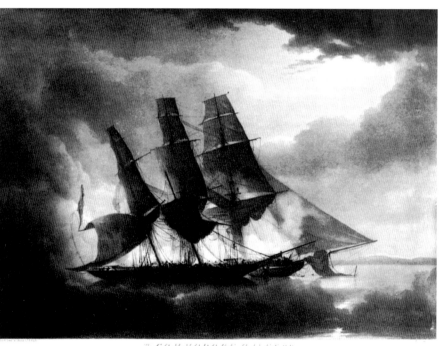

REINAGLE, George Philip. 'H.M. Brig. *Black-Joke*...engaging the Spanish Slave Brig. *Maranerito*....1831'.

REYNOLDS, Samuel William I. 'Henry Gally Knight', after H. Edridge.

REYNOLDS, Samuel William I. 'The Relief of Prince Adolphus and Field Marshal Freytag', after M. Brown, 1794.

Reynolds, although he engraved numerous plates after that artist, including the series of 357 small mezzotints issued in four volumes between 1820 and 1826. He lived and worked in London, with extended stays in Paris, and died in Bayswater. He was the father of S.W. Reynolds II (q.v.) and taught him to engrave as well as teaching S. Cousins, D. Lucas and G. Maile (qq.v.).
'John Goldham, Field Adjutant of the London Volunteer Cavalry Executing the Six Divisions of the Austrian Broad Sword Exercise at Speed', after D. Wolstenholme, 1806, 16¾ x 23½in/42.5 x 59.5cm, £200-£400.
'The Relief of Prince Adolphus and Field Marshal Freytag', after M. Brown, 1794, 19 x 23¾in/48.5 x 60.5cm, £200-£400 prd. in col.
'Lord Glammis and Staghounds', after D. Wolstenholme, 1823, 23 x 31in/58.5 x 79cm, £300-£600.
'Lion and Snake', after J. Northcote, 1799, 19 x 23¾in/48.5 x 60.5cm, £1,000-£1,600, fine imp. prd. in col. fetched £4,000 April 1990.
'Setters', after G. Morland, 1799, 12¼ x 14¼in/32.5 x 37.5cm, £150-£300.
'Paying the Hostler', after G. Morland, 1805, 19 x 23¾in/48 x 60.5cm, £500-£700 prd. in col.
'Sir Henry Russell, Chief Justice of Bengal', after G. Chinnery, 24¼ x 17¾in/61.5 x 45cm, £60-£90.
'Henry Gally Knight', after H Edridge, £80-£100.
'The Marchioness of Exeter', WL, after T. Lawrence, 24½ x 18in/62 x 45.5cm, and other ladies and actors of similar size, £80-£200.
Male WLs and TQLs of similar size £40-£100.
Various HLs £10-£30.
'Rembrandt's Mill, after Rembrandt, 1822, 17¾ x 21½in/45 x 54.5cm, £15-£25.
'Battle of Navarino', after C. Langlois, with Sixdeniers, 21 x 31in/53.5 x 78.5cm, £600-£1,000.
'Wreck of the Medusa', after T. Géricault, 21½ x 31in/54.5 x 78.5cm, £400-£600.
Pl. for J.M.W. Turner's Liber Studiorum *£80-£200.*

Other bookplates after J.M.W. Turner and T. Girtin e. £15-£40.
Other bookplates and small portraits small value.
Bibl: Whitman, A., *S.W.R.*, George Bell & Sons, London, 1903.

REYNOLDS, Samuel William II 1794-1872
Portrait painter, etcher and mezzotint and stipple engraver of portraits and historical, sporting and decorative subjects after his contemporaries. He was the son and pupil of S.W. Reynolds I (q.v.), and originally worked as a painter before assisting his father when he became ill. He lived and worked in London and died in Sussex.
'The Waterloo Coursing Meeting', after R. Ansdell, 1842, 19 x 40in/48.5 x 101.5cm, £300-£500.
'The County Meeting of the Royal Agricultural Society', after R. Ansdell, 19 x 40in/48.5 x 101.5cm, £250-£400.
'The Acquittal of the Seven Bishops, A.D. 1688', after J.R. Herbert, 1849, 21 x 33in/53.5 x 84cm, £20-£40.
Larger portraits, £10-£25.
Add more if in fine contemporary frame.
Small portraits and bookplates small value.
Bibl: Whitman, A., *S.W.R.*, George Bell & Sons, London, 1903, pp.125-145.

REYNOLDS, Warwick, R.S.W. 1880-1926
Illustrator, draughtsman and occasional etcher of animal subjects. Born in Islington, he studied at the St. John's Wood Art School and in Paris. He made many drawings of animals at London Zoo. He lived in Glasgow.
£15-£40

RHEAD, George Wooliscroft, R.E.
1855-1920
London painter and etcher of genre and classical subjects and topographical views after his contemporaries and his own designs. He studied under A. Legros (q.v.) and Ford Madox Brown and contributed several plates

to *The Portfolio.*
Views of Eton and Cambridge colleges £30-£80.
Others £8-£20.

RHODES, Marion, R.E. b.1907
Painter, etcher and aquatint engraver of landscapes and architectural views. Born in Huddersfield, she studied at the Art School there, at Leeds College of Art and at the Central School of Arts and Crafts under W.P. Robins (q.v.). She lived in London.
£20-£50.

RHODES, Richard 1765-1838
Line engraver of small bookplates including portraits, antiquities, etc. He worked for C. Heath (q.v.) for many years.
Small value.

RICHARDS, B. fl. mid-/late 18th century
Mezzotint engraver of portraits after his contemporaries and Old Master painters.
'Mary, Countess of Portmore' and 'Frederick, Earl of Carlisle', both after J. Reynolds, 5¼ x 4¼in/13.5 x 11cm, e. £5-£15.
CS

RICHARDS, Frederick Charles, R.E.
1887-1932
Etcher of architectural views. Born at Newport, Monmouthshire, he studied at the R.C.A. and lived in London where he died.
£30-£80.

RICHARDSON, Charles fl. mid-19th century
Line engraver of small bookplates including landscapes and topographical views after his contemporaries.
Small value.

RICHARDSON, Charles James 1806-1871
Architect, draughtsman and lithographer of architectural views and designs. He was a pupil of Sir John Soane and died in London.
Small value.

RICHMOND, George. 'The Good Shepherd', 1827-9.

RICHMOND, George. 'The Fatal Bellman', 1827.

RICHARDSON, George
fl. late 18th/early19th century
Draughtsman and aquatint engraver of architectural designs. He worked for the Adam brothers for a time and published several books of architectural designs. He died in London.
Small value.

RICHARDSON, George K.
fl. mid-/late19th century
Line engraver of small bookplates including landscapes and topographical views after his contemporaries.
American views £5-£10.
Others small value.

RICHARDSON, J.
fl. mid-18th century
Etcher of small portraits and bookplates mainly after his contemporaries.
Small value.

RICHARDSON, Jonathan
c.1665-1745
Portrait painter and writer on art who etched a few plates including portraits of himself and others, copies of classical statues, Old Master paintings, etc.
Self portraits £20-£60.
Others small value.

RICHARDSON, Thomas Miles I 1784-1848
RICHARDSON, Thomas Miles II, R.W.S.
1813-1890
Father and son, both natives of Newcastle and both landscape and topographical draughtsmen and watercolourists. They collaborated to draw and lithograph 'Sketches at Shotley Bridge Spa'.
'Sketches at Shotley Bridge Spa', 1839, fo., 7 tt. pl., e. £15-£30.
Views of Newcastle, after and etched by T.M.R. I, aq. by D. Havell and T. Sutherland (qq.v.), 1819, 10 pl., set £1,500-£3,000 col.

RICHARDSON, William fl. mid-19th century
Line engraver of landscapes and architectural views after his contemporaries. He appears to have been a native of Edinburgh.
'Edinburgh Old and New', after D.O. Hill, 1854, 17¼ x 28½in/44 x 72.5cm, £150-£300.
'Glasgow from the Necropolis', after J.A. Houston, 1850, 14½ x 24in/37 x 61cm, £150-£300.
'Windsor Castle from the North West (Summer Evening)', after D.O. Hill, 17½ x 28in/44.5 x 71cm, £100-£200.
Add more if in fine contemporary frame.
Small bookplates and pl. for the Annuals small value.

RICHMOND, George, R.A.
1809-1896
Eminent Victorian portrait painter who produced two line engravings very early in his career. He was a follower of W. Blake (q.v.) in the 1820s and was one of a group of artists who called themselves the 'Ancients'. His prints show the influence both of Blake and also of the latter's collection of early German and Italian masters.
'The Good Shepherd', 1827-9, 6¾ x 4½in/17.5 x 11.5cm, £3,000-£5,000.
'The Fatal Bellman', 1827, 2¾ x 1¾in/7 x 4.5cm, £2,000-£3,500.

RICHTER, H.C. *see* GOULD, J.

RICHTER, Henry James. 'The Wild Rose', pair with 'The Garden Rose', 1799.

RICHTER, Henry James
1772-1857
Figure painter, draughtsman and stipple and aquatint engraver of decorative subjects and portraits. Born in London, he was a pupil of T. Stothard (q.v.) and studied at the R.A. Schools. He died in London.
'The Poor Soldier and the Rich Farmer', after Lady Bedingfield, 1802, 17¼ x 19½in/45 x 50cm, aq., £100-£200 col.
'The Garden Rose' and 'The Wild Rose', 1799, 16¼ x 12¼in/41.5 x 32.5cm, pair £200-£400 prd. in col.
'Illustrations to Cinderella', 8 x 10in/20.5 x 25.5, £30-£60 prd. in col.
'George III, Prince of Wales, etc., at a Review of Volunteers', 1806, 10¼ x 19½in/26 x 49.5cm, £30-£60.
Small portraits small value.

RICKARDS, T. fl. early 19th century
Draughtsman and aquatint engraver.
Pl. for J. Baker's Home Beauties, *1803, small 4to., small value.*

RICKETTS, Charles, R.A. 1866-1931
Painter, writer on art, designer and publisher of fine books, draughtsman and wood engraver of figure subjects. Born in Geneva, he came to London and studied at the City and Guilds Art School in Kennington where he befriended C.H. Shannon (q.v.). They collaborated on an edition of *Daphnis and Chloe*, 1893, with illustrations drawn by Ricketts and engraved on wood by Shannon. They also produced *The Dial*, a periodical which appeared at intervals between 1889 and 1897, and together founded the Vale Press, 1896-1904. Most of Ricketts' wood engravings were illustrations for his books. He lived in London.
'Dynasts', signed by the novelist Thomas Hardy, 23½ x 18½in/60 x 47cm, litho., £200-£300.
Wood eng. £20-£60.

RIDER, William fl. early/mid-19th century
Landscape painter, draughtsman and lithographer of topographical views. He lived and worked in Leamington.
6 views of Warwick and Kenilworth Castles and of Guy's Cliff, 1824, fo., e. £15-£25.

RIDGWAY, William fl. mid-/late 19th century
Line engraver of small bookplates and plates for the Annuals, including figure subjects after his contemporaries. He worked in London.
Small value.

RIDLEY, H. fl. mid-/late 19th century
Etcher and aquatint engraver of military costume plates.
Pl. for The Gentleman's Magazine of Fashions, *1828-94, 7¼ x 5¼in/18.5 x 13.5cm, e. £8-£15.*

RIDLEY, Matthew White 1837-1888
Painter of portraits, landscapes and genre subjects, etcher of landscapes and shipping subjects. Born in Newcastle upon Tyne, he studied at the R.A. Schools. He contributed plates to *The Portfolio* and *The Etcher*.
£5-£10.

RIDLEY, William 1766-1838
Stipple and line engraver of small bookplates including religious subjects and portraits after his contemporaries and Old Master painters.
Small value.

RIGAUD, Jacques 1681-1754
French draughtsman, etcher and line engraver mainly of landscapes and topographical views. He visited England in 1736 and drew and engraved views of four palaces: Greenwich, St. James's, Hampton Court and Richmond. He also drew views of gardens, most importantly Stowe; according to Vertue, he had not finished engraving the set of 16 pl. before he left England, and B. Baron (q.v.), who had only done 3 pl., put his name on all of them.
London palaces e. £50-£150
'The Representations . . . in the Siege of a Place', 1752, 6 pl., 10½ x 17¼in/26.5 x 44cm, set £140-£200.

RITCHIE, Alexander
fl. mid-/late 19th century
Lithographer working in Edinburgh.
'Royal Volunteer Review in the Queen's Park,

ROBERTS, David. One of eight plates from 'The Antiquities of Scotland: Sweet-Heart, Dumfriesshire'.

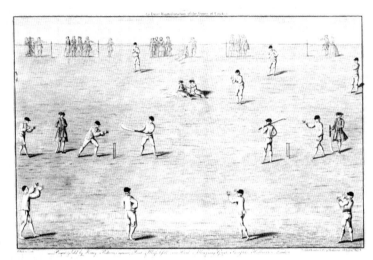

ROBERTS, Henry. 'An Exact Representation of the Game of Cricket', 1743.

Edinburgh, 7th Aug. 1860', 9¼ x 18¾in/23.5 x 47.5cm, tt. pl., £40-£80.

RIVERS, J. fl. late 18th/early 19th century
Stipple and line engraver of small bookplates including portraits after his contemporaries. There was another engraver of the same period by the name of Charles R.
Small value.

RIXON, Edward fl. late 17th century
Early mezzotint engraver of royal portraits. All are rare.
£100-£200.
CS lists 5 pl.

ROBERTS, C. fl. late 19th century
Wood engraver of illustrations for magazines and newspapers after his contemporaries.
Small value.

ROBERTS, David, R.A. 1796-1864
Eminent painter of landscapes and architectural and topographical views. While most of his prolific output was engraved or lithographed by professionals, e.g. the Holy Land, Egypt and Nubia series lithographed by L. Haghe (q.v.), he

himself etched a few plates early in his career.
'The Antiquities of Scotland', 1831, 8 pl., fo., set £300-£600.

ROBERTS, Edward John 1797-1865
Etcher and line engraver of small bookplates including landscapes, architectural views, portraits and figure subjects after his contemporaries and Old Master painters. He was a pupil of C. Heath (q.v.) and often worked on the latter's plates.
Small value.

ROBERTS, Henry d.1790
Etcher and line engraver of sporting subjects, portraits, landscapes and topographical views after his contemporaries. He lived and worked in London and was also a printseller and publisher.
'High Bred Running Horses', after J. Roberts, c.1750, 12 pl., 7 x 10¾in/18 x 27.5cm, e. £50-£100.
Portraits of racehorses, after T. Spencer and J. Seymour, 1741-54, 11¼ x 11¾in/30 x 30cm including decorative border, e. £80-£160; e. £250-£400 with contemporary col. (set of 33 pl. fetched £7,000 May 1989).

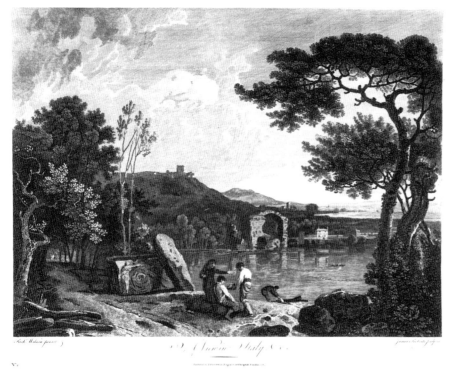

ROBERTS, James. 'A View in Italy', after R. Wilson, 1765.

Views of Vienna, after J.E.F. van Ert, etc., 7½ x 10in/ 19 x 25.5, e. £50-£100 col.
'View of Bath from Beechencliff', after T. Robins, 1757, 14½ x 24½in/37 x 62.5cm, £150-£300.
'An Exact Representation of the Game of Cricket', 1743, 11¼ x 16½in/28.5. x 42cm, £600-£1,200.
Portraits, other than small bookplates, £3-£12.
Small views of churches, etc., near London, by J.B.C. Chatelain (q.v.) and H.R., 1750, 50 pl., e. £5-£10.
Other small bookplates small value.

ROBERTS, James b.1753
Painter and line engraver of portraits, landscapes and topographical views after his contemporaries and his own designs. He entered the R.A. Schools in 1771. Later he worked for a time as a drawing master in Oxford and c.1795 was appointed Portrait Painter to the Duke of Clarence. He is best known for the series of portraits of actors used as illustrations for Bell's *British Theatre*, 1776.
Lge. pl.: landscapes and topographical views £50-£150.
Portraits and bookplates small value.

ROBERTS, Piercy
fl. late 18th/early 19th century
Stipple engraver of portraits and decorative and sporting subjects after his contemporaries.
'Prudence', 'Temperance', 'Fortitude' and 'Virtue', after H.C. Richter, with J. Peirson (q.v.), 1798, 15¼ x 11¼in/40 x 30cm, set £300-£500 prd. in col.
'Le Menuet à la Française' and 'Le Menuet à l'Anglaise', and other pl. after A. Buck, all aq. by J.C. Stadler (q.v.), e. £100-£200 col. or prd. in col.
'The British Admirals: Britannia Viewing the Conquerors of the Sea', 1800, 17½ x 14in/44.5 x

35.5cm, £60-£120.
Others mostly small value.

ROBERTS, William Patrick, A.R.A. b.1895
Eminent painter of figure subjects and portraits who produced six small etchings. Born in London, he studied at St. Martin's School of Art and at the Slade. He was influenced by the Cubists and joined the Vorticist Group in 1914. He was an Official War Artist, 1917-18. His six etchings were produced in the early 1920s and

ROBERTS, William Patrick. 'Bathers', one of the artist's six rare etchings.

only three impressions seem to have been taken from each plate.
Two portraits: artist's son and brother e. £400-£700.
'Bathers', and other subjects, £600-£1,000.

ROBERTSON, Archibald fl. late 18th century
Landscape painter, aquatint engraver of topographical views and naval subjects after his contemporaries and his own designs. He published his engravings from an address in St James's Square, London.
'The Destruction of the Spanish Battering Ships', after W. Hamilton, 16½ x 24¼in/42 x 61.5cm, £150-£250 col.
'The Conflagration during the Defence of Toulon', 1794, 16 x 24in/40.5 x 61cm, £150-£250 col.
'Rodney's Seizure of St. Eustatius in the West Indies', after Lieut. C. Forrest, 1782, 15½ x 38in/39.5 x 96.5cm, £500-£900 col.
'View of the Island of St. Lucia', after Lieut. C. Forrest, 1783, 14¼ x 29½in/37.5 x 75cm, £1,000-£2,000 prd. in sepia.
'Views in and Near Naples', after P. Fabris, 1777-82, fo., e. £150-£250 prd. in sepia.
'Neapolitan Costumes', 1781, 8¾ x 6¼in/22 x 17.5cm, £30-£60 col.

ROBERTSON, Charles 1844-1891
Painter and etcher of genre subjects. He lived in England and France and died at Walton-on-Thames. He was the father of Percy Robertson, (q.v.).
Small value.

ROBERTSON, David 1886-1944
Scottish architect, draughtsman and etcher of architectural views. He studied at the Glasgow School of Art and was later assistant architect to Middlesex County Council.
£20-£50.

ROBERTSON, Henry Robert, R.E.
1839-1921
Painter and etcher of landscapes, architectural views, sporting and sentimental subjects after

his contemporaries and his own designs. Born in Windsor, he studied at the R.A. Schools and lived in London. He wrote several books on painting and etching.
Sporting subjects after C. Whymper, 1886-91, ave. 14¼ x 23in/36 x 58.5cm, £80-£200.
Other lge. pl. £15-£40.
Add more if in fine contemporary frame.

ROBERTSON, Percy 1869-1934
Painter and etcher of landscapes and Thames views. Born in Italy, the son of C. Robertson (q.v.), he was educated in England and lived in London.
£30-£80.

ROBINS, William fl. mid-18th century
Mezzotint engraver of portraits after his contemporaries and Old Master painters. His subjects seem to have been mainly founders and heads of Oxford and Cambridge colleges.
'Sir Isaac Newton', after J. Thornhill, 11½ x 8½in/29 x 21.5cm, £30-£80.
Others £10-£30.
CS lists 12 pl.

ROBINS, William Palmer, R.W.S., R.E.
 1882-1959
Painter, etcher, aquatint and wood engraver and lithographer of landscapes. Born in London, he studied at St. Martin's School of Art, at Goldsmiths' College and at the R.C.A. He taught at St. Martin's and also at the Central School of Arts and Crafts. He lived in Surrey and London.
£30-£80.
Bibl: Salaman, M.C., 'Etchings and Drypoints of W.P.R.', *Bookman's Journal*, 1922, V, p.113; Dodgson, C., 'The English Landscapes of W.P.R.', *Bookman's Journal*, 1925, XII, p.93.

ROBINSON, Charles F., A.R.E.
 fl. late19th/early 20th century
Painter and etcher of landscapes. Possibly the lithographer as well as draughtsman of the following print:
'The Dead Heat • the University Boat Race', 1877, 14 x 24in/35.5 x 61cm, £400-£700 col.
Landscape etchings £5-£15.

ROBINSON, Gerald Philip, A.R.E.
 1858-1942
Mezzotint engraver of portraits after British 18th century and Old Master painters and sentimental subjects after his contemporaries. Born in London, the son of J.C. Robinson (q.v.), he studied at the Slade and was appointed Mezzotint Engraver firstly to Queen Victoria and then to Edward VII after her death. He lived in Somerset.
'The Passing of Arthur', after F. Dicksee, 1892, 19¼ x 31¼in/49 x 80.5cm, £300-£600.
Portraits £10-£40.

ROBINSON, Henry fl. mid-/late 19th century
Stipple and line engraver of small bookplates, including portraits, religious and decorative subjects after his contemporaries and Old Master painters.
Small value.

ROBINSON, Sir John Charles, R.E.
 1824-1913
Landscape and flower painter, etcher of landscapes. Born in Nottingham, he studied art in Paris. At the age of twenty-eight, he was appointed first Superintendent at South Kensington Museum (now the Victoria & Albert

ROBINS, William Palmer. A typical landscape drypoint.

Museum), a post he held until 1869. He was also Surveyor of the Queen's Pictures for twenty years. He was the father of G.P. Robinson (q.v.).
£20-£60.
Bibl: Allhusen, E.L., 'Sir J.C.R.'s Etchings', *P.C.Q.*, 1921 (with the Catalogue by A.M. Hind), VIII, p.299.

ROBINSON, John Henry, R.A. 1796-1871
Line, stipple and mezzotint engraver of portraits and historical and decorative subjects after his contemporaries and Old Master painters. Born in Bolton, Lancashire, he moved to London in 1814 where he became a pupil of J. Heath (q.v.).

Late in life, he married and retired to Petworth in Sussex where he died.
'A Consultation Previous to an Aerial Voyage from London to Weilberg in Nassau, Nov. 1836', after J. Hollins, 1843, 8 x 11¾in/20.5 x 30cm, £60-£120.
'Deer Stalking in the Highlands', after E. Landseer, 1846, £100-£160.
'Little Red Riding Hood', after E. Landseer, 1853, 14½ x 10½in/37 x 26.5cm, and subjects of similar size after the same, £20-£50.
Lge. historical and decorative subjects, around 18 x 24in/45.5 x 61cm, £30-£90.
Add more if in fine contemporary frame.
'Sir Walter Scott', after T. Lawrence, 1838,

ROBINSON, John Charles. Landscape etching.

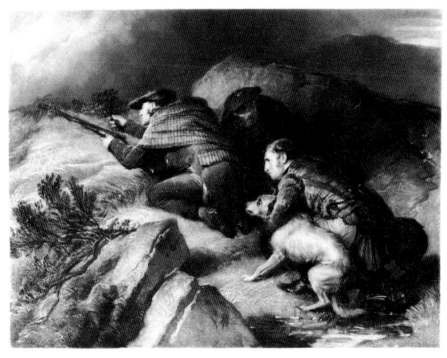

ROBINSON, John Henry. 'Deer Stalking in the Highlands', after E. Landseer, 1846.

12 x 9¾in/30.5 x 25cm, and portraits of similar size, £10-£30.
Small portraits and bookplates small value.

ROBINSON, Mabel Catherine, A.R.E.
 b.1875
Painter, etcher and aquatint engraver of landscapes and architectural views. Born in London, she studied at Lambeth School of Art and at the R.A. Schools. She lived in London.
£30-£80.

ROBINSON, Robert
 fl. late 17th/early 18th century
Mezzotint engraver of portraits, still life, capricci, etc., after his own designs, those of his contemporaries and Old Master painters.

ROBINSON, Robert. A typical capriccio.

'Vanitas', 9¾ x 7in/24.5 x 18cm, £150-£300.
Capricci, still life, landscapes, etc., £100-£200.
Portraits £20-£60.
CS lists 8 pl.

ROBINSON, William R.
 fl. early 19th century
Engraver of topographical views. He may have been a Yorkshireman, since the following print was published there.
'A View of the Ruins of Barnard Castle', 1820, 16¼ x 20in/42.5 x 51cm, £20-£60.

ROCK & CO. fl. mid-19th century
Line engravers and publishers of small topographical bookplates depicting places in England.
Small value.

ROCQUE, John d.1762
Huguenot surveyor, etcher and line engraver of topographical views after his contemporaries and his own designs. In the 1730s, he engraved influential Rococo pattern books, and in the 1740s he made maps of Bristol, London and its environs, and other cities.
£10-£50.

ROFFE, A. fl. mid-19th century
Stipple engraver of small bookplates including portraits after his contemporaries and 18th century painters. He was probably related to the other Roffes mentioned below.
Small value.

ROFFE, Edwin fl. mid-19th century
Line engraver of small bookplates including portraits, sculptures, etc., after his contemporaries. He was a member of a family of painters and engravers.
Small value.

ROFFE, John 1769-1850
Stipple and line engraver of architectural views

and portraits after his contemporaries. He was a member of a family of painters and engravers. All of his work seems to consist of bookplates.
'Holwood House, Keston', a pair, 1824, 7 x 11in/18 x 28cm, £15-£30.
Bookpl. small value

ROFFE, R. fl. mid-19th century
Line and stipple engraver of small bookplates, including portraits, landscapes and topographical views after his contemporaries. He was a member of a family of painters and engravers.
Small value.

ROFFE, William Callio b.1817
Stipple and line engraver of small bookplates including portraits and sculptures after his contemporaries, mezzotint engraver of plates for The Library Edition of *The Works of Sir Edwin Landseer*. He was a member of a family of painters and engravers.
Small value.

ROGERS, J. fl. mid-19th century
Lithographer.
'Longwaist' and 'Rubens' (racehorses), 12¼ x 16in/31 x 40.5cm, e. £150-£250 col.

ROGERS, John c.1808-c.1888
Line and stipple engraver of small bookplates, including portraits, landscapes, architectural views, religious and genre subjects after his contemporaries and Old Master painters.
Small value.

ROLFE, Edmund fl. mid-19th century
Draughtsman and lithographer.
8 views of Dover, c.1837, obl. 4to., e. £10-£30 col.

ROLLS, Charles 1800-c.1856
Painter of still life and fruit, line engraver of small bookplates including portraits, historical, biblical and sentimental subjects after his contemporaries and Old Master painters. He worked in London.
Small value.

ROLLS, Henry fl. mid-19th century
Line engraver of small bookplates including historical, biblical and sentimental subjects after his contemporaries. He was probably related to C. Rolls (q.v.)
Small value.

ROLPH, J.(?John) A. 1799-1862
Line engraver of small bookplates including landscapes and topographical and architectural views after his contemporaries. He later emigrated to America where he died in New York City.
Small value.

ROMNEY, John 1786-1863
Etcher and line engraver of small bookplates including portraits, satirical and genre subjects and topographical views after his contemporaries and 18th century painters. He died in Chester.
Small value.

ROOK, J. fl. mid-19th century
Lithographer and publisher.
'The Whitehaven Races', 1852, 12½ x 16¼in/32 x 41.5cm, tt. pl., £100-£200.

ROOKER, Edward c.1712-1774
Draughtsman, etcher and line engraver of

A VIEW OF St JAMES'S GATE, FROM CLEVELAND ROW.

ROOKER, Edward. 'A View of St. James's Gate, from Cleveland Row', from 'London Views', after P. Sandby.

topographical and architectural views after his contemporaries, Old Master painters and his own designs. Born in London, he was a pupil of H. Roberts and the father of M.A. Rooker (qq.v.).
'London Views' after P. Sandby, 1766, 6 pl., 14¼ x 20½in/37.5 x 52cm, e. £200-£500, 4 pl. very fine imp. fetched £2,400 June 1992.
'View from Somerset Gardens', after Canaletto, £50-£100.
Oxford views £50-£100.
'The Marino Casino', after T. Ivory, 1774, £600-£800.

ROOKER, Michael (Angelo), A.R.A.
1747-1801
Landscape painter, draughtsman, etcher and line engraver of topographical and architectural views. Born in London, he was taught engraving by his father, E. Rooker, and drawing and landscape painting by P. Sandby (qq.v.). He was for several years principal scene painter at the Haymarket Theatre, but he is best known as the designer and engraver of headpieces for the Oxford Almanacks, 1769-88. From 1788 he made autumnal tours of the counties drawing picturesque ruins.
Oxford Almanacks e. £20-£50.

ROSENBERG, Charles I
fl. late 18th/early 19th century
Portrait painter, aquatint engraver of sporting, coaching and naval subjects after his contemporaries. He appears to have lived and worked in London and was the father of C. Rosenberg II and F. and R. Rosenberg (qq.v.). Plates signed 'C.' or 'Charles Rosenberg' may have been engraved by C. Rosenberg II.
'Mr. H. Angelo's Fencing Academy', drawn and etched by T. Rowlandson, aq. by C.R., 13 x 19½in/33 x 50cm, £300-£600 col.
'Sir Joshua and Filho da Puta' (horserace), after J. Pollard, 1816, 11¼ x 15in/28.5 x 38cm, £600-£1,200 col.
'Rodney's Victory over de Grasse in the West Indies', after Capt. Miller, 1795, pair with J. Goldar (q.v.), 14¾ x 23½in/37.5 x 59.5cm, pair £500-£700 col.
'Engagement between the Blanche' and 'Engagement between the Pique', after Lieut. T. Orde, 1797, 11½ x 17in/29 x 43cm, pair £300-£500 col.

ROSENBERG, Charles II
fl. mid-19th century
Aquatint engraver of sporting, coaching and naval subjects after his contemporaries. He was

the son of C. Rosenberg I (q.v.). Plates signed 'C.' or 'Charles Rosenberg' may have been engraved by C. Rosenberg I.
'The Victory of Cape St. Vincent, 1797', after W.J. Huggins, 1837, 14½ x 21½in/37 x 55cm, £300-£400 col.
'Pulo Penang or Prince of Wales's Island', after W.J. Huggins, 13 x 22in/33 x 56cm, £1,500-£3,000 col.
'West Country Mails at the Gloucester Coffee House, Piccadilly', after J. Pollard, 1828, 25 x 31½in/63.5 x 80cm, £1,500-£3,000 col.
'Hyde Park Corner', after J. Pollard, 1828, with R.R., 16½ x 24in/42 x 61cm, £900-£1,600 col.
'Scottish Election', after C.B. Newhouse, 1837, 15¾ x 19½in/40 x 50cm, pair £600-£1,000 col.
'The Road-side', after J.-L. Agasse, 1833, 25 x 33in/63.5 x 84cm, £500-£900 col.
'The Burial of Tom Moody', after E. Duncan (q.v.), 1831, 16½ x 21in/42 x 53.5cm, companion to 'The Death of Tom Moody', by E. Duncan, pair £250-£400 col.
Colour plate page 57.

ROSENBERG, Frederick fl. mid-19th century
Aquatint engraver of coaching subjects after his contemporaries. He was the son of C. Rosenberg I (q.v.).

295

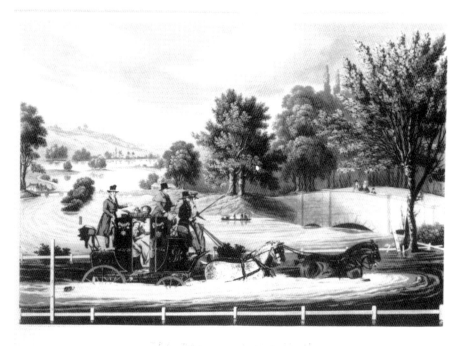

ROSENBERG, Frederick. 'The Mail Coach in a Flood', after J. Pollard, 1827.

'Opposition Coaches at Speed', after C.B. Newhouse, 1832, 11¼ x 15¾in/28.5 x 40cm, £300-£500 col.
'The Mail Coach in a Flood', after J. Pollard, 1827, £500-£800 col.
'Mail Coach' and 'Stage Coach', after J. Pollard, 1829, 10¼ x 14½in/27 x 37cm, pair £600-£1,000 col.
'The Royal Mails Preparing to Start for the West of England', after J. Pollard, 17 x 23¾in/43 x 60.5cm, £1,200-£1,800 col.

ROSENBERG, Richard fl. mid-19th century
Aquatint engraver of coaching subjects after his

contemporaries. He was the son of C. Rosenberg I (q.v.).
'Hyde Park Corner', after J. Pollard, 1828, with C.R. II (q.v.), 16½ x 24in/42 x 61cm, £900-£1,600 col.
'Stage Coach Travelling', after J. Pollard, 1828, 10¼ x 16in/27.5 x 40.5cm, £600-£1,000 col.

ROSS, James 1745-1821
Draughtsman and line engraver of topographical views after his contemporaries and his own designs. A pupil of R. Hancock (q.v.), he appears to have lived and worked in

the West Midlands which formed the subject matter for most of his engraved views. His work consists mainly of small bookplates. He died at Worcester.
'South West View of the County of Hereford', after G. Powle, 1778, £10-£30.
Others mostly small value.

ROTH, George Jun. fl. late 18th century
Portrait painter who engraved a few mezzotints after his own designs and those of his contemporaries. He was the son of the drapery painter, George Roth.
Portraits: 'John Alder', after C.V. Stoppelaer, 12¼ x 8½in/32.5 x 22cm, £10-£25; 'Mr. Brodeau', 6 x 4½in/15 x 11.5cm, £5-£10.
'Girl with Looking-glass', 12¼ x 9¾in/31 x 25cm, £20-£50.
CS lists 3 pl., noted above, but attributes them to William Roth.

ROTHENSTEIN, William. 'Arnold Bennett', a very rare etching.

ROTHENSTEIN, Sir William 1872-1945
Painter, lithographer of portraits and etcher of landscapes and townscapes with figures. Born in Bradford, he studied at the Slade and in Paris. He was an Official War Artist in France 1917-19 and was Principal of the R.C.A. 1920-35.
'Arnold Bennett', a v. rare etching, £60-£140.
Litho. portraits £40-£100 signed; £20-£60 unsigned.
Etchings of France during World War 1, £15-£40.
Bibl: Rothenstein, J., The portrait drawings of W.R., London, 1926.

ROTHWELL, P. and T.
 fl. late 18th/early 19th century
Line and stipple engravers of small portraits after their contemporaries and Old Master painters. Most of their plates were engraved as book illustrations.
Small value.

ROUSSEL, Theodore Casimir, A.R.E.
 1847-1926
French painter, etcher and lithographer of

ROSS, James. 'South West View of the City of Hereford', after G. Powle, 1778.

landscapes and townscapes, still life, genre subjects and portraits. Born in Brittany, he fought in the French Army in the Franco-Prussian war of 1870, after which he came to England, settling in Chelsea. His prints display the strong influence of J.A.M. Whistler (q.v.), not only in their choice of subject matter, but also in technique and in printing. Like Whistler, he also cut the margins off his impressions and signed them on a tab. He made a number of experiments with colour printing and was President of the Society of Graver-Printers in Colours.
'Chelsea Palaces (colour version)', 1890-97, 3¼ x 5 in/8.5 x 13cm, fetched £520 April 1994. Most other Thames and Chelsea subjects £100-£300.
'L'Agonie des Fleurs', 17 x 14in/43 x 35.5cm, £500-£800 (fetched £1,600 Nov.1989).
'The Sea at Bognor' in mount and frame designed by artist, fetched £2,800 April 1988. Add £500 or so if in original artist-designed and -printed frame.
Bibl: Dodgson, C., 'The Etchings of T.R.', *P.C.Q.*, 1927, XIV, p.325.

ROWBOTHAM, Claude fl. early 20th century
Painter, etcher and aquatint engraver of landscapes and coastal scenes. His prints are invariably found printed in colours.
£15-£50.

ROWE, George 1797-1864
West Country draughtsman, lithographer and publisher of topographical views mainly after his own designs. Born in Dartmouth, he worked in Hastings, Exeter and Cheltenham.
Views showing railways £20-£60.
Small views of North Devon, Hastings, Sidmouth, etc., £10-£20.
Pl. for Mrs. Adler's Views of and from the House and Grounds of Coolmore, Kilkenny, 1839, obl. fo., tt. pl., e. £15-£30.

ROUSSEL, Theodore Casimir. A Thames-side view.

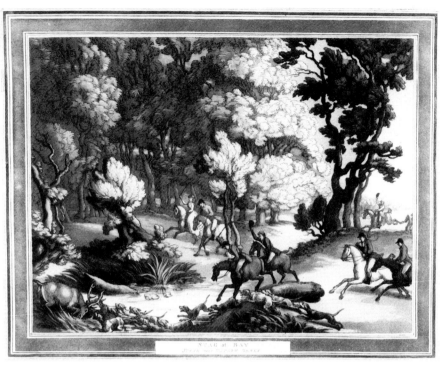
ROWLANDSON, Thomas. One of four plates from 'Hunting, with Scenes in Berkshire: Stag at Bay, scene near Taplow, Berks', 1801.

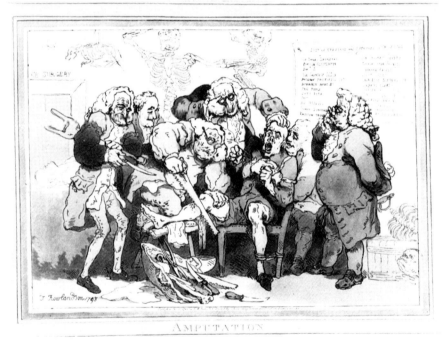
ROWLANDSON, Thomas. 'Amputation', 1793.

ROWLANDSON, Thomas 1756-1827
Famous draughtsman, etcher and aquatint engraver of political and social satires, sporting subjects, landscapes and topographical views. Born in London, the son of a bankrupt merchant, he studied at Dr. Barrow's School and at the R.A. Schools. Before 1800, he travelled extensively on the Continent and in the British Isles. He lived and worked in London, etching single plates, sets of sporting prints and book illustrations for the publishers S.W. Fores, R. Ackermann and T. Tegg. It is said that he gambled away most of his earnings as well as inheritances.
'Hunting, with Scenes in Berkshire', 1801, 4 pl., 18¼ x 23¼in/46.5 x 59cm, set £5,000-£8,000 col.
'The Overdrove Ox', 1787, 15¼ x 21½in/39 x 54.5cm, £700-£1,200 col.

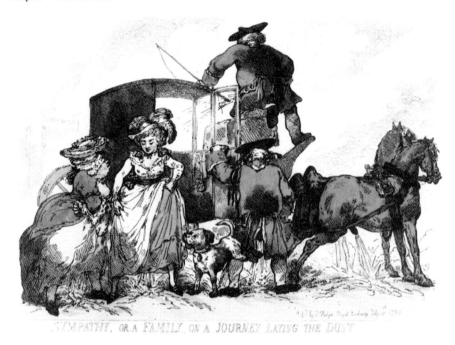

ROWLANDSON, Thomas. 'Sympathy, or a Family on a Journey Laying the Dust', 1784.

'Four O'clock in Town' and 'Four O'clock in the Country', 1788, 12¼ x 16¼in/31 x 41cm, pair £700-£1,200 col.
'Foxhunting', 1786, 6 pl., 16½ x 21½in/42 x 54.5cm, set £2,500-£3,500 col.
'Loyal Volunteers of London', 1799, 86 pl., e. £15-£30 col.
'Shooting', after G. Morland, etched by T.R. and aq. by S. Alken (q.v.), 1789, 4 pl., 17 x 22in/43.5 x 56cm, set £4,000-£6,000 col.
Pl. for W. Combe's Dr. Syntax, and similar illustrations, e. £5-£10 col.
'A Kick-up at a Hazard Table', 1790, 16¼ x 21½in/41.5 x 54.5cm, £900-£1,600 col.
'The Boxes', after A.P. Opie, 1809, 13 x 8in/33 x 20.5cm, £300-£500 col.
'Amputation', 1793, 11½ x 16in/29.5 x 40.5cm, £600-£1,000, £1,000-£1,600 finely col.
'Public Characters', c.1800, etching, £200-£300 col.
'Sympathy, or a Family on a Journey Laying the Dust', 1784, £250-£400 col.
Later caricatures publ. by T. Tegg, mostly e. £50-£150 col., but good subjects, e.g. ballooning, military, fashion, up to £350 col.
See also Malton Jun., T. and Schutz, H. for prices.
Grego, J., R. the Caricaturist, London, Chatto & Windus, 1880.
Colour plates pages 58 and 59.

ROYDS, Mabel A. 1874-1941
Colour woodcut artist. After working with W. Sickert (q.v.) in Paris and teaching in Canada for some years, she returned to the UK to train at Edinburgh School of Art. She married E. S. Lumsden (q.v.) in 1913, and travelled widely throughout the East with him, the subject-matter of her prints reflecting her travels. Later, she produced flower and religious subjects.
£50-£150.

RUDGE, Bradford 1805-1885
Landscape painter, drawing master, draughtsman and lithographer of some architectural views and one coaching print. He settled in Bedford in 1837 and lived and worked there for the remainder of his life.
'The Bedford Times' (stagecoach), 12¼ x 21¼in/32.5 x 55cm, £250-£400 col.
'Views of Burghley House, Northamptonshire', 1842, fo., 4 tt. pl., e. £10-£20.

RUDGE, Margaret M.
 fl. early/mid-20th century
Etcher of architectural views and figure subjects.
£20-£50.

RUGENDAS, G. fl. late 18th century
Mezzotint engraver. He was presumably a member of the large family of engravers based at Augsburg.
'The Truants' and 'The Romps', after W.R. Bigg, 1798, 19 x 23¾in/48.5 x 60.5cm, pair £250-£400.

RUNCIMAN, Alexander 1736-1785
Scottish landscape and historical painter from Edinburgh, who etched a few figure subjects while he was a student in Rome between 1766 and 1771. His brother, John Runciman, 1744-68, who went to Rome with him, also etched one or two plates in the same style.
Contemporary imp. generally £100-£300; from the collected edn. of pl. reprinted in 1826, e. £25-£40.
'St. Margaret landing at Dunfermline', fine, early imp. fetched £900 Dec. 1991; two other etchings, superb and fine, early imp., pair fetched £3,500.
Bibl: MacMillan, Duncan, Life and Catalogue of A.R., in progress.

RUPERT, Prince, of Palatine
 fl. mid-/late 17th century
Professional soldier whose importance to the development of English printmaking lies in the introduction of mezzotint engraving to England, when he engraved a reduced-size version of his large plate of the 'Executioner' as an illustration to Evelyn's Sculptura. Prices for his mezzotints can be several thousand pounds, but his prints are really beyond the scope of this book.

RUSHBURY, Sir Henry George, R.A., R.W.S., R.E. 1889-1968
Watercolourist, draughtsman, etcher and drypointer of architectural views. Born near Birmingham, he studied at the School of Art there. In 1912, he went to live in London, where he met F. Dodd and D.M. Bone (qq.v.) by whom he was influenced. He worked throughout England, France and Italy.
£50-£150.
Bibl: Schwabe, R., 'The Etchings of H.R.', P.C.Q., 1923, X, pp.403-33, (with catalogue 1912-23 by H.J.L. Wright).

RUSHWORTH fl. late 18th century
Draughtsman and etcher of caricatures.
'The Bum Shop' and 'The Supplemental Magazine', 1785-6, 11½ x 17in/29 x 43.5cm, e. £100-£200 col.

RUSKIN, John 1819-1900
Well-known art critic, poet and painter who etched a few plates.
Rare set of 6 etchings, before mezzo. and letters added, executed for 'Modern Painters', £300-£500.

RUSSELL, S. fl. mid-19th century
Line engraver and lithographer of landscapes and topographical views.
'North Midland Railway: Bridge under the Cromford Canal at Bull Bridge', 10¼ x 14¼in/26 x 37.5cm, tt. pl., £140-£200 col.
'Sketches in New Brunswick', after various artists, 1836, 4to., e. £80-£160.
Line eng. small value.

RUTHERSTON, Albert Daniel, R.W.S 1881-1953
Painter of portraits, figure subjects and landscapes who etched a few plates. Born in Bradford, the younger brother of W. Rothenstein (q.v.), he studied at the Slade and was Ruskin Master of Drawing at Oxford University from 1929 to 1948.
£20-£50.

RUNCIMAN, Alexander. A typical etching.

RYALL, Henry Thomas 1811-1867
Line, stipple and mixed-method engraver of portraits and sporting, genre and historical subjects after his contemporaries. Born at Frome, Somerset, he was a pupil of S.W. Reynolds (q.v.) and lived and worked in London. He was later appointed Portrait and Historical Engraver to the Queen. He died at Cookham, Berkshire.
'The Coronation of Queen Victoria', after G. Hayter, 1842, 22 x 34in/56 x 86.5cm, and Royal subjects of similar size, £200-£400.
'Morning of the Chase, Haddon Hall' and 'Return from Hawking', after F. Taylor, 1843, 22 x 34in/56 x 86.5cm, pair £600-£800.
'John Knox Administering the First Protestant Sacrament', after W. Donner, 1849, 24 x 36in/61 x 91.5cm, £60-£120.
'Deerstalkers Returning', after E. Landseer, 1854, 22 x 29in/56 x 73.5cm, £250-£400.
'Landais Peasants Going to the Market', after R. Bonheur, 1858, 19 x 33¼in/48.5 x 84.5cm, £20-£50.
'The Pursuit of Pleasure', after N. Paton, 1864, 25½ x 41in/65 x 104cm, £200-£400.
Add more if in fine contemporary frame.
Small portraits and bookplates small value.

RYDER, Thomas 1746-1810
Line and stipple engraver of portraits and historical, classical and decorative subjects after his contemporaries. Born in London, he was a pupil of J. Basire I (q.v.), and apparently entered the R.A. Schools as Thomas Ride, before starting work as an engraver for J. Boydell and other publishers.
'A Girl of Carnarvonshire' and 'A Boy of Glamorganshire', after R. Westall, circles, pair £250-£400 prd. in col.
Other ovals and circles, after A. Kauffmann, etc., £100-£300 prd. in sepia or in col.
'H.W. Bunbury', after T. Lawrence, 1787, 16¼ x 12¾in/41 x 32.5cm, £100-£200.
'The Politician' (Dr. Benjamin Franklin), after S. Elmer, 16¼ x 13in/41 x 33cm, £200-£300.
Pl. for Boydell's Shakespeare, Jo., e. £10-£25.
Small portraits and bookplates small value.

RYLAND, Edward d.1771
Line engraver and printer. He was the father of W.W. Ryland (q.v.).
Small value.

RYLAND, William Wynne 1723-1783
Eminent line and stipple engraver of portraits and historical, classical and decorative subjects after his contemporaries. Born in Wales, he was apprenticed to S.F. Ravenet (q.v.) and studied in France and Italy. He was appointed Engraver to King George III and received a pension of £200. He also ran a successful print selling business. In 1783, however, he was convicted of forgery and hanged.
Ovals and circles after A. Kauffmann, etc., £100-£300 prd. in sepia or in col.
'John, Earl of Bute', after A. Ramsey, 20½ x 14in/52 x 35.5cm, £15-£35.
'Queen Charlotte', after F. Cotes, 1770, 21 x 13¼in/53.5 x 33.5cm and 'King George', after A. Ramsey, 1761, 20½ x 13¼in/52 x 35cm, e. £20-£50.
Small portraits and bookplates small value.
Bibl: Bleackley, R., 'A list of W.R.R.'s engravings', *The Connoisseur*, 1905, XII, pp.110-1.

RUSHBURY, Henry George. View of Durham.

RYLEY, Charles Reuben c.1752-1798
Painter, decorator and drawing master who etched a few plates. Born in London, he entered the R.A. Schools in 1769 and studied under J.H. Mortimer (q.v.). He died in London.
'A Deer Hunter of the Last Age', after R. Byng, 1782, 15 x 12in/38 x 30.5cm, £50-£80.
Small portraits small value.

RYLEY, T. fl. mid-18th century
Mezzotint engraver of portraits after his contemporaries. He was probably taught by J. Faber II (q.v.) and copied many of his works.
'The Dancing Master', after P. Veneto, 13¾ x 10in/35 x 25.5cm, £70-£150.
'Mdlle. Auretti' (dancer), after C. Amiconi, 13¾ x 9¼in/35 x 25cm, £40-£90.
'George Graham, Clockmaker', after Hudson, 13¾ x 9¼in/35 x 25cm, £200-£300.
Others £15-£50.
CS lists 13 pl.

RUSSELL, S. 'North Midland Railway: Bridge under the Cromford Canal at Bull Bridge'.

SADDLER, John 1813-1892
Line and mezzotint engraver of landscapes, architectural views, portraits and sentimental subjects after his contemporaries. A pupil of G. Cooke (q.v.), he lived and worked in London, later moving to Wokingham in Berkshire, where he died.
Lge. pl. £30-£100.
Add more if in fine contemporary frame.
Bookplates and portraits small value.

SADLER, William fl. mid-/late 18th century
History and portrait painter who worked in Dublin and engraved a few mezzotints. He studied at the Dublin Academy.
'John Kemble in the Count of Narbonne', 13¼ x 9¾in/35 x 25cm, £40-£100.
'George, Earl Temple', after R. Hunter, 19¼ x 13¼in/50 x 33.5cm, £30-£80.
CS lists 2 pl., noted above.

SAILLIAR (Saillier), L. fl. late 18th century
Stipple engraver of small portraits after his contemporaries.
Small value.

SALA, George Augustus 1828-1895
Journalist, art critic, draughtsman and etcher of panoramas and humorous illustrations. He wrote for *The Daily Telegraph, The Illustrated London News* and *Punch*. He died in Brighton.
'Great Glass House' (the Crystal Palace), 5 x 216in/12.5 x 549cm, £600-£1,000 col.
'Funeral of the Duke of Wellington', aq. by H.T. Alken (q.v.), 1853, 5½ x 80½in/14 x 204cm, £500-£800 col.

SALLES, Leon b.1868
French etcher, stipple and mezzotint engraver of portraits and sentimental subjects after 18th century British and French painters and his contemporaries. Born in Paris, he was a pupil of A. Boulard (q.v.).
Small value.

SALMON, J. I fl. mid-19th century
Lithographer.
Pl. for Relics of Shakespeare, after Mrs. Dighton, 1835, obl. 4to., e. £5-£10 col.

SALMON, J. II fl. mid-19th century
Mezzotint engraver.
'Tom Maley', 5¾ x 5in/14.5 x 12.5cm, £3-£8.

SALOMONS, E. fl. mid-19th century
Draughtsman and lithographer of architectural outlines.
Small value.

SALTER, John William fl. mid-19th century
Painter and lithographer of landscapes, coastal scenes and architectural views. He lived and worked in Torquay.
6 views of Torquay and neighbourhood, c.1838, fo., tt. pl., e. £10-£30.
5 views of Kenilworth Castle, c.1840, fo., tt. pl., e. £10-£20.

SALWAY, N. fl. mid-18th century
Mezzotint engraver of portraits after his contemporaries.
Small value.

SAMS, William fl. early 19th century
Publisher of decorative subjects and caricatures. Published the following panorama (no artist or engraver mentioned):
'Roman Procession', 1822, aq., 5¼ x 195in/13.5 x 495cm, complete set joined together, col., sold for £750 April 1994 (see col. illus. pages 58 and 59).

SANDBY, Paul, R.A. 1730-1809
Important watercolourist, etcher and aquatint engraver of landscapes, architectural views and occasional portraits. Born in Nottingham, he came to London with his elder brother Thomas, the architect, in 1747. From 1747 to 1752 he worked as draughtsman to the Survey of the Highlands and learnt to etch in Edinburgh, producing etchings of romanticised landscapes with figures. His importance as a printmaker, however, lies in his adoption and development of the aquatint medium which had been brought to England from France by the Hon. C. Greville. *XII Views in South Wales*, 1774-5, was the first book to be published in England with aquatint plates. This was followed by two further sets of Welsh views, and then by views of Windsor and Warwick Castles and other English views, as well as a series of views in and near Naples, after P. Fabris, and some views in Greece, 1777-82. The original editions of all his aquatints were printed in sepia or dark brown and not issued hand-coloured like later aquatints.
Etchings:
Early proofs, £20-£60, otherwise £5-£15; rare caricatures £50-£150.
Aquatints:
'XII Views in South Wales', 1774-5, 9¼ x 12¼in/23.5 x 31cm, e. £70-£140 prd. in sepia.

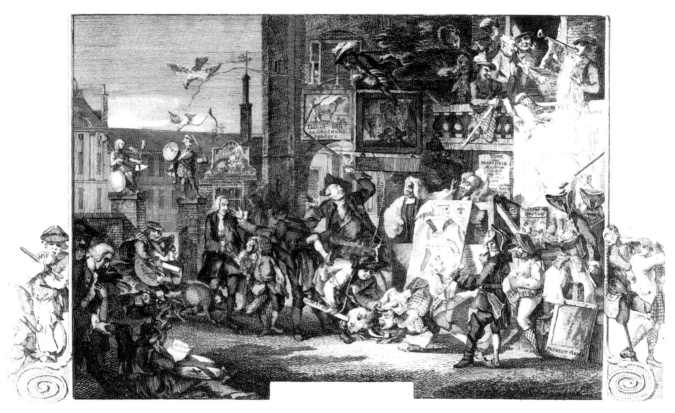

SANDBY, Paul. A rare caricature etching.

Views of Windsor Castle and Eton, 1776-7, 13¼ x 19¼in/33.5 x 49cm, e. £200-£400.
4 views of encampments in London, 1780-3, 13½ x 18¼in/34.5 x 47.5cm, e. £400-£600.
'The Carnival at Rome', after D. Allan, 1780, 4pl., 14 x 20in/35.5 x 51cm, set £800-£1,200.
Views in and near Naples, after P. Fabris, 1777-82, fo., e. £200-£300.
'H.R.H. Prince William as Midshipman', after B. West, with F. Bartolozzi, 1782, 23½ x 18½in/60 x 47cm, £200-£400.

SANDERS, Arthur N. b.1838
Mezzotint engraver of portraits and genre and sentimental subjects after his contemporaries.
Lge. subject pl. £30-£100.
Add more if in fine contemporary frame.
Portraits small value.

SANDERS, George fl. 1837-66
Mezzotint engraver of portraits and genre and sentimental subjects after his contemporaries and 18th century painters. Born in Exeter, he worked in London, with a period in Dublin, 1845-c.1858.
Lge. portraits and subject pl. £30-£100.
Add more if in fine contemporary frame.
Small portraits small value.

SANDERS (Saunders), J. fl. late 18th century
Etcher, line and aquatint engraver of portraits and topographical views after his contemporaries and his own designs.
6 views near Margate, 1790, obl. fo., aq., e. £50-£90 col.
Small portraits and bookplates small value.

SANDS, James fl. mid-19th century
Line engraver mainly of small bookplates including landscapes and architectural views after his contemporaries. He may have been related to R. Sands (q.v.).
'Windsor Castle', after T. Allom, for the Stationer's Almanack, 1837, 8 x 16in/20.5 x 40.5cm, £15-£40.
Small bookplates; American views £5 £10; others small value.

SANDS, Robert 1782-1855
Line engraver of small bookplates including landscapes, architectural views, plans and sections after his contemporaries. He may have been related to J. Sands (q.v.).
American views £5-£10.
Others small value.

SANGER, A.T fl. mid-/late 19th century
Mixed-method engraver. Possibly related to F. and T.L. Sanger (qq.v.).
'Coming from The Horse Fair', after R. Bonheur, 1875, 8 x 16½in/20.5 x 42cm, £10-£30.

SANGER, F. fl. mid-/late 19th century
Mixed-method engraver. Possibly related to A.T. and T.L. Sanger (qq.v.).
'Sea Shore of Old England', after G.E. Hicks, 1872, 16 x 20in/40.5 x 51cm, £15-£40.
Add more if in fine contemporary frame.

SANGER (Sangar), Thomas L fl. mid-19th century
Line and mixed-method engraver of sporting subjects after his contemporaries. Possibly related to A.T. and F. Sanger (qq.v.).
'Punchestown Races', after H. Barraud, 1867, 17¼ x 40in/44 x 101.5cm, £400-£600.
'Baying the Stag', after E. Landseer, 1875,

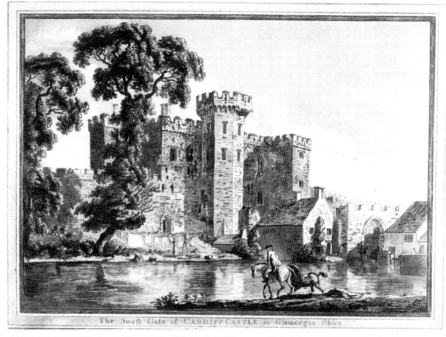

SANDBY, Paul. 'The South Gate of Cardiff Castle in Glamorgan Shire', from 'XII Views in South Wales', 1774-5, aquatint printed in sepia.

22½ x 24in/57 x 61cm, £150-£300.
'First of September', after F. Taylor, 1855, 16 x 24in/40.5 x 61cm, £120-£250.
Add more if in fine contemporary frame.

SANGSTER, Samuel 1804-1872
Line engraver of small bookplates and plates for the Annuals, including genre and sentimental subjects after his contemporaries. He died in London.
Small value.

SANSOM, F. fl. late 18th/early 19th century
Etcher and stipple engraver of portraits, caricatures, topographical views, etc., after his contemporaries.

SASS, Richard. One of thirty-three plates from 'Sketches of Nature: Charlton King's Cheltenham', 1810.

Pl. for G.M. Woodward's Pygmy Revels, 1800-1, 18½ x 13in/47 x 33cm, e. £10-£25 col.
Pl. for W. Gell's The Itinerary of Greece, 1810, 4to., e. £5-£10.
Portraits small value.

SARGENT, Frederick 1837-1899
Miniaturist, painter and etcher of portraits.
'Drawing-Room at Buckingham Palace', after F.S. with mezzo. by A. Turrell (q.v.), 1888, 24¼ x 38½in/61.5 x 98cm, £300-£500.
'The House of Commons', after F.S., 1880-1, 22 x 37¼in/56 x 94.5cm, £150-£300.
Add more if in fine contemporary frame.
Single portraits small value.

SARJENT, Francis James d.1812
Aquatint engraver of topographical views after his contemporaries and his own designs.
8 views in Berkshire, 1808, 16 x 20in/40.5 x 51cm, e. £200-£300 col.
'View of London and Westminster from Greenwich Park', 1804, 22¼ x 30½in/56.5 x 77.5cm, £800-£1,600 col.
Small bookplates small value.

SARTAIN, John 1808-1897
Miniaturist, etcher and mezzotint engraver of portraits after his contemporaries. After studying in London, he emigrated to the United States in 1830, settling in Philadelphia.
'William Penn', after H. Inman, 20 x 16in/50.5 x 40.5cm, £20-£50.
Others small value.

SARTOR, Johann fl. early/mid-18th century
German etcher and line engraver who worked in London from 1715-19.
'Ships of the Line in a Stiff Breeze', after T. Baston, 11½ x 15¼in/29 x 39cm, £100-£200.

SASS, Richard 1791-1849
Watercolourist, draughtsman and soft-ground etcher of the following series:
'Sketches of Nature', 33 pl., fo., set £200-£300.

SAVAGE, John. 'The Merry Fidler', after M. Laroon, from Tempest's 'Cries of London'.

SAY, William. Plate from *Liber Studiorum*, after J.M.W. Turner, 1814.

SAUNDERS, J. (?Joseph) fl. late 18th century
Mezzotint engraver of portraits after his contemporaries.
'Moody and Packer in the Farce of the Register Office', after B. Vander Gucht, 1773, 17¼ x 17⅜in/45 x 45cm, £100-£200.
Other WLs £60-£100.
'Miss Brockhurst', after M. Benwell, 1772, 15 x 10¾in/38 x 27.5cm, £60-£100.
Various HLs £15-£50.
CS lists 9 pl.

SAVAGE, John fl. late 17th century
Line engraver of portraits and genre subjects after his contemporaries. He was born in and worked in London.
Portraits and frontis. small value.
Pl. for Tempest's 'Cries of London', after M. Laroon, fo., e. £10-£20.
Other bookplates small value.

SAVAGE, William fl. 1770-1843
Painter and wood engraver. He published *Practical Hints on Decorative Printing*, with illustrations engraved on wood and printed in colours by the type press, 1822.
Bookplates small value.

SAWTHEM, I. fl. early 19th century
Mezzotint engraver. The name may be a pseudonym.
'April Fools: Country Musicians Celebrating a Regional Coronation', 1821, 4½ x 10½in/11.5 x 27cm, £60-£80.

SAY, William 1768-1834
Mezzotint engraver of portraits and historical, genre and decorative subjects after his contemporaries and Old Master painters. Born near Norwich, he came to London at the age of twenty and was apprenticed to J. Ward (q.v.). In 1807 he was appointed engraver to the Duke of York. He engraved no less than 335 plates and was one of the first mezzotint engravers to use steel instead of copper to engrave on. He died in London.
Pl. for J.M.W. Turner's Liber Studiorum, 1814, e. £80-£200.
'The Farrier's Shop', after J. Ward, 1806, 19 x 23¾in/48.5 x 60.5cm, £300-£500.
'Morelli' (racehorse), after H.B. Chalon, 1810, 18½ x 22½in/47 x 57cm, £400-£600.

'Prince of Wales' Loyal Volunteers Preparing for the Grand Review by His Majesty', after M.W. Sharp, 1805, 21¼ x 31in/54 x 78.5cm, £400-£700 prd. in col.
'Mrs. Siddons', after T. Lawrence, 1810, 32 x 21in/81.5 x 53.5cm, £200-£300.
'Love Sheltered', after H. Thomson, 1806, 24 x 16in/61 x 40.5cm, £300-£500 prd. in col.
Lge. pl. after Old Masters £5-£15.
Lge. historical subjects £20-£60.
WL portraits of military men, ave. 25 x 16in/63.5 x 40.5cm, £70-£140.
Small portraits and bookplates small value.

SAYER, Robert (and BENNETT, John)
fl. mid-/late 18th century
London publisher of decorative and sporting subjects, caricatures, topographical views, portraits, etc. His shop was in Fleet Street. He later formed a partnership with John Bennett. The topographical views are in etching and line

SAYER, Robert (and BENNETT, John). 'Age and Folly, or the Beauties', 1776.

engraving; the other subjects are mainly in mezzotint. Many of the prints he published do not bear the name of the artist or engraver.
Mezzotints:
'Age and Folly, or the Beauties', 1776, 'The Camp Laundry', 1782, 'The Swing', 1786, 14 x 10in/35.5 x 25.5cm, and other caricatures and decorative subjects of similar size, £150-£250 uncol.; £200-£500 contemporary gouache col.
'An Arabian (racehorse) belonging to Mr. Gregory', after G. Stubbs, 1777, 9¾ x 13¾in/25 x 35cm, and others after Stubbs £500-£1,000, £800-£1,600 col. with contemporary gouache; other similar sporting subjects of similar size £200-£400, £400-£600 col. with contemporary gouache.
Etchings and line engravings:
'Foxhunting', after J. Seymour, and 'Stag Hunting', after J. Wootton, both sets of 4 pl., obl. 4to., e. set £300-£500.

SAYERS, James 1748-1823
Draughtsman and etcher of caricatures. Born in Great Yarmouth, he originally trained as an articled clerk. After being left a small fortune by his father, however, he came to London about 1780 where he drew caricatures attacking James Fox. William Pitt rewarded him by making him a clerk in the Court of Exchequer.
£5-£15.

SCHACHER, C. fl. mid-19th century
Edinburgh lithographer.
'Royal Scottish Volunteer Review, Holyrood Park, 7th. Aug. 1860', 12¼ x 20½in/31 x 52cm, tt. pl., £50-£70.
Portraits small value.

SCHARF, George 1788-1860
German miniaturist and watercolourist, lithographer of topographical views, natural history subjects, processions, portraits, etc., after his contemporaries and his own designs. Born in Bavaria, he settled in London in 1816 after having fought with the British Army at Waterloo.
'The Coronation Procession of His Majesty George IV', 12½ x 17½in/32 x 44.5cm, £50-£80 col.
'A View of the Northern Approach to London Bridge While in a State of Progress' and 'A View of High Street, Southwark . . . Previous to its

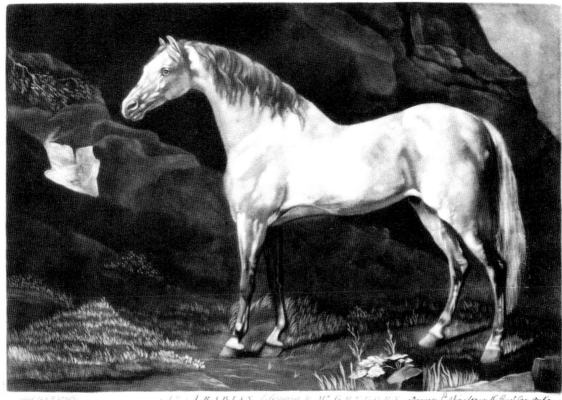

SAYER, Robert (and BENNETT, John). 'An Arabian belonging to Mr. Gregory', after G. Stubbs, 1777.

SCHARF, George. One of the artist's 'Views in the Zoological Gardens, Regent's Park', 1835.

Removal', 1830, each on two sheets, 22½ x 63½in/57.5 x 161cm, e. £300-£600.
'Views in the Zoological Gardens, Regent's Park', 1835, 8¼ x 12½in/21 x 31.5cm, e. £100-£200 col.
Pl. for P. Schmidtmeyer's Travels into Chile, 1824, 4to., e. £10-£30 col.
Pl. for W.D. Conybeare and W. Dawson's Landslips in East Devon, 1840, obl. fo., tt. pl., e. £10-£20.
Small bookplates illustrating fossils, botanical specimens, etc., small value.

SCHELL, Henry fl. late 19th century
Wood engraver.
'The Triumph of Labour', after W. Crane, 1891, 13½ x 32in/34 x 81.5cm, woodcut, £200-£400.

SCHENK, Francis fl. mid-19th century
Edinburgh lithographer of military subjects after his contemporaries.
'Memorial of the Grand Review of the Derbyshire Volunteers in Chatsworth Park,

24th Oct. 1860', after J. Gordon, 14½ x 22¼in/37 x 56.5cm, col., £200-£300.
Music covers small value.

SCHENK, Peter 1660-1718/9
German line and mezzotint engraver of portraits after his contemporaries. Born in Elberfield, he lived and worked in Amsterdam for the whole of his life and is mentioned here for having engraved several British portraits.
£15-£50

SCHIAVONETTI, Luigi (Lewis) 1765-1810
Eminent Italian stipple engraver of portraits and decorative, biblical and military subjects, etc., after his contemporaries and Old Master painters. Born at Bassano, he taught himself to engrave by copying prints by F. Bartolozzi (q.v.) and, when he eventually came to England, he worked for Bartolozzi before setting up on his own.
'The Landing of the British Troops in Egypt', after P.J. de Loutherbourg, 1804, 21 x 29½in/53.5 x 75cm, £300-£500 prd. in col.
'Lot and his Daughter', after G. Reni,

SCHELL, Henry. 'The Triumph of Labour', after W. Crane, 1891, woodcut.

22 x 16in/56 x 40.5cm, £30-£60 prd. in col.
'The Cries of London', after F. Wheatley, 1793-7, *16½ x 13in/42 x 33cm, e. £250-£400 prd. in col.*
'The Hon. Mrs. Damer' and 'Mrs. Cosway', after R. Cosway, 1794, *5 x 3¼in/12.5 x 8.5cm, pair £200-£300 prd. in col.*
'Marchioness Camden', after J. Reynolds, *11½ x 9½in/129 x 24cm, £250-£400 prd. in col.*
'A Party of Westminster Volunteer Cavalry Performing the Attack and Defence at Speed', after S. Edwards, 1801, *19 x 26in/48.5 x 66cm, £150-£250.*
'The Trial and Condemnation of Louis XVI', after Sintzenich, 1796, 4 pl., *12 x 17in/30.5 x 43cm, set £200-£400 prd. in col.*
'Academical Study for an Eve', after B. West, 1814 (apparently L.S.'s last eng. but publ. 4 years after his death), *24½ x 18in/62.5 x 45.5cm, £70-£140.*
'The Father's Admonition', after F. Wheatley, 1801, *16 x 18in/41 x 45.5cm, £150-£250 prd. in col.*
Pl. for W. Blake's Grave, 12 pl., set £300-£500.
Pl. for Boydell's Shakespeare, fo., e. £10-£25.
Larger portraits £5-£20.
Small portraits and bookplates small value.
Colour plate page 60.

SCHIAVONETTI, Niccolo (Nicholas)
1771-1813
Stipple engraver of portraits and decorative subjects after his contemporaries and Old Master painters. He was presumably related to L. Schiavonetti (q.v.), and was probably the latter's younger brother.
'Charlotte, Viscountess St. Asaph', after A. Mee, 1812, *11 x 9in/28 x 23cm, £8-£12.*
'Betsy in Trouble', after J. Russell, 1797, *12¼ x 15¼in/32.5 x 39cm, £100-£200 prd. in col.*
Pl. for H. L'Eveque's Campaigns in Portugal, 1812-13, *15½ x 21½in/39.5 x 54.5cm, e. £30-£80.*
'The Last Effort and Fall of Tippoo Sultan', after H. Singleton, 1802, *23½ x 27½in/59.5 x 70cm, £150-£250 prd. in col.*
'Adam and Eve', after H. Tresham, 1795, *15¼ x 19¼in/39 x 49.5cm, £200-£300 prd. in col.*
'Joseph Addington', after G. Kneller, 1809, *4 x 3in/10 x 7.5cm, and other small portraits and bookplates, small value.*
'The Cries of London', after F. Wheatley, 1793-7, *16½ x 13in/42 x 33cm, £250-£400 prd. in col.*
Colour plate page 60.

SCHMITZ, J. fl. late 18th/early 19th century
Stipple engraver of decorative subjects after his contemporaries. He seems to have produced reduced-size versions of prints by better-known engravers.
'The Shipwrecked Sailor' and 'The Sailor Boy's Return', after W.R. Bigg, pair £250-£350 prd. in col.

SCHURTZ, Cornelius Nicholas
fl. late 17th century
German line engraver of portraits after his contemporaries. He lived and worked in Nuremberg and is mentioned here for having engraved several British portraits.
Larger portraits £10-£40.
Small portraits small value.

SCHUTZ, H. fl. late 18th/early 19th century
Aquatint engraver of social satires, topographical views, architectural designs, etc., after his contemporaries. He seems to have worked mainly for T. Rowlandson (q.v.) around the turn of the century.

'Soldiers Cooking, Recreating, Attacking, etc.', drawn and etched by Rowlandson, 1798, 6 pl., *7½ x 9¾in/19 x 25cm, e. £100-£160 col.*
'She Will Be a Soldier' and 'He Won't Be a Soldier', drawn and etched by Rowlandson, 1798, *14¼ x 16in/35.5 x 40.5cm, pair £300-£400 col.*
'An Extraordinary Scene on the Road from London to Portsmouth', drawn and etched by Rowlandson, 1798, *15½ x 25¼in/39.5 x 64cm, £600-£1,000 col.*
Pl. for F.I. Mannskirsch's Views of Parks and Gardens, 1813, 8 pl., obl. fo., *e. £100-£200 col.*
Pl. for W. Roberton's A Collection of Various Forms of Stoves, 1798, obl. 4to., small value.
'London Turnpikes', 2 by and after Dagaty, 4 drawn and etched by Rowlandson, aq. by H.S., *e. £400-£600 col.*

SCORE, William
fl. late 18th/early 19th century
Portrait painter who engraved one mezzotint.
'John Quick, the Actor', 1791, *12 x 9¾in/30.5 x 25cm, £20-£50.*
CS lists 1 pl., noted above.

SCORODOMOFF, Gabriel
fl. late 18th century
Russian stipple engraver of decorative and classical subjects and portraits after his contemporaries. He was born in and died in St Petersburg, but in early life he visited England where he was a pioneer of stipple engraving; it is possible that he studied under F. Bartolozzi (q.v.).
Circles and ovals, after A. Kauffmann, etc., *£100-£300 prd. in sepia or in col.*

SCOTIN, Louis Gerard b.1690
French etcher and line engraver of genre, military and decorative subjects and portraits after his contemporaries. He is mentioned here for having engraved some plates when he visited England in 1733.
2 pl. for 'Marriage-à-la-Mode', after W. Hogarth (q.v.), see under Hogarth for price; individually £100-£150.
Pl. for 8 views of Derbyshire, after T. Smith, 1744, *15¼ x 21½in/39 x 54.5cm, set £1,400-£2,000.*
Lge. anatomical illustrations, 1747, *21¼ x 15¼in/55 x 40cm, e. £100-£200.*
'Capt. J. Miller', after P. Le Bouteux, *12½ x*

8½in/32 x 22cm, £6-£12.
'William Augustus', 1747, *11½ x 8¼in/29 x 21cm, £4-£8.*
Small portraits small value.

SCOTT, Alexander fl. mid-19th century
Mezzotint engraver of portraits and sentimental subjects after his contemporaries. He worked in London.
'James, Earl of Dalhousie', after J.W. Gordon, 1847, *23½ x 14¼in/59.5 x 37.5cm, and similar WLs, £30-£100.*
'E.W. Hassell', after F. Grant, *16½ x 13in/42 x 33cm, and similar TQLs, £20-£60.*
'The Farewell Caress', after C.B. Barber, 1875, with F. Stacpoole (q.v.), *22½ x 30in/57 x 76cm, £30-£50.*
Add more if in fine contemporary frame.

SCOTT, B.F fl. late 18th century
Mezzotint engraver.
'A Fencer' (Henry Angelo), after J.R. Smith, *12 x 7½in/30.5 x 19cm, £30-£60.*
CS lists 1 pl., noted above.

SCOTT, Edmund b.1758
Stipple engraver of portraits, decorative subjects and some caricatures after his contemporaries. Born in London, he entered the R.A. Schools in 1781 and was a pupil of F. Bartolozzi (q.v.). He was later appointed Engraver to the Duke of York, but gave up engraving for portraiture and settled in Brighton.
Illustrations to Milton's Comus, after T. Stothard, 1793, *16 x 19in/40.5 x 48.5cm, and other illustrations of similar size, e. £50-£100 prd. in col.*
'The Age of Bliss', after J. Russell, 1790, *10½ x 8½in/27 x 22cm, £50-£100 prd. in col.*
'Boys Skating', 'Bathing', 'Robbing an Orchard' and 'The Angry Farmer', after G. Morland, 4 pl., 1802, *14½ x 17in/36.5 x 43cm, set £600-£1,000 prd. in col.*
'The Smoking Club', after J. Boyne, 1792, *13½ x 17½in/34.5 x 44.5cm, £150-£250 prd. in col.*
'J. Edwin and Mrs. Wells as Lingo and Cowslip in The Agreeable Surprise', after H. Singleton, 1788, circle *12in/30.5 diam., £100-£200 prd. in col.*
Small portraits and bookplates small value.
'The Scott Family at Home', exhibition catalogue, Hove Art Gallery

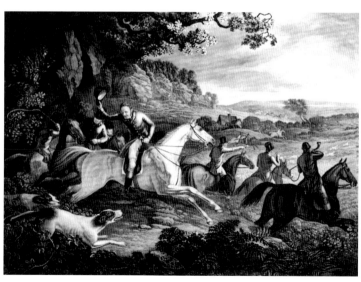

SCOTT, John.
'Breaking Cover',
after P. Reinagle,
pair with 'The
Death of the Fox',
after S. Gilpin,
1811.

SCOTT, William Bell. A dramatic illustration, this proof described as 'unfinished'.

SCOTT, G. fl. early 19th century
Stipple engraver of small portraits and bookplates after his contemporaries.
Small value.

SCOTT, James fl. mid-19th century
Mezzotint engraver of portraits and historical and sentimental subjects after his contemporaries and British 18th century painters. He was born in London where he lived and worked.
'The Duke and Duchess of Beaufort with Hounds', after F. Grant, 1865, 29 x 23½in/73.5 x 59.5cm, £250-£400.
'Sportsmen Halting at a Highland Bothie', after F. Taylor, 1856, 20¼ x 30in/52 x 76cm, £150-£300.
'Robert Stephenson and the Most Celebrated Engineers Raising the Tubular Bridge', after J. Lucas, 1858, 21½ x 28½in/54.5 x 72.5cm, £250-£500.
Other lge. historical and sentimental subjects and group portraits £60-£180.
'The Duke of Wellington', after Lilley, 1837, 24 x 16in/61 x 40.5cm, £80-£160.
Add more if in fine contemporary frame.
Small portraits, pl. for the Library Edition of The Works of Sir Edwin Landseer *and other bookplates, small value.*

SCOTT, John 1774-1828
Line engraver of sporting and animal subjects, costumes and portraits after his contemporaries. Born in Newcastle, he was taught drawing and engraving by R. Pollard (q.v.). He lived and worked in London, dying in Chelsea.
'The Spaniel', after R.R. Reinagle, with John Webb, 1830, 12¾ x 16in/32.5 x 40.5cm, £150-£250.
'Breaking Cover', after P. Reinagle, and 'The Death of the Fox', after S. Gilpin, 1811, 18 x 25½in/45.5 x 65cm, pair £300-£500.
'Race Horse Orville', after C. Thomson, 1812, 20 x 25in/51 x 63.5cm, £200-£400.
Pl. for F.B. Solvyn's The Costume of Hindostan, *1807, fo., e. £10-£20 col.*
Bookplates and other small plates: sporting and animal subjects £5-£10; portraits small value.

SCOTT, Robert 1771-1841
Scottish line, stipple and mezzotint engraver of portraits, animal subjects, landscapes and topographical views after his contemporaries. Born in Lanark, he was a pupil of Andrew Robertson and lived and worked in Edinburgh. He was the father of W.B. Scott (q.v.).
'The Northumberland Ox', after J. Howe, 18¼ x 23in/46.5 x 58.5cm, £500-£800 col.
'Robert Balfour D.D.', after P. Paillou, 1818, 17¼ x 13¼in/44 x 35cm, £7-£14.
'General Washington', after Peale, 12½ x 8in/32 x 20.5cm, £30-£80.
Small portraits and bookplates small value.

SCOTT, William, R.E. 1848-1918
Architect and etcher of architectural views. He worked in England and on the Continent.
£10-£30.

SCOTT, William Bell 1811-1890
Scottish poet, art history writer, painter, etcher and line engraver of portraits, landscapes, architectural views, biblical subjects, etc., after his own designs, those of his contemporaries and Old Master painters. Born in Edinburgh, he was the son and

pupil of R. Scott (q.v.), and also studied at the Trustees' Academy. After assisting his father in his engraving business, he went to live in London in 1837. In 1843, he was appointed Master of the Newcastle School of Design, returning to London in 1864. Most of his plates were book illustrations, including many for his own books. He died at Penkill Castle, Argyllshire.
Most bookpl. £5-£15, but signed or inscribed proofs (as illustrated) £20-£50.

SCOTT of Brighton,
William Henry Stothard 1783-1850
Draughtsman and occasional lithographer of topographical views. He was the son of E.S. (q.v.)
'Picturesque Views in the County of Sussex', 1821, 6 pl., obl. 4to., £10-£20.

SCRIVEN, Edward 1775-1841
Line, stipple and aquatint engraver of portraits and decorative, religious and classical subjects after his contemporaries and Old Master painters. Born at Alcester, Warwickshire, he was apprenticed to R. Thew (q.v.). He later lived and worked in London. He was appointed Historical Engraver to George IV.
'Sappho', after R. Westall, 1802, 16¼ x 13½in/42.5 x 34.5cm, stipple, £100-£200 prd. in sepia or in col.
'Sportive Innocence', after R. Cosway, 16 x 12½in/40.5 x 32cm, stipple, £150-£250 prd. in sepia or in col.
'Christ Rejected', after B. West, 1814, 5 pl., 18 x 14in/45.5 x 35.5cm, stipple, set £40-£80.
'H.R.H. The Prince Regent Accompanied by the Emperor of Russia and the King of Prussia, etc., in Hyde Park, after the Review on 20th June 1814', after A. Sauerweid, with J. Hill (q.v.), 18 x 29¾in/45.5 x 75.5cm, aq., £300-£400 col.
Lge. portraits £10-£30.
Small portraits and bookplates small value.

SCRUTTON, J. fl. mid-19th century
Lithographer.
'A Sketch of the New Race Stand at Goodwood', c.1829, 16¼ x 21½in/41.5 x 55cm, £300-£400 col.

SEABY, Professor Allen William 1867-1953
Colour woodcut engraver of ornithological and animal subjects. Born in London, he studied at Isleworth and was later Professor of Fine Art at Reading University from 1920 to 1933.
£60-£140.

SEARS, R. fl. mid-19th century
Line engraver of small bookplates including

SCRUTTON, J. 'A Sketch of the New Race Stand at Goodwood', c.1829.

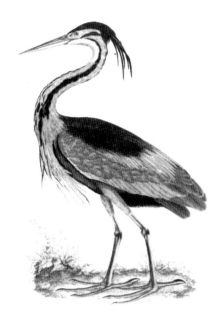

SELBY, Prideaux John. A typical subject from 'Illustrations of British Ornithology', 1819-34.

landscapes, architectural views and portraits after his contemporaries.
Small value.

SEDCOLE, Herbert Edward b.1864
Etcher and mezzotint and mixed-method engraver of sentimental, genre and sporting subjects after his contemporaries and Old Master painters. Born in London, he was a pupil of J.B. Pratt (q.v.) and lived in Hertfordshire.
'Pheasant Shooting (An Awkward Dilemma)', after C. Whymper, 1890, 13¼ x 22in/33.5 x 56cm, and other sporting subjects of similar size, £60-£100.
'Dante's Dream at the Time of the Death of Beatrice', after D.G. Rossetti, 16 x 21in/40.5 x 53.5cm, £400-£700.
Lge. genre and sentimental subjects £30-£120.
Add more if in fine contemporary frame.
Pl. for the Library Edition of The Works of Sir Edwin Landseer *and other small plates small value.*

SEDDON, John P. fl. mid-19th century
Architect who also lithographed a few plates.
Pl. for Rev. J.E. Jackson's Ruins of St. Mary Magdalene, Doncaster, *1853, tt. pl., e. £5-£10.*

SEDGWICK, William b.1748
Stipple engraver of genre and decorative subjects after his contemporaries. He was born in London.
'Widow Costard's Cow' and 'Goods Distrained Upon for Rent', after E. Penny, 1784, 10 x 13in/25.5 x 33cm, pair £30-£60.
'Apparent Dissolution' and 'Returning Animation', after E. Penny, pair £30-£60.
'Brotherly Affection', after A. Kauffmann, oval, £100-£250 prd. in sepia or in col.

SEED, T.S. fl. late 18th/early 19th century
Southampton line and stipple engraver and publisher.
'Southampton Volunteers', 1798, 10¼ x 7¼in/27.5 x 18.5cm, £20-£50 col.
'The Bargate, Southampton, with Volunteers',

after S. Taylor, 1814, 12¼ x 15in/32.5 x 38cm, £50-£90 col.
Small portraits and bookplates small value.

SELBY, Prideaux John 1788-1867
Draughtsman and etcher of ornithological and other natural history subjects. Born at Alnwick, he lived and worked in Northumberland all his life, except when he was an undergraduate at Oxford University.
'Illustrations of British Ornithology (British birds in their full natural size)', 1819-34, 21¼ x 15¼in/55 x 40cm and smaller, e. £60-£200 col. (set of 218 fetched $60,000 June 1989).

SERRES, John Thomas 1759-1825
Landscape and marine painter who executed two early lithographs, both marine subjects, and a very rare set of etched views of Liverpool.
Both marine litho. in 2 edn., 1803 and 1807, 8¾ x 11½in/22 x 29cm, and 8¾ x 12½in/22 x 32cm, e. £200-£300.
4 views of Liverpool, e. £600-£1,400 col.
Man Cat.

SEVERN, Joseph 1793-1879
Historical and portrait painter, etcher of genre subjects. Born in London, he was apprenticed to an engraver but turned to painting. He emigrated to Italy in 1861 where he became Consul in Rome, dying there in 1879. Italy provided the subject matter of many of his etchings.
Small value.

SEVERN, Walter 1830-1904
Landscape painter who contributed etchings to the publications of the Junior Etching Club. He was the son of J. Severn (q.v.) and was born in Rome.
£10-£25.

SEYMOUR, Robert 1800-1836
Draughtsman, etcher and lithographer of

caricatures and humorous illustrations. He is best known as the first illustrator of Charles Dickens' *Pickwick Papers.*
'The Heiress', 1830, 6 etchings, obl. fo., set £100-£200 col.
'The Schoolmaster Abroad', 1834, 9 pl., obl. fo., litho., set £150-£300 col.
Single caricatures £50-£100 col.
Small bookplates small value.

SHANNON, Charles Hazelwood, R.A., A.R.E. 1863-1937
Painter, lithographer and wood engraver of figure subjects, rustic genre, portraits, etc. Born in Lincolnshire, he studied at the City and Guilds Art School in Kennington where he met C. Ricketts (q.v.). They collaborated on an edition of *Daphnis and Chloe*, 1893, with illustrations drawn by Ricketts and engraved on wood by Shannon. They also produced *The Dial*, a periodical which appeared at intervals between 1889 and 1897, and together founded the Vale Press, 1896-1904. Shannon lived in London.
Mostly £80-£200; some lge. pl. £200-£400.
'Self-Portrait, No2', 1918, edn.50, 9½ x 9¼in/24 x 23.5cm, £200-£300.
Bibl: Ricketts, C., *A Catalogue of Mr. S.'s Lithographs,* London, 1902; Walker, R.A., *The Lithographs of C.S.,* London, 1920.

SHARP, M.W. fl. mid-19th century
Lithographer of portraits and military costumes after his contemporaries.
'The Guards', 13½ x 24¾in/34.5 x 63cm, £250-£400 col.
'Oxford University Rifle Volunteers', c.1860, 10 x 7¾in/5.5 x 19.5cm, £70-£140 col.
Pl. for Lieut. J.E. Alexander's Travels from India to England, *1827, 4to., small value.*
'Military Series', 1859-60, 8 sheets with vignettes, 14½ x 21in/37 x 53.5cm, e. sheet £80-£150 col.
Portraits small value.

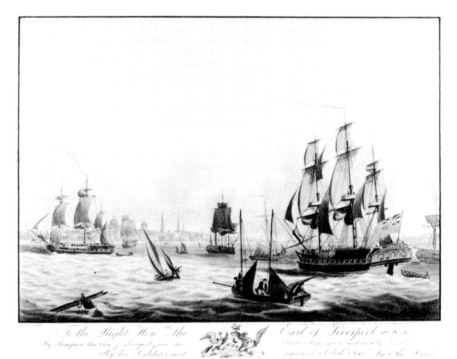

SERRES, John Thomas. 'View of Liverpool from the Powder Magazines', from the set of four views of Liverpool.

SHANNON, Charles Hazelwood. 'The Rising Tide', lithograph.

SHARP, William. 'Niobe', after R. Wilson, 1792.

SHARP, William 1749-1824
Eminent engraver of portraits and historical, religious and decorative subjects after his contemporaries and Old Master Painters. He was born in London and died in Chiswick.
'The Sortie Made by the Garrison of Gibraltar', after J. Trumbull, 1799, 23 x 33in/58.5 x 84cm, £200-£400.
'Charles II Landing at Dover', after B. West, with W. Woollett, 1789, 19½ x 24½in/49.5 x 62cm, £80-£160.
'The Holy Family', after J. Reynolds, 1792, 15 x 20in/38 x 51cm, £10-£20.
'Niobe', after R. Wilson, 1792, and other lge. landscape pl. £50-£150.
'King Lear, Act III, Sc. 4', after J. Reynolds, £20-£50.
'The Children in the Wood', after J. Benwell, 1786, 9 x 8in/23 x 20.5cm, £10-£25.
'John Hunter, F.R.S.', after J. Reynolds, 1788, 16¼ x 13¼in/42.5 x 33.5cm, £15-£30.
Small portraits and bookplates small value.
Bibl: Baker, W.S., W.S. engraver, with a descriptive catalogue of his works, Philadelphia, 1875.

SHARPE, Charles William 1818-1899
Eminent line, stipple and mixed-method engraver of sporting, historical, genre and sentimental subjects and portraits after his contemporaries. Born in Birmingham, he worked in and around London.
'Life at the Seaside - Ramsgate Sands', after W.P. Frith, 1854, 21 x 42in/53 x 107cm, £200-£400.
'Lord Nelson in his Cabin on the Victory', after C. Lucy, 1854, 17¾ x 13½in/5 x 34.5cm, £40-£80.
'The Smile' and 'The Frown', after T. Webster, 1848, 10 x 20in/25.5 x 51cm, pair £60-£140.
'Hamlet, the Play Scene', after D. Maclise, 1868, 18 x 33½in/45.5 x 85cm, £40-£80.
Add more if in fine contemporary frame.
Small portraits small value.

SHARPLES, James 1825-1892
Birmingham amateur artist who produced one major mixed-method engraving. He worked in a steel foundry and engraved 'The Forge' in his spare time between 1847 and 1858.

'The Forge', 1847-58, 18 x 21in/45.5 x 53cm, £400-£800.

SHAW, Charles E. fl. late 19th century
Etcher.
'The "Anchor", Ripley (with a Meeting of Cyclists)', 1897, 8 x 15½in/20.5 x 39.5cm, £20-£50.

SHAW, George B. fl. mid-19th century
Line, stipple, mezzotint and mixed-method engraver of portraits and sentimental subjects after his contemporaries. He worked in London.
'Hush', after J. Sant, 1874, 12½ x 10½in/32 x 26.5cm, £20-£50.
'The Silver Cord Loosed', after N. Paton, 1865, 16½ x 22in/42 x 56cm, £20-£50.
Add more if in fine contemporary frame.
'Thomas Thomson', after R.S. Lauder, 10¾ x 8½in/27.5 x 21.5cm, £15-£25
Small portraits and bookplates small value.

SHARPLES, James. 'The Forge', 1847-58.

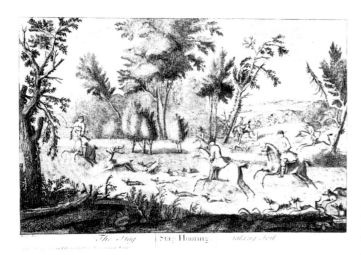

SHEPPARD, Robert.
One of four plates
from 'Stag Hunting:
The Stag Taking
Soil', after J. Wyck.

SHAW, Henry 1800-1873
Draughtsman and line and aquatint engraver of architectural views, antiquities, costumes and portraits. Born in London, he published several books on medieval dress and furniture, heraldry, etc., illustrated with his own plates. He died at Broxbourne in Hertfordshire.
Small value.

SHELLEY, Samuel 1750-1808
Miniaturist, historical painter and occasional stipple engraver of decorative subjects after his own designs.
£20-£60.

SHENTON, Henry Chawnes 1803-1866
Line engraver of sentimental and historical subjects and portraits after his contemporaries and Old Master painters. Born in Winchester, he studied under C. Warren (q.v.) and lived and worked in London. Much of his work consists of bookplates and plates for the Annuals.
Small value.

SHEPHERD (Shepheard), George
fl. late 18th/early 19th century
Etcher and aquatint, mezzotint and stipple engraver of decorative, genre and religious subjects and occasional portraits after his contemporaries, Old Master painters and his own designs. He was born in London.
'Thomas Fagan', after G.S., 1810, 11 x 14in/28 x 35.5cm, etching and aq., £30-£60 col.
'The Fleecy Charge', after G. Morland, 1796, 14 x 18in/35.5 x 45.5cm, stipple, £150-£250 prd. in col.
'Going to Market' and 'The Market Woman', after H.W. Bunbury, 1791, 11 x 15in/28 x 38cm, stipples, pair £200-£400, prd. in col.
'St. Cecilia', after Domenichino, 1784, 14 x 20in/35.5 x 51cm, £5-£10.
'The Veterinary College', after S. Gilpin, 15 x 18½in/38 x 47cm, mezzo £300-£600.
'George Washington . . .', after A. Campbell, 1775, 14 x 9¾in/35.5 x 25cm, by 'C.' Shepherd, £200-£400.
'The Attitudes of Lady Hamilton', 15 pl., obl. 4to., e. small value.

SHEPPARD, Robert fl. mid-18th century
Line engraver of portraits and sporting subjects after his contemporaries and Old Master painters.
'Stag Hunting', after J. Wyck, 4 pl., 11½ x 17½in/29 x 44.5cm, set £300-£600.
Portraits and bookplates small value.

SHEPPERSON, Claude Allin, A.R.A., A.R.E. 1867-1921
Magazine illustrator, lithographer and etcher mainly of decorative subjects and landscapes. Born in Kent, he studied in Paris and also at Heatherley's in London where he settled.
'Tending the Wounded', published as part of The Great War: Britain's Efforts and Ideals, *1917, 6 pl., 14 x 18in/35.5 x 45.5cm, litho., set £250-£400.*
Others e. £20-£50.
Bibl: Hardie, M., 'Etchings and Lithographs of C.S.', *P.C.Q.*, 1923, X, p.444.

SHERBORN, Charles William, R.E. 1831-1912
Line engraver of ex-libris, portraits and landscapes after his own designs, those of his contemporaries and Old Master painters. Born in London, he studied there and on the Continent and is best known for his ex-libris.
'Bookplate for Sir Francis Seymour Haden', 1880, very rare, 6¼ x 3½in/16 x 9cm, £40-£80
Others mostly £10-£40.
Bibl: Sherborn, C.D., *The Life and Work of C.W.S.*, London, 1912.

SHERINGHAM, C. fl. early 19th century
Line engraver.
'March of the Guards &c. Towards the Sea Coast', 1806, 9½ x 15in/24 x 38cm, £60-£100 col.

SHERLOCK, A. Marjorie 1897-1973
Painter and etcher of landscapes. Born at Wanstead, she studied at the Slade, at Westminster School of Art and at the R.C.A. She lived in Cambridge and Devon.
£10-£30.

SHERLOCK, William b.1738
Irish painter and line engraver of small portraits after his contemporaries and Old Master painters. He was a pupil at St. Martin's Lane Academy and studied engraving in Paris, 1761. He engraved plates for Smollett's *History of England*, 1757.
Small value.

SHERLOCK, William P.
fl. late 18th/early 19th century
Landscape and topographical painter, line and stipple engraver of small portraits after his contemporaries and Old Master painters, softground etcher of landscapes and topographical views after his own designs and those of his contemporaries. He was the son of W. Sherlock (q.v.).
Small value.

SHERMAN, Welby fl. 1820s-1830s
A member of the group of artists, who called themselves 'The Ancients', including S. Palmer, G. Richmond, E. Calvert (q.q.v.) and others. During Palmer's Shoreham years, S. engraved a very few pl. after the designs of his fellow artists.
'The Shepherd', 1828, 5 x 3½in/12.5 x 8.5cm, one of three known imp. fetched £2,600 April 1989.

SHERRAT, Thomas fl. mid-19th century
Line and stipple engraver of portraits and biblical and historical subjects after his contemporaries. He worked in London mainly on small plates for books and magazines.
'Storming of Delhi', after M.S. Morgan, 1859, 18½ x 24in/47 x 61cm, £200-£400.
'Charge of the Heavy Cavalry at Balaclava', after A. Elliott, 1860, 21½ x 35in/54.5 x 89cm, £200-£400.
Add more if in fine contemporary frame.
Bookplates and other small plates small value.

SHERWIN, Charles fl. late 18th century
Line and stipple engraver of portraits after his contemporaries and Old Master painters. He was the brother of J.K. Sherwin (q.v.).
Small value.

SHERWIN, John Keyse.
'The Forsaken Fair'.

SHORT, Frank Job. 'The Mooring Stone, Polperro Harbour', a typical etching, this impression from an early state touched with pencil by the artist.

SHERWIN, John Keyse 1751-1790
Eminent line and stipple engraver of portraits and decorative, historical and religious subjects after Old Master painters, his contemporaries and his own designs. Born of a peasant family at East Dean in Sussex, he was a pupil of the painter John Astley, 1769, and studied at the R.A. Schools, 1770, as well as under F. Bartolozzi (q.v.) until 1774. He succeeded W. Woollett (q.v.) as Engraver to King George III in 1785. He led a dissolute life, however, and died in poverty in London.
'The Happy Village' and 'The Deserted Village', after J.K.S., 1787, 17 x 23in/43 x 58.5cm, pair £250-£400 prd. in col.
'The Death of Lord Robert Manners', after T. Stothard, 1782, 18 x 24in/45.5 x 61cm, £60-£100.
'The Forsaken Fair' £40-£70.
'Mrs. Abingdon as Roxalana in The Sultan,' after J. Reynolds, 1791, 8¼ x 7¼in/22 x 18.5cm, £60-£100 prd. in col.
'The Finding of Moses (the Duchess of Devonshire as Pharaoh's Daughter)', 1789, 22¼ x 30½in/56.5 x 77.5cm, £40-£80.
'Liminla', after A. Kauffmann, 1781, oval, 12½ x 10in/32 x 25.5cm, and other ovals £100-£300 prd. in sepia or in col.
Small portraits and bookplates small value.

SHERWIN, William 1645-1711
Line and mezzotint engraver of portraits and frontispieces after his contemporaries and Old Master painters. Born at Wellington in Shropshire, the son of a clergyman, he was one of the earliest and possibly the first English mezzotint engraver.
'Charles II' and 'Queen Catherine', 1669, 17½ x 13½in/44.5 x 34.5cm (the former apparently the first mezzo. produced in England), respectively £1,000-£2,000 and £800-£1,600. Others £200-£500.

SHIPSTER, R. fl. late 18th/early 19th century
Line and stipple engraver of small portraits and bookplates after his contemporaries.
Small value.

SHORT, Professor Sir Frank Job, R.A., P.R.E. 1857-1945
Painter, etcher, mezzotint and aquatint engraver and lithographer of landscapes mainly after his own designs, but also after early 19th century British painters and his contemporaries. Born at Stourbridge, he originally trained as an engineer before studying art at South Kensington and Westminster. From 1891 to 1924 he was Head of the Engraving School at the R.C.A., becoming Professor in 1913. He was also responsible for reviving interest in mezzotint and aquatint engraving. He lived in London and in Sussex.
Original mezzo., etchings and aq. £40-£100, imp. from an early state touched with pencil by artist £80-£160;
'Headlights over the Hill', 1927, 6 x 8in/15 x 20cm, etching £80-£160.
'Hammersmith Bridge Under Repair', 7½ x 10½in/19 x 27cm, litho., £40-£80.
Mezzo. after G.F. Watts, c.1900, ave. 12 x 24¼in/31 x 61cm, e. generally £200-£400, but 'Diana and Endymion', trial proof, fetched £470 Feb. 1996.
Mezzo. after J.M.W. Turner and P. de Wint £10-£30.
Bibl: Hardy, M., *The Liber Studiorum Mezzotints of Sir F.S., R.A., P.R.E., after J.M.W. Turner, R.A.*, Print Collectors' Club, London, 1938; Hardy, M., *The Mezzotints and Aquatints of Sir F.S., R.A., P.R.E. Other Than Those for the Liber Studiorum*, Print Collectors' Club, London, 1939; Hardy, M., *The Etchings, Drypoints and Lithographs of Sir F.S., R.A., P.R.E.*, Print Collectors' Club, London, 1940.

SHURY, George Salisbury b.1815
Line, stipple and mezzotint engraver of historical and sentimental subjects and portraits after his contemporaries and Old Master painters. He was born in London where he lived and worked.
'Kars and its Defenders', after W. Simpson, 1856, 29 x 40in/73.5 x 101.5cm, £200-£400.
'The Poacher' and 'The Rabbit Fancier', after G. Armfield, 1881 and 1882, 13 x 19in/33 x 48.5cm, pair £100-£200.
'The Skipper Ashore', after J.C. Hook, 1883, 12 x 18in/30.5 x 45.5cm, £15-£40.
'Sir John Jarvis', after H. Weighell, 1857, 16¼ x 13¼in/42.5 x 33.5cm, and other larger mezzo. portraits, £12-£25.
Add more if in fine contemporary frame.
Smaller portraits and bookplates small value.

SHURY, J. fl. mid-19th century
Line, stipple and mezzotint engraver of small bookplates including landscapes, architectural views and portraits after his contemporaries and British 18th century painters.
Small value.

SIBDY, Charles fl. mid-19th century
Line engraver of military costumes
Pl. for Cyclopedia of British Costumes, 1828-32, folio, e. £10-£20 col.

SICKERT, Walter Richard, R.A., A.R.E. 1860-1942
Well-known painter and etcher of genre subjects, townscapes and portraits. His early etchings, executed between 1883 and 1890, were strongly influenced by J.A.M. Whistler (q.v.) under whom he studied. Later prints, beginning with 'Noctes Ambrosianae' in 1906, include domestic subjects and theatre and musical hall interiors for which he is better known.
Early etchings mostly £200-£500.

SICKERT, Walter Richard. 'Noctes Ambrosianae', 1906.

SIMMONS, William Henry. 'Claudio and Isabella', after W. Holman Hunt, 1864.

Later prints: 'Noctes Ambrosianae', 1906, £1,500-£2,500, other theatre and music hall subjects £500-£1,000; domestic/interior subjects and townscapes £300-£700.
'Quai Duquesne, Dieppe' fetched £2,600; 'Ennui' £2,800 and 'Passing Funeral' £3,800, all sold Oct. 1993.
'Handicap', one of only few proofs of this unpublished print, fetched £7,500 Nov. 1994, an auction record for the artist.
Bibl: Troyen, A., *W.S. as Printmaker*, Yale Center for British Art, 1979.

SIEVIER, Robert William 1794-1865
Stipple engraver of portraits and decorative subjects after his contemporaries and Old Master painters. He gave up engraving for sculpture in the 1820s.
Small value.

SIMKIN, Richard fl. late 19th century
Draughtsman and occasional lithographer of military costumes.
'Uniforms of the British Army', 1886, 12 pl., 7¼ x 5¼in/18.5 x 13.5cm, e. £30-£80 col.
'The Royal Horse Artillery', 'The Royal Field Artillery', c.1890, 11 x 14½in/28 x 37cm, e. £100-£200 col.

SIMMONS, William Henry 1811-1882
Notable line, mezzotint and mixed-method engraver of historical, biblical, sentimental and sporting subjects and portraits after his contemporaries. Born in London, he was a pupil of W. Finden (q.v.) who taught him line engraving; he later gave up line for mezzotint. He reproduced pictures by many of the most famous artists of his day and was very successful. He died in London.
'The Departure (Second Class)' and 'The

Return (First Class)', after A. Solomon, 1857, 22¼ x 29½in/58 x 75cm, pair £400-£700.
'The Meet of the Vine Hounds', after H. Calvert, 1844, 17 x 29in/43 x 73.5cm, £300-£500.
'Marriage of T.R.H. The Prince and Princess of Wales', after W.P. Frith, 1870, 24 x 34¼in/61 x 87cm, £200-£400.
'Hyde Park 1864 (Rotten Row)', after H. Barraud, 1867, 30 x 54in/76 x 137cm, £300-£500.
'The Light of the World', after W. Holman Hunt, 1858, 25¼ x 12½in/64 x 32cm, £200-£400.
'Claudio and Isabella', after W. Holman Hunt, 1864, 28¼ x 18½in/73 x 47cm, £150-£300.
'The Proscribed Royalist', after J.E. Millais, 1858, 25 x 18in/63.5 x 45.5cm, £150-£300.
'The Trial of Earl Stratford in Westminster Hall', after Fisk, 1846, 22½ x 34½in/57 x 87.5cm, £30-£80.
'The Baptism of Christ', after J. Wood, 1858, 26 x 33½in/66 x 85cm, £30-£80.
'The Horse Fair', after R. Bonheur, 1871, 8 x 16½in/20.5 x 42cm, £20-£40.
'Gaffing a Salmon', after R. Ansdell, 1857, 13½ x 25½in/34.5 x 65.5cm, £300-£500.
Add more if in fine contemporary frame.
Small portraits and bookplates small value.

SIMMS, Charles, R.A., R.W.S. 1873-1928
Painter and etcher of figure subjects and landscapes. Born in London he studied at the R.C.A., in Paris and at the R.A. Schools. He was an Official War Artist in 1918 and Keeper of the R.A. from 1920-6. He committed suicide while in Scotland.
'The Three Graces', aq. prd. in col., 11¼ x 9¼in/30 x 25cm, £60-£140.
Others £30-£80.
Bibl: Dodgson, C., 'The Engraved Work of C.S. with Catalogue', *P.C.Q.*, 1930, XVIII, p.375.

SIMMS, P. fl. mid-18th century
Line engraver of portraits and bookplates after his contemporaries and Old Master painters.
Small value.

SIMON, Jean Pierre fl. late 18th/early 19th century
Stipple engraver of decorative subjects and portraits after his contemporaries. He was born in London where he worked for John Boydell (q.v.) and other publishers.
Pl. for Boydell's Shakespeare, fo., £10-£25; but after Fuseli £20-£60, £200-£400 prd. in col.
'The Lady and the Astrologer', after J.R. Smith, oval, 14 x 10in/35.5 x 25.5cm, £140-£200 prd. in col.
'Vicar of Wakefield', after T. Stothard, circle, £50-£150 prd. in sepia or in col.
'Mrs. Opie as The Sleeping Nymph', after J. Opie, 12 x 9½in/25.5 x 24cm, £60-£100 prd. in col.
'The Woodman', after T. Gainsborough, 26 x 17in/66 x 43cm, £200-£300 prd. in col.
'Wisdom', from a set of 4 with 'Providence' and 'Innocence' by B. Smith (q.v.), and 'Happiness' by T. Burke (q.v.), all after J. Rigaud, 1799, 22½ x 16in/57 x 40.5cm, set £500-£800 prd. in col.
'The Months' set £600-£1,000 prd. in col.

SIMON, John (Jean) 1675-1755
French line and mezzotint engraver mainly of portraits, but also some biblical and allegorical subjects, etc., after his contemporaries and Old Master painters. Born in Normandy, he came to work in England and gave up line engraving for mezzotint on seeing some prints of J. Smith I

(q.v.). He settled in London, publishing many of his own prints from addresses in and around Covent Garden.
'Princess Caroline', WL, after P. Mercier, 1728, 18¼ x 12in/47.5 x 30.5cm, and similar portraits, £100-£300.
'A Sketch of a Topeing', 9¾ x 14in/25 x 35.5cm, £40-£80.
'Indian Kings', after Verelst, 4 pl., 16¼ x 10in/41.5 x 25.5cm, e. £100-£200.
'Poets and Philosophers of England', 6 pl., e. with 4 ovals, e. pl. 14 x 10in/35.5 x 25.5cm, set £300-£400.
'The Seasons', after Rosalba, 14 x 9¾in/35.5 x 25cm, set £300-£500.
HLs £15-£50.
TQLs £25-£80.
CS.

SIMPSON, A. Brantingham fl. 1920s
Landscape painter and etcher of fancy subjects. He lived in London.
£10-£30.

SIMPSON, Herbert W. fl. 1930s
Line engraver of genre subjects.
£30-£80.

SIMPSON, Joseph 1879-1939
Painter and etcher of portraits and sporting subjects. Born in Carlisle, he studied at Glasgow School of Art. He lived in London, working mainly as an illustrator.
£50-£150.
Bibl: L.H.G., 'The Etched Work of J.S.', *P.C.Q.*, 1932, XIX, pp.213-233.

SIMPSON, Joseph I and II *see* SYMPSON

SIMPSON, William 1823-1899
Scottish painter, illustrator and lithographer of naval and military subjects and topographical views after his own designs and those of his contemporaries. He was born in Glasgow, where he was apprenticed to a firm of lithographers. In 1851 he moved to London to work for Day & Son (see William Day, 1797-1845). His best known work, for which he produced all the drawings as well as

SIMON, John. A typical half-length male portrait.

SIMPSON, Joseph. 'The Mummer'.

lithographing several of the plates, was his *Seat of War in the East,* depicting the Crimean War. From 1866 he was on the staff of *The Illustrated London News,* for which he travelled widely.
Pl. for Seat of War in the East, *1855-6, fo., e. £4-£8, £10-£30 col.; but 'Charge of the Light Brigade' £80-£160 col.*
Pl. for E. Walker's Views of the Principal Buildings in London, *1852, 12½ x 16¼in/32 x 41.5cm, tt. pl., e. £200-£400.*

SIMPSON, William. 'London Bridge, 'From Above Bridge', from E. Walker's *Views of the Principal Buildings in London,* 1852.

Pl. for J. McNevin's Souvenir of the Great Exhibition, *1851, fo., e. £15-£30 prd. in col.*
Pl. for Capt. G.F. Atkinson's The Campaign in India, *1859, fo., tt. pl., e. £4-£8.*
'Launch of the Royal Albert at Woolwich', 1854, 11½ x 20½in/29 x 52cm, £300-£500 col.

SINCLAIR, John　　　　fl. mid-19th century
Mezzotint engraver of portraits after his contemporaries.
£5-£15.

SINGLETON, Henry　　　　1766-1839
Well-known portrait and historical painter whose works were much engraved by professionals. He produced one early lithograph himself:
'Oriental with a Beard Reading a Book', 1803, publ. 1807 by Vollweiler, 9 x 12¼in/23 x 31cm, £300-£500; on original mount £600-£900.
Man Cat.

SKEAPING, John Rattenbury, R.A.
　　　　　　　　　　　　1901-1980
Sculptor, draughtsman, etcher and lithographer of animal subjects. Born in Essex, he studied at Goldsmiths' College School, the Central School of Arts and Crafts and at the R.A. Schools. He was married for some years to Barbara Hepworth, was an Official War Artist from 1940-5, and Professor of Sculpture at the R.C.A. from 1953. He lived in Devon.
£50-£150.

SKELTON, Joseph　　　　1785-1850
Etcher, line and stipple engraver of topographical views, antiquarian subjects and portraits after his contemporaries and Old Master painters. He was the younger brother of W. Skelton (q.v.). Most of his work consisted of bookplates.
Pl. for Oxford Almanacs, *after F. MacKenzie*

and C. Wild, 1815-31, e. £15-£35.
Pl. for R.B. Harraden's Cantabrigia Depicta, *1830, obl. 4to., e. £10-£25.*
Larger portraits £5-£15.
Small portraits and other bookplates small value.

SKELTON, William　　　　1763-1848
Line and stipple engraver of portraits, historical subjects and antiquities after his contemporaries and Old Master painters. Born in London, he studied at the R.A. Schools and was a pupil of J. Basire I and W. Sharp (qq.v.). He was the elder brother of J. Skelton (q.v.). He lived and worked in London.
Lge. portraits £5-£15.
Small portraits and bookplates small value.

SKIPPE, John D.　　　　1742-1796
Amateur artist and engraver of chiaroscuro woodcuts after Old Master drawings. Born in Herefordshire, he lived in Heatherbury, Worcestershire, where he produced woodcuts based on Italian drawings in the 1780s in the style of J.B. Jackson (q.v.).
Rare proofs £80-£200.
Others £30-£70.

SKRIMSHAW, Alfred J.
　　　　　　fl. late 19th/early 20th century
Mezzotint engraver of sentimental subjects and portraits after Old Master and British 18th century painters and his contemporaries.
£10-£30.

SLATER, I.W.　　　　fl. mid-19th century
Lithographer of small portraits and bookplates after his contemporaries.
Small value.

SLEIGH, Bernard　　　　1872-1954
Painter and wood engraver of figure subjects. Born in Birmingham, he studied at the School of Art there, staying on to become a teacher.
£10-£30.

SLEIGH, John　　　　fl. mid-19th century
Painter and etcher of illustrations for the publications of the Junior Etching Club and the Etching Club.
Small value.

SLOANE, Mary Anne　　　　b.1861
Etcher of figure subjects and landscapes. Born in Leicester, she studied under H. von Herkomer (q.v.) at Bushey. She lived in Enderby, Leics., for many years, recording the local craft of weaving in several of her plates. She later moved to London, becoming close friends with F. Short and C.M. Pott (qq.v.).
£30-£80.

SLOANE, Michael
　　　　　　fl. late 18th/early 19th century
Stipple engraver of portraits and decorative and historical subjects after his contemporaries. He was a pupil of F. Bartolozzi (q.v.).
'Christening', after F. Wheatley, 25 x 19in/63.5 x 48.5cm, £150-£250 prd. in col.

SLOCOMBE, Alfred
　　　　　　　　fl. mid-/late 19th century
Etcher of landscapes and topographical views. He was a member of a family of etchers, lived in London and contributed plates to *The Etcher.*
Sporting subjects £20-£50.
Signed etchings £10-£30; unsigned pl. for The Etcher *and* The Portfolio *small value.*

SLEIGH, Bernard. A typical wood engraving.

SLOCOMBE, Charles Philip 1832-1895
Watercolourist and etcher of landscapes, portraits and genre subjects after his contemporaries and his own designs. He was a member of a family of etchers, lived and worked in London and contributed plates to *The Portfolio* and *The Etcher.*
Sporting subjects £20-£50.
Signed etchings £10-£30; unsigned pl. for The Etcher *and* The Portfolio *small value.*

SLOCOMBE, Edward C.
 fl. late 19th/early 20th century
Etcher and mezzotint engraver of landscapes, architectural views and occasional portraits after his contemporaries and his own designs.

Born in London, he was a member of a family of etchers, and contributed plates to *The Portfolio.*
Sporting subjects £20-£50.
Signed etchings £10-£30; unsigned pl. for The Etcher *and* The Portfolio *small value.*

SLOCOMBE, Frederick Albert b.1847
Painter and etcher of landscapes and genre and sporting subjects after his contemporaries and his own designs. Born in London he was a member of a family of etchers, and contributed plates to *The Etcher* and *The Portfolio.*
Sporting subjects £20-£50.
Signed etchings £10-£30; unsigned pl. for The Etcher *and* The Portfolio *small value.*

SMALLFIELD, Frederick 1829-1915
Genre and portrait painter who contributed plates to publications of the Junior Etching Club. Born at Honington in Middlesex, he studied at the R.A. Schools and lived and worked in London.
£10-£25.

SLOCOMBE, Frederick Albert. A landscape by the best of a family of mediocre etchers.

SMART, Douglas Ian, R.E. 1879-1970
Watercolourist, etcher, line and aquatint engraver of landscapes and architectural views. He was a pupil of F. Short (q.v.) and lived in London and Hampshire.
London and Thames views £50-£150.
Others £30-£80.

SMART, John, R.S.A., R.S.W. 1838-1899
Scottish painter and etcher of landscapes. Born in Leeds, he worked in Edinburgh.
Small value.

SMART, Robert William. 'Battle of Navarin', one of a pair, after J.T. Lee, with H. Pyall, 1827.

SMETHAM, James. Studies from a sketch book, No. 1: 'Forsake not the law of thy mother'.

SMART, Robert William
fl. early/mid-19th century
Etcher of topographical views and sporting and coaching subjects after his contemporaries. All his plates were aquatinted by other engravers, mainly G. and C. Hunt I (qq.v.).
6 views of the City of Bath, after D. Cox, aq. by T. Sutherland (q.v.), 1820, e. £60-£140 col.
'Doncaster Races', after J. Pollard, aq. by C. Hunt, 1832-3, 13½ x 24½in/34.5 x 62.5cm, pair £800-£1,400 col.
'The Elephant and Castle, Newington', after S.J.E. Jones, aq. by G. Hunt, 1826, 20 x 29¼in/51 x 74.5cm, £1,500-£2,500 col.
Pl. for R.B. Harraden's Cantabrigia Depicta, 1830, obl. 4to., e. £10-£25.
'Locomotive Engine and Train of the Birmingham and Liverpool Railroad', after S. Bourne, with R. Reeve (q.v.), 1825, 8 x 24½in/20 x 62.5cm, £300-£450 col.
'Touchstone, Winner of the Great St. Leger, 1834', after J.F. Herring, with C. Hunt, 14½ x 18¾in/37 x 47.5cm, and similar racehorse portraits, £400-£800 col.
'Battle of Navarin', after J.T. Lee, 2 pl. with H. Pyall, 1827, 21¼ x 24¾in/54 x 63cm, pair £1,200-£1,800 uncol., £2,000-£3,000 col.

SMETHAM, James
1821-1889
Victorian painter influenced by the pre-Raphaelites who etched a set of twelve studies from a sketch book in 1861.
£5-£15.

SMITH, Ankers
1759-1819
Etcher, line and stipple engraver of portraits and historical, allegorical and mythological subjects after his contemporaries and Old Master painters. He was born in London and died there. Most of his plates were executed for books.
Pl. for Boydell's Shakespeare, fo., e. £10-£25.
'Sir William Walworth Killing Wat Tyler', after J. Northcote, 1786, 17½ x 24in/44.5 x 61cm, £20-£50.
'The Duke of Wellington Giving Orders to His Generals Previous to a General Action', after and finished by T. Heaphy, 1822, 22 x 34in/56 x 86.5cm, £40-£100.
Lge. portraits £15-£40.
Pl. after Old Master painters, small portraits and bookplates small value.

SMITH, Benjamin
d.1833
Stipple engraver of portraits and historical, allegorical and biblical subjects after his contemporaries. Born in London, he was a pupil of F. Bartolozzi (q.v.).
Pl. for Boydell's Shakespeare, fo., e. £10-£25.
'Providence' and 'Innocence', from a set of 4 with 'Wisdom', by J.P. Simon (q.v.) and 'Happiness' by T. Burke (q.v.), all after J.F. Rigaud, 1799, 22½ x 16in/57 x 40.5cm, set £500-£800 prd. in col.
'George III Dismounted from his Horse', after Sir W. Beechey, 1804, 21 x 15in/53.5 x 38cm, £30-£80.
'William Hogarth', after W. Hogarth, 1795, 20 x 14in/51 x 35.5cm, £20-£50.
'Samuel and Eli', after J.S. Copley, 14 x 10in/35.5 x 25.5cm, £30-£60 prd. in col.
'The Annual Ceremony of Administering the Oath of Allegiance on November 8th, Preceding Lord Mayor's Day', after W. Miller, 1801, 22½ x 30½in/57 x 77.5cm, £40-£80.
'The Infant Shakespeare Attended by Nature in the Passions', after G. Romney, 1799, 23 x 17in/58.5 x 43cm, £10-£30.
'Resurrection of a Pious Family', after W.M. Peters, 17 x 12½in/43 x 32cm, £80-£160 prd. in col.

SMITH, Charles John
1803-1838
Line engraver of small bookplates including landscape and architectural views after his contemporaries. Born in Chelsea, he was a pupil of C. Hines and died in London.
Small value.

SMITH, C.N.
fl. mid-19th century
Aquatint engraver of sporting subjects after his contemporaries.
'The Cambridgeshire Stakes 1853', after S. Hawkin, 4 pl., 13¼ x 21in/35 x 53cm, set £1,500-£2,500 col.
'The St. Leger 1850', after H.T. Davis, 1850, 17¼ x 28 1/4in/45 x 72cm, £800-£1,200 col.
'Nancy' (racehorse), after A.F. de Prades, 1851, 17 x 26in/43 x 66cm, £300-£600 col.
'The Young Warrener', after G.A. Smith, 19¼ x 23½in/50 x 60cm, £250-£450 col.

SMITH, Edward
fl. mid-19th century
Line engraver mainly of bookplates including portraits, genre subjects and landscapes after his contemporaries and Old Master painters. He worked in London.
Small value.

SMITH, Frederick
fl. mid-19th century
Line engraver of small bookplates including architectural views after his contemporaries.
Small value.

SMITH, Gabriel
1724-1783
Line and stipple engraver of portraits and decorative subjects after his contemporaries and Old Master painters. He learnt stipple (or crayon manner) engraving in Paris and practised in England with the assistance of W.W. Ryland (q.v.).
'The Hen-Harrier', after Hayes, £50-£150 col.
Others mainly £10-£40.

SMITH, G.B.
fl. mid-/late 19th century
Line engraver of small bookplates including architectural views after his contemporaries.
Small value.

SMITH of Chichester, George 1714-1776
SMITH of Chichester, John 1717-1764
Brothers who painted and etched landscapes and rustic scenes after their own designs and Old Master painters. They were born in Chichester where they lived all their lives. Many of their paintings were reproduced by professional engravers. Their own etchings are somewhat crude.

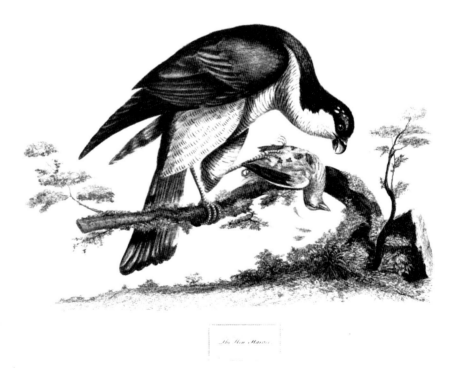

SMITH, Gabriel. 'The Hen-Harrier', after Hayes.

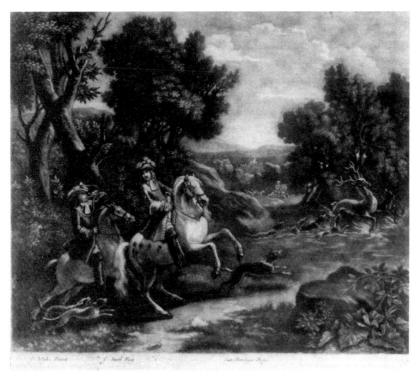

SMITH, John I. 'Deerhunting', after J. Wyke.

SMITH, John I. A typical half-length male portrait.

'A Collection of Fifty Three . . .' prints were issued by Boydell in 1770.
£5-£15.

SMITH, George Barnet 1841-1909
Journalist, biographer, amateur etcher of portraits and architectural views. Born in Yorkshire, he worked in London and died in Bournemouth.
Small value.

SMITH, Jacob fl. mid-18th century
Etcher and line engraver of portraits after his own designs.
Small value.

SMITH, James fl. mid-18th century
Line engraver of small bookplates including portraits after his contemporaries and Old Master painters.
Small value.

SMITH, John, of Chichester
see **SMITH, George, of Chichester**

SMITH, John I c.1652-1742
Eminent early mezzotint engraver of portraits and religious, allegorical and genre subjects after his contemporaries and Old Master painters. Born in Daventry, he learnt mezzotint engraving from I. Beckett (q.v.) and was later taught by J. van der Vaart. He was frequently employed by Sir Godfrey Kneller to engrave his paintings. He died in Northampton.
'The Quaker Meeting', after E. van Heemskerk, 9¾ x 7in/25 x 18cm, £20-£50.
'Deerhunting', after J. Wyke, 10¼ x 11¾in/26 x 30cm, £70-£140.
Religious subjects £5-£15.
Portraits: WL female £100-£300, WL male £70-£150, TQL male £30-£80, HL male £15-£60, but 'Thomas Tompion' (watchmaker), after G. Kneller, 13½ x 9¼in/34.5 x 25cm, £300-£600.

Small pl., e.g. 'William III', after G. Kneller, 7¾ x 5¾in/19.5 x 14.5cm, £8-£20.
A collection of 284 pl., probably assembled by the engraver for the original purchaser, good, fine and very fine imp., fetched £17,500 June 1988.
CS.

SMITH, John II fl. early 19th century
Scottish stipple engraver of portraits after 18th century painters and his contemporaries.
Small value.

SMITH, John Raphael. 'Miss Macaroni and her Gallant at a Print Shop', 1773. An early caricature by this master of the mezzotint medium.

SMITH, John III fl. mid-19th century
Line engraver of small bookplates including landscapes and historical subjects after his contemporaries.
Small value.

SMITH, John Orrin 1799-1843
Wood engraver of small book illustrations after his contemporaries and Old Master painters. He was a pupil of W. Harvey (q.v.) and F. Williams.
Small value.

SMITH, John Raphael 1752-1812
Portrait painter, miniaturist, print publisher, eminent mezzotint and stipple engraver of portraits and decorative subjects after his contemporaries and his own designs. Born in Derby, the son of a landscape painter, Thomas Smith of Derby, he came to London in 1767, scraping his first mezzotint in 1769. His first job as an engraver was working for Carington Bowles (q.v.) in St. Paul's Churchyard. Although very successful as an engraver, becoming Mezzotint Engraver to the Prince of Wales in 1784, he gave up the medium to draw chalk portraits in 1802. He published about 300 prints including many of his own engravings. He died in Doncaster.
Mezzotints except where otherwise indicated:
'Lady Caroline Montagu', after J. Reynolds, 1777, 20 x 14in/51 x 35.5cm, £200-£300.
'Love in Her Eye Sits Playing', after Rev. M.W. Peters, 1778, 14¼ x 15¾in/36 x 40cm, £400-£600.
'The Dream' and 'The Romance', after R. Westall, 1791, 9¼ x 11¼in/23.5 x 28.5cm, pair £300-£500.
'Miss Macaroni and her Gallant at a Print Shop', 1773, 14 x 9¾in/35.5 x 25cm, £500-£700.
'A. Carlini, F. Bartolozzi and G.B. Cipriani', after H. Rigaud, 1778, 16 x 18in/40.5 x 45.5cm, £200-£300.
'Mrs. Carnac', after J. Reynolds, 1778, 19 x

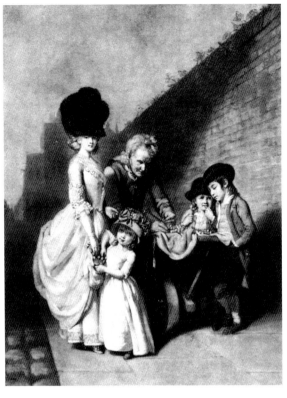

SMITH, John Raphael. 'The Fruit Barrow', after H. Walton. A classic 18th century decorative print.

SMITH, John Raphael. 'The Honble. Mrs. Stanhope', after J. Reynolds.

12in/48.5 x 30.5cm, £70-£140.
'Lord Richard Cavendish', after J. Reynolds, 1781, 18 x 14in/45.5 x 35.5cm, £30-£60.
'Lady Catherine Pelham Clinton', after J. Reynolds, 1782, 19¾ x 14in/50 x 35.5cm, £300-£500.
'The Honble. Mrs. Stanhope', after J. Reynolds, £200-£300.
'George, Prince of Wales' (WL standing with charger), after T. Gainsborough, 1783, 26 x 18in/66 x 45.5cm, £300-£500.
'Lady Hamilton as a Bacchante', after J. Reynolds, 1784, 10 x 8in/25.5 x 20.5cm, stipple, £300-£500 prd. in col.
'Edward Wortley Montagu in Eastern Dress', after Rev. M.W. Peters, 1776, 20 x 14in/51 x 35.5cm, £70-£140.
'Miss Mortimer as Hebe', after Rev. M.W. Peters, 16½ x 13in/42 x 33cm, 1779, £200-£300.
'Mr (Joseph) Banks', after B. West, 1773, 23½ x 15½in/60 x 39.5cm, first state, very good imp. fetched £4,000 May 1989.
'African Hospitality' and 'The Slave Trade', after G. Morland, 1791, 19 x 26in/48.5 x 66cm, pair £600-£1,000 prd. in col.
'Bannister and Parsons as Scout and Sheep Face in the Village Lawyer', after S. De Wilde, 24½ x 19½in/62 x 49.5cm, £150-£250.
'The Fruit Barrow', after H. Walton, £300-£500.
'The Corn Bin', after G. Morland, 1797, 23 x 31in/58.5 x 78.5cm, £300-£500 prd. in col.
'Delia in the Country' and 'Delia in the Town', after G. Morland, 1788, ovals, 9½ x 8½in/24 x 21.5cm, stipple, pair £600-£800 prd. in col.
'The Fortune Teller' and 'The Gamesters', by W. Ward, both after Rev. M.W. Peters, 1786, 14¼ x 17¼in/37.5 x 44cm, pair £400-£600.
'A Lady at Haymaking', after W. Lawrenson, oval, 20 x 14in/51 x 35.5cm, stipple, £300-£500 prd. in col.
'Macbeth and the Weird Sisters', after H. Fuseli, 1785, 18 x 22in/45.5 x 56cm, £80-£140.

'Snake in the Grass', after J. Reynolds, 1787, 8 x 10in/20.5 x 25.5cm, stipple, £10-£20
'Laetitia' series, after G. Morland, 1789, 6 pl., 14½ x 12in/37 x 30.5cm, stipple, set £900-£1,600 prd. in col.
'Visit to the Grandmother', after J. Northcote, 1785, 20½ x 16in/52 x 40.5cm, £150-£250 prd. in col.
'Benevolent Sportsman' and 'Sportsman's Repast', 1801, 17¾ x 22in/45 x 56cm, pair £800-£1,200 prd. in col.
'A Long Story', after H.W. Bunbury, 1782, 14 x 16¾in/35.5 x 42.5cm, stipple, £200-£300 prd. in col.
Most HL female portraits £30-£80, HL male portraits £15-£50.
CS.
Bibl: Frankau, J., *J.R.S.*, 1902.

SMITH, John Rubens 1775-1849
Painter, stipple and mezzotint engraver of portraits and decorative subjects after his contemporaries. Born in London he was the son and pupil of John Raphael Smith (q.v.) and also studied at the R.A. Schools. He emigrated to America in 1806, where he continued to engrave and also taught engraving. He died in New York.
'Crazy Jane', after S. Drummond, 1805, 21½ x 14¼in/54.5 x 37.5cm, £100-£200 prd. in col.
British portraits £8-£25.
American portraits, e.g. 'Lincoln', £300-£600; James Bowdoin £100-£200.

SMITH, John Thomas 1766-1833
Draughtsman and etcher of architectural and topographical views and antiquities. Born in London, he studied under Nollekens and at the R.A. Schools, later becoming a pupil of J.K. Sherwin (q.v.). He worked as a drawing master and as a portrait painter, and in 1816 was appointed Keeper of Prints and Drawings in the British Museum. He published several books for which he drew all the illustrations; he also

etched many of the plates as well which were then aquatinted by professional engravers. Best known of these are probably the 'Antiquities of London and its Environs', and the 'Antiquities of Westminster'.
'Etchings of Rural Scenery', e. £15-£50.
'Etchings of Remarkable Beggars, Itinerant Traders and other Persons of Notoriety in London and its Environs', 23 pl., 1815-1816, 7½ x 4½in/19 x 11cm, e £10-£30
'J.M.W. Turner, R.A., in the Print Room of the British Museum', c.1825, rare litho. made when Smith was Keeper of Prints at the BM, 8¾ x 7in/22.5 x 18cm, £100-£160.
Pl. for Antiquities of London and its Environs, *1800. fo., and* Antiquities of Westminster, *1807, fo., individually small value.*

SMITH, Percy John Delf 1882-1948
Painter, etcher and drypoint etcher of figure subjects and landscapes. He lived and worked in London, having studied at Camberwell and Central Schools of Art. He is best known for his etchings of World War I. He was also a calligrapher and book designer.
12 drypoints of the war, 1916-18, publ. 1925, edn. 12, set £800-£1,600.
Others £30-£80.
Bibl: Leake, S., 'War and Peace in the Etchings and Drawings of P.S.', *Bookman's Journal*, 1926, XIII, p.215.

SMITH, R. fl. mid-19th century
Stipple engraver of portraits after his contemporaries.
Small value.

SMITH, Samuel fl. late 18th/early 19th century
Line engraver of landscapes and animal, historical, allegorical subjects, etc., after his contemporaries and Old Master painters. He was apparently born in and died in London.

SMYTHE, Richard.
'The Royal Family', after
J. Lavery.

'The English Setter', after J. Milton, with
T. Cook (q.v.), 1768, 17½ x 22¼in/44.5 x 56.5cm,
£400-£600.
'The Death of Captain Cook', with
J. Thornthwaite (q.v.), 1791, 17¼ x 23¾in/44 x
60.5cm, £200-£400.
'A Storm', after P.J. de Loutherbourg, 1794, 15
x 21in/38 x 53.5cm, £50-£150.
'The Immortality of Garrick', after G. Carter
with J. Caldwell, 1783, 16¼ x 23¼in/42.5 x
59cm, £30-£60.
Landscape pl. after 17th century painters £50-
£150.

SMITH, Samuel S. 1809-1879
Line engraver of small bookplates, including
religious and genre subjects after his
contemporaries and Old Master painters. He
was born in and died in London.
Small value.

SMITH of Derby, Thomas d.1767
Landscape painter who etched a few plates
himself. Many of his paintings and drawings
were engraved by F. Vivares (q.v.) and other
professional engravers.
*4 views of the Lake District, lge. fo., set £600-
£1,200.
'Cullen Arabian' (racehorse), after T. Smith,
with W. Elliot (q.v.), 1758, 15¼ x 21¼in/39 x
54cm, £200-£400.*

SMITH, William fl. mid-18th century
Portrait and landscape painter, mezzotint
engraver of portraits and decorative subjects
after his contemporaries and Old Master
painters. Born in Guildford, he was a pupil of
W. Pether (q.v.). He apparently gave up
engraving to become a stockbroker and died

near Chichester.
*'Sport of Innocence' and 'Rural Felicity', after
P.J. de Loutherbourg, ovals, 13 x 17in/33 x
43cm, pair £200-£400.
HL portraits £15-£50.
CS lists 5 pl.*

SMITH, William Raymond
 fl. mid-19th century
Line engraver mainly of small bookplates after
his contemporaries, including landscapes,
topographical views and animal subjects. He

lived and worked in London.
Small value.

SMYTH (Smythe), John Talfourd 1819-1851
Scottish line engraver of small bookplates,
including portraits, topographical views and
historical subjects after his contemporaries.
Born in Edinburgh, he studied art at the Trustees
Academy but taught himself to engrave. He
worked in Glasgow and Edinburgh, dying at an
early age from overwork.
Small value.

SMYTHE (Smythe), Frederick Coke
 fl. mid-19th century
Draughtsman and lithographer of topographical
views. He travelled extensively through Europe,
the Middle East, North America, etc. and later
lived in London and Brighton.
*'Sketches in the Canadas', 1840, 23 tt. pl. (inc.
title), set £4,000-£6,000 col.
Pl. for C. Bentley and R.M. Schomburgk's
Twelve Views in the Interior of Guiana, 1841, tt.
pl., e. £200-£400 col.*

SMYTHE, Richard b.1863
Portrait painter, mezzotint engraver of portraits
after British 18th and early 19th century
painters and his contemporaries. Born in
Derbyshire, he studied at the Manchester
School of Art and worked in London and
Middlesex.
*'The Royal Family', after J. Lavery, £60-£120.
Others mostly £30-£80 prd. in col., £10-£30 b.
& w.*

SNAPE, Martin
 fl. late 19th/early 20th century
Genre and animal painter who etched a few
views of his native Hampshire and contributed
several plates to *English Etchings*.
Small value.

SOIRON, François Davide d.1813
Swiss stipple engraver of decorative and genre
subjects and some military costumes after his
contemporaries. Born in Geneva, he worked in
London for a few years and died in Paris.
*'St. James's Park' and 'A Tea Garden', after
G. Morland, 1805, ovals, 12¼ x 15½in/32.5 x
39.5cm, pair £1,500-£3,000 prd. in col.*

SOIRON, Francois
Davide. 'A Tea Garden',
pair with 'St. James's
Park', after G. Morland,
1805.

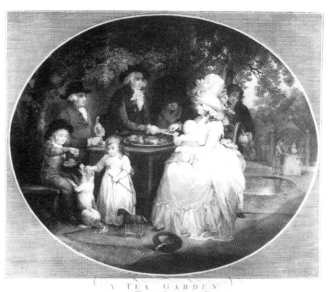

SOMERVILLE, DANIEL. 'Portrait of a Man with Foliage in his Hat', 1811, lithograph.

'*The Promenade in St. James's Park*', *companion to 'An Airing in Hyde Park', by T. Gaugain (q.v.), after E. Dayes, 1793, 15¼ x 25½in/40 x 65cm, pair £2,000-£4,000 prd. in col.* '*British Army Costumes', after H.W. Bunbury, 1791, 8 pl., 16¼ x 11½in/41.5 x 29.5cm, e. £70-£140 prd. in brown.* '*Village Dance of an Italian Family' and 'Fatal Effect of a Roman Quarrel', both after G. Grignion, 1790, 14 x 17½in/35.5 x 44.5cm, pair £100-£200.* Colour plate page 61.

SOLOMON, Simeon 1840-1905
Pre-Raphaelite painter who etched a few rare plates.
1 pl. for Portfolio of Illustrations of Thomas Hood, *publ. by the Junior Etching Club, 1858, etching, £10-£25.*

SOLY, Arthur fl. late 17th century
Line engraver of portraits and sporting subjects after his contemporaries.

SOPER, George.
A typical rural subject.

Pl. for R. Blome's Gentlemen's Recreation, *after various artists, 1686, 4to., e. £15-£40.* *Portraits small value.*

SOMERVILLE, Daniel
 fl. late 18th/early 19th century
Line and wood engraver and lithographer who worked in Edinburgh. The two prints noted are extremely rare.
'*The Brooding Patriarch', 1820, 11¼ x 9½in/28.5 x 24.5cm, wood eng., £300-£600.* '*Portrait of a Man with Foliage in his Hat', 1811, 3 x 2in/7.5 x 5.5cm, litho., £100-£200.*

SOMERVILLE, Howard 1873-1952
Scottish painter and etcher of portraits, figure subjects and interiors. He was born in Dundee, where he studied at the Technical and University Colleges. He worked in Glasgow, New York and London.
£15-£40.

SOPER, Eileen Alice b.1905
Painter and etcher of figure subjects, particularly featuring children. Born in Enfield, she was the daughter of G. Soper (q.v.) and lived in Hertfordshire.
Generally £60-£140, but 'Cricket', 4¼ x 8¾in/ 11 x 22cm fetched £160 Dec. 1995.
Bibl: Salaman, M.C., 'Miss E.S.'s Etchings, 1923', *Studio*, 1923, LXXXV, p.262.

SOPER, George, R.E. 1870-1942
Painter, etcher and wood engraver of rustic scenes and townscapes. Born in London, he studied at Ramsgate and lived in Hertfordshire. He was the father of E.A. Soper (q.v.).
£50-£100.
Bibl: Salaman, M.C., 'Etching and Drypoints of G.S.', *Studio*, 1920, LXXX.

SOUTER, John B. b.1890
Painter and etcher of figure subjects.
£20-£50.

SOWERBY, George Brettingham 1788-1854
Draughtsman and lithographer of natural history subjects. He was the son of J. Sowerby (q.v.). All his work seems to consist of small bookplates.
Small value.

SOWERBY, James 1757-1822
Draughtsman and line engraver of botanical subjects. He studied at the R.A. Schools and was the father of G.B. and J. de C. Sowerby (qq.v.). All his work seems to consist of small bookplates.
Small value.

SOWERBY, James de Carle 1787-1871
Draughtsman and line engraver of natural history bookplates. He was the son of J. Sowerby (q.v.). All his work seems to consist of small bookplates.
Small value.

SPARKS, Nathaniel, R.E. 1880-1957
Watercolourist and etcher of landscapes, architectural views, figure subjects and portraits. Born in Bristol, he studied at the School of Art there and at the R.C.A. under F. Short (q.v.). He lived in London and Hampshire.
£30-£80.

SPARROW, S. fl. late 18th/early 19th century
Line engraver of small bookplates including landscapes and topographical views after his contemporaries.
Small value.

SPENCE, Robert, R.E. 1871-1964
Etcher of historical subjects. Born in Northumberland, he studied at Newcastle School of Art, the Slade and in Paris. He lived in London.
£30-£80.
Bibl: Gibson, F., 'Etchings of R.S.', *Studio*, 1917, LXIX, p. 29.

SPENCER, Gervais d.1763
Miniaturist, etcher of a few small portraits after his contemporaries and his own designs.
Small value.

SPENCER, Noel Woodward b.1900
Illustrator, painter and etcher of architectural and topographical views. Born at Nuneaton, he studied at Ashton-under-Lyne and Manchester School of Art as well as at the R.C.A. He taught at several art schools, eventually becoming Principal of Norwich Art School.
£15-£40.

SPENCER, Sir Stanley, R.A. 1891-1959
Important modern British painter who produced a few lithographs in the early 1950s.
'*Retrieving a Ball', c.1953, 15½ x 20½in/39.5 x 52cm, £3,000-£5,000 prd. in col.* '*Marriage at Cana', 1953, 20½ x 17in/52 x 43.5cm: signed imp. from uncompleted edn. of 30 £800-£1,600; posthumous edn. of 75 £300-£500.*

SPICER, fl. late 18th century
Mezzotint engraver of portraits after his contemporaries.
'*Barbara, Countess of Coventry', after J. Reynolds, 13¾ x 9¾in/35 x 25cm, £50-£100.* '*Katherine Trapaud', after J. Reynolds, 5 x 4½in/12.5 x 11.5cm, £10-£30.*
CS lists 2 pl., noted above.

SPILSBURY, John 'Inigo' b.1730
Etcher and line engraver of landscapes, antiquities, etc. He also worked as drawing master in a Paris school and was the brother of J. Spilsbury and uncle of M. Spilsbury (qq.v.).
Small value.

SPENCER, Stanley. 'Marriage at Cana', 1953, from uncompleted edition of thirty.

SPILSBURY, Jonathan
fl. late 18th/early 19th century
Mezzotint engraver of portraits and genre, biblical and decorative subjects, after his contemporaries and Old Master painters. He was the brother of J.I. Spilsbury and father of M. Spilsbury (qq.v.).
'Miss Jacobs', after J. Reynolds, 1762, 18 x 14in/45.5 x 35.5cm, £150-£300.
'Augusta Charlotte', after A. Kauffmann, 22¾ x 16¾in/58 x 42.5cm, £200-£400.
'Mrs. Richards', after T. Gainsborough, oval, 12½ x 10in/32 x 25.5cm, £80-£160.
'Thomas Bradbury', after M. Grace, oval, 6¼ x 4in/16.5 x 10cm, £5-£10.
'Benjamin West', oval, 9 x 5in/23 x 12.5cm, £30-£60.
'John Bunyan', after T. Sadler, 14 x 9¾in/35.5 x 25cm, £60-£120.
'John Wesley', after G. Romney, 1789, 12¼ x 9in/32.5 x 23cm, £60-£120.
Various male HLs £15-£40.
Religious subjects and pl. after Old Master painters £10-£30.
CS.

SPILSBURY, Maria 1777-1823
Landscape, genre and portrait painter who made

a few etchings. She was the daughter of J. Spilsbury and niece of J.I. Spilsbury (qq.v.).
Small value.

SPINELLI, Raphaeli fl. late 19th century
Italian etcher of genre and sentimental subjects after his Continental and British contemporaries.
Small value.

SPOONER, Charles d.1767
Irish mezzotint engraver of portraits and genre and decorative subjects after his contemporaries and Old Master painters. Born in County Wexford, he studied engraving in Dublin where he practised from 1749 to 1752. He then moved to London, living there until his death.
'The Four Times of Day', after W. Hogarth, 14 x 10in/35.5 x 25.5cm, set fetched £900 May 1989.
'Earth', after R. Pyle, 1768, 14 x 10in/35.5 x 25.5cm, £60-£100.
Pl. after Old Master painters £5-£15.
Portraits £10-£30.
CS.

SPOWERS, Ethel 1890-1947
Colour linocut artist in the school of W.C. Flight

(q.v.).
'Wet Afternoon', 1929, £600-£1,000.
'The Plough', 1933, 8 x 12½in/20.5 x 31.5cm, fetched £1,300 June 1996.

SPREAT, William fl. mid-19th century
Painter, draughtsman and lithographer mainly of West Country views. He worked in Exeter and was also a publisher of prints.
'Six Sketches Illustrative of the South Devon Railway', after W. Dawson, 1848, 12¼ x 20in/31 x 51cm, set £2,000-£3,000 prd. in col.
Smaller versions of above e. £50-£100.
West Country views £10-£25.
'India in the Vicinity of Bombay', after Major Pouget, fo., 7 tt. pl., e. £30-£80.

SQUIRRELL, Leonard Russell, R.W.S., R.E. 1893-1979
Etcher and aquatint engraver of landscapes and architectural views. Born in Ipswich, he studied at the School of Art there as well as at the Slade. £30-£80.

STACEY, Doris M. fl. early/mid-20th century
Etcher of figure subjects.
£10-£30.

STACK, W. fl. early 19th century
Aquatint engraver.
'Exeter College Eight on the Isis, Oxford', after W. Turner of Oxford, 1824, 11¼ x 19¼in/28.5 x 49cm, £300-£600 col.
Small bookplates small value.

STACKPOOLE, Frederick, A.R.A. 1813-1907
Notable line, mezzotint and mixed-method engraver of portraits and genre, military and sentimental subjects after his contemporaries. A student of the R.A. Schools, he worked in London.
'A Drawing Room at St. James's Palace in the Reign of Victoria', after J. Barrett, 1869, 23 x 42in/58.5 x 106.5cm, £200-£400.
'Hunting', after R. Ansdell, 1857, 14 x 26in/35.5. x 66cm, £200-£400.
'The Scotch Gamekeeper' and 'The English Gamekeeper', after R. Ansdell, 1858, 28 x 20in/71 x 51cm, pair £200-£400.
'The Shadow of Death', after W. Holman Hunt, 1878, 31½ x 24½in/80.5 x 62.5cm, £100-£200.
'Sympathy', after B. Riviere, 25½ x 21½in/65 x 54.5cm, and other sentimental subjects of similar size after the same, £20-£50.
'Roll-Call 1874', after E. Thompson, Lady Butler, 20 x 40in/51 x 101.5cm, and other military subjects of similar size after the same, £200-£400.
'Crossing the Tay', after F. Tayler, 1880, 25¼ x 35½in/65.5 x 90cm, £200-£400.
Add more if in fine contemporary frame.

STADLER, Joseph Constantine fl. late18th/early 19th century
Prominent and prolific aquatint engraver of topographical views, marine, military, sporting and decorative subjects and portraits after his contemporaries. Of German extraction, he worked in London.
'Woburn Sheepshearing', after G. Garrard, with M.N. Bate, T. Morris and Garrard (qq.v.), 1811, 18½ x 30in/47 x 76cm, £400-£600.
'The View of the Horseguards from Whitehall', after T.H. Shepherd, 1816, 17½ x 20½in/44.5 x 52.5cm, and other London views of similar size, £600-£1,200 col.
'The London Volunteer Cavalry and Flying

SPREAT, William. A plate from 'Six Sketches Illustrative of the South Devon Railway: Viaduct Over the Valley of The Erme at Ivy Bridge', 1848.

Artillery as Reviewed in Hyde Park', after Cranmer, with S. Mitan (q.v.), 1805, 18½ x 19½in/47 x 49.5cm, £300-£500 col.
Pl. for Ackermann's Oxford, *1814,* Cambridge, *1815, and* Public Schools, *1816, e. £20-£60 col.*
Pl. for T. Rowlandson and A.C. Pugin's Microcosm of London: law courts, *e. £30-£70; others £20-£60.*
Pl. for R.K. Porter's Letters from Portugal and Spain, *1809, 8vo., sepia aq., small value.*
Pl. for J. and J. Boydell's History of the River Thames, *after and etched by J. Farington (q.v.), 1794-6, fo., e. double pl. £100-£250 col., single £30-£70 col.*
'George III', after Rosenberg, 1812, 8¾ x 6½in/22 x 16.5cm, £25-£40 col.
'The Royal Review, in Hatfield Park', after and etched by R. Livesay, 1802, 18 x 26½in/45.5 x 67.5cm, £500-£800 col.
'A View of the High Street, Birmingham', after and etched by T. Hollins, 23 x 31½in/58.5 x 80cm, £600-£1,200 col.
'The Blue Egyptian Water-Lily' after P. Henderson, from Thornton's Temple of Flora, *1804, 20¼ x 15½in/52.5 x 40cm, £300-£500 prd. in col. and col.*
'Large Flowering Sensitive Plant', after P. Reinagle, from Thornton's Temple of Flora, *1799, 18½ x 14in/47 x 35.5cm, £600-£1,000 prd. in col. and col.*
Pl. for T. Girtin's Picturesque Views in Paris, *1803, obl. fo., e. £50-£100 prd. in sepia.*
Pl. for C. Willyams' A Voyage up the Mediterranean, *1802, 41 pl., 4to., e. £10-£25 col.*
Pl. for G. Heriot's Travels to the Canadas, *1807, fo., £20-£40.*
Pl. for W. Combe's Wars of Wellington, *30 pl. etched by W. Heath, 1819, 4to., e. £10-£25 col.*
Pl. for J. Laporte and G. Walker's Four Views

of Ramsgate, Margate and Broadstairs, *1809, obl. fo., e. £30-£70 uncol.*
Pl. for H. Repton's Brighton Pavilion, *1808, fo., 12 pl., e. £50-£100 col., set col. fetched £1,450 April 1989.*
'The Admiral Mitchell and a French Flotilla, Oct. 31 1803', both after J. Livesay, 14 x 21in/35.5 x 53.5cm, pair £400-£600 col.
'View at Lynn', after and etched by J. Farington, 9 x 10in/23 x 25.5cm, and other experimental pl. by the two, £80-£160.
Pl. after A. Buck £70-£150 prd. in col.
Colour plates pages 62 and 63.

STAINES, Robert 1805-1849
Line engraver of small bookplates, including historical subjects, after his contemporaries. A pupil of J.C. Edwards (q.v.), he was apprenticed to the Findens (qq.v.).
Small value.

STAINFORTH, Martin F.
fl. late 19th century
Line engraver of religious and genre subjects after his contemporaries and Old Master painters. He worked in London and later emigrated to Australia.
Small value.

STAINIER (Stanier), R.
fl. late 18th/early 19th century
Stipple engraver of portraits and decorative subjects after his contemporaries. He worked in London.
'Mary, Duchess of Rutland', after Stuker, 1780, oval, 18¼ x 14½in/46.5 x 37cm, £100-£150 prd. in sepia or in col.
'The Recruiting Officer', after F. Wheatley, 19 x 14in/48.5 x 35.5cm, £150-£250 prd. in col.
'Lindor and Clara', after F. Wheatley, 1789, 17

x 30½in/43 x 77.5cm, pair £200-£400 prd. in col.
Small bookplates and portraits small value.

STALKER, Ebenezer
fl. early/mid-19th century
Line engraver of portraits and military and sporting subjects, etc., after his contemporaries and 18th century painters.
'The Death of Colonel Moorhouse at the Storming of Bangalore', after R. Home, 1811, 20½ x 24½in/52 x 62cm, and other lge. pl., £200-£400.
Add more if in fine contemporary frame.
'Lord's Cricket Ground', after G.H. Laporte, 5 x 7½in/12.5 x 19cm, £50-£150.
Small portraits and bookplates small value.

STAMP, Ernest, A.R.E. 1869-1942
Etcher and mezzotint engraver of portraits after 18th and early 19th century British painters, and of landscapes, topographical views and sentimental and genre subjects after his contemporaries and his own designs. Born in Yorkshire, he was a pupil of H. Herkomer (q.v.).
'View of Trinity College, Cambridge', after F. Barraud, 1891, £50-£150.
Mezzo. portraits £20-£60 prd. in col.
Others mostly £8-£20.

STANNARD, Joseph 1797-1830
Painter and etcher of coast, river and rustic scenes. Born at Norwich, he was a pupil of R. Ladbrooke (q.v.) and became a member of the Norwich Society. He was one of the better etchers of the Norwich School. Only 12 etchings by him are known.
£50-£150.
Bolingbroke.

STANNARD, Joseph. A typical etching of a rustic scene.

STARK, James 1794-1859
Norwich school painter and etcher of
landscapes. Born in Norwich, he was
apprenticed to J. Crome (q.v.) in 1811 and was
elected a member of the Norwich Society in
1812. He also later studied at the R.A. Schools.
He worked in Norwich, London and Windsor.
*Mostly £15-£50; rare trial proof of unpubl.
etching £80-£160.*
*'Scenery of the Rivers of Norfolk', 1834, 4to, 35
pl., set £150-£250.*
Bolingbroke.

STARLING, J. and M.J. fl. mid-19th century
Line engravers of small bookplates including
landscapes and topographical views after their
contemporaries. They were members of a large
family of engravers.
Small value.

STARLING, William Francis
 fl. mid-19th century
Line, stipple and mezzotint engraver of
landscapes and topographical views, genre
subjects and occasional portraits after his
contemporaries. He was a member of a large
family of engravers and worked in London.
*'Admonition, Jenny and Effie Deans', after E.K.
Johnson, 1863, 18 x 24in/45.5 x 61cm, and other
lge. pl., £20-£80.*
Add more if in fine contemporary frame.
Small bookplates and portraits small value.

STEEL, Kenneth 1906-1970
Watercolourist, line engraver and lithographer
of landscapes and architectural views. Born in

Sheffield, he studied at the College of Art there.
£30-£70.

STEELE, Louis John
 fl. mid-/late 19th century
Etcher and line engraver of genre and
sentimental subjects after his contemporaries.
He worked in London.
*'Napoleon on Board the Bellerophon', after
W.Q. Orchardson, 1881, 23½ x 35in/59.5 x
89cm, £30-£80.*
*'His Only Friend', after B. Riviere, 1882, 12 x
18in/30.5 x 45.5cm, and other sentimental
subjects of similar size, £20-£60.*
Add more if in fine contemporary frame.
Others small value.

STEPHENS, Geoffrey Howard b.1899
Book illustrator, painter, etcher, engraver and
lithographer of landscapes and architectural
views. He studied at Chelsea School of Art and
at Goldsmiths' College School of Art. He lived
in Cardiganshire.
£15-£50.

STEPHENSON, James 1808-1886
Etcher, line and mezzotint engraver of
landscapes, topographical views, portraits and
genre and sentimental subjects after his
contemporaries and 18th century painters. Born
in Manchester, he went to London, after an
apprenticeship to a local engraver, to work for
W. Finden (q.v.). He lived in London and
Manchester, working at first on book
illustrations and later on larger single plates. He
died in London.

*'Ophelia', after J.E. Millais, 1866, 20½ x
34in/52 x 86.5cm, £300-£500.*
*'Queen Victoria at Osborne', after E. Landseer,
1871, 21 x 34in/53.5 x 86.5cm, £300-£500.*
*'Taming of the Shrew (The Pretty
Horsebreaker)', after E. Landseer, 1864, 20¼ x
34½in/52.5 x 87.5cm, £150-£250.*
*'My Ain Fireside', after T. Faed, 1861, 24¼ x
18¾in/61.5 x 47.5cm, £40-£100.*
*'The Baptism of Our Lord', after R. Dowling,
1865, 27 x 18in/68.5 x 45.5cm, £16-£35.*
Lge. portraits £16-£40.
Add more if in fine contemporary frame.
Small portraits and bookplates small value.

STERNBERG (Sternburgh), Frank
 1858-1924
Mezzotint engraver of portraits and genre and
sentimental subjects after 18th century British
painters, his contemporaries and his own
designs. A pupil of H. Herkomer (q.v.), he
worked in London and in Leeds.
*'In Fairyland', after C.E. Halle, 1891, 24¼ x
14½in/63 x 37cm, and other lge. subjects, £20-
£60.*
*'Samuel Montague Butler', after H. Herkomer,
18 x 14in/5.5 x 35.5cm, and other lge. portraits,
£15-£30.*
Add more if in fine contemporary frame.
Others small value.

STEVENS, Francis 1781-1823
Watercolourist who etched a volume of plates
depicting English cottages and farmhouses
which he published in 1815.
Small value.

STOCK, C.R. 'Changing Horses at the Plough', pair with 'The Halt at the Black Swan', after H.G. Alken.

STEVENSON, F.G.
fl. late 19th/early 20th century
Etcher and mixed-method engraver of portraits, landscapes and topographical views, genre, sentimental and religious subjects after his contemporaries, 18th century British painters and Old Master painters.
'Rugby School, Big Side Football', after T.H. Hemy, and 'Rugby School - New Big Side Cricket', after H.J. Brooks, both 1890, both 21 x 14in/53.5 x 35.5cm, e. £100-£200.
Other public school views £30-£70
Others small value.

STEWART, Ethel, A.R.E. fl. early 20th century
Etcher of landscapes. She lived in Truro, Cornwall.
£10-£30.

STEWART, James 1791-1863
Scottish line and aquatint engraver of genre, historical and occasional sporting subjects after his contemporaries. Born in Edinburgh, he was a pupil of R. Scott (q.v.) and moved to London in 1830. Unable to make a living there, he emigrated in 1833 to South Africa where he remained for the rest of his life.
Lge. line eng. mostly £30-£80; add more to these if in fine contemporary frame.
'Coursing', after D. Wolstenholme, 1823, 4 pl., 3 by T. Sutherland (q.v.), 1 by Stewart, 9½ x 13in/24 x 33cm, aq., set. £600-£1,000 col.
Small bookplates small value.

STEWART, John fl. early/mid-19th century
Stipple engraver.
'Miss Paton', 1823, 18 x 13¼in/45.5 x 33.5cm, £40-£60 prd. in col.

STEWART, Robert
fl. late 18th/early 19th century
Mezzotint engraver and publisher of portraits after his own designs and those of his contemporaries.

'James Ferguson', after J. Townsend, 1776, 14 x 9¾in/35.5 x 25cm, and other portraits of similar size, £15-£40.
Small portraits £2-£8.
CS lists 13 pl.

STOCK, C.R. fl. late 19th century
Aquatint and occasional mixed-method engraver of sporting and coaching subjects after his contemporaries.
'The Up Journey', 'The Halfway Change', and 'The Down Journey', after L.A.S. Douglas, 1881, 3 vignettes on 1 pl., 10¼ x 22¼in/26 x 58cm, aq., £100-£200 col.
'Dodgson's Coaching Incidents', after T.N.H. Walsh, 1881, 4pl., 18¼ x 32¼in/46.5 x 82cm, aq., set £1,000-£2,000 col.
Dodgsons Racing Incidents', after T.N.H. Walsh, 1887, 4 pl., 8½ x 14in/21.5 x 35.5cm, aq., set £600-£1,000 col.
'The Seasons' (coaching scenes), after W.J. Shayer, 1886, 4 pl., 8½ x 25½in/21.5 x 64.5cm, aq., set £600-£1,000 col.
'Cock Fighting', after H. Alken, 1892, 4 pl., 7 x 8½in/18 x 22cm, aq., set £80-£160 col.
'Changing Horses at the Plough' and 'The Halt at the Black Swan', after H.G. Alken, 1882, 15¼ x 26½in/40 x 67.5cm, aq., pair £600-£1,000 col.
'North Country Jockeys', after G. Veal, 1887, 19½ x 36in/49.5 x 91.5cm, mixed method eng., £300-£500.

STOCKS, Bernard fl. late 19th century
Mezzotint engraver of sentimental and genre subjects after his contemporaries. He was the son of L. Stocks (q.v.) and worked in London.
'Sermon Time', after A. Stocks (his brother), 1881, 40¼ x 23½in/102 x 59.5cm, £20-£60.
Add more if in fine contemporary frame.

STOCKS, Lumb, R.A. 1812-1892
Line engraver of religious, genre and historical subjects and portraits after his contemporaries and Old Master painters. Born in Yorkshire, he

was apprenticed in 1827 to C. Rolls (q.v.) and worked for him in London for six years. He died in London.
'The Meeting of Wellington and Blucher After Waterloo', 1872, and 'The Death of Nelson', 1875, both after D. Maclise, 15½ x 47¼in/39.5 x 120cm, e. £30-£80.
'The Dame School', after T. Webster, 1849, 16¼ x 29¼in/41.5 x 74.5cm, £60-£120.
Add more if in fine contemporary frame.
Magazine and bookplates small value.

STODART, Edward Jackson 1879-1934
Stipple engraver of portraits and decorative subjects after 18th century British painters and his contemporaries. The son of E.W. Stodart (q.v.), he lived and worked in Essex. His engravings are mostly found printed in colours.
£15-£50 prd. in col.

STODART, Edward William 1841-1914
Stipple engraver of portraits and sentimental and allegorical subjects after paintings and sculptures by his contemporaries. He was probably the son of G.J. Stodart and was the father of E.J. Stodart (qq.v.). He engraved several plates for *The Art Journal*.
Small value.

STODART, George J. d.1884
Line and stipple engraver of portraits and sentimental and allegorical subjects after his contemporaries and 18th century British painters. He was probably the father of E.W. Stodart (q.v.). Much of his work consisted of bookplates.
Small value.

STOKES, George Vernon 1873-1954
Painter and drypoint etcher of animal subjects and birds. Born in London, he lived in the Lake District and later in Kent. He also worked as an illustrator of magazines and books.
£50-£100 b. & w., £100-£200 prd. in col.

STOTHARD, Thomas. 'The Lost Apple', 1803.

STOKES, J. fl. mid-19th century
Line engraver of small bookplates including landscapes and topographical views after his contemporaries.
Small value.

STONE, Frank, A.R.A. 1800-1859
Portrait and genre painter who etched a few plates. He was a member of The Etching Club and contributed plates to *The Songs of Shakespeare.*
Small value.

STONEHOUSE, Charles fl. mid-19th century
Etcher of figure subjects, who contributed a plate to The Etching Club, 1944.
£10-£20.

STORER, James Sargant 1771-1853
Draughtsman and line engraver of architectural views and antiquities. Born in Cambridge, he later moved to London. He was assisted by his son, Henry Sargant Storer (1797-1837), in several of his publications.
Views of Trinity College, c.1840, 10 pl., fo., and other Cambridge and London views of similar size, £15-£40.
Small bookplates and pl. of antiquities small value.

STOREY, Harold 1888-1965
Scottish painter and etcher of landscapes and architectural views. He lived and worked in Glasgow.
£10-£30.

STORM, G.F. fl. mid-19th century
Line engraver of small bookplates including portraits and architectural outlines after his contemporaries.
Small value.

STOTHARD, R.T. fl. early/mid-19th century
Draughtsman and lithographer of portraits.
Small value.

STOTHARD, Thomas, R.A. 1755-1834
Well-known illustrator and historical and portrait painter who produced the following early lithograph and two etchings:

'The Lost Apple', 1803, litho. publ. in Specimens of Polyautography, 1803 and 1806, 12 x 8½in/30.5 x 22cm, £200-£400; on original mount £400-£700.
'William Blake, T. S. and Mr Ogleby in Custody on the Medway', rare etching, c.1789, 8 x 9⅝in/20.5 x 24.5cm, fetched £1,900 Dec. 1993.
'The Wellington Shield - Centrepiece', 1820, etch. and eng., 24 x 23in/61 x 58.5cm, fetched £12,000 June 1994 (in elaborate carved and gilded frame).

STOW, James fl. late 18th/early 19th century
Line engraver of portraits, landscapes and figure subjects. Born near Maidstone, the son of a labourer; he was apprenticed to W. Woollett (q.v.) and, on the latter's death, to W. Sharp (q.v.) to whom he became an assistant. He failed to live up to his early promise and died a poor man.
Pl. for Boydell's Shakespeare, *fo., e. £10-£25.*
Portraits and small bookplates small value.

STRANG, David b.1887
Portrait painter and master printer of etchings, who also produced a few plates himself. Born in Dumbarton, he was the son of W. Strang and brother of I. Strang (qq.v.). He studied in Glasgow and lived in London.
£30-£70.

STRANG, Ian, R.E. 1886-1952
Draughtsman and etcher of architectural views. Born in London, he was the son of W. Strang (q.v.). He studied at the Slade and in Paris, and lived in Buckinghamshire.
£40-£90.
Bibl: Walker, R.A., 'The Etchings of I.S.', *P.C.Q.*, 1931, XVIII, p.129.

STRANG, William, R.A., R.E. 1859-1921
Scottish portrait painter, prolific etcher and engraver in aquatint, and occasionally in mezzotint and on wood, of portraits and figure subjects. Born in Dumbarton, he came to London in 1875 where he studied at the Slade under A. Legros (q.v.). The father of D. and I. Strang (qq.v.), he lived in London and later in Bournemouth. While his work in oils has been recently reappraised, it seems likely that his prints will find few collectors at the present time. Technically excellent, they all too often lack any inspiration and their grim atmosphere becomes monotonous.
'Socialists' £100-£200.
'A Print Auction', 1889, £400-£600.
'Portrait of Rudyard Kipling with Puppets' £200-£400.
Others mainly £20-£80.
Bibl: Binyon, L., 'Etchings and Engravings of W.S.', *P.C.Q.*, 1921, VIII, p.349; Strang, D., *W.S. Catalogue of Etchings and Engravings,* Glasgow, 1962.

STRANGE, Sir Robert 1721-1792
Etcher and line engraver of portraits and religious, classical and allegorical subjects mainly after Old Master painters. Born in the Orkneys, he was a pupil of R. Cooper I (q.v.) in Edinburgh and also trained in the studio of J.P. LeBas in France in 1749. His stated aim was to reproduce works by the great Italian masters for the British public, and he travelled in Italy from 1760 to 1764 copying paintings. The technical excellence of his engravings was much admired in the 18th century and Strange was knighted in 1787 for his engraving of Benjamin West's 'Apotheosis of the Princes Octavius and Alfred'. Today, however, these reproductive engravings are neglected due to dullness of subject matter.
'Charles I' (standing before his horse), WL, after A. Van Dyck, 22¼ x 17½in/58 x 45cm, £80-£160.
'Apotheosis of Princes Octavius and Alfred', after B. West, 22¼ x 16¾in/58 x 42.5cm, £60-£140.
'Le Retour du Marché', after P. Wouvermans,

STRANG, William. 'A Print Auction', 1889.

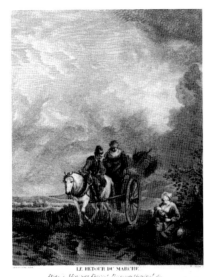

STRANGE, Robert. 'Le Retour du Marché', after P. Wouvermans. A typical reproductive engraving.

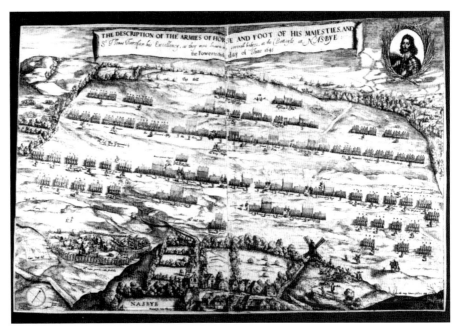

STREETER, Robert. 'The Description of the Armies...at the Battayle at Nasbye...June 1645'.

£15-£40.
Others mostly £5-£25.
Bibl: Leblanc, *Catalogue de L'Oeuvre de R.S., Graveur,* 1848.

STREET, T.C. fl. late 18th century
Mezzotint engraver of decorative subjects after his contemporaries.
'The Wandering Sailor' and 'The Market Girl', after H. Singleton, 1798, 19¼ x 16¾in/50 x 42.5cm, pair £250-£450.

STREETER, Robert fl. mid-17th century
Draughtsman and etcher.
'The Description of the Armies . . . at the Battayle at Nasbye . . . June, 1645', 20 x 30¼in/50.5 x 78cm, £300-£500.

STRUTT, Alfred William, A.R.E. 1856-1924
Genre, animal and portrait painter who etched a few plates.
Small value.

STRUTT, Jacob George 1790-1864
Landscape and portrait painter, draughtsman and etcher of topographical views and studies of trees. He published three series of prints.
Views of Bury St. Edmunds, 1821; 'Sylva Britannica', 1822, and 'Sylvarum Deliciae', 1828, fo., e. pl. from these series £10-£30.

STRUTT, Joseph 1749-1802
Line, stipple and mezzotint engraver of portraits and decorative subjects after his contemporaries. Born in Chelmsford, Essex, he was apprenticed to W.W. Ryland (q.v.) and studied at the R.A. Schools. He is best known as a writer on art, illustrating his books with his own engravings. His biographical *Dictionary of Engravers*, published 1785-6, was one of the earliest English works of its kind. He died in Hatton Garden, London.
'The Innocent Strategem' and 'The Power of Innocence', after T. Stothard, 1792, 13½ x 14½in/34.5 x 36.5cm, stipples, pair £200-£400, prd. in col. or in sepia.
Similar decorative prints e. £60-£140 prd. in

col. or in sepia.
'Elizabeth Bull', after H. Hamilton, 13¾ x 9¾in/35 x 25cm, mezzo., £20-£60.
Bookplates small value.
CS lists 1 mezzo. portrait, noted above.

STUBBS, George, A.R.A. 1724-1806
Important and famous animal painter. He illustrated his *The Anatomy of the Horse*, 1766, with his own engraved plates, as well as engraving several animal and rustic genre subjects in mixed method after his own designs. His first engravings were illustrations to John Burton's *An Essay Towards a Complete New System of Midwifery*, 1751. For *The Anatomy of the Horse* he was obliged to make all the eighteen plates after his own drawings based on his dissection of carcasses because he could find no engraver willing to take on the task.

He produced no more prints until 1777 when he engraved a series of 18 separate plates, mostly between 1788 and 1791. The first two consisted of etching reinforced by line

engraving. The next few plates consisted of a combination of various different engraving media, including mezzotint, soft ground, aquatint, line and stipple. These represent the most important British artist-engraver's experiments in the 18th century, although the engravings did not sell well at the time and consequently are rare today. All of his paintings were engraved by professional engravers including G.T. Stubbs, W. Woollett, R. Earlom (qq.v.), etc.
Bookplates, early imp., e.£40-£100.
Separate pl., depending on rarity, £6,000-£20,000. 'Horse Frightened by a Lion', 1777, etching and eng., £8,000-£15,000; 'A Recumbent Lion', 1788, mixed-method eng., £12,000-£18,000; 'A Recumbent Leopard by a Tree', 1788, £15,000-£20,000. ('A Recumbent Lion' fetched £17,000, and 'Two Tygers' £16,000 June 1993).
Bibl: Taylor, B., *The Prints of G.S.*, London, The Paul Mellon Foundation for British Art, 1969.

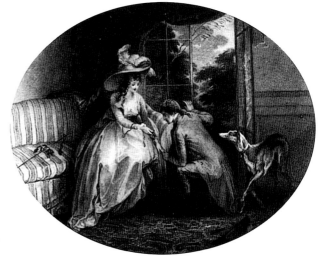

STRUTT, Joseph. A decorative subject after T. Stothard.

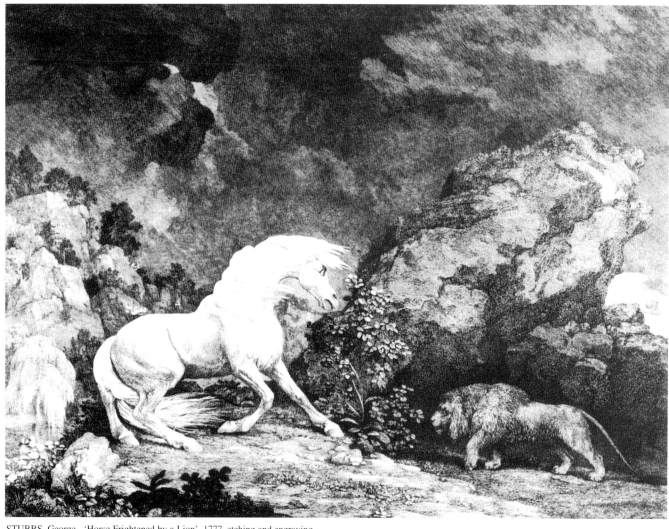

STUBBS, George. 'Horse Frightened by a Lion', 1777, etching and engraving.

STUBBS, George Townly 1756-1815
Stipple and occasional mezzotint engraver of sporting and animal subjects and portraits after his contemporaries. Born in London, he was the illegitimate son and pupil of G. Stubbs (q.v.) and most of his engravings reproduced his father's paintings.
Stipples:
Racehorses, after G. Stubbs, 2 edn. and 2 sizes: 1794, 15½ x 20in/39.5 x 51cm, £1,000-£2,000;
1794, 7¼ x 9¼in/19.5 x 25cm, £500-£1,000; 1817, 15½ x 20in//39.5 x 51cm, £500-£900; 1817, 7¼ x 9¼in/19.5 x 25cm, £300-£500; sometimes prd. in col. in which case prices could be up to double: 6 pl. of larger size, from 1794 edn., prd. in col. and finished by hand, sold May 1989: 3 fetched e. £4,200, and 3 fetched £2,000, £2,500 and £3,000.
Portraits of 'Josiah Wedgwood', 1795, and 'Warren Hastings', both after G. Stubbs, 6¼ x
5½in/17 x 14cm, e. £200-£400 prd. in col.
'Elizabeth, Countess of Derby', after H.D. Hamilton, 1777, 6¼ x 5¼in/17 x 13.5cm, £30-£50.
'The Lincolnshire Ox', after G. Stubbs, 1791, 18 x 19in/45.5 x 48.5cm, £500-£1,000.
Mezzotints:
'The Sebra [sic] or Wild Ass', after G. Stubbs, 1771, 22 x 26in/56 x 66cm, £1,500-£2,500.
'Two Hounds', after Titian, 1792, 16 x

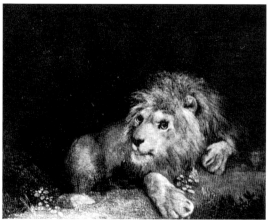

STUBBS, George. 'A Recumbent Lion', 1788, mixed method engraving.

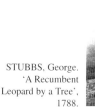

STUBBS, George. 'A Recumbent Leopard by a Tree', 1788.

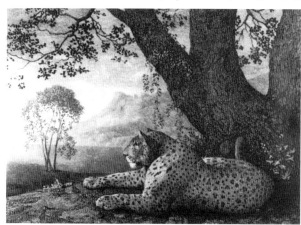

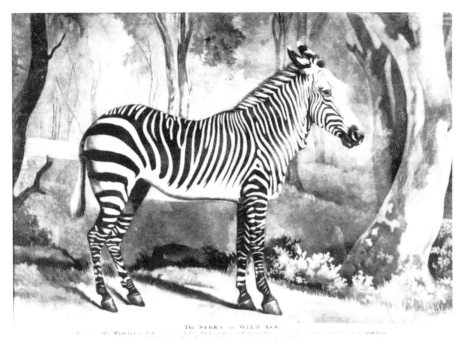

STUBBS, George Townly. 'The Sebra or Wild Ass', after G. Stubbs, mezzotint.

19½in/40.5 x 50cm, £200-£300.
'Stallion and Mare', after G. Stubbs, 1776, 10 x 13¾in/25.5 x 35cm, £700-£1,200, fetched £1,200 Dec. 1995.
Colour plates pages 64 and 65.

STUBBS, J. I fl. mid-19th century
Line engraver of small bookplates including genre and landscapes after his contemporaries and 18th century painters.
Small value.

STUBBS, J. II fl. mid-19th century
Lithographer of topographical views after his own designs. He appears to have been a native of Liverpool.
Views of Liverpool £15-£30.
Others £10-£20.

STUMP, John Samuel d.1863
Miniaturist, stipple engraver of portraits after his own designs.
'Harriet, Duchess of St. Albans', 1803, 11 x 7⅛in/28 x 18.5cm, £60-£100 prd. in col.
'Louisa, Countess of Craven', 1806, 4¾ x 3in/12 x 7.5cm, small value.

STURGESS, ?J. fl. mid-19th century
Lithographer.
'Blair Atholl' (racehorse), 14 x 19in/35.5 x 48.5cm, £80-£120.

STURT, John 1658-1730
Author, line engraver of portraits after his own designs. He was apprenticed to R. White (q.v.) and engraved plates to illustrate his own and other works.
Small value.

SUDLOW fl. mid-19th century
Line engraver.
'A View of St. Peter's Plain, Manchester, on a Memorable 16th August, 1819, Representing Forcible Dispersion of the People by the Yeomanry Cavalry', after Whaite, 40¼ x 80½in/103.5 x 204.5cm, £300-£600.

SULLIVAN, Edmund Joseph, A.R.E. 1869-1933
Illustrator, watercolourist, etcher and lithographer of genre and allegorical subjects, views and portraits. He was born in London where he also lived. He worked on *The Graphic* and other newspapers and illustrated several books.
£30-£70.

SULLIVAN, Luke fl. mid-18th century
Irish etcher and line engraver of religious, military and genre subjects, landscapes and topographical views after his contemporaries and his own designs. Born in Co. Louth, he came to London where he was a pupil of T. Major (q.v.) and then assistant to W. Hogarth (q.v.). He also drew architectural views and painted miniatures. He led a dissolute life and died in Piccadilly.
'The Battle of Culloden', after A. Heckel, 1747, 14¼ x 20in/37.5 x 51cm, £100-£200.
'March to Finchley', after W. Hogarth, 1745, 16¼ x 21⅛in/41.5 x 54cm, £150-£250.
'Moses and Pharaoh's Daughter', after W. Hogarth, 1752, 15½ x 19½in/9.5 x 49.5cm, £20-£50.
Topographical views, e.g. 'Views of Cliveden, Esher, Wilton, Ditchley and Woburn', 14¼ x 20in/36 x 51cm, 6 pl., set £800-£1,400.
Landscapes £50-£150.

SULPIS, Emile Jean b.1856
French etcher of reproductions after Old Master painters and his contemporaries. He is mentioned here for 'The Mill' after E. Burne-

SULLIVAN, Edmund Joseph. 'Melancholy', etching.

STUBBS, J. II. 'Spaw Well, Low Harrogate', 1829.

SULPIS, Emile Jean. 'The Mill', after E. Burne-Jones, 1899.

SUMMERS, William. 'The Royal Navy', after O. Norie and T.G. Dutton.

SUMMERS, William fl. mid-/late 19th century
Aquatint engraver of sporting subjects and some military and naval subjects after his contemporaries. He was a pupil of and collaborated with J. Harris III (q.v.).
'Foxhunting', after J.F. Herring, 1857, 4 pl. with J. Harris, 14 x 20¼in/35.5 x 51.5cm, set £1,200-£1,800 col.
'Foxhunting', after J. Sturgess, 1878, 4 pl., 24¼ x 46in/61.5 x 117cm, set £3,000-£5,000 col.
'Racing: Tattenham Corner' and 'The Finish', after H. Alken, 1871, 17½ x 30in/44.5 x 76cm, pair £600-£1,200 col.
'McQueen's Steeple Chasings', after A.W. Neville, 1871, 22½ x 34½in/57 x 88.5cm, pair £1,000-£2,000 col.
Portraits of racehorses after H. Hall, ave. 19¼ x 23½in/50 x 60cm, £400-£600 col.
'The Royal Navy', after O. Norie and T.G. Dutton, £700-£1,200 col.

SUNTACH, Antoine. 'The Communion', after F. Wheatley, 1798.

Jones.
'The Mill', after Burne-Jones, 1899, £600-£1,200.
Others small value.

SUMMERFIELD, John d.1817
Stipple engraver of decorative and religious subjects and portraits after his contemporaries. He was a favourite pupil of F. Bartolozzi (q.v.) but failed to live up to his early promise. He died in Buckinghamshire.
'Thomas Buick', after D.B. Murphy, 1816, 3½ x 2¼in/9 x 7cm, small value.
'Rubens and His Wife', after Rubens, 1801, 18½ x 19¼in/47 x 49cm, £10-£30.

SUMMERS, J. fl. mid-19th century
Aquatint engraver of the aquatints 'The Silks and Satins of the Turf', and 'The Silks and Satins of the Field', after B. Herring. It is possible that he is the same engraver as W. Summers (q.v.).
'The Silks and Satins of the Turf' and 'The Silks and Satins of the Field', after B. Herring, 1867-8, 24½ x 46½in/62 x 118cm, pair £800-£1,400 col., fetched £1,700 May 1987.

SUTHERLAND, Graham Vivian. 'Cottage in Dorset', 1929. Typical of the artist's early etchings.

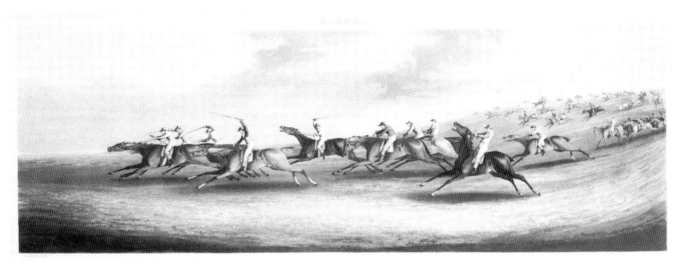

SUTHERLAND, Thomas. One of four plates from 'Racing: Epsom – Running', after H. Alken, 1818.

Add more if in fine contemporary frames, e.g. 'Foxhunting' after J. Sturgess, set col. fetched £7,500 May 1987.

SUNTACH, Antoine　　　　　　1776-1842
Line and stipple engraver of sporting, decorative and religious subjects after his contemporaries and Old Master painters. Primarily a copyist of English prints working abroad, he may also have lived in London for a time.
'The Communion', after F. Wheatley,1798, 25 x 19in/63.5 x 48.5cm, £100-£200 prd. in col.
Shooting subjects after G. Morland, 1791, 12 x 15in/30.5 x 38cm, line, e. £60-£120.
'A Party Angling' and 'The Anglers' Repast', after G. Morland, 12½ x 15¾in/32 x 40cm, pair £200-£250.
Religious subjects and pl. after Old Master painters small value.

SUTHERLAND, Graham Vivian, O.M.
　　　　　　　　　　　　　　　1903-1982
Important modern British painter, etcher and lithographer of landscapes, animals, birds, portraits and still life. Born in London, he studied at Goldsmiths' College from 1920 to 1925. He produced about thirty-five etchings in the 1920s and early 1930s; several of these in their romantic representation of the countryside show the strong influence of the etched work of S. Palmer (q.v.). His later graphic work consisted of lithographs and some aquatints depicting grotesquely abstracted creatures and landscapes and occasional portraits. He was Official War Artist from 1941 to 1944. He lived in Kent.
Early etchings range from a small pl. in lge. edn., e.g. 'Michaelmas', £300-£400 (edn. of 109), to a v. rare pl., e.g. 'The Philosophers', £1,200-£1,600; trial proofs worked on by the artist could fetch up to £5,000.
'Cottage in Dorset', 1929, £500-£1,000.
Litho. £200-£600.
Later etchings with aq., prd. in col. generally £200-£400.
Bibl: Man, F.H., G.S., *Das Grafischer Werk 1922-70, Munich, 1970.*

SUTHERLAND, Thomas
　　　　　　　　fl. early/mid-19th century
Prominent aquatint engraver of sporting, coaching, naval and military subjects, and topographical views after his contemporaries. He lived and worked in London.
'The Leicestershire Covers', after H. Alken, 1824, 4 pl., 8¼ x 27½in/21 x 70cm, set £1,500-£2,500 col. (set col. fetched £2,800 Dec. 1992).
'Shooting', after D. Wolstenholme, 1823, 4 pl., 10 x 12½in/25.5 x 32cm, set £1,400-£2,000 col.
'Racing' (Newmarket, Ascot, Epsom and Ipswich), after H. Alken, 1818, 4 pl., 8½ x 24¾in/21.5 x 63cm, set £2,000-£3,000 col.
'Epsom Races', after H. Alken, 1819, 12½ x 24¼in/31.5 x 61.5cm, pair £800-£1,400 col.
Portraits of racehorses, after J.F. Herring, 1820s, ave. 15 x 19½in/38 x 50cm, e. £400-£800 col.
'North-Country Mails at The Peacock, Islington', after J. Pollard, 1823, 11½ x 16in/29 x 40.5cm, £2,500-£3,500 col.
'Disturbed' and 'The Biter Bit', 1820, 11¼ x 15½in/28.5 x 39.5cm, pair £300-£500 col.
'The High Mettled Racer', after H. Alken, 1821, 6 pl., 10 x 15in/ 25.5 x 38cm, set £1,400-£2,200 col.
'Foxhunting', after H. Alken, 1821, 4 pl., 9¾ x 17¼in/25 x 44cm, set £1,000-£1,600 col.
'Gathering of Tea' and 'Taching or Firing of Tea', after Sang-so, 1808, 17½ x 21¼in/44.5 x 54cm, pair £200-£300 col.

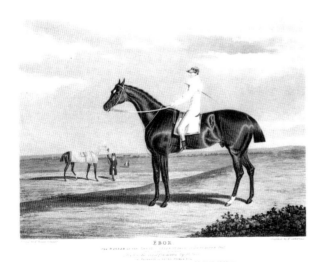

SUTHERLAND, Thomas. 'Ebor', after J.F. Herring, 1817.

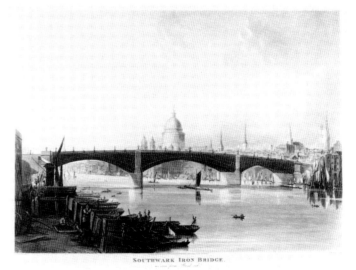

SUTHERLAND, Thomas. 'Southwark Iron Bridge', after J. Gendall, 1819.

SWARBRECK, Samuel Dukinfield. A plate from 'Sketches in Scotland: Jail Governor's House from the College Church', 1839.

'Southwark Iron Bridge' after J. Gendall, 1819, 14 x 22in/35.5 x 56cm, and other London views of similar size, £600-£1,200 col.
'The Bombardment of Algiers', after T. Whitcombe, 12 x 20in/30.5 x 51cm, pair £300-£500 col.
'Ramsgate with Royal Sovereign and City of London Steamboats', after W.J. Huggins, 1823, 14½ x 25in/37 x 63.5cm, and other shipping subjects of similar size, £600-£1,000 col.
Pl. for J. Jenkins' Naval Achievements, after T. Whitcombe, e. £40-£80 col.
Pl. for J. Jenkins' Martial Achievements, after W. Heath, e. £20-£35 col.
Pl. for the Microcosm of London, after T. Rowlandson and A. Pugin: law courts e. £30-£70 col., others £20-£60 col.
Pl. for W.H. Pyne's Royal Residences, 1819, and Ackermann's Westminster Abbey, 1812, e. £20-£60 col.
Pl. for Ackermann's Oxford, 1814, e. £20-£60 col.
Pl. for E.E. Vidal's Picturesque Illustrations of Buenos Ayres and Monte Video, 1820, lge. 4to., e. £100-£200 col.
Pl. for J. Hakewill's Picturesque Tour of the Island of Jamaica, 1824-5, fo., e. £150-£200 col.
Pl. for C.R. Forrest's Picturesque Tour along the Rivers Ganges and Jumna, 1824, 4to., e. £50-£100 col.
Pl. for Baron Gerning's Picturesque Tour along the Rhine, 1820, fo., e. £80-£160 col.
Colour plates pages 66 and 67.

SWAIN, Edward b.1847
Etcher of landscapes and architectural views. He worked in London and Kent and contributed to *English Etchings*.
Small value.

SWAINE, John 1775-1860
Line engraver of small portraits and bookplates after his contemporaries and Old Master painters including topographical views and antiquarian subjects. Born at Stanwell, Middlesex, he was a pupil of Jacob Schnebbelie and B. Longmate I (q.v.) and his son. He died in Soho, London.
Small value.

SWAN, Joseph d.1872
Line engraver of small bookplates including topographical views and botanical subjects after his contemporaries. He lived and worked in Glasgow.
Small value.

SWARBRECK, Samuel Dukinfield
fl. mid-19th century
Painter and lithographer of architectural and topographical views.
'Sketches in Scotland', 1839, fo., 25 tt. pl., e. £15-£25.

SYER, John fl. mid-19th century
Draughtsman and lithographer.
'Marine Sketches', c.1840, 7¼ x 10in/19.5 x 25.5cm, tt. pl., e. £5-£10.

SYMPSON (Simpson), Joseph I
fl. early 18th century
Line engraver of sporting subjects and portraits after his contemporaries. He began his early career as an engraver on plate and, after studying at the Artists' Drawing Academy, was employed by P. Tillemans (q.v.) to engrave his Newmarket subjects.
'View of the Noblemen's and Gentlemen's Several Strings, or Training of Running Horses Taking Their Exercise up the Watering Course on the Warren Hill at Newmarket', after P. Tillemans, c.1725, 16¼ x 43½in/42.5 x 110.5cm, £1,000-£2,000.
'View of the Round Course or Plate Course with Diverse Jockeys and Horses in Different Actions and Postures Going to Start the King's Plate', after P. Tillemans, c.1725, 16¼ x 43½in/42.5 x 110.5cm, £1,000-£2,000.
'A Dark Grey Hunter Upon Full Chase', 1739, 2 pl. joined together, 22½ x 32¼in/57 x 82cm, £600-£1,200.
Portraits of racehorses, c.1739, 7¼ x 8½in/18.5 x 22cm, e. £80-£160.
Portraits small value.

SYMPSON (Simpson), Joseph II d.1736
Mezzotint engraver of portraits after his contemporaries, and of religious subjects after Old Master painters, line engraver of sporting subjects after his contemporaries. He was the son of J. Sympson I (q.v.). He published his prints from The Dove in Russell Court, Drury Lane, London.
'A View of a Horse Match at Newmarket Between Grey Windham and Bay Bolton', after J. Wootton, 10¼ x 16¼in/26 x 42.5cm, line, £200-£400.
'John Henley, the Preacher' (in group of WL figures), possibly after W. Hogarth, 15½ x 11½in/39.5 x 29cm, £50-£90.
Others £30-£60.
CS lists 4 pl.

SYNGE, Edward Millington, A.R.E.
1860-1913
Irish painter and etcher of landscapes and architectural views. He studied under F. Short and F.S. Haden (qq.v.) and worked in England and on the Continent.
£30-£70.

SYMPSON, Joseph I. 'View of the Noblemen's and Gentlemen's Several Strings, or Training of Running Horses Taking their Exercise up the Watering Course on the Warren Hill at Newmarket', after P. Tillemans.

T

TADEMA, Sir Lawrence Alma
see **ALMA-TADEMA, Sir Lawrence**

TAIT, Arthur Fitzwilliam fl. mid-19th century
Animal and landscape painter, draughtsman and lithographer of railway subjects and architectural views. Born near Liverpool, he was a pupil at the Manchester Royal Institute. He executed the following lithographs before emigrating to America in 1850 where he settled in New York:
'Views on the Manchester and Leeds Railway', 1845, fo., 20 tt. pl., set £900-£1,200.
'Views on the London and North Western Railway - Northern Division', 1848, title and 17 tt. pl., fo., v. rare, set £2,000-£4,000.
Pl. for H. Bowman and J.S. Crowther's Churches of the Middle Ages, 1850, fo., small value.

TALLBERG, Professor Axel, A.R.E.
1860-1928
Swedish etcher and engraver in aquatint and mezzotint of portraits and landscapes after his contemporaries. He is mentioned here for having worked in England from 1886 to 1895. He was later first Principal of the School of Etching and Engraving at the Royal Academy of Arts in Stockholm.
'Views of Public Schools', after F. Barraud, £30-£90.
Others small value.

TALLIS, Frederick fl. mid-19th century
Lithographer and publisher.
'Agricultural Hall, Islington', after A. Bragg, 21¼ x 23½in/54 x 59.5cm, £300-£500 prd. in col.

TALMAGE, Algernon Mayow, R.A., A.R.E.
1871-1939
Painter and etcher of landscapes and animal and figure subjects. Born in Oxfordshire, he was a pupil of H. Herkomer (q.v.) and ran an art school in St. Ives before coming to London in 1907. He was Official War Artist for the Canadian Government during World War I and started etching in the 1920s.
£30-£70.

TANDY, John 1905-1982
Woodcut engraver of abstract compositions in the late 1920s.
£20-£50.

TANNER, Robin, A.R.E. b.1904
Etcher of rustic scenes. Born in Bristol he studied at the Goldsmiths' College School of Art and was a pupil of A.C.S. Anderson (q.v.); he was also much influenced by S. Palmer (q.v.). He lives in Wiltshire.
Generally £100-£200, but 'Christmas' 1929, fetched £720; 'Martin's Hovel', 1928, £320; 'Wiltshire Woodman' £350, all in Oct. 1993.

TASSAERT, Philip J. d.1803
Flemish painter and mezzotint engraver of portraits and decorative subjects after his contemporaries, Old Master painters and his own designs. Born in Antwerp, he came to

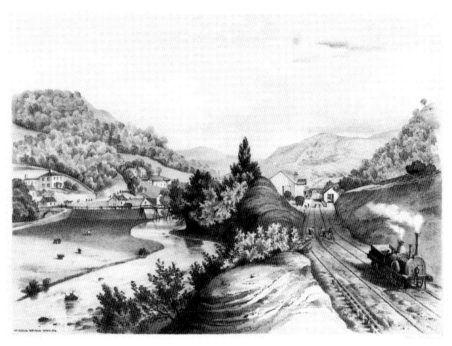

TAIT, Arthur Fitzwilliam. One of twenty plates from 'Views on the Manchester & Leeds Railway: Hebden Bridge Station', 1845.

London at an early age. He worked as an assistant to Hudson and later dealt in and cleaned pictures. He died in Soho.
'The Four Ages', after P.T., 1768, 14 x 9¾in/35.5 x 25cm, set £400-£700.
'John Harrison', after T. King, 1768, 15½ x 11¼in/39.5 x 28.5cm, £50-£150.
Pl. after Rubens e.£20-£50.
CS lists the set noted above and 3 portraits.

TATHAM, Charles Heathcote 1772-1842
Architect, draughtsman and etcher of architectural antiquities. Born in London, he studied in Italy and was elected a member of the academies of Rome and Bologna. He published several volumes of etchings of Greek and Roman ornamental architecture. He was Warden of Norfolk College, Greenwich.
Small value.

TAYLOR, Charles 1756-1823
Line and stipple engraver of decorative, classical and allegorical subjects after his contemporaries. He was apparently born in

TALLIS, Frederick. 'Agricultural Hall, Islington', after A. Bragg.

TANNER, Robin. 'Martin's Hovel', 1928. The artist's best-known etching.

TAYLOR, Charles William. A typical landscape etching.

London and was a pupil of F. Bartolozzi (q.v.).
Ovals after A. Kauffmann e. £100-£300 prd. in red or in col.
Small bookpl. small value.

TAYLOR, Charles William, R.E. 1878-1960
Etcher, wood and line engraver of landscapes and coastal scenes. Born in Wolverhampton, he studied at the School of Art there and the R.C.A. He lived and worked in Essex as an art teacher.
£60-£120
Bibl: Bliss, D.P., 'The Engravings of C.W.T.', *P.C.Q.*, 1936, XXIII, p.125.

TAYLOR, C.S. fl. early/mid-19th century
Stipple engraver of small portraits and bookplates after his contemporaries.
Small value.

TAYLOR, Eric Wilfred, R.E. b.1909
Painter, sculptor, etcher of portraits and figure and genre subjects. He was a pupil of M. Osborne (q.v.) at the R.C.A. He taught art at several London schools and was Principal of Leeds College of Art, 1956-69, and Assistant Director of Leeds Polytechnic, 1969-71.
£30-£70

TAYLOR, Isaac I 1730-1807
Line engraver of small portraits and bookplates after his contemporaries, Old Master painters and his own designs. Born at Worcester, he came to London in 1752 and worked for a silversmith before engraving plates for *The Gentleman's Magazine*. He died at Edmonton, London. He was the father of I. Taylor II (q.v.).
Pl. for Boydell's Shakespeare, *fo., e. £10-£25.*
Small bookplates small value.

TAYLOR, Isaac II 1759-1829
Stipple engraver of decorative and historical subjects after his contemporaries. Born in London he was the son of I. Taylor I and a pupil of F. Bartolozzi (qq.v.). About 1768 he moved to Suffolk and became minister of an Independent Congregation at Colchester and at Ongar, where he died.
Small value.

TAYLOR, James 1745-1797
Painter on porcelain, illustrator and line engraver of small bookplates after his contemporaries. He was the brother and pupil of I. Taylor I (q.v.) with whom he collaborated.
Small value.

TAYLOR, John 1739-1838
Draughtsman and mezzotint engraver of portraits after his own designs. Born in Bishopsgate, he was a pupil of Francis Hayman. He later worked as a teacher and died in Cirencester Place, London.
'Thomas Norris', (singer), 1777, 14 x 10in/35.5 x. 25.5cm, £20-£60.
'Elizabeth, Duchess of Kingston', 1776, 15 x 11in/38 x 28cm, £70-£140.
CS lists 2 pl., noted above.

TAYLOR, John Frederick, P.R.W.S.
1802-1889
Watercolourist, etcher and lithographer of landscapes, sporting and other figure subjects. Born at Boreham Wood, Hertfordshire, he

TAYLOR, John Frederick. One of twenty-five plates from Frederick Taylor's 'Portfolio: The Falconer's Daughter', 1844-5, lithotint.

studied at Henry Sass's, the R.A. Schools and on the Continent. He was a member of the Etching Club and contributed many plates to their publications, being best known for sporting subjects in period costume. He died in London.
Frederick Tayler's 'Portfolio', 1844-5, fo., 25 lithotints, set £800-£1,600 col.
Etchings £10-£30.

TAYLOR, Joshua fl. mid-19th century
Painter of landscapes, marines, portraits and genre subjects, lithographer of marine subjects. He lived and worked in London.
Most barge and yachting subjects £300-£600 col., but 'Fiona, in the Royal Thames Yacht Club Match, June 17, 1868', 13½ x 23¾in/34.5 x 60.5cm, tt. pl., £600-£800 col.

TAYLOR, Luke, R.E. 1876-1916
Etcher and aquatint engraver of landscapes, pastoral and genre subjects and portraits after his own designs and those of his contemporaries, Old Master and 19th century painters. He studied at the R.C.A. and was killed in World War I.
Original etchings £30-£70.
Reproductive pl. £5-£15.

TAYLOR, R., & Company fl. late 19th century
Wood engravers of illustrations for magazines and periodicals after their contemporaries. They worked mainly for *The Illustrated London News*.
Small value.

TAYLOR, Samuel fl. early 18th century
Mezzotint engraver of portraits after his contemporaries and 17th century painters.
'Gen. Joshua Guest', TQL, after J. Van Diest, 1724, 14½ x 9½in/37 x 24cm, £40-£90.
Small pl. £10-£40.
CS lists 4 pl.

TAYLOR, Weld fl. mid-19th century
Lithographer of portraits, military subjects and costumes after his contemporaries.
'Officer of the 2nd Lifeguards', after C. Grant, 1839, 17½ x 20in/44.5 x 51cm, £100-£200 col.
Pl. for Lieutenant J. Wingate's Storming of Ghuznee and Kelat, *1839, fo., e. £7-£15.*
Small portrait vignettes small value.

TAYLOR, William fl. mid-19th century
Line engraver of small bookplates, including landscapes and architectural views after his contemporaries.
Small value.

TAYLOR, William Benjamin Sarsfield
 1781-1850
Irish landscape and military painter who drew and etched plates for the *History of Dublin University*.
Pl. for History of Dublin University, *aq. by R. Havell I (q.v.), 1819, 9 pl., 4to., e. £30-£60 col.*

TAYLOR, William Dean 1794-1857
Line engraver of portraits and figure subjects after his contemporaries.
'The Smile', 'The Frown', after T. Webster, 10 x 20in/25.5 x 51cm, pair £20-£40.
Others mostly small value.

TAYLOR, W.J. fl. early 19th century
Line engraver of small bookplates, including portraits after his contemporaries and Old Master painters.
Small value.

TESTOLINI, Gaetano. 'Isabella Czarloryska', after R. Conway, 1791.

TEMPEST, Pierce d.1717
Printseller, publisher, possibly also a mezzotint engraver of portraits after his contemporaries. He was a pupil of and assistant to W. Hollar (q.v.), and worked in London. Since he signed his mezzotint plates 'Excudit' (published) and there is no engraver's name, it is not possible to know whether he or another engraver executed the plates. He died in London.
'Fortune Teller', 10¼ x 7½in/26 x 19.5cm, £80-£160.
HL portraits, ave, 11¼ x 8¼in/30 x 22cm, £20-£80.
Small portraits £10-£40.
CS lists 15 pl.

TEMPLE, W.W. fl. late 18th century
Wood engraver of bookplates, he was a pupil of and apprentice to T. Bewick (q.v.) and executed some plates for Bewick's *British Birds*. At the end of his apprenticeship, he gave up his craft and went into business as a linen draper.
Small value.

TEMPLETON, John Samuelson
 fl. mid-19th century
Irish portrait and landscape painter, lithographer of portraits and marine subjects after his own designs. Born in Dublin, he studied at the Dublin Society's Drawing School and then came to England where he worked in London.
'The Crew of the Edward Landing from the Wreck on the North Wall, Dublin Bay, November 1825', 8 x 11in/20.5 x 28cm, £20-£40 col.
'Making for Port, a Gale Coming On', 1827, 8 x 11in/20.5 x 28cm, £10-£20 col.
Portraits small value.

TENNANT, Norman b.1896
Minor etcher. Born in Yorkshire, he studied at Bradford School of Art and lived in Staffordshire.
Small value.

TENNICK, W.G. b.1856
Etcher of landscapes. He was born in Darlington.
Small value.

TENNIEL, Sir John 1820-1914
Best known as the illustrator of *Alice's Adventures in Wonderland*, also a *Punch* cartoonist. He etched a few plates and contributed to the publications of the Junior Etching Club of which he was a member.
£10-£30.

TERRY, Garnet fl. late 18th century
Line engraver of small portraits and bookplates after his own designs and those of his contemporaries.
Small value.

TERRY, George fl. late 18th century
Mezzotint engraver.
'The Church of God in Her Fivefold State', after E.F. Burney, 1791, 13 x 19½in/33 x 49.5cm, with explanatory vol., £40-£80.
'Rev'd John Towers', after Fisher, 11½ x 9¼in/29 x 25cm, 1770, £15-£50.
CS lists 1 pl. eng. with 'Batley', that of 'Rev'd John Towers' noted above.

TESTOLINI, Gaetano fl. late 18th century
Stipple engraver of portraits and decorative subjects after his contemporaries. He lived in London for some years but resided mainly in Paris.
'Isabella Czarloryska', after R. Cosway, 1791, £80-£160 prd. in col.
'George III', after T. Stothard, 11½ x 7½in/ 29 x 19cm, £20-£30.
Small decorative subjects, roundels, ovals, etc., £50-£150 prd. in sepia or in col.

THEW, Robert 1758-1802
Stipple engraver of portraits and decorative subjects after his contemporaries. Born in Partington, he settled in Hull in 1783 where he engraved shop-bills, cards, etc. He later turned to portraits and figure subjects, gaining employment with J. Boydell (q.v.). He was appointed Engraver to the Prince of Wales. He died in Stevenage.
Pl. for Boydell's Shakespeare, *fo., e. £10-£25.*
'Mr. and Mrs. Cosway', after R. Cosway, 1789, 12½ x 8in/32 x 20cm, £50-£100.
'Richard Crosse', after Crosse, 1792, 4 x 3in/10 x 7.5cm, £10-£20 prd. in col.
'Sir Thomas Gresham', after A. Morro, 1792, 13 x 10¼in/33 x 26cm, £5-£10.
'Conjugal Affection' (George III, Queen Charlotte and children), after R. Smirke, 1780, 24 x 18in/61 x 45.5cm, £200-£300 prd. in col.
'The Nursing of Bacchus', after A. Kauffmann, 1789, circle, £100-£200 prd. in sepia or in col.

THIELCKE, H.D. fl. early 19th century
Stipple engraver of portraits and decorative subjects after his contemporaries.
6 eng. after the designs of the Princess Elizabeth, 1813, e. £5-£8.
Small portraits small value.

THOMAS, John fl. mid-19th century
Line engraver of small bookplates, including landscapes and architectural views after his contemporaries.
Small value.

THOMAS, Percy, R.E. 1846-1922
Painter and etcher of landscapes, architectural

THEW, Robert. 'Taming of the Shrew', after R. Smirke, from Boydell's *Shakespeare*.

and river views, portraits and figure subjects. Born in London, he studied at the R.A. schools and was the first pupil of J.A.M. Whistler (q.v.). He lived in London and Sussex.
'The Temple, London', 6 x 8½in/15 x 21.5cm, set £600-£1,000.
Others £20-£60.

THOMAS, Philip fl. mid-19th century
Etcher, mezzotint and mixed-method engraver of portraits and genre subjects after his contemporaries.
'Waiting for the Laird', after W. and H.

THOMAS, Robert Kent. 'Royal Southern Yacht Club House, Southampton'.

Barraud, 1849, oval, 19 x 15in/48.5 x 38cm, £40-£100.
Add more if in fine contemporary frame.
Portraits small value.

THOMAS, Robert Kent 1816-1884
Lithographer of architectural views and military and marine subjects after his contemporaries and his own designs; later etcher of architectural views after his own designs. He was born in London and appears to have worked as a lithographer for Day and Son (see W. Day 1797-1845), a firm of lithographic publishers. After

becoming an etcher, he contributed to *The Etcher* and *The Portfolio*.
Lithographs:
'Royal Southern Yacht Club House, Southampton', £40-£90.
'The Rowing Match between Eton and Westminster at Putney', 1843, £300-£600 col.
'Storm and Capture of the Fort of Punalla in the Southern Mahratta Country on 1st December, 1844', after Lieutenant J. Puckle, 12 x 15¾in/30.5 x 40cm, £60-£140 col.
Pl. for Lieutenant C.H. Mecham's Sketches & Incidents of the Siege of Lucknow, 1858, fo., tt. pl., e. £5-£15.
'Royal Horse Artillery', after R. Hay, c.1845, 2 pl., 8½ x 10½in/21.5 x 26.5cm, pair £80-£160 col.
Pl. for J.R. Lewis' The Church of Shogden, Hertfordshire, 1852, fo., small value.
'Thames Embankment: Steamboat Landing Pier at Westminster Bridge', 1864, 10 x 14in/25.5 x 35.5cm, £150-£250 prd. in col.
Etchings e. £10-£30.

THOMAS, Vernon fl. early/mid-20th century
Draughtsman and etcher of figure subjects including children.
£20-£50.

THOMAS, William Luson 1830-1900
Best known as the founder of *The Graphic* in 1869 (later *The Daily Graphic*), he engraved on wood some illustrations for *The Illustrated London News* early in his career.
Small value.

THOMPSON, Charles 1791-1843
Wood engraver of book illustrations. Born in London, he was the brother of J. Thompson and a pupil of T. Bewick (qq.v.). In 1816 he settled in Paris where he became very successful. He remained in France until his death.
Small value.

THOMPSON, Charles Thurston 1816-1868
Wood engraver of book illustrations. The son of J. Thompson (q.v.) and probably a pupil of his father, he later became a photographer.
Small value.

THOMPSON, D. fl. mid-19th century
Line engraver of small bookplates including landscapes and topographical views after his contemporaries.
American views £5-£10.
Others small value.

THOMPSON, David George
 fl. mid-19th century
Etcher, mezzotint engraver and lithographer of sporting subjects after his contemporaries. Although born in England he was brought up in India. In 1856 he emigrated to America and lived in New York.
'Farmer's Hack and Lady's Palfrey' from British Horses, after J.F. Herring, 1860, 11½ x 15in/29 x 38cm, £100-£200.
'Shooting Grouse, Partridge, Pheasant', after R. Ansdell, 1852, 3 pl., 11¼ x 22¼in/30 x 56.5cm, e. £200-£300.
'Thomas Assheton Smith', after W. Sextie, 1853, 20¼ x 28in/52.5 x 71cm, litho., £300-£400.
Add more if in fine contemporary frame.

THOMPSON (Thomson), ?E. or F.W.
 fl. late 18th century
Line and stipple engraver of portraits and decorative and allegorical subjects after his

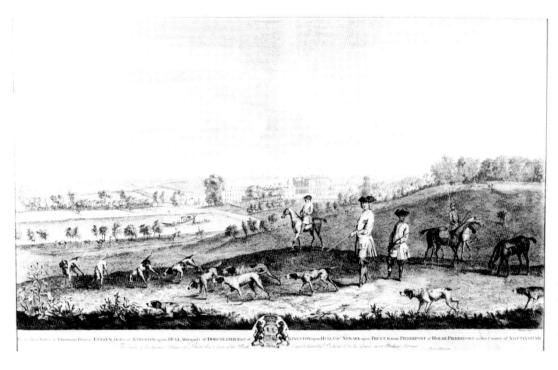

TILLEMANS, Peter. 'View of the Duke of Kingston's House at Thoresby and part of the Park with his Grace the Duke and Attendants Going a 'Setting'.

contemporaries. He was a pupil of F. Bartolozzi (q.v.).
'The Muse Crowning a Bust of Pope', after A. Kauffmann, 1783, 11 x 9in/28 x 23cm, £50-£100.
'James Wolfe's Monument in Westminster Abbey', after J. Wilton, 11½ x 8½in/29 x 21.5cm, £5-£10.

THOMPSON, J. fl. late 18th century
Mezzotint engraver.
'Lady Charlotte Johnstone', after J. Reynolds, 6 x 4½in/15 x 11.5cm, £8-£16.
'Sarah Woodcock', after J.T., 13¾ x 9¾in/35 x 25cm, £60-£120.
CS lists 2 pl., noted above.

THOMPSON, James *see* THOMSON, James

THOMPSON, Jane fl. late 18th century
Mezzotint engraver of portraits after her contemporaries. The daughter of Rev. John Bourne, she married Benjamin Thompson and apparently learnt engraving from John Raphael Smith (q.v.).
Portrait of her father, after Smith, 8 x 6in/20.5 x 15cm, £10-£25.
Portrait of Miss Thompson, after Smith, 11 x 8½in/
28 x 21.5cm, £20-£50.
CS lists 2 portraits, noted above.

THOMPSON, John 1785-1886
Prolific wood engraver of book illustrations. Born at Manchester, he was the father of C.T. Thompson, brother of C. Thompson and a pupil of A.R. Branston (qq.v.). Amongst his many works, he was employed by the Bank of England to engrave on steel the figure of Britannia still found on banknotes today. He also engraved on brass W. Mulready's design for the old penny postage envelope. From 1852 to 1859 he was Professor of Wood Engraving at South Kensington School of Art (female school).
Small value.

THOMSON (Thompson), James 1790-1850
Stipple engraver of small portraits and bookplates, occasional mezzotint engraver of larger portraits and sporting subjects after his contemporaries and his own designs. Born in Northumberland, he was apprenticed to an engraver in London and later was also a pupil of A. Cardon (q.v.). He lived and worked in London where he died.
Stipples small value.
Mezzotints:
'Morning of the Chase', after F. Grant, 1845, 19¼ x 24in/49 x 61cm, £250-£400.
'Royal Recreation' (Queen Victoria Prince Albert and the court on horseback), after J.T., 1851, 21 x 29in/53.5 x 73.5cm, £300-£500.
Add more if in fine contemporary frame.
'Bardsley, Samuel Argent, M.D.', after C.A. Duval, 13¼ x 10½in/33.5 x 26.5cm, and other portraits of similar size, £10-£30.

THOMSON, Paton
 fl. late 18th/early 19th century
Line and stipple engraver of small portraits and bookplates after his contemporaries. He worked in London.
Small value.

THORBURN, Archibald 1860-1935
Well-known ornithological artist. While he produced no prints of his own he is mentioned here because many of his paintings were reproduced by photography.
Prd. in col. and signed in pencil ('signed artist's proofs') e. £100-£300.
B. & w. signed e.£60-£140.

THORNTHWAITE, J. fl. late 18th century
Line engraver of small portraits and bookplates after his contemporaries and Old Master painters. He was born in and worked in London.
Small value.

THORNTON fl. late 18th century
Line engraver of small bookplates.
Small value.

THORPE, John Hall fl. 1920s
Colour woodcut artist.
£70-£150.

THOUVENIN, Jean P.
 fl. late 18th/early 19th century
French line and stipple engraver of decorative, religious and historical subjects after his contemporaries and Old Master painters. He is mentioned here because he worked in London for some time, engraving several plates after English painters.
'The Citizens' Retreat', after J. Ward, 16½ x 21in/42 x 53.5cm, £150-£300 prd. in col.
'Rustic Employment' and 'The Happy Family', both after F. Wheatley, 19 x 23¼in/48 x 59cm, pair £400-£600 prd. in col.

TIDEY, H. fl. mid-19th century
Draughtsman and lithographer. He was possibly the painter Henry F. Tidey 1814-72.
'Norfolk Suspension Bridge, Shoreham', 6½ x 9¼in/16.5 x 23.5cm, £10-£20.

TILLEMANS, Peter 1684-1734
Landscape and sporting painter who etched a few rare plates. Born in Antwerp, he came to England in 1708 where he executed views of country houses, Newmarket Heath racing scenes at Newmarket and other topographical and sporting subjects; several of these were engraved by professional engravers. He died at Norton in Suffolk.
'View of the Duke of Kingston's House at Thoresby and Part of the Park with His Grace The Duke and Attendants Going a 'Setting', 17 x 28¼in/43.5 x 72cm, £800-£1,600.
'The Fox Chase', 16¼ x 43½in/42.5 x 110.5cm, £1,000-£2,000.

TILY, Eugene James b.1870
Painter, etcher, stipple and mezzotint engraver of portraits and decorative subjects after 18th century painters and his contemporaries. Born in Hertfordshire, he studied at Bedford Park School of Art and was best known for producing

TISSOT, James Joseph. 'Les Deux Amis', 1882.

Mezzotints:
'Catherine Clive', after J. Ellys, 13¼ x 9¾in/35 x 25cm, £40-£90.
'Sir Thomas Parker', 14 x 9¾in/35.5 x 25cm, £15-£40.
'George II', after J. Highmore, 13¼ x 9¾in/35 x 25cm, £20-£50.
'John Wesley', 13¼ x 9¾in/35 x 25cm, £30-£80.
Portraits of 2 ladies: 'Noon' and 'Afternoon', after F. Boucher and Fenouil respectively, 13 x 9¼in/33 x 23.5cm, e. £60-£120.
CS lists 8 pl.

TISSOT, James (Jacques) Joseph 1836-1902
French painter and etcher of portraits and genre subjects. Born in Nantes, he had established himself as a painter in Paris before being obliged to flee France after the defeat of the Paris Commune in 1871. He came to England and set up home in St John's Wood, London, becoming a fashionable society painter of women. He started making prints after 1875 using a combination of etching and drypoint, often reproducing his own paintings. Stylistically, his work is closer to the French school than to the British. After his mistress, Mrs Newton died, Tissot gave up etching and turned to religious illustration, leaving England to go and work in Palestine.
'Entre les Deux, Mon Coeur Balance' £600-£1,000.
'Les Emigrants' £800-£1,200.
'Soirée d'Eté' £600-£1,000.
'Deuxième Frontispiece (Assise sur le Globe)' £150-£250.
'Les Deux Amis', 1882, £800-£1,200; with flags below coloured up to £2,000
'Le Hamac' £600-£1,000.
'La Thamise' £1,200-£1,600.
'La Galerie du Calcutta' £7,000-£9,000, fetched £11,000 June 1991.
'Octobre', 1878, £8,000-£12,000, fetched Yen 5,000,000 (=£19,400) Oct. 1990.
Bibl: Wentworth, M.J., J.T., Catalogue Raisonné of his Prints, Minneapolis Institute of Arts, 1978.

TOBIN, J. fl. late 18th century
Line engraver of figure and genre subjects after his contemporaries and Old Master painters.
Small value.

TODD, Arthur Ralph Middleton, R.A., R.E. 1891-1966
Painter and etcher of portraits and figure studies. Born in Cornwall, he studied at the Central School of Arts and Crafts and at the Slade. He lived in London and later taught at the City and Guilds School, Kennington.
£30-£80.

TOMKINS, Charles
 fl. late 18th/early 19th century
Painter and aquatint engraver of military subjects, landscapes and topographical views after his own designs and those of his contemporaries. Born in London, he was the eldest son of the painter William Tomkins.
'The Approach and Defeat of the Spanish Floating Batteries at Gibraltar', after J. Cleveley, 2 pl. with F. Jukes (q.v.), 1785, 9¾ x 14½in/25 x 36.5cm, pair £250-£400 col.
'View of Plymouth Sound' and 'View of Mount Edgecumbe', after W. Tomkins, 1790, 17 x 14½in/43 x 36.5cm, pair £200-£400 sepia.
Views of Reading Abbey, 1791 and 1805-10, obl. 4to., e. £10-£20 col.
'A Tour to the Isle of Wight', 1796, 80 pl., obl.

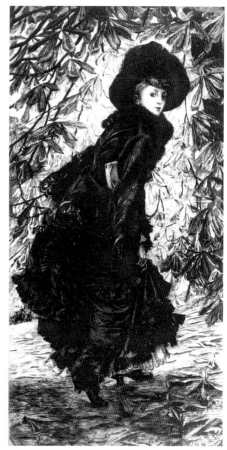

TISSOT, James (Jacques) Joseph. 'Octobre', 1878.

4to., e. £6-£14 col.
'The British Volunteer', 1799-1800, 6 pl., 11¼ x 9in/28.5 x 23cm, e. £80-£160 col.
'Review in Hyde Park', 1799, £500-£1,000 col.

TOMKINS, Charles Algernon b.1821
Etcher and mezzotint engraver of portraits and historical and sentimental subjects after his contemporaries. He was born in London where he worked.
'The Last Eleven at Maiwand', after F. Feller, 1884, 25½ x 36½in/65 x 92.5cm, £200-£300 col.
'Out for a Day's Sport', after G. Armfield, 1852, 19½ x 25½in/49.5 x 65cm, £200-£300.
Other lge. pl. £30-£100.
Add more if in fine contemporary frame.
Small portraits and bookplates small value.

TOMKINS, Charles John b.1847
Etcher and mezzotint engraver of portraits and sentimental subjects after his contemporaries. He was born in London, the son of C.A. Tomkins (q.v.).
'Vivisection', after J.H. Hamilton, 1883, 24 x 17½in/61 x 44cm, £250-£400.
Other lge. pl. £20-£80.
Add more if in fine contemporary frame.
Pl. for the Library Edition of The Works of Sir Edwin Landseer, and other small pl., small value.

TOMKINS, Peltro William 1760-1840
Eminent etcher and stipple and aquatint engraver of portraits and decorative and military subjects after his own designs, Old

18th century-style furniture prints.
£15-£50 prd. in col.
Add more if in 18th century-style frame.
Others small value.

TIMMS, W.H. fl. early 19th century
Draughtsman and aquatint engraver of landscapes and topographical views. He was also a tinter of prints and a mounter of drawings who worked in Hampstead Road, London.
Views of Reading, 1823, obl. 4to., e. £20-£60 col.
Others small value.

TINGLE, James fl. mid-19th century
Line engraver of small bookplates including landscapes and architectural views after his contemporaries.
Small value.

TINNEY, John d.1761
Etcher and line engraver of topographical views and decorative subjects, mezzotint engraver of portraits after his contemporaries. Born in London, he ran a business as a printseller and publisher at the Golden Lion in Fleet Street. He also apparently worked in Paris for some time. A. Walker, J. Browne and W. Woollett (qq.v.) were among his pupils.
Etchings and engravings:
'The Four Times of Day', after N. Lancret, fo., set £400-£700.
8 views of Kensington Palace and Hampton Court after A. Highmore, 13¼ x 19½in/35 x 49.5cm, e. £150-£250, set of fine imp. fetched £3,900 June 1992.

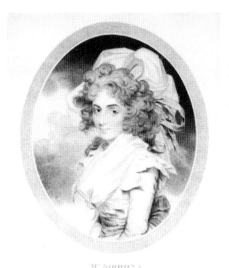

MᶜSIDDONS.

TOMKINS, Peltro William. 'Mrs. Siddons', after J. Downman.

TOMS, William Henry. 'Prospect of St. Peter's Port and Town in the Island of Guernsey taken from Castle Cornet', after J. Bastide and C. Lemprière.

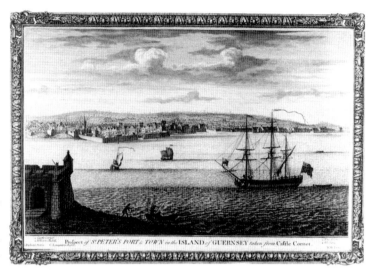

Prospect of ST PETER'S PORT & TOWN in the ISLAND of GUERNSEY taken from Castle Cornet

Master painters and his contemporaries. Born in London, he was the son of the painter William Tomkins and a pupil of F. Bartolozzi (q.v.). He ran a business as a print publisher in New Bond Street. He died in London.
'Mrs. Siddons', after J. Downman, 11 x 8½in/28 x 21.5cm, £300-£500 prd. in col.
'The Vestal' (Duchess of Rutland), after J. Reynolds, 1798, 18½ x 14½in/47 x 37cm, and decorative portraits of similar size, £150-£300 prd. in col.
'Encampment at Fornham near St. Edmondsbury', after J. Kendall, 15 x 24½in/38 x 62cm, £300-£600 col.
'Loyal London Volunteers', 1803-4, 10pl., 14 x 10¼in/35.5 x 26cm, e.£100-£160 col.
'A Village Girl Gathering Nuts' and 'A Cottage Girl Shelling Peas', after W.R. Bigg, 1783, ovals, 9¾ x 8¼in/25 x 21cm, pair £400-£600 prd. in col.
'He Sleeps', after Tomkins, 1789, 12 x 9in/30.5 x 23cm, £200-£300 prd. in col.
'Maria', after J. Russell, 1792, 8½ x 6in/21.5 x 15.5cm, £100-£160 prd. in col.
Pl. for H.W. Bunbury's Illustrations to Shakespeare, *1792-4, 16½ x 19in/42 x 48.5cm, £40-£80 prd. in col.*
'The Final Interview of Louis XVI and His Family', after M. Brown, 1795, 23 x 17½in/58.5 x 44.5cm, £50-£100 prd. in col.
'Dressing Room à l'Anglaise' and 'Dressing Room à la Française, after R. Ansdell, 11 x 8in/28 x 20.5cm, pair £500-£700 prd. in col.
Ovals, after A. Kauffmann, £100-£300 prd. in red or in col.
Religious subjects small value.
Bookplates small value.

TOMLINSON, John d.1824
Engraver of landscapes. He worked in London and later in Paris. He drowned himself in the Seine when drunk.
Small value.

TOMPSON, Richard d.1693
London printseller who published a group of mezzotint portraits, mostly after Sir Peter Lely, with no engraver's name but possibly by Tompson himself.
WL and TQL female portraits £100-£300.
TQL male portraits £40-£100.
HL male portraits £20-£60.
CS.

TOMS, William Henry b.1712
Etcher and line engraver of architectural and topographical views, naval and military subjects and a few portraits. He was born in and died in London.
'The Taking of Portobello by Admiral Vernon', after S. Scott, 1740, 17¾ x 26¼in/45 x 66.5cm, £250-£400.
Pl. for R. West's Perspective Views of all the Ancient Churches in London, *1736-9, fo., e. £20-£60.*
English views after J.B. Chatelain e. £20-£60.
'Perspective View of the Colonnade of Greenwich Hospital', after T. Lawrenson, 19½ x 27¾in/49.5 x 70.5cm, £200-£400.
'Perspective View of Greenwich Hospital', after T. Lawrenson, 2 pl. joined, 19½ x 56in/49.5 x 142cm, £600-£1,000.
'St. Mary Redcliff, Bristol', after Stewart, 1745, 30 x 22in/76 x 56cm, £150-£250.
4 views of Gibraltar, after I. Mace, 1775, 11½ x 18¼in/29 x 46.5cm, set £800-£1,600.
'South East View of Castle Cornet in Guernsey', after C. Lemprière, 11¼ x 17in/28.5 x 43.5cm, and other Channel Island views, e. £200-£500.
'Stained Glass Window in York Cathedral',

after Haynes, 5 pl., small value.
Portraits and small bookplates small value.

TOMSON fl. mid-18th century
Line engraver.
'A Beautiful Running Horse Belonging to His Grace the Duke of Bolton', after P. Tillemans, 1738, 2 pl. joined, 22½ x 36in/57 x 91.5cm, £800-£1,400.

TOOKEY, James fl. late 18th/early 19th century
Etcher and line engraver mainly of small bookplates including animal subjects and portraits after his contemporaries.
'Winter Amusement in Hyde Park', after J.C. Ibbetson, etched by Tookey, aq. by Edy (q.v.), 1787, 12¼ x 15¼in/31.5 x 39cm, pair £600-£900 col.
Bookplates small value.

TOOVEY, Richard Henry Gibbs, R.E. 1861-1927
Painter and etcher of landscapes, coastal scenes and figure subjects. He worked in London and Leamington and contributed to *English*

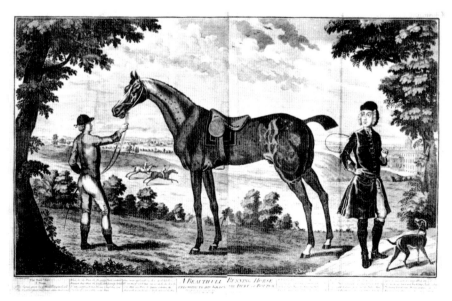

TOMSON. 'A Beautiful Running Horse Belonging to His Grace the Duke of Bolton', after P. Tillemans, 1738.

TOWNSEND, Henry James. A Typical etching executed for the Etching Club.

Etchings. He ceased work in 1889 due to illness.
£8-£16.

TOPHAM, F.W. fl. mid-19th century
Line engraver of small bookplates including
topographical views after his contemporaries.
Small value.

TOPHAM, T. fl. early/mid-19th century
Line engraver of small bookplates including
topographical views after his contemporaries.
Small value.

TOVEY, T. fl. early/mid-19th century
Etcher and line engraver of small bookplates
including architectural and topographical views
after his contemporaries.
Small value.

TOWNLEY, Charles b.1746
Mezzotint and occasional stipple engraver of
portraits and decorative, historical and animal
subjects after his contemporaries and Old Master
painters. Born in London, he at first practised as
a painter of portraits and miniatures before
turning to engraving. He then went to Italy to
study art in Florence and Rome before returning
to work again in London. In the late 1780s, he
visited Berlin where he painted miniatures and
engraved portraits, becoming Engraver to the
Court there. He came back to England via
Hamburg in 1790 and settled in London.
Mezzotints:
*'Adonis' and 'Bungay' (racehorses), both after
B. Marshall, 1796, 15 x 18in/38 x 45.5cm, e.
£300-£600.*
WL portraits £80-£200.
HL portraits after Old Master painters £8-£20.
HL portraits after contemporaries £15-£40.
Stipples:
After R. Cosway £80-£200 prd. in col.
Small portraits and bookplates small value.

TOWNSEND, Frederick Henry, A.R.E.
 1868-1920
Magazine illustrator who etched a few figure

studies and satirical subjects. A student at
Lambeth School of Art, he drew for *The
Illustrated London News* and other periodicals
and became art editor of *Punch* in 1905. His
prints are rare.
*'A Gyroscopic Judge's Box for the Detection of
Foul Riding', 1913, £100-£200.*
'Caught!' £50-£100.

TOWNSEND, Henry James 1810-1890
Historical, portrait and genre painter,
draughtsman and etcher of figure subjects. Born
at Taunton, he originally trained as a surgeon
before becoming a painter. Settling in London,
he was later appointed director of the
Government School of Design. He was a
member of the Etching Club and contributed
illustrations to several of their publications.
£15-£40.

TSCHUDI, Lill. 'Underground' 1930.

TOWNSEND, T.S. fl. late 19th century
Etcher of landscapes and rural scenes. He
contributed plates to *The Portfolio.*
Small value.

**TOWNSHEND, George,
first Marquis of** 1724-1807
Amateur draughtsman and possibly etcher of
caricatures. A professional soldier, Townshend
served under the Duke of Cumberland at
Culloden and took part in the expedition against
the French in Canada. After the death of Wolfe,
Townshend took the surrender of Quebec. He
was appointed Lord Lieutenant of Ireland in
1761. Although he certainly drew caricatures of
his contemporaries which earned him a great
deal of enmity, it cannot be said with certainty
whether he actually etched his designs, since
none of them are signed, but it is generally
believed now that he did.
£50-£100.

TRENCH, Frederick W. fl. early 19th century
Amateur draughtsman and early lithographer of
landscapes and topographical views, including
views of Belvoir Castle and Salamanca.
£20-£50.
Man Cat.

TRERY, H.C. fl. mid-19th century
Animal painter, draughtsman, lithographer and
publisher of 'Sketches in Lowestoft'.
*'Sketches in Lowestoft', c.1852, fo., tt. pl., e.
£20-£40.*

TROTTER, Thomas d.1805
Line and stipple engraver of portraits and
decorative subjects after his contemporaries and
his own designs. Born in London, he was a
pupil of W. Blake (q.v.). When his eyesight
failed due to an accident later in his career, he
was forced to give up engraving and turned
instead to drawing architectural views for
antiquarian publications. He died in London.
*'Dr. Johnson in Travelling Dress', 1786, 10 x
7in/25.5 x 18cm, £10-£20*
*'The Toilet of Venus', after A. Kauffmann, £100-
£200 prd. in sepia or in col.*
*'A Peasant Woman in a Storm', after H.W.
Bunbury, 1788, circle, £50-£150 prd. in sepia or
in col.*
Small portraits and bookplates small value.

TRUCHY, L. 1721-1764
French etcher and line engraver of sporting and
decorative subjects after his contemporaries and
17th century painters. Born in Paris, he worked
in London mainly for J. Boydell (q.v.). He died
in London.
*'Foxhunting', after J. Wootton, with Canot
(q.v.), 1735, 7 pl., 19¼ x 15¼in/50 x 40cm, set
£5,000-£7,000; 1770 edn. set £1,200-£1,800.*
*'Village Dance' and 'Playing at Bowls', both
after D. Teniers, e. £10-£25.*
Bookplates small value.

TSCHUDI, Lill b.1901
Linocut artist in the school of W.C. Flight (q.v.).
*'London Buses', c.1935, £600-£1,200 prd. in
col.*
'Knaben mit Skis', c.1935, £150-£300.
*'Difficult Parking', c.1931, £500-£900 prd. in
col.*
'Underground', 1930, £1,000-£1,600.
*'Paris Cafe', 8¼ x 9¾in/21 x 25cm, fetched
£4,600; 'Waiters', 1936, 11 x 10¼in/28 x 26cm,
£2,600; and 'In the Circus', 1932, 9½ x
10¼in/24 x 26cm, £4,800, all in Nov. 1989.*

TUNNICLIFFE, Charles Frederick, R.A., R.E. 1901-1982
Eminent painter and wood engraver of ornithological subjects, etcher and aquatint engraver of agricultural subjects and farm animals. Born near Macclesfield, he lived on Anglesey.
Wood eng. mainly £100-£200, but some rare prints of farm animals and birds £200-£500.
'The Ram' £300-£500.
Other etchings and aq. mainly £200-£400, but 'The Colt', 8¼ x 9¾in/22 x 25cm, £400-£600.
Bibl: Salaman, M.C., 'Etchings of C.F.T.', *Studio*, 1927, XCIII, p.91.

TURNBULL, Andrew Watson b.1874
Painter and etcher of landscapes, architectural views and figure subjects. He lived at Richmond in Surrey.
£10-£30.

TURNBULL, T. fl. early/mid-19th century
Line engraver of small bookplates including architectural designs after his contemporaries.
Small value.

TURNER, Charles, A.R.A. 1773-1857
Eminent and prolific mezzotint engraver, occasional stipple and aquatint engraver of portraits, sporting, military, decorative and animal subjects and topographical views after his contemporaries, Old Master painters and his own designs. Born at Woodstock, Oxfordshire,

TUNNICLIFFE, Charles Frederick. 'The Ram'.

TURNER, Charles. 'Durham Twin Steers', after J. Barenger, 1817, mezzotint.

Turner

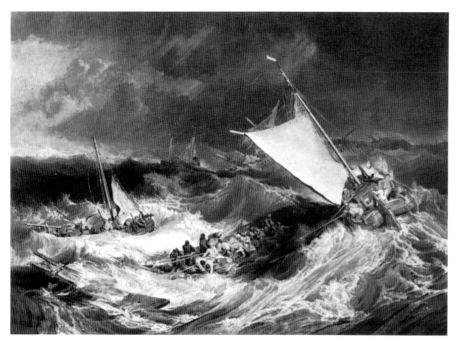

TURNER, Charles. 'A Shipwreck', after J.M.W. Turner. The first engraving after a Turner painting, 1805.

he studied at the R.A. Schools and was possibly a pupil of J. Jones (q.v.). His earliest dated engraving is a portrait of 'John Kirby, Keeper of Newgate', after his friend J.J. Masquerier's painting, published 20th February, 1796. He went on to produce over 900 plates, including over 600 portraits. His diary for the years 1798-1804 reveals that he had a good head for business. He published many of his prints himself from his address at 50 Warren Street, Fitzroy Square. From 1812, Turner had described himself as 'Mezzotinto Engraver in Ordinary to His Majesty', and in 1828 he was elected Associate Engraver of the R.A. On most of his plates he etched the outline of the subject before laying the mezzotint ground; exceptions being, for instance, plates for J.M.W. Turner's *Liber Studiorum*, which the latter had etched himself. Most of his prints are mezzotint portraits.

HL male portraits £10-£40.
WL male portraits, except sporting and decorative subjects, £30-£80.
'Apotheosis of Princess Charlotte', after A.W. Devis, 1819, 23½ x 16½in/59.5 x 42cm, mezzo., £40-£90.
'The Madonna', after Carlo Dolci, 1810, 12¼ x 9in/32.5 x 23cm, mezzo., £6-£12.
'A Shipwreck', after J.M.W. Turner (the first eng. after a Turner painting), 1805, 23¼ x 32½in/59 x 82.5cm, mezzo., £700-£1,200.
'Ralph John Lambton and Hounds', after J. Ward, 1821, 19 x 29½in/48.5 x 75cm, mezzo., £400-£700.
'Mademoiselle Parisot', after J.J. Masquerier, 1799, 8½ x 6¾in/21.5 x 17cm, stipple, £40-£70.
'Napoleon Reviewing the Consular Guards', after J.J. Masquerier, 1802, 21 x 26in/53.5 x 66cm, mezzo., £400-£600 prd. in col.
'Lady Louisa Manners in Peasant's Dress', after J. Hoppner, 19½ x 13½in/49.5 x 34.5cm, £250-£400 prd. in col.
'Rev. Dr Morrison Translating the Bible into the Chinese Language', after G. Chinnery, 1830, 24¼ x 18½in/63 x 47cm, mezzo., £300-£500.

'Part of St. James's Valley With a Distant View of the Town of St. Helena', after Capt. Barnett, 1806, 18½ x 23½in/47 x 60cm, aq., £200-£400 col.
'Hawking', after J. Howe, 1816, 22 x 24½in/55.5 x 62.5cm, mezzo., £800-£1,200 prd. in col.
'Fox and Cubs', after T. Bennet, 1821, 18½ x 20¼in/47 x 51.5cm, mezzo., £300-£500 prd. in col.
'British Feather Game', after J. Barenger, 1810, 14 pl., 14¾ x 17½in/37.5 x 44.5cm, mezzo., e. £300-£400 prd. in col.

'The Fortune Teller', after W. Owen, 1824, 21¾ x 16¼in/55 x 41.5cm, £150-£300 prd. in col.
'Durham Twin Steers', after J. Barenger, 1817, 19 x 23½in/48 x 59.5cm, mezzo., and other similar livestock subjects, £600-£900.
'Preparing to Start' and 'Coming In', after J-L. Agasse, 1803, 16 x 24½in/40.5 x 62cm, mezzo., pair £1,400-£2,200 prd. in col., fetched £2,600 Oct. 1993.
'Interior of the Fives Court with Randall and Turner Sparring', after T. Blake, 1821, 18¼ x 26in/146.5 x 66cm, aq., £600-£1,400 col.
'The Watermill', after A.W. Calcott, 1812, 23½ x 16¼in/59.5 x 42.5cm, mezzo., £80-£160.
'Simon Bolivar', after Por Gil, 1827, 23¼ x 15¼in/60.5 x 38.5cm, £200-£300.
'The Marlborough Family', after J. Reynolds, 1815, 32¼ x 26¼in/83 x 66.5cm, £150-£250.
'Durbar at Poonah', after T. Daniell, 1807, 24 x 35¼in/61 x 91cm, mezzo., £1,000-£2,000.
Pl. for Gems of Art, after Rembrandt and others, 1823, 5½ x 7in/14 x 18cm, mezzo., small value.
'Delights of Fishing', after R. Frankland, 1823, 6 pl., 8 x 10½in/20.5 x 26.5cm, aq., set £800-£1,200 col.
'Poachers', after C. Blake and I.L. Turner, 1825-6, 8 pl., 13¼ x 18in/33.5 x 46cm, aq., set £1,600-£2,400 col.
Pl. for 'Greece Illustrations to a Poem', after W. Haygarth, 1814, 9 pl., 8¼ x 11½in/21 x 29cm, etchings with mezzo. and aq., e. £30-£60.
Pl. for J. Dennis' Views in Savoy, Switzerland and on the Rhine, 1820, 8 pl., 5¼ x 8½in/14.5 x 21.5cm, mezzo., e. £20-£30.
Pl. for J.M.W. Turner's Liber Studiorum, 1809-17, mezzo., e. £80-£200; trial proofs, with latter's instructions or touched by him, £500-£1,000.
'Tiger & Crocodile', after J. Northcote, 1799, 19¼ x 24in/49 x 61cm, imp. prd. in col. and finished by hand fetched £4,000 April 1989 (see col. ill.).
Bibl: Whitman, A., *C.T.*, London, 1907.
Colour plates pages 68 and 69.

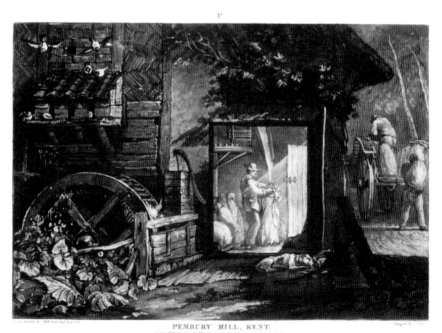

TURNER, Joseph Mallord William. 'Pembury Mill, Kent', 1808, from the *Liber Studiorum*.

TURRELL, Arthur. A typical sentimental subject.

TURNER, David fl. late 18th century
Draughtsman, etcher and line engraver of landscapes, architectural views and antiquarian subjects. He was a pupil of J. Jones (q.v.).
Small value.

TURNER, George Archibald 1821-1845
Aquatint engraver of sporting subjects after his father F.C. Turner. He was born in London where he lived and worked, dying at an early age of consumption.
'Battue Shooting', after F.C. Turner, 1840, 17 x 22in/43 x 55.5cm, £300-£500 col.
'Refraction' (racehorse), after F.C. Turner, 16¼ x 25in/42.5 x 63.5cm, £300-£600 col.
'Race for the Wolverhampton Stakes, 1839', after F.C. Turner, 1840, 20½ x 30in/52 x 76cm, £600-£1,200 col.

TURNER, H.S. fl. mid-19th century
Lithographer of portraits after his contemporaries
Small value.

TURNER, Joseph Mallord William, R.A. 1775-1851
Famous and important landscape painter. Although many of Turner's paintings were engraved throughout the 19th century, the artist did not make many prints himself. However, he both drew and etched in outline the plates for his *Liber Studiorum*, 1809-17 and these etchings were then mezzotinted, or occasionally aquatinted, by professional engravers, including C. Turner, F.C. Lewis I, W. Say, T. Lupton (qq.v.) and others. Turner mezzotinted a very few of the plates himself and also engraved the unpublished mezzotints of the 'Little Liber' sometime in the 1820s. These very rare prints are considered by some critics to be the finest examples of the medium.
Liber Studiorum: *trial proofs with Turner's instructions, or touched by him, £600-£1,000; etched proofs before mezzo. e. £150-£400; etchings with mezzo. as publ. e. £80-£200; complete set of 71 pl. as publ. £14,000-£18,000. 'Little Liber': lifetime proof imp. £4,000-£8,000, from posthumous printing of 1871-3 e. £800-£1,600.*
Bibl: Rawlinson, W.G., *T.'s Liber Studiorum*, London, second edn., 1906.
Colour plate page 69.

TURNER, Mary (née Pulgrave) 1774-1850
Amateur draughtswoman and etcher of portraits. She was married to the antiquary Dawson Turner and was taught by J.S. Cotman (q.v.).
Small value.

TURNER of Oxford, William 1789-1862
Well-known watercolourist who produced one early lithograph.
'Trees by the Water', 1806, 13¼ x 8½in/33.5 x 21.5cm, litho., £200-£300; on original mount £300-£400.
Man Cat.

TURRELL, Arthur fl. late 19th century
Etcher, mezzotint and mixed-method engraver of genre and sentimental subjects after his contemporaries. He lived and worked in London. He was the father of A.J. Turrell (q.v.).
'Drawing Room at Buckingham Palace', after and etched by F. Sargent (q.v.), 1888, 24¼ x 38½in/61.5 x 98cm, £300-£500.
'A Love Story', after J.M. Strudwick, 1890, 20¼ x 15½in/51.5 x 40cm, £150-£300.
Other lge. sentimental subjects mostly £30-£100.
Add more if in fine contemporary frame.
Small pl. and bookplates small value.

TURRELL, Arthur James, A.R.E. b.1871
Etcher of architectural views after his own designs and sentimental subjects after his contemporaries. Born in London, the son of A. Turrell (q.v.), he studied at the R.C.A. and in Paris. He worked in London and on the Continent.
£15-£50.

TURRELL, Edmund
fl. early/mid-19th century
Draughtsman and etcher of architectural views.
'View of the Suspension Bridge Over Menai Straits', after W.A. Parris, 15¾ x 25½in/40 x 65cm, £100-£200.

TUSHINGHAM, Sidney, A.R.E. 1884-1968
Painter and etcher of landscapes, architectural views and figure subjects. Born at Burslem in Staffordshire, he studied at the School of Art there and at the R.C.A. He lived in London and Sussex.
£30-£70.
Bibl: Konody, P.G., *Etchings and Drypoints by S.T.*, Glasgow.

TYSON, Rev. Michael 1740-1780
Fellow of Corpus Christi College, Cambridge, antiquarian and topographical draughtsman who etched a few portraits after his own designs and Old Master painters. In 1776 he was appointed parish priest of Lambourne where he died.
Small value.

TYTLER, George 1798-1859
Portrait painter, draughtsman and lithographer of caricatures, topographical views, etc. He was Lithographic Draughtsman to the Duke of Gloucester from 1819 to 1829 and travelled in Italy, publishing some views on his return. He also produced a large panoramic view of Edinburgh and a pictorial alphabet. He died in London.
Italian views £10-£30.
'Panorama of Edinburgh from Calton Hill', 1822, 11¼ x 86in/28.5 x 218.5cm, £500-£1,000 col.

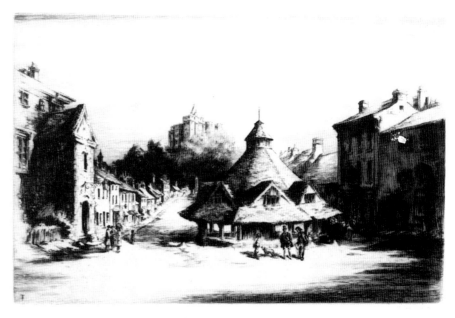
TUSHINGHAM, Sidney. An architectural view.

UNDERWOOD, Leon b.1890

Painter, sculptor, wood engraver, etcher and lithographer of figure subjects. Born in London he studied at the Regent Street Polytechnic, the R.C.A. and the Slade. He travelled widely abroad and wrote several books on art.
'Self portrait', white-line engraving, very rare, 1922, 4¾ x 3in/12.2 x 7.5cm, £300-£500.
Others mostly £40-£90.

UNWIN, Francis Sydney 1885-1925

Draughtsman, lithographer and etcher of landscapes, architectural views and agricultural subjects after his own designs and those of 19th century and Old Master painters. Born in Dorset, he studied at Winchester School of Art

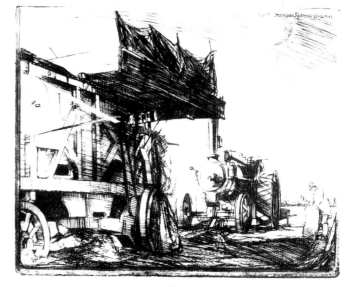

UNWIN, Francis Sydney. One of this artist's agricultural subjects.

and at the Slade, and travelled extensively on the Continent and in Egypt. He lived in London and later in Norfolk, dying of consumption at an early age.
Original prints: 'Maloja' (Swiss mountain views) and agricultural subjects e. £30-£70; others £20-£50.
Reproductive prints small value.
Bibl: Laver J., 'The Etched Work of F.U.', *Studio*, 1927, p.250; Dodgson, C., *F.U., Etcher and Draughtsman*, London, 1928; Schwab, R., 'F.S.U. Etcher and Lithographer', *P.C.Q.*, 1934, XXI, pp.59-91.

URWICK, William H., R.E.

 fl. late 19th/early 20th century
Painter and etcher of landscapes. He lived and worked in London and contributed plates to *The Etcher* and *English Etchings*.
Small value.

UTTERSON, Edward Vernon d.1856

Lawyer and watercolourist who produced one early lithograph.
'Knight in Armour on Horseback', 1806, 12½ x 9in/32 x 23cm, litho., £100-£200; on original mount £200-£300.
Man Cat.

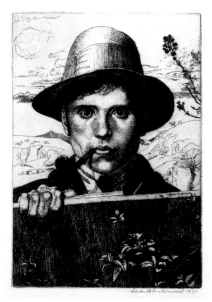

UNDERWOOD, Leon. Self-portrait.

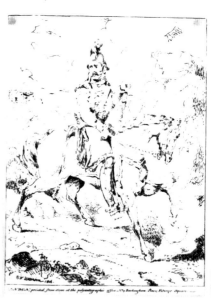

UTTERSON, Edward Vernon. 'Knight in Armour on Horseback', 1806.

VALCK, Gerard

 fl. late 17th/early 18th century
Netherlandish line and mezzotint engraver of portraits after his contemporaries. Born in Amsterdam, he was apprenticed to A. Blooteling (q.v.), whose sister he eventually married, and accompanied him to England where he remained for seven or eight years.
Line engravings:
'Hortense Mancini, Duchess of Mazarene', after P. Lely, 1678, 'Nell Gwynne', after Cooper and P. Lely, good early imp., e. £80-£150.
Other lge. portraits £20-£50.
Mezzotints:

'Louise, Duchess of Portsmouth', after P. Lely, 1678, 13¼ x 10in/35 x 25.5cm, £100-£200.
HL portraits £20-£80.
CS lists 10 pl.

VALMON, Léonie

 fl. late 19th/early 20th century
French etcher of landscapes, architectural views, sentimental subjects, etc., after French and British contemporaries.
Small value.

VAN BLEECK, P. see BLEECK, P. van

VANDERGUCHT, Gerard 1695-1776

Netherlandish etcher and line engraver of portraits, topographical views, animal subjects, etc., after his contemporaries and Old Master painters. The son of M. Vandergucht (q.v.), he was born in London and was a pupil of Louis Cheron. He originally worked mainly for booksellers engraving portraits and

frontispieces. Later, he became a dealer in paintings and works of art. He was apparently the father of thirty children.
'Still Life with Dead Game', after P.A. Rysbrack, e. £100-£200 col.
Views in India, including Bombay, Madras, etc., after P. Lambert and S. Scott, 1736, 15¼ x 22¼in/40 x 56.5cm, e. £300-£500 col.
'John Barber', after B. Dandridge, 16¼ x 10in/41.5 x 25.5cm, and other portraits of similar size, e. £10-£50.
Small bookplates and portraits small value.

VANDERGUCHT, Michael 1660-1725

Netherlandish line engraver of portraits after his contemporaries and Old Master painters. Born in Antwerp, he settled in London where he lived and worked, being mainly employed by booksellers to engrave portraits and frontispieces. He was the father of G. Vandergucht (q.v.).
Small value.

VAN DER MYN, A. (?Andrew/Agatha)
fl. mid-18th century
Netherlandish mezzotint engraver of portraits and decorative subjects after his or her contemporaries and Old Master painters. Possibly a son or daughter of Hermann Van Der Myn who resided in London 1719-36.
£20-£80.
CS lists 6 pl.

VAN DER MYN, G. (?Gerhard)
fl. mid-18th century
Netherlandish painter and engraver of a mezzotint. Possibly a son of Hermann Van Der Myn who resided in London 1719-36.
'Lady Sitting in a Landscape', 14 x 9¾in/35.5 x 25cm, mezzo., £50-£150.
CS lists 1 pl., noted above.

VANDER SPRIETT, John
fl. late 17th century
Netherlandish painter, mentioned here for two mezzotint portraits of English teachers engraved when he visited London.
'Thomas Cole' and 'Timothy Cruso', 13½ x 10in/34.5 x 25.5cm, e. £30-£80.
CS lists 2 pl., noted above.

VANDERVAART, John 1647-1721
Netherlandish painter and mezzotint engraver of portraits after his contemporaries. Born at Haarlem, he came to England in 1674 and practised as a painter with Wyck and Wissing, as well as producing a few early mezzotints. He died in Covent Garden, London.
'Elizabeth, Duchess of Somerset', after P. Lely, 13½ x 9½in/34 x 24cm, £200-£300.
'Lady Essex Finch', after P. Lely, 13½ x 9¾in/34 x 25cm, £150-£250.
Various HLs £20-£80.
CS lists 9 pl.

VAN HAECKEN, Alexander b.1701
Netherlandish mezzotint engraver of portraits after his contemporaries. He came over to England and apparently became a painter after a few years.
'Gentleman' and 'Lady' (both in riding costume), 18 x 12in/45.5 x 30.5cm, pair £300-£400.
'Jonathan Swift', after Markham, 1740, 13¼ x 9¾in/35 x 25cm, £150-£250.
Various TQLs £40-£100.
Various HLs £20-£80.
CS lists 22 pl.

VAN SOMER, Paul d.1694
Netherlandish etcher and line and mezzotint engraver of portraits and decorative subjects after his contemporaries, Old Master painters and his own designs. Born at Amsterdam, he practised as a painter, working in Paris for some time, before coming to London where he died. He is mentioned here for having executed several mezzotints in England.
'Coke Family', after Huysman, 19 x 25½in/148.5 x 65cm, £300-£500.
'Ladies Henrietta and Ann Churchill', after P. Mignard, 14 x 10in/35.5 x 25.5cm, £100-£200.
Various TQLs £40-£100.
Various HLs £20-£80.
CS lists 17 pl.

VAN WERDLEN fl. early 18th century
Netherlandish mezzotint engraver of portraits after his contemporaries. He worked in London.
'Princess Augusta', after G. Hansson, 13 x

VARLEY, John. A crayon-lithograph landscape.

8½in/33 x 22cm, £60-£140.
'Charles, Lord Cathcart', after W. Aikman, 13¾ x 9¾in/35 x 25cm, £60-£140.
'Sir Chaloner Ogle', after G. Hansson, 14 x 9¾in/35.5 x 25cm, £60-£140.
CS lists 3 pl., noted above.

VARLEY, Cornelius 1781-1873
VARLEY, John 1778-1842
These brothers, both well-known painters and

VAUGHAN, Robert. Engraved frontispiece to a work by Hobbes.

draughtsmen of landscapes, produced a few prints early in their careers. They collaborated to publish 'Etchings of Shipping, Barges, Fishing Boats and Other Vessels', 1809, a set which included five etchings and three early pen-lithographs. They also produced individually other pen- and crayon-lithographs.
Etchings £20-£50; litho. £60-£120.
Man Cat.

VARLEY, William Fleetwood 1785-1856
Watercolourist who was the younger brother of C. and J. Varley (q.v.). He drew and lithographed the following:
'Four Views in the Isle of Wight', c.1816, fo., e. £20-£50 col.

VARRALL, John Charles
fl. mid-19th century
Line engraver of small bookplates including landscapes and architectural views after his contemporaries.
Small value.

VAUGHAN, Robert fl. mid-17th century
Line engraver of portraits and frontispieces after his contemporaries and Old Master painters.
Small value.

VENDRAMINI, Giovanni (John) 1769-1839
Italian stipple engraver of decorative, religious and historical subjects and portraits after his contemporaries and Old Master painters. Born near Bassano, he came to London in 1788 and completed his studies under F. Bartolozzi (q.v.). In 1805 he went to Russia to work for two years; however, the Emperor and his court were so impressed with his work that he was refused a passport when he eventually wanted to leave. He finally managed to escape disguised as a courier. He died in London.
'Cries of London', after F. Wheatley, 1793-7, 16½ x 13in/42 x 33cm, e. £250-£400 prd. in col.
'The Storming of Seringapatam', after R.K. Porter, 1803, 3 pl., 25¼ x 37in/64 x 94cm, set £400-£800, fetched £1,500 in special Indian

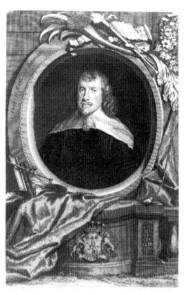

VENDRAMINI, Giovanni. 'The Storming of Seringapatam', after R.K. Porter, 1803.

VERTUE, George. 'Francis, Earl of Bedford', after A. Van Dyck, from *Illustrious Personages of Great Britain*.

sale May 1995.
'The Death of Sir Ralph Abercrombie in Egypt', after R.K. Porter, 14 x 20in/35.5 x 51cm, £200-£400 prd. in col.
Pl. for H. L'Eveque's Campaigns in Portugal, 1812-13, 15½ x 21½in/39.5 x 54.5cm, e. £30-£70.
'Mary Magdalen', after F. Bartolozzi, 1802, oval, 12 x 14in/30.5 x 35.5cm, £50-£150 prd. in sepia or in col.
'Cupid Refusing Love to Desire', after F. Bartolozzi, 1800, 11½ x 17in/29 x 43cm, £150-£250 prd. in sepia or in col.
Small portraits and bookplates small value.

VERNON, Rev. Henry John
fl. mid-19th century
Draughtsman, lithographer and publisher of shipping and naval subjects. The publication line on his prints reveals that he was based in Portsmouth.
'H.M. Steam Frigate Firebrand and the

Experimental Squadron' £150-£250.
Others £150-£350.

VERNON, Thomas 1824-1872
Line engraver of bookplates including portraits and religious subjects after his contemporaries and Old Master painters. Born in Staffordshire, he studied in Paris, was a pupil of P. Lightfoot (q.v.), and lived and worked in London.
Small value.

VERTUE, George 1684-1756
Eminent antiquary, draughtsman, line and mezzotint engraver of portraits and topographical architectural views after his contemporaries, Old Master painters and his own designs, ceremonial and antiquarian subjects after his own researches. An apprentice of M. Vandergucht (q.v.) for seven years, he started working for himself in 1709, becoming one of the first members of the academy for painting which was started in London by

G. Kneller in 1711. In 1717 he was appointed first Draughtsman and Engraver to the Society of Antiquaries. Much of his work from this date on was spent recording and illustrating archaeological finds, ancient buildings, historical portraits, antiquities, etc. Forty volumes of his notes were edited and published by Horace Walpole after his death as *Anecdotes of Painting*. He was also employed engraving the Oxford Almanacs from 1723 until his death.
'Kings and Queens of England', 1736, 38 pl., fo., set £200-£400; individually small value.
Pl. for Vertue and Houbracken's Illustrious Personages of Great Britain, 1743-52, e.£5-£15.
Oxford Almanacs e. £25-£40.
Pl. eng. for the Society of Antiquaries bearing inscription 'Sumptibus Societatis Antiquariae Lond.' depend on subject, e.g. 'Old London Gates', and similar topographical views, £10-£50; historical portraits and antiquities small value.

VICTORIA, H.M. Queen 1819-1901
Amateur draughtswoman and etcher of portraits, figure and animal subjects. She was a pupil of R. Westall and G. Hayter (qq.v.) and in her etchings collaborated with her husband Prince Albert (q.v.). All her plates were produced early in her reign, c.1840-1.
£100-£200; more if contained in a presentation set.
'The Princess Royal, holding a doll', one of only two lithos. by V., 1846, extremely rare, 8 x 10¼in/20.5 x 26cm, £150-£300.

VERNON, Henry John. 'H.M. Steam Frigate *Firebrand* and the Experimental Squadron'.

VICTORIA, H.M. Queen. 'Eos', 1841. A charming portrait of one of the Queen's pets, executed in the typical scratch manner.

VINCENT, George. A landscape, dated 1827.

Bibl: Scott-Elliot, A.H., 'The Etchings of Queen Victoria and Prince Albert', *Bulletin of the New York Public Library,* 65, 1961.

VINCENT fl. early 19th century
Line engraver.
'A View of the British Army on the Peace Establishment in the year 1803', after C. de Bosset, 24½ x 19in/62 x 48.5cm, £300-£400.

VINCENT, George b.1796
Norwich School landscape and marine painter who etched a few plates. Born in Norwich, he was a pupil of J. Crome (q.v.). He settled in London in 1819 and apparently died young.
£30-£70.

VINCENT, William fl. late 17th century
Mezzotint engraver of portraits after his contemporaries. He was born in and worked in London.
'Coke Family', after Huysman, 12 x 9in/30.5 x 23cm, £40-£100.
Otherwise mostly small HLs £10-£25.
CS lists 15 pl.

VINTER, John Alfred 1828-1905
Lithographer of portraits, particularly of royalty, after his contemporaries. He lived and worked in London and most of his work seems to be vignettes. He also executed a few bookplates.
Small value.

VISPRE, ?François Saveris/Victor
 fl. mid-/late 18th century
French painter and engraver who worked in Dublin and executed a few mezzotints which appear to have been published in England.
'Mary Vispre', 13 x 9in/33 x 23cm, £30-£80.
'Louis XV of France', after Liotard, 13 x 9in/33 x 23cm, £20-£50.
'Chevalier d'Eon', 13 x 9in/33 x 23cm, £15-£40.
CS lists 3 pl., noted above.

VIVARES, François (Francis) 1709-1780
Eminent French etcher and line engraver of landscapes, topographical views and genre, classical and religious subjects after his contemporaries and Old Master painters. Born near Montpellier, he came to London when he was about eighteen and studied there under J. B. Chatelain (q.v.). He was particularly successful at reproducing paintings by Claude and Poussin; however, these are considered of relatively small value today compared to many of his other works. He worked for J. Boydell (q.v.) for a number of years and then became his own publisher. He died in London.
Landscapes after Poussin and Claude Lorraine £50-£150.
'The East Prospect' and 'The West Prospect of the Giant's Causeway, Co. Antrim, Ireland', after S. Drury, 1777, 16½ x 27¼in/42 x 69cm, pair £400-£700.
8 views of Derbyshire, after T. Smith, 1744, 15¼ x 21½in/39 x 54.5cm, set £1,400-£2,000.
'Views in the Island of Jamaica', after G. Robertson, 1778, 16 x 20½in/40.5 x 52cm, e. £200-£500.
'The Rural Italian's Ball' after F. Zucarelli, 1775, circle, 18in/45.5cm diam., £40-£70.
'The Happy Peasant', after N. Berghem, 9¼ x 13 ¾in/25 x 35cm, £10-£20.
'Views of the Works at Coalbrook Dale . . .', after G. Perry and T. Smith, 1758, 15¼ x 21½in/39 x 54.5cm, pair £400-£700.

VIVARES, Thomas b.1735
Etcher and line engraver of landscapes, architectural views, sporting subjects and occasional caricatures after his contemporaries. He was the son and pupil of F. Vivares (q.v.) and was born in London.
Pl. for Robert and James Adam's Works in Architecture, 1773, small value.
Pl. for Orme's British Field Sports, after S. Howitt, with aq. by H. Merke, 1807-8, 14½ x 19in/37 x 48.5cm, e. £500-£1,000 col.
'Hunting Jackals' from Oriental Field Sports, after Captain T. Williamson and S. Howitt, 1805-7, fo., £150-£300 col.
'A Sepoy and Gentoo Bazaar Girl of the Western Army', after G.A. Byron, 1793, £30-£70 col.

VIVARES, François. 'A View of the Upper Works at Coalbrook Dale in the County of Salop', one of a pair after G. Perry and T. Smith, 1758.

W

WADSWORTH, Edward Alexander, A.R.A.
1889-1949

Important British painter, wood engraver and lithographer of shipping subjects, landscapes and townscapes, still life and figure subjects. Born at Cleckheaton in Yorkshire, he studied art on the Continent, at Bradford School of Art and at the Slade. His finest woodcuts date from just before World War I until its end. These prints, often abstract in design and printed in black or in a number of colours, usually in very small editions, show the influence both of Wadsworth's association with the Vorticist movement and his later work on the dazzle camouflage of shipping in Liverpool.

'Drydocked for Scaling and Painting', 1918, 9 x 8¼in/23 x 21cm, signed and dated, woodcut, £5,000-£7,000; similar camouflage and dazzle subjects £2,500-£7,000.
From a collection of small woodcuts sold June 1994: 'Newcastle', 'Bradford: View of a Town', and 'Riponelli: a Village in Lemnos', e. fetched £1,600, other landscapes and townscapes between £480 and £1,350; and Portrait of Rupert Doone £350.
'Crouching Nude', 1921, 10¼ x 15¼in/26 x 40cm, litho., £500-£800.
Untitled: port scene, publ. by Contemporary Lithographs, 17¼ x 24in/45.5 x 61cm, £400-£600.
Bibl: Colnaghi & Co. Ltd., *P. and D., E.W. Paintings, Drawings and Prints*, London, July-August 1974.

WAGEMAN, Thomas Charles
d.1863

Painter, etcher and stipple engraver of portraits after his contemporaries and occasionally his own designs.
'William Dowton as Major Sturgeon in Foote's Mayor of Garratt', after S. de Wilde, 1808, 14½ x 9½in/37 x 24cm, £15-£40 col.
Small portraits and bookplates small value.

WAGSTAFF, Charles Edward
1808-1850

Line, mezzotint and mixed-method engraver of portraits and historical and genre subjects after his contemporaries. He was born in London where he appears to have lived and worked.
'The Trial of Charles I at Westminster Hall', after W. Fiske, 1846, 22½ x 34¼in/57 x 87cm, and other lge. pl. depicting earlier historical events, £40-£100.
'The Coronation of Queen Victoria', after E.T. Parris, with T. Hyam, 1840, 23½ x 34in/59.5 x 86.5cm, £200-£400.
'The Marriage of Queen Victoria', after G. Hayter, 1844, 22½ x 34½in/57 x 87.5cm, £200-£400.
'The Wesleyan Centenary Meeting', after C.A. du Val, 1843, 24 x 33¼in/61 x 84.5cm, £100-£200.
'John Musters and Hounds Meeting at the Cover Side in Annesley Park, Nottinghamshire', after R.B. Davis, 1847, 21 x 27in/53.5 x 68.5cm, £300-£500.
'The Golfers: A Grand Match Over St. Andrews' Links', after C. Lees, 1850, 25½ x 37in/65 x 94cm, £1,200-£2,400.
'The Duke of Wellington', after W. Pickersgill,

WADSWORTH, Edward Alexander. 'Drydocked for Scaling and Painting', 1918.

1841, 26 x 16in/66 x 40.5cm, and similar lge. WL portraits, £30-£100.
'Prince Albert', after G. Patten, 1840, 15 x 12in/38 x 30.5cm, and similar size TQL portraits, £20-£60.
Add more if in fine contemporary frame.
Small portraits and bookplates small value.

WALCOT, William, R.E.
1874-1943

Watercolourist, draughtsman and etcher of architectural views. Born in Russia (his father was English and his mother Russian), he studied architecture at St Petersburg and, after further studies in Paris, practised for a few years in Moscow. Coming to London, he took up painting and was sent by the Fine Art Society to Italy. His subjects consisted of contemporary views and imaginary classical scenes taken from ancient Egypt or Rome. He lived and worked in London.
'View of New York from Brooklyn' £200-£300.
Other lge. pl. £100-£300.
Small London views and other small pl. £60-£140.
Bibl: Salaman, M.C., 'W.W.'s Etchings of the Old and New World', *Studio*, 1923, LXXXV, p.311; Salaman, M.C., 'W.W.', Modern Masters of Etching, No.16, *Studio*, 1927.

WALKER, Anthony
1726-1765

Line engraver of topographical views, religious and genre subjects and portraits after his contemporaries and Old Master painters. Born at Thirsk in Yorkshire, he studied at St Martin's Lane Academy in London and under J. Tinney (q.v.). He was employed engraving

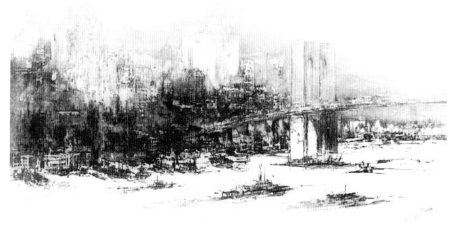

WALCOT, William. 'View of New York from Brooklyn'.

frontispieces and vignettes for the booksellers and larger plates for John Boydell (q.v.). He died in London.

'The Country Attorney and His Client', after H. Holbein, approx. 20 x 26in/51 x 66cm, £100-£200.

'The Angel Departing from Tobit', after Rembrandt, 1765, 20 x 26in/51 x 66cm, £10-£20.

'Curius Dentatus and the Samnites', after Cortona, 1763, 26 x 18in/66 x 45.5cm, £15-£40.

'Prior Park, the Seat of Ralph Allen, near Bath' (showing the railway to the canal), c.1750, 11 x 17in/28 x 43.5cm, £100-£250 col.

London views £80-£160 col.

Bookplates, frontis., etc., small value.

WALKER, Bernard Eyre, A.R.E b.1886
Watercolourist and etcher of landscapes. Born in Essex, he settled in the Lake District.
£30-£70.

WALKER, Edmund fl. mid-19th century
Lithographer of topographical views and military and sporting subjects after his contemporaries. He worked in London for the firm of Day & Son (see William Day II).

'Tiger Hunting', after P. Trench, 1846, 4 tt. pl., lge. obl. fo., set £1,500-£3,000.

'Pig Sticking in India', after P. Carpenter, 1861, 8 tt. pl., 13½ x 18in/34 x 45.5cm, set £1,500-£2,500.

'Wild Boar Hunting', 'Hog Hunting', both sets of 4, fetched £3,500 and £6,500 in special Indian sale May 1995.

'Kabul Monument and Mess House, Headquarters of the Bengal Artillery, Dumdum', c.1888, 27 x 19½in/68.5 x 49.5cm, £100-£200 col.

Pl. for Simpson's Seat of War in the East, fo., e. £10-£30 col.

'Lloyd's Cavalry Prints', after R.R. Scanlon, 1847-50, 18 x 21in/45.5 x 53.5cm, tt. pl., £140-£200 col.

'Panorama of Cape Town', after T W Bowler 1854, 12½ x45½in/32 x 116cm, £1,000-£2,000 prd. in col.

'View of St. Lucia', after Oldershaw, 1854, 16¼ x 20½in/42.5 x 52.5cm, tt. pl., £500-£800 col.

'Views of Barbados, Looking Towards the Artillery and Line Barracks', after W.H. Freeman, 1853, 14½ x 21¼in/37 x 54cm, pair £600-£1,000 col.

'Views of the Principal Buildings in London', 1852, after his own drawings, 12½ x 16 1/4in/31.5 x 41cm, tt. pl., e. £200-£400.

WALKER, Frances Sylvester, R.H.A., R.E. 1848-1916
Irish landscape and genre painter, magazine illustrator, etcher of landscapes and architectural views after his own designs, mezzotint engraver of portraits, decorative and religious subjects after Old Master and 18th century British painters. Born in County Meith, he studied at the Royal Hibernian Academy before coming to London in 1868. He worked at The Graphic and The Illustrated London News and later took up etching and engraving.
Etchings £8-£20.
Mezzo. £15-£50 prd. in col.

WALKER, George
 fl. late 18th/early 19th century
Landscape painter who produced a few early lithographs.
'Landscape with Two Cows', 1807, 8 x 11in/20.5 x 28cm, £150-£250; on original

WALKER, Edmund. 'Royal Horse Guards Blue' from 'Lloyd's Cavalry Prints', after R.R. Scanlon, 1847-50.

mount £250-£350

'Thatched Cottage by a Pond', 1807, 7½ x 10½in/19 x 26.5cm, £150-£250; on original mount £250-£350.

2 others of 1809 £50-£100.

Man Cat.

WALKER, I. fl. 1920s
Etcher of marine subjects and coastal scenes.
£10-£30

WALKER, James 1748-c.1808
Mezzotint engraver of portraits and decorative, classical and religious subjects after his

contemporaries and Old Master painters. The son of a merchant navy captain, he was a pupil of V. Green (q.v.) at the age of fifteen. In 1784 he went to St Petersburg, having been appointed Engraver to the Empress of Russia. He remained there for seventeen years, engraving portraits of the Imperial family, and plates after the Old Masters which he lost on his return in 1802 when his ship sank. He died in London.

'Miss Frances Woodley', after G. Romney, 1781, 24¼ x 15in/61.5 x 38cm, and WL female portraits of similar size, £300-£500.

'Sophia Musters', after G. Romney, 1780, 13 x 10½in/33 x 26.5cm, and HL female portraits of similar size, £60-£140.

'Sir Hyde Parker', after G. Romney, 24½ x 15¼in/ 62 x 38.5cm, and male portraits of similar size, £70-£150.

'The Infant Hercules', after J. Reynolds, 1792, 26 x 23in/66 x 58.5cm, £40-£90.

'The Entombment of Elspada', 1816, 21 x 26in/53.5 x 66cm, £15-£40.

CS.

WALKER, John
 fl. late 18th/early 19th century
Line engraver of small bookplates including landscapes and topographical views after his contemporaries. He was the son of W. Walker I (q.v.) and finished many of his father's plates. He lived and worked in London.
Small value.

WALKER, R. fl. mid-19th century
Draughtsman and lithographer.

'Household Cavalry 1845', 4 pl., 15 x 12in/38 x 30.5cm, set £500-£800 col.

'Hong Kong and the Town of Victoria', after Lieut. Bellairs, R.N., c.1845, 9¾ x 65½in/25 x 166cm, tt. pl., £1,000-£2,000 col.

WALKER, William I 1729-1793
Line engraver of portraits, landscapes, topographical views, genre and allegorical subjects after his contemporaries and Old Master painters. Born at Thirsk in Yorkshire, the brother and pupil of A. Walker (q.v.), he lived and worked in London, mainly engraving bookplates.

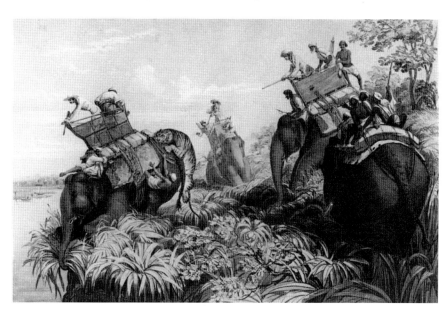

WALKER, Edmund. One of four plates from 'Tiger Hunting: The Escape', after P. Trench, 1846.

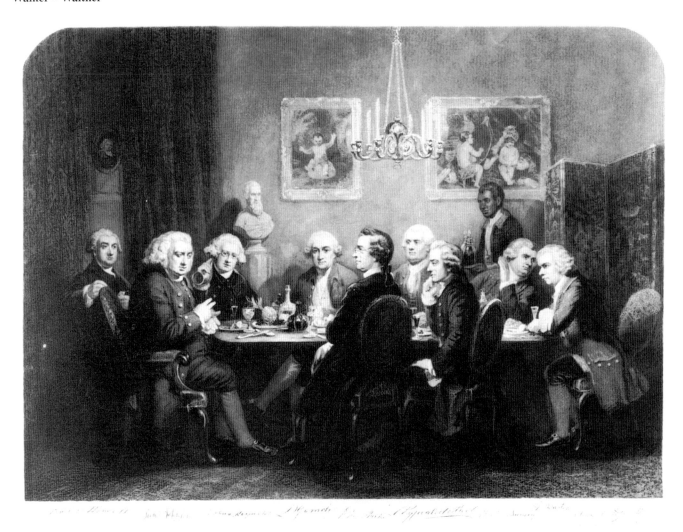

WALKER, William II. 'Literary Party at Sir Joshua Reynolds', after J.E. Doyle with D.G. Thompson.

Lge. landscape and topographical pl. £50-£150.
Small pl. and pl. after Old Masters small value.

WALKER, William II 1791-1867
Scottish line, stipple, mezzotint and mixed-method engraver of portraits and historical subjects after his contemporaries. Born in Midlothian, he came to London in 1815 to study engraving under J. Stewart, T. Woolnough and T. Lupton (qq.v.). After working in Scotland again from 1819 to 1832, he finally settled in London.
'Literary Party at Sir Joshua Reynolds', after J.E. Doyle with D.G. Thompson (q.v.), 1848, 16 x 22¼in/ 40.5 x 56.5cm, £60-£140.
'The First Reformers Presenting their Protest ...', after Cattermole, 1844, 26 x 34in/66 x 86.5cm, and historical subjects and group portraits of similar size, £40-£160.
Larger mezzo. portraits £16-£50.
Add more if in fine contemporary frame.
Small stipple portraits and bookplates small value.

WALKER, William III, R.E. 1878-1961
Scottish painter and etcher of architectural views. Born in Glasgow, he studied there as well as in London and on the Continent. He lived in Perthshire and Edinburgh.

£30-£70.
Bibl: 'Etchings and Drypoints by W.W.', Studio, 1913, LIX, p.271.

WALLACE, Robin b.1897
Painter and occasional drypoint etcher of landscapes. He was born at Kendal.
£20-£50.

WALLIS, Henry d.1890
Etcher and line engraver of small bookplates including landscapes and architectural views after his contemporaries. He was the son of T. Wallis and the brother of R. and W. Wallis (qq.v.). He later became an art dealer when two strokes prevented him from continuing to engrave.
Small value.

WALLIS, Robert 1794-1878
Etcher and line engraver of small bookplates including landscapes, coastal and architectural views, religious and historical subjects after his contemporaries and Old Master painters. The son of T. Wallis, he was the brother of H. and W. Wallis (qq.v.). He was born in London where he lived and worked.
Swiss views £5-£10.
Pl. after Turner when proofs or early imp. £20-

£80.
Others small value.

WALLIS, Thomas d.1839
Etcher and line engraver of small bookplates including figure subjects after his contemporaries and Old Master painters. The father of H., R. and W. Wallis (qq.v.), he worked as an assistant to C. Heath (q.v.).
'The Laws of the Noble Game of Cricket', after F. Hayman, 1809, vignette as head-piece £250-£350 col.
Others small value.

WALLIS, William b.1796
Etcher and line engraver of landscapes and architectural views and historical subjects after his contemporaries. Son of T. Wallis, he was the brother of H. and R. Wallis (qq.v.).
Swiss views £5-£10.
Others small value.

WALTNER, Charles Albert 1846-1925
French etcher of portraits and figure subjects after his French and British contemporaries and Old Master painters. Born in Paris, the son of an engraver, he studied painting before taking up etching. He lived and worked in Paris.
'A Sibyl', after E. Burne Jones, 1882, 17¼ x

7in/44 x 18cm, £500-£800.
'The Gambler's Wife', after J.E. Millais, 1879, 18 x 8½in/45.5 x 21.5cm, £20-£40.
'Romeo and Juliet', after F. Dicksee, 1886, 10 x 9¼in/25.5. x 23.5cm, £20-£40.
Others mostly small value.

WALTON, W.L. fl. mid-19th century
Lithographer of landscapes, topographical views, military and transport subjects after his contemporaries. He worked in London for Day & Son (see William Day II).
Pl. for W. Simpson's Seat of War in the East, 1855-6, fo., tt. pl., e. £10-£30 col.
Pl. for J. LeCapelain's Queen's Visit to Jersey, 1847, fo., tt. pl., e. £30-£70.
Pl. for J. Burkill's Picturesque Views of Bolton Abbey, c.1848, fo., tt. pl., e. £5-£10.
'The Aerial' ; (fictional flying machine) £60-£100 col.
'The Cricket Match at Tonbridge School', after J.J. Dodd, 20 x 31¼in/51 x 80.5cm, tt. pl., £500-£900.
'View of Quebec, from Point Levy', 1832, after R.A. Sproule, 10¼ x 14¼in/26.5 x 37.5cm, fetched £650 April 1989.

WARD, George Raphael d.1879
Mezzotint engraver of portraits after his contemporaries. Son and pupil of James Ward (q.v.), he was born in London. Apart from engraving he also copied portraits by Thomas Lawrence in miniature.
'Tatton Sykes', after F. Grant, 31½ x 21in/80 x 53cm, and similar equestrian portraits, £200-£500.
'Lady Mathilda Butler', after J.R. Swinton, 23¾ x14in/60.5 x 35.5cm, and other female WL portraits of similar size, £60-£160.
HL male portraits £20-£40.
Add more if in fine contemporary frame.

WARD, James, R.A. 1769-1859
Eminent animal and landscape painter, mezzotint engraver of portraits, farm and

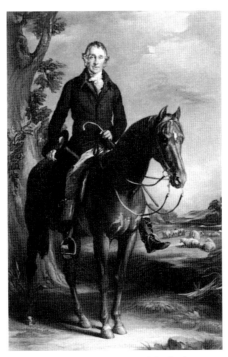
WARD, George Raphael. 'Tatton Sykes', after F. Grant.

animal subjects, naval and decorative subjects after his contemporaries, his own designs and Old Master painters, lithographer of equine portraits and etcher of some miscellaneous figure studies. Born in London, he was the younger brother of W. Ward (q.v.), and father of G.R. Ward (q.v.). He was apprenticed to John Raphael Smith (q.v.) at about the age of twelve, and then to his brother, with whom he later formed a partnership. He executed most of his engravings around the turn of the century,

concentrating on his painting after 1804 when he was commissioned to paint livestock by the Royal Agricultural Society. Between 1823 and 1824, however, he lithographed a series of portraits of 'Celebrated Horses' which are important early examples of artist's lithography. He died at Cheshunt.
'A Series of Lithographic Drawings of Celebrated Horses', 1823-4, 14 pl., set £5,000-£7,000; individually prices vary between 'Marengo' and 'Adonis' e. £600-£900, and 'Primrose and Foal' £200-£400.
Etchings:
Animal studies, mostly dating 1794, e. £30-£80.
'Mary Thomas the Welsh Fasting Woman' and 'Anne Moore, the Fasting Woman of Tetbury', 1812, 7 pl., set £100-£200; individually £10-£15.
Mezzotints:
'Sir Francis and Charles Baring and Charles Wall', after T. Lawrence, 22 x 25¼in/56 x 65.5cm, £300-£500, fetched £950 May 1989.
'Lady Heathcote as Hebe', after J. Hoppner, 1804, 24½ x 16¾in/62 x 42.5cm; 'Mrs. Michael Angelo Taylor as Miranda', after Hoppner, 20 x 15¼in/51 x 38.5cm; 'Mrs. Billington as St. Cecilia', after J. Reynolds, 1803, 25 x 16¼in/63.5 x 41.5cm, e.£200-£400.
'The Hoppner Children', after Hoppner, 1799, 18¾ x 16in/47.5 x 40.5cm, £200-£400.
''George III on his Charger Adonis', after W. Beechey, 1800, 21½ x 25½in/54.5 x 65cm, £400-£700.
The Right Hon. Adam Duncan', after J. Hoppner, 1798, and other WL male portraits, £60-£120.
TQLs £30-£80.
Various HLs £15-£50.
'A Livery Stable', after J. Ward, 20¼ x 24in/51.5 x 61cm, £800-£1,200 col.
'Cottagers Going to Market' and 'The Return from Market', after J. Ward, pair £600-£1,000 prd. in col.
'A Poultry Market', after J. Ward, 18 x 24in/45.5 x 61cm, £500-£800 prd. in col

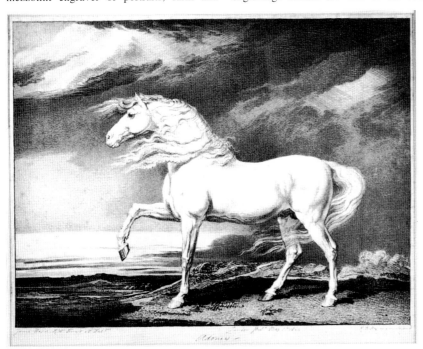
WARD, James. One of fourteen plates from 'A Series of Lithographic Drawings of Celebrated Horses: Adonis', 1823-4.

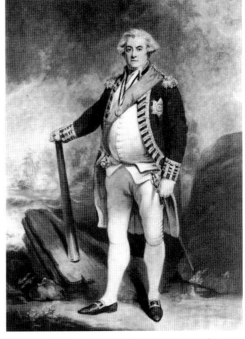
WARD, James. 'The Right Hon. Adam Duncan', after J. Hoppner, 1798.

Ward

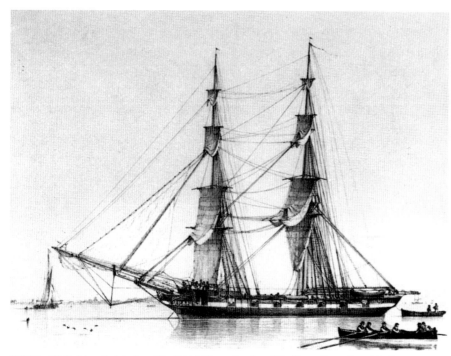

WARD of Hull, John. A plate from 'The British Navy - A series of Ten Views Illustrative of the Several Rates and Classes of Vessels in H.M. Navy: The Gun Brig'.

'The Rocking Horse', after J. Ward, 1783, 18 x 21in/45.5 x 53.5cm, £700-£1,000 prd. in col.
'The Misers', after Q. Matsys, 16¼ x 13¼in/42.5 x 33.5cm, £15-£30.
'A Lion and Tiger Fighting', after J. Ward, 1799, 19 x 23¾in/48.5 x 60.5cm, £800-£1,400, imp. prd. in col. and finished by hand fetched £2,600 April 1989.
'Shorn Ewe of the New Leicestershire Stock', 1800, 11½ x 13¾in/29.5 x 35cm, £400-£700 prd. in col.
'The Spottiswoode Ox', after A. Nasmyth, 1804, 18¼ x 23½in/46.5 x 60cm, £700-£1,000 prd. in col.
Bibl: Frankau, J., William Ward, A.R.A. and J.W., London, 1904; Grundy, C.R., J.W. His Life and Works, London, 1909; Siltzer, F., The Story of British Sporting Prints, 1925.

WARD of Hull, John 1798-1849
Painter and occasional lithographer of marine subjects. Born in Derbyshire he lived and worked in Hull painting ships and shipping scenes, as well as visiting the Arctic with the whaling fleet and painting on the South Coast.
'The British Navy - A Series of Ten Views Illustrative of the Several Rates and Classes of Vessels in H.M. Navy' (an extremely rare series), small obl. fo., 10 tt. pl., set £800-£1,200.

WARD, Sir Leslie Matthew ('Spy')
 1851-1922
Portrait painter and draughtsman of portrait caricatures. Born in London, he trained as an architect but is best known for the caricatures which he drew for Vanity Fair under the name 'Spy', and which were lithographed by Vincent Brooks (q.v.). He lived and worked in London.
Politicians, clergy, nobility, statesmen, lawyers small value.
Sportsmen, musicians and other special subjects £10-£80, but 'Cricket' (W.G. Grace) £200-£400.
A collection of caricatures of cricketers by Spy,

34 pl., including W.G. Grace, fetched £3,500 Oct. 1989.

WARD, Leslie Moffat, R.E. b.1888
Painter and etcher of landscapes and architectural views. He lived in Bournemouth where he studied at the School of Art. £30-£70.

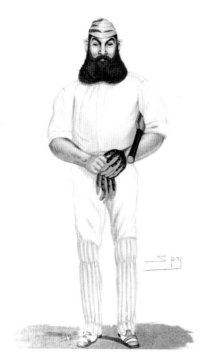

WARD, Leslie Matthew. 'Cricket', caricature of W.G. Grace. One of the most desirable subjects of the many executed for Vanity Fair.

WARD, William, A.R.A. 1766-1826
Eminent mezzotint and occasional stipple engraver of portraits, decorative, genre, sporting and animal subjects after his contemporaries, his own designs and Old Master painters. Born in London, he was the elder brother of James Ward (q.v.), whom he taught to engrave and with whom he formed a partnership to produce engravings. He was apprenticed to John Raphael Smith (q.v.), and on completing his time became the latter's assistant. He married a sister of George Morland, many of whose paintings he engraved. He was appointed Mezzotint Engraver to the Duke of York in 1803, and Engraver to the Duke of Clarence, later William IV. In 1814 he was elected Associate Engraver of the Academy. He died in London.
Mezzotints:
'Thomas William Coke, M.P. for Norfolk Inspecting Some of His Southdown Sheep', after T. Weaver, £800-£1,200 prd. in col.
'Daughters of Sir Thomas Frankland Bart.' (one of Ward's most famous mezzo. portraits), after J. Hoppner, 1797, 21½ x 17¼in/54.5 x 45cm, £400-£800.
'Sir Joshua Beating Filho da Puta', after B. Marshall, 1818, 20½ x 23½in/52 x 59.5cm, £400-£700.
'Sir Mark Masterman Sykes and Hounds', after H.B. Chalon, 1821, 24 x 30in/61 x 76cm, £400-£600.
'John Wesley', after G. Romney, 1825, 14 x 11in/35.5 x 28cm, £60-£120.
'Mrs. Benwell', after J. Hoppner, 1783, 14¼ x 10¾in/37.5 x 27.5cm, £200-£400 prd. in col.
'Alehouse Politicians', after G. Morland, 16 x 24in/40.5 x 61cm, £400-£700 prd. in col.
'The Angler's Repast', after G. Morland, 1789, companion to 'A Party Angling', by G. Keating (q.v.), 18 x 22in/45.5 x 56cm, pair £800-£1,200.
'Babworth Ox', after T. Weaver, 1818, 19¾ x 23¾in/50 x 60.5cm, £700-£1,000 prd. in col.
'The Brewery, Chiswell Street', after G. Garrard, 1792, 18 x 21½in/45.5 x 55cm, £700-£1,000.
'The Citizen's Retreat' and 'Selling Rabbits', after James Ward, 1796, 18¾ x 24in/47.5 x 61cm, pair £500-£900 prd. in col.
'The Effects of Extravagance and Idleness', after G. Morland, 23 x 18in/58.5 x 45.5cm, pair £400-£700 prd. in col.
'Hay Makers', after J. Ward, 1793, 19 x 23¾in/48.5 x 60.5cm, £700-£1,000 prd. in col.
'Inside of a Country Alehouse', after G. Morland, and 'Outside of a Country Alehouse', after J. Ward, 1797, 24 x 16in/61 x 40.5cm, pair £800-£1,200 prd. in col.
'The Reading Magdalen', after Coreggio, 1792, 14¼ x 10¼in/37.5 x 26cm, £5-£10.
Pl. for Dr. Thornton's Temple of Flora: 'The Snowdrop', after Pether, 'The Dragon Arum', after P. Henderson, both approx. 18¾ x 13¾in/47.5 x 35cm, e. £300-£400 prd. in col. and finished by hand.
'Pointers', after Sartorius, and 'Setters', after G. Morland, 1806, 12 x14in/30.5 x 35.5cm, pair £300-£500.
Racehorse portraits £400-£600.
'The Earl of Chesterfield's State-Carriage' and 'His Majesty's State Horses', after H.B. Chalon, 1800, 18 x 22¾in/46 x 58cm, pair £1,000-£1,800.
'Portrait of the Artist', after J. Wright of Derby, 1807, 15 x 10½in/38 x 27.5cm, £250-£350.
Portraits: HLs £15-£50; TQLs £30-£80; WL female £100-£200; WL male £60-£140.

WARD, William. 'Hay Makers', after J. Ward, 1793, mezzotint. One of several classic decorative plates engraved after Ward's brother's paintings.

WARD, William. 'Daughters of Sir Thomas Frankland Bart', after J. Hoppner, 1797, one of Ward's most famous portrait mezzotints.

Stipples:
Various decorative subjects and portraits, ovals, £200-£400 prd. in col.
Bibl: Frankau, J., *W.W., A.R.A., and James Ward,* London, 1904.
Colour plate page 70.

WARD, William James 1800-1840
Mezzotint engraver of portraits and decorative and religious subjects after his contemporaries and Old Master painters. Born in London he was the son and pupil of W. Ward (q.v.).
'Thomas Thynne, 2nd Marquis of Bath', after H.W. Pickersgill, 1834, 24 x 15in/61 x 38cm, and other WL male portraits of similar size, £40-£80.
'Adolphus Frederick, Duke of Cambridge', after W. Beechey, 1825, 10½ x 9in/26.5 x 23cm, and other HL male portraits of similar size, £8-£20.

'Lady Anne Harcourt', after J. Jackson, 1831, 15 x 12in/38 x 30.5cm, £20-£50.
'Lady Sophia Brownrigg', TQL, after T. Lawrence, £40-£90.
'Garrick in the Green Room', after W. Hogarth, 1829, 19 x 24¼in/48.5 x 62cm, £30-£80.
Pl. after Old Masters small value.
Decorative subjects £10-£50.

WARING, Miss F. fl. early 19th century
Amateur artist.
'Twelve Views of Scotland Delineated by a Lady in the Polyautographic Art of Drawing on Stone', 1803, fo., crayon litho. on brown paper, v.rare, set £600-£1,000.

WARING, John Burley 1823-1875
Architect, draughtsman and lithographer of architectural views. Born in Lyme Regis he was apprenticed to an architect and studied at the RA schools. He produced folios of architectural views of buildings sketched in Italy and Spain. *Small value individually.*

WARLOW, Herbert Gordon, A.R.E. 1885-1942
Etcher of architectural views. He was born in Sheffield, where he lived for some years before moving to Surrey.
£60-£120.

WARNER, Thomas fl. late 18th/early 19th century
Line and mixed-method engraver of plates for Dr. Thornton's *Temple of Flora* and small bookplates.
'Hyacinths', 1801, after S. Edwards, 'The

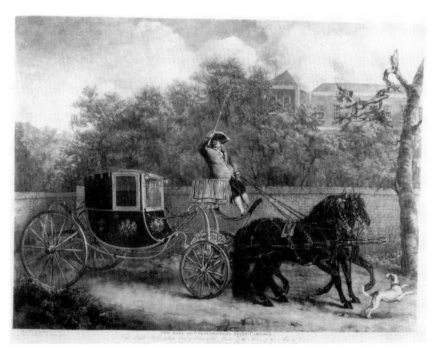

WARD, William. 'The Earl of Chesterfield's State-Carriage', pair with 'His Majesty's State Horses', both after H.B. Chalton, 1800.

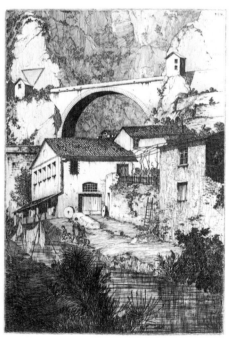

WARLOW, Herbert Gordon. A typical etching.

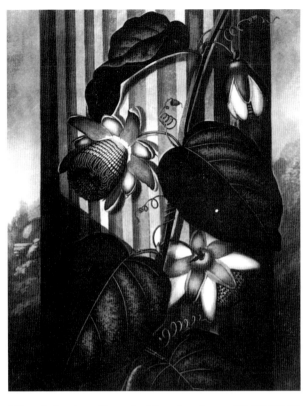

WARNER, G. 'The Winged Passion Flower', after P. Henderson, 1802, from Dr Thornton's *Temple of Flora*.

WARWICK, Henry Richard Greville. 'Landscape with Old Trees by Water', 1803.

Winged Passion Flower', 'The American Cowslip', both after P. Henderson, 1802 and 1801, fo., respectively £600-£900, £400-£700, £300-£400 prd. in col. and finished by hand. Small bookplates small value.

WARREN, Alfred William d.1856
Etcher, line and mezzotint engraver of small bookplates, including portraits and sporting, religious and historical subjects after his contemporaries and Old Master painters. He was the brother of C.T. Warren (q.v.).
Small value.

WARREN, Charles Turner 1762-1823
Line engraver mainly of small bookplates including portraits and figure subjects after his contemporaries and Old Master painters. He was the brother of A.W. Warren (q.v.) and lived and worked in London. He is credited with the development of steel plates for engraving, the first of which was used in 1822. He was awarded the large Gold Medal by the Society of Arts in 1823 but died before he could receive it. He was also a founder member of the Artists' Annuity Fund in 1810 and its President from 1812 to 1815.

Pl. for Boydell's Shakespeare, fo., e. £10-£25. Small bookplates small value.

WARWICK, Henry Richard Greville, third Earl of 1779-1853
Amateur artist who produced one early lithograph.
'Landscape with Old Trees by Water', 1803, publ. in Specimens of Polyauthography 1803 and 1806, 11¼ x 8½in/30 x 21.5cm, pen litho., £200-£300; on original mount £300-£400.
Man Cat.

WASHINGTON, William, A.R.E. 1885-1956
Painter and line engraver of architectural views, portraits and figure subjects. Born in Cheshire, he studied at the R.C.A. after working as a railwayman and for a firm of lithographic printers. He taught at Southend and Clapham Art Schools and was head of the Department of Arts and Crafts at Hammersmith.
£60-£160.

WASS, Charles Wentworth 1817-1905
Line, stipple, mezzotint and mixed-method engraver of portraits, mythological, historical and animal subjects after his contemporaries. He lived and worked in London and was appointed Engraver to the Duchess of Cambridge.
'The Biter Bit', after J. Bateman, 1847, 17 x 21in/43 x 53.5cm, £30-£80.
'Duke' (a dog), after R. Ansdell, 1849, 20 x 30in/51 x 76cm, £120-£250.
'Joan of Arc', after W. Etty, 1851, triptych, centre 23 x 34in/58.5 x 86.5cm, sides 59.5 x 39.5cm, set £100-£200.
'Pharaoh's Horses', after J.F. Herring, 1849, circle, 24in/61cm, diam., £150-£250.
'Poppy and Frog', after E. Landseer, 1851, 16½ x 20¼in/42 x 51.5cm, £80-£160.
'The Successful Deer Stalkers', after J. Bateman, 1848, 18 x 26in/45.5 x 66cm, £150-

· MALCOLM · C · SALAMAN ·

WASHINGTON, William. 'Malcolm C. Salaman', 1935.

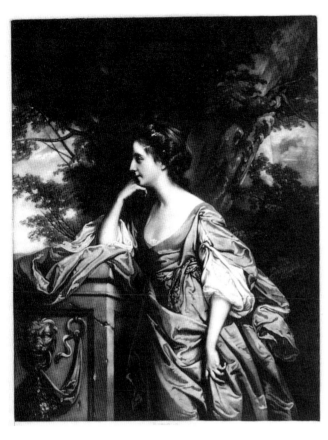

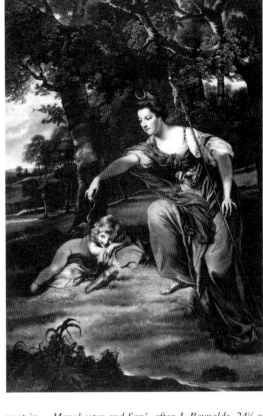

WATSON, James.
'Lady Bridges',
after F. Cotes,
1768.

WATSON, James.
'The Duchess of
Manchester and
Son', after
J. Reynolds.

£300.
Add more if in fine contemporary frame.
'Anthony Brown', after S. Lane, 13½ x 11in/34.5
x 28cm, and mezzo. portraits of similar size,
£15-£30.
Small portraits in stipple and small bookplates
small value.

WATERSON, David, R.E. 1870-1954
Scottish painter and etcher of landscapes. He
lived at Brechin in Angus.
£30-£70.

WATKINS, H.G. fl. mid-19th century
Line and mezzotint engraver of landscapes,
topographical views and sentimental subjects
after his contemporaries. He lived and worked
in London.
'Tranquil Enjoyment', after J.F. Herring, 1848,
15 x 14in/38 x 35.5cm, £30-£60.
'Waiting for Master', after J.F. Herring, 1847,
22 x 34½in/56 x 87.5cm, £200-£400.
Add more if in fine contemporary frame.
Small bookplates small value.

WATKINS, John fl. late 19th/early 20th
century
Etcher of architectural views, he studied at the
National Art Training School in South
Kensington and lived and worked in London.
£10-£30.

WATSON, Caroline 1760-1814
Stipple engraver of portraits and decorative
subjects after her contemporaries and Old
Master painters. Born in London, she was the
daughter and pupil of J. Watson (q.v.). In 1785
she was appointed Engraver to Queen Charlotte.
After retiring to Harpenden Common,
Hertfordshire, she eventually died in Pimlico,

London. Goodwin records that, unlike most in
her craft, she was well off when she died.
'The Hon. Mrs. Stanhope', after J. Reynolds,
1790, oval, 14 x 11¾in/35.5 x 30cm, £150-£250
prd. in col.
'David Garrick', after R. Pine, 1784, 24¼ x
17½in/62 x 44.5cm, £80-£100.
'Sarah, Countess of Kinnoull', after S. Shelley,
1798, 7 x 6½in/18 x 16.5cm, and similar
portraits and decorative subjects, £50-£150
prd. in col.
Pl. for Boydell's Shakespeare, fo., e. £10-£25.
Small portraits and bookplates small value.
Goodwin, G., *Thomas Watson, James Watson,*
Elizabeth Judkins, London, 1904.

WATSON, Charles John, R.E. 1846-1927
Painter and etcher of landscapes and
architectural views. Born in Norwich, he lived
and worked in Norfolk and London, as well as
on the Continent.
Signed etchings £30-£70.
Unsigned plates from The Etcher *and* The
Portfolio *£5-£10.*
Bibl: Watson, C.J., *Catalogue of the Etched and*
Engraved work of C.J.W., 1931., prd. for private
circulation for Mrs. C.J.W. by E. Walker Ltd.

WATSON, James d.1790
Eminent Irish mezzotint engraver of portraits
and decorative subjects after his contemporaries
and Old Master painters. Born in Dublin, he
lived and worked in London, at first in Drury
Lane and later in Little Queen Anne Street, near
Oxford Street. He was the father of C. Watson
(q.v.). Between 1764 and 1775 he published his
own prints. He executed about two hundred
plates during his thirty year career.
'Mrs. Hale as Euphrosyne', after J. Reynolds,
24¼ x 15in/61.5 x 38cm; 'The Duchess of

Manchester and Son', after J. Reynolds, 24½ x
16in/62 x 40.5cm; 'Mrs. Abington', after
J. Reynolds, 1769, 24¼ x 15in/61.5 x 38cm, and
other similar size WL female portraits, £200-
£500.
'Lady Bridges', after F. Cotes, 1768, £200-
£300.
'John Bartlett and Thomas Phelps' (using
telescope to observe stars), 1778, 14¾ x
10¾in/37.5 x 27.5cm, £150-£300.
'Musical Family', after P. Mercier, 9¼ x
13¾in/23.5 x 35cm, £80-£150.
'Spaniel and Wild Duck', after G. Barret, 1768,
16¼ x 21in/42.5 x 53.5cm, £400-£700.
Various WL male portraits £70-£150.
Various HL male portraits £15-£50.
Various TQL male portraits £30-£80.
Bibl: Goodwin, G., *Thomas Watson, J.W.,*
Elizabeth Judkins, London, 1904.
CS.

WATSON, John Dawson 1832-
1892
Painter, draughtsman and etcher of book
illustrations after his own designs. Born in
Sedbergh, Yorkshire, he studied at Manchester
School of Art and at the R.A. Schools. After
living in Manchester for a few years, he settled
in London. As well as his illustration work, he
also contributed plates to *The Etcher* and *The*
Portfolio.
Small value.

WATSON, M. fl. mid-19th century
Lithographer of portrait vignettes from music
and song sheets.
Small value.

WATSON, Thomas d.1781
Stipple and mezzotint engraver of portraits and

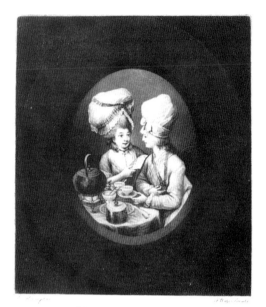

WATSON, Thomas. 'The Confidants', after E. Martin, 1780.

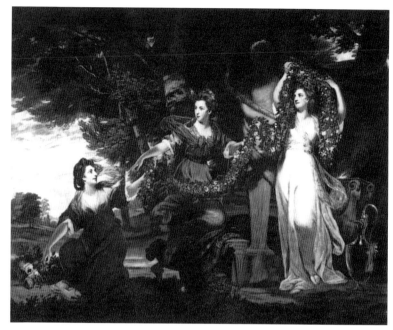

WATSON, Thomas. 'The Three Montgomery Sisters Adorning a Term of Hymen', after J. Reynolds, 1776.

decorative subjects after his contemporaries and Old Master painters. He was born in London, the son of a printseller, also Thomas. In 1770 he began publishing prints with Walter Shropshire in New Bond Street and, on the latter's retirement in 1779, he formed a partnership with W. Dickinson (q.v.), also in New Bond Street, which lasted until Watson's early death in 1781. Goodwin attributes several humorous subjects after H.W. Bunbury published in this period to Watson in conjunction with Dickinson.

Mezzotints:

'The Beauties of Windsor', after P. Lely, 6 pl., set in second state after lettering £200-£400; before lettering £400-£700.
'The Confidants', after E. Martin, 1780, oval. 8¼ x 7½in/22 x 19.5cm, £200-£300.
'The Hon. Mrs. Beresford, Mrs. Gardner and Lady Townsend as the Graces', after J. Reynolds, 1784, 27¼ x 21½in/69 x 55cm, £300-£500.
'The Three Montgomery Sisters Adorning a Term of Hymen', after J. Reynolds, 1776, 22¼ x 27in/56.5 x 68.5cm, £300-£500, proof before letters, fetched £700 Oct. 1994.
'Lady Bampfylde', after J. Reynolds, 1779, 25 x 14⅔in/63.5 x 37.5cm, £200-£300.
'Warren Hastings', after J. Reynolds, 1777, 21¼ x 13in/55.5 x 33cm, £160-£280.
'Lady Melbourne and Son', after J. Reynolds, 1775, 15 x 24½in/38 x 62cm, £80-£160.
'The Strawberry Girl', after J. Reynolds, 1774, 13 x 11in/33 x 28cm, £60-£120.
'Miss Kitty Dressing', after J. Wright of Derby, 1781, proof before title, 18 x13in/45.5 x 33cm, fetched £1,600 June 1990.
Various male HL portraits £15-£50.
Pl. after Old Masters £10-£20.

Stipples:
'Mrs. Sheridan as Saint Cecilia', after J. Reynolds, 1779, 12 x 10in/30.5 x 25.5cm, £100-£200 prd. in col.
'Abelard and Eloisa', after Gardener, 1776, ovals, 5¼ x 4in/13.5 x 10cm, pair £100-£200 prd. in sepia or in col.

'The Departure of La Fleur', after H.W. Bunbury, 1781, circle, 12¼ in/31cm diam., £80-£160 prd in sepia or in col.
'The Death of Mark Antony', after N. Dance, 1780, 15 x 20½in/38 x 52.5cm, £30-£70.
Bibl: Goodwin, G., T.W., James Watson, Elizabeth Judkins, 1904, London.

WATT, James Henry 1799-1867
Line engraver of historical, genre and religious subjects and portraits after his contemporaries and Old Master painters. Born in London, he was apprenticed to C. Heath (q.v.). Early in his career he engraved book illustrations and plates for the Annuals, later engraving larger separate plates. He died in London.
'Christ Blessing Little Children', after C.L. Eastlake, 1859, 22½ x 29in/57 x 73.5cm, £20-

£50.
'The Flitch of Bacon', after T. Stothard, 1833, 18 x 35in/45.5 x 89cm, £60-£140.
'The Highland Drovers: Scene in the Grampians', after E. Landseer, 1838, 26 x 35in/66 x 89cm, £300-£500.
Add more if in fine contemporary frame.
Small portraits and bookplates small value.

WATT, Thomas fl. mid-19th century
Line engraver of small bookplates including topographical views after his contemporaries. Small value.

WATT, William Henry b.1804
Line engraver mainly of small bookplates including portraits and figure subjects after his contemporaries and Old Master painters. He

WATTS, George Frederick. 'Lion Attacking a Tiger', after G. Stubbs.

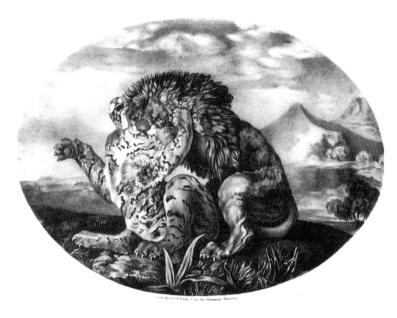

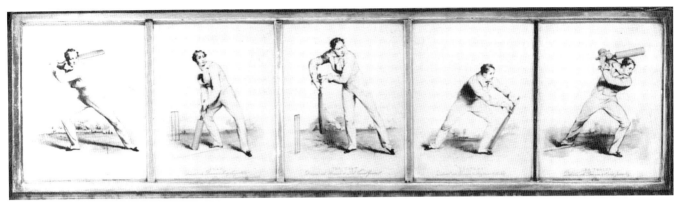

WATTS, George Frederick. 'Cricket: The Cut, Play, The Draw, Forward and Leg Forward', c.1837.

was probably related to J.H. Watt (q.v.) and could have been his younger brother.
'The Pets', after E. Landseer, 17 x 14in/43 x 35.5cm, 1836, £50-£100; other lge. pl. £30-£80.
Add more if in fine contemporary frame.
Small portraits and bookplates small value.

WATTS, George Frederick 1817-1904
Well-known painter of historical subjects and portraits who lithographed some cricketing subjects and one print after G. Stubbs when he was only twenty, and etched a few portraits later in his career.
'Lion Attacking a Tiger', after G. Stubbs, 7¼ x 10in/18.5 x 25.5cm, £300-£500.
'Cricket: The Cut, Play, The Draw, Forward and Leg Forward', c.1837, 5 pl.,11½ x 9½in/29.5 x 24cm, set £1,200-£1,800 col.
'The Batsman', 10½ x 8in/26.5 x 20.5cm, £300-£400 col.
'Portrait of Alphonse Legros', 1879, £30-£60.

WATTS, John fl. late 18th century
Mezzotint engraver of portraits after his contemporaries and 17th century painters. He was born in London and describes himself on two of his prints as a printseller and dealer in prints and drawings in Hanover Square.
'Miss Berridge as Hebe', after J. Berridge, 1770, 19¼ x 14in/50 x 35.5cm, £120-£200.
'Joseph Baretti', after J. Reynolds, 1780, 18 x

13in/45.5 x 33cm, £200-£300.
Other male portraits £15-£40.
CS lists 6 pl. dated between 1771 and 1786.

WATTS, S. (?Simon) fl. late 18th/early 19th century
Line and stipple engraver of portraits after his contemporaries and Old Master painters.
Pl. for C. Rogers' Prints in Imitation of Drawings, after various artists, 1778, 14¼ x 10¾in/37.5 x 27.5cm, £10-£30.
Others small value.

WATTS, William 1752-1851
Etcher, line and aquatint engraver of landscapes, topographical views and figure subjects after his contemporaries and his own designs. Born in London, he was a pupil of P. Sandby and E. Rooker (qq.v.). After a stay of over one year in Italy, he lived in Wales and the West Country, 1789-93. At the beginning of the French Revolution, he went to Paris where he invested in the public funds most of his fortune. When this was subsequently confiscated, he was obliged to continue his profession until he retired to Cobham in 1814.
'The Seats of the Nobility and Gentry', after various artists, 1779-86 , 80pl., 4to., etchings with eng., small value individually.
Pl. for Ainslie's Views in the Ottoman Dominions, after L. Mayer, 1812, fo., aq., e.

£10-£30 col.
'Twelve Views in Bath' (eng. when he lived there), 1791-3, 6 x 8in/15 x 20.5cm, etchings with aq., e. £15-£30.

WAY, Thomas Robert d.1913
Landscape painter, master printer and cataloguer of J.A.M. Whistler's (q.v.) lithographs, lithographer of London and Thames views and portraits after his own designs and those of his contemporaries. He lived and worked in London where he died.
£10-£40.

WEBB, Clifford Cyril, R.E. 1895-1972
Painter, illustrator, wood engraver and occasional etcher of landscapes and animal subjects. Born in London, he studied at Westminster School of Art. He taught art in Birmingham and later in London at St. Martin's and Westminster Art Schools. He lived in Surrey.
£20-£50.

WEBB, John fl. late 18th/early 19th century
Line engraver of portraits and sporting subjects after his contemporaries. He appears to have lived and worked in London.
'Sarah Siddons as the Tragic Muse', after J. Reynolds, 1798, 21½ x 15¼in/55 x 40cm, £20-£50.

WATTS, William. 'Caravansera at Kustchiuck-Czemege', from Ainslie's *Views in the Ottoman Dominions*, after L. Mayer, 1812.

WAY, Thomas Robert. A typical London view.

WEBB, John Cother. One of the artist's renderings of a contemporary sentimental painting.

WEBB, Joseph. 'Chepstow', One of the artist's largest and grandest etchings.

'The Spaniel', after R.R. Reinagle, 1830, with John Scott (q.v.), 12¼ x 16in/32.5 x 40.5cm, £150-£250.
Portraits of racehorses after J. Ferneley, aq. by E. Duncan (q.v.), 1830-32, each approx. 15¼ x 20¼in/38.5 x 51.5cm, e. £400-£800 col.

WEBB, John Cother 1855-1927
Mezzotint engraver of portraits and sporting, decorative and sentimental subjects after his contemporaries and British 18th and early 19th century and Old Master painters. Born in Torquay, he studied under T. Landseer and E. Landseer (qq.v.), and lived and worked in London.
'Floreat Etona' (Battle of Laing's Neck), after Lady Elizabeth Butler, 22½ x 24in/57 x 61cm, £200-£400.
'Duck Shooting: Irish Retriever and Wild Duck', after R. Ansdell, 1881, 17¼ x 11¼in/44 x 28.5cm, £100-£200.
'Dulcie', after W. Wontner, 1891, 14 x 11in/35.5 x 28cm, and other sentimental subjects of similar size, £20-£80.
Add more if in fine contemporary frame.
Portraits and decorative subjects after British 18th and early 19th century painters £15-£50 prd. in col.

Pl. for the Library Edition of The Works of Sir Edwin Landseer small value.

WEBB, Joseph, A.R.E. 1908-1962
Painter and etcher of landscapes, architectural views and a few mystical and symbolist subjects. He studied at Chiswick School of Art and then at Hospital Field Academy in Arbroath. Later he taught at Hammersmith School of Art. His romantic vision of the English landscape shows the influence of S. Palmer (q.v.), and his technique is reminiscent of the etchings of F. Griggs and G. Sutherland (qq.v.).
'Chepstow', etching, £250-£400.
Others £150-£400.
Bibl: Guichard, K.M., British Etchers 1850-1940, London, 1977, p.66 and appendix 5.

WEBBER, John, R.A. 1752-1793
Landscape painter, draughtsman, etcher and aquatint engraver of landscapes, topographical views and figure subjects. Born in London of Swiss parents, he studied art in Paris and at the R.A. Schools. He was the draughtsman on Captain Cook's third and last voyage to the South Seas. Although his sketches for the Admiralty's account of the expedition were engraved by professional engravers and

published in 1784, he himself also etched and aquatinted a series of views of places and figures seen during the expedition which he published between 1788 and 1792, colouring some impressions by hand in brown and blue washes. He died in London.
'Views in the South Seas' e. pl. £200-£500 col., set of 16 fetched £10,500 Nov. 1992.

WEBSTER, Thomas, R.A. 1800-1886
Portrait and genre painter who produced a few etchings for Songs of Shakespeare, 1852, and other Etching Club publications.
£10-£30.

WEDGWOOD, Geoffrey Heath, R.E. b.1900
Etcher, line and mixed-method engraver of architectural views and town scenes. He studied at Liverpool City School of Art and at the R.C.A., as well as in Rome. He won a Prix de Rome and produced about forty plates between 1924 and 1940 which possess a distinctive style.
£60-£120.
Bibl: Laver, J., 'The Etchings of G.H.W.', Bookman's Journal, 1925, XII, p.231.

WEDGWOOD, John Taylor 1783-1856
Line and stipple engraver of small bookplates including portraits, antiquities, landscapes and figure subjects after his contemporaries and Old Master painters. He was born in London where he lived, worked and died.
Small value.

WEHRSCHMIDT, Daniel Albert 1861-1932
American mezzotint engraver of portraits and sentimental subjects after his contemporaries and 18th and early 19th century British painters.
Prints after British painters £15-£50.

WELLES, E.F fl. mid-19th century
Animal painter who etched a set of twenty-five plates of sheep and cattle, published 1835.
£4-£10 e. pl.

WELLS, J.G. fl. late 18th/early 19th century
Aquatint engraver of landscapes, topographical views and naval and military subjects after his contemporaries. He lived and worked in London at the turn of the century and then emigrated to Norway in 1809. He often collaborated with other engravers and also engraved plates after his own designs.
Pl. for Captain A. Allan's Collection of Views in the Mysore Country, 1794, fo., e. £30-£60.
'North West View of the King's Barracks and Parade, Fort, House, Church, etc., at Fort St. George, India', after Capt. Trapaud, 1788, 13 x 19¼in/33 x 49cm, £240-£400 col.
'South View of the Gateway Tower of Lancaster Castle', after R. Freebairn, 1802, 21 x 25¼in/53 x 64cm, £80-£140 col.
'Isle of Wight Volunteers, on Parade, on the March, Receiving the Banner', after R. Livesay, 1799, 5 pl., 15½ x 21½in/39.5 x 54.5cm, e. £200-£400 col.
'The Royal Hospital at Haslar', after Rev. J. Hall, 1799, 13½ x 13½in/34 x 34cm, pair £100-£160.
'A View of Margate', after T. Smith, 1786, 12¼ x 18¼in/32.5 x 47.5cm, £250-£400 col.
Various lge. prints of naval engagements £300-£500 col.

WELLS, William Frederick 1762-1836
Painter, draughtsman and soft-ground etcher of landscapes after his contemporaries. Born in

WEDGWOOD, Geoffrey Heath. A typical town scene.

WEHRSCHMIDT, Daniel Albert. One of this artist's sentimental subjects.

London, he was a pupil of J.J. Barralet. He was a founder and President of the Old Watercolour Society and was Professor of Drawing at Addiscombe College for twenty years.
Pl. for T. Gainsborough's English Scenery, *with J. Laporte (q.v.), 1819, fo., e. £5-£10 col.; small value uncol.*
Pl. for Rev. J. Wilkinson's Cumberland, Westmoreland and Lancashire, *1810, fo., e. £8-£15 col.*

WELSH, E. fl. late 18th century
Mezzotint engraver.
'Portrait of Mrs. Baddeley', after J. Reynolds, 1772, 13¾ x 10in/35 x 25.5cm, £30-£70.
CS lists 1 pl., noted above.

WELLS, William Frederick. 'View Above Seatoller', from Rev. J. Wilkinson's *Cumberland, Westmoreland and Lancashire*, 1810.

WEST, Benjamin, P.R.A. 1738-1820
Well-known American historical and portrait painter who settled in London in 1763 and executed two early lithographs in 1801.
'The Angel of Resurrection', 1801, publ. 1803 and 1806, 12¾ x 8½in/32.5 x 22cm, £500-£800; on original mount £2,000-£3,000.
'St. John the Baptist', 1801, 12¾ x 8in/32.5 x 20.5cm, £500-£800.
Man Cat.

WEST, C. fl. late 18th century
Engraver.
'Cast Iron Bridge, Coalbrook', after E. Edgecumbe, 1782, 18 x 26in/46 x 66cm, £400-£600.

WEST, Joseph Walter 1860-1933
Painter and etcher of sentimental and genre subjects after his own designs and those of his contemporaries. Born in Hull, he studied at St John's Wood School of Art and at the R.A. Schools under Edwin Moore, as well as in Paris. Much of his work consisted of bookplates and ex-libris. He lived in Middlesex.
Small value.

WEST, Raphael Lamar 1766-1850
History painter who produced a few prints. He was the son of B. West (q.v.) and executed two early lithographs in 1802, the year after his father was working in the same medium. He also etched two figure subjects.
'Study of a Tree', 1802, publ. 1807, 13 x 8½in/33 x 22cm, litho., £200-£300; on original mount £300-£400.
'Bearded Man with Oak Garland', 1802, 10½ x 8½in/26.5 x 21.5cm, litho., £500-£800, £800-£1,400 on original mount.
'Brigand Reposing Beneath a Tree' and 'Hercules Slaying the Hydra', latter 14½ x 11½in/37 x 29cm, etchings, e. £300-£400.
Man Cat.

He is not here: for he is risen. &c.

WEST, Benjamin. 'The Angel of Resurrection', 1801. One of the most famous early lithographs.

WEST, Raphael Lamar. 'Bearded Man with Oak Garland', 1802, lithograph.

WEST, Richard William b.1887
Scottish portrait and landscape painter who etched a few little figure subjects. Born in Aberdeen, he studied at the School of Art there and at the Allen Fraser Art College.
£15-£30.

WESTALL, Richard 1765-1836
Well-known history and genre painter, illustrator, occasional soft-ground etcher and mezzotint engraver of figure subjects and rustic scenes. He executed one early lithograph.
'Head', 1803, 9½ x 7½in/24 x 19cm, litho., £200-£400.
Soft-ground etchings, col. by the artist or

assistant with watercolour and crayon, e. £100-£200.
Mezzo., late 1820s, e. £10-£20.
Man Cat.

WESTALL, William, A.R.A. 1781-1850
Painter, etcher, aquatint engraver and lithographer of landscapes and topographical views mainly after his own designs. Born in Hertford, he was the younger brother and pupil of R. Westall (q.v.) and studied at the R.A. Schools. Early in his career he went on expeditions to the Pacific and Australia, returning by way of China and India, and then to the West Indies by way of Madeira. He remained in England for the rest of his life apart from a visit to Paris in 1847. Many of his drawings were reproduced by professional printmakers.
Views on the Thames at Richmond, Eton, Windsor and Oxford, 1824, 35pl., set £700-£1,400.
Views of the Vale of Keswick, 1820, small 4to., aq., e.£10-£25 col.
Views of Windsor Castle, 1831, after S. Scarthwaite, fo., litho., e.£15-£30.
Views of Fountains Abbey and Studeley Park, 1846, fo., eng., e.£10-£30.
Views for Britannia Delineata, 1822, fo., litho., e. £20-£50.
Pl. for Lieut. J.H. Caddy's Scenery of the Windward and Leeward Islands, 1837, obl. fo., aq., e. £40-£60 col.

WESTERN, J. fl. late 18th century
Mezzotint engraver.
'Lady Ligonier', after T. Wilson, 1771, 14 x 10in/35.5 x 25.5cm, £20-£40.
CS lists 1 pl., noted above.

WESTWOOD, Charles d.1855
Line engraver of small bookplates including landscapes and architectural views after his contemporaries. He emigrated to the United States in 1851 where he later committed suicide.
Small value.

WESTALL, Richard. 'A Peasant Returning to His Family in the Evening', soft-ground etching coloured by artist or assistant.

RICHMOND BRIDGE

WESTALL, William. 'Richmond Bridge', one of thirty-five views on the Thames at Richmond, Eton, Windsor and Oxford, 1824.

WHEATLEY, Francis. 'The Smoaker', after Vandermyn, one of two recorded mezzotints by the artist.

The Smoaker

WESTWOOD, William fl. mid-19th century
Draughtsman and lithographer.
4 views in Coalbrookdale, 1833, obl. fo., e. £80-£200 col.

WETHERED, Maud fl. mid-20th century
Wood engraver of landscapes and figure subjects. She lives and works in London.
£10-£30.

WHAITE, Henry Clarence, R.W.S.
1828-1912
Mancunian genre and landscape painter who was a member of the Junior Etching Club and contributed plates to its publications.
£8-£20.

WHEATLEY, Francis, R.A. 1747-1801
Famous portrait, genre and landscape painter who etched and engraved a very few plates himself. Many of his paintings were reproduced by professional engravers and he is best known as the painter of the series 'The Cries of London', engraved by A. Cardon, T. Gaugain and G. Vendramini (qq.v.).

'Christian VII of Denmark', 1768, 13¾ x 14in/35 x 35.5cm, mezzo., £40-£80.
'The Smoaker', after Vandermyn, 12½ x 9in/32.5 x 23cm, mezzo., £60-£140.
Etchings e. £80-£200.
CS lists 2 mezzo., noted above.

WHESSELL, John
fl. late 18th/early 19th century
Line and stipple engraver of sporting and genre subjects and portraits after his contemporaries. He lived and worked in London.
'This Remarkable Animal' (pig), after B. Gale, 1808, 17¾ x 20in/45 x 51cm, £1,200-£1,800 prd. in col.
'The Durham Ox', after J. Boultbee, 1802, 17¾ x 23½in/45 x 59.5cm, £400-£700 prd. in col.
'Peace' and 'War', after H. Singleton, 1797, 18½ x 23in/47 x 58.5cm, pair £600-£1,000 prd. in col.
'Lop', after B. Marshall, 1802, 14¼ x 19¼in/36 x 49cm, and similar portraits of racehorses after various artists and his own designs, £250-£400; £500-£900 prd. in col.
'The Cottage Girl' and 'The Young Cottager',

after T. Gainsborough, 1806, 20 x 24in/51 x 61cm, pair £500-£800 prd. in col.
Pl. for R. Harraden's Costume of Cambridge, 1805, 4to., e. £6-£14 col.
Small portraits and other small bookplates small value.

WHISTLER, James Abbott McNeill 1834-1903
Possibly the most famous etcher after Rembrandt. Although he was born in America, Whistler is included here because he is considered by many to be part of the British School, and he certainly had a profound influence on his British contemporaries. Born in Massachusetts, he started etching while at West Point Military Academy which he left in 1854, continuing to etch while he worked as a cartographer. He moved to Paris in 1855 where he studied art, at first under Gleyre. He arrived in London in 1858 where he completed the 'Twelve Etchings from Nature' (the 'French' set), living initially with F.S. Haden (q.v.) whose daughter he married. The collaboration of Whistler and Haden during this period helped to develop both their etching styles. It was in

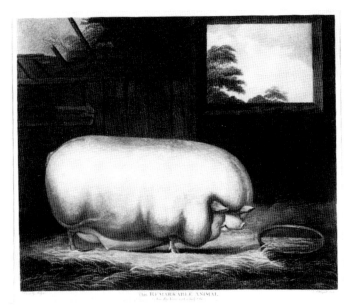

THE REMARKABLE ANIMAL

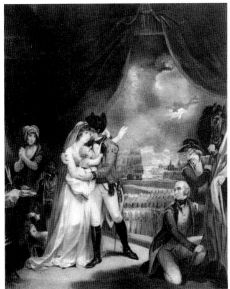

WHESSELL, John. 'This Remarkable Animal', after B. Gale, 1808.

WHESSELL, John. 'War', pair with 'Peace', after H. Singleton, 1797.

WHISTLER, James Abbott McNeill. 'Nude Model Reclining', 1893, from the signed edition of twenty-five.

£300-£400.
'Rotherhithe' £3,000-£5,000.
'Wine Glass' £800-£1,200.
'Soupe à Trois Sous' £500-£800.
Venetian and Amsterdam subjects from £2,000 up to perhaps £30,000 depending on subject and quality of printing.
Among recent highlights: 'Nocturne: Palaces' fetched £27,000, and 'Nocturne: Salute' £23,000 in July 1994, while a unique working proof of a very rare etching 'Sunflowers, Rue des Beaux-Arts', extensively worked on with pen with the artist, fetched $72,000 in May 1995, an auction record for the artist.
Litho.:
'Nude Model Reclining', 1893, from the signed edn. of 25, £2,500-£3,500; later reprint £400-£700.
'Savoy Pigeons', and other litho. publ. in The Studio, £60-£200.
Bibl: Kennedy, E.G., The Etched Work of Whistler, 1910, now reprd.; Way, T.R.,

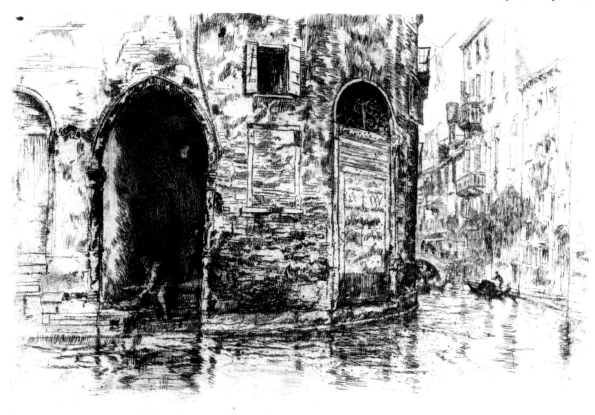

WHISTLER, James Abbott McNeill. One of his famous etchings of Venice.

1859 that Whistler began work on the 'Thames' set, consisting of sixteen etched views of London's dockland and published in 1869. But he is best known probably for his etchings of Venice, where he went in order to earn money to pay off his legal costs after the famous libel case in which he sued Ruskin, the critic, for attacking his 'Nocturnes'. The first 'Venetian' set was published in 1880 by the Fine Art Society. A second set was published by Dowdeswells in 1886 entitled 'A Set of Twenty-six Etchings by James A. McNeill Whistler'.

Apart from his Venetian etchings, the plates which Whistler executed as a result of a trip to Amsterdam in 1888 are the most highly prized and are much rarer. Impressions of his earlier etchings, e.g. from the 'French' and 'Thames'

sets, are often found with margins but unsigned. His later etchings, e.g. the Venetian and Amsterdam prints, are often found trimmed to the plate mark and signed with the butterfly monogram on a tab below. Whistler was introduced to lithography in 1878 by T.R. Way (q.v.), but went back to etching after producing only a few prints in this medium until 1887 when he issued a set of six in the portfolio Notes. Apart from some imitations of his 'Nocturnes' paintings most of his lithographs consist of figure studies.
Etchings:
'Adam and Eve, Old Chelsea' £800-£1,200.
'Alderney Street', published in Gazette des Beaux Arts, £250-£400.
'Billingsgate', publ. in Etching and Etchers,

Lithographs by Whistler, 1914. Many other publications and catalogues exist on Whistler and his works, but these two are the major ones covering his prints.

WHITE, Charles 1751-1785
Stipple and line engraver of portraits and decorative subjects after his contemporaries. Born in London, he was a pupil of R. Pranker (q.v.), and began as a line engraver before turning to stipple. He died in Pimlico, London.
'A Camp Scene', after H.W. Bunbury, 1794, 11¼ x 15½in/30 x 39.5cm, £50-£100.
Decorative subjects: ovals, circles, etc., £100-£300 prd. in col. or in sepia; portraits £20-£60 prd. in red or sepia.
Small portraits and bookplates small value.

WHITE, Ethelbert, R.W.S. 1891-1972
Painter and wood engraver of landscapes and rustic scenes. Born at Isleworth he studied at St John's Wood School of Art and worked in England and occasionally on the Continent.
£40-£100.

WHITE, George fl. late 17th/early 18th century
Line and mezzotint engraver of portraits after his contemporaries. The son of R. White (q.v.), he lived and worked in London, practising first as a portrait painter, then as a line engraver before turning to the mezzotint medium about 1714.
Line eng. small value.
Mezzotints:
'Jemima Palmer', after D'Agar, 13¼ x 9¾in/35 x 25cm, £40-£80.
TQL male portraits £20-£60.
HL male portraits £15-£40.
CS.

WHITE, Henry fl. early/mid-19th century
Wood engraver of small bookplates. A pupil of T. Bewick (q.v.), he worked for James Lee and later for himself.
Small value.

WHITE, Robert 1645-1704
Line engraver of portraits and architectural views after his contemporaries and Old Master painters. He was possibly also a mezzotint engraver of portraits after his contemporaries. Born in London, he was a pupil of and assistant to D. Loggan (q.v.). In 1674 he engraved a heading to the first *Oxford Almanac*. He died in Bloomsbury, London.
Mezzotints:
£70-£200.
Line engravings:
'Interment of the Duke of Albemarle (panorama of the procession), after F. Barlow, 1670, 21 pl., £300-£500.
Oxford Almanac headings £20-£40.
Portraits £5-£15.
CS lists 9 pl., one signed 'R.W. fecit', the others listing R.W. as publisher.

WHITE, Thomas fl. late 18th century
Line engraver of architectural views after his

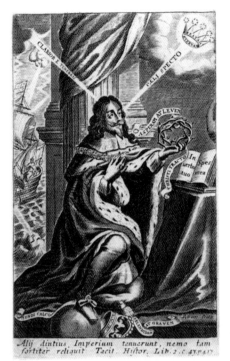

WHITE, Robert. A portrait of Charles I, line engraving.

contemporaries. He was employed by W.W. Ryland (q.v.) to assist in the background of his plates, and afterwards engraved the greater part of the architectural prints for Wolfe and Gandon's continuation of the *Vitruvius Britannicus*.
Small value.

WHITE, W.J. fl. late 18th/early 19th century
Etcher, line and stipple engraver of small portraits and bookplates after his contemporaries and Old Master painters.
'The Jenny attacked by a French privateer', after W. Anderson, aq. by J. Jeakes (q.v.), £100-£300 col.
Others small value.

WHITFIELD, Edward Richard b.1817
Line and mezzotint engraver of portraits and figure subjects after his contemporaries and Old Master painters. Born in London, he was a pupil of Augustus Fox and engraved plates for *The Art Journal*. He emigrated to Dresden in 1859.
Small value.

WHITING, Frederick, R.S.W. 1874-1962
Painter and etcher of landscapes and figure subjects. Born in London, he studied at St John's Wood Art School and at the R.A. Schools as well as in Paris. Early in his career, he recorded scenes from the Boxer War in China and the Russo-Japanese War of 1904 for *The Graphic*.
£20-£60.

WHITTLE, J. see LAURIE R.

WHITTOCK, Nathaniel fl. mid-19th century
Draughtsman, lithographer and aquatint engraver of landscapes and topographical views after his own designs and those of his contemporaries. Working in London and Oxford, he styled himself 'Teacher of Drawing and Perspective and Lithographist to the University of Oxford'. He published topographical works and also some drawing books. Early in his career, he etched a few small bookplates after his own designs or those of his contemporaries.
'Castle and Marine Parade, Dover', litho., £15-£40.
'The Art of Drawing and Colouring from Nature, Flowers, Fruits and Shells', 1829, individual pl. small value.
'Bird's-Eye View of the University and City of Oxford', 14 x 22in/35.5 x 55.5cm, aq., £100-£200.
'The Cricket Ground, Harrow', 4¾ x 7in/12 x 18cm, litho., £80-£160 col.
Bookplates small value.

WHYDALE, Ernest Herbert, A.R.E. 1886-1952
Painter and etcher of landscapes and rustic scenes. Born in Yorkshire, he studied at Westminster School of Art and at the Central School of Arts and Crafts. He lived in Hertfordshire.
£25-£60.

WHYMPER, E., F. and T.W. fl. mid-/late 19th century
Wood engravers of book illustrations, portraits, etc.
Small value.

WIGLEY, J. fl. late 18th century
Line engraver of bookplates.
Small value.

WILD, Charles 1781-1835
Watercolourist, draughtsman and aquatint engraver of architectural views. Born in London, he was articled to T. Malton (q.v.). In 1807, he began a series of publications on English cathedrals (1807 Canterbury, 1809 York, 1813 Chester and Lichfield, 1819 Lincoln, 1823 Worcester). Finally, in 1826, he published his series of 'Views of Foreign Cathedrals'. His prints were trimmed to the image and mounted on card in the manner of watercolours. He lost his sight in 1827. He died near Piccadilly.
£15-£50 col.
Colour plate page 71.

WHITTOCK, Nathaniel. 'Castle and Marine Parade, Dover', lithograph.

WILKIE, David. 'Reading the Will', 1819.

WILKIN, Charles. 'Children Relieving a Beggar Boy', after W. Beechey, 1796.

WILKIE, Sir David, R.A. 1785-1841
Eminent genre, historical and portrait painter who etched thirteen plates between 1815 and 1820 and produced one lithograph. Seven of the etchings were published as an album in 1824.
Early imp. of etchings and litho. e. £80-£200.
Album £200-£400.
Bibl: Reprints by D. Laing publ. in his book *Etchings* by Sir D.W., Edinburgh, 1875, small value.
Dodgson C., *The Etchings of Sir D.W. and Andrew Geddes*, London, Print Collectors' Club, 1936.

WILKIN, Charles 1750-1814
Stipple engraver of portraits and decorative subjects after his contemporaries. He was born and died in London.
'Children Relieving a Beggar Boy', after W. Beechey, 1796, 20 x 15¼in/51 x 40cm, £150-£250 prd. in col.
'A Young Spartan' and 'A Young Virgin', 1788, 5 x 4¼in/12.5 x 11cm, pair £60-£120 prd. in col.
'Britannia Crowning the Escutcheon', after H.P. Danloux, 23½ x 18in/59.5 x 45.5cm, £20-£50.
Male portraits £10-£25.
Female portraits, depending on decorative appeal, £15-£70.

WILKINS, G. fl. mid-19th century
Draughtsman and lithographer.
4 views of Ilfracombe, c.1830, obl. fo., e. £15-£40.

WILKINSON, G. fl. mid-19th century
Draughtsman and lithographer.
5 Views in the Isle of Man, c.1840, obl. 4to., e. £15-£40.

WILKINSON, Henry b.1921
Line engraver. Born in Bath he studied under M. Osborne and R.S. Austin (qq.v.) at the R.C.A. and lived in London.
£15-£50.

WILKINSON, Norman, C.B.E. 1878-1971
Painter and etcher of marine, angling and historical subjects. Born in Cambridge, he studied at Portsmouth and Southsea School of Art. From 1898 he drew illustrations for *The Illustrated London News*. He was also responsible for developing camouflage techniques in both World Wars.
£60-£180.

WILKINSON, W.S. fl. mid-19th century
Line engraver of bookplates including landscapes and architectural views after his contemporaries.
Small value.

WILL, Johan Martin fl. late 18th century
Augsburg mezzotint engraver of portraits after his contemporaries. He is mentioned here for several plates of American interest published in London.
'Colonel David Wooster, Commander in Chief of the Provisional Army Against Quebec', 1776; 'Major Robert Rogers, Commander in Chief of the Indians in the Back Settlements of America', 1776; 'George Washington', 1775, all ave. 14 x 9¼in/35.5 x 23.5cm, e. £400-£800.

WILLIAMS, Alfred Mayhew 1826-1893
London etcher of topographical views and genre and animal subjects. He lived in South Tottenham, Middlesex. He contributed plates to *English Etchings* and executed the unusual series 'Etchings of Celebrated Shorthorns'.
'Etchings of Celebrated Shorthorns', 1871-81, 2¼ x 3in/5.5 x 7.5cm, e.£8-£20.
Topographical views and genre scenes £10-£30.

WILLIAMS, C. fl. early 19th century
Aquatint engraver of small bookplates including landscapes and topographical views after his contemporaries.
Small value.

WILLIAMS, Charles
fl. late 18th/early 19th century
Draughtsman and etcher of caricatures after his own designs and those of his contemporaries, especially J. Gillray (q.v.).
Own caricatures £50-£100 col.
Copies of other caricaturists £15-£50 col.

WILLIAMS, Edward
fl. late 18th/early 19th century
Etcher and stipple engraver of caricatures and decorative subjects after his contemporaries and his own designs. He worked in London.
'The Country Vicar's Fireside', after H. Wigstead, and 'A College Scene', after T. Rowlandson, 1787, fo., e. £50-£100.
'George Wilson the Pedestrian Accomplishing his Task of Walking One Thousand Miles in

Twenty Days', 1815, 9½ x 7¼in/24 x 18.5cm, £15-£30 col.

WILLIAMS, Edward Charles b. 1815
Landscape and genre painter, etcher of genre and sentimental subjects after his contemporaries. He was the son of the painter Edward Williams (1782-1855).
Small value.

WILLIAMS, J. fl. late 18th century
Line engraver of small bookplates.
Small value.

WILLIAMS, John 1761-1818
Art critic who engraved one portrait in mezzotint. He studied under M. Darly (q.v.) and wrote in the name of Anthony Pasquin. He emigrated to the United States.
'Prince Charles, the Young Pretender', TQL in female attire, 12¼ x 9in/32.5 x 23cm, £40-£80. CS lists 1 pl., noted above.

WILLIAMS, Joseph Lionel d.1877
Genre and historical painter, wood engraver of illustrations for magazines and books. His work included plates for *The Art Journal* and *The Illustrated London News*. He died in London.
Small value.

WILLIAMS, ?Robert or Roger
 fl. late17th/early 18th century
Welsh mezzotint engraver mainly of portraits after his contemporaries. He was said to be a pupil of Theodore Freres. He survived for many years after his leg was amputated.
'Vanitas Vanitatum', after G. Schalcken, £250-£00. Small pl., 5 x 3½in/12.5 x 9cm, £8-£15. HLs, ave. 13 x 9¼in/33 x 23.5cm, £15-£40.

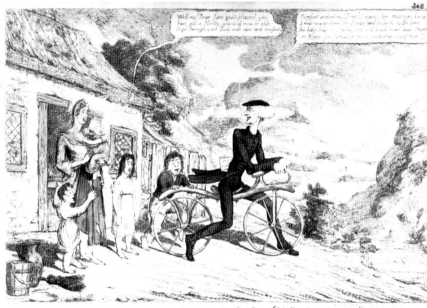

WILLIAMS, Charles. 'The Parsons Hobby – or – Comfort for a Welch Curate', one of Williams' own caricatures.

WL female portraits, ave. 16¼ x 9¼in/42.5 x 25cm, £80-£200.
'A King Charles Spaniel', after P. Lely, 5¼ x 7½in/13.5 x 19cm, £50-£100.

WILLIAMS, Samuel 1788-1853
Draughtsman and wood engraver of bookplates including topographical views, natural history subjects, portraits, illustrations for novels after his contemporaries, his own designs and Old Master painters. He was born in Colchester and, in 1819, settled in London where he died.
Small value.

WILLIAMS, Thomas
 fl. early/mid-19th century
Wood engraver of small bookplates including illustrations for novels, biblical subjects, etc. He was the brother and pupil of S. Williams (q.v.).
Small value.

WILLIAMS, Thomas II.
 fl. early/mid-19th century
West Country draughtsman and occasional lithographer of landscapes and topographical views. He lived in Exeter and Plymouth. He wrote and illustrated several books.
5 views of South Devon, 1821, fo., e. £15-£30.

WILLIAMS, W
 fl. late 18th/early 19th century
Draughtsman, etcher and aquatint engraver of portraits.
£6-£20 col.
Small value uncol.

WILLIAMSON (Willemsen), Peter
 fl. late 17th century
Line engraver of portraits after his contemporaries. He was a pupil of D. Loggan (q.v.) and worked in London, possibly also as a publisher.
Small value.

WILLIAMSON, Thomas
 fl. early/mid-19th century
Soft-ground etcher and stipple engraver of portraits and decorative subjects after his contemporaries. He worked in London.
Stipples after G. Morland £100-£200 prd. in col.
'Telemachus Relating his Adventures to Calypso', after R. Westall, 1810, 23 x 30in/58.5 x 76cm, £70-£140 prd. in col.
Pl. after A. Buck, e. £150-£250 prd. in col.

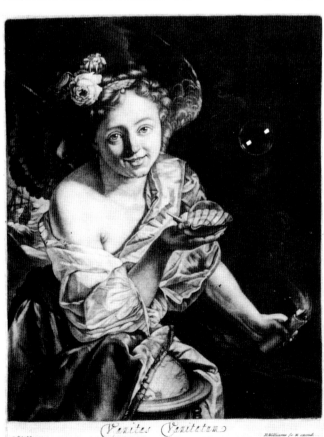

WILLIAMS, ?Robert or Roger. 'Vanitas Vanitatum', after G. Schalcken.

Soft-ground etchings £20-£60 col.
Small portraits and bookplates small value.

WILLIS, Frank, A.R.E.　　　1865-1932
Etcher and line engraver of landscapes, architectural views and animal and figure subjects. Born in Windsor, he was a pupil of C.W. Sharpe (q.v.). He later lived in Kent.
£8-£20.

WILLIS, Henry Britten　　　1810-1884
Animal and landscape painter who lithographed a few portraits.
'Eliza Cook', after J. Watkins, 17 x 12¼in/43 x 31cm, £6-£12.
Small portraits and vignettes small value.

WILLIS, John　　　fl. mid-19th century
Draughtsman and lithographer.
5 views of Chepstow, c.1830, obl. fo., e. £10-£30.

WILLIS, T.　　　fl. late 18th century
Line engraver of bookplates after his contemporaries.
Small value.

WILLMORE, Arthur　　　1814-1888
Line engraver of landscapes, architectural views, animal, shipping and religious subjects after his contemporaries and Old Master painters. Born in Birmingham, he was the brother of J.T. Willmore (q.v.), and was probably taught by him. Most of his work consisted of plates for *The Art Journal* and other books. He worked in London.
Some lge. pl. £20-£80.
Add more if in fine contemporary frame.
Proofs or early imp. of small eng. after J.M.W. Turner £20-£60.
Pl. for The Art Journal *and other books small value.*

WILLMORE, James Tibbitts, A.R.A.　　　1800-1863
Line engraver of landscapes, architectural views and marine, classical and historical subjects after his contemporaries and Old Master painters. Born at Erdington, Staffordshire, he was apprenticed to W. Radclyffe (q.v.) in Birmingham. In 1823 he moved to London where he worked for C. Heath (q.v.) for a few years. Most of his work consists of plates for *The Art Journal* and other books, but he is probably best remembered for his large plates after J.M.W. Turner. He died in London.
Lge. pl. after Turner £100-£200.
'Harvest in the Highlands', after E. Landseer and A.W. Calcott, 1856, 14 x 38½in/35.5 x 98cm, £100-£200.
'Queen Victoria Sketching at Loch Laggan', after E. Landseer, 1858, 13½ x 19½in/34.5 x 49.5cm, £60-£160.
'Volunteer Review at Edinburgh: the Royal Scottish', after S. Bough, finished by A. Willmore (q.v.), 1862, 20 x 30in/51 x 76cm, £150-£300.
'Departure of the Highland Bride', after J. Thompson, 1857, 19 x 29in/48.5 x 73.5cm, £40-£100.
Add more if in fine contemporary frame.
Proofs or early imp. of small eng. after Turner £20-£600.
Pl. for The Art Journal *and other books mostly small value, but American views £5-£10.*

WILLSON　　　fl. mid-18th century
Line engraver of some rare sporting subjects after his contemporaries.
'Two Hunters Belonging to His Grace The Duke of Bolton', after J. Seymour, 1738, 23½ x 38in/59.5 x 96.5cm, and 'Mouse, a Running Horse Belonging to the Right Honourable The Earl of Portmore', after P. Tillemans, 1738, 23½ x 36½in/59.5 x 92.5cm, 2 pl. joined together, e. £600-£1,000.

WILLSON, J. see WILSON, James

WILSON, Benjamin　　　1721-1788
Painter of portraits and theatre pieces, draughtsman and etcher of portraits after his own designs and copies of etchings by Rembrandt. Some of these copies he sold as originals and even the artist Thomas Hudson, who considered himself a connoisseur, was taken in by one of them in 1751.
Etchings: portraits after his own designs e. £20-£60, after Rembrandt small value.
'Lady Harriet Grosvenor', after F. Cotes, 1770, 6 x 4½in/15 x 11.5cm, £10-£30.
'Maria Gunning', 13¾ x 9¾in/35 x 25cm, £40-£80.
CS lists 2 mezzo., noted above, which he believed to be by B.W.

WILSON, Edgar　　　1861-1918
Etcher of marine subjects and coastal and river scenes.
£15-£50.

WILSON, Eli Marsden　　　b.1877
Painter, etcher and mezzotint engraver of landscapes. Born in Yorkshire, he studied at Wakefield School of Art and at the R.C.A. He lived in London.
£10-£20.

WILSON (Willson), James
　　　fl. mid-/late 18th century
Mezzotint engraver of portraits, caricatures and decorative subjects after his contemporaries, Old Master painters and occasionally his own designs. Many of his portraits are copies of works by other engravers.
'Greenland Whale Fishery', after Van Meulen, 9¾ x 13¾in/25 x 35cm, £500-£700 col.
'A Midnight Modern Conversation', 18 x 24in/46 x 61cm, £300-£400.
'The Ludicrous Operator or Blacksmith Turned Tooth Drawer', after J. Harris, 12¼ x 9¾in/32.5 x 25cm, £100-£200.
Other caricatures and decorative subjects mostly £50-£150.
Portraits: small pl., ave. 6 x 4½in/15 x 11.5cm, £5-£10; lge. pl. £20-£80.
CS. lists 24 pl.

WILSON, Sidney Ernest　　　b.1869
Mezzotint engraver of portraits and decorative subjects after 18th and early 19th century British and Continental painters. Born in Middlesex, he was apprenticed to J.B. Pratt (q.v.) at the age of fifteen. He continued to work for Pratt for seventeen years after finishing his articles, before setting up on his own. His plates are mostly found printed in colours.
£20-£60 prd. in col.

WILSON, Stanley Reginald　　　1890-1973
Painter and etcher of landscapes and marine and ornithological subjects. Born in Camberwell, he studied at Goldsmiths' College of Art and lived in London. He sometimes coloured impresssions of his etchings.
£30-£70.

WILSON, ?T.C. or T.H.　　fl. mid-19th century
Draughtsman and lithographer of portraits.
Small value.

WILSON, William I
　　　fl. late 17th/early 18th century
Mezzotint engraver of portraits after his contemporaries.
'John Hardman', after T. Murray, 10½ x 7½in/26.5 x 19.5cm, £15-£35.
'Frances, Countess of Newburgh', after M. Dahl, 13½ x 9¾in/34.5 x 25cm, £40-£80.
CS lists 2 pl., noted above.

WILSON, William II　　fl. early/mid-18th century
Line engraver of landscapes after his contemporaries and 17th century painters.
Lge. pl. £50-£150; £100-£200 col.
Various small bookplates small value.

WILSON, William III　　fl. late 18th century
Line engraver of bookplates including portraits after his contemporaries, etc.
Small value.

WILSON, William IV, R.S.A., R.S.W. 1905-1972
Scottish painter and etcher of landscapes and architectural views. He studied at Edinburgh School of Art and at the R.C.A. He lived in Edinburgh, working in Scotland as well as on the Continent.
£30-£70.

WILSON, William Charles fl. late 18th century
Line engraver of topographical views and figure subjects after his contemporaries. His work appears to consist entirely of bookplates.
Pl. for Boydell's Shakespeare, fo., e. £10-£25.
Small bookplates small value.

WINCHESTER, G.　　　fl. mid-19th century
Lithographer.
'A Subaltern's Life in Madras', 92 pl., 12¼ x 19in/32.5 x 48.5cm, set £300-£400; individually small value.

WING, C.W.　　　fl. mid-19th century
Draughtsman and lithographer.
Views of Brighton, 8¾ x 13¼in/22 x 33.5cm, e.£20-£50.

WING, William　　　fl. mid-19th century
Draughtsman and lithographer of entomological subjects, mainly small bookplates.
Small value.

WINKLES, Benjamin　　fl. mid-19th century
Line engraver of small bookplates including landscapes and architectural views after his contemporaries. He was probably the brother of H. and R. Winkles (qq.v.).
Small value.

WINKLES, Henry fl. early/mid-19th century
Line engraver of small bookplates including landscapes and architectural views. He was probably the brother of B. and R. Winkles (qq.v.).
Small value.

WINKLES, Richard　　fl. mid-19th century
Line engraver of landscapes and architectural views after his contemporaries. He was probably the brother of B. and H. Winkles (qq.v.).
Small value.

WINSTANLEY, Hamlet　　　1698-1756
Portrait and landscape painter, draughtsman, etcher and line engraver of copies of Old Master painters. Born in Warrington, the son of Henry Winstanley (q.v.), he originally studied painting under Godfrey Kneller, but after a visit to Italy took up etching and engraving. He is best

WINSTANLEY, Henry. 'The Prospect of the South Side of the Great Court', from the set of twenty-four views of Audley End.

known for his copies of Lord Derby's pictures at Knowsley, but he also engraved plates after Thornhill's paintings in the cupola of St Paul's. G. Stubbs (q.v.) was his apprentice for a short time. He died in Warrington.
A colln. of 18 pl. (include. 4 dble.) sold for £3,200 June 1994.

WINSTANLEY, Henry 1644-1703
Architect, draughtsman and etcher of architectural views. Born at Littlebury, he was Clerk of the Works at Audley End and in 1688 etched a series of views of the house. He also etched a view of Eddystone Lighthouse which he designed and built and in which he died when it was destroyed by a storm.
Views of Audley End House, 24 pl., fo., set £400-£800.
'Eddystone Lighthouse' £200-£400.

WINTER, George fl. mid-19th century
Etcher and line engraver of architectural views, outlines and details. He lived and worked in London.
Small value.

WISE, William fl. early/mid-19th century
Etcher and line engraver of portraits, landscapes and topographical views after his contemporaries.
Lge. topographical views £20-£50.
Others small value.

WITHERS, Alfred 1856-1932
Painter and etcher of landscapes and architectural views. He was born in and lived in London, and contributed to *The Etcher* and *English Etchings*.
Small value.

WIVELL, A. fl. late 18th/early 19th century
Etcher, stipple and mezzotint engraver of portraits after his own designs and those of his contemporaries.
Small value.

WOLF, Joseph 1820-1899
German painter, draughtsman and lithographer of animal and bird subjects after his contemporaries and his own designs. Born in Prussia he came to England in 1848 and settled in London working on the publications of J. Gould (q.v.) and the Zoological Society for many years. He died in London.
Pl. for Zoological Society £8-£20.
Pl. for Gould's publications, see under J. Gould.

WOLSTENHOLME, Dean, Jun. 1798-1882
Painter and aquatint engraver of sporting subjects after his own designs and those of his contemporaries. Born in Waltham Abbey, he was the son of the famous sporting artist Dean Wolstenholme Sen. He studied painting and drawing under the latter as well as at the R.A. Schools. Much of his work consisted in reproducing his father's paintings, the first sets appearing in 1817. He lived and worked in London, retiring to Highgate in 1862. The first three sets listed below are very rare as well as being particularly sought after for their county views. All are after D. Wolstenholme Sen.
'The Essex Hunt', 1831, 4 pl., 19 x 26in/48.5 x 66cm, set £4,000-£7,000 col.; litho. copies of set £800-£1,200 col., fetched £1,700 April 1996; mechanical reproductions no value.
'Hertfordshire: Village Scenery', 1830, 4 pl., 10 x 14¼in/ 25.5 x 36cm, set £2,000-£4,000 col.
'Foxhunting: Surrey Views', 4 pl., 13 x 18in/33 x 45.5cm, set £2,500-£5,000 col.
'The Burial of Tom Moody', after D. Wolstenholme Sen., 1823, 4 pl., 14½ x 19½in/37 x 49.5cm, set £500-£800 col.
'Coursing', after D. Wolstenholme Sen., 1817, 4 pl., 6½ x 9½in/16.5 x 24cm, set £1,000- £1,600 col.
'Racing', after his own designs, 1834, 4 pl., 7 x 10½in/18 x 26.5cm, set £1,800-£2,600 col.
'Timothy Luff Mullins with his Harriers', after his own design, 1832, 14¼ x 19in/36 x 48.5cm,

£600-£1,000 col.
Pl. for Eaton's Book of Pigeons, 1852-60, 12 x 13in/30.5 x 37.5cm, e. £70-£120 col.
A few small architectural bookplates after various artists, small value.

WOOD, J.E. fl. mid-19th century
Line engraver of small bookplates after his contemporaries.
Small value.

WOOD, Joseph fl. 1744-d.1763/4
Line engraver of landscapes, topographical views and occasional sporting subjects after his contemporaries and 17th century painters. Born in London, he was a pupil of J.B.C. Chatelain (q.v.). He lived and worked in London.
'The Gypsies', etched by T. Gainsborough (q.v.) and, in the final state, finished by J. Wood, £200-£300.
'View of London from One Tree Hill in Greenwich Park', after P. Tillemans, 1774, 14 x 19in/35.5 x 48.5cm, £150-£300.
'The Lake of Nemi', after R. Wilson, 1764, 16½ x 18¼in/42 x 47.5cm, and landscapes of similar size, £50-£150.
'Sir Charles Sedley's Bay Gelding True Blue', after J. Seymour, 1753, 15¼ x 18¼in/40 x 47.5cm, £200-£400.
Small bookplates small value.

WOOD of Calcutta, William 1774-1857
A zoologist and surgeon practising in Calcutta who drew and lithographed a series of panoramic views of the city.
Views of Calcutta, 1833, 28 pl., fo., e. £10-£30.

WOODMAN, Richard 1784-1859
Stipple and line engraver of portraits and sporting and decorative subjects after his contemporaries and his own designs. Born in London, the son of a stipple engraver of the same name, he was apprenticed to

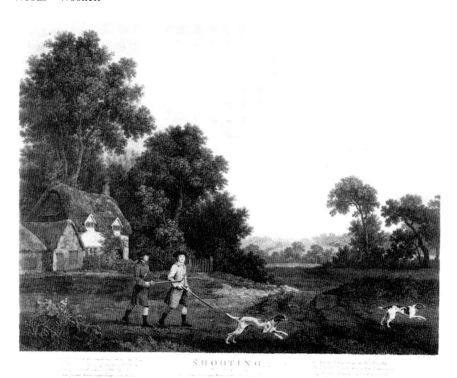

WOOLLETT, William. A plate from 'Shooting', after G. Stubbs, 1769-71, one of the most famous sets of shooting prints.

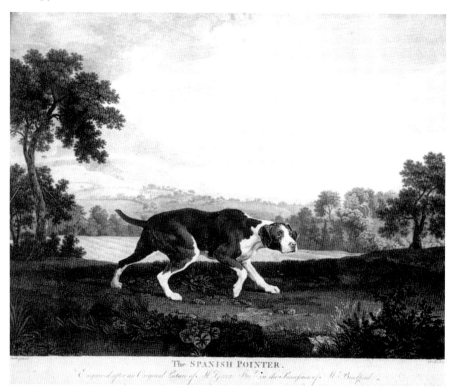

WOOLLETT, William. 'The Spanish Pointer', after G. Stubbs, 1768.

R.M. Meadows (q.v.) and was then employed colouring engraved facsimiles of R. Westall's (q.v.) drawings. In 1808 he superintended for a short time the engraver's department at Wedgwood's Etruria; he then settled in London.

£500.
'*Francis Duckenfield Astley and Harriers*', after B. Marshall, 1809, 21¼ x 25in/55 x 63.5cm, £600-£900 prd. in col.
'*Eight Representations of Shooting*', after R. Frankland, 1813, with C. Turner (q.v.), 5½ x 8in/14 x 20.5cm, etching with aq., set £600-£1,200 col.
Small portraits and bookplates, including pl. by his father, small value.

WOODS, John fl. mid-19th century
Line engraver of small bookplates including architectural views after his contemporaries. He lived and worked in London.
German views £5-£10.
Others small value.

WOODTHORPE, Vincent fl. 1794-1824
Line and stipple engraver of portraits and military subjects after his contemporaries.
'*The Landing of the Lord Mayor, etc., at Greenwich, on Their Way to Blackheath to Present Colours to the Several Regiments of Loyal London Volunteers*', after W. Burney, 1805, 8¾ x 17in/22 x 43cm, £50-£90.
'*The Battle before Alexandria*', after F. Drummond, 1802, 9 x 17¼in/23 x 44cm, £50-£90.
Portraits and bookplates small value.

WOOLLARD, Dorothy E.G., R.E 1886-1986
Painter, mezzotint, aquatint and stipple engraver of portraits, etcher of landscapes and architectural views. A pupil of R.E.J. Bush and F. Short (qq.v.), she lived and worked in London.
£30-£70.

WOOLLETT, William 1735-1785
Celebrated etcher and line engraver of landscapes, topographical views, naval, military, historical, sporting, religious, classical and genre subjects and portraits after his contemporaries and Old Master painters. Born at Maidstone, he was a pupil of J. Tinney (q.v.) and also studied at St. Martin's Lane Academy. He began his career engraving bill heads, cartouches, vignettes, etc., and went on to produce typical mid-18th century country house views. In the 1760s, however, he began engraving large landscape plates after Richard Wilson, George Smith of Chichester and others and was commissioned by J. Boydell (q.v.) to engrave 'Niobe', after Wilson. This became one of the most popular plates in the 18th century and it set the seal on Woollett's success. He later went on from engraving landscapes to sporting subjects and historical dramas.
'*The Destruction of the Children of Niobe*, after R. Wilson, 1761, 18¾ x 23½in/47.5 x 60cm, £150-£300.
'*The Spanish Pointer*', after G. Stubbs, 1768, 17½ x 22¼in/4.5 x 56.5cm, £700-£1,400.
'*Shooting*', after G. Stubbs, 1769-71, 4 pl., 17½ x 21½in/44.5 x 55cm, set £1,500-£3,000.
'*Charles II Landing at Dover*', after B. West, with W. Sharp (q.v.), 1789, 19½ x 24½in/49.5 x 62cm, £100-£200.
'*The Death of General Wolfe*', after B. West, 18¾ x 24¼in/47.5 x 61.5cm, £150-£250.
'*Celadon and Amelia*' and '*Ceyx and Alcione*', both after R. Wilson, 17¼ x 22in/45 x 55.5cm, pair £250-£300.
'*The Cottagers*' and '*The Jocund Peasants*', after C. Dusart, 1765 and 1767, 20 x 15in/51 x 38cm, pair £30-£70.
'*View of the Royal Dockyard at Deptford*', after

'*His Majesty's Harriers*', after R.B. Davis, 1815, 22 x 26in/56 x 66cm, £600-£900 prd. in col.
'*John Corbet and his Foxhounds*', after T. Weaver, 1814, 2½ x 25½in/54.5 x 65cm, £300-

R. Paton and J.H. Mortimer, 1775, 19¼ x 26¼in/50 x 66.5cm, £500-£600.
English country house views, ave. 14½ x 21in/37 x 53.5cm, £80-£200.
Views in Switzerland £60-£120.
Bibl: Fagan, *Catalogue Raisonné of the Engraved Works of W.W.*, 1885.

WOOLNOTH, Thomas 1785-c.1841
Stipple and line engraver of portraits, religious subjects and architectural views after his contemporaries and Old Master painters. Most of his work consists of small portraits and bookplates.
'Uniform of First Regiment of Foot Guards', 1808, 13½ x 10¼in/34.5 x 27.5cm, £100-£160 col.
Religious subjects, small portraits and bookplates small value.

WOOLNOTH, William 1770-1835 or later
Line engraver of landscapes and architectural views after his contemporaries. He was probably related to T. Woolnough (q.v.). Most of his work consists of small bookplates.
'Fashion at the Coronation of King William IV and Queen Adelaide', after G. Cattermole, c.1831, 19 x 23in/48.5 x 58.5cm, £100-£200.
'View on the North Side of Kangaroo Island', after W. Westall, 1814, 10½ x 14¼in/26.5 x 37.5cm, £150-£300.
Small bookplates small value.

WORLIDGE, Thomas 1700-1766
Portrait painter, etcher of portraits and figure subjects after his contemporaries, Old Master painters and his own designs. Born in Peterborough, he was a pupil of A.M. Grimaldi and L.P. Boitard (q.v.) and worked in Bath and then in London from 1740. Modelling his style on that of Rembrandt, he both copied directly the latter's etchings, such as 'Christ Healing the Sick' (the 'Hundred Guilder Print'), or used one of his compositions for a contemporary portrait, such as 'Sir Edward Astley as the Burgomaster Jan Six'. He is also known for a set of prints, published in 1768: 'Drawings from Curious Antique Gems'. He worked mainly with drypoint rather than etching. Later in life he lived in Bath, but died in Hammersmith.
The 'Hundred Guilder Print', after Rembrandt, 1758, 15½ x 11in/39.5 x 28cm, £20-£40.
'Installation of the Earl of Westmorland as Chancellor of the University of Oxford in 1761', 16 x 20in/40.5 x 51cm, £150-£250.
'Sir Edward Astley as Burgomaster Jan Six', 1765, 9¼ x 11in/23.5 x 28cm, £30-£80.
Various HL portraits and vignettes small value.
'Drawings from Curious Antique Gems', 1768, first states on satin, set of 182 £600-£1,000; individual plates small value, except self-portrait £40-£90.

WORTHINGTON, William Henry
 c.1795-c.1839
Line engraver of portraits, antiquities, and religious, historical and allegorical subjects after his contemporaries and Old Master painters. He was born in London. Most of his work consisted of small bookplates.
Lge. pl. £20-£80.
Add more if in fine contemporary frame.
Small bookplates small value.

WRAY, P. fl. late 18th century
Line and stipple engraver of small portraits and bookplates after his contemporaries.
Small value.

WRIGHT, John Buckland. 'Combat', 1942, line engraving.

WRIGHT, H. Boardman, A.R.E. 1888-1915
Etcher of landscapes and architectural views. He was born in Hammersmith.
£8-£20.

WRIGHT, John I fl. 1769-71
Painter and mezzotint engraver of portraits after his contemporaries and his own designs.
£15-£50.
CS lists 7 pl.

WRIGHT, John II c.1770-1820
Miniature painter, soft-ground etcher and stipple engraver of sporting and decorative subjects after his contemporaries, Old Master painters and his own designs. He was perhaps also the etcher of pl. after A.Buck, aquatinted by C.Ziegler (q.v.).
'Foxhunting', after G. Morland, 1794-5, 6 pl., 13¼ x 16¼in/35 x 41.5cm, soft-ground etchings, set £1,400-£2,000 col.
'Boy and Pigs', after G. Morland, 14 x 20in/35.5 x 51cm, soft-ground etching, £15-£30.
'A Pottery (in India)', stipple, 17½ x 24in/44.5 x 61.5cm, imp. col. fetched £800 May 1995.
'Sir Rayner' and 'Tambourine', after Buck with Ziegler, e. £150-£250 prd. in col.
Small portraits and bookplates small value.

WRIGHT, John Buckland 1897-1954
Painter, illustrator, etcher and wood engraver of figure subjects. Born at Dunedin in New Zealand, he taught himself to paint. He lived and worked in London and taught engraving at Camberwell School of Arts and Crafts from 1948. He illustrated several private press books before World War II, particularly for the Golden Cockerel Press.
£100-£250

WRIGHT, R. L.
 fl. late 18th/early 19th century
Aquatint engraver of fat cow illus. in col. (page 72).
£500-£1,000 col.

WRIGHT, Thomas 1792-1849
Painter and stipple engraver of portraits after his contemporaries and Old Master painters. Born in Birmingham, he was apprenticed to H. Meyer (q.v.) and then worked for four years for W.T. Fry (q.v.). In 1822 he went to St Petersburg to engrave George Dawe's portraits of the Russian Royal family and generals. Returning to England in 1826, he engraved plates for 'Lodge's Portraits', 'Mrs. Jameson's Beauties of the Court of Charles II' and other works. He set out again for Russia in 1830 and ended up staying fifteen years during which time he published *La Russe Contemporain* after his own designs. He died in London.
Small portraits and bookplates of small value.

WRIGHT, W fl. early 19th century
Etcher and aquatint engraver.
'Portrait of a Shropshire Pig', after W. Gwynn, 13 x 16in/33 x 41cm, £400-£600.

WYLLIE, Harold b.1880
Painter and etcher of marine subjects. Born in London, the son of W.L. Wyllie (q.v.), he was a pupil and unsuccessful imitator of his father. He lived in Portsmouth and later in Perthshire.
£60-£120.

WYLLIE, William Lionel, R.A., R.E. 1851-1931
Well-known painter, etcher and aquatint engraver of marine, coastal and river subjects. Born in London, he studied at Heatherly's and at the R.A. Schools. He lived in Portsmouth and died in London. His prints have recently regained the popularity which they enjoyed during his lifetime.
'The Pyramids from the Nile' £140-£200.
Yachting subjects and London and Newcastle views £200-£500.
Others mainly £80-£300.

WYLLIE, William Lionel. 'The Pyramids from the Nile'.

YEATES, N. fl. late 17th century

Line engraver of portraits, frontispieces and book illustrations.
Pl. for R. Blome's Gentlemen's Recreation, after various artists, 1686, 4to., e. £10-£30.
Other bookplates, portraits and frontis. small value.

YEATHERD, John 1765-1795

Portrait painter, mezzotint engraver of portraits and decorative subjects after his own designs and those of his contemporaries. He entered the R.A. Schools in 1788 and was a pupil of V. Green (q.v.).
'Morning, Cottagers Going Out Haymaking' and 'Evening, the Return From the Fair', after F. Wheatley, approx. 22 x 26in/56 x 66cm, pair £800-£1,200 prd. in col.
Portrait of Queen Charlotte, 15 x 3¼in/3 x 8.5, £100-£150.
3 male portraits e. £15-£40.
CS lists 3 male portraits, noted above.

YEATS, Jack Butler 1871-1957

Irish painter and wood engraver of landscapes and genre scenes. Born in London, the son of the artist John Butler Yeats and brother of the poet W.B. Yeats, he studied at Westminster School of Art. He was later Governor and Guardian of the National Gallery of Ireland, wrote several books and lived in Dublin. He often coloured by hand with watercolour impressions of his wood engravings.
£100-£300.

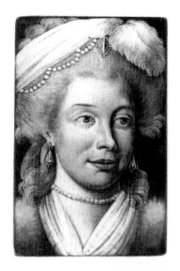

YEATHERD, John. Portrait of Queen Charlotte.

YOUNG, John 1755-1825

Prominent mezzotint engraver of portraits and decorative subjects after his contemporaries and Old Master painters. A pupil of John Raphael Smith (q.v.), he lived and worked in London. He was appointed Mezzotint Engraver to the Prince of Wales in 1789. He died in Upper Charlotte Street, Fitzroy Square, after a long illness.
'Coach Horses' after G. Garrard, 1798, 18½ x 23½in/47 x 59.5cm, £500-£800.
'The Stray'd Child' and 'The Stray'd Child Restored', both after J. Ward, former by B. Pym (q.v.), 1798, 19 x 24in/48.5 x 61cm, pair £500-£800 prd. in col.

'Thomas Cribb, the British Champion' (boxer), after D. Guest, 1811, 22 x 17in/56 x 43cm, £300-£500.
'Richard Humphreys, the Celebrated Boxer', after J. Hoppner, 1788, 22¾ x 17in/58 x 43cm, £300-£500.
'Thomas King as Puff in The Critic', after J. Zoffany, 1803, 23 x17in/58.5 x 43cm. Other male WLs mostly £80-£160.
'Christ Giving Sight to the Blind', after H. Richter, 24 x 30in/61 x 76cm, £20-£40.
'The Gypsy Fortune Teller', after W. Beachey, 1792, 23 x 27in/58.5 x 68.5cm, £60-£120.
'Lady Anne Lambton and Family (Domestic Happiness)', after J. Hoppner, 1799, 25¾ x 18¾in/65.5 x 47.5cm, £300-£500 prd. in col. Other female WLs £200-£400.
'The Goose with the Golden Eggs' and 'The Boy Disappointed of His Treasure', after R.M. Paye, 1790, 24 x 17½in/61 x 44.5cm, pair £300-£500 prd. in col.
'The Fisherman', after G. Morland, 1800, 15¼ x 18in/38.5 x 45.5cm, £150-£250.
'The Flower Girl' and 'The Watercress Girl', by John Raphael Smith, both after J. Zoffany, 1785, with 'The Grape Girl' and 'The Oyster Girl', both after J.G. Huck, 1786, all approx. 15 x10¾in/38 x 27.5cm, 2 pairs, e. pair £300-£400.
'Portraits of the Emperors of Turkey', 1815, 31 pl., fo., e. £300-£600 prd. in col., set prd. in col. fetched £29,000 July 1992.
'The Happy Cottagers' and 'The Beggar Boy', after J. Rising, 1802, 16¾ x 19in/42.5 x 48.5cm, pair £150-£250.
Various male and female HLs £15-£50.

YOUNGMAN, John Mallows 1817-1899

Painter and etcher of landscapes. A pupil of Henry Sass, he worked at Saffron Walden, Essex, and later settled in London. Richmond and Richmond Park form the subject matter of many of his etchings.
£5-£15.

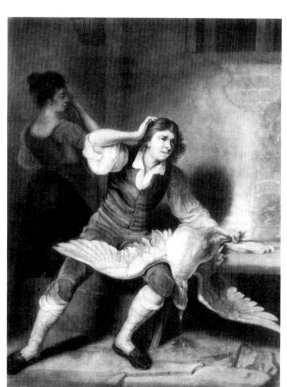

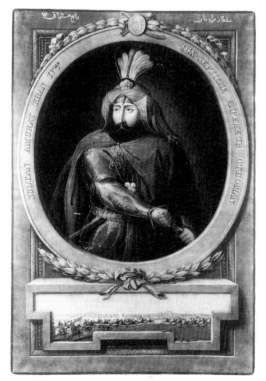

YOUNG, John. 'The Boy Disappointed of His Treasure', pair with 'The Goose with the Golden Eggs', after R.M. Paye, 1790.

YOUNG, John. 'Sultan Amurat Khan IVme, Dix Septième Empereur Othoman', from 'Portraits of the Emperors of Turkey', 1815.

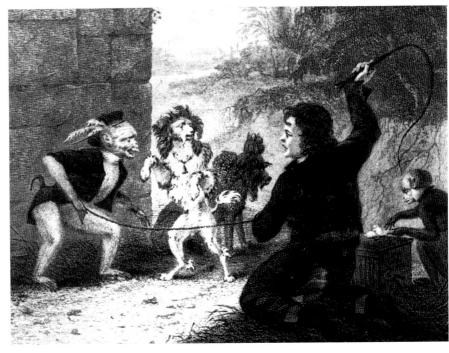

ZEITTER, John Christian d.1862
German landscape and genre painter who settled in England and became naturalised. He produced a few prints.
'Don Quixote', after H.T. Alken (his father-in-law), 1831, 13 pl., fo., etchings, e. £6-£12.
'Robert Burns', after A. Naismith, 16 x 12¼in/40.5 x 32.5, mezzo., £15-£40.
'Senor Paulo, the Clown', 6½ x 5in/16.5 x 12.5cm, litho., £4-£10.
'The Dancing Lesson', 1827, after E. Landseer, 7¾ x 9¾in/19.5 x 25cm, £10-£20.

ZIEGLER, Conrad c.1770-1810
Swiss-born aquatint engraver of decorative and military subjects after his contemporaries. He studied under C.Gessner (q.v.), and was active in London by 1796.
'Military Evolutions', after Gessner, with J.Bluck (q.v.), 1799-1803, 30 pl., set £5,000-

ZEITTER, John Christian. 'The Dancing Lesson', 1827, after E. Landseer.

£7,000 col.
'Sir Rayner' and 'Tambourine', after A. Buck, with J. Wright II (q.v.), e. £150-£250 col.

ZIEGLER, Henry Bryan 1793-1874
Portrait and landscape painter who etched a series of views of Ludlow. These are some of the earliest examples of steel engraving.
6 views of Ludlow, 1826, obl. fo., set £150-£300.
'View of Worcester Race Course and Grand Stand', aq. by G. Hunt, 1823, 12½ x 22¼in/32 x 58cm, £1,500-£2,500 col.
'Samson Overcome by the Philistines', 6½ x 9¾in/16.5 x 25cm, £30-£60.

ZOBELL, James George
 1792-1879 (?1812-1881)
Line, mezzotint and mixed-method engraver of portraits and historical, sporting, animal and sentimental subjects after his contemporaries and 18th century British painters. He lived and worked in London.
'Still for a Moment', after J.E Millais, 1876, £100-£200.
'Laying Down the Law', after E. Landseer, 21 x 20½in/53 x 52.5cm, £100-£160.
'Elizabeth, Duchess of Bedford', after R. Buckner, 24 x 15½in/61 x 39.5cm, and portraits of similar size, £30-£80.
'Wild Cattle of Chillingham', after E. Landseer, 1873, 13½ x 19½in/34.5 x 50cm (reduced size), and other reduced size versions of Landseer's works, £60-£160.
'Coming from the Horse Fair', after Rosa Bonheur, 1875, 19¾ x 42in/50 x 106.5cm, and other sentimental, historical and genre subjects of similar size, £40-£120.
Add more if in fine contemporary frame.
Small portraits and vignettes small value.

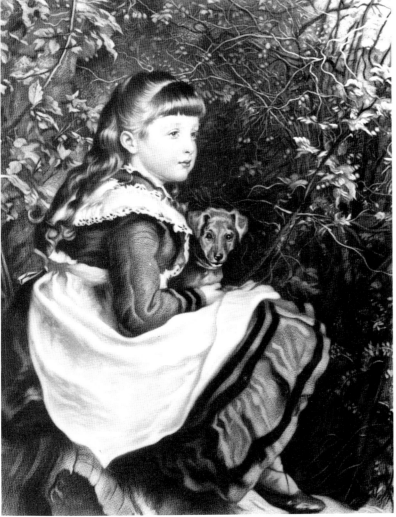

ZOBELL, James George. 'Still for a Moment', after J.E. Millais, 1876.

Bibliography

Abbey, J.R., *Life in England in Aquatint and Lithography 1770-1860*, 1953.

Abbey, J.R., *Scenery of Great Britain and Ireland in Aquatint and Lithography 1770-1860*, from the library of J.R. Abbey, London, 1952.

Abbey, J.R., *Travel in Aquatint and Lithography 1770-1860*, 2 vols., 1956, 1957.

Beck, H., *Victorian Engravings*, London, 1973.

Bénezit, E., *Dictionnaire critique et documentaire des Peintres, Sculpteurs, Dessinateurs et Graveurs*, 8 vols., revised edn., Paris, 1976.

Bryan, M., *Biographical and Critical Dictionary of Painters and Engravers*, revised by G.C. Williamson, 5 vols., London, 1903-4.

Calloway, Stephen, *English Prints for the Collector*, 1980.

Carey, F. & Griffiths, A., *Avante-Garde British Printmaking, 1914-1960*, London, 1990.

Chaloner-Smith, J., *British Mezzotint Portraits*, 4 vols., London, 1878-83.

Colnaghi & Co. Ltd., P. and D., *Original Printmaking in Britain 1600-1900*, 1972.

Coppel, S., *Linocuts of the Machine Age, Claude Flight and the Grosvenor School*, Aldershot, 1995.

Daniell, F.B., *A Catalogue Raisonné of The Engraved Works of Richard Cosway, R.A.*, London, 1890.

Dolman, B., *A Dictionary of Contemporary British Artists*, 1929, reprinted 1981.

Dunthorne, G., *Flower and Fruit Prints of the 18th and Early 19th Centuries*, Washington, 1938.

Engen, R.K., *Dictionary of Victorian Engravers, Print Publishers and Their Works*, Cambridge, 1979.

Engen, R., *Pre-Raphaelite Prints: The Graphic Art of Millais, Holman Hunt, Rossetti and their Followers*, London, 1995.

Fitzwilliam Museum, *The Print in England 1790-1930*, Cambridge, 1985.

Garton, R. (editor), *British Printmakers, 1855-1955*, Devizes, 1990.

Godfrey, R.T., *Printmaking in Britain*, Oxford, 1978.

Grant, Col. M.H., *Catalogue of British Etchers*, 1952.

Guichard, K.M., *British Etchers: 1850-1940*, London, 1977.

Hamilton, J., *Wood Engraving & the Woodcut in Britain, c.1890-1990*, London, 1994.

Hunnisett, Basil, *A Dictionary of British Steel Engravers*, Leigh-on-Sea, 1980.

Lane, C., *Sporting Aquatints and their Engravers*, 2 vols., Leigh-on-Sea, 1978, 1979.

Le Blanc, C., *Manuel de l'Amateur d'Estampes*, 4 vols., Paris, 1854-89.

Lister, R., *Great Images of British Printmaking*, 1978; *Prints and Printmaking: A Dictionary and Handbook of the Art in Nineteenth-Century Britain*, 1984.

Mallalieu, H., *The Dictionary of British Watercolour Artists up to 1920*, vol. I – The Text, vol. II – The Plates, Woodbridge 1976 and 1979.

Man, F.H., *Lithography in England, 1801-10*, in Prints, C. Zigrosser, New York, 1963.

O'Donoghue, F.M., and Hake, H.M., *Catalogue of Engraved British Portraits in The Department of Prints and Drawings, British Museum*, 6 vols., London, 1908-25.

Ogilby, Army Museum's Ogilby Trust, compiler and publisher, *Index to British Military Costume Prints 1500-1914*, London, 1972.

Parker, H., *Naval Battles from the Collection of Prints Formed and Owned by Commander Sir Charles Leopold Cust, Bt.*, London, 1911.

Print Collector's Quarterly (Campbell Dodson editor), London, 1912-1936, (J. Bender Editorial Director), Kansas City, U.S.A., 1937-42.

Redgrave, R., *Dictionary of Artists of the English School*, revised edn., 1878.

Russell, C.E., *English Mezzotint Portraits and their States*, 2 vols., London, 1926.

Siltzer, F., *The Story of British Sporting Prints*, London, revised edn., 1929.

Slater, J.H., *Engravings and their Value*, London, 1929.

Stephens, F.G., *Catalogue of Political and Personal Satires in the British Museum*, vols. I-IV, 1870-83; George, M. Dorothy, vols. V-VII, 1935-8.

Thieme, Ulrich, and Becker, Felix, *Allgemeines Lexikon der Bildenden Künstler*, 37 vols., Leipzig, 1907 *et seq.*

Tooley, R.V., *English Books with Coloured Plates 1790-1860*, 1973.

Twyman, M., *Lithography 1800-1850: The techniques of drawing on stone in England and France and their application in works of topography*, London, 1970.

Wilder, F.L., *How to Identify Old Prints*, 1969; *English Sporting Prints*, 1974.

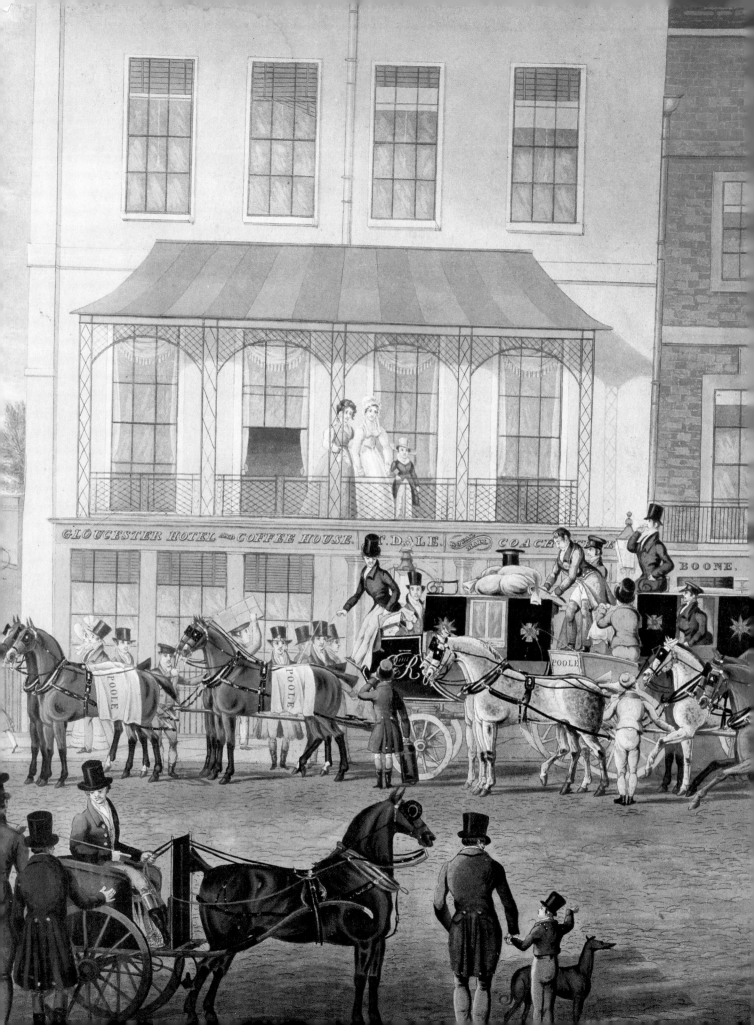